THE AGE OF CARAVAGGIO

THE AGE
OF CARAVAGGIO

The Metropolitan Museum of Art
New York
Electa International

This catalogue has been published in conjunction with the exhibition held at The Metropolitan Museum of Art, New York, February 5–April 14, 1985, and at the Museo Nazionale di Capodimonte, Naples, May 12–June 30, 1985.

The exhibition, organized by The Metropolitan Museum of Art and the Museo Nazionale di Capodimonte, has been supported by a generous grant from the National Endowment for the Humanities, which was matched by FMR, the magazine of Franco Maria Ricci; The Real Estate Council of The Metropolitan Museum of Art; and by an anonymous donor. Alitalia has been designated by The Metropolitan Museum of Art as the official carrier of the exhibition. An indemnity has been granted by the Federal Council on the Arts and Humanities.

Library of Congress Cataloging in Publication Data

Main entry under title:

The Age of Caravaggio.

Catalog of an exhibition held Feb.–April, 1985 at the Metropolitan Museum of Art, and May–June, 1985 at the Museo Nazionale di Capodimonte, Naples.

Bibliography: p.
1. Painting, Italian—Italy—Rome—Exhibitions.
2. Painting, Baroque—Italy—Rome—Exhibitions.
3. Caravaggio, Michelangelo Merisi da, 1571–1610—Exhibitions. 4. Painting, Italian—Italy, Northern—Exhibitions. I. Metropolitan Museum of Art (New York, N.Y.) II. Museo e Gallerie Nazionali di Capodimonte (Naples)

ND620.A36 1985 759.5'074'01471 84–25386

ISBN 0–87099–380–1 (hardcover)
ISBN 0–87099–382–8 (paperback)

Bradford D. Kelleher, Publisher
John P. O'Neill, Editor in Chief
Ellen Shultz, Editor,
with the assistance of John Daley,
Laura Hawkins, and Emily Walter
Translations by Keith Christiansen,
assisted by Carmen Gómez-Moreno,
Alison Luchs, and Susan Taylor
Design and layout by
Marcello Francone and F. G. Confalonieri
of Electa Editrice

Front cover / jacket:
Caravaggio. *The Sacrifice of Isaac* (detail).
Galleria degli Uffizi, Florence
(See catalogue number 80)

In memory of Roberto Longhi
(1890–1970)

Contents

8 Foreword
 by Philippe de Montebello

10 Acknowledgments

11 Organizers of the Exhibition

12 Lenders to the Exhibition

13 Contributors and Note to the
 Catalogue

15 **Introductory Essays**

17 The Roman World of Caravaggio:
 His Admirers and Patrons
 by Luigi Salerno

22 The Critical Fortune of a Realist
 Painter
 by Richard E. Spear

28 Caravaggio Today *by Mina Gregori*

49 **Caravaggio's Precursors in
 North Italy**

89 **Caravaggio's Contemporaries in
 Rome and Naples**

197 **Caravaggio**

355 **Bibliography and Photograph
 Credits**

Foreword

In May 1982, The Metropolitan Museum of Art and the Ministero per i Beni Culturali e Ambientali signed an agreement initiating a series of collaborative exhibitions marking an exchange between this institution and Italian national museums. It was suggested by the late Raffaello Causa, Soprintendente per i Beni Artistici e Storici in Naples, that the first exhibition should be devoted to the work of Caravaggio. This proposal was warmly welcomed by the Metropolitan Museum. Acting jointly with the Soprintendenza in Naples, a committee of international specialists was formed to give the exhibition a focused structure that would at once reflect current scholarship and add significantly to our perceptions of Caravaggio. The result is "The Age of Caravaggio"—which attempts to present the visitor with an unparalleled survey of painting during Caravaggio's lifetime, thereby permitting the artist to be seen in his historical context.

The first major exhibition devoted to Caravaggio was the great "Mostra del Caravaggio e dei Caravaggeschi" held at the Palazzo Reale in Milan in 1951. It was a landmark on several counts: First, because it brought together the largest group of works by or attributed to Caravaggio —just under sixty paintings—that has ever been assembled. Caravaggio's three canvases from San Luigi dei Francesi, the two paintings from the lateral walls of the Cerasi Chapel in Santa Maria del Popolo, the Madonna di Loreto from Sant'Agostino, Rome, and the Raising of Lazarus and the Adoration of the Shepherds from Messina—in short, an incomparable and perhaps unique representation of Caravaggio's altarpieces— provided a singular testimony to his achievement. Not surprisingly, public consciousness of Caravaggio's artistic stature can be traced to this single exhibition. But scarcely less important was the seminal effect of the exhibition on Caravaggio scholarship. A quick glance at the bibliography of the most recent monograph on the artist reveals that more has been published about Caravaggio in the last three decades than during the preceding three hundred and fifty years. Moreover, whereas what had been written during the centuries following Caravaggio's death was frequently censorial or, at best, lukewarm in its criticism, a dramatic shift has taken place, and Caravaggio is now accorded a pivotal position as one of the truly revolutionary figures of European painting.

The Milan exhibition was organized by Roberto Longhi, the foremost Italian art critic of our century and Caravaggio's most eloquent apologist, and it dealt not only with Caravaggio, but with his influence on seventeenth-century painters—among them the Caravaggisti in Rome as well as artists as removed by time and place as Georges de La Tour and Rembrandt. This established the general format for such subsequent exhibitions as "Le Caravage et la peinture italienne du XVIIᵉ siècle" at the Louvre in 1965, "Caravaggio e Caravaggeschi nelle gallerie di Firenze" at the Palazzo Pitti in Florence in 1970, and "Caravaggio and His Followers" at The Cleveland Museum of Art in 1971. However, since 1951, research on Caravaggio has taken a decisive turn. Not only would we now tend to draw a tighter circle around those artists directly influenced by Caravaggio's work—this matter is addressed by Richard Spear in his introduction to the Cleveland exhibition catalogue—but our understanding of the artist's development has been altered substantially in a number of respects. Documentary discoveries have provided new evidence for the dating of his paintings and for an understanding of his working habits; even his birth date (1571 rather than 1573) and the year in which he arrived in Rome (1592/93 rather than 1589) have been affected, to say nothing of the discovery of the documents relative to his work in San Luigi dei Francesi. Biographical information about Caravaggio's patrons, both private and ecclesiastical, has radically altered our perception of the cultural circles in which the artist moved, spurring a round of sometimes bafflingly complex and contradictory iconographic readings of his paintings. Caravaggio's relationship to the art of his contemporaries has also been investigated with renewed intensity. Finally, there is the discovery, or rediscovery, of documented paintings by Caravaggio—The Musicians, The Martyrdom of Saint Ursula, and The Crucifixion of Saint Andrew are but three examples included in the present exhibition—that have, in turn, provided grounds for the attribution of other works to the master: No one now would subscribe to the restricted catalogue that Friedlaender and others upheld in the 1950s. In all of these respects, the Caravaggio we know today differs substantially from the figure of thirty years ago, and this change is manifest and tangible in the present exhibition.

The first decision made by the organizing committee was that work by Caravaggio's followers, as a category, should be excluded. Not only had Caravaggism, as a theme of the earlier exhibitions mentioned above, been adequately explored, but it also sheds little light on Caravaggio's development and his relation to his contemporaries (Caravaggism as a movement only developed in the decade following the artist's death). The novelty of the present exhibition resides precisely in its

focus on Caravaggio's relationship to his precursors and his contemporaries. Caravaggio's Lombard origins, as well as Bellori's attestation that Caravaggio visited Venice, have been given full weight in an introductory section to the exhibition. Another area that has been the focus of recent scholarship, Counter-Reformation painting (by which is meant work by those artists patronized by the new orders of the Catholic reform—the Capuchins, the Theatines, the Oratorians, and the Jesuits—and by some of its most outstanding individuals, such as Saints Charles Borromeo and Filippo Neri, and the church historian Cesare Baronio), is the subject of a further section. A number of these Counter-Reformation artists are familiar only to specialists, but they constituted the artistic establishment when Caravaggio arrived in Rome, a completely unknown figure, in 1592/93, and he specifically singled out some of them for praise (his own term was "valenthuomini"). Still another section is given over to the cousins Ludovico and Annibale Carracci, whose reform of painting in Bologna along naturalistic lines predates Caravaggio's earliest certain works by more than a decade and may well have exerted a determining influence on his development. Annibale came to Rome just two years after Caravaggio, and his work there—which evolved along opposing lines—is also amply documented. Still another section of the exhibition presents a representative selection of the most prominent younger artists active in Rome and Naples during Caravaggio's lifetime. Paintings by Rubens, Elsheimer, Guido Reni, Domenichino, Orazio Gentileschi, and Carlo Saraceni, among others, provide an index of the rich diversity of styles in Rome—the art capital of Europe—prior to 1610, and, incidentally, shed light on the nascent Baroque style. The visitor will come upon Caravaggio's paintings in this historical context, and it is hoped that an awareness of Caravaggio's relationship to his forebears and contemporaries will add to a heightened and more profound understanding of the works of this revolutionary genius—for every artist, no matter how great and inventive, is, to some extent, the product of his times.

Fame is usually acquired at a price, and Caravaggio's modern celebrity is no exception. The altarpieces that traveled to Milan in 1951 and to Paris in 1965 have been deemed by the Italian ministry to be too important to be lent to the present exhibition. This means, of course, that the most signal aspect of Caravaggio's career in Rome—those public altarpieces on which so much of his contemporary fame and notoriety was based—cannot be represented here. For the organizing committee, this seemed an irreparable loss, but it is one that any future exhibition devoted to Caravaggio will have to confront as well.

A special word should be said about the author of the catalogue entries on Caravaggio's work. Professor Mina Gregori was a pupil of Roberto Longhi, and assisted him in the organization of the Milan exhibition of 1951. She is, moreover, the leading expert on Lombard painting of the sixteenth century and has made fundamental contributions to our understanding of Caravaggio. It is, again, to Professor Causa's credit that, on behalf of the organizing committee, he was able to persuade her to undertake the arduous task of writing this major part of the catalogue—which she has carried out in so exemplary a manner.

Finally, I would like to extend my personal thanks to the organizing committee, and to the private individuals and public institutions who have made "The Age of Caravaggio" possible. The Museum is exceedingly grateful to the National Endowment for the Humanities for its generous support of the exhibition. Their grant was matched by FMR, the magazine of Franco Maria Ricci; The Real Estate Council of The Metropolitan Museum of Art; and an anonymous donor. In addition, Alitalia has offered its services as the official carrier of the exhibition. An indemnity has been granted by the Federal Council on the Arts and Humanities.

Philippe de Montebello
Director

9

Acknowledgments

Work on this exhibition began in earnest some two years ago, and during that time a number of debts have been incurred. The first is to Sir John Pope-Hennessy, Consultative Chairman of the Department of European Paintings, to the late Raffaello Causa, Soprintendente per i Beni Artistici e Storici, Naples, and to the members of the organizing committee and the lenders to the exhibition, whose names are listed on these pages. I owe special thanks to Erich Schleier, Pierre Rosenberg, and Richard Spear for their exceptional interest in the exhibition, their advice in areas where my own knowledge was sadly deficient, and their intervention in securing key loans of works of art. My colleagues in Naples, Nicola Spinosa, Soprintendente Reggente, and Mariella Utili, have worked unstintingly—frequently under very difficult circumstances—to assure the success of this exhibition. Contributors to the catalogue have been quick to respond to my queries, and a debt of gratitude is owed them for the remarkable entries they produced, sometimes on short notice. Among the many who should be thanked for a variety of favors are Mia Cinotti; Giuliana Guidi; Laura Giovannini; Rossella Foggi; Luisa Bandera; Diana Scarisbrick; and Paola Bracco of the Fortezza da Basso, Florence; John Brealey and his staff of the Conservation Department at the Metropolitan Museum; Joyce Plesters, Principal Scientific Officer at the National Gallery, London; Maurizio Seracini of E.Di.Tech, Florence; and the curatorial staffs of lending institutions, who have responded to numerous queries and requests.

In every exhibition a good deal of work involves loan arrangements, insurance, and transportation. These tasks have been carried out by John Buchanan, Registrar, in his customary thoroughness, and by Herbert Moskowitz, Senior Associate Registrar. Among the numerous others who have made this exhibition possible, I should mention, in Naples, Piero Avallone, and at the Metropolitan Museum, James Pilgrim, Deputy Director; Ashton Hawkins, Vice President, Secretary, and Counsel; Emily Rafferty, Vice President for Development; Richard Morsches, Vice President for Operations; Linda Sylling, Assistant Manager for Operations; and Joseph Volpato, Security Manager. The design of the exhibition was carried out under the guidance of Maureen Healy.

The production of the catalogue, of unusual complexity, was facilitated by Bradford Kelleher, Vice President and Publisher; John P. O'Neill, Editor in Chief and General Manager of Publications; and Massimo Vitta Zelman and Carlo Pirovano of Electa Editrice, Milan. The exceptionally complicated editorial work on this catalogue was carried out with remarkable competence by Ellen Shultz, Editor, who was ably assisted by John Daley and Emily Walter. Laura Hawkins undertook the arduous task of coordinating the various bibliographies. It is doubtful that any catalogue would have appeared without the efforts of Gabriella Borsano, Editor at Electa Editrice, who has seen to countless details and specifications in an exemplary way. Further thanks are due Roxanne Robbin, who was a summer intern in the Department of European Paintings, and Carol Weingarten.

My debt to Professor Mina Gregori is of a different order, not only because the catalogue entries she has written far exceeded expectations, but because through it all she has remained both a colleague and a friend.

Keith Christiansen
Coordinator of the exhibition
at The Metropolitan Museum of Art

10

Organizers of the Exhibition

Organizing Committee

the late Raffaello Causa, Soprintendente per i Beni Artistici e Storici, Naples

Sir John Pope-Hennessy, Consultative Chairman, Department of European Paintings, The Metropolitan Museum of Art

Nicola Spinosa, Soprintendente Reggente per i Beni Artistici e Storici, Naples

Keith Christiansen, Associate Curator, Department of European Paintings, The Metropolitan Museum of Art

Mariella Utili, Ispettore Storico dell'Arte della Soprintendenza per i Beni Artistici e Storici, Naples

Executive Committee

Dante Bernini, Soprintendente per i Beni Artistici e Storici, Rome

Carlo Bertelli, former Soprintendente per i Beni Artistici e Storici, Milan

Luciano Berti, Soprintendente per i Beni Artistici e Storici, Florence and Pistoia

the late Raffaello Causa, Soprintendente per i Beni Artistici e Storici, Naples

Michele d'Elia, Soprintendente per i Beni Artistici e Storici, Matera

Philippe de Montebello, Director, The Metropolitan Museum of Art

Sir John Pope-Hennessy, Consultative Chairman, Department of European Paintings, The Metropolitan Museum of Art

Consultative Committee

Giuliano Briganti, Professor, Università degli Studi, Siena

Jonathan Brown, Professor, Institute of Fine Arts, New York

Maurizio Calvesi, Professor, Università degli Studi, Rome

Charles Dempsey, Professor, The Johns Hopkins University, Baltimore

Oreste Ferrari, Direttore dell'Ufficio Centrale per il Catalogo e la Documentazione, Ministero per i Beni Culturali e Ambientali, Rome

Sydney J. Freedberg, Chief Curator, National Gallery of Art, Washington, D.C.

Giuseppe Galasso, Professor, Università degli Studi, Naples

Mina Gregori, Professor, Università degli Studi, Florence

Julius S. Held

the late Howard Hibbard, Professor, Columbia University, New York

Irving Lavin, Professor, Institute for Advanced Study, Princeton

John Rupert Martin, Professor, Princeton University

Alfonso Pérez Sánchez, Director, Museo del Prado, Madrid

Donald Posner, Professor, Institute of Fine Arts, New York

Pierre Rosenberg, Conservateur en Chef, Département des Peintures, Musée du Louvre, Paris

Luigi Salerno

Erich Schleier, Curator, Gemäldegalerie, Staatliche Museen Preussischer Kulturbesitz, Berlin-Dahlem

Richard E. Spear, Professor, Oberlin College, Oberlin, Ohio

Lenders to the Exhibition

Austria
Vienna: Kunsthistorisches Museum

France
Douai: Musée de la Chartreuse
Orléans: Musée des Beaux-Arts
Paris: Musée du Louvre
Rouen: Musée des Beaux-Arts
Sens: Musée Municipal

Germany
Berlin-Dahlem: Staatliche Museen
Preussischer Kulturbesitz, Gemäldegalerie
Braunschweig: Herzog Anton
Ulrich-Museum
Darmstadt: Hessisches Landesmuseum
Frankfurt am Main: Historisches Museum
Stuttgart: Staatsgalerie

Great Britain
Edinburgh: The National Gallery
of Scotland
London: Italian Embassy; National
Gallery; Private collection
Northumberland: His Grace the Duke
of Northumberland, K.G.; Alnwick Castle
Oxford: The Governing Body,
Christ Church

Italy
Bologna: Pinacoteca Nazionale
Carpineto Romano: San Pietro
Cremona: Pinacoteca del Museo Civico
Florence: Palazzo Pitti, Galleria Palatina;
Palazzo Vecchio; Galleria degli Uffizi
Genoa: Galleria di Palazzo Rosso
Milan: Pinacoteca di Brera; San Fedele;
San Paolo
Naples: Banca Commerciale Italiana;
Museo Nazionale di Capodimonte;
Quadreria dei Girolomini
Prato: Cassa di Risparmio e Depositi
Rome: Chiesa dei Cappuccini; Galleria
Borghese; Galleria Doria-Pamphili;
Galleria Nazionale d'Arte Antica, Palazzo
Barberini; Galleria Nazionale d'Arte
Antica, Palazzo Corsini; Galleria Spada;
Pinacoteca Capitolina; Private collection;
San Marco; Santa Maria in Vallicella
(Chiesa Nuova); Santi Nereo ed Achilleo
Urbino: Galleria Nazionale delle Marche
Venice: Gallerie dell'Accademia;
Santo Stefano

The Netherlands
Amsterdam: Rijksmuseum

Spain
Madrid: Museo del Prado; Real Academia
de San Fernando
Montserrat (Barcelona): Museu

Switzerland
Lugano: Thyssen-Bornemisza collection;
Private collection

U.S.A.
Atlanta: The High Museum of Art
Baltimore: Walters Art Gallery
Chicago: The Art Institute of Chicago
Cleveland: The Cleveland Museum of Art
Detroit: The Detroit Institute of Arts
Hartford: Wadsworth Atheneum
Kansas City: The Nelson-Atkins Museum
of Art
Malibu: The J. Paul Getty Museum
Memphis: The Brooks Memorial Art
Gallery
New York: E. V. Thaw and Co., Inc.;
The Metropolitan Museum of Art
Richmond: Virginia Museum of Fine Arts
Washington, D.C.: National Gallery of Art

Contributors
to the Catalogue

K. A.	Keith Andrews
D. B.	Dante Bernini
C. B.	Carlo Bertelli
G. B.	Giulio Bora
M. C.	Miles Chappell
K. C.	Keith Christiansen
C. D.	Charles Dempsey
M. T. F.	Maria Teresa Fiorio
M. G.	Mina Gregori
M. J.	Michael Jaffé
A. M.	Alfred Moir
A. O. C.	Anna Ottani Cavina
D. S. P.	D. Stephen Pepper
A. P. S.	Alfonso Pérez Sánchez
W. R. R.	W. Roger Rearick
P. R.	Pierre Rosenberg
H. R.	Herwarth Röttgen
L. S.	Luigi Salerno
E. S.	Erich Schleier
R. S.	Richard Spear
N. S.	Nicola Spinosa
S. Z.	Silla Zamboni
A. Z.	Alessandro Zuccari

Note to the catalogue
Within each section, artists are listed
alphabetically. Paintings are arranged
chronologically under each artist.
The Caravaggio section includes paintings
by, after, or attributed to Caravaggio.

Introductory Essays

The Roman World of Caravaggio: His Admirers and Patrons

Luigi Salerno

Today, a great deal more is known about the cultural environment in which Caravaggio worked. Not only has modern research provided information about his patrons, but inventories of the collections of the men who acquired his paintings have become available. Arriving in Rome in 1592, Caravaggio discovered important developments in the artistic world. That January, a new pope, Clement VIII Aldobrandini, was elected; his papacy coincided almost exactly with Caravaggio's presence in the eternal city. To the incomparable tradition offered by the ancient and Renaissance monuments was added the potential of a new "rinascita," sparked by exceptional patronage; in five short years, from 1585 to 1590, Sixtus V had made a considerable beginning, and Clement intended to follow in his path. This activity attracted artists to Rome from every country in Europe.

One of the distinctive features of ecclesiastical life in Rome was a return to Christian origins and a concomitant revival of the art of mosaics. At Saint Peter's, monumental projects in mosaic were undertaken in the Cappella Clementina, under the direction of Cristoforo Roncalli (Pomarancio), and in the cupola, by the Cavaliere d'Arpino. The promoter of this revival, which met with Clement's approval, was Cardinal Cesare Baronio. In 1592, Alessandro and Giovanni Alberti were called to the city to fresco the Lateran sacristy (completed in 1594). They received many commissions during Clement's reign and initiated the use of perspectival illusionism (*quadratura*)—so important for Seicento painting.

Caravaggio, who was trained in Lombardy and had neither experience with nor sympathy for large-scale decoration, made a good choice when he succeeded in becoming an assistant to the Cavaliere d'Arpino, who, along with Federico Zuccari and Pomarancio, was one of the three most fashionable artists. Arpino was almost the same age as Caravaggio and the two may have shared some similarities of character. Although Arpino was not yet well known, he was favored by Clement and, more than any other artist, he painted small-scale pictures for private collectors. This was a type of painting that was not yet in vogue, but at which the young Lombard painter felt confident.

The Accademia di San Luca, previously merely a guild for painters, was reestablished in 1593 to regulate artistic life. In November, Federico Zuccari became its *Principe* and thereafter sought to give the organization a theoretical and didactic bent by introducing discussions on his theory of *disegno*—as opposed to the concept of *colore* recently sustained in the treatise of Caravaggio's compatriot, Giovanni Paolo Lomazzo (the treatise appeared in 1590). The protector of the *Accademia* was Cardinal Federigo Borromeo, a noted art-lover. When Borromeo was appointed Archbishop of Milan in 1596, his former position was taken over by the collector Cardinal Francesco Maria del Monte and by the elderly Cardinal Gabriele Paleotti, a participant at the Council of Trent and the author of the well-known treatise *Discorso intorno alle immagini sacre*, in which a set of standards for artists was prescribed.

Another novelty was occasioned by the presence in Rome in 1593 of Jan Brueghel of Velours, a specialist in small-scale paintings of flowers and landscapes. With few exceptions, mostly in the work of Northern painters, landscape and flowers were only subordinate elements in mural painting. Brueghel's work, however, met with success, and it is perhaps not coincidental that the first cabinet picture by Paul Bril, who frequently painted murals, dates from 1594 and that only later did he begin to paint on copper and canvas with greater frequency. Cardinal Borromeo—who owned the still life by Caravaggio now in the Ambrosiana, Milan—was an ardent admirer of Brueghel's work. The artist was a guest of the Cardinal in Milan and even after the Fleming's return to Antwerp Borromeo continued to commission paintings from him. Borromeo also purchased paintings by Bril. This new interest in cabinet pictures after about 1593 marked a true change in taste.

Official commissions—for Saint Peter's and for other major basilicas in the city—were awarded to the most traditional-minded artists, who were also preferred for academic posts. Generally, however, the clergy had no single preference, and certain religious orders, such as the Oratorians, the Franciscans, and the Carmelites, sought a simple, human—in short, a naturalistic—sort of art. Scipione Pulzone was popular—his portraits were also highly appreciated—and it is significant that, as Baglione (1642, p. 34) reports, he had "a falling out with Federico Zuccari over matters of art and no longer wanted to frequent the Accademia di San Luca." Barocci's *Visitation* (cat. no. 17), with its spirit of domesticity and of everyday life, must have appeared exceptional when it was installed in the Chiesa Nuova in 1586. It was both admired and revered by Saint Filippo Neri and the Oratorians, who, in 1593–94, commissioned Barocci to paint the *Presentation in the Temple* (it was only delivered in 1603). In 1594, Cardinal Odoardo Farnese brought Annibale Carracci to Rome. Annibale was the artist who, in Baglione's words

(1642, p. 109), revived "the good method of coloring after life, a practice that in these days had lost its proper path." Barocci's commission, Brueghel's success, and the summoning of Annibale to Rome attest to a growing interest in a type of painting that spoke with a spirit of truth. This worked in Caravaggio's favor—the more so in that private patronage was, by its nature, more liberal and tolerant, and the hedonistic intellectualism of the new connoisseurs incited them to discover young talent and to appreciate even a small painting of a landscape or of flowers.

However, the intellectual life of this aristocracy was still dominated by the antique, by intellectual conceits, and by symbolism, all of which had come increasingly into favor in the course of a Mannerist-dominated Cinquecento. Music, theater, literature, and poetry were especially important. Caravaggio's apprenticeship with the Cavaliere d'Arpino served to introduce him into this cultivated society, for Arpino belonged to one of the many private associations in Rome, the Accademia degli Insensati (so named because its members wished to deny the experience of the senses in order to give themselves up to the contemplation of the celestial and the divine). Among its members was Torquato Tasso, who had been invited to Rome in 1594 by the pope and Cardinal Pietro Aldobrandini to be crowned on the Capitoline. Other members of the Insensati included the poet Aurelio Orsi, brother of Prospero (a painter of grotesques, an assistant to the Cavaliere d'Arpino, and a close friend of Caravaggio), Cardinal Carlo Emanuele Pio, the poet Giovanni Battista Lauri, and Maffeo Barberini, who continued to write poetry even after his election as Pope Urban VIII in 1623. It is certain, then, that these men were in direct contact with Caravaggio, and that some of them penned verses about his paintings or composed songs (*Academicorum Insensatorum Carmina,* of 1606) on poetic themes analogous to those treated in his pictures. The influence of literature on painting is evident if one considers what the writings of Tasso and the pastoral dramas so much in vogue at the time contributed to the development of landscape painting. The "Insensati" were exponents of "concettismo" (or literary conceits); both Gaspare Murtola and G. B. Marino wrote verses about Caravaggio's paintings, and Marino commissioned Caravaggio to paint his portrait (now lost). These writers constantly praised the perfect imitation of reality in paintings, and in their madrigals they tried to present vivid images—both pictorial and real—with an implicit moral lesson summarized by a motto, since they were convinced that metaphor would lend nobility to their discourses. Caravaggio was influenced by the group of men dominated by Cesare Ripa and by Andrea Alciati—who would never have accepted a painting that simply portrayed everyday reality—and he sought to ennoble his models by incorporating a moral lesson in each picture (frequently in Northern and North Italian painting the motto was inscribed on the painting itself). In his early works, Caravaggio—like these poets—alluded to the disappointments of the sensory world, the disillusionment of youth, and to eternal poetic themes. Significantly, these symbolic intentions were soon forgotten, and, indeed, ignored for centuries, so compelling are Caravaggio's representations of his model. If Caravaggio maintained that the painting of flowers required the same mastery as the painting of figures, he intended this in a technical and stylistic sense, for he did not grant to these two genres the equality that we do today. Caravaggio's first pictures sold for very little. Alessandro Vittrici acquired the *Fortune Teller* for a few *giulj*. It is worth mentioning that a later print of the same subject, inscribed with the motto Fur, Demon, Mundus, is dedicated to the Cavaliere d'Arpino. In addition, an X-ray of the Capitoline version of Caravaggio's painting (perhaps left incomplete, and finished by someone else), has revealed an image by Arpino underneath—proof that the canvas came from his studio. Did Arpino perhaps invent the theme? In any case, these youthful half-length figures soon captured the admiration of collectors, prompting Baglione's bitter remark that Caravaggio "was paid more for his individual figures than others for history paintings." Caravaggio's first great admirer and patron was Cardinal Francesco Maria del Monte, a fervent supporter of the new music (with its naturalistic bias) and the new science (based on an examination of nature and an empirical methodology). At a time when alchemy was freeing itself from magic and was beginning to approximate modern chemistry, Del Monte kept an alchemist's study, where he experimented with pharmacology and medicine. The Cardinal's brother, Guidubaldo, published a number of treatises on mechanics, mathematics, and perspective, and both men were in touch with Galileo. That the discoveries of Galileo were of interest to painters can be concluded from the well-known correspondence between the scientist and Cigoli. In Del Monte's inventory compiled in 1627, eight paintings by Caravaggio are listed.

Artists who, from the time of Leon Battista Alberti to

that of Leonardo, had defined their work in scientific terms now did so in relation to poetry, and sought other goals, such as beauty and moral instruction, emphasizing the ancient notion of the affinity of painting to poetry (*ut pictura poësis*). Although Caravaggio followed this tendency, he was alone in positioning himself on the side of the new men of science, rejecting tradition and basing his work on nature alone. He did not indulge in technical experimentation but, instead, concerning himself with the object to be depicted, and referring to it as his sole point of departure, he was convinced that for painters truth lay in the rendering of the tangible world (he would have included the subjective emotions in his definition of the tangible). The development of this point of view, the stylistic evolution toward a new articulation of space and a new concept of light and shade, as well as interest in music and a literary bent incorporating an ideal of androgynous physical beauty (considered by some critics as a type of eroticism), are factors that relate to the cultural stimuli Caravaggio could have experienced in the circle of Cardinal del Monte between 1596 and 1600.

Caravaggio's other patrons during these years were financiers and bankers whose attitudes toward life were as positivistic as those of the new scientists. These men included Ottavio Costa, banker to the pope, who purchased Caravaggio's *Judith and Holofernes, The Stigmatization of Saint Francis*, and *The Conversion of the Magdalen* (cat. nos. 74, 68, 73), among other works; Vincenzo Giustiniani, a Genoese nobleman, who owned the *Amor Vincit Omnia* (cat. no. 79) as well as twelve other paintings by Caravaggio listed in the 1638 Giustiniani inventory; and Ciriaco Mattei, whose collection included at least five paintings by Caravaggio.

In the decade between 1590 and 1600, another change in current tastes occurred. Almost for the first time, the lateral walls of a chapel were decorated not with frescoes, but with paintings on canvas, a practice that would become common (among the few earlier examples are Girolamo Muziano's paintings in Santa Maria in Aracoeli, Rome). In 1599, Santi di Tito, Cigoli, and Passignano sent paintings to Rome for the lateral walls and the altar of a chapel in San Giovanni dei Fiorentini. The same year, Caravaggio was commissioned to paint his canvases for the lateral walls of the Contarelli Chapel (the initial plan had been to decorate them with frescoes). Caravaggio's first public commission was completed by July 4, 1600, and aroused great interest, as demonstrated by the episode of Federico Zuccari's visit to the chapel and by his reaction: "Io non ci vedo

altro che il pensiero di Giorgione" ("I see nothing here beyond the idea of Giorgione")—an allusion to the well-known controversy between *disegno* and *colore*. Contrary to the teachings of Zuccari, Caravaggio did not draw, but, as Mancini reports, painted directly on the canvas from a live model in artificial light; to make corrections, he repainted, as the X-rays of the *Martyrdom of Saint Matthew* have revealed. His success was immediate: About two months later Tiberio Cerasi commissioned two paintings from him for the lateral walls of his chapel in Santa Maria del Popolo, while the altarpiece was entrusted to Annibale Carracci. Thus, the two most important painters in Rome were brought together in the same place: Annibale, who had just finished the ceiling of the Palazzo Farnese, and Caravaggio, who had just completed the Contarelli paintings. Even on this occasion Caravaggio was uncertain as he undertook "historie" (full-length figures in action), and he found it necessary (or was he constrained?) to redo the compositions on canvas (the first versions were on panel). Cardinal Giacomo Sannesio, a perceptive collector, acquired the original versions of the commission—a course of action that was often repeated in the years to come (Vincenzo Giustiniani obtained the first, rejected version of Caravaggio's *Saint Matthew*). Setting aside the controversial reasons for the frequent rejection of completed altarpieces, it should be emphasized that both Caravaggio and Annibale were excluded from the much sought-after official commissions, which were awarded, instead, to the "reformed" or transitional Mannerist artists. For example, from 1601 to 1605, commissions for the large altarpieces for Saint Peter's (later copied in mosaic, and now almost all lost) were given to Francesco Vanni, Passignano, Lavinia Fontana, and Cigoli, as well as to Roncalli (Pomarancio), Cesare Nebbia, and even Baglione. A confrontation between Caravaggio and the "reformed" Tuscan painters seemed inevitable, and, indeed, G. B. Cardi recounts how Monsignor Massimi commissioned Caravaggio, Passignano, and Cigoli each to paint an *Ecce Homo*—without informing them of the participation of the other two. Cigoli's rendering (cat. no. 35) was preferred. In point of fact, Caravaggio was paid very little for his work: 200 *scudi* for a major picture for a church, 150 *scudi* for the *Saint Matthew*, and only 75 *scudi* for the *Madonna dei Palafrenieri*. On February 16, 1608, Eleonora Gonzaga, Duchess of Mantua, complained that Rubens had valued a painting by Pomarancio at 400 gold *scudi*; she had paid only 300 *scudi* for Caravaggio's *Death of the Virgin*, which had

been refused by the church of Santa Maria della Scala. Early sources refer to Annibale Carracci's mental depression at the token appreciation that his work received, and we can assume that Caravaggio suffered from more serious neuroses and conflicts arising from professional rivalry.

It is not known whether Giustiniani in some way influenced Caravaggio's first public commissions, but, in fact, these works show a change in style. Giustiniani had equal admiration for the antique, the Renaissance, and his contemporaries: in his collection Caravaggio and Guido Reni held the same position of importance. Giustiniani's one reservation was about the use of excessive realism—and he preferred noble and religious themes to genre painting. In line with these preferences, Caravaggio abandoned his own predilection for naturalistic detail, which had given his early works a "genre" character, and he created religious pictures infused with classical monumentality and nobility, avoiding the accentuated realism that would later typify the paintings of Ribera and of certain Northern artists.

Among collectors, sympathy for the work of Caravaggio did not exclude admiration of other painters as well. Caravaggio's most faithful partisans and his closest followers were a few artists who, about 1600, were converted to his novel manner of painting. For some, such as Gentileschi and Baglione, the change in style was abrupt. Of these artists, the most important was Elsheimer who, in Rome in 1600, developed a Caravaggesque sensibility to the fullest degree in his small-scale paintings, experimenting with the use of light and shadow even in the depiction of landscape, water, and nocturnal starlit skies. The relationship—perhaps only coincidental—between this pictorial vision and the telescope that, in these same years, enabled Galileo to observe the stars and the lunar craters, has been pointed out. In addition, confirming evidence for Caravaggio's contact with the scientific circle of Del Monte is provided by Elsheimer's friendship with Johannes Faber, and the almost certain fact that the German artist knew Del Monte, since a number of his paintings were in the Cardinal's collection. Moreover, a direct contact between Elsheimer and the Caravaggisti is attested by Gentileschi's *Saint Christopher* (cat. no. 41) and by the possible collaboration between the Caravaggesque painter Saraceni and Elsheimer's follower, Jacob Pynas, on the *Icarus* series in Naples (see cat. no. 58), which was, for a time, attributed to Elsheimer himself. It was not only the German

Elsheimer ("Adamo tedesco") who approached Caravaggio's style, but also the Fleming Rubens, "Cecco del Caravaggio" (a sobriquet for a foreigner), the so-called Pensionante del Saraceni (perhaps a Frenchman), and the Spaniard Juan Bautista Maino; for the most part, they were non-Italians who initiated what was to become an international Caravaggesque movement.

Caravaggio obtained still other private commissions for altarpieces for family chapels. These were invariably carried out in oil on canvas (in 1605, Caravaggio was offered 6,000 *scudi* by Principe Doria to fresco a gallery, but he refused). The Vittrici family, who owned a number of paintings by Caravaggio, commissioned the *Entombment* for the Chiesa Nuova (the Oratorians favored the new naturalism in painting); the Cavalletti commissioned the *Madonna di Loreto* for Sant'Agostino, Rome; and the jurist Laerzio Cherubini commissioned the *Death of the Virgin* for the Carmelite church of Santa Maria della Scala. The Carmelites also favored naturalism, although in 1607 Caravaggio's altarpiece was rejected—evidently by higher authorities. Through the intervention of Rubens, it was purchased by the Duke of Mantua. That the rejection of the altarpiece was not due to lack of appreciation of its pictorial qualities is demonstrated by the fact that it was exhibited for one week for the admiration of the "università delli pittori."

Caravaggio's difficulties with the law increased soon after the election of Pope Paul V Borghese on May 16, 1605. Twelve days later, he was arrested for bearing dangerous arms (in 1607, the Cavaliere d'Arpino was imprisoned for the same reason: possession of a harquebus). The "cardinali della fabbrica" of Saint Peter's ordered the *Madonna dei Palafrenieri* removed within a few days of its installation; it was initially transferred to the church of Sant'Anna dei Palafrenieri, and then, having been definitively rejected by the Arciconfraternita, it was sold on June 14, 1606, to Cardinal Scipione Borghese. The following year, the pope granted Scipione Borghese paintings sequestered from the Cavaliere d'Arpino, among which were a number of early works by Caravaggio. Thus, it is clear that there existed two distinct standards for judging paintings, by which those deemed unsuitable for public display might nonetheless be highly valued for a private collection.

It is not known who commissioned the *Madonna of the Rosary* (Kunsthistorisches Museum, Vienna) which Caravaggio tried to sell in Naples in 1607 with the aid of his foreign friends, Abraham Vinck, Frans Pourbus,

and Louis Finson. It was finally purchased by Finson (who painted a number of copies of Caravaggio's pictures) after an unsuccessful offer to the Duke of Mantua. The painting was taken to Antwerp and, upon Finson's death, Rubens, together with a committee of experts, was called upon for an appraisal. Even at this time, Caravaggio was not without success. He not only received commissions from such private patrons as Tommaso de Franchis, for the *Flagellation* (cat. no. 93) but from an institution such as the Pio Monte della Misericordia, which brought together the best of the Neapolitan aristocracy, and from the Viceroy of Naples, Juan Alonso Pimentel y Herrera for whom he painted the *Crucifixion of Saint Andrew* (cat. no. 99). Caravaggio also enjoyed great fame in Malta, where the Grand Master, Alof de Wignacourt, made him a Knight of the Order of Malta. Yet, while his art gave him entrée into the palaces of viceroys and rulers, Caravaggio's life-style had the opposite effect—as his subsequent imprisonment and flight from the island demonstrates. Still, in Sicily—where, perhaps, he was able to hide the fact that he was a fugitive—Caravaggio obtained the commission from the senate of Messina for the *Adoration of the Shepherds*, and a wealthy Genoese merchant commissioned the *Resurrection of Lazarus*. In Palermo, another religious order devoted to poverty, the Franciscans, obtained a picture from him. As previously in Rome, Caravaggio's presence was a revelation for the local painters of Naples (Carlo Sellitto and Caracciolo) and of Sicily (Alonso Rodriguez). In short, Caravaggio was not a rebel confronting polemically those painters whom subsequent historiographers have contrasted with him. He was, in fact, a friend of the Cavaliere d'Arpino and, during the libel suit of 1603, he judged Annibale Carracci, Pomarancio, and even Zuccari "valenthuomini" (good painters). Only in the decade following his death, and that of Annibale and of Elsheimer—in 1609 and 1610—did their followers form truly opposing camps. With Domenichino and, on a theoretical plane, Giovanni Battista Agucchi, classicism was affirmed in opposition to the numerous international Caravaggesque painters. When, about 1620, Giulio Mancini wrote his *Considerazioni sulla pittura*, and the first biography of Caravaggio—taking from artists the exclusive prerogative as critics and historians of painting that they claimed—almost all of the Caravaggisti had left Rome and classicism was in the ascendance. When one of Caravaggio's first admirers, Maffeo Barberini—who had experienced the vicissitudes of art and culture in Rome during these years—became Pope Urban VIII in 1623, he set in motion yet another change, promoting a kind of visual orchestral poetry that reconciled realism, classicism, and fantasy. The advent of the Baroque signaled the glory of the Roman Church, but also the condemnation of Caravaggio for almost three centuries.

The Critical Fortune of a Realist Painter
Richard E. Spear

No painting included here would have personally interested Roberto Longhi more than the *Boy Bitten by a Lizard* (cat. no. 70), considering that the great expert owned and published one of the two best versions of this startling work—and no picture included here more clearly mirrors the varied reactions to Caravaggio's art, from van Mander's time onward. Many of these responses were collected and published by Longhi himself in his valuable series of notes entitled "Alcuni pezzi rari nell'antologia della critica caravaggesca."[1] Hence, the focus of this *piccolo omaggio storiografico a Roberto Longhi.*[2]

It is fair to take the physician Mancini's brief reference to the *Boy Bitten by a Lizard*, penned about 1620, as typical of much seventeenth-century interpretation of Caravaggio's work. "He painted for sale a boy who cries out because he has been bitten by a lizard that he holds in his hand," is what the amateur art historian-critic specifically wrote about the image, although it is the sort of picture he had in mind when he also noted, "it cannot be denied that for single figures, heads, and coloration [Caravaggio] attained a highpoint, and that artists of our century are much indebted to him."[3] In one of the most prophetic passages from among all the early writings on Caravaggio and his followers, Mancini further observed, "this school . . . is closely tied to nature, which is always before their eyes as they work. It succeeds well with one figure alone, but in narrative compositions and in the interpretation of feelings, which are based on imagination and not direct observation of things, mere copying does not seem to me to be satisfactory."

Baglione (1642) reacted no differently to Caravaggio's marvelous realism: "[Caravaggio] painted a boy bitten by a lizard . . . you could almost hear the boy scream, and it was all done meticulously." In a similar fashion, the German painter and art scholar Joachim von Sandrart, writing a few decades later, limited his remarks to pointing out that in one of Caravaggio's early half-lengths, there is "a child with a basket full of flowers and fruit, out of which a lizard bites him on the hand, making him seem to cry bitterly, which is wonderful to see, and it made his reputation grow notably all over Rome." Many of the earliest authors had heard what Mancini put so succinctly, and they savored recounting stories to prove it so, namely that "Caravaggio was a very odd person and his eccentricities served to shorten his life." In essence, his irascibility and devotion to Nature as a model, and the consequent assumed weakness of his inventions as "history paintings," are the

recurring, dominant leitmotifs in seventeenth-century literature. That he "lacked the necessary basis for good design" and was wanting in "decorum," as the doctor from Forlì, Francesco Scannelli, wrote (1657), was especially disturbing to Caravaggio's most thorough and learned early biographer, Giovanni Pietro Bellori, whose life of the artist (1672), the most detailed before the twentieth century, codified earlier attitudes and laid the foundation for two more centuries of "official" thought (or, as Longhi colorfully put it, "Italian critics of Caravaggio slid into the quagmire of Bellori's 'Idea' and remained there croaking at him until neoclassic times").[4]

Bellori does not happen to say anything about the *Boy Bitten by a Lizard* in particular, although his critical position is perfectly clear and much more reasoned than the earlier diatribe by Vincencio Carducho (1633). For that Florentine-born Spaniard, Caravaggio was an "evil genius, who worked naturally, almost without precepts, without study, but only with the strength of his talent . . . the coming of this man to the world was an omen of the ruin and demise of painting . . . this anti-Michelangelo, with his showy and superficial imitation, his stunning manner, and liveliness, has been able to persuade such a great number and variety of people that this is good painting . . . that they have turned their backs on the true way."[5] In contrast to Carducho's view, Bellori recognized the painter's talent and historical importance ("Caravaggio advanced the art of painting, for he lived at a time when realism was not much in vogue and figures were made according to conventions and *maniera*, satisfying more a taste for beauty than for truth").

Bellori nonetheless persuasively developed what writers such as G. B. Agucchi had initiated, the classicist's attack on the painter's unforgivable breaches of decorum ("Michele's work often degenerated into common and vulgar forms"), and on his disregard for "academic" procedures and disrespect for the Old Masters ("he lacked *invenzione*, decorum, *disegno*, or any knowledge of the science of painting . . . it seems that he imitated art without art"). Theoretically, this meant that any concept of "ideal beauty" was repudiated by Caravaggio, and, still worse, that the very status of painting as a liberal, rather than manual, art—as a manifestation of the mind rather than the hand—was threatened ("the moment the model was taken from him, his hand and mind became empty. . . . Caravaggio suppressed the dignity of art, everybody did as he pleased, and what followed was contempt for beautiful

things, the authority of antiquity and Raphael destroyed").

None of these seventeenth-century writers, including the poet G. B. Marino (1620) and Cardinal Federigo Borromeo (1625), leads us to believe that he saw more in Caravaggio's art than what meets the eye. That is, there is not a word about meaning in pictures such as the *Boy Bitten by a Lizard* (although Bellori discusses the subtle iconography of other artists), nothing about them as reflections of the artist's personality or beliefs, and no reference to the patrons' interests. A general awareness of the chronological development of the works is to be found, but exceedingly little about their stylistic antecedents. (Baglione's report that Federico Zuccari equated the *Calling of Saint Matthew*, fig. 4, p. 34, with "il pensiero di Giorgione" is a very rare exception, and it simply refers to a North Italian attitude toward picture-making.) Thus, the naturalism of Caravaggio's art was *the* critical issue of the seventeenth century, as is evident in Scannelli's praise of the *Saint John the Baptist* and the *Amor Vincit Omnia* (cat. no. 79) precisely because of their convincing mimesis. The odd man out in all of these early interpretations was the remarkably sensitive collector, Vincenzo Giustiniani, who perspicaciously saw that Caravaggio rivaled the Carracci and Guido Reni in practicing "the most perfect" of all modes of painting by combining style with nature, "without however neglecting the one or the other, as well as insisting on good design, true coloration, and appropriate lighting."

That the *Boy Bitten by a Lizard* disappeared from eighteenth- and nineteenth-century writings is symptomatic of the disdain Caravaggio's art increasingly suffered, and of the growing indifference to establishing on documentary grounds what he really painted. His plunge from critical attention took him through a negative phase to not-benign neglect. Roger de Piles, for instance, in his famous *Balance* (1708), or "scorecard," of noted painters gave Caravaggio sixteen of twenty possible points for "color" (that high ranking was due to his naturalism), but only six for "composition," six for "drawing," and zero for "expression," which de Piles measured by the standards of Bolognese art, of Charles Lebrun, and the like. This total of twenty-eight points equaled what de Piles had given to Giuseppe Cesari d'Arpino, Caravaggio's teacher, but, to make comparisons with other artists discussed in these pages, that score was less than half of what Rubens (sixty-five) and the Carracci and Domenichino earned (fifty-eight each); it was far below Barocci's forty-five and Lanfran-

co's forty-two; and it was even less than Pourbus's thirty-one. In fact, on this scale of measuring the "absolute perfection" of fifty-seven painters in all, Caravaggio was fifth from the bottom, surpassing only Giovanni Bellini, Lucas van Leyden, Palma Vecchio, and Francesco Penni.[6]

At the middle of the eighteenth century, the Venetian count and critic Francesco Algarotti called Caravaggio "the Rembrandt of Italy" (Rembrandt, however, had scored fifty on de Piles's *Balance*), but such seemingly illustrious company meant little, if anything, to the rising generation of neoclassicists. In the 1760s, Anton Raphael Mengs decided that Caravaggio "was thoroughly defective in *disegno*" and that his and his followers' pictures "make a strong impression on the senses but nothing on the spirit; they leave it as they found it." Even the astute Italian historian, Luigi Lanzi, wrote with scorn (1789) that the "features [of Caravaggio's figures] are remarkable only for their vulgarity . . . his figures inhabit dungeons." Basing his opinion on many pictures that were not actually by Caravaggio, Lanzi both misunderstood and misrepresented the artist by believing that "he appeared most highly pleased when he could load his pictures with rusty armour, broken vessels, shreds of old garments, and attenuated and wasted bodies . . . he was . . . successful in representing quarrels and nightly broils."[7]

One might suppose that the Romantic writers would have resurrected a personality as colorful and independent as Caravaggio's, or at least that his naturalism would have attracted whoever agreed with John Ruskin's advice (1843) that young painters "should go to Nature in all singleness of heart, and walk with her laboriously and trustingly, having no other thoughts but how best to penetrate her meaning, and remembering her instruction; rejecting nothing, selecting nothing, and scorning nothing."[8] Yet, throughout the nineteenth century, as judgment shifted to weigh the moral fiber of the creator as well as his work, a major criterion of merit remained ethical goodness. On these grounds, Caravaggio and his art seemed downright dangerous, and doubly damnable as the concept of Sincerity took hold and led outspoken, influential critics such as Ruskin to put the artist among the "worshippers of the depraved," and to declare, "there is *no* entirely sincere or great art in the seventeenth century."[9] Ironically, by cultural association, Caravaggio's reputation suffered the virulent attacks leveled at the Carracci, Domenichino, and Guido Reni—those very artists whose moral values had been regarded as so

much higher than Caravaggio's two centuries earlier. Occasionally, other nineteenth-century critics, writing in the decades when modern realism took hold, intimated that, despite serious shortcomings, there was something important in Caravaggio's work. As early as 1834, for example, Gabriel Lavrion reached the pre-Marxist conclusion that Caravaggio "discovered the painting of the people, the painting that could be easily understood and judged by everyone."[10] A play entitled *Caravage* was staged the same year, and a second drama and a novella appeared during the 1840s.[11] (It is telling that the painter's personality did not again stimulate biographical fiction until recently, when a play, a mystery story, and three novels based on his "romantic" life were published,[12] echoing the contemporary interest in psychoanalytic art history.) Jakob Burckhardt, writing at the time of Courbet's emergence in the 1850s, further remarked that "modern naturalism *stricto sensu* begins with the crude style of Caravaggio."[13]

The first reevaluation in earnest, however, did not occur until this century, and when it did, it came from a painter-critic who was enormously sensitive to formal values and championed the modern, anti-academic movement: Roger Fry. His astute comments, published in 1905, remain poignant to this day, although their acumen cannot be conveyed through these brief citations. It was Fry who declared that "there is hardly any one artist whose work is of such moment as [Caravaggio's] in the development of modern art . . . he was, indeed, in many senses the first modern artist; the first . . . to proceed not by evolution but by revolution; the first to rely entirely on his own temperamental attitude and to defy tradition and authority. Though in many senses his art is highly conventional . . . he was also the first realist . . . his force and sincerity compel our admiration, and the sheer power of his originality makes him one of the most interesting figures in the history of art."[14]

Concurrently, Wolfgang Kallab (1906) initiated serious art-historical research on Caravaggio by seeking to explain the painter's artistic heritage and by reopening questions of attribution.[15] Kallab was followed by Roberto Longhi, Lionello Venturi, Matteo Marangoni, and Hermann Voss. Of these pioneers of modern Caravaggio scholarship, Longhi was the most perceptive and productive. Like the first writers on Caravaggio, he was concerned with visual problems, understood the significance of the tradition of forms, and was able —with the hindsight of three centuries—to rebut the complaints of early critics. He began to emphasize

Caravaggio's roots in the Lombard tradition of *veracità pittorica* (pictorial truthfulness), which he traced from Foppa, Moroni, and Savoldo down to the Campi and Peterzano.[16] This was in distinction to Kallab and others, who stressed Venetian influences, and to Voss, who argued for Tuscan-Roman Mannerist sources. In a revealing essay on Longhi's attitudes, Giovanni Previtali has linked aspects of Longhi's critical vision to Longhi's experience of seeing Courbet's work in the Venice Biennale of 1910, and to Longhi's deep interest in the new art of real life—the film.[17] Interestingly, Roger Fry, looking at the *Conversion of Saint Paul*, exclaimed in 1922, "we see [Caravaggio's] essentially journalistic talent—what an impresario for the cinema!"[18]

It was during this phase of redefining Caravaggio's oeuvre that the groundbreaking exhibition of Sei- and Settecento painting was held in Florence at the Palazzo Pitti (1922), giving scholars their first chance to study and compare a large body of the artist's work. Shortly after, Borenius (1925) reascribed the *Boy Bitten by a Lizard* in the Korda collection to Caravaggio and Longhi (1928–29) acquired and published another version of the picture. However, the real lionization of Caravaggio occurred only in 1951, when a wide public saw the "Mostra del Caravaggio e dei Caravaggeschi" in Milan. (Berenson's Zuccaresque insistence two years later that, "apart from his technical innovations, [Caravaggio] betrays nothing startlingly new, and still less revolutionary,"[19] deservedly fell on deaf ears). It was after that milestone exhibition, organized by Longhi himself, that a stream of articles and monographs poured forth in which various scholars (foremost among whom was Denis Mahon) further refined an understanding of the chronological development of the painter and his oeuvre, often on the basis of important archival research.

Nonetheless, the general thrust of Caravaggio scholarship soon was directed elsewhere. Content, rather than style, became the central issue, whether with regard to the significance of the religious paintings— which, as early as 1938 (through the writings of Pierre Francastel), had begun to be understood as inseparable from Counter-Reformation movements in the Church (W. Friedlaender, 1955, developed that view most fully and persuasively)— or of the secular pictures. In both cases, the painter's or his patron's personality was emphasized more than artistic-iconographic conventions. Hinks, for instance (1953), placed special emphasis on Caravaggio's presumed psychological

makeup. Białostocki (1955), Argan (1956), Frommel (1971), and Spezzaferro (1971) linked the works to a *Weltanschauung* variously shared by Copernicus, Giordano Bruno, Tommaso Campanella, Francis de Sales, Teresa of Ávila, Galileo, or Cardinal del Monte. Argan further applied a metaphysical-existentialist reading to Caravaggio's pictorial realism and found a vision of death replacing that of life. He, Bauch (1956), Salerno (1966), and Spezzaferro equated Caravaggio's early genre pictures with emblematic poetry, whereas Frommel (1971 a, 1971 b), Röttgen (1974), and Hibbard (1983), through Freudian analyses, interpreted the same images as the expression of an egocentric, aggressive, yet highly vulnerable and insecure homosexual. Calvesi (1971), from a radically different point of departure, saw the identical paintings as metaphors of Christian salvation, and Caravaggio's interpretation of light as the illumination of Grace and a triumph over the darkness of Sin. As a consequence, pictures such as the *Boy with a Basket of Fruit* and even the *Still Life* in Milan (cat. nos. 66, 75) have been explained by Calvesi as Christian symbols, the former of the Resurrected Christ, the latter of *vanitas*.

One only can speculate to what degree Longhi might have equated many of these contradictory analyses, or still other "structuralist" or "semeiological" views,[20] with Lanzi's earlier attitude: "poor Lanzi, he was sadly led astray by the cultural aberrations of his time."[21] Longhi admired a picture such as the *Boy Bitten by a Lizard* for many of the same reasons that Mancini and Baglione had. It seemed to him a demonstration of Caravaggio's artistic skill in capturing "the fleeting moment in which sharp pain is reflected in the boy's expression." As for the type of boy and his counterpart in the painter's other early pictures, "the simplest explanation is perhaps the most satisfactory," Longhi posited. "Since Caravaggio was poor, he certainly could not afford to pay for the various models he would have liked to employ, and hence it is not surprising that he should take advantage of the free services of friends of his own age." Expanding on Baglione's remark that Caravaggio "painted some portraits of himself in the mirror," Longhi wrote that the young artist "looked about himself, he saw the real world as solid 'pieces' where there was no place for outline, relief, or colour as abstractions. And since the field of vision of the unaided human eye may wander and go out of focus, was it not better to give reality the definition which it has in the life-like picture provided by a mirror?"[22] Chiaroscuro, too, was seen by Longhi primarily as a

function of Caravaggio's attempt to resolve artistic, not symbolic, problems, and more specifically of his ongoing investigation of "this most dramatic aspect of nature in all its complexity . . . if Caravaggio were to remain faithful to the physical world, he had to ensure that the shadows he created should seem to be the result of chance, not the effect of the human figures themselves. Only in this way could he avoid restoring to man his ancient humanist role as eternal hero and lord of creation. That is why Caravaggio devoted years of effort to his investigation of the nature of light and accidental shadows. The fact is," Longhi added, "every painter ends up by supplying society with what it requires of him, though he will, within limits, resist as best he can. At the time we are considering, history paintings of pathetic and religious subjects were the order of the day, and it was this which set Caravaggio off along a fresh path. Thus the strengthened shadows were bound to become a matter of content sooner or later; and the eye of a great painter is fortunately able to ensure that the new form affects the content of his works without delay. In this way there is a continuous reciprocal influence between art and society."[23]

Whether in response to a "crisis" of contemporary art history caused in part by a stagnation of methodology, or due to the influence of recent social developments, the *Boy Bitten by a Lizard* has become a different image from the one described by Longhi. Battisti, for example (1960), connected its theme with a poem by G. B. Lauri entitled "De Puero, et Scorpio" (1605), whose implicit message is the delusion and danger of life, although Lauri's poem actually describes circumstances quite different from those portrayed by Caravaggio. The view that the *Boy Bitten by a Lizard* not only is like a literary conceit, but understandable solely in the context of emblematic literature, was further developed by Salerno (1966) in a study of the connection between early Seicento poetry and Caravaggio's genre paintings, the conclusions of which are summarized in his essay in this catalogue. Whereas these interpretations of Caravaggio's early work as "moral lessons" reflect a broader and often fruitful tendency in recent scholarship to examine Renaissance and Baroque images in light of literary models, and to allow that the "significance" of a work for the receptor can complement its "meaning" for the creator, it is difficult not to associate the new obsession with Caravaggio's sexuality with the sexual revolution of the 1960s and Gay Liberation.

In 1971, it was argued that "the homosexual character of the figure" in the *Boy Bitten by a Lizard* is "pro-

nounced" because of "the squeamishness and effeminacy of his reaction. His hands do not tense with masculine vigor in response to the attack; they remain limp in a languid show of helplessness. His facial expression suggests a womanish whimper rather than a virile shout. These details . . . leave no doubt about the kind of youth Caravaggio represents."[24] Perhaps by post-Freudian homophobic standards there can be "no doubt," but whether a viewer in Caravaggio's time would have thought in those terms is far less clear. In light of the very meager and contradictory evidence available, one also must question that "the nature of Caravaggio's sexual tastes can hardly be questioned"; and, cutting to the heart of the matter methodologically, that "the androgynous character of the figures [is] central to the artist's intended aesthetic statement."[25] Citing Carlyle (1827) on the then-new vogue of "discovering and delineating the peculiar nature of the poet from his poetry," Abrams writes that, "for good or ill, the widespread use of literature [read, "art"] as an index—as the most reliable index—to personality was a product of the characteristic aesthetic orientation of the early nineteenth century."[26] The difficulty of appropriating Romantic procedures for evaluating pre-Romantic art is that, as Hirsch has shown—again through literary parallels—"the intended meaning of a work can *only* be established once we have decided what category or genre of literature the work in question was *intended* to belong to."[27] Gombrich's critique of Freud's study of Leonardo should be reread by those who seek to interpret Caravaggio's art through psychiatry. "The discoveries of psycho-analysis have certainly contributed to the habit of finding so many 'levels of meaning' in any given work," he observes. "But this approach tends to confuse cause and purpose. . . . What would matter in any of these cases is only that the innumerable chains of causation which ultimately brought the work into being must on no account be confused with its meaning."[28] These interpretations hardly exhaust the conflicting views of Caravaggio's work. For Calvesi, the meaning of the *Boy Bitten by a Lizard* is Christian, the androgynous appearance of the youth an intentional allusion to Love and Eternity. For Slatkes (1976), it shows the choleric temperament; for Costello (1981), it represents Touch forming part of a series illustrating the Senses;[29] and for Marini (1974), it has some unexplained, unidentifiable association with Isaiah 11:8, "And the suckling child shall play on the hole of the asp, and the weaned child shall put his hand on the cockatrice's den." What may seem to be no more than arcane arguments among scholars over what kind of animal (an amphibious salamander or a reptilian lizard, poisonous or nonpoisonous) bites Caravaggio's boy are, in fact, disproportionately important to these analyses, since Posner's homosexual must "overreact" to a "harmless" bite, Slatkes's heterosexual must "justifiably" withdraw from "real" pain and danger, and so forth. This problem results from the use by seventeenth-century authors of different words (*racano, ramarro, lucerta*)[30] to describe the animal, which disparity has led to the hypothesis that two different compositions once existed, even though such a strict reading of the early sources is hardly justified in light of their usual lack of specificity. It might be asked whether the ambiguous terminology does not suggest instead that, to the seventeenth-century eye and mind, identification of the animal was quite irrelevant.

Other problems, more significant than any of a zoological sort, beset these new interpretations of Caravaggio's iconography.[31] Too often, their premises admit a variety of textual parallels and symbolic conventions as relevant to the secular and religious pictures, without preliminary clarification of what was the artist's probable mode of thinking and, therefore, without differentiating between legitimate causation on the one hand and unintentional analogy on the other. As a consequence, one reads in the recent literature that the lizard/salamander in the *Boy Bitten by a Lizard* means deceit, a cold heart, jealousy, death, wrath, fire, passion, or warmth in love; the roses symbolize youth, pleasure, love, venereal disease, silence; the curly, scented (?) hair alludes to delicacy, lust, effeminacy; the cherries refer to spring or to lust; the bared shoulder implies *voluptas*; the middle finger signifies the *digitus impudicus*; and the figs, which are not present, have overt sexual implications. It is tempting to believe that Caravaggio would have shared Picasso's sentiments (1923)[32] that "mathematics, trigonometry, chemistry, psychoanalysis, and whatnot, have been related to Cubism to give it an easier interpretation. All this has been pure literature, not to say nonsense, which brought bad results, blinding people with theories." Caravaggio absorbed the world of art and nature around him, and, as a painter, must have interpreted it more in the artistic sense that Mancini, Baglione, Bellori, and Longhi appreciated than through the complex body of learning recently marshaled by art historians to understand it. This does not preclude the legitimacy of seeking in Caravaggio's work possible reflections of his

personality (some artists undoubtedly paint more of themselves into their work than others do), or any other unintentional, if probable, content; nor does it exclude the presence of what literary historians call intertextuality in Caravaggio's work. It only suggests that before the historian can accept any of these points of view as viable, it is incumbent on us to argue, from seventeenth-century evidence, that purposefully embedded references, recondite symbolism, secondary meanings, intentional ambiguities, etc., are compatible with the images *and* with what we think we know about Caravaggio, his probable education, and his working conditions. It is especially relevant to the meaning of the *Boy Bitten by a Lizard* to bear in mind the earliest information known about it, Mancini's report of about 1620, that young Caravaggio simply painted the picture *per vendere*, to sell on the open market (which he did, cheaply), and therefore without any patron in mind and almost surely without an iconographic advisor at hand.

1. R. Longhi, 1951.
2. In addition to Longhi's essay (cited above) on Caravaggio's reputation with critics (an issue quite different from Caravaggio's reputation among artists, who historically have tended to be more receptive to his work, as Longhi, 1968, pp. 53–58, stressed), the most important writings include M. Cutter, 1941; A. Berne-Joffroy, 1959; M. Fagiolo dell'Arco and M. Marini, 1970; L. Salerno, 1970; G. A. Dell'Acqua and M. Cinotti, 1971, pp. 164–71; Cinotti, 1973; and Dell'Acqua, 1983. Also, see the exhaustive bibliography in Cinotti, 1983.
3. For this and the other passages from Mancini, Giustiniani, Baglione, Scannelli, Bellori, and Sandrart quoted in this essay, see the original texts with parallel English translations—which are adopted here—in H. Hibbard, 1983, pp. 343 ff.
4. Longhi, 1968, pp. 54–55.
5. Translated by J. Brown, in R. Enggass and J. Brown, 1970, pp. 173–74.
6. R. de Piles, 1708, pp. 489 ff.
7. For Algarotti, Mengs, and Lanzi, see Longhi, 1951, 21, pp. 48–50.
8. J. Ruskin, 1903–12 ed., I, p. 624.
9. Ruskin, op. cit., V, pp. 56, 400; on the latter passage and Bolognese painting, see also R. Spear, 1982, p. 118.
10. Edited by G. Previtali, in Longhi, 1982, p. 8 n. 3.
11. Longhi, 1968, p. 57.
12. Michael Straight, *Caravaggio: a Play in Two Acts*, 1979; Oliver Banks, *The Caravaggio Obsession*, 1984; and Robert Payne, *Caravaggio*, 1968; Charles Calitri, *The Goliath Head*, 1972, and Linda Murray, *The Dark Fire*, 1977.

13. Dell'Acqua, 1983, p. 264.
14. Longhi, 1951, 23, pp. 48–49.
15. For the most thorough assessment of Kallab's writing, see Berne-Joffroy, 1959, pp. 31 ff.
16. In particular, see Longhi, 1928–29, 1968.
17. Previtali, in Longhi, 1982, pp. 7–30.
18. R. Fry, 1922, p. 163.
19. B. Berenson, 1953, p. 94.
20. See Dell'Acqua, 1983, pp. 279, 286 n. 14.
21. Longhi, 1968, p. 57.
22. Longhi, 1968, pp. 12, 14, 17.
23. Longhi, 1968, pp. 22, 23.
24. D. Posner, 1971, pp. 304–5.
25. D. Posner, 1971, p. 302.
26. M. H. Abrams, 1953, pp. 226–27.
27. E. H. Gombrich, 1972, p. 5, on Hirsch's position [italics mine].
28. Gombrich, 1972, p. 17.
29. My own suggestion (1971) that the *Boy with a Vase of Roses* (see cat. no. 62) may have copied a lost original by Caravaggio, which, together with the *Boy Bitten by a Lizard*, formed part of an allegorical series, rightly has been doubted, although Röttgen's and Hibbard's attribution of the *Boy with a Vase of Roses* to Baglione seems to me unlikely.
30. For detailed discussions of the animal, see L. Slatkes, 1976, and D. Posner, 1981.
31. Also see the skeptical remarks in F. Bologna, 1974; C. Brandi, 1974; Cinotti, 1983; Hibbard, 1983; and Spear, 1984.
32. H. Chipp, 1968, p. 265.

Caravaggio Today

Mina Gregori

Thirty-four years have passed since the great "Mostra del Caravaggio e dei Caravaggeschi," organized by Roberto Longhi at the Palazzo Reale in Milan in 1951. That exhibition was a unique occasion, for it gathered together, side by side, almost all of Caravaggio's paintings, copies after lost works by the master, and a selection of pictures by his followers. The exhibition provided a remarkable impetus to Caravaggio studies, and, through firsthand examination of the paintings, it enabled the personalities of individual artists to be better understood. Only a few of Caravaggio's large-scale paintings for churches could be lent to the present exhibition, yet "The Age of Caravaggio," as conceived by the late Raffaello Causa, is also an important event—and not just for scholars—for, once again, it presents the work of an artist who radicalized all the concerns and artistic problems of his time, and who, for that very reason, appears as though detached from his own epoch and closer to ours.

Beyond the overview that this exhibition provides—within the limits imposed—of Caravaggio's work, "The Age of Caravaggio" affords us the opportunity to verify the majority of paintings that have been added to the artist's oeuvre since 1951. Some of these were previously known through copies. A comparison between two versions of a composition, for which there exists no consensus as to the identity of the original, is facilitated in a couple of cases. Moreover, the exhibition may offer more positive answers to problems of attribution that earlier critics, who adopted a restrictionist point of view stemming from the polemical climate of the 1950s, left unresolved. In so doing, these critics inhibited the advancement of our knowledge of this great artist. Indeed, it is now evident that their too rigorous approach was more harmful than the proposals of the so-called "attributional expansionists," the most astute of whom—placing their faith in the verdict of history—have had the courage to make new attributions to Caravaggio. By providing the opportunity to examine the artist's paintings directly, the present exhibition will affect our attitudes toward them by prompting a reconsideration of their revolutionary novelties—not only those having to do with iconography and iconology, but also with those intimately related, but specifically pictorial, values. Partly as a result of the recent restoration of such paintings as the *Stigmatization of Saint Francis* (cat. no. 68), *The Musicians* (cat. no. 69), and the *Amor Vincit Omnia* (cat. no. 79)—presented here to a large public for the first time in their new state—and partly because of our knowledge, albeit still sketchy, of Caravaggio's working habits, we are now in a better position to evaluate these aspects of his work.

The dominant feature of Caravaggio studies in the 1950s was the discussion of the cycle of paintings in San Luigi dei Francesi (figs. 4–7, pp. 34 ff.) and their date. Roberto Longhi, Jacob Hess, and Denis Mahon were the major contributors to the debate; it was Mahon who established what remains in large part the most convincing chronology of Caravaggio's work. Since then, research has largely shifted to iconographic and iconologic analyses—an area of investigation opened up by Walter Friedlaender's monograph, of 1955—to research on Caravaggio's patrons, and to studies of the artist's personality.

Mia Cinotti's research has added a quantity of biographical material that is a major contribution to our understanding of Caravaggio's youth. However, in the present writer's opinion, this information implies a good deal more than has yet been realized. The artist was probably born in Milan in October 1571—not on September 28, 1573, as had earlier been thought—and he did not leave Northern Italy before July 1592, when he is documented in the town of Caravaggio, where his family owned property. He was then more than twenty years old—of an age when an artist's apprenticeship should already have been complete. These facts encourage a reconsideration of his youthful experiences in Northern Italy, based on the evidence of those works that he painted shortly after his arrival in Rome.

Röttgen's archival discoveries, published in 1965, have established that the contract, with an obligation of payment, for the two lateral canvases in the Contarelli Chapel in San Luigi dei Francesi was drawn up on July 23, 1599, and that the pictures were already finished by July 4, 1600. Earlier conjectures have thus been resolved and, to some extent, confirmed. The contract for the altarpiece dates from February 7, 1602. Contrary to what the diverse styles of the two versions of the *Saint Matthew and the Angel* (figs. 6, 7, pp. 36 f.) would suggest, they appear to have been painted within a short time of each other—by September 1602 or, at the latest, February 1603.

Pacelli's documentary work has further clarified Caravaggio's activity in Naples, the period that has been most enriched by recent rediscoveries of works of art. According to the proposals of Mahon and of Longhi, Caravaggio's Neapolitan period is divided into two phases. The first begins soon after the artist's flight from Rome in May 1606—between October 1606 and,

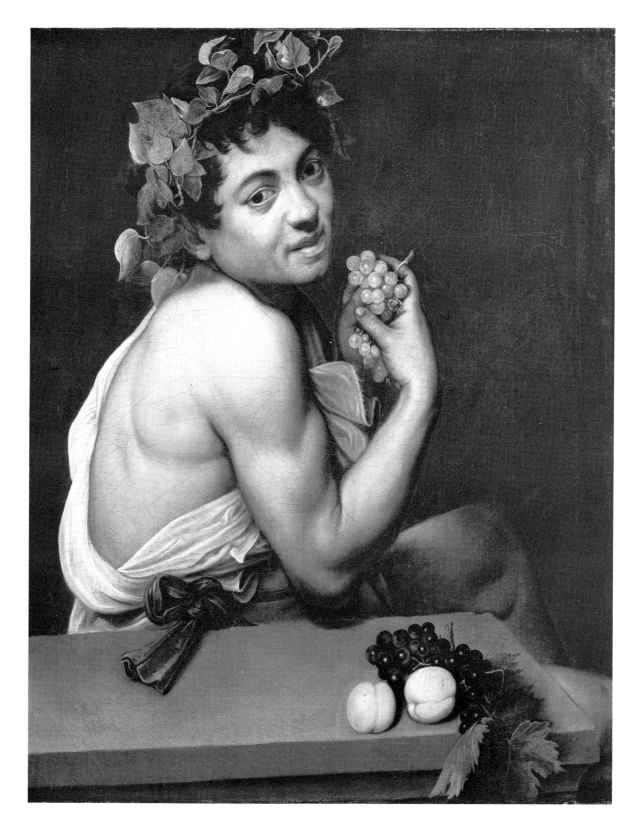

presumably, July 14, 1607; the second is marked by the artist's debarkation from Sicily prior to October 24, 1609, and his departure for Porto Ercole, where he died on July 18, 1610. Pacelli discovered documents suggesting that the *Flagellation* (cat. no. 93) should be dated to the Spring of 1607, but we now await publication of the important findings of an X-ray analysis of the picture, including the discovery that, originally, a donor was included in the picture. Pacelli has demonstrated that the *Martyrdom of Saint Ursula* (cat. no. 101), painted for Marcantonio Doria, is a late work by Caravaggio—as the present writer had suggested.

Research on Caravaggio's patrons—by Engass (in 1967), on Vincenzo Giustiniani; by Frommel and by Spezzaferro (in 1971), on Cardinal Francesco Maria del Monte; by Spezzaferro (in 1974 and 1975), on the banker Orazio Costa; and by Calvesi (in 1974–75), on the Sforza Colonna, marchesi of Caravaggio—led to an understanding of the cultural ambiance in which the artist lived and worked. Certainly most important for Caravaggio was the period of his association with Cardinal del Monte, which is attested by the works that he painted during the years in which he lived in the Cardinal's palace. However, even in this case, Caravaggio's dependence should be understood within certain limits. For example, the homosexual orientation attributed to Del Monte in the literature of the 1960s and 1970s now appears in a different light, but that does not mean that one should no longer give serious weight to this aspect of Caravaggio's personality, as have Frommel and Posner. There is, in addition, the work of Röttgen—which is anything but useless and improper—on Caravaggio's temperament as it emerges from the documents. Röttgen's observations were preceded by some suggestions in Longhi's 1952 monograph and in Hinks's study, of 1953. The indubitable relationship of Caravaggio's lifestyle to his work is evident in the strong, subjective element of the paintings, and in their apparent motivation, which varies, depending upon the period, from themes related to youth, in the early pictures, to his later concerns, which were dominated by the omnipresence of death. Nonetheless, one should avoid a determinist point of view that links Caravaggio's sense of guilt and his desire for expiation with the murder of Ranuccio Tommasoni on May 28, 1606, and that regards the works painted after the artist's flight from Rome as a manifestation of that state of mind. Caravaggio's pessimistic and troubled vision is already evident during his last years in Rome.

Caravaggio was prone to profound reflection, and he was inclined to reduce his experiences to a few principles that were valid for him. He was certainly aware of the importance of the various movements directed against Mannerist art, and of the new interest in the great masters of the High Renaissance, championed by the Carracci in Bologna shortly after 1580. In the work of the Campi in Lombardy, "maniera" was coupled with illusionism. With a precocity that should not be overlooked, a crisis caused Cremonese painters to reevaluate various tendencies within early Cinquecento art, and to restudy the works of Lorenzo Lotto and of Brescian artists. While the Campi carried on the optical and luministic experiments that derived from Lombard empiricism and the influence of Northern art, the scientific investigations of Leonardo, extending to the study of psychophysical reactions and expressions (the "moti dell'animo"), survived not only in the work of the Cremonese Sofonisba Anguisciola, but in the anecdotes of Gian Paolo Lomazzo's treatises (1584; 1590), modeled on the writings of ancient authors. Other aspects of sixteenth-century Lombard painting were nourished by the example of Giorgione. Implicitly, Caravaggio indicated Giorgione as the recognized authority and theoretical reference point—the inspiration for his method of representing nature and for painting directly from life without preparatory drawings. Caravaggio based his vision on perception and the evidence of the senses. However, his controversial statements—which, to judge from the reports furnished Carel van Mander by Floris Claesz. van Dyck, caused an uproar in Rome—recall Vasari's description of Giorgione's manner, as well as a passage in the *Dialogo della pittura* (of 1557) by the Venetian Ludovico Dolce, describing the mimetic function of painting. Quite possibly, Caravaggio found the teachings of his master, Simone Peterzano, insufferable. Nonetheless, to a degree, his sense of form in such early works as the *Boy with a Basket of Fruit* (cat. no. 66) depends from the older artist. In the contract drawn up on April 6, 1584, Caravaggio was apprenticed to Peterzano for four years. Assuming that Caravaggio completed the four-year term, what did his activity consist of between 1588 and 1592? Where did he travel? When did he move to Rome? The young artist was in Caravaggio for the sale of properties in 1589, 1590, 1591, and 1592. It is probable that, during these years, removed from the sphere of Peterzano's influence, Caravaggio followed his own inclinations and explored the places and monuments of Cinquecento Lombard painting, meeting artists associated with Lombard traditions. Follow-

ing, to some extent, the hindsighted example of the Campi, he must have studied the work of Lorenzo Lotto, and of the artists of the Brescian school—Savoldo, Moretto, and Romanino—Pordenone's works in Cremona, those of Callisto Piazza in Lodi, and the paintings of the Bergamask Giovan Battista Moroni. It is inconceivable that he did not visit Venice, the artistic capital of Northern Italy in the sixteenth century, and the one city able to oppose the supremacy of the artistic traditions of Central Italy with new methods and ideas—even on a theoretical plane.

In his biography of Caravaggio, Susinno states that Caravaggio began his career in Lombardy painting potraits, and we may, by way of extension, suppose that he also painted compositions of half-length figures, and subjects taken from Nature. The *Boy Peeling a Fruit* (cat. no. 61), the earliest of his works that we know, seems to bear this out. It is a work that displays the most advanced naturalistic tendencies of Northern Italian painting, and manifests a striking modernity. In its transparency and its study of light, it is a Lombard counterpart to the subjects painted in Bologna by Annibale Carracci and his circle—works such as the *Boy Drinking*, which is known in a number of versions (in the Van Buren Emmons collection, Hamble, Southampton, and at Christ Church, Oxford). The *Boy Peeling a Fruit* was widely copied, but its success cannot be attributed to its pictorial qualities. The novelty of the subject, perhaps after a time, must have stirred the interest of those who eyed with a growing curiosity this singular Lombard artist—a messenger from the north—with his new themes and a new conception of painting. In fact, the themes that he painted during his first years in Rome are an important key to understanding his work. The youthful, half-length figures have no apparent subject. Their creation was possibly encouraged by the descriptions of ancient writers (the *Boy with a Basket of Fruit*, cat. no. 66); by the artist's wish to personify himself as a classical divinity (the *Bacchino Malato*, fig. 1, p. 29, described by Mancini as a "beautiful Bacchus, beardless"); or, perhaps, by the desire to explore moral allusions related to the pitfalls and experiences of youth (the *Boy with a Vase of Roses*, cat. no. 62, known through a number of versions; the *Boy Bitten by a Lizard*, cat. no. 70; the *Cardsharps*, fig. 1, cat. 67; and the *Fortune Teller*, cat. no. 67—the last two of which profoundly transform themes already treated in Northern painting). The *Boy with a Basket of Fruit* reveals an interest in still-life painting for which there are Lombard precedents. This is attested by Bellori's

recognition of Caravaggio's importance for this genre, and by the presence of a painting of a vase of flowers, such as Bellori describes, in the inventory of Cardinal del Monte's collection. The inclusion in the present exhibition of a group of still lifes believed by Zeri to document Caravaggio's work as a member of the workshop of the Cavaliere d'Arpino may clarify Caravaggio's activity in this genre. Setting aside the practical explanations offered for the self-portrait in the *Bacchino Malato* (the artist's inability to hire a model during his first, desperate years in Rome), the picture heralds Caravaggio's frequent projection of himself and his own problems into his work.

These compositions of half-length figures, which reevoke the poetic aura of Giorgionesque painting, and seem to possess an erotic or homosexual significance, may also be classified as "comic" or moralizing works, both for their realism and for their moral intent. Their relationship to history painting is the same as that of comedy—the didactic genre of classical poets—to tragedy. While antiquity was certainly Caravaggio's first inspiration upon his arrival in Rome (the *Bacchino Malato*, and the Uffizi *Bacchus*, cat. no. 71, attest to this), his intellectual growth, through a laborious process that has little in common with the normal development of contemporary painters, is doubtlessly linked to his stay with Cardinal del Monte. Caravaggio took up residence in the Cardinal's palace about 1594–95, and during the period that he lived there the subjects of his pictures were enriched with music (the *Musicians*, cat. no. 69; the *Lute Player*, fig. 3, cat. 69; and the *Rest on the Flight into Egypt*, fig. 3, p. 33), of which Del Monte was a passionate patron. The *Stigmatization of Saint Francis* (cat. no. 68) provides evidence that, even in these years, Caravaggio was rethinking religious themes in a radical and novel way, in order to rediscover the textual and human truth underlying the conventions inherent in the subjects. Important, iconographic innovations resulted, which his first patrons were certainly aware of.

The compositions of half-length figures and their related themes were a novelty in Rome. Thereafter, Caravaggio set about to solve the difficulties of applying his method of painting to the representation of several figures in action. His use of light and his recourse to perspective intensified (for example, in the *Lute Player* and the *Rest on the Flight into Egypt*). Spezzaferro's hypothesis that, in the last years of the sixteenth century Caravaggio became interested in the perspective studies of the Cardinal del Monte's brother, Guidubal-

3. Caravaggio. *The Rest on the Flight into Egypt.*
Galleria Doria-Pamphili, Rome

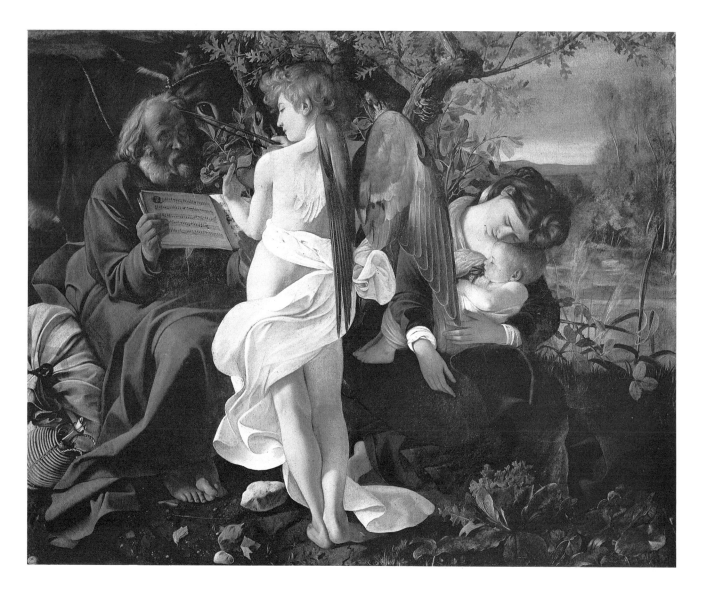

4. Caravaggio. *The Calling of Saint Matthew.*
Contarelli Chapel, San Luigi dei Francesi, Rome

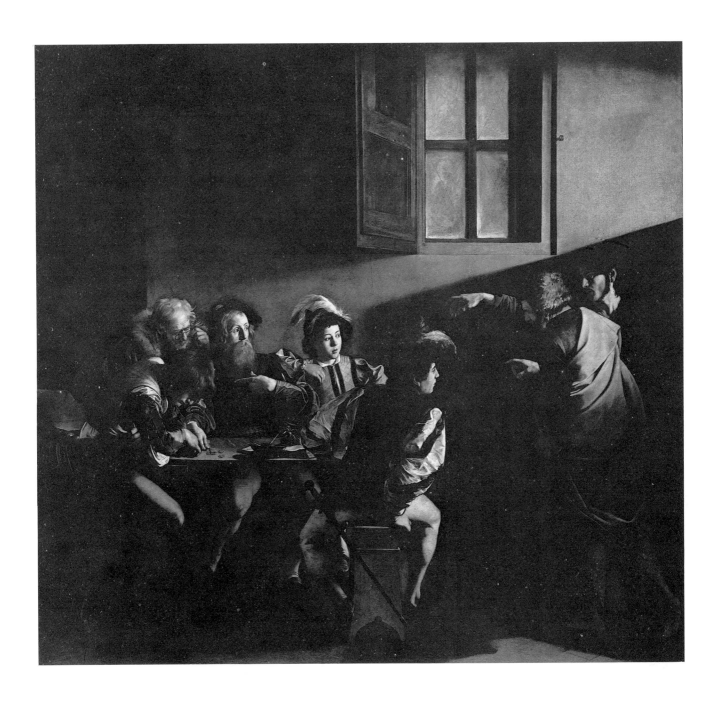

5. Caravaggio. *The Martyrdom of Saint Matthew*.
Contarelli Chapel, San Luigi dei Francesi, Rome

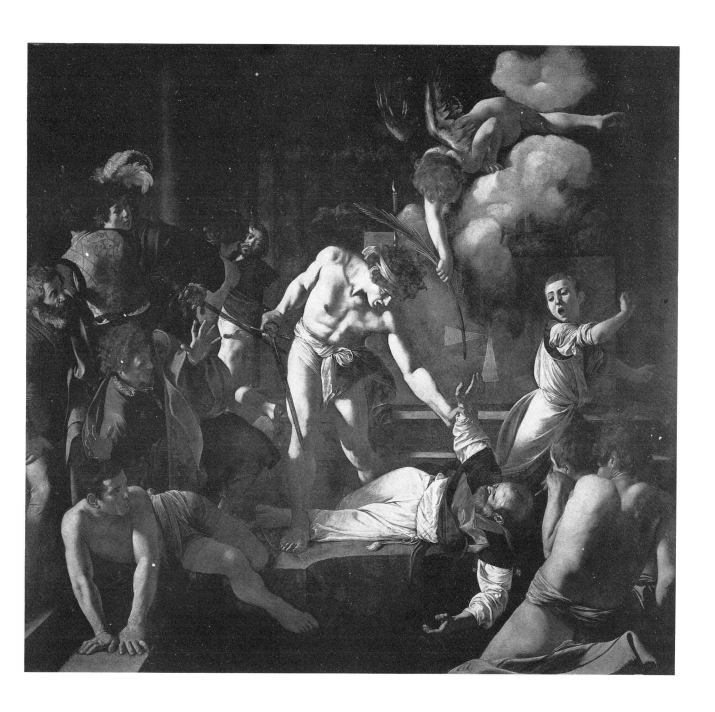

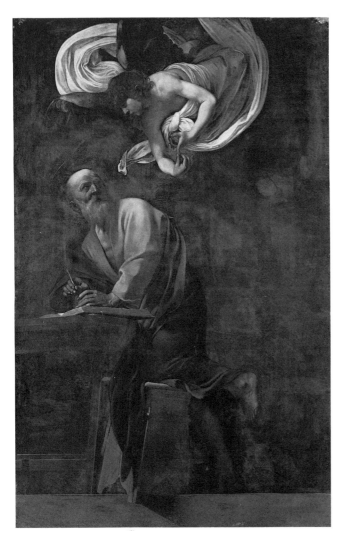

6. Caravaggio. *Saint Matthew and the Angel.*
Contarelli Chapel, San Luigi dei Francesi, Rome

do—who, in 1600, published his treatise *Perspectivae libri sex*—does not seem to conflict with his empirical approach to painting. This is demonstrated by the ceiling that Caravaggio painted (in oils) in the *camerino* of the casino of Cardinal del Monte—a work mentioned by Bellori and recently reattributed to Caravaggio—in which his interest in perspective was realized via principles that he had learned in Lombardy (fig. 2, p. 30). The attribution of this ceiling painting to Caravaggio is anything but unanimous, and the work, itself, is not easily legible. Indeed, so precarious is its condition that a restoration is highly desirable. Nonetheless, the connections between this work and Caravaggio's early easel paintings is indisputable. Since the casino was acquired by the Cardinal toward the end of 1596, the work may be dated about 1597, thereby furnishing a concrete reference point in establishing a chronology for Caravaggio. Its scale, and its iconographic and representational qualities, place the ceiling painting among the most important of the artist's early works. It has, without basis, been attributed to Cristoforo Roncalli (Pomarancio), but the artist's rendering of the nude, recalling the work of Northern "Romanist" painters, and the way in which Neptune and Pluto are viewed behind the frame, betray the Lombard origins of their author. Bellori himself (1671, p. 214) commented on the exaggerated foreshortening: "It is said that Caravaggio, hearing himself maligned for not understanding planes or perspective, took the opportunity of showing the figures viewed *sotto in sù* so that the most difficult foreshortenings are exhibited." This aspect of the representation derives from those perspectival studies dealing with the human figure carried out in sixteenth-century Lombardy, as is seemingly indicated by the close parallels between the *camerino* ceiling and the ideas expressed in the *Codex Huygens* (in the Pierpont Morgan Library, New York). Panofsky has examined the Leonardesque component of the *Codex Huygens*, and Pouncey and Bora have identified its author as the painter Carlo Urbino, a collaborator of, and source of inspiration for, Bernardino Campi until the seventh decade of the sixteenth century. The content of the codex has analogies with aspects of Lomazzo's and Urbino's frescoes in San Marco, Milan, as well as with Vincenzo Campi's ceiling decorations in the Milanese church of San Paolo. These analogies demonstrate that the author of the ceiling of Del Monte's casino was trained in Lombardy, confirming the attribution to Caravaggio—about 1597. They also lend added weight to the importance for Caravaggio of

7. Caravaggio. *Saint Matthew and the Angel* (destroyed, World War II). Formerly Kaiser-Friedrich-Museum, Berlin

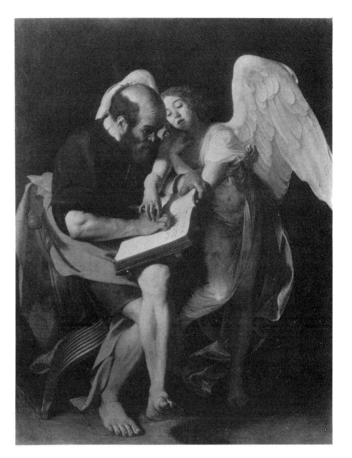

Lombard precedents, a matter magisterially treated by Longhi in his "Quesiti caravaggeschi."

Caravaggio's "comic" and moralizing approach to painting lent itself to realistic representation, and to the depiction of violent, instantaneous action. This attitude—even as a dialectical variation (Testori)—evolved throughout the Veneto, Lombardy, and even as far as Ferrara, in the sixteenth century, and was linked to both Northern painting and to the mimetic features of Giorgione's pictorial revolution. Significant examples of this tendency are Dosso Dossi's paintings for the via Coperta in Ferrara, and the sacred and profane scenes in the loggia of the Bishops' Palace in Trent, commissioned from the Brescian artist Romanino by the humanist Bernardo Clesio; some of Romanino's paintings—one of a concert, and another illustrating the story of Judith and Holofernes, for example—serve as an introduction to those themes favored by Caravaggio and his circle. Pordenone's frescoes with scenes from the Passion of Christ, in the cathedral of Cremona, and their local derivations are also relevant. In this mode of painting, events were represented as though they took place in the present, and this played into Caravaggio's revolutionary and naturalistic conception of art. It was through his meditation on Leonardo's experimental approach to the representation of emotions ("moti"), which turned on the two opposite reactions of laughter and of grief in the face of death, that these features of moralizing painting—instantaneous and violent action—found expression in Caravaggio's work. Lomazzo's *Trattato dell'arte della pittura, scoltura, et architettura* (of 1584) attests to these concerns of Leonardo. However, the fashionable comparison between painting and poetry—*ut pictura poësis*—was not valid for Caravaggio. Like Leonardo, he prized painting over poetry. This had decisive consequences for his representation of gestures and expressions ("gli affetti").

The shield with the head of Medusa (in the Galleria degli Uffizi, Florence; fig. 16, p. 47), sent by Cardinal del Monte to Ferdinando de' Medici, is, perhaps, Caravaggio's earliest experiment with representing the victim's reaction to a violent action. According to Vasari, the subject had been treated by Leonardo. The key to understanding this image of a fatal, violent moment is provided by Lomazzo's treatise, where, in indicating how to express emotions ("moti") "as powerful in touching souls as when they are expressed in a way that seems natural," Lomazzo recalls that Leonardo "liked to go and observe the expressions of those condemned

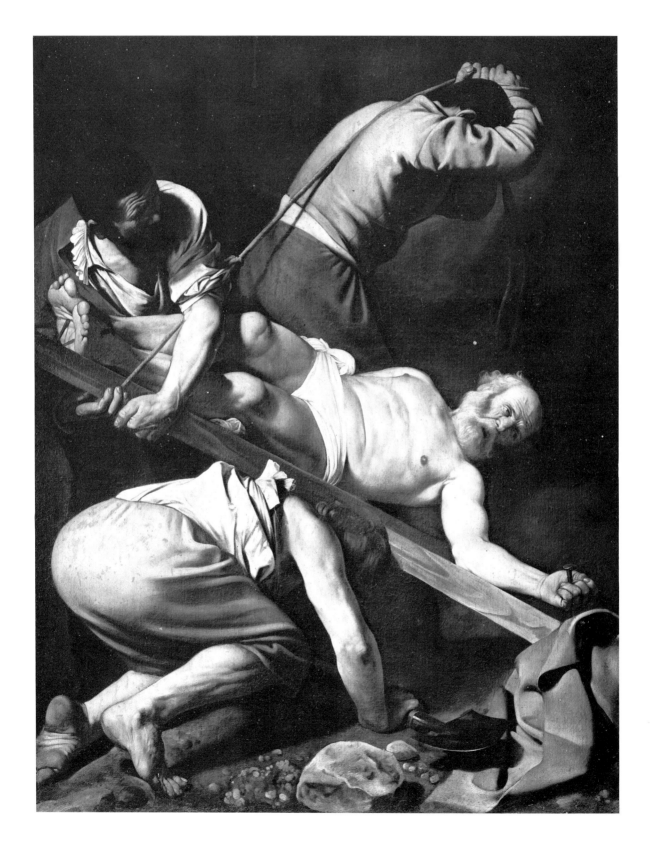

to death—those archings of the brow, those expressions of the eyes and of life." With an analogous intent, Caravaggio chose to depict the extreme case of the decapitation of Holofernes by Judith (cat. no. 74). Rather than following the conventions of narrative, or history, painting, Caravaggio illustrates the climax of the event, captured instantaneously. In so doing, he certainly wished to create a new, tragic style that had an immense impact on Seicento art and that has a striking parallel in the theater of Shakespeare. Bellori found Caravaggio's pictures "lacking in action." One reason that the artist's public commissions caused such a scandal was because his contemporaries discerned in them qualities proper to moralizing painting, with its emphasis on realism and actuality. They regarded this as an inferior mode, unsuited to history painting. However, he recognized these very differences and broke down the distinctions between history and genre painting. In the lateral canvases in San Luigi dei Francesi, Caravaggio did not hesitate to include youths in contemporary dress to personify a morality that, in the *Calling of Saint Matthew*, has evident connections with the theme of the early *Cardsharps*.

In the *Martyrdom of Saint Matthew*, Caravaggio painted himself, his face overwhelmed with sadness, escaping from the scene of martyrdom, which is portrayed as a grave, violent deed with no cathartic outlet. His presence in this and in other paintings of tragic events—the *Taking of Christ*, the *Burial of Saint Lucy*, and the *Martyrdom of Saint Ursula* (cat. no. 101)—is yet another hint of his revolutionary conception of history painting as an actual event.

The two lateral canvases in San Luigi dei Francesi are the most important testimony to the transformation in Caravaggio's work from the transparency of his early pictures to a new, more highly contrasted use of light. From the evidence of X-rays, it seems that this profound change occurred during the painting of the *Martyrdom of Saint Matthew*. It may have been related to the necessity of showing many figures in action, a task that Caravaggio would have had great difficulty carrying out in the careful, diligent style of his early paintings. He may have recalled the possibilities offered by a Cinquecento workshop practice employed by, among others, Tintoretto, whereby mannequins were draped and placed in a dark setting with the light focused on the key points of the story to facilitate the description of the relative positions of the various figures. The highly contrasted lighting, creating a polarity of darkness and intense illumination, was used by Caravaggio to obtain

a strong effect of relief and volume. Passages in the writings of Vasari and of Lomazzo clarify this intention on the part of Leonardo, and Bellori alludes to it in explaining the mature works of Caravaggio.

Caravaggio's revival, in the first version of the *Saint Matthew and the Angel* (fig. 7, p. 37) for the altar of the Contarelli Chapel, of a sort of sublimated poetry that characterized his early style, is not easy to explain. Nor are the profound differences that would seem to separate the two versions of the *Saint Matthew and the Angel* (figs. 6, 7, p. 36 f.) by several years easily comprehensible. It is probable that the change in the two *Saint Matthews* was a response to criticism, although it is worth noting that, as in the two versions of the *Conversion of Saint Paul* (figs. 9, 10, pp. 40 f.) for the Cerasi Chapel in Santa Maria del Popolo, Caravaggio substituted a less "realistic" picture, in which the light is no longer rendered with his earlier care, for one that exhibited a lucid, transparent vision, which can be termed "mimetic," since it sought to reveal reality.

The crowded composition of the *Martyrdom of Saint Matthew* seems to transmit the high tension of the executioner's scream, a feature that recurs in the densely packed pictures from Caravaggio's Sicilian period. The smaller canvases for Santa Maria del Popolo (figs. 8, 9, pp. 38, 40), painted between 1600 and 1601, mark a more profound meditation on sacred themes and their human significance, and Caravaggio endows these themes with new, psychological implications. In the calm detachment of the *Crucifixion of Saint Peter*, he exalts the Stoic attitude of the saint, and in the *Conversion of Saint Paul* he interiorizes the event, eliminating any visible presence of the Divine.

In the first years of the seventeenth century, Caravaggio dedicated himself principally to the representation of sacred themes. Through his examination of the subtle, textual interpretations of these canonical subjects, he was able to turn his attention to the fundamental problems of the relationship of Man to God, Sin, and Salvation, arriving at important innovative iconographic solutions. He chose to represent the sublime themes of religious art in the guise of humble appearances, thereby creating a scandal that led to the refusal of some of his work. In this choice, he was perpetuating the traditions of religious painting in Brescia, which may have been stimulated by local Populist movements, as well as by ideas deriving from Erasmus. If the *Crucifixion of Saint Peter* is regarded as the highest expression of Caravaggio's profound pessimism, in the *Conversion of Saint Paul*—which violates the con-

9. Caravaggio. *The Conversion of Saint Paul.*
Cerasi Chapel, Santa Maria del Popolo, Rome

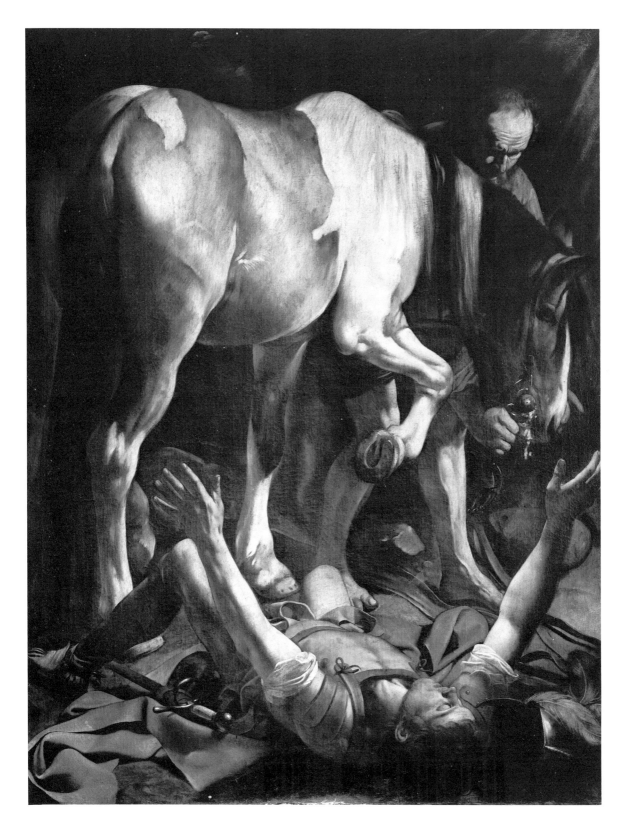

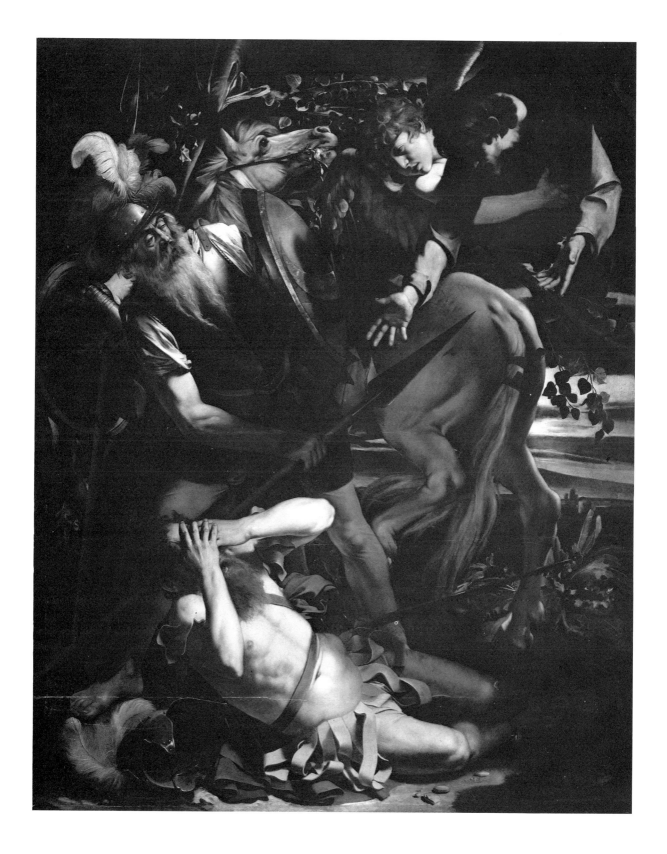

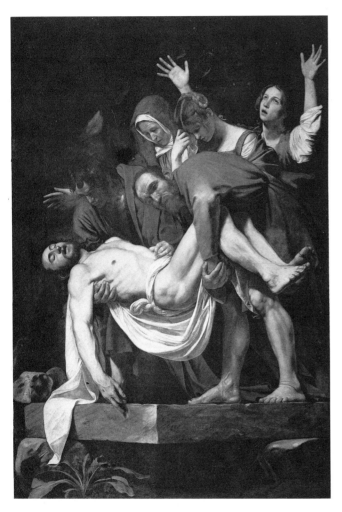

11. Caravaggio. *The Entombment.*
Pinacoteca Vaticana

ventions of decorum in showing, quite simply, a fallen soldier, and in filling the space with a horse that, as Panofsky has demonstrated, is taken from an engraving by Dürer—he wished to convey that the presence of Divine Grace is apprehended not through external signs but in the heart of Man.

Like Northern painters, Caravaggio conceived of a religious picture as an object of piety, as with the *Crowning with Thorns* (cat. no. 81). In a painting such as the *Ecce Homo* (cat. no. 86), he followed Michelangelo's example in expressing his own participation in the drama. Some subjects—Saint John the Baptist, Saint Francis, or Saint Jerome—were chosen by Caravaggio as the means to express his personality and his state of mind. Through his careful study of the Scriptures, the artist was able to visualize these subjects in terms of their actuality, and also to extract their symbolic significance. Caravaggio lived at a time when the events of daily life were pregnant with symbolic allusions, and the interpretation of his work in terms of our modern idea of realism is unacceptable. On the other hand, the multiplicity of meanings that have been read into his paintings were clearly not intended by him. There is, at present, a need to remove the stratification of these interpretations—which sometimes contradict the basic textual significance of the subject represented, and which conflict with Caravaggio's own conception of the relationship of painting to reality. That conception is coherently expressed in his preference for subjects that communicate directly their dogmatic, intellectual, and spiritual content. One of Caravaggio's motivating themes is the Incarnation, and the visible and tangible revelation of the Divine. This theme is referred to in his portrayal, from a close viewing point, of scenes from Christ's Passion, as in the *Taking of Christ* (a copy of which is in the museum in Odessa); and of those events following Christ's death, as in the *Incredulity of Saint Thomas* (at Sanssouci, Potsdam) and in the two versions of the *Supper at Emmaus* (cat. nos. 78, 87). Caravaggio also touches on the theme of the Incarnation in a detail of three of his pictures—all close in date—that convey the idea with great subtlety. In the Prato *Crowning with Thorns* (cat. no. 81), the hand of one of the torturers presses the body of Christ. The same gesture is made by Saint John in the Vatican *Entombment* (fig. 11, p. 42), and by the Virgin, who sweetly grasps the Christ Child, in the *Madonna dei Pellegrini*. In the last picture, the meaning of the motif is self-explanatory.

The challenge presented by his public commissions

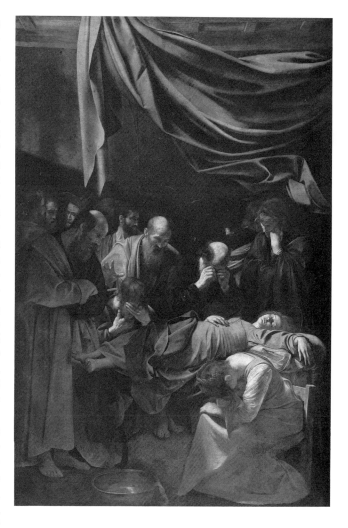

and his exposure in Rome to works by Renaissance masters led to the creation of Caravaggio's monumental style. In the *Entombment*—his most celebrated picture, and the one most frequently mentioned, and copied, as late as the nineteenth century, because of its union of Populist realism with the "Grand Manner"— echoes of the work of Savoldo, Callisto Piazza, and Simone Peterzano occur in a composition in which the figures, shown in motion, as in Raphael's *Entombment* (in the Galleria Borghese, Rome), are arranged in the manner of an ancient relief. Even Caravaggio was not immune to the influence of ancient art during his Roman years. His reinterpretation of a classical model in naturalistic terms—as expressed in the *Crowning with Thorns* (cat. no. 81), where the torso of Christ is taken from the *Belvedere Torso*—has more in common with Rubens's vision (this great student of the art of antiquity was in Rome during these years) than with the classicism of Annibale Carracci. During the same period, just after completing the canvases in Santa Maria del Popolo, Caravaggio changed his manner of rendering drapery, abandoning the rhythmic cadences of his earlier work for long, sharp folds that are clearly derived from classical sculpture—as in the *Amor Vincit Omnia* (cat. no. 79), the second version of the *Saint Matthew and the Angel*, and the *Sacrifice of Isaac* (cat. no. 80). In the subjects of his religious paintings, Caravaggio perceived—over and beyond the interpretations current during the Counter-Reformation—a human drama, and in carrying out these works, he sought to express a subjective truth rather than to pursue the goal of achieving an objective beauty. He thereby distanced himself from the ideals of his time. In the *Death of the Virgin* (fig. 12, p. 43), the various gestures of the apostles, and their grief, are conveyed with supreme dignity, revealing the degree to which the artist had restored the profound values attached to Man in classical art and in the work of Raphael (the picture contains echoes of Raphael's *Transfiguration*). At the same time, there is the sense of an actual event. The Virgin has just died, and her body has not yet been arranged decorously, and the Magdalen, dressed in everyday garb and posed in an indescribably unconventional way, resembles a figure from a genre painting. Like other altarpieces dating from Caravaggio's last years in Rome, the *Death of the Virgin* was rejected. In fact, the public commissions that Caravaggio undertook following the *Entombment* encountered a series of difficulties in ecclesiastical circles. The *Death of the Virgin* was rejected by the Capuchin friars of Santa Maria della Scala, Rome,

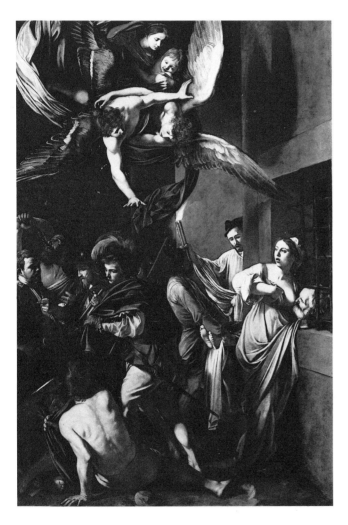

13. Caravaggio. *The Seven Acts of Mercy*.
Pio Monte della Misericordia, Naples

and, on the advice of Rubens, was sold to the Duke of Mantua. The *Madonna dei Palafrenieri* was taken down from its altar in Saint Peter's in early 1606. According to Baglione, the *Madonna dei Pellegrini* was the object of scorn ("schiamazzo"). Caravaggio's run-ins with the law during these same years came to a tragic conclusion with the murder of Ranuccio Tommasoni on May 28, 1606.

At the Colonna estates, where Caravaggio took refuge, he painted medium-sized canvases, one of which, the Brera *Supper at Emmaus* (cat. no. 87), was sent to Rome to be sold. The *Magdalen in Ecstasy* (cat. no. 89) seems to have ended up in Naples, where it enjoyed great fame, as attested by the numerous copies of it that were made. The intense activity of Caravaggio's few months in Naples, before he left for Malta (he is documented in Malta in July 1607), demonstrates that his fame had preceded him. However, an altarpiece that he may have painted in Naples, the *Madonna of the Rosary* (now in the Kunsthistorisches Museum, Vienna), was offered for sale in September 1607, having evidently been rejected. The lay theme of the *Seven Acts of Mercy* (fig. 13, p. 44)—commissioned by the Pio Monte della Misericordia, Naples—stimulated the artist to revive the moralizing style he had last employed in the *Calling of Saint Matthew*. It is, however, conceived like a large genre painting, to which the group with the Madonna and Child was added in a second phase. In a dark street in Naples is gathered a most desperate crowd of people, whose actions illustrate the different acts of mercy, but who, in fact, make up a colorful and—it may be imagined—a noisy assemblage.

After leaving Naples, Caravaggio's life was punctuated by repeated moves from place to place, and his work reflects a profoundly troubled state of mind, obsessed with thoughts of death and violence. In the *Beheading of Saint John the Baptist* (fig. 14, p. 45), the only work signed by Caravaggio, the signature is scrawled in the blood of the martyr—an indication that the painter identified with the saint. The figure of Lazarus in the *Raising of Lazarus* (fig. 15, p. 46) seems to express an almost equal attraction to death and to life.

The technique of the late paintings shows an extreme simplification of means that can, however, be traced back to works of Caravaggio's late Roman period and to the Brera *Supper at Emmaus*, painted at the Colonna estates. The forms, revealed by light, are implacably characterized in an abbreviated fashion, and the ground is employed as a background color over which the artist paints in a stenographic manner, sometimes

14. Caravaggio. *The Beheading of Saint John the Baptist*. Co-Cathedral of Saint John, La Valletta, Malta

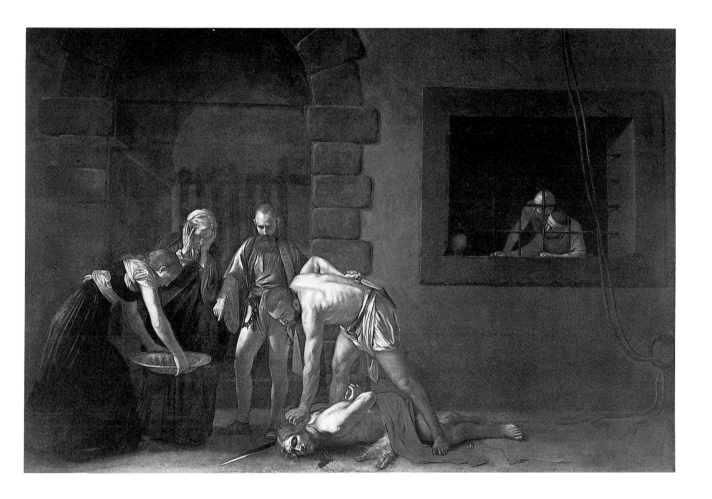

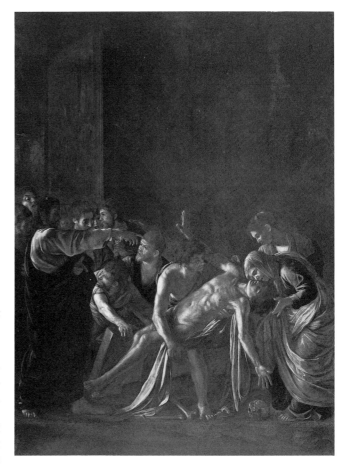

using areas of strong local color.

A better understanding of Caravaggio's techniques and, through them, of his working methods, is one aim of this exhibition. What we now know confirms what his early biographers have written regarding the speed with which he worked, but it also underscores the artist's deep meditation on the symbolic and emotive significance of his subjects that preceded their actual execution. His practice of painting directly on the canvas, without the use of drawings, is easily ascertained—nor is it contradicted by the presence of incised lines, especially in the Roman works and, more rarely, on such later paintings as the Rouen *Flagellation* (cat. no. 91). The incisions, which usually appear along portions of the contours of the figures, were made by a stylus or the butt end of the brush in the ground or the background color of a picture. This technique was used by the Cavaliere d'Arpino in his frescoes—regardless of whether a cartoon was employed—and by Barocci. For Caravaggio, it must have served as a means of tracing out some points of reference in the composition.

A direct and comparative examination of Caravaggio's work also reveals how much of his technique derives from the Cinquecento Lombard tradition that was still valid for Giacomo Ceruti in the eighteenth century. The ground color was used for a variety of ends: It might be held "en reserve" as a pictorial device, and it sometimes appears around the contours of the flesh areas of a figure, as a means of creating, through contrast, an illusionistic effect.

One of the interesting features uncovered by research on Caravaggio's patrons and associates is the quantity of copies of his work that seem to have been in circulation from an early date, sometimes replacing the originals. A case in point is the history of the *Stigmatization of Saint Francis* (cat. no. 68), a copy of which is in Udine. Perhaps, as Salerno has suggested, Caravaggio permitted his paintings to be copied in order to spread their fame. However, this does not mean that any importance should be attached to these copies—especially to those of feeble quality—beyond their documentary value. That they may have been painted in Caravaggio's workshop or even, in some cases, been touched by the master—as has been recently proposed by one scholar—is a misconception. The two versions of the *Fortune Teller,* of the *Saint Matthew and the Angel*, and of the *Conversion of Saint Paul* cannot be considered replicas in the true sense of the term, for the differences between each version are too great. However, the no-

tion that Caravaggio painted true replicas—with few variations—cannot be ruled out. He may have done so either out of financial need, or in response to the pressing requests of his fanatic supporters. Nonetheless, it is this writer's opinion that even with the two versions of the *Saint John the Baptist* (in Rome, in the Galleria Doria-Pamphili and in the Pinacoteca Capitolina) we are not dealing with an autograph replica: Only the Capitoline picture is by Caravaggio. The large number of old, probably contemporary, copies of Caravaggio's paintings is a singular phenomenon that has already been emphasized. The existence of these copies is explained by the interest and curiosity that Caravaggio's novel works inspired. One should not forget that, at the time, the distinction between an original work and a copy of a composition that a collector may have wanted was less important than now, except insofar as the price was concerned.

The ability to distinguish between an original and a faithful copy may at times require an exceptional ability to apprehend not only the quality of Caravaggio's artistic vocabulary, but some of the characteristics of his technique. This is an area reserved for connoisseurs, and it necessitates direct comparisons of the actual works of art. This exhibition provides such an occasion by including the two versions of the *Saint Francis in Meditation* (in the Chiesa dei Cappuccini, Rome, and in Carpineto Romano; cat. nos. 82, 83), and the two, still much disputed, versions of the *Flagellation* (in Rouen, and in a Swiss private collection; cat. nos. 91, 92). The identification, via copies, of a lost original by the master is an even more arduous task. Roberto Longhi's talent in this area has not been surpassed. Not only did he recognize such works as the Uffizi *Bacchus* and the *Narcissus* (cat. nos. 71, 76), but between 1939 and 1951—the dates marking the completion of the "Ultime ricerche sul Caravaggio e la sua cerchia" and the publication, in *Paragone*, of "Sui margini caravaggeschi"—he also identified more than ten of Caravaggio's compositions through some good copies. Some of his discoveries have, in turn, enabled others to recover the prototype. Sometimes Longhi followed the hints provided by old sources, which described subjects by the artist—as, for example, with the *Boy Peeling a Fruit,* the *Magdalen*, the *Martyrdom of Saint Sebastian*, and the *Crucifixion of Saint Andrew*. In other instances, he relied upon his exceptional capacity to perceive the specific, Caravaggesque element in a painting, even when this involved a composition known only through derivations by various artists or through a copy, of poor

quality. A verification of the autograph status of the Manzella *Conversion of the Magdalen* (cat. no. 73) and of the Prato *Crowning with Thorns* (cat. no. 81), two paintings that Longhi published as copies after lost originals, was made possible only by a direct examination of the first, and by the cleaning and restoration of the second.

The appearance of an unknown pictorial invention of Caravaggio, either in an original or a copy, marks the discovery of a new, unforseeable conception on a chosen theme—albeit even a canonical one. This is always an exciting event. But only those with an intimate knowledge of Caravaggio's world have been able to recognize his hand in previously unknown works. Longhi himself often explained how he arrived at "understanding, in the first place, if a certain 'natural situation' could have been chosen by Caravaggio, or not." Regarding copies, he wrote in 1960 that "in the case of an art of daring 'veracity,' as was Caravaggio's, even a copy that is enfeebled by its execution and impoverished in its handling of paint, in comparison to an original, nonetheless transmits the mental, almost moral core of the prototype—the core that one must, mentally, re-invest with its formal (I don't wish to use the term grammatical) integrity."

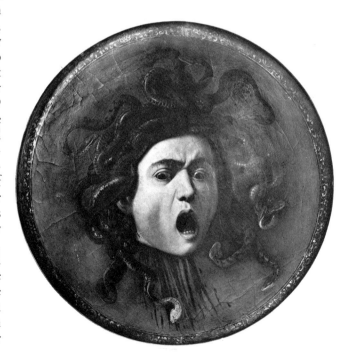

Caravaggio's Precursors
in North Italy

Jacopo dal Ponte
called Bassano

Jacopo dal Ponte was born in the village of Bassano at the foot of the Dolomites north of Venice about 1510. He began his apprenticeship with his father, Francesco, a minor provincial painter and artisan. In 1535, he was briefly in Venice, where he was associated with the workshop of Bonifazio de' Pitati and where his lifelong admiration for Titian began. He chose, however, to remain in Bassano, assuming responsibility for the family establishment with his less-talented brother Giambattista after their father's death about 1540. From this vantage point evolved his discriminating approach to developments in Venice, Central Italy, and north of the Alps—in most cases by way of his extensive collection of prints. During the 1540s, he explored a sophisticated and often rarified series of variations on maniera *style, and, in the 1550s, an increasingly crepuscular tonality lent his paintings a dramatic chiaroscuro that was prophetic of effects that would prevail only in the following century. He devoted his efforts not only to painting in oil and fresco but also to artisans' work of all sorts. Through his constant love of the bucolic life around him, Jacopo maintained a fresh vein of naturalism in his work during the course of his career, as well as the humble simplicity that underlies the familiar peasant genre settings of the paintings with biblical themes that he produced, often in collaboration with his sons, after 1560. The popularity of these pictures, first in Venice and later throughout Italy, increased so rapidly that Jacopo's son and surrogate, Francesco the younger, won the commission to paint the* Assunta *for the high altar of San Luigi dei Francesi, Rome, only yards from the chapel where Caravaggio would soon begin his Saint Matthew cycle. At his death in 1592, Jacopo was regarded as the foremost painter of naturalistic genre subjects in Europe.*

1. The Adoration of the Shepherds

Oil on canvas, 38 3/16 x 53 15/16 in. (97 x 137 cm.) Gallerie dell'Accademia, Venice

The theme of the Adoration of the Shepherds was favored by Jacopo Bassano and his patrons throughout his long career, beginning with the modest, early picture (W. R. Rearick, 1980, p. 372) painted about 1534 in collaboration with his brother Giambattista, and concluding with the monumental altar for San Giorgio Maggiore, Venice, completed with some assistance from his son Francesco just before both died in 1592. The paintings were inspired by Titian, but it is the rustic naturalism, so appropriate to the subject, which remains constant in Jacopo's approach. The present picture (formerly in the Giusti del Giardino collection and recently acquired by the Accademia, Venice) falls in his early maturity, when his experimental implementation of Emilian Mannerist devices was at its apogee. The pear-shaped anatomy, convoluted folds of the drapery, and the tortuously stylized facial features suggest that the Madonna was influenced by a print by Parmigianino, although it does not follow slavishly any of the latter's models. Bassano's earlier enthusiasm for Titian is still evident in the compositional format, derived from Giovanni Britto's woodcut of about 1534, and his debt to Dürer is clear in the architectural ruins. In general, however, these sources had been incorporated into Jacopo's repertory about a decade earlier, so that by 1546–48, the approximate date of the Accademia *Adoration,* he could refine them, with subtle variations, according to his own highly personal pictorial idiom.

In this *Adoration*, Jacopo explores a novel interpretation of the natural world around him. A brilliant, even illumination banishes shadow to a thin penumbra along the left edges of the forms, setting off the inlay-like passages of discreet color with a fine black line applied with the point of the brush. Through this rigorously concentrated *disegno*, realistic detail becomes analytical surface detail that is both pitiless in its penetrating candor and touching in the artist's evident affection for his rustic subjects. Few figures in Cinquecento painting equal the awed and reverent shepherds for gnarled, weatherbeaten simplicity; the attentive ox is surely the skinniest, scruffiest animal to be found in Venetian art.

After an earlier intense and restless absorption of Mannerist form and color, in the later 1540s Jacopo's convoluted stylistic argosy is distinguished by a subtle juxtaposition of fastidious artifice and blunt naturalism. The Accademia *Adoration* marks the culmination of this phase, a finely tuned interaction of opposing elements that would, within less than a decade, be replaced by a notably contrasting crepuscular style.

W. R. R.

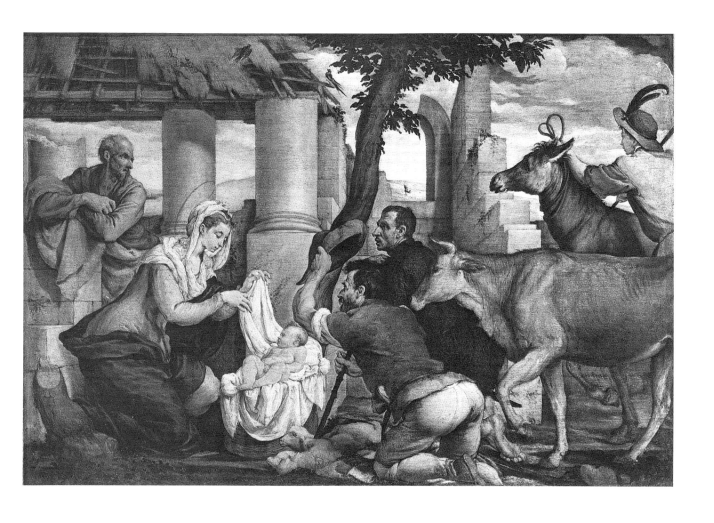

2. Lazarus at the Feast of Dives

Oil on canvas, 57 1/2 x 87 in.
(146 x 221 cm.)
The Cleveland Museum of Art

This *Lazarus at the Feast of Dives* and its pendant, *The Miracle of the Quails* (now in a Florentine private collection: see R. Longhi, 1948, p. 42), might have faced one another across the choir of the parish church of a small market town near Bassano: The theme of sustenance—God-given in the facing canvas and, here, denied by uncharitable man—is appropriate in the context of the altar sacrament. Both canvases must have been removed from such a church at an early date since they remained unnoted until this century, when the *Miracle of the Quails* turned up in Bergamo as a Tintoretto and the *Lazarus* was discovered in Rome with a traditional attribution to Jacopo Bassano. The striking, unexpected pictorial character of the present painting, often described as proto-Baroque (M. Marangoni, 1927, p. 27), has wrongly led to its attribution to Marescalchi (W. Arslan, 1931, p. 343) or even to a seventeenth-century imitator, perhaps not necessarily Italian (G. Fiocco, 1957 p. 96).

Although Jacopo's associate of twenty years before, Bonifazio de' Pitati, had treated this theme as an elegant garden party in a patrician villa, Bassano casts the scene in a simple setting of hypnotic austerity. The receding line of columns, and the elegantly stylized lady at the center, in particular, distantly echo *maniera* elements from his own earlier works, but Jacopo shifts his concern to the representation of a transfixed stillness in which all participants await Dives's harsh dismissal of the pathetic derelict recumbent at the left. Massively coarse in physique, Lazarus is sniffed by the menacing dogs while the lutenist falls silent and the page is lost in a melancholy reverie on the impending tragedy.

After mid-century, the brilliant, almost shadowless clarity and the linear discipline in Jacopo's work began to darken and to loosen—doubtless, partly in response to the later works of Titian, but also in reaction to a new interest in Tintoretto's Tenebrist tendencies of these years. In the *Lazarus*, saturated passages of phosphorescent color gleam through a deepening but still luminous shadow, and surface detail is absorbed in broad and—in the figure of Lazarus—roughly applied brushstrokes. One passage in particular seems prophetic of the concentrated realism of Caravaggio: the broad back of the lutenist, where deep shadow suddenly gives way to a glaring and richly textured illumination. By 1554, the approximate date of the *Lazarus*, the *maniera* element of restlessness in Jacopo's work had begun to wane, and the constant component of a naturalistic concern for the rustic world around him once again emerged, in a form that, in the next decade, coalesced into the influential peasant genre paintings for which the name Bassano became famous: first in Venice, where they were widely admired by connoisseurs and, later—through his son Francesco—even as far afield as Rome, where major commissions would be awarded to the dal Ponte family on the eve of Caravaggio's arrival in the city.

W. R. R.

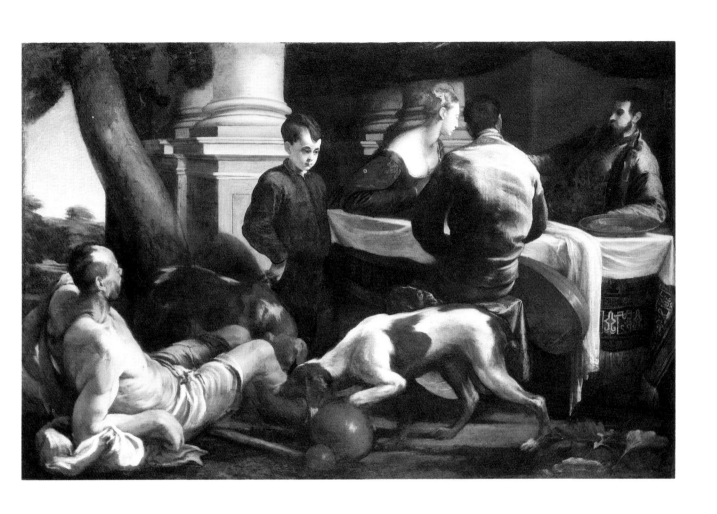

Antonio Campi

Antonio Campi was born in 1524 into a family of Cremonese painters. The followers of Camillo Boccaccino and his own brother Giulio—with whom he collaborated on the frescoes at Santa Margherita, Cremona, in 1547—were among the formative influences on his style. His first signed painting, the Holy Family with Saint Jerome and a Donor, in Sant'Ilario, Cremona, dates from 1546. He next executed a series of chiaroscuro prints, following the example of Parmigianino. In the 1550s, Antonio worked on the fresco cycles at the palace at Torre Pallavicina and at the Palazzo Maggi, Cadignano, and he collaborated with Giulio on the decoration of the first bay of the nave of San Sigismondo, Cremona, and on a series of eight canvases, illustrating Justice, for the Collegio dei Giudici, Brescia. In the following decade, he painted important altarpieces in which lively and exuberant Mannerist experiments alternate with exaggerated naturalistic effects: The Resurrection, of 1560, in San Celso, Milan; three episodes from the life of Saint Paul, of 1564, in San Paolo, Milan; and, in Cremona, paintings for the cathedral (the Pietà, of 1566), San Sigismondo (The Beheading of Saint John the Baptist, of 1567), and San Pietro al Po (The Holy Family, of 1567). There followed several paintings with nocturnal settings: The Temptation of Saint Anthony, of 1568, now in a Danish private collection; The Agony in the Garden and Christ before Caiaphas, formerly at Torre Pallavicina; The Beheading of Saint John the Baptist, of 1571, in San Paolo, Milan; The Adoration of the Shepherds, of 1575, in Santa Maria della Croce, Crema; a triptych, of 1577, in San Marco, Milan; and The Martyrdom of Saint Lawrence, of 1581, in San Paolo, Milan.

A sumptuous, decorative vein is revealed in the Cremonese frescoes of Christ in the House of the Pharisees, of 1577, in San Sigismondo; in those, dating from 1579, in the transept of San Pietro al Po; and in the Christ and the Centurion, of 1582, in the cathedral—as well as in the frescoes carried out in collaboration with his brother Vincenzo on the vault of San Paolo, Milan. Also noteworthy are Antonio's important canvases in Sant'Angelo, Milan: Saint Catherine in Prison, and The Martyrdom of Saint Catherine, both dating from 1583.

In addition to his activity as a painter, Antonio Campi was also an architect, a writer, and a scholar. His history of Cremona, Cremona fedelissima, of 1585, was illustrated with prints after his designs executed by Agostino Carracci. Antonio's ties with Lombard nobility and with Saint Carlo Borromeo and Gregory XIII were also important; for his work as an architect at the Vatican, Antonio was knighted by the pope. He died in 1587.

3. The Beheading of Saint John the Baptist

Oil on canvas, 110 1/4 x 75 5/8 in.
(280 x 192 cm.)
Signed and dated (lower center, on the executioner's block): ANTONIVS CAMPVS CREMONENSIS 157[1 ?]
San Paolo, Milan

When the painting was restored in 1973, a date (the last digit is scarcely visible) was revealed on the block on which Saint John leans, thereby enabling the Beheading of Saint John to be correctly placed in Antonio's career; Longhi (1929; 1968 ed., p. 127) and W. Friedlaender (1955; 1969 ed., p. 40) previously had thought the picture contemporary with The Martyrdom of Saint Lawrence in the adjacent chapel. In addition to painting the altarpiece, Antonio decorated the chapel to which it belongs—the third on the right—with three episodes from the Baptist's life (on the vault) and two angels (on the back wall). He had already experimented with nocturnal effects and the representation of artificial light sources —in The Visitation, of 1567, in the Museo Civico, Cremona; The Temptation of Saint Anthony (see H. Olsen, 1961, pl. XLIII b); and the contemporary Christ before Caiaphas (see M. L. Ferrari, 1979, fig. 200)—before painting this canvas, which Longhi singled out as a precedent for Caravaggio. In the Christ before Caiaphas, the characteristics of the Beheading of Saint John are already present: the torchlight that illuminates the faces of the bystanders, accentuating the drama of the scene; and the warm tonality and brilliant colors that disclose Campi's ties to Brescian painting— above all, to the work of Savoldo. It is important to recall that in Milan there were several paintings by Savoldo "di notte e di fuochi"—among them probably the Saint Matthew and the Angel (now in The Metropolitan Museum of Art; cat. no. 13)— whose importance for Caravaggio has been shown by Longhi. To Antonio, Savoldo's experiments were critical, but Antonio's preference for everyday settings and the direct, objective representation of reality is due in part to the example of Flemish painting—as evidenced by his Temptation of Saint Anthony—but especially to the tradition of portraiture in Cremona: for in-

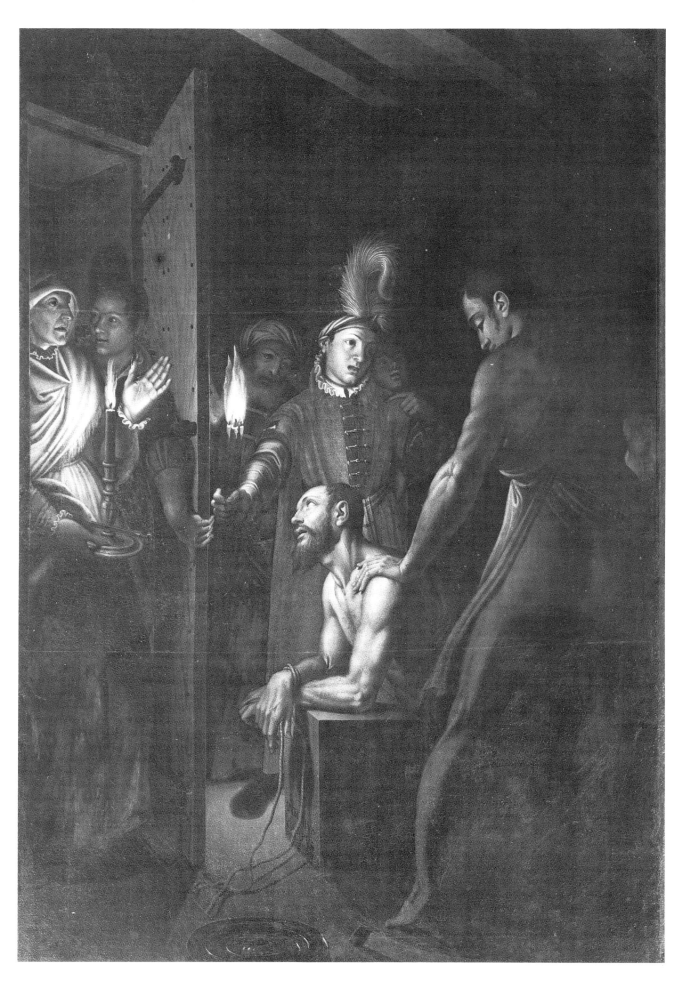

stance, to the work of Sofonisba Anguissola.

Antonio's practice of making life studies of faces and figures is revealed even more clearly in his numerous contemporary drawings in which anatomy and individual features are rendered with dense shadows that often confer an exaggerated, pathetic quality upon the forms. Several drawings in the Uffizi (inv. 2129 F, 13501 F *r.*, 2128 F *v.*), related to Giacomo Valesio's engraving, of 1575, of the mysteries of the Passion —which was based on a design by Campi— underscore this aspect of Antonio's style. Antonio had also used the design for a painting to decorate the private chapel of Archbishop Carlo Borromeo of Milan (G. Bora, 1977, p. 54).

The artist's close ties with Borromeo, which are documented by works known to have been painted expressly for the archbishop (among them a Nativity), may, perhaps, be taken as an indication of the apparent relationship between Campi's revolutionary pictorial language, on the one hand, and, on the other, the policies of the Counter-Reformation and the dispositions of the Council of Trent that Borromeo had been introducing into the archdiocese in the preceding years. Religious paintings were to engage the faithful in a more immediate and profound way. In *The Beheading of Saint John the Baptist* this involvement of the viewer is achieved through the dramatic and theatrical light effects, the studied bareness of the setting, and the everyday attitudes and expressions of the figures— especially of the women, one old and one young, who appear unexpectedly behind the half-open door, caught as if by surprise. Moreover, they are shown in accurately detailed, contemporary dress. This stark realism—almost brutal in the case of the seminude figure of the executioner—the reduction of the representation to essentials, and the use of violent contrasts of light would become the basis of Caravaggio's mature works, from *The Calling of Saint Matthew* (in San Luigi dei Francesi) to *The Beheading of Saint John the Baptist* (in La Valletta, Malta).

The church and convent of San Paolo were governed by the Angelines, a newly founded pietistic and ascetic order that enjoyed the approval of Carlo Borromeo; upon the Archbishop's death, Campi's painting of the mysteries of the Passion was given to the convent. Among the Angelines was the Cremonese noblewoman Giulia Sfondrati —the aunt of the Bishop of Cremona, the future Pope Gregory XIV—who bequeathed many of her possessions to the church and convent. It is not unlikely that she was responsible for commissioning the present altarpiece from Antonio, as well as earlier ones that are related to the decorative program of the church carried out by Antonio and his brother Giulio.

A reduced copy of the picture, considered by Puerari (1951, no. 136 a) and Longhi to be an autograph *modello*, is in the Pinacoteca, Cremona. In addition, the 1708 inventory of the Duke of Parma's gallery mentions a "beheading of Saint John the Baptist with a soldier viewed from the back who sheathes his sword" (G. Campori, 1870, p. 474).

G. B.

Vincenzo Campi

The son of Galeazzo Campi and the younger brother of Giulio and Antonio, Vincenzo Campi was born in Cremona, probably between 1530 and 1535. The earliest reference to him—of 1563—is for portraits (now lost) of Rudolph and Ernest of Austria, who were in Cremona that year. Vincenzo must have been trained in Giulio's workshop, along with Antonio. Significantly, Vincenzo is documented in 1564, together with Giulio and Antonio, at San Sigismondo, Cremona, as well as in Milan. Vincenzo's earliest dated paintings—of 1569—the Deposition (in Foppone) and the Portrait of Giulio Boccamallon (in the Gallerie dell'Accademia Carrara, Bergamo) already reveal the two essential components of his style: the complex tradition of Cremonese Mannerism and an interest in Lombard naturalism, which was later combined with Flemish influences. In 1573, he frescoed ten roundels in the choir of the cathedral of Cremona with representations of the prophets. During this decade his work, like Antonio's, shows an increasing naturalism based on the example of Brescian painting. The Christ Supported by Angels, in Bordolano; the Christ About to Be Crucified, of 1575, in the Certosa di Pavia; the Prado Christ Nailed to the Cross, of 1577; and the Virgin and Saint Anne, of 1577, in Santa Maria Maddalena, Cremona, are from this period. His activity in the dominions of the Farnese was important both for the quality of his works in Piacenza (specifically, his fresco in the choir of San Sisto) and in Busseto (The Trinity with Saints Apollonia and Lucy, of 1579, and The Annunciation, of 1581), and because, in Parma, Vincenzo would have been able to study Correggio's frescoes as well as Joachim Beuckelaer's genre paintings (now in the Museo Nazionale di Capodimonte, Naples), which were sent to Parma by Alessandro Farnese. In fact, the genre subjects (fruit and fish vendors, and cooks) that Vincenzo painted at this time—together with works by Bartolomeo Passarotti—influenced Annibale Carracci. The most outstanding of these pictures was the series commissioned from Campi by Hans Fugger in 1580–81, still in the castle at Kirchheim, Bavaria (four of the five paintings are signed and two are dated). Similar paintings are in the Brera,

Milan; in Lyons; and in Modena. Vincenzo's last task—undertaken with the partial collaboration of Antonio (who died in 1587) and completed in 1588—was the decoration of the vault of San Paolo, Milan, with The Ascension of Christ and The Assumption of the Virgin; to this he brought his earlier experience at San Sigismondo, now further invigorated by a study of Correggio's works. Vincenzo died in October 1591.

4. Christ Nailed to the Cross

Oil on canvas, 82 11/16 x 55 1/2 in. (210 x 141 cm.)
Inscribed and dated (on reverse):
VINCENTIVS CAMPVS CREMONĒSIS
PINXIT 1577
Museo del Prado, Madrid

Among Vincenzo's relatively few works, the Madrid painting is a fundamental one both for the complexity of influences that it exhibits and for the naturalistic tendency that it expresses. Although the painting is signed and dated, it is not mentioned in early sources and only its modern provenance is known: it was left to the Prado by Don José Maria d'Estoup in 1917 (F. J. Sánchez Cantón, 1963, p. 110). Puerari (1953, p. 44) has suggested that it formed a triptych (similar to one painted in the same year by Antonio Campi in San Marco, Milan) along with the Deposition in the Museo Civico, Cremona, and a center painting (now lost or unidentified) that would have depicted the Crucifixion. This hypothesis is corroborated by the style of the paintings as well as by their dimensions. The Madrid picture marks a particularly intense moment in Vincenzo's development when, like his brother Antonio, he espoused the tradition of such Brescian painters as Moretto and Savoldo, investigating the potentials of naturalism. To be sure, "Romanist" elements persist in his work (the soldier seen from the back in the middle distance, for example, recalls engravings after Michelangelo by Marcantonio Raimondi and Agostino Veneziano), but they have been assimilated into a surprisingly new conception. The theme echoes that of such earlier works as Dürer's woodcut from The Small Passion series (of 1509–11), Giovanni Antonio Pordenone's fresco (of 1521) in the cathedral of Cremona, and Callisto Piazza's painting (of 1534–38) for the Incoronata, Lodi, which Longhi (1929) considered the immediate precedent of Vincenzo's work. In fact, Callisto Piazza's cautious attempt to translate a Mannerist-rooted plasticity into the terms of Lombard naturalism is revived by Vincenzo with a peremptoriness that must have impressed the young Caravaggio. Vincenzo was able to conceive the theme afresh, creating an unbalanced composition and immersing the

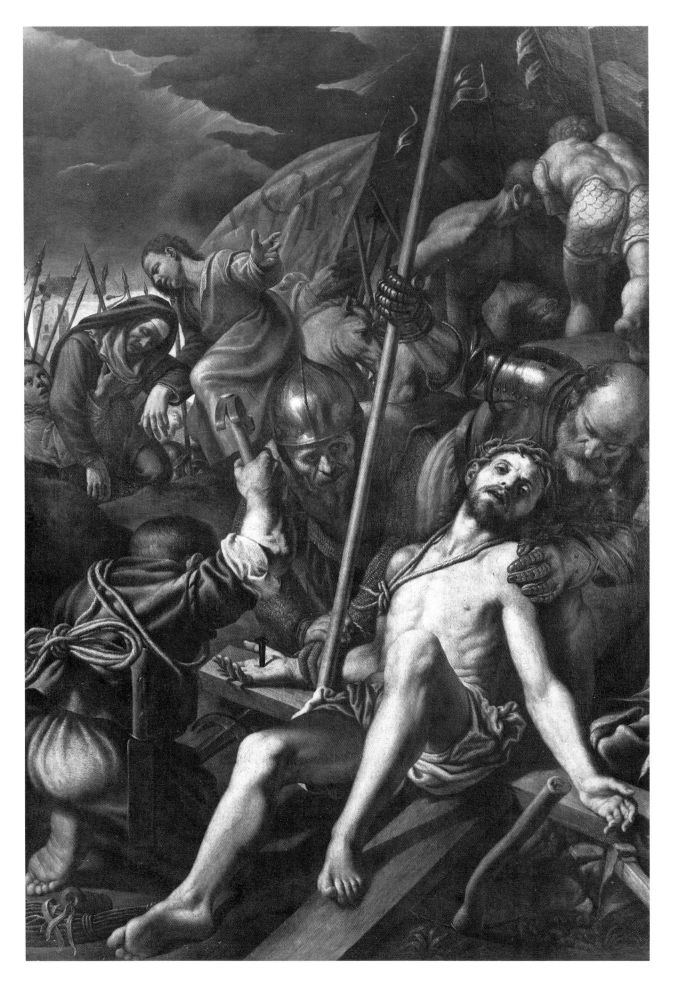

narrative in a vibrant, stormy light. Indeed, in this dramatic dialectic of light, formal problems are apprehended in terms of the empirical evidence of bodies in motion. A primary example of this is the figure of Christ, which is revealed by a raking light. As Longhi (1929, p. 309; 1968 ed., p. 129) observed, "The effectiveness of the sudden movements, the physical violence of the action, the heads of Christ and of the bald soldier in armor, foretell in a striking fashion the work of Caravaggio; and the executioner at the left with his hammer raised is like a study—however clumsy—for the analogous figure in Caravaggio's *Crucifixion of Saint Peter*."

S. Z.

Giovanni Paolo Lomazzo

The main source for Lomazzo, who was both a painter and a writer, is his autobiographical poem "Breve trattato della vita dell'autore descritta da lui medesimo in rime sciolte," published as a section of his Rime in Milan in 1587. In the poem, he declares that he was born in Milan at the seventeenth hour of Friday, April 26, 1538—a child of Taurus under the spell of Saturn. A deed of 1561 suggests that Lomazzo was of noble birth, and that he had relatives who were involved in the arts. He had contacts with such prominent figures as Philip II of Spain, Duke Carlo Emanuele of Savoy, and the Grand Duke of Tuscany, Ferdinando de' Medici. One of Lomazzo's earliest recorded works, a copy (now lost) after the Last Supper by Leonardo, which he painted for the monastery of Santa Maria della Pace, in Milan, seems to have been poorly received, and perhaps as a result Lomazzo left Milan and undertook what was a rather unusual cultural tour for an Italian artist. Between 1559 and 1565, he traveled not only to Rome and Florence but also to Antwerp, where he met Frans Floris and Maarten van Heemskerck. He was also acquainted with a descendant of Dürer's (possibly Hans Dürer, court painter to the king of Poland), for whom he painted a dramatic Crucifixion (Brera, Milan; temporarily removed to the Seminario Arcivescovile, Venegono). By 1565, he had settled in Milan, where his busy life was divided between painting and theoretical studies. His first public commission after his return was the fresco decoration, still extant, of the Foppa (or Brasa) Chapel in San Marco, Milan. The majority of his paintings—especially the portraits he lists in his autobiography—are now lost. About 1571, when he was thirty-three years old, Lomazzo became blind. Thereafter, he devoted himself to raising a family and to dictating and editing his theoretical works. The impressive drawing for the frontispiece of the Trattato, published by Lynch (1968), and the very important manuscript in the British Museum (ms. add. 12196), containing the text of Gli sogni e raggionamenti . . . con le figure . . . da egli dessignate, prove that Lomazzo began his theoretical works long before his blindness and that he intended to illustrate them in a Leonardesque manner. Lomazzo was trained by Giovanni Battista della Cerva and, possibly, by Cerva's master, Gaudenzio Ferrari, whom Lomazzo praises in his treatise, giving him the role of the father figure of the planet Jupiter. His revival of Leonardo's ideas—Gaudenzio had witnessed Leonardo at work—is possibly the most outstanding element in Lomazzo's theories. In contrast to Vasari's definition of painting as consisting of disegno and colorito ("painting being the counterfeiting of nature by the simple use of drawing and colors"), Lomazzo proposed a revised Leonardesque definition in which, "by way of proportioned lines and with colors similar to those in nature, following the perspective illumination ["lume perspetivo"], [painting] imitates the nature of bodies to the point that it represents not only their magnitude and relief but also their moti [an ambiguous term that indicates action, reaction, and movement] and so makes clearly visible the affections and passions of the spirit." This attention to natural light effects and to psychology may have influenced Caravaggio, and it is fascinating to read, in Gli sogni, a dialogue between Leonardo and Phidias in which Leonardo, having confessed that in painting the Last Supper he was subjected to the wishes of his patrons, declares that in more favorable circumstances he would have painted the apostles as fierce men with suntanned faces and dusty feet ("con piedi pulverti"). This comment makes the loss of Lomazzo's copy of Leonardo's Last Supper all the more regrettable.

Lomazzo's influence on young contemporary artists was not limited to his published works. Prior to his grand tour, he was a member of the Accademia della Valle di Bregno, of which he became abbot in August 1568. But the eccentric academy, which was a vehicle of artistic propaganda for Lomazzo in Caravaggio's Milanese years, does not seem to have survived its learned abbot.

5. Self-Portrait

Oil on canvas, 22 1/4 x 17 3/8 in. (56.5 x 44 cm.)
Inscribed and monogrammed (at the bottom): ZAVARGNA.NABAS VALLIS BREGNI $_\times$ ET. Ɖ. PI[C]T[O]R
Pinacoteca di Brera, Milan

"Lomazzo has represented himself wearing a large old-fashioned hat of straw–like material, folded at the brim, and wreathed with a crown of laurel, oak, and vine leaves. Pinned to the hat is a medallion decorated with a pot of leaves [actually, a watering can with a branch of vine leaves]. Around his shoulders the painter wears a mantle of fur, and over his left shoulder he carries a thyrsus sprouting vine and ivy leaves . . . in his right hand Lomazzo holds a book or tablet, while between thumb and forefinger he grasps a compass." Lynch (1964, pp. 192 f.), to whom we owe this description, concludes that the picture "is an obvious representation of Lomazzo as Bacchus as well as a self-portrait of the artist." Lomazzo appears to be in his thirties, and his unusual attire corresponds to the official dress of the abbot of the Accademia della Valle di Bregno as recorded in the artist's Rabisch dra Academiglia dor Compá Zavargna, Nabad dra Vall d' Bregn of 1580.

Lomazzo was granted the title of abbot in August 1568 and took the nickname of Zavargna.

The academy gathered together artists and other men of distinction with the intention of parodying the more ambitious academies; Lynch (1966) notes a parallel with the better-known Accademia dei Vignaiuoli in Rome. The Val di Bregno, a picturesque valley in the Ticino at the foot of the Adula glacier, passed with the rest of the region, under Swiss rule in 1512. Nonetheless, from the valley, facchini, or wine porters, migrated to Milan, bringing with them their vivid folklore, which the academicians transformed into a sort of primitive cult of Dionysus. The Accademia della Valle di Bregno, which was founded about 1560, adopted Bacchus as its patron and employed a sort of perfected form of the local dialect as its mystic tongue. This linguistic experimentation with the jargon of the lower classes can be compared to the almost

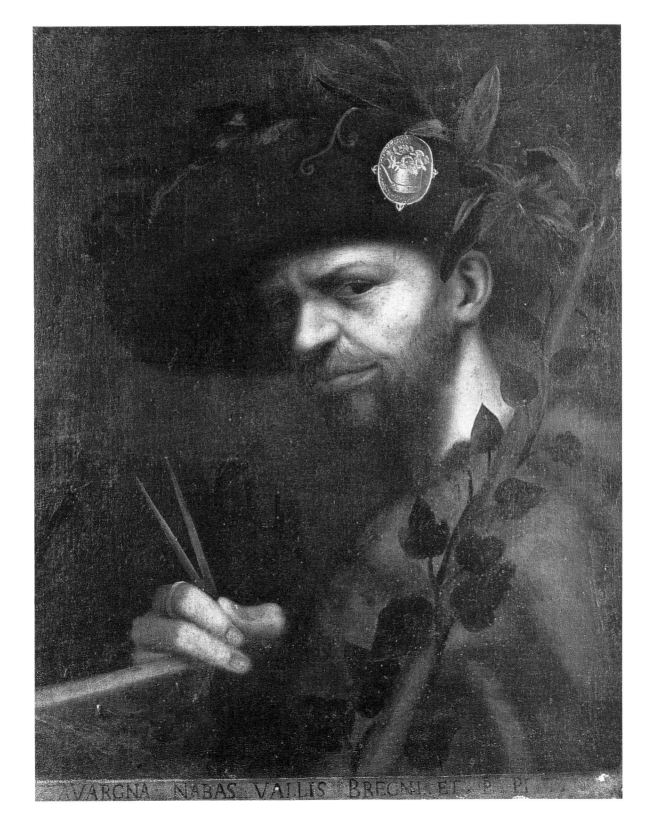

VARGNA NABAS VALLIS BRECNI ET P PI

contemporary theater of Angelo Beolco (Il Ruzzante) in Padua. The academy's motto was *Bacco inspiratori*, which suggests that the ceremonies included substantial wine drinking. Lynch, noting that Lomazzo was a member of the academy before 1565, conjectures that it was mainly because of the criticism in the academy of his copy of Leonardo's *Last Supper* that Lomazzo decided to undertake an extensive journey in 1559.

In Florence in 1562, Pier Paolo Galeotti cast a medal with an *impresa* vindicating Lomazzo's honor. In Galeotti's medal the artist's profile has no specific connotations, but in a medal that had been cast in Milan by Annibale Fontana prior to Lomazzo's departure, he is dressed with a tunic that leaves his right shoulder bare while on the left shoulder is a very conspicuous knot. In classical archaeology, the dress would be described as typical of the Cynic philosophers. It is interesting to note that the same dress appears in youthful works by Caravaggio, such as the *Bacchino Malato* (see fig. 1, p. 29) and the *Boy Bitten by a Lizard* (cat. no. 70). Vine and ivy leaves and a black ribbon also sometimes appear. It is also notable that both Caravaggio's *Bacchus* (cat. no. 71) and the *Boy Bitten by a Lizard* show unkempt, dirty fingernails, more in keeping with a *facchino* than a gentleman of standing. Both Lynch and Spear (1984) have pointed out the connection between Lomazzo's self-portrait as *Bacchus* and Caravaggio's in the Galleria Borghese, Roma.

The present picture was purchased in 1806 as a part of Giuseppe Bossi's program of assembling a cabinet of artists' portraits in the Brera. Between 1877 and 1906, it was listed as a self-portrait by Lomazzo in the museum's catalogues. Its authorship was first doubted when Berenson (1896, p. 198) mentioned it as a copy after the *Flute Player* in The New-York Historical Society, a picture that he ascribed to Cariani but which was previously believed to be by Giorgione. Lynch (1964, pp. 189 ff.) has definitively identified the painting as Lomazzo's. Nevertheless, Berenson's judgment underscores the picture's apparent Giorgionesque qualities, while the naturalism of the vine and ivy leaves, no less than the subtlety of the smile, points toward a renewal of the heritage of Leonardo. In a truly Mannerist spirit, the Saturnine Lomazzo has represented himself as under the spell of the moon, symbol of Melancholy.

C. B.

Lorenzo Lotto

Lotto was, without doubt, the most idiosyncratic Venetian artist of the sixteenth century. Both his character—unstable and fervently religious—and his art were outside the mainstream of Venetian norms, and were greeted with incomprehension and criticism by such contemporaries as Pietro Aretino and Ludovico Dolce. Born in Venice in 1480, Lotto was trained in the tradition of Giovanni Bellini, and, in certain respects, he never abandoned an essentially Quattrocentesque descriptive approach to painting; Dürer's work in Venice only served to reinforce this tendency. Lotto's earliest documented activity was in Treviso, north of Venice, from 1503 to 1506. Thereafter, his peripatetic career was passed principally in the provinces of Venetian territory: in Recanati, in the Marches (1506–8); Jesi (1512 ?); Bergamo and Brescia (1513–25); Venice (1525–32); Jesi and Ancona (1533–39 ?), Venice (1540–42); Treviso (1542–45); Venice (1545–49); Ancona (1549–51); and in Loreto (1552–56/57), where he died a brother of the Santa Casa. The twelve years that Lotto spent in Bergamo and in Brescia were particularly fruitful, for in those cities he encountered a tradition of naturalism that was akin to his own. "Lotto," wrote Longhi (1929; 1968 ed., p. 116), "saw more clearly in the Lombard tradition than the Brescians themselves knew how to." Indeed, his depiction of light, his mastery of landscape (recognized even by Vasari, whose life of Lotto is otherwise disappointingly uninformative), and his abilities as a portraitist struck a responsive chord among the Bergamasks and Brescians. In Lombardy, Lotto exerted an influence— on Moretto, especially, but also on Moroni—that was denied him in his native city, and a number of later writers, such as Carlo Ridolfi and Francesco Tassi, actually believed that Lotto was from Bergamo. The emotional quality of Lotto's work, which was—to a peculiar degree—the expression of his own personality, was inimitable, but the pictures by him in and around Bergamo were avidly studied right down to the time of Caravaggio, who may have recognized them as the paintings of a fellow nonconformist.

6. Madonna and Child, with Two Donors

Oil on canvas, 34 x 45 1/2 in.
(86.4 x 115.6 cm.)
The J. Paul Getty Museum, Malibu

The picture has been plausibly identified with a painting of the Madonna and Child and two donors that was seen by Boschini (1660; 1966 ed., p. 395) in the collection of the Florentine painter Paolo del Sera, who was Cardinal Leopoldo de' Medici's artistic adviser in Venice:

> *Gh'è de Lorenzo Loto a maravegia*
> *Una Madona bela, e 'l Bambineto*
> *Signor nostro Giesù cusì perfeto,*
> *Che veramente el fa inarcar la cegia.*
> *Con do retrati, veramente vivi,*
> *Adoranti, devoti e spiritosi*
> *D'Omo e de Dona, cusì artificiosi,*
> *Che se ghe vede i spiriti efetivi.*

(There is by Lorenzo Lotto, marvelously done / A beautiful Madonna and the infant / Christ Child, so perfect, / That truly it causes eyebrows to raise. / With two portraits, truly alive, / Adoring, devout and filled with spirit / Of a Man and a Woman, so well conceived, / That their very spirits are revealed.)

The picture was evidently sold not to Leopoldo, but to his brother Giovan Carlo de' Medici, for it is described minutely (without, however, the name of the artist) in an inventory of Giovan Carlo's collection following his death in 1663 (S. Mascalchi, 1984, pp. 229, 427, 633; this notice was brought to my attention by B. Fredericksen). Pallucchini's proposal (1966, p. 398, n. 22) that Boschini may actually have referred to Lotto's *Holy Family, with Saints Anne and Jerome* (now in the Uffizi) carries no weight whatsoever. In fact, the Getty picture is the only work by Lotto that corresponds to Boschini's description. It is said to have been in the Palazzo Rospigliosi, Rome, prior to its purchase by Robert Benson about 1905.

Holmes (1923, p. 237) first noted that the pose of the Madonna and Child recurs in Vincenzo Catena's *Holy Family, with Saint Anne* (Gemäldegalerie, Dresden), which, in turn, is related to a composition from Raphael's circle that is known in two drawings (one, in the Duke of Devonshire's collection at Chatsworth; the other, in the Earl of Pembroke's collection at Wilton House; see S. A. Strong, 1900, II, no. 19). In addition, there is a version of the Dresden picture, by Catena (formerly in the collection of the Earl of Mexborough), in which the figures are cropped just below the knees (see G. Robertson, 1954, pp. 56 ff.). According to Robertson, Catena's half-length version is perhaps slightly earlier than the Dresden picture, although both date from shortly before 1520. Logically, however, the Dresden picture, which repeats virtually all of the details of the Raphaelesque design—adding only a landscape viewed through a window in the background and two partridges and a terrier in the foreground—would precede the ex-Mexborough version, in which the composition has been rather mindlessly cut down and the frame of the window moved to the left to isolate the Madonna and Child. As Strong has suggested, Catena was probably sent a drawing of the composition from Rome by one of his acquaintances—possibly Marcantonio Michiel, who was in touch with Catena in these years (see G. Robertson, 1954, p. 10). Catena's cropped version, rather than either the Raphaelesque drawing or the Dresden picture, would seem to have been the point of departure for Lotto's painting, since it repeats the placement of the window frame in the ex-Mexborough painting, and the figure of the Virgin is cut off at precisely the same point below her left knee. In other respects, however, Lotto has treated his model with considerable freedom, altering the position of the Virgin's hands and the arrangement of her hair and drapery, and transforming the Child's gesture from one of reaching to one of blessing. In Lotto's composition, the Madonna and Child seem to be elevated before two pilgrims, who raise their hands in deference to the holy mother and child; the artist has further enriched the scene by including a green curtain behind the Madonna and Child and by showing a fig branch—symbol of Christ's Resurrection— outside the window.

The relationship of Lotto's picture to Catena's is of more than passing interest, for, while there is a general consensus that Lotto's was painted in the 1520s, he resided continuously in Venice between 1525 and

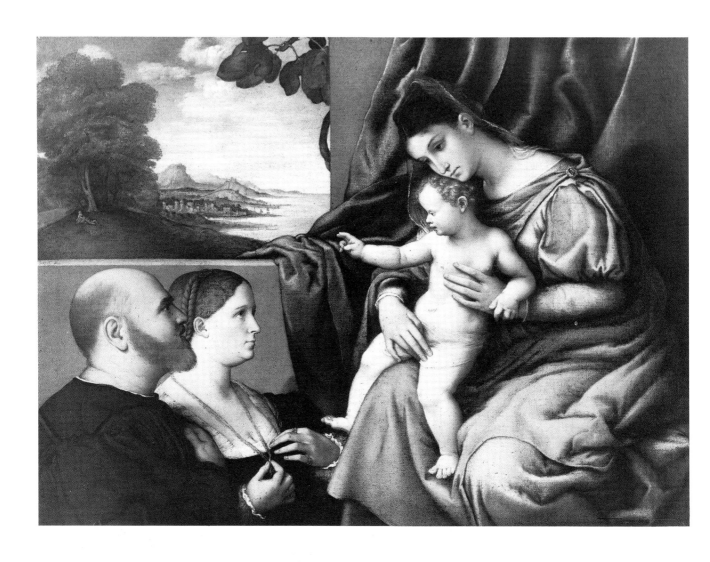

1532, and there is, consequently, a presumption that the picture dates from this time. Indeed, the closest analogies of style are with his *Holy Family with Saint Catherine of Alexandria*, dated 1529 (private collection, Bergamo). Although the picture is more likely to have been painted in Venice than in Bergamo, it nonetheless documents one of Lotto's most important contributions to Lombard painting—what Longhi (1929; 1968 ed., p. 117) described as "the manner of transforming the Venetian *sacra conversazione* into a confidential reunion that gathers together on the same terrain the divine and the human, giving to both the same character" ("il modo di trasformare la Santa Conversazione dei veneti in una riunione confidenziale che accomuni sullo stesso terreno e distribuisca la stessa indole ai personaggi divini ed umani"). Also notable is Lotto's naturalistic treatment of light: specifically, his description of the arbitrary patches of illumination and shadow on the figures. In both of these respects Lotto's work seems to belong as much to Lombard painting traditions as to the world of his Venetian contemporaries. What such a picture may have meant to Caravaggio can be surmised from his *Rest on the Flight into Egypt* (Galleria Doria-Pamphili, Rome) or the later *Sacrifice of Isaac* (cat. no. 80), in which Lotto's favored formula of placing the figures against a dark background, which serves as a foil, enlivened at one side by a distant landscape, is taken up —although with a different expressive purpose and a more truly Lombard feeling for describing form in terms of light.

K. C.

Alessandro Bonvicino
called Moretto da Brescia

Moretto was the foremost Lombard painter of the sixteenth century, and was recognized as such by Vasari. "Ragionevoli," "molto naturali," and "vivissime," are among the adjectives that Vasari used to describe Moretto's work. Longhi (1917; 1961 ed., p. 337) has emphasized that Moretto's strength lay in the description "of substance, matter, atmosphere, light, and tone that were the most singular heritage of the Brescian school." According to Moretto's own, later, testimony, he was born about 1498 in Brescia. His father was a painter, but nothing is known about his work. There can be little doubt that Moretto's earliest training was in the tradition of Vincenzo Foppa—his greatest predecessor and the founder of Renaissance painting in Lombardy. Nonetheless, from an early age, Moretto was open to a wide variety of influences. His organ shutters, painted from 1515 to 1518 in collaboration with Floriano Ferramola for the cathedral of Brescia, so resemble the work of Romanino that even Longhi (1917; 1961 ed., p. 331) at first attributed them to the latter artist; and Moretto's Christ Bearing the Cross, with a Donor *(Gallerie dell'Accademia Carrara, Bergamo), dated 1518, reveals a direct debt to Titian. What is more remarkable still is Moretto's assimilation of Central Italian art through the study of prints after Raphael (Vasari noted that the heads of Moretto's figures were in the manner of Raphael, adding, "and they would resemble his manner even more were it not that Moretto was so distant from Raphael"). There is, throughout Moretto's work, a tension between the artifice of his High Renaissance compositions and his native naturalism, although in his greatest masterpieces—his work in the Cappella del Sacramento in San Giovanni Evangelista, Brescia (1521–24); the* Nativity, *the* Supper at Emmaus, *and the* Christ with an Angel *(in the Pinacoteca Tosio Martinengo, Brescia); and the* Christ in the House of the Pharisee, *in Santa Maria Calchera, Brescia—he achieved a synthesis that was the basis of subsequent Lombard painting and that provided the most important precedent for the young Caravaggio, whose hometown was about forty miles west of Brescia. No less important for the character of Moretto's paintings was his association with religious leaders and confraternities in*

Brescia. Elegant testimony to this is the provision of the Scuola del Santissimo Sacramento—to which Moretto belonged from 1517 until his death in 1554—to commemorate with the celebration of a mass every year for five years "the soul of the painter, Master Alexander, a worthy member of this scuola, *who made many contributions by his art and industry in decorating the same* scuola, *and for his notable virtues" (V. Guazzoni, 1981, p. 22).*

7. The Entombment

Oil on canvas, 94 1/2 x 74 1/2 in. (240 x 189.2 cm.)
Dated and inscribed (lower left): AN[N]O.DŌM[INI]/MDLIV MENS[IS] OCT[OBRIS] *(In the year of our Lord 1554 in the month of October); (lower center, on tomb slab):* FACTVS EST/OBEDIENS / VSQVE AD MORTEM *("He . . . became obedient unto death . . ." Philippians 2:8)*
The Metropolitan Museum of Art, New York

The picture is first recorded in the oratory of the Disciplina di San Giovanni Evangelista in Bernardino Faino's seventeenth-century guide to Brescian churches. The manuscript gives the following description: "In the upper oratory of this church there is the altarpiece by Moretto, a most beautiful thing and worthy of consideration. In it are shown the Dead Christ with many figures. On the walls are painted in fresco two busts of Saints John the Baptist and John the Evangelist by Gandino [Bernardino Gandini, 1587–1651] and Baruccho [Giacomo Barucco, 1582–1630]" (C. Boselli, 1961, p. 147). In all likelihood, the painting was commissioned by the confraternity for their oratory attached to the church of San Giovanni.

This is the last major altarpiece by Moretto—it was completed just two months before he died—and it postdates the beautiful *Entombment* in the National Gallery of Art, Washington, D.C., by perhaps three decades. It is in comparison with the Washington picture—with its rich, saturated colors; its intense, almost raking light; and its dramatic interpretation of the theme—that the present painting has been considered an inferior product of Moretto's declining years, carried out with the assistance of his workshop. Gombosi (1943, pp. 64, 110) went so far as to interpret the inscription from Philippians as a memorial to Moretto added by his pupils (see also V. Guazzoni, 1981, p. 53).

The comparison with the Washington *Entombment* is relevant not as an index of quality but of Moretto's approach to the subject, for there can be no reasonable doubt that, whereas in the Washington pic-

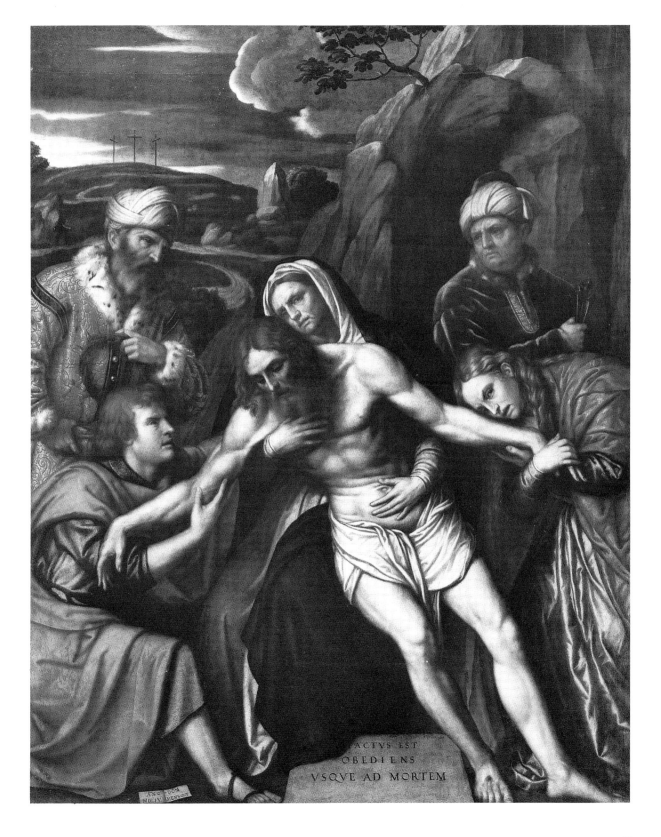

ANO · DOM
MDLV · MENSOCT

FACTVS EST
OBEDIENS
VSQVE AD MORTEM

ture Moretto treated the theme as a narrative, here he purposely adopted an expository approach with a view to the function of the painting. As is so often true of Moretto's work, the inscription underscores its expressive and didactic content.

The passage inscribed on the tomb slab derives from an exhortation to the Philippians (2:5-8) for unity and humility. "Let this mind be in you," writes Saint Paul, "which was also in Christ Jesus . . . who . . . took upon him the form of a servant . . . and . . . humbled himself, and became obedient unto death, even the death of the cross." To the members of the confraternity who commissioned the altarpiece (and who obviously selected the biblical text), these words would have had a direct application by presenting Christ as an exemplar. Moretto shows the dead Christ with both arms extended, supported by his mother and mourned by Mary Magdalen and Saint John—the patron of the church to which the oratory was attached. The figures are placed insistently close to the picture plane, and one of Christ's wounded feet is shown frontally, aligned with the edge of the tomb slab. Both the Virgin and the Magdalen look toward the viewer to solicit his participation in the scene. Behind this symmetrical group are Joseph of Arimathea, who devoutly clasps the crown of thorns to his breast, and Nicodemus, who holds the three spikes used to nail Christ to the cross. Behind Nicodemus is the dark tomb opening, above which what appears to be a fig sapling—the symbol of Christ's Resurrection—grows; behind Joseph of Arimathea is Golgotha, with the three empty crosses silhouetted against a beautiful, crepuscular sky. As in Moretto's great *Christ with an Angel* (in the Pinacoteca Tosio Martinengo, Brescia), probably painted just a few years earlier for a confraternity in the cathedral of Brescia (see V. Guazzoni, 1981, pp. 52 f.; 1983, pp. 185 f.), each element in the composition is meant to serve as an inducement to meditation, so that the entire picture becomes a visual exposition of the biblical text in a way that anticipates the definition of sacred images by the Council of Trent in 1563. To appreciate Moretto's extraordinary balance between means and end, one has only to compare the *Entombment* to the almost contemporary *Christ in the House of*

the Pharisee (in Santa Maria Calchera, Brescia), where a more descriptive style and an interior, focused light have been adopted to enhance the dramatic moment (R. Longhi, 1929; 1968 ed., p. 109, called the picture "the most pre-Caravaggesque work Moretto ever painted").

It has long been known that a large number of Moretto's paintings were commissioned by confraternities in Brescia, and that Moretto himself was a lifelong member of the Scuola del Santissimo Sacramento in the cathedral. However, only recently has his association with these confraternities and with pre-Council reformers—and the resulting relationship to his work—been examined (V. Guazzoni, 1981). As a result, Moretto's paintings now appear more varied, and his manipulation of style more purposive. If, on the one hand, his treatment of religious narratives as "monumental genre scenes" ("scene di genere monumentale": Longhi) presages the work of Caravaggio, on the other hand, his professional standards and his devotional altarpieces forecast aspects of Counter-Reformation painting.

K. C.

Giovanni Battista Moroni

Born between 1520 and 1524 to an architect and stonemason in the town of Albino, northeast of Bergamo, Moroni was trained in Brescia by Moretto, whose workshop he may have joined as early as 1532, and with whom he collaborated as late as 1549 (M. Gregori, 1979 a, p. 97).

The importance of this training is evident both in the figure types and the technique of Moroni's early pictures, as well as in his continued reliance on his teacher's work for the compositions of his religious paintings. Scarcely less important was his presence in Trent during the first two sessions of the Church Council, which were held between 1545 and 1547, and 1551 and 1552. In Trent, Moroni was employed by the Madruzzo family—he painted portraits of Gian Ludovico and Gian Federico Madruzzo, whose uncle, Cristoforo, was the Prince-Bishop of Trent and one of the organizers of the council—and his continued contact with members of the Counter-Reformation has been thought to have affected his conception of religious painting, although the council did not issue its statement, "On Sacred Images," until 1563 (but see M. Calì, 1980, pp. 11 ff., for a contrary view). It also seems probable that, in Trent, Moroni became familiar with Northern painting, which, together with the realist tradition of his native Lombardy, influenced his work as a portraitist. From 1561 until his death in 1578, Moroni lived in Albino, and the majority of his pictures were painted for patrons and churches in the surrounding territory (which may be the reason that he is not even mentioned by Vasari).

From an early date, Moroni's work evolves along divergent paths, his portraits attaining a level of accomplishment and sophistication that stands in marked contrast to the apparent provincialism of his religious images. Berenson (1907, p. 128) described Moroni as "the only mere portrait painter that Italy has ever produced," condemning his religious paintings as "pitiful shades or scorched copies of his master's," and even Longhi (1929; 1968 ed., pp. 121 f.) considered Moroni a specialist in portraiture. However, following the major exhibition devoted to Moroni in Bergamo in 1979, when a substantial number of his portraits and altarpieces were shown together, it has

been possible to reevaluate these in the light of the environment in which he worked, and to begin to appreciate his contribution to religious painting, the cultural significance of which extends well beyond the confines of Lombardy.

8. Portrait of a Man and Woman, with the Madonna and Child and Saint Michael

Oil on canvas, 35 1/4 x 38 1/2 in.
(89.5 x 97.8 cm.)
Virginia Museum of Fine Arts, Richmond

Domestic paintings that combined portraits and religious figures—usually of the Madonna and Child—were current throughout the Veneto in the early sixteenth century. One need only cite Titian's *Madonna and Child, with Saints Catherine and Dominic and a Donor*, at La Gaida (Parma); Palma Vecchio's splendid *Madonna and Child, with Saints and a Member of the Priuli Family*, in the Thyssen-Bornemisza collection, Lugano; and Lorenzo Lotto's *Madonna and Child, with Two Donors*, in The J. Paul Getty Museum, Malibu, to realize the popularity of the type. In these pictures the sitter or donor and the religious figures occupy a common space and, in both their uniform scale and their treatment, are integrated aesthetically. Moroni himself painted a picture of this kind (now in the Brera, Milan) earlier in his career, but with the portrait separated from the holy figures by a ledge. The sitter is, moreover, almost in profile, his hands clasped in prayer—in a fashion that seems to consciously revive an earlier tradition of donor portraits in altarpieces. In the present picture, which Gregori (1979 a, p. 298; 1979 b, p. 118) convincingly dates between 1557 and 1560, the process of separating the secular from the religious, and the real from the imagined or visionary, has been taken one step farther. The sitters—dressed in the severe costumes popularized in Lombardy by the Spanish—are the principal elements of the composition. The woman is shown in strict profile, her hands joined in prayer; what is probably a breviary rests on the parapet behind her. The upper body of the husband is also in profile, but his head is turned to address the viewer as he indicates with his right hand an apparition of the Virgin and Child and Saint Michael in the sky. The resultant image, having almost the appearance of a popular votive painting, was a novelty, although Gregori (1979 a, p. 285; 1979 b, p. 92) has acutely noted that the compositional scheme shows the possible influence of Northern Mannerist paint-

ings, such as Maarten van Heemskerck's self-portrait with a view of the Colosseum (in the Fitzwilliam Museum, Cambridge). The most immediate precedent was Lotto's portrait of Fra Gregorio Belo (in The Metropolitan Museum), painted in 1546–47, in which the Hieronymite brother faces the viewer, holding an edition of the homilies of Gregory the Great in one hand (opened to the conclusion of the thirty-seventh homily ?; see *Patrologia Latina*, LXXVI, pp. 1274 ff.) and striking his breast penitentially with the other, while the scene in the background shows Golgotha, with the crucified Christ surrounded by his mother, Mary Magdalen, and Saint John. However, in Lotto's picture the setting of the Crucifixion is coterminous with Fra Gregorio's, and all of the figures are treated consistently, as though the artist wished to emphasize the psychological unity between the background scene and the action of the main figure. Moroni has differentiated between the imagined and the real not only through the device of a separating ledge and the use of the profile portrait, but in his treatment of the figures: meticulous and unidealized for the portraits; stiff and schematic for the sacred figures. The pose of the Madonna is clearly based on such paintings by Moretto as the *Madonna and Child, with Saints and Divine Wisdom* (in the Palazzo Vescovile, Brescia) on which Moroni may, indeed, have worked (see M. Gregori, 1979 a, p. 98; 1979 b, p. 41), and, to an even greater degree, on the earlier *Madonna and Child in Glory, with Saints*, in San Giovanni Evangelista, Brescia, but a comparison with these pictures only underscores the archaic, almost neo-Quattrocentesque, quality of Moroni's figure group.

Moroni's reliance on compositional formulas for his religious paintings has been much commented upon, and regarded as an inherent weakness—not unlike the similar, later phenomenon in the work of Moroni's compatriot, Giacomo Ceruti—and as a consequence of the provincial patrons for whom he painted. Yet, in this picture, as in the closely related *Donor, with the Baptism of Christ* (in a private collection, Milan), the manipulation of style and the use of earlier compositions for the religious scenes are certainly intentional. Freedberg (1971, pp. 408 f.) has stressed the probable relationship of Moroni's religious art to the Counter-Reformation (see also G. Gombosi, 1943, p. 69), and Gregori (1979 a, p. 285; 1979 b, p. 92) has cited Saint Ignatius's *Spiritual Exercises* (published in Bergamo in 1551), with its emphasis on mental images as a focus for meditation, as the ideological source for these singular paintings. Gregori's idea would appear especially apposite to the present picture, where the attitude of the woman is physically unrelated to the background figures—themselves, evidently the focus of her meditation rather than a miraculous apparition—while her husband seems to urge our participation. Saint Michael, who prominently displays his sword and the scales while he gazes imploringly at the Christ Child, may be the patron saint of one of the two sitters or, alternatively, a reminder of the Last Judgment (in fact, in the *Spiritual Exercises*, the first meditation urges the participant to consider sin, beginning with that of the angels and ending with the sins of the participant). Recently, however, Calì (1980, pp. 19 ff.) has interpreted this and similar paintings by Moroni in terms of the influence of Erasmus's writings and of the *Devotio moderna* . She has also underscored the direct relationship that the contemporary figures portrayed seem to have with the sacred ones—and she specifically denies any connection between these pictures by Moroni and the Counter-Reformation. While several of her arguments are extremely persuasive, the matter is not clear-cut; certainly it is not true that Moroni's treatment of subjects that are private and devotional in character are uniformly of a higher quality than a number of his altarpieces with strictly Catholic themes, "as though frequently the artist had to submit himself to the will of his patrons" (M. Calì, 1980, p. 18). Regardless of Moroni's own religious sympathies or those of his patrons, his work seems to anticipate by at least two decades the conservative, almost reactionary aspect of much Counter-Reformation religious painting—what Zeri (1957) has called *arte sacra*—with its evident divergence from what was expected of secular painting.

K. C.

Simone Peterzano

Of Bergamask origin, Peterzano is documented in Milan between 1573 and 1596. However, he must have been trained in Venice, since he designated himself as a disciple of Titian, and contemporary sources refer to him as Simone Veneziano. His apprenticeship with Titian was questioned by Longhi (1929, p. 311), but there is much evidence in its favor: the presence of his works in Venetian collections; contemporary references; and, above all, the style of his first Milanese paintings, such as those of 1573, in San Barnaba. The decoration of the presbytery (1578–82) of the Certosa di Garegnano, just northwest of Milan, is his masterpiece, but Peterzano also worked in the most important churches in the city—in San Maurizio (on the frescoes on the interior façade), Santa Maria presso San Celso (on the organ shutters, of 1577; now lost), Santa Maria della Passione (The Assumption of the Virgin, of 1580), San Vito al Pasquirolo (The Madonna and Saints, of 1589), the cathedral (the altarpiece for the altar of Sant'Ambrogio, of 1594, now in the Pinacoteca Ambrosiana; identified by M. Valsecchi, 1971, pp. 178, 182), and Sant'Angelo (on the frescoes in the chapel of Sant'Antonio; reascribed to Peterzano by M. Calvesi, 1954, pp. 127 ff.)—where he was esteemed (G. P. Lomazzo, 1587, II, p. 207; 1590, p. 141) and much in demand. Other works by Peterzano are in the church of the Carrobiolo, Monza (G. Bora, 1980, p. 68), in Sant'Agostino, Como (C. Baroni, 1944, pp. 305 ff.), and in Santa Maria di Canepanova, Pavia (R. Longhi, 1929, p. 311).

In the documentation of Peterzano's activity, there is a hiatus between 1585 and 1589, and it has been suggested that at this time the artist traveled to Rome, perhaps accompanied by his young apprentice, Caravaggio (M. Calvesi, 1954, p. 120; E. Baccheschi, 1978, p. 473).

Between 1584 and 1588, Caravaggio was a member of Peterzano's workshop—already well-established by 1575 (N. Pevsner, 1927–28, pp. 390 ff.). Longhi (1929, p. 311) recognized Peterzano's influence on Caravaggio's earliest Roman works—the Boy with a Basket of Fruit *and the* Bacchus *(cat. nos. 66, 71)—and Gregori (1973 b, p. 17) has noted that the frescoes at Garegnano served as the largest and most influential*

repertory of images accessible to the young Caravaggio. These observations are further enhanced by the realization that the Bacchino Malato *(in the Galleria Borghese) is a direct quote from the Persian Sibyl on the vault of the Certosa di Garegnano. Indeed, the relationship between the two figures is so close as to raise the suspicion that Caravaggio may have employed his teacher's preparatory drawing, which still exists in the vast collection of Peterzano's graphic work in the Civico Gabinetto dei Disegni of the Castello Sforzesco, Milan (M. T. Fiorio, 1974, pp. 96 f., figs. 21–22). Caravaggio's fidelity to his Lombard background—even at the time of his first Roman commissions—sheds light on that period in his training when he was still removed from the Mannerist tendencies prevalent in Rome.*

9. The Entombment

Oil on canvas, 113 3/16 x 72 7/8 in. (290 x 185 cm.)
Signed (lower left): SIMON PET[E]RZANNVS TITIANI DISCIPVLIS
San Fedele, Milan

As the small figure of Saint Veronica in the background testifies, Peterzano painted this picture for the chapel dedicated to the saint in Santa Maria della Scala, Milan. The church was demolished in 1776, and *The Entombment* was moved with other paintings to San Fedele, where it was placed on the first altar to the left.

Recent restoration has solved the controversy about the inscription: The signature in the lower left has been retouched but is authentic. There is, however, no trace of the "1591" mentioned by many scholars. Longhi (1929, p. 311) and Baroni (1940, p. 179) had both questioned this date because of its apparent contradiction of the strongly Venetian character of the painting. The color scheme—Veronesian in its warm tonality and brilliant harmony—has regained its richness since cleaning, thereby confirming that the painting dates from Peterzano's early maturity, perhaps prior to his work on the frescoes at the Certosa di Garegnano and closer to the paintings in San Barnaba. Longhi (1929, pp. 312, 315) traced the iconography to Savoldo—a pertinent observation so far as concerns the naturalism of the picture, which is obviously Lombard. However, the relation to the *Pietà* by Francesco Salviati painted for the church of the Corpus Domini in Venice (D. McTavish, 1981, p. 83), and now in Viggiù (on loan from the Brera), seems more to the point. Borrowed from Salviati's *Pietà* was the idea of linking the three principal figures along a diagonal: Nicodemus, who stands on the tomb slab intent on supporting the inert body of Christ; Christ himself; and Mary Magdalen. A drawing by Salviati (now in the Uffizi) thought to be a study for the *Pietà* (E. A. Carrol, 1971, p. 28) confirms this dependence. In the study, the abandoned body of the Savior, with the feet crossed and the arm hanging at his side in accordance with a well-known Michelangelesque formula, coincides exactly with Peterzano's Christ. Nor are other features

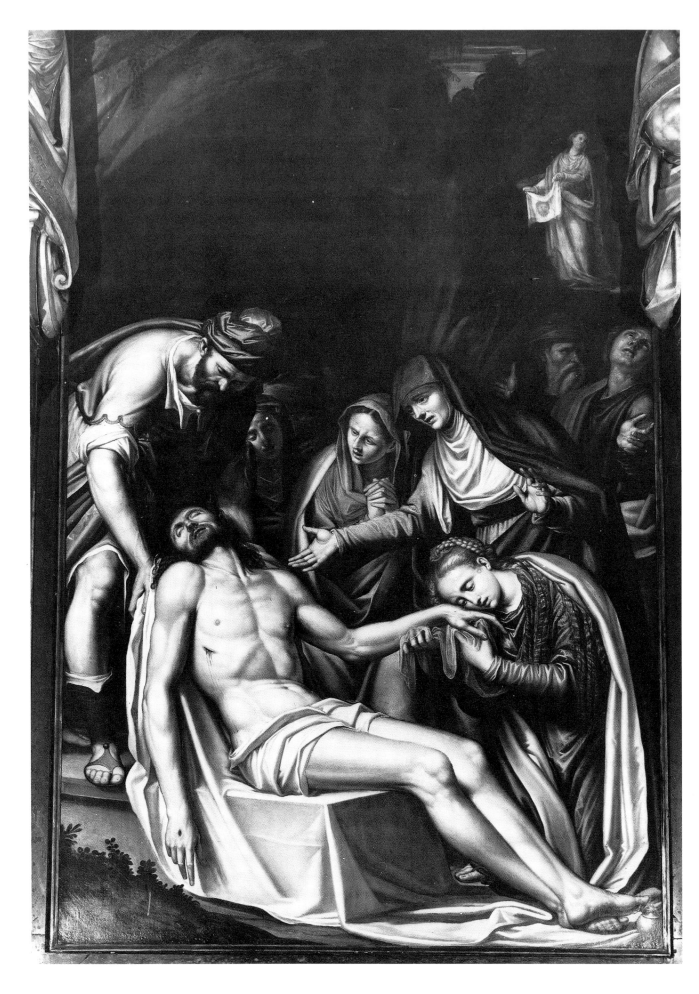

of Peterzano's *Entombment*—the strong plasticity of the figures, the academically described musculature, and the slightly emphatic gestures—foreign to the example of the Mannerist Salviati. Not only do the Salviati-like qualities of the San Fedele altarpiece underscore its placement among Peterzano's earliest works; they also give additional weight to the notice of Peterzano's presence in Venice—where Salviati also worked between 1539 and 1540 —thereby providing complimentary evidence for Peterzano's stated apprenticeship with Titian. This complex and carefully considered work was preceded by an extensive series of preparatory drawings (published by C. Baroni, 1944, pl. X). The San Fedele altarpiece must have enjoyed some celebrity, as there is a replica of the *Entombment* in San Vittore, Varese, which substantially agrees with the one in Milan except for the unnatural extension of the upper portion of the composition to suit a more vertical format, the elimination of Veronica, and the substitution of Mary Cleophas with a figure in a nun's habit that later frescoes in the same chapel identify as Saint Martha. Probably a shop work, the San Vittore version must have been painted after 1583, the date when work in the chapel of Saint Martha began.

Peterzano returned to the theme of the Pietà for the parish church of Casolate—in a painting that has recently been added to his oeuvre (M. Bona Castellotti, 1979, pp. 80 ff.). Its employment of a more typically Lombard composition reminiscent of those of Bernardino Campi and of a less sumptuous use of color further emphasize the precedence of the San Fedele altarpiece —echoes of which, as Longhi (1929, p. 312) pointed out, reappear in Caravaggio's work. Indeed, in painting the *Entombment* (in the Vatican), Caravaggio seems to have recalled the animation of Peterzano's violently lit figures, who are the dramatic participants in a tragedy, and yet, the relationship of Caravaggio's painting to Peterzano's is not direct—as it was with the *Bacchino Malato.*

M. T. F.

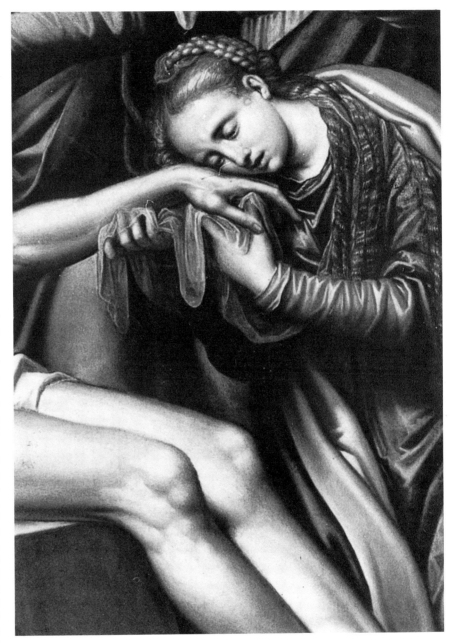

Girolamo di Romano
called Romanino

Romanino was born between 1484 and 1487 in Brescia, where he must have received his initial training. However, his earliest dated work, a Lamentation painted in 1510 for San Lorenzo, Brescia (now in the Gallerie dell'Accademia, Venice), already reveals firsthand knowledge of Venetian art. To a far greater extent than is true for his contemporary, Savoldo, and his somewhat younger compatriot, Moretto, the example of Giorgione and Titian was a determining influence on his technique and his sense of color and light. Nonetheless, Romanino retained a typically Lombard concern for description. To an unusual degree, it was the expressive potential of a scene that interested him. This was in part due to early contact with the work of Boccaccio Boccaccino and of Altobello Melone in Cremona. Romanino's scenes from the Passion of Christ, painted between 1519 and 1520 in the cathedral of Cremona, are the earliest clear indication of his essentially unclassical, expressionistic approach to narrative. In 1521, Romanino contracted with Moretto to decorate the Cappella del Sacramento in San Giovanni Evangelista, Brescia. Although an obvious effort was made by the two artists to bring their very different styles into accord, Romanino's work is, again, distinguished by its comparative indifference to the idealizing Central Italian models manifest in Moretto's scenes. From 1531 to 1532, Romanino frescoed a loggia in the Castello del Buonconsiglio, Trent, with a variety of mythological and pure genre subjects (including concert scenes) that gave full scope to his inventiveness. Perhaps his most extreme statements are the subsequent fresco cycles in the provincial churches of Santa Maria della Neve, Pisogne, and Sant'Antonio, Breno, which are deeply influenced by Pordenone's work in Cremona and reveal an almost Germanic intensity of expression. There can, indeed, be little doubt that Dürer's prints struck a responsive chord in Romanino.

He died between 1559 and 1561.

The validity of including Romanino in an exhibition devoted to Caravaggio might well be questioned. Longhi (1928–29; 1968 ed., p. 99), in his celebrated article on Caravaggio's predecessors, specifically denied Romanino any determining role, contrasting his "venezianissimo" style to that of Moretto, Savoldo, and even Lotto. Yet, in a number of respects, this position may now seem extreme (see G. Panazza, 1975, p. 166). It is Romanino's Saint Matthew and the Angel in San Giovanni Evangelista that most clearly foreshadows Caravaggio's first treatment of the theme in exclusively human terms. And although it is true that the roots of Caravaggio's style are in the work of Moretto and Savoldo rather than in that of Romanino, the sense of drama and urgency in the latter's paintings must have impressed him. Romanino's nudes in the loggia of the Castello del Buonconsiglio are the closest precedent for the unorthodox ceiling in Cardinal del Monte's casino—recorded by Bellori (1672, p. 214) among works attributed to Caravaggio—with their empirical approach to foreshortening and their naturalistic treatment of an allegorical theme. Moreover, despite Romanino's enormous debt to Venetian painting in general, and to Titian in particular, he shared with his compatriots an acute, Lombard sensitivity to detail and to the poetic properties of light.

10. The Mystic Marriage of Saint Catherine, with Saints Lawrence, Ursula, and Angela Merici

Oil on canvas, 60 1/4 x 81 3/4 in.
(153 x 207.7 cm.)
Brooks Museum of Art, Memphis

The picture was first described in 1760, when in the Maffei collection, Brescia, as "Saint Catherine married to the celestial Child held in the Blessed Virgin's arms" (G. B. Carboni, 1760, p. 153). Only recently has the figure in the habit of a Franciscan tertiary, who kneels next to Saint Ursula, been identified as Angela Merici (1474–1540) and the painting of the altarpiece linked to the founding of the society of Ursulines (Orsoline Dimesse) on November 25, 1535 (M. L. Ferrari, 1961, pp. 47, 74, pl. 91). The only certain portrait of Angela Merici is one still in the Casa di Sant'Angela, Brescia, that was painted after her death as a sort of funerary mask (V. Guazzoni, 1981, p. 41, tentatively attributes it to Moretto).

There are differences between the physiognomic features shown in this work and those of the sitter in Romanino's altarpiece, but they are minor. Of decisive importance in identifying the sitter as Angela Merici is her appearance next to Saint Ursula—the patron of both Angela Merici and of the Ursulines—her apparent age, and the relative date of the picture. On stylistic grounds, Longhi (1926; 1967 ed., p. 108) had dated the picture to about 1530, but, as Ferrari pointed out, a somewhat later date is more probable. In 1535, Angela Merici would have been sixty-one years old, which is certainly a plausible age for the sitter portrayed by Romanino. Moreover, Angela Merici was a Franciscan tertiary. Vezzoli (1974, pp. 394 f.) has noted that the feast of Saint Catherine (November 25) coincides with the date when the Ursuline society was founded, and that a depiction of the mystic marriage of Saint Catherine to Christ is highly appropriate for a society of virgins dedicated to Christian instruction. Vezzoli also tentatively identified the figure of Saint Lawrence, shown in his dalmatic among the ruined columns at left, with the vicar of the Bishop of Brescia, Lorenzo Muzio, who procured the bishop's approval of the Ursulines in 1536 (see V. Guazzoni, 1981, p. 43,

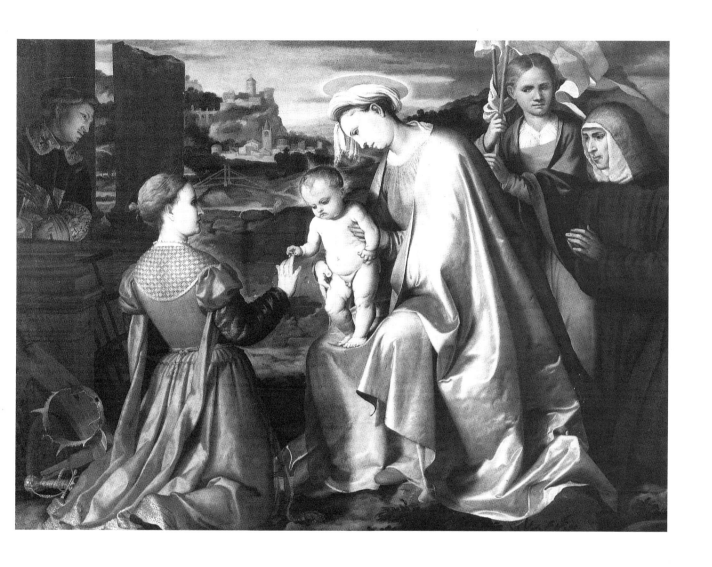

who associates this work with that act).

The Ursulines are the oldest women's teaching order in the Catholic church, and they may be considered one of the earliest manifestations of the Counter-Reformation, alongside the Theatines, the Capuchins, and the Jesuits. Their initial rule was approved by Paul III in 1544. In 1572, Gregory XIII introduced community life (the early members had lived at home) and simple vows, on the instigation of Carlo Borromeo, a staunch supporter of both the Ursulines and of their offshoot, the Angelines (see cat. no. 3). Angela Merici was elected superior in 1537. Although, in her lifetime, she was widely regarded as a saint, she was only canonized in 1807.

The picture marks an uncharacteristic moment in Romanino's career when, having returned to Brescia after his work in Trent, he seems to have responded anew to the work of Moretto and of Savoldo. Indeed, Romanino has treated the theme of the *sacra conversazione* in terms of everyday life, with an eye to homely detail that belies his early Venetian background. The Virgin's remarkably unidealized appearance is enhanced by the contemporary turban that she wears. The texture and sheen of her silvery cloak are painted in the descriptive manner of Savoldo rather than in the more pictorial mode of Titian, and her halo is treated as though it were an actual luminary phenomenon rather than a symbolic attribute. In a like manner, Saint Catherine's attributes—the broken wheel, the crown that hangs on one of the projecting blades, and the sword—resemble a casually arranged but carefully transcribed still life, a precursor of the objects in studied disarray at the feet of cupid in Caravaggio's *Amor Vincit Omnia* (cat. no. 79). The saint's dress is painted with an obvious attention to detail and a love for the abstract patterns created by the drapery that, again, foreshadow, to a degree, Caravaggio's early work in general and his *Saint Catherine* (cat. no. 72) in particular. On the other hand, the stern, straightforward treatment of Angela Merici's features foreshadows Moroni's great Counter–Reformation portraits—especially his painting, of 1557, of the Carmelite abbess Lucrezia Agliardi Vertova (in the Metropolitan Museum). It is small wonder that Bossaglia (1967, p. 1052, n. 2)

thought that the portrait of Angela Merici was added later, although there is no technical basis for the supposition.

Of particular beauty are the face of Saint Lawrence, illuminated by reflected light, and the landscape with a view of Brescia, behind the crumbling brick wall. In these various ways, the picture reveals Romanino's basic affinity with his Lombard contemporaries. Perhaps, like Moretto (cat. no. 7), he tempered his usually more Venetian, agitated style in accordance with the sacral event that his altarpiece was evidently meant to commemorate.

K. C.

Giovanni Gerolamo Savoldo

Information about Savoldo is both sparse and misleading. The earliest notice of him is in 1508, when he joined the painters' guild in Florence. He seems to have returned to his native Brescia by about 1514, but, by 1521, he had taken up residence in Venice, where he is periodically mentioned (mainly as a witness or as an executor of wills) until 1548. According to his pupil Paolo Pino (1548, p. 99), Savoldo spent his life painting few works with little honor to his name ("ha ispesa la vita sua in poche opere e con poco preggio del nome suo"); his one true patron appears to have been Duke Francesco II Sforza of Milan (see cat. no. 13). Vasari describes Savoldo's work only in passing but, it should be noted, he mentions the artist with his Brescian compatriots rather than with his contemporaries among Venetian painters. Indeed, despite Savoldo's presence in Florence and his prolonged residence in Venice (it is not certain that he ever lived in Brescia or in Milan for any length of time), his work is typically Lombard in both its naturalistic bias and its treatment of "the human image as still life" (S. Freedberg, 1971, p. 226). "Eccelente imitator del tutto" is how Pino describes him, and Boschini (1660, p. 365) echoed this judgment when he characterized the action of the figures in the Transfiguration *(now in the Uffizi) as "più che vive e più che humane" (more real than life itself). To Vasari—who admired Savoldo's effects of light and his nocturnal scenes—the Brescian was "capriccioso e sofistico." In fact, Savoldo must have been something of an outsider in Venice. While he was certainly influenced by Titian's work from about 1515–20, and, to an even greater degree, by Lotto, his real fascination was with the Northern paintings that were to be seen in such abundance in the city —especially those by Bosch and his followers—which obviously influenced his representation of light effects. It is significant that whereas Savoldo's pictures seem to have made little impression on Venetian painters, they were the basis of much subsequent painting in Milan, where Caravaggio almost certainly studied them firsthand.*

11. Portrait of a Man with a Flute

Oil on canvas, 29 1/4 x 39 1/2 in.
(74.3 x 100.3 cm.)
Signed (upper left, on sheet of music):
 Joānes Jeronimus Sauoldis de / brisia /
 faciebat
Private collection

This picture was exhibited at the Royal Academy, London, in 1894 (no. 117), as *The Flute-Player*, and it was published by Ffoulkes (1894, p. 268) as "a portrait of a flautist." In subsequent literature, it is usually cited with one or the other title. However, there is no reason to believe that the sitter was a professional musician, as this designation would suggest; his fur-trimmed coat and elegant hat are proper to a gentleman (see, for example, Lorenzo Lotto's 1527 portrait of the merchant Andrea Odoni, at Hampton Court). Rather, the sheet of music affixed to the wall and the open music book propped before the young man are, like the two books on the ledge of the architectural niche, symbols of his cultural achievement.

Portraits in which music or musical instruments appear as cultural symbols only gained currency in Italy in the sixteenth century, with the new prestige accorded musical performance as opposed to musical theory (see P. Egan, 1961, pp. 186 ff.). Perhaps the most concise statement on the matter is the judgment that Castiglione attributes to Lodovico Canossa in *Il Cortigiano* (1967 ed., pp. 94 f.): "Gentlemen, I must tell you that I am not satisfied with our courtier unless he is also a musician and unless as well as understanding and being able to read music he can play several instruments. For when we think of it, during our leisure time we can find nothing more worthy and commendable to help our bodies relax and our spirits recuperate. . . . Moreover, I remember having heard that Plato and Aristotle insist that a well-educated man should also be a musician" The instrument most frequently represented in such portraits is the lute, for, in the sixteenth century, pride of place was given to the accompanied voice. According to Castiglione's friend, the diplomat Federico Fregoso, "Truly beautiful music consists, in my opinion, in fine singing" (p.

120). The music of stringed instruments, such as the lute and the viola da braccia— the contemporary counterpart of Apollo's cithara—was also thought to embody higher values than that of wind instruments (see P. Egan, 1959, pp. 306, 308 ff.). In his ideal society, Plato would have excluded all instruments except "the lyre and the cither. These are useful in the city, and in the fields the shepherds would have a little piccolo to pipe on" (*The Republic*, III). It is, accordingly, as a pastoral instrument that the flute, or recorder, appears in Giorgionesque paintings of figures or shepherds in arcadian settings (see cat. no. 12). That the instrument retained this association in portraits is demonstrated by a picture by Francesco Torbido in the Museo Civico, Padua. The painting—plausibly identified by A. Venturi (1928 a, pp. 914 f.) with a portrait that had been seen by Vasari (1568; 1906 ed., III, p. 654, V, p. 294)—shows a man holding a flute, dressed as a shepherd and with laurels on his head, and a landscape visible through a window (see L. Grossato, 1957, pp. 166 f.). A much copied portrait by Sebastiano del Piombo of a gentleman holding a flute (the best version is in the Earl of Pembroke's collection at Wilton House) obviously alludes to the same type of pastoral imagery.

To a degree, Savoldo's portrait is also indebted to this tradition. Indeed, the flute (an alto recorder) in the young man's hands is identical to that held by the *Shepherd with a Flute* (cat. no. 12). However, Savoldo has transformed the Giorgionesque imagery through the reference to a portrait by Lorenzo Lotto very like the *Portrait of a Gentleman* in the Gallerie dell'Accademia, Venice (the connection with Lotto was first made by S. Ortolani 1925, p. 172). It is the Lottesque quality of Savoldo's picture that establishes its date in the 1520s, perhaps not long after the Treviso altarpiece for which Savoldo was paid in 1521. Moreover, he has represented his sitter with a forthrightness that belies any allegorical intention. The figure, dressed in contemporary clothes, is viewed in a domestic interior of great sobriety and exceptional geometric clarity—even the table and the angle at which the music book has been placed seem predetermined by an abstract, geometrical scheme. An opening above the wall against

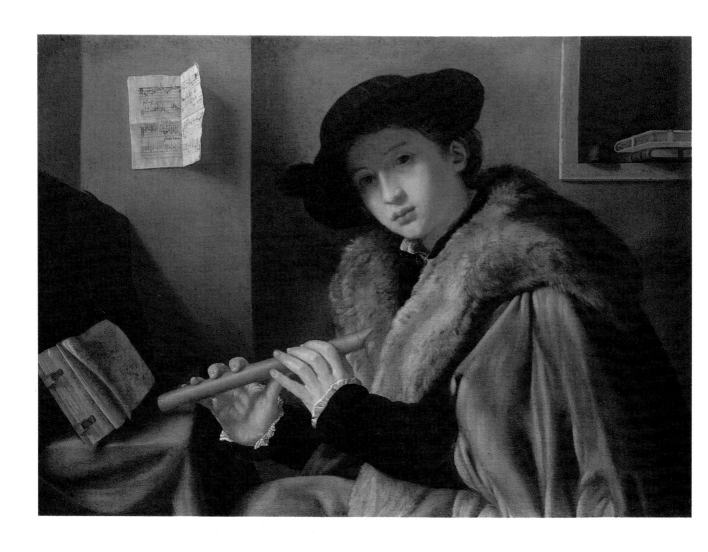

which the book is propped admits the light, which is studied with the care that normally characterizes still-life painting. As in the *Shepherd with a Flute*, the rim of the hat throws the upper half of the sitter's face into shadow (the same device recurs in Sebastiano's portrait), and the fingers and the flute cast well-defined shadows on the palm of his right hand. In this representation, Savoldo has applied the same method that Mancini (about 1617–21; 1956–57 ed., I, p. 108) later ascribed to Caravaggio and his followers: "Lighting from a single source, up high, without reflections, as in a room with one window, the walls of which are painted black." Indeed, to an exceptional degree the picture foreshadows Caravaggio's *Lute Player* in the Hermitage (fig. 2, cat. 69), in which a figure playing a lute occupies an interior setting where the light enters from the left. The comparison between the two works extends to a number of details: the like concern for strongly defined shadows (note, for example, the shadows cast by the lute player onto his instrument in Caravaggio's canvas); an interest in spatial illusionism (the projecting book of music in Savoldo's picture and the violin in Caravaggio's); and an emphasis on naturalism. Savoldo's pupil, Paolo Pino, stresses the importance of naturalism in his *Dialogo di pittura* of 1548 (1948 ed., p. 145) and his judgment presumably reflects Savoldo's teaching: "I do not, however, wish our painter to become ensnared in things other than the painting of the figure in imitation of nature, but this should be his foundation." Whatever the allegorical intention of Caravaggio's picture, there can be little doubt that much of its fascination and novelty resides in his naturalistic treatment of the subject; he rendered the model—dressed in a vaguely *all'antica* costume—as if he were painting a portrait. It might also be noted that, as in many of Caravaggio's pictures, so in Savoldo's the ground was left exposed around certain forms, such as the sleeve, as though the artist had attacked the canvas directly, area by area.

Although Savoldo's picture is a portrait, it is worth considering whether it contains some sort of an allegorical allusion. It is not uncommon to find a piece of music—usually a madrigal—transcribed by artists in their pictures. In the present work, the score in the music book is no longer legible, but that on the sheet of paper on the back wall is. While certainly playable, its source has not been identified. Moreover, where the text would normally appear, Savoldo has inscribed his name, as though he had not only painted the picture but composed the melody played by the flautist. It is, unfortunately, not known whether Savoldo, like so many of his fellow Venetian painters, was also a musician. In any event, this detail suggests a comparison, or "paragone," between the two sister arts of painting and music. In the opening lines of the *Poetics*, Aristotle states that the basis of music, as of poetry (and painting), is the representation of life. This Savoldo achieves to a remarkable degree.

K. C.

12. Shepherd with a Flute

Oil on canvas, 38 3/16 x 30 11/16 in.
(97 x 78 cm.)
Private collection, England

The subject of the picture—or rather the lack of any specifiable subject (the proposals of A. Venturi, 1928 a, p. 767, and R. Longhi, 1927; 1967 ed., p. 152, that Savoldo has represented the Prodigal Son, or Abraham's servant and Rebecca, are not convincing)—derives from Giorgione. However, if the picture is compared to its Venetian counterparts—Giorgione's *Tempesta*; Titian's *Fête Champêtre* and *The Three Ages of Man*; Palma Vecchio's fragmentary *Shepherd and a Maiden* at Norton Hall, Gloucester; or Giulio Campagnola's engraving of a young shepherd in a landscape—the extent to which Savoldo has demythicized the theme becomes readily apparent. Savoldo's picture is dominated by a monumental, individualized shepherd (for his costume, which may initially seem overly fine, see Savoldo's paintings of the Nativity, and C. Vecellio, 1590, pl. 149) posed against a minutely detailed and completely convincing depiction of rural life. He rests one arm on his walking stick while, with the other, he gestures toward the flock of sheep who have been returned safely to their home (C. Gilbert, 1983, p. 203, notes that it is evening). The only allusion to an Arcadian vision is the ruins of an ancient building that rise up behind the cluster of thatch-roof farmhouses. To appropriate an analogy of Longhi, the landscape is more a foretaste of Manzoni than a reflection of Bembo or Sannazzaro. When this shepherd raises his wooden flute to his lips, the music that he makes will be as pastoral as the bagpipe played by his companion in the distance.

The picture may date from about 1525–30, when Savoldo was most influenced by Titian's example (of almost a decade earlier, however). Yet, Savoldo's technique is more descriptive than Titian's, and he uses light to enhance the truthfulness of the image rather than to unify its various parts. Longhi (1928–29; 1968 ed., p. 119) first recognized that Savoldo's most significant link with Giorgione and Venetian painting was in their respective themes—"qualche motivo

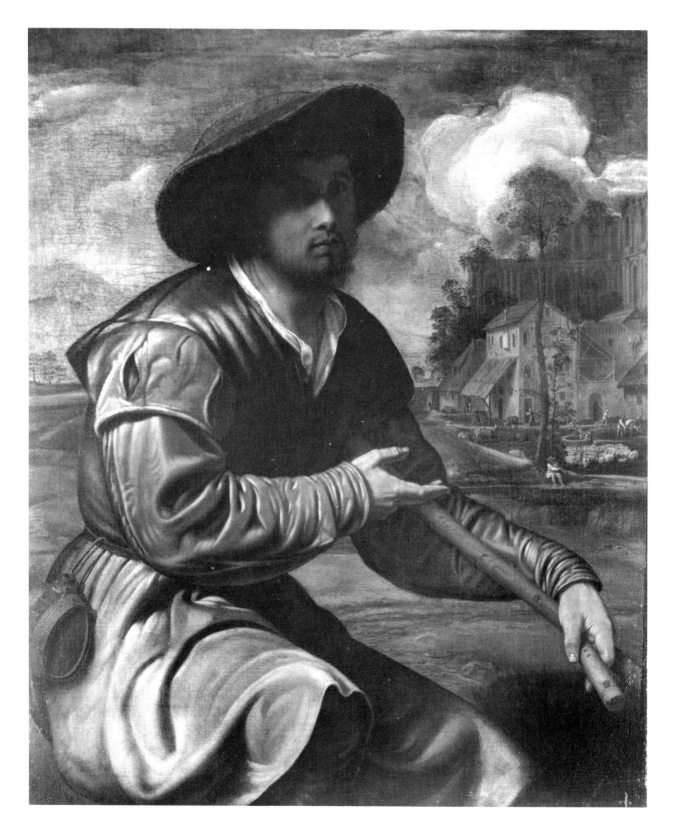

esterno di evocazioni astrologiche e amorose" (a superficial motif with an astrological or amorous evocation)—but that Savoldo's more factual approach was Lombard rather than Venetian in origin. This distinction would have seemed irrelevant to sixteenth-century critics, who divided painting between Venetian devotion to color and naturalism and the Central Italian advocacy of *disegno* as the basis of excellence. When Federico Zuccari passed his famous verdict on Caravaggio's *The Calling of Saint Matthew*, "Io non ci vedo altro, che il pensiero di Giorgione . . ." ("I see nothing here beyond the idea of Giorgione"), he may just as easily have had a painting by Savoldo in mind. However, if one recalls contemporary characterizations of Caravaggio's work—his reliance on the model, his naturalism, his bold use of color and lighting effects—then it is clear, as Longhi insisted, that native Lombard traditions rather than Venetian painting were fundamental to his artistic formation—*pace* Zuccari and Bellori.

K. C.

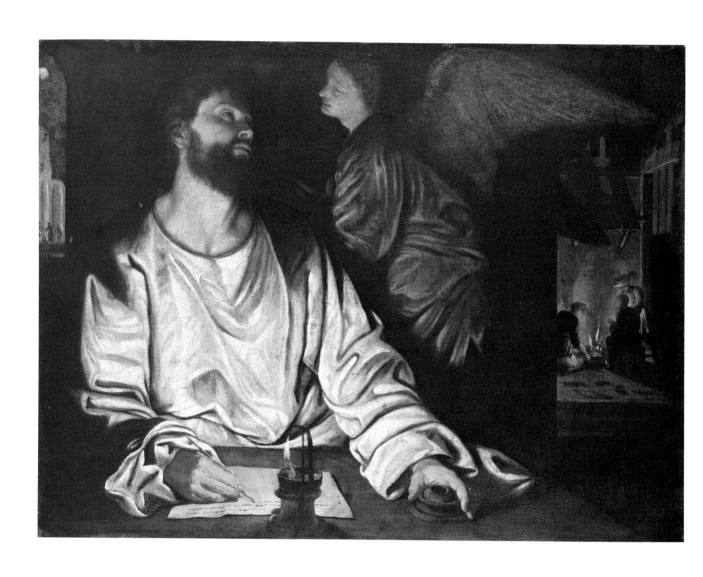

13. Saint Matthew and the Angel

Oil on canvas, 36 3/4 x 49 in.
(93.3 x 124.5 cm.)
The Metropolitan Museum of Art,
New York

Behind a table in a dark interior lit by an oil lamp sits Saint Matthew, holding a pen in one hand and an inkwell in the other while he gazes at the angel who dictates the gospel to him. Through a door to the right is a rustic courtyard with three figures clustered around a fire (a seated, bearded man—his hands clasped as though in prayer—is greeted by a standing figure dressed in red and wearing a plumed, red hat, as a kneeling figure offers the seated one a basin of water to wash his feet). An arched window at the left frames the ruins of a tower, in front of which are four figures (three stand—one has a walking stick and another seems to be cowled—while the fourth reclines). It has been suggested that these scenes show Saint Matthew receiving the hospitality of the eunuch of the Queen of Ethiopia, and the saint's martyrdom (H. B. Wehle, 1940, p. 158). The identification of the first scene is complicated by the fact that the seated figure does not resemble Saint Matthew as seen in the foreground, and the interpretation of the second scene may be categorically dismissed, since Matthew was martyred inside a newly completed church. It is possible, however, that Savoldo has represented an aging Matthew greeted by the queen's eunuch and, at the left, his healing of the citizens of Nadaber, who had become lame through the sorceries of two magicians. Alternatively, the tower may refer to a passage in *The Golden Legend* (J. de Voragine, 1941 ed., p. 562) in which Matthew explains how, just "as those who had sought from pride to build a tower reaching to Heaven had been stayed therefrom by the confusion of tongues, so by the knowledge of tongues the apostles might build a tower, not of stones but of virtues." The confusion around the tower would then contrast with the effect of Saint Matthew's Gospel.

The first mention of this beautiful but badly damaged picture was in 1911, when it was owned by the Florentine dealer Luigi Grassi. It has, however, been identified as one of the four paintings "di notte e di fuochi" (of night and fire) seen by Vasari in the Mint in Milan (C. Gilbert, 1945, pp. 131 ff.; W. Friedlaender, 1955, pp. 39 ff.). The series was apparently painted between 1530 and 1535 for Savoldo's principal patron in Milan, Duke Francesco II Sforza. Gilbert (1952, pp. 151 f., and, most recently, 1983, p. 204) has also argued that the *Tobias and the Angel* in the Galleria Borghese, which has the same dimensions and was discovered at the same time, also belonged to this series. The two pictures differ drastically in figure scale, lighting, and condition (the Borghese picture is well preserved), and it seems doubtful that they ever belonged together. Gilbert himself has admitted that the *Tobias* does not really conform to Vasari's description of the pictures. On the other hand, the representation of the fire and the moonlight in the *Saint Matthew* matches Vasari's passage perfectly. Saint Matthew, who was a tax collector, would be an appropriate subject for a picture intended for a mint, although it may seem curious that there is no allusion to this occupation in the picture.

Savoldo's interest in internally lit scenes is well attested by a number of representations of the Nativity, in nocturnal settings, with more than one source of illumination, as well as by Vasari, who considered Savoldo a specialist in this sort of painting. Even so, the *Saint Matthew* is exceptional. Not even in Romanino's depiction of Saint Matthew, of 1521–24, in San Giovanni Evangelista, Brescia—a picture that must, to some degree, have inspired Savoldo's—do the poetic and formal properties of light become the primary subject, as they do here (the two subsidiary scenes are really excuses for the portrayal of different kinds of light). Without a painting very like the present one, works such as Antonio Campi's *Saint Catherine in Prison* (in Sant'Angelo, Milan) or the *Beheading of Saint John the Baptist* (cat. no. 3) would be inconceivable. However, more than any other Lombard painting, it is Caravaggio's *Stigmatization of Saint Francis* (in Hartford; cat. no. 68) that seems most directly indebted to Savoldo—not only for the contrasts between the divine radiance that illuminates Saint Francis, the pre-dawn light that streaks the clouds behind the cyprus-studded horizon, and the campfire of the shepherds (all traditional elements in the story of the saint's stigmatization) but, even more importantly, for the manner in which light describes the solidity of the forms. It was this aspect of Savoldo's work that Longhi (1929; 1968 ed., pp. 98 f., 119 f.) correctly recognized as fundamental to Caravaggio's development as a painter, referring specifically to the *Saint Matthew*.

K. C.

Jacopo Robusti
called Tintoretto

Jacopo Tintoretto (1518–1594), one of the few major masters of Cinquecento Venice to be native born, is reputed to have studied briefly with Titian, but his essential training was in the busy workshop of Bonifazio de' Pitati. At an early age, however, he embraced a turbulent maniera *style observed locally in the work of Pordenone and Schiavone and in that of such visitors to the city as Giuseppe Porta (called Salviati). His study of Central Italian models—among them a tapestry cartoon of* The Conversion of Saint Paul, *by Raphael (then in the Palazzo Grimani, Venice) and casts after Michelangelo's sculpture—brought him to the attention of Pietro Aretino, a friend of Titian and of Jacopo Sansovino and the self-styled arbiter of taste in Venice. These heterogeneous experiences fused in the 1548* Miracle of the Slave *for the Scuola di San Marco, and led to numerous commissions for private patrons, confraternities, church, and state. His aggressive audacity won him a monopoly in undertaking the vast decorative cycle of the Scuola di San Rocco, a task that largely occupied his attention during three campaigns (of 1564–67, 1575–81, and 1583–87). At the Scuola, he developed a powerful fusion of spacial ambiguity, sharply patterned chiaroscuro, lurid color, and slashing brushstrokes to produce a virtuoso ensemble of epic scope. Although he seldom ventured outside Venice and was rivaled there by Paolo Veronese, Tintoretto came to dominate Venetian painting through his large and industrious workshop, which included his talented son Domenico, his other children, and a host of apprentices. Just as Tintoretto's volcanic power of invention provided a climax to the Venetian Renaissance, the progressively mechanical production of his followers announced its inexorable decline into dispirited routine.*

14. The Agony in the Garden

Oil on canvas, 131 1/2 x 115 3/8 in. (334 x 293 cm.)
Santo Stefano, Venice

Originally, the choir of the Venetian church of Santa Margherita contained three of Tintoretto's mural-sized paintings—a long *Last Supper* on the left wall, and a *Christ Washing the Feet of the Apostles* and the present canvas on the right, apparently separated by a door to the sacristy. First mentioned by Sansovino in 1581 (p. 88 *v.*), when they were presumably quite new, the paintings have always been attributed to Tintoretto, although more recently it has been suggested (R. Pallucchini and P. Rossi, 1982, I, no. 412, p. 219) that Jacopo's son Domenico collaborated in their execution. After the Napoleonic suppression, all three paintings were transferred to the sacristy of Santo Stefano, where they remain today. Although most of the literature has noted a close relationship between the present picture and Tintoretto's monumental version in the upper hall of the Scuola di San Rocco —usually considering the latter to be a replica carried out with workshop participation—there are chronological contradictions in this explanation. The San Rocco *Agony* is generally and correctly considered to be one of the last in the series of Tintoretto's canvases that was complete by July 1581. The present picture was also noted in 1581 in a publication for which material had been gathered during the course of several years. Since both paintings are very close in composition but differ in all the major figures save the apostle in the lower center, it seems probable that the San Rocco and Santa Margherita commissions were received almost simultaneously in 1579, the compositions of the *Agony* sketched almost contemporaneously, and the present picture allocated in part to the workshop for execution.

Less visionary in its irrational space and transfiguring illumination than the San Rocco painting, the Santo Stefano *Agony* goes further in exploring an abstracting chiaroscuro in which ribbons of glaring light trace edges of drapery and fleck leaves and grass into a nervous pattern of flickering accents. Phosphorescent tones of pale rose, acid green, mustard, and burnt orange glow against a densely opaque bitumen ground to create a pictorial vision now nearly disassociated from the objects that it describes.

There can be little doubt that Tintoretto designed this composition, a responsibility attested by a drawing for the sleeping apostle at the center in the British Museum (inv. 1913-3-31-199). He doubtless painted parts of the picture as well, but a second hand is clearly evident in many passages of the principal figures, all of the angel, and much of the subsidiary landscape. This assistant was clearly not Jacopo's son Domenico, whose abrupt, blocky handling of form is already clear in passages of the Scuola di San Rocco decoration. Although his identity remains a mystery, his dense impasto, sulfurous color, and slippery forms can be found in many of Tintoretto's workshop products of these years.

W. R. R.

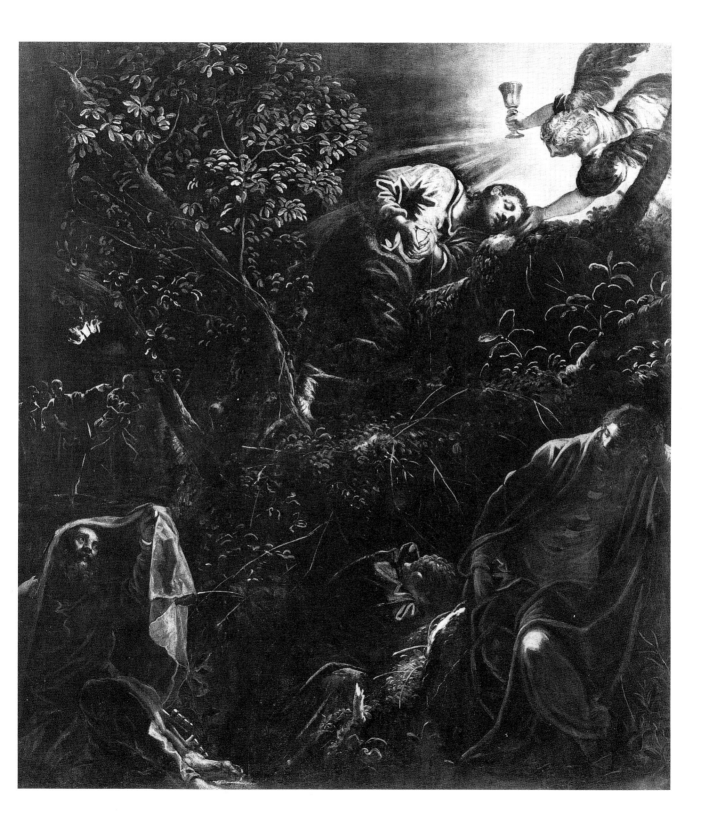

Caravaggio's
Contemporaries in Rome
and Naples

Giovanni Baglione

Along with Orazio Borgianni, Giovanni Baglione has the rare distinction among those artists included here of being Roman born (about 1566), which underscores the role of the papal capital as an attraction, but not a cradle, for artistic talent during the later sixteenth century. After working for the Santacroce family at Oriolo Romano during the late 1580s, Baglione received his first Roman commissions from Sixtus V and Clement VIII to carry out the vast decorative programs at the Vatican and the Lateran. These projects were headed by such Late Mannerist painters as Giovanni Guerra and Cesare Nebbia, whose styles, like those of the Cavaliere d'Arpino and Cristoforo Roncalli—as well as the Roman "Barocceschi" Beccafumi, Francesco Vanni, and Ventura Salimbeni—had a profound effect on Baglione's formation in the maniera.

Shortly after 1600, however, while working for Cardinal Sfondrato at Santa Cecilia in Trastevere, Baglione was attracted to Caravaggio's art. In 1601, he painted the Ecstasy of Saint Francis (private collection), which is noteworthy not only as one of his most successful essays in a Caravaggesque manner, but as the earliest known Caravaggesque picture altogether. (It even has been engraved and published as by Caravaggio, despite Longhi's correct attribution to Baglione.) About the same time, he painted Divine Love (cat. no. 15) in competition with, and in emulation of, Caravaggio's famous Amor Vincit Amnia (cat. no. 79). Perhaps in direct response to these adaptations of his style, Caravaggio publicly ridiculed Baglione's work in general, and his Resurrection for the Jesuits (cat. no. 16) in particular, testifying, "I know nothing about there being any painter who will praise Giovanni Baglione as a good painter" at the trial for slander that Baglione initiated in 1603 against Caravaggio and his cronies. Evidently litigious, Baglione again brought action against Caravaggio, Carlo Saraceni, and Borgianni in 1606.

Not surprisingly, Baglione's affair with Caravaggesque painting was brief, although aspects of the style sporadically crop up later in his career, during which he did prestigious work for Saint Peter's (1607), the Cappella Paolina in Santa Maria Maggiore (1611–12), Scipione Borghese's palace (1614), the Gonzaga court at Mantua (1621–23), and various Roman churches.

When Baglione died in Rome in 1643, he not only had been knighted and had served as Principe (president) of the Accademia di San Luca—the artists' professional association in Rome (in whose activities Caravaggio took no part)—but he had written two books of fundamental importance for knowledge of the period. Le nove chiese di Roma, published in 1639, was the most carefully compiled guidebook of its kind. Le vite de' pittori, scultori et architetti, which appeared three years later, provides invaluable biographical information on the lives of the artists who were active in Rome from the time of Gregory XIII (1572) to Urban VIII (1642), including a rich autobiography and the most important early vita of Caravaggio himself. In neither life does Baglione make mention of his lawsuits against Caravaggio and his friends, nor admit to his own phase of Caravaggesque painting. In his vita of Caravaggio, which is remarkably objective given the circumstances, Baglione, not surprisingly, relates that Caravaggio "sometimes would speak badly of the painters of the past, and also of the present, no matter how distinguished they were"

R. E. S.

15. Divine Love

Oil on canvas, 94 1/2 x 56 5/16 in.
(240 x 143 cm.)
Galleria Nazionale d'Arte Antica,
Palazzo Corsini, Rome

As one of the defendants at Baglione's libel case, Orazio Gentileschi gave deposition on September 14, 1603. He named the principal painters of Rome, said he knew them all, admitted that there was "a certain rivalry among us," and then related that "when I placed a picture of Saint Michael the Archangel in San Giovanni dei Fiorentini, [Baglione] showed his competitiveness by putting opposite it a Divine Love, which he had done in rivalry with an Earthly Love by Michelangelo da Caravaggio. The Divine Love he had dedicated to Cardinal Giustiniani, and though it was not as well liked as Caravaggio's, the Cardinal still reportedly presented [Baglione] with a chain. That picture had many imperfections and I told [Baglione] so—that he depicted a grown-up, armored man, who should have been young and nude, and therefore he then did another, which was entirely nude" (W. Friedlaender, 1955, pp. 278-79). Baglione himself (1642, p. 403) lists among his commissions "two Divine Loves done for Cardinal Giustiniani, which have Profane Love, the World, the Devil, and the Flesh beneath their feet. . . . "

There is firm evidence, therefore, that Baglione painted Divine Love twice. One canvas, now in Berlin-Dahlem, came directly from the Giustiniani collection and presumably is the prime original. The present picture (see Rome, 1970, no. 37) logically, would seem to be the second one that Baglione redid, were it not that Gentileschi said the second figure of Divine Love was "entirely nude," whereas here he only has shed some of his armor, exposing one leg. Martinelli (1959) sought to identify a third, totally nude Divine Love by Baglione, but neither his attribution, nor another first proposed by Longhi and supported (but then retracted) by Spear, has found acceptance (see R. Spear, 1975, pp. 46–49, no. 4, p. 227, no. 4). The third Divine Love may be a chimera, the product of taking too literally Gentileschi's words, "tutto ignudo." If so, the present picture is the one that Baglione

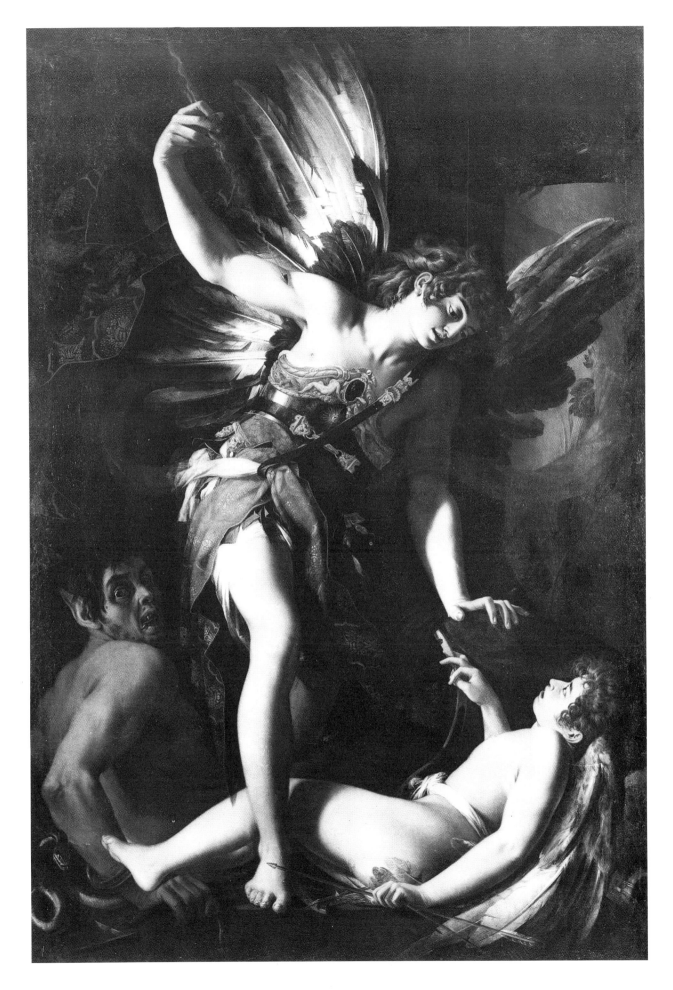

made in response to Gentileschi's criticism, probably in 1602 or earlier 1603—shortly after Caravaggio had painted the *Amor Vincit Omnia* (cat. no. 79) for Vincenzo Giustiniani. As for the *Saint Michael* that Gentileschi said Baglione wished to challenge by putting opposite it his *Divine Love*, Bissell (1974, p. 116; 1981, pp. 145-46, no. 14) suggests that it may have resembled the archangel in Gentileschi's *Saint Michael Overcoming the Devil*, in San Salvatore, Farnese. That would mean that each of the artists' vanquishing, striding figures could have been inspired by an ancient statue of a gladiator in the Giustiniani collection itself. Judged by the standards of Caravaggio's *Amor*, which Baglione himself must have admired for its scrutinizing, denuding light, this *Divine Love* may appear more contrived (Caravaggio's picture scarcely is unaffected), not only because so many forms are packed tightly together, but because individual figures seem to "represent" their actions by striking studio poses rather than by carrying out their intentions gracefully and naturally. By contrast, Bartolomeo Manfredi's *Cupid Punished by Mars* (cat. no. 45) makes equally apparent that Baglione's sense of space and action are not Caravaggesque, but more a legacy of the *maniera*, onto which the painter skillfully grafted aspects of Caravaggio's chiaroscuro, naturalism, and figure types. Unfortunately, nothing is known about a "Divine Love who subdues Profane [Love]" that Baglione claims Caravaggio painted for Cardinal del Monte (see M. Cinotti, 1983, pp. 577-78, no. 152) and whose title seems so relevant to Baglione's own picture.

The pairing of *Amor divinus* with *Amor terrenus* had a rich iconographic tradition. Only a few years before Baglione's competitive move, it had served as the linchpin of Annibale Carracci's entire fresco program in the Galleria Farnese (J. R. Martin, 1965, pp. 86–89; C. Dempsey, 1968). Baglione's selection of *Amor divinus* for Cardinal Benedetto Giustiniani, Vincenzo's older brother, clearly was motivated by this complementary iconography, although the painter must have calculated, too, that it probably would have been received as a more decorous subject by the cleric.

R. E. S.

16. The Resurrection

Oil on canvas, 33 7/8 x 22 1/4 in. (86 x 56.5 cm.)
Musée du Louvre, Paris

On August 28, 1603, Baglione testified in his action for libel that he "had painted a picture of Our Lord's Resurrection for the Father General of the Society of Jesus. Since the unveiling of said picture on Easter Sunday of this year, Onorio Longo, Michelangelo Merisi [Caravaggio], and Orazio Gentileschi, who had aspired to do it themselves—I mean Michelangelo— . . . have been attacking my reputation by speaking evil of me and finding fault with my works." In response, Caravaggio denied even knowing of the existence of the verses that Baglione said were being passed around Rome to discredit him, although he did not check his candor in stating, "I have seen nearly all of Giovanni Baglione's works . . . and lately Christ's Resurrection in the Gesù. . . . I don't like this painting, because it is clumsy. I regard it as the worst he has ever done" (W. Friedlaender, 1955, pp. 271-73, 276-77).

Baglione's commission for the Gesù was most thoroughly discussed by Longhi (1963), who first published the *modello* exhibited here and whose earlier writings (1930; 1943 a) formed the foundation for later studies of the painter (see, more recently, C. Guglielmi Faldi, 1963; L. Spezzaferro, 1975; C. Bon, 1979, 1981). By the end of the seventeenth century, however, Baglione's canvas had been replaced with the altarpiece by Carlo Maratta that remains *in situ*. Baglione tells in his autobiography (1642, p. 402) that he painted the *Resurrection* "con amore," and that it measured a monumental 35 by 20 *palmi*: that is, nearly eight by four-and-a-half meters, or twice the height of Caravaggio's *Seven Acts of Mercy*. Despite its imposing size, the *Resurrection* disappeared, but its preparatory stages are preserved both in the quick pen sketches that comprise a two-sided drawing in the British Museum (J. A. Gere and P. Pouncey, 1983, I, p. 36, no. 38)—first identified as studies for the Gesù commission by Guglielmi Faldi (1954, p. 314) although rejected as such by Longhi (1963, p. 25)—and, more informatively, in this grisaille *modello*.

As Longhi (1963, p. 26) emphasized, Baglione's conception of the triumphant but static Christ, risen above his tomb in glory, conforms to a "usual scheme of the late Tuscan-Roman *maniera*, perhaps with some Emilian echoes in the angels budding in the light, which seem to allude to young Lanfranco. . . . " How different this is from what one knows of Caravaggio's late *Resurrection*, wherein Christ was shown earthbound—like a metaphor of the painter's art and religion. That Caravaggio reportedly aspired to win the Gesù commission could account for his hostility toward Baglione's accomplishment, but jealousy does not imply perjury in his statement that he found the *Resurrection* to be clumsy. For, even if the sprawling figure in the foreground may be derived from Caravaggio's *Calling of Saint Matthew*—which, in turn, seems to have influenced Juan Bautista Maino's *Resurrection*, of 1612–13 (one of the earliest Caravaggesque pictures by a Spaniard—the crowded, visionary staging of the episode could not be more foreign to Caravaggio's naturalistic interpretations of the Bible.

It even has been suggested (F. Bologna, 1974, pp, 164-66) that Claudio Acquaviva, the Father General of the Jesuits, may have surmised that it was safer to hire a more traditional painter such as Baglione than to risk Caravaggio's interpretation of sacred text. In fairness to Baglione, it is essential to recall that those elements in the *modello* are only a tenth of their final size.

Longhi plausibly argued that in the violent, dramatic, "crepuscular" mise-en–scène of the soldiers at the tomb, Baglione was challenging Caravaggio on his own ground. One must also bear in mind that emphasis on chiaroscuro—on the *ordine* and *rilievo* (or value structure and sculptural relief) of the image—is intrinsic to monochromatic *modelli* (see L. Bauer, 1978); and that Baglione probably derived his preparatory technique from artists in Rome such as the Cavaliere d'Arpino and Roncalli, his early mentors, rather than from any of the related Lombardic methods described by Lomazzo that Caravaggio undoubtedly knew but probably never practiced.

R. E. S.

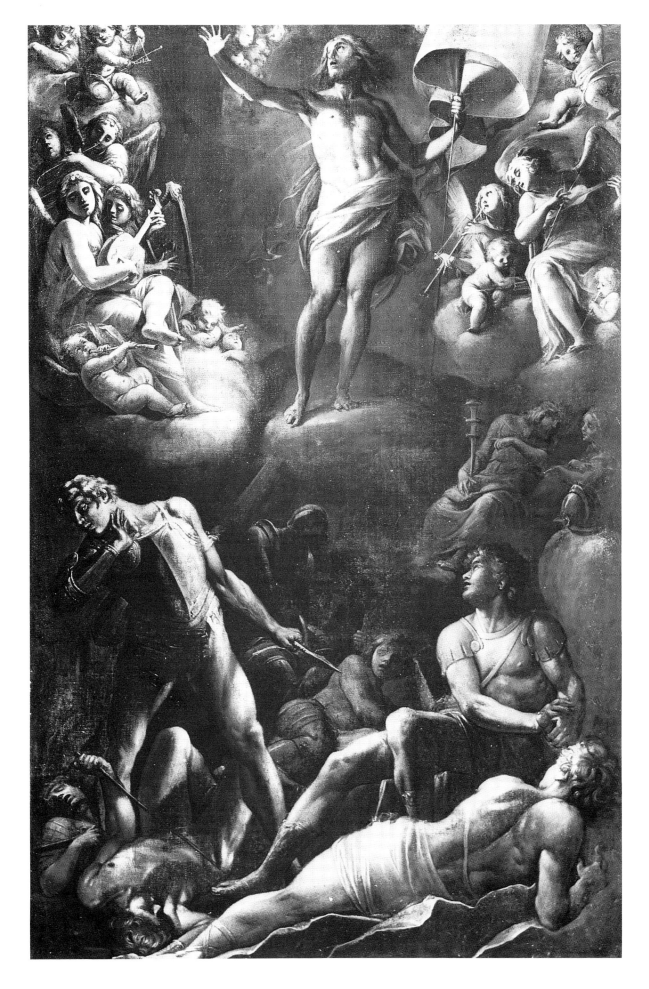

Federico Barocci

Barocci was probably born in Urbino in 1535, during the reign of Guidobaldo II della Rovere. Following the troubled reign of his father, Francesco Maria I, and preceding the reign of his son Francesco Maria II, under whom the duchy disintegrated, Guidobaldo created a climate of enthusiastic support for the arts, reviving the tradition of Federigo da Montefeltro. Guidobaldo employed the painter and architect Girolamo Genga, who conferred on the city those distinguishing features that even today make it as much a creation of the school of Raphael as of the brilliant humanist enterprise of Federigo da Montefeltro. Through Guidobaldo, Barocci came into contact with the work of Titian. Titian was favored by Guidobaldo even more than he had been by Francesco Maria I, who first began collecting works by the Venetian artist that, together with those by Raphael, were to be fundamental to Barocci's rapid artistic development. It was inevitable, given the limited opportunities afforded by the small city isolated by the Apennines, that Barocci would leave Urbino early in his career to perfect his art in Rome. There, he enjoyed, the protection of Guidobaldo's son Cardinal Giulio della Rovere, and was given the major responsibility in the decoration of the casino of Pius IV, carried out between 1561 and 1563—his first definitive artistic statement. Perhaps Barocci's work was too advanced for the culture and tastes of Rome. In any event, it was not well received—nor did Rome suit Barocci. Suffering from a serious illness, he returned to his native city by 1565. There, he developed his own very personal style, which set him apart from the mainstream of contemporary Italian painting. It is difficult to imagine how, isolated in this way, Barocci was able to create an art responsive to the religious climate of his day—the same climate manifest in the doctrines of the Council of Trent and in the religious orders that had emerged during the turbulent years of the Counter-Reformation. Nevertheless, when his Visitation (cat. no. 17) was sent from Urbino to Rome in 1586, it was so well received that for three days a continuous line of people waited to see it. It appears to have had an immediate impact on the artists of Rome, as well.

So far as is known, Barocci made only one trip to Rome in his youth. Beset by neuroses, he allied himself ever more closely with the ideologies of the bigoted and equally neurotic duke, Francesco Maria II della Rovere. He remained in the service of the duke for the rest of his life, establishing a relationship of mutual affection and assistance. Indeed, the duke became Barocci's chief advisor, sharing with the artist his religious scruples and intellectual predilections. He may also have played a part in Barocci's long and complex activity for the Franciscans, for whom the artist painted a number of pictures, among them the famous Perdono di Assisi (in San Francesco, Urbino), executed between 1574 and 1576, during the first years of Francesco Maria II's reign. This picture is of special importance in understanding the doctrinal position of the Franciscans, within the Counter–Reformation, on the matter of indulgences. The picture was widely disseminated at a popular level through an engraving, made by Barocci himself. Barocci's last works are the products of his particular local culture. His Last Supper for the cathedral of Urbino, for example, reflects the influence of the fifteenth-century altarpiece of the Institution of the Eucharist by Justus van Ghent in the Chiesa del Corpus Domini, the ducal oratory in Urbino. The picture is redolent with nostalgia and sentimentality, reflecting a life dominated by professional interests and religious devotion—or, rather, a life lived as though it had been a religious devotion. Barocci died on the last day of September, 1612.

17. The Visitation

Oil on canvas, 112 x 73 5/8 in.
(285 x 187 cm.)
Chapel of the Visitation, Santa Maria in Vallicella (Chiesa Nuova), Rome

The Visitation is one of Barocci's most famous pictures, and the history of its commission and execution is, in many respects, emblematic of his personality: of his eccentric temperament; his close relationship with Francesco Maria II, Duke of Urbino; and his obsessive reworking of his paintings. On June 7, 1582, Francesco Pozzomiglio obtained the rights to the Chapel of the Visitation in the Chiesa Nuova, with the intention of commissioning an altarpiece from Barocci. Several days later, between June 9 and June 13, the duke's minister in Rome was approached by the Oratorians to write to the duke, explaining that: They "have many paintings by very good artists in their newly completed church and would also like one from the hand of Federico Barocci; and since they know how difficult it is to persuade him, they wish your highness to intervene on their behalf" (G. Gronau, 1936, p. 156). Shortly thereafter, a memorandum was sent with suggestions as to how the Oratorians wished the picture to appear (the memorandum is lost). Barocci may have already tentatively accepted the commission by this time and requested specifications for the commission himself (see, however, H. Olsen, 1962, p. 179, and A. Emiliani, 1975, p. 147). It is clear, in any event, that his residence in Urbino did not isolate him from the concerns of the Oratorians.

In 1584, Cardinal Pierdonato Cesi, who had financed the building of the Chiesa Nuova, addressed the duke on behalf of the Oratorians in an attempt to speed matters along. The duke replied that the picture was nearly complete. Nevertheless, another two years elapsed before the painting was finished and was ready to be sent from Urbino to Rome to be installed in the Chiesa Nuova. The duke's new minister, Grazioso Graziosi, wrote his master that "in general the picture . . . pleases everyone a good deal, and even more those of the profession. . . . For three days there was a line to see it." He added, "I know all the paint-

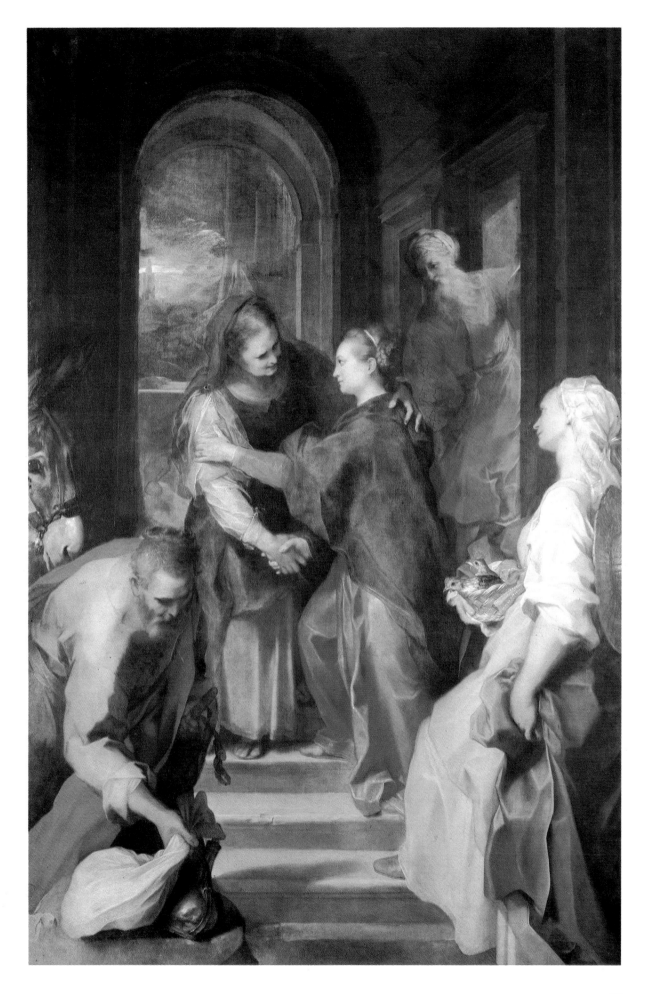

ers admire it as marvelous, but the chief of them, who is my great friend, told me in confidence that although the work is truly beautiful, he had expected something even better from the hand of Barocci" (G. Gronau, 1936, p. 157). This artist may have been Scipione Pulzone, who, about this time, painted an altarpiece for the Chapel of the Crucifixion in the Chiesa Nuova and was engaged by the Jesuit architect and painter Giuseppe Valeriano to assist in decorating the Chapel of the Madonna della Strada in Il Gesù. It is Pulzone's *Visitation* for the latter chapel that shows most markedly the influence of Barocci's picture. The two works even share a poetic intimacy that, on the one hand, might be interpreted as the most obvious sign of Barocci's love of the familial atmosphere that pervaded his native city, and, on the other, would appear to be the antithesis of the type of painting frequently inspired by the neo-medieval rigors of the Jesuits. In this context, especially notable in Barocci's composition are the basket of chickens held by the woman at the right, her broad-brimmed straw hat, the dented metal vessel that Joseph stoops to retrieve, and the head of the donkey—whose insertion is as unexpected as that of the donkey in Caravaggio's *Rest on the Flight into Egypt* in the Galleria Doria-Pamphili, Rome (fig. 3, p. 33). The similarities between Pulzone's work in the Chapel of the Madonna della Strada and Barocci's *Visitation* suggest that the latter picture should be viewed within the broader context of the new orders of the Counter-Reformation—the Jesuits, the Oratorians, the Capuchins—and not simply as the manifestation of Barocci's own artistic evolution (see G. Walters, 1978, p. 122).

Saint Filippo Neri's personal attachment to the picture is well known. His biographer, Pietro Giacomo Bacci (1699 ed., pp. 171 f.), tells how the saint would visit the chapel frequently, and one day, "having seated himself on a small stool, as was his wont, he was, without realizing it, rapt in the sweetest ecstasy, which was observed by some penitents standing nearby"; the story is repeated by Baglione (1642, p. 134). The event confirmed both the sanctity of the "apostle of Rome" and the devotional content of Barocci's painting. Bellori (1672, pp. 180 f.), in his discussion of the picture,

singles out Barocci's genius "in painting sacred pictures . . . that correspond to the requirements of decorum and sanctity and excite devotion." The picture's fame was diffused through engravings by Gysbert Veen in 1588 and by Philippe Thomassin in 1594. It was among the works studied closely by the young Rubens. Indeed, such was the picture's fame that it became, for many critics, synonymous with Barocci's achievement.

A number of preliminary drawings exist documenting the transformation of the composition from a discursive to a more focused treatment of the subject (see H. Olsen, 1962, pp. 73 ff., and A. Emiliani, 1975, pp. 143 ff.).

D. B.

18. The Stigmatization of Saint Francis

Oil on canvas, 141 3/4 x 96 1/2 in.
(360 x 245 cm.)
Galleria Nazionale delle Marche, Urbino

The renewed interest in the late sixteenth century in Saint Francis and in his mystical experiences and visions was due principally to the influence of the Capuchin Friars Minor. The order, whose rules were drawn up in 1529, was founded by Matteo di Bassi of Urbino in an attempt to revive the austere, simple life of the early Franciscans. Its first houses were primarily in the Marches, but in 1574 Gregory XIII lifted a ban that had prohibited them from expanding beyond Italy, and in the ensuing years the order spread rapidly, becoming one of the principal instruments of the Counter-Reformation. At an early date, a Capuchin monastery was founded at Crocicchia, south of Urbino, and in 1589 the order established another house just outside the city. Barocci's close association with the new order, as well as with the older Conventuals, is well documented. Following his return to Urbino and his recovery from the illness that had precipitated his departure from Rome, he painted the *Madonna and Child, with Saint John the Evangelist* for the Capuchin church at Crocicchia. According to Borghini (1584, p. 569), Barocci painted the picture as an ex-voto (the fact that Saint John is shown with the chalice of poison that he drank, unharmed, would seem to support this claim, since Barocci's illness was attributed to an attempted poisoning). For San Francesco, Urbino, Barocci painted the *Perdono di Assisi*, between 1574 and 1576, commemorating the Franciscans' special privilege of the Portiuncula Indulgence, as well as two other altarpieces. Contemporaneously, Barocci conceived two related compositions showing the stigmatization of Saint Francis: an etching, and an altarpiece that was possibly painted for the Oratorians in Fossombrone, a cradle of the Capuchin order. He also painted altarpieces for Capuchin churches in Mondavia, Macerata, and Fossombrone.

The present picture was painted for the Capuchin's new church at Urbino, which is shown in the background. Payments for the work were made by the duke himself in

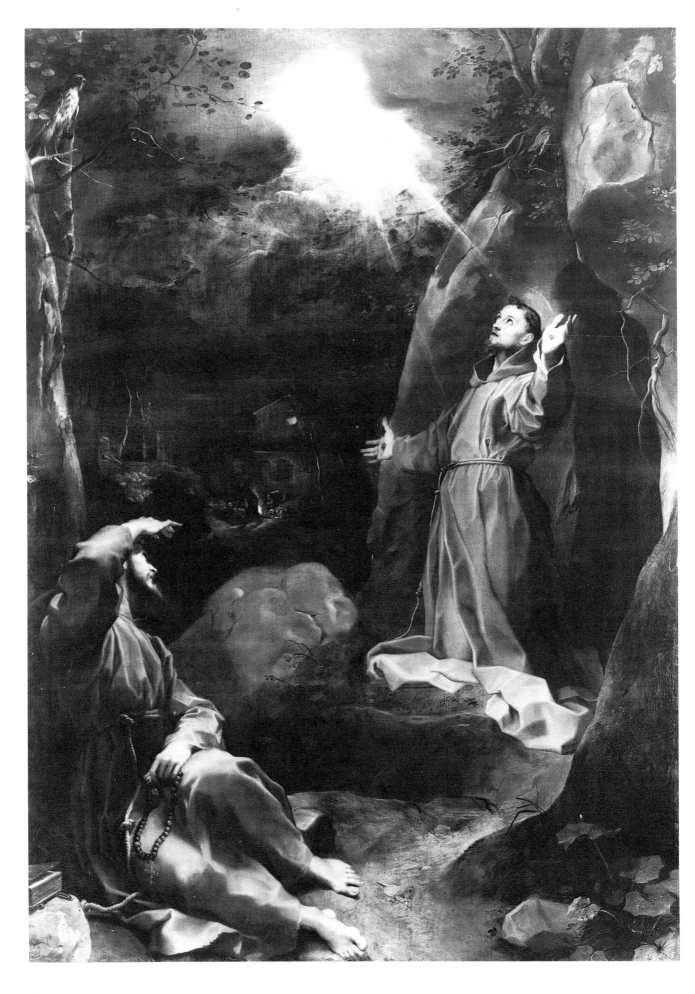

February 1594 and September 1595, and in September 1597, he had a small copy made for himself by Morbidello (possibly the version in the Uffizi).

In the earlier *Stigmatization*, Barocci adapted the figure of Saint Francis from the *Perdono di Assisi*, and he followed the traditional iconography by showing Francis in the foreground, his hands outstretched, and Brother Leo in the background reading, oblivious to the miracle. In the Capuchin altarpiece, on the other hand, the scene was treated with unusual accuracy. As Meiss (1964, pp. 24 f.) noted, Barocci's source was almost certainly the *Fioretti*, and it is probable that the choice of this popular work—which traced its authorship back to Saint Francis's first followers—over that of Saint Bonaventure's canonical life was made by the Capuchins. It is the *Fioretti* that describes in the greatest detail the nocturnal setting with the brilliant light emanating from Francis's seraphic vision, and it is the *Fioretti* that notes how "shepherds who were watching in that country saw the mountain aflame and so much brightness round about they were sore afraid." Barocci shows the shepherds gathered around a fire, pointing excitedly toward the miraculous light. Askew (1969, p. 285) has related this episode to the annunciation of Christ's birth to the shepherds; certainly, there is no precedent in representations of the stigmatization of Saint Francis for Barocci's evocative, romantic landscape (the only contemporary parallel is Caravaggio's *Stigmatization* in Hartford, cat. no. 68). The falcon in the branches of the tree at the left is mentioned in the appendix to the *Fioretti*, the *Considerazioni sulle sacre sante stimmate* (II), where he is said to have befriended the saint on Mount La Verna, waking Francis for matins (a precedent for this detail is Bartolomeo della Gatta's depiction of an owl—not a falcon—in his *Stigmatization* in the Pinacoteca Comunale, Castiglion Fiorentino; see M. Meiss, 1964, p. 47, n. 84). The cleft in the rock behind Saint Francis is, again, described in the *Considerazioni* but not in Bonaventure's life.

One of the most striking details in the picture is the depiction of the stigmata as actual nails piercing the saint's hands. Although they are so described in all early Franciscan sources, traditionally they were represented as simple wounds. Their precise description here—Barocci even shows the light reflecting on the metallic nailheads—is in response to the demand by numerous Counter–Reformation churchmen that artists follow to the letter historical sources. The rosary held by Brother Leo—the only significant detail that cannot be accounted for in textual sources—underscores the function of the picture as an *exemplum* of devotional practice. The small skull that Brother Leo fingers may also allude to the analogy between Francis's stigmatization and Christ's crucifixion on Golgatha—*Franciscus alter Christus*—a well-established theme.

Olsen (1962, p. 193) considered the picture to be only partially autograph, but its cleaning for the 1975 Barocci exhibition in Bologna confirmed its autograph status (see A. Emiliani, 1975, p. 182).

This is one of Barocci's most dramatically charged and forward-looking compositions. The figure of Brother Leo is placed insistently close to the picture plane, establishing a strong diagonal thrust into space, a common device of later Baroque painting. In like fashion, the brilliant light effects and the use of the broken rhythm of the drapery patterns to enhance the supernatural character of the scene foreshadow the work of Lanfranco (who shared Barocci's debt to Correggio) and of even later artists such as Bacciccio. We know from contemporary sources the extraordinary care that Barocci took in composing and painting his pictures. Bellori (1672, p. 194) noted that Barocci "always turned to nature, nor did he introduce the smallest details without first-hand observation." A marvelously sensitive drawing (in the Kupferstichkabinett, Berlin-Dahlem) for the falcon in the tree bears out the truth of this statement. From the evidence of drawings for other works, Barocci must have made equally careful studies for the trees, rocks, and the firelit scene in the background. This was, however, only the first stage in his creative process. Bellori (p. 195) goes on to relate how Barocci "had his models strike the pose he had in mind, and asked them if it felt forced in any way, and whether, by turning more or less, they felt more at ease. By this manner he experimented with the most natural actions, without affectation, and sketched them." In the present picture, this process of refinement and the search for an apparently effortless solution to the poses of the figures can be traced via a drawing (in the Uffizi) for Brother Leo. He was initially conceived viewed from the back, leaning on a rock, his head bent backward. The splendid, serpentine pose that Barocci finally settled upon is a perfect visual abstraction of Brother Leo's conflicting responses to the miracle of meditation and surprise. It is, moreover, a paradigm of what, for Bellori, was the most praiseworthy feature of Barocci's work—its blend of facility, naturalism, and grace ("una proprietà facile, naturale, e graziosissima"). This elaborate creative process had its roots in the practice of Raphael, and it was, to a degree, paralleled by that of Annibale Carracci, whose early work Barocci had influenced. However, whereas for both Raphael and Annibale this process aimed at perfecting the so-called accidents of nature, endowing their pictures with the timeless, ideal beauty found in ancient art, Barocci's goal was effortless perfection and an abstracting, personal conception of beauty. It was the artifice and beauty ("artificio e vaghezza") of his paintings that his patrons prized (see the letter from Matteo Sanarega to the artist, reprinted by Bellori, 1672, pp. 183 f.), but these same traits place Barocci's pictures at the opposite pole to Caravaggio's.

K. C.

19. Portrait of a Nobleman, possibly the Marchese Ippolito della Rovere (about 1554–1620)

Oil on canvas, 46 1/2 x 37 3/8 in.
(118 x 95 cm.)
Signed and dated (lower left): FED.BAR.
URB./ AD MDCII
Italian Embassy, London

The picture has been associated with a passage in Bellori (1672, p. 192) and with a painting described in a 1652 inventory as "a canvas 1 5/6 *braccio* high and 1 3/5 *braccio* wide [about 42 x 36 7/8 in.] showing the Marchese Ippolito della Rovere—By Barocci" (see H. Olsen, 1962, pp. 204 f., and A. Emiliani, 1975, pp. 200 ff., both of whom trace the earlier history of the picture, prior to its purchase in 1952 by the Italian government). The identification is not certain. Indeed, the date inscribed on the canvas, 1602, might be taken as contradictory evidence, since in that year Ippolito was exiled by his cousin Francesco Maria II, Duke of Urbino. It seems unlikely that Barocci would have portrayed the marchese at this period, especially since there is no sign of discord between the artist and his protector, the duke. This period was among the happiest in Barocci's career, one during which he undertook a number of important official tasks, such as the commission for the Cappella del Santissimo Sacramento in the cathedral of Urbino and the *Presentation of the Virgin* (dated 1603) for the Chiesa Nuova, Rome.

Although the identity of the sitter cannot, at present, be definitively established, the picture's intrinsic qualities are apparent. Barocci's point of departure was Titian's portrait (now in the Uffizi) of Francesco Maria I, painted some sixty-five years before. Indeed, a drawing in the Uffizi that Emiliani (1975, p. 201) has plausibly related to the present painting suggests that, like Titian, Barocci initially conceived a full-length portrait. Titian's original composition is known through a preliminary drawing, also in the Uffizi (see W. R. Rearick, 1976, pp. 46 ff.). He then settled upon a more informal, half-length composition (documented in a preliminary study in the Martin von Wagner Museum, Würzburg) in which neither the armrest of the chair nor the sword appear; these were obviously added to enhance the official status of the sitter. It was Titian's model that inspired Barocci's warm flesh tones and his painterly rendering of such details as the ruffed collar, the rings, and the fringes of the chair, endowing the figure with a credibility and a vitality that stands in marked contrast to Pulzone's meticulously detailed *Portrait of a Lady* (cat. no. 49), in which the sitter's personality is made a function of her social status.

D. B.

Orazio Borgianni

The son of a carpenter of Florentine origin, Borgianni was born in Rome about 1578. He was probably trained by his stepbrother, the sculptor and architect Giulio Lasso (or Scalzo), with whom he must have traveled to Sicily while still young.

Baglione mentions that Borgianni made a trip to Spain, where he married, and that he later returned to Rome. Recently discovered documentary evidence has confirmed the hypothesis that Borgianni was in Spain twice. The first trip, of some duration, must have taken place between 1598 and June 1603. During this time, Borgianni took part in the creation of an academy of painting in Madrid (A. E. Pérez Sánchez, 1982, pp. 285 ff.). He was present in Rome in February 1604, but by the beginning of the following year he had returned to Madrid, as attested by his signature on a valuation of paintings dated January 9, 1605. He was probably in Spain until about October 1607, when he was at the Accademia di San Luca, Rome. Although Borgianni seems to have remained in Rome until his death on January 15, 1616, the dedications on some of his engravings, and the paintings in the Convento de Portacoeli, Valladolid—which were installed in 1613 after having been sent from Italy—prove that he continued to maintain ties with Spain.

Borgianni is an artist of considerable individuality. He enjoyed a certain prominence in Rome in Caravaggio's time; indeed, it is known that he clashed with the great master, who according to Baglione (1642, p. 143), "spoke badly of [Borgianni]." Although he owed much to Caravaggio's example, Borgianni's art is absolutely independent in his assimilation of Venetian elements in the tradition of the Bassani. Some of his compositions also reveal the influence of Tintoretto's dramaticism, and there was an obvious contact with the young Giovanni Lanfranco, from whom Borgianni's work derived its Correggesque qualities. Caravaggio's influence is strongest in what are presumed to be Borgianni's late paintings, but even then his own strong personality dominates. In Spain, Borgianni's influence was considerable, and affinities with such artists as Eugenio Caxes (1574–1635), his colleague at the academy in Madrid, are undeniable.

20. David and Goliath

Oil on canvas, 46 7/8 x 56 1/4 in.
(119 x 143 cm.)
Real Academia de San Fernando, Madrid

This is undoubtedly the picture described by Baglione (1642, p. 143) in great detail: "I must not omit a picture by Orazio of David cutting off the head of the giant Goliath. The David is a marvelously posed youth; the giant, in full armor, has fallen to the ground and the wound on his forehead from the stone is very well depicted. He looks like an enraged mastiff, and with one hand he claws the ground; and so well is his pose foreshortened that although the picture is not very large it shows the whole of the giant's oversized body. The picture exhibits great style [*maniera*] and taste and is excellently painted." According to Baglione, the picture once was owned by the Duke of Mantua's ambassador to Rome. How it reached Spain is not known, but, at the beginning of the nineteenth century, the painting belonged to Godoy, the all-powerful *Principe de la Paz*; upon the confiscation of his property following his downfall in 1808, it entered the collection of the Academia de San Fernando (A. E. Pérez Sánchez, 1965, p. 241).

The bold conception of the picture evidently derives from a composition by Daniele da Volterra that is known through a number of versions employing the same striking foreshortening. However, whereas in Daniele's composition the foreshortening is Mannerist in emphasis, in Borgianni's picture it creates the impression of a powerful naturalism. The dramatic lighting reveals an evident debt to Caravaggio, but Borgianni's approach is completely different. Compared to Caravaggio's representations of David and Goliath—the severe and monumental one in the Prado (cat. no. 77), or the introspective and anguished one in the Galleria Borghese (cat. no. 97), in which the horrific and cadaverous rigidity of the victim contrasts with the impassive and melancholic attitude of the young hero— Borgianni underscores the violence, physical exertion, and tension of the action at its most dramatic moment. The violent expressiveness and the energetic linear pattern created by the tensed muscles make this one of the artist's most powerful works. Wethey's comment (1964, p. 154) that the effect of the picture is "more comic than horrifying" is incomprehensible. Wethey has, however, acutely observed that Borgianni did not follow the biblical narrative exactly, for there the giant has already been killed by the stone when David cuts off his head, whereas in the painting he is alive, contorted by pain. It is evident that Borgianni was more interested in conveying movement and psychological drama than in remaining faithful to the text. Nonetheless, it should be noted that he was not alone in adopting this interpretation. Orazio Gentileschi, who, in his pictures in the Galleria Spada, Rome (cat. no. 42), and in the Gemäldegalerie, Berlin-Dahlem, portrayed David meditating before the fallen giant, also painted the dynamic and violent version in the National Gallery of Ireland, Dublin, in which David cuts off the head of the giant who is still alive. The elegant rhythms of the forms in Gentileschi's picture are, however, a far cry from the brutality and immediacy of Borgianni's dramatic representation.

The *David and Goliath* must be a late painting, executed after the artist returned to Rome in 1607, when he was already familiar with Caravaggio's work.

The picture was exhibited in Bordeaux in 1955 (no. 10); in Madrid in 1970 (no. 21); and in Seville in 1973 (no. 9).

A. P. S.

21. Saint Christopher

Oil on canvas, 39 x 29 1/16 in.
(99 x 73.8 cm.)
National Gallery of Scotland, Edinburgh

This is the best of several known versions of a composition by Borgianni that dates from about 1610 to 1615; it also exists in an engraving (Bartsch, XVI, no. 53) that Borgianni dedicated to the Spanish nobleman Don Giovanni de Lezcano, secretary to the Conde de Castro, Spanish ambassador to the Vatican between 1609 and 1616. Don Giovanni was certainly close to Borgianni, who named him executor of his will of 1616 (H. E. Wethey, 1970, p. 746). Another picture of the same saint by Borgianni, earlier in date and still bound by Mannerist traditions, was formerly in the Milicua collection, Barcelona, and is now on the art market in London (H. E. Wethey, 1964, fig. 4; A. E. Pérez Sánchez, 1964, fig. 5). The Edinburgh picture is directly related to a composition by Adam Elsheimer that exists in three versions, the original of which appears to be that in Leningrad, datable to about 1598–99 (see K. Andrews, 1977, p. 140, fig. 23). It is unclear how Borgianni knew Elsheimer's composition, but it is not unlikely that when the German artist came to Rome in 1600, he brought with him drawings or a replica of the picture that he had painted earlier, in Germany or in Venice. Whatever the explanation, in his own picture Borgianni has united the dark, atmospheric effects of Elsheimer's painting, and its strong Venetian accents, with a fully assimilated Caravaggism, evident in the strong light that vigorously outlines the anatomy and the clothing of the giant and in the coarse features of the saint.

The provenance of the picture is not known prior to 1850, when it was given to the Royal Scottish Academy. There are, however, seventeenth-century Italian references to two versions of the subject. Baglione (1642, p. 141) mentions a large picture ("di grandissima forma") in the church of San Lorenzo in Lucina, Rome. The other picture belonged to Giovanni Imperiale and was offered for sale in Genoa to Charles II of England in 1661 (H. E. Wethey, 1964, p. 153, n. 36). A version of the present picture, evidently of equal quality, was owned by Dr. H. Voss prior to World War II (its whereabouts are unknown). Among the extant copies is one in the National Gallery of Scotland (H. Brigstocke, 1978, p. 21, no. 20), one in the Martin von Wagner Museum, Würzburg, and one in the church of San Vicente, Seville. Recently, Professor A. Morales of the University of Seville has identified what appears to be an autograph version of the subject: It is in a village near Seville. Although the painting awaits restoration and proper publication, it is of excellent quality, and was perhaps the prototype for the copy in San Vicente, to which there are old references.

A. P. S.

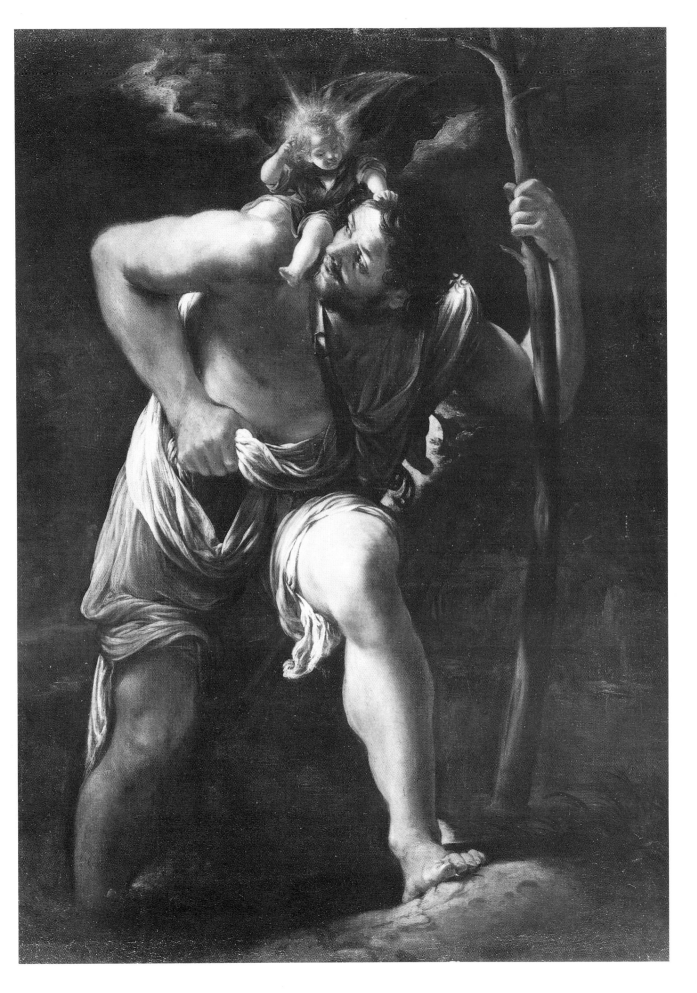

Giovanni Battista Caracciolo called Battistello

Battistello (1578–1635), who was associated variously with the circle of Neapolitan and Spanish painters (Ribera, Bernardo Cavallino, Giovanni Dò, and Paolo Domenico Finoglia) connected with the parish of San Liborio alla Carità, Naples, began his long career as a master in oil and fresco technique alongside the Late Mannerist artist Belisario Corenzio. Battistello's output is represented today by just under one hundred extant works, and his career is amply documented by records of numerous payments made to him. One early document mentions his collaboration with Corenzio and with Luigi Rodriguez on the fresco decoration of the façade of the Monte di Pietà, Naples (in 1601; later destroyed); he also frescoed some of the vaults in the upper rooms of the same building, for which, however, Corenzio was paid. The frescoes of putti and drapery on the interior façade of Sant'Anna dei Lombardi at Monte Oliveto, Naples, although still in a Late Mannerist vein, already mark Battistello's first reaction to Caravaggio.

Battistello's passage from his youthful, late maniera to the naturalistic style of his key works is usually related to Caravaggio's first trip to Naples. In fact, even though it is probable that Battistello was already familiar with Caravaggio's Roman paintings, his earliest documented Caravaggesque picture is the Immaculate Conception, with Saints Dominic and Francis of Paola, in Santa Maria della Stella, Naples, for which he received two payments in 1607. From that date until 1617, when Battistello traveled as far north as Genoa to work and study—stopping in Rome (where he had spent some time in 1614, and where he was in touch with Orazio Gentileschi) and Florence—Battistello's paintings are based on an investigation and an elaboration of Caravaggesque naturalism and light; those pictures painted by the Lombard during his two Neapolitan trips, especially, provided Battistello with a point of departure. A number of paintings document this phase in Battistello's career: several versions of the Ecce Homo (in Leningrad; in the Museo Nazionale di Capodimonte, Naples; and in Paola), the Qui vult venire post me (dated about 1610) painted for Marcantonio Doria (and now in the University of Turin), the Liberation of Saint Peter painted in 1615 for the Pio Monte della Misericordia, Naples, and the Trinitas terrestris painted in 1617 for the Pietà dei Turchini, Naples. These works represent the summit of the naturalist tendency that Caravaggio had inspired in Naples. Battistello achieved this with a vigor that is shared by none of his related Neapolitan contemporaries (for example, Carlo Sellitto and Filippo Vitale). At the same time, he retained an accentuated propensity for carefully conceived, solemn compositions, and a preference for portraying figures according to the traditional rules of disegno uncompromised by their modeling. Soon after his trip north in 1617, Battistello began to emphasize certain formal qualities in his work and to favor compositional solutions that betray a renewed interest in Cinquecento maniera, or a moderate acceptance of the recent examples of Domenichino and Lanfranco—without, however, abandoning his prior naturalistic, Caravaggesque tendencies. This change came about through his increased interest in the work of Annibale Carracci (which had already impressed Battistello during his visit to Rome in 1614), as well as through his study of Early Cinquecento painters in Florence and his contact with Florentine artists of the Early Seicento.

By the mid-1620s, Battistello's work was no longer part of the naturalistic current in Naples that Ribera was then reviving. In fact, during the last decade of his activity, Battistello found himself in a position of cultural and ideological isolation. His paintings—both on canvas and in fresco—elaborate images of an ever more sustained and solemn monumentality, with a rigorous formal abstraction, and saturated, luminous colors that are far removed from any reference to the real or natural world.

22. The Baptism of Christ

Oil on canvas, 45 11/16 x 57 1/8 in. (116 x 145 cm.)
Quadreria dei Girolomini, Naples

The picture was mentioned as in the Girolomini in 1692 by Celano (p. 696), then again in 1788 by Sigismondo (I, p. 189), and in 1845 by Catalani (I, p. 86). In 1915, Longhi (1961 ed., I, pp. 184, 209), who was the first to praise its exceptional pictorial qualities, suggested that the painting was a fragment of another Baptism by Battistello (now lost) recorded as in the church of San Giorgio dei Genovesi, Naples, by De Domenici in 1742 and by a number of nineteenth-century guidebooks. Although this hypothesis has been accepted by several scholars, recently it has been definitively disproved following a restoration to the Girolomini picture. Whereas the painting formerly in San Giorgio dei Genovesi must have measured at least 310 x 220 cm. (judging from the original frame still in situ), the Gerolomini Baptism shows no signs of having been significantly reduced—only trimmed at the top and sides, while at the bottom there are traces of the original preparation (evidently covered by an extension of the frame of approximately four centimeters). Moreover, the stylistic features of the Girolomini composition, with the two half-length figures of Christ and Saint John the Baptist grouped closely together in the foreground in a manner that recalls a similar solution employed by Caravaggio for the Denial of Saint Peter and the Martyrdom of Saint Ursula (cat. nos. 100, 101)—both dating from the Lombard painter's second Neapolitan period—positively exclude the possibility that this picture is the result of a substantial reduction. The same features that have correctly suggested a fairly early date in Battistello's career—in any event, prior to about 1610—also have given rise to two different hypotheses for a more exact placement within the artist's first Caravaggesque phase. On the basis of its compositional affinities with the two works by Caravaggio already mentioned (works that the Baptism also recalls in the way in which both the half-length figures emerge from the dark shadows), almost all recent critics have suggested grouping the present

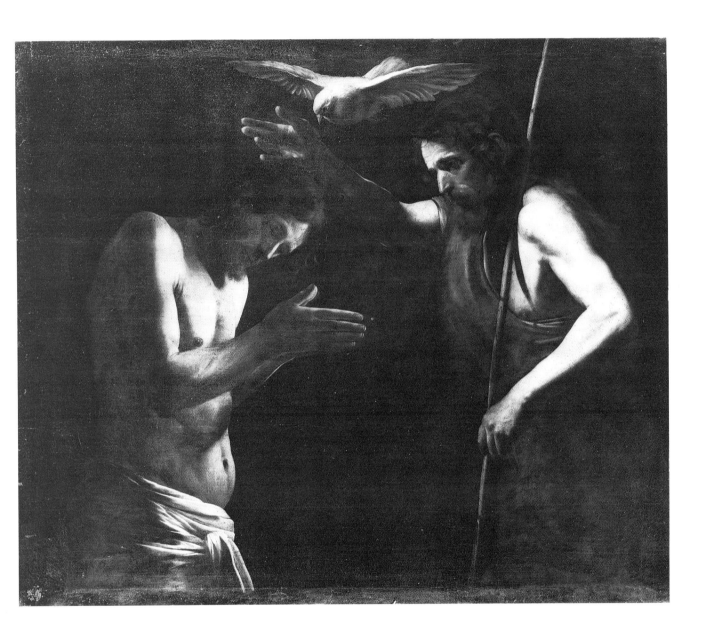

picture with those paintings that date from between about 1609 and 1610 (the *Ecce Homo*, in Leningrad, the *Qui vult venire post me*, in Turin, the *Madonna and Child* at Capodimonte, and the *Crucifixion*, in the Santissima Annunziata, Naples), and, in any event, after the *Immaculate Conception*, in Santa Maria della Stella, Naples (two payments are recorded in October 1607 for this picture, but they do not indicate for certain whether or not the work was yet finished). Causa (verbally) advanced the interesting hypothesis that because of the coloring of the flesh—still markedly Mannerist in the cool, metallic tones employed—and the accentuated tendency to define form and volume by means of a vigorously drawn contour rather than through the natural play of light on bodies in shadow, the Girolomini canvas may be contemporary with Caravaggio's first trip to Naples. This hypothesis—which is based on the discernment of Mannerist features that, in the *Immaculate Conception* and, above all, in the works of 1609–10, are superceded by an understanding of Caravaggio's naturalism and light in his late work—could confirm the opinion that Battistello was familiar with Caravaggio's Roman works even prior to the Lombard's arrival in Naples in 1606. Whatever the case, the Girolomini *Baptism* lucidly demonstrates Battistello's rare capacity to grasp the most profound and truthful essentials of Caravaggio's lessons—whether in its extremely simple yet extraordinary composition, in the use of actual models (albeit submitted to an attentive and considered study), or, above all, in the intensity of the beam of natural light that conjures fragments of humanity from the darkness and fixes them with great immediacy in an eternity that has neither time nor history.

N. S.

Annibale Carracci

Born in Bologna in 1560, the son of a tailor, Annibale was trained in painting by his cousin Ludovico (1555–1619) and learned engraving from his brother Agostino (1557–1602). Like Ludovico, he, too, studied the art of Northern Italy, traveling to Parma in 1580, to Venice with Agostino in 1581–82, and probably also to Florence. He returned to Bologna sometime in 1582, the year that the three Carracci established their academy and shortly afterward began the first of their joint commissions, the fresco decorations in the Palazzo Fava. From then on, there followed a succession of stupendous altarpieces in which the critical lessons of such artists as Correggio, Titian, and Veronese are progressively developed and integrated by Annibale within a unifying concept of naturalistic illusionism, based, in particular, upon an unmannered design that is given optical verisimilitude through the manipulation of pure, saturated colors and the atmospheric effects of light and shadow. In 1595, Annibale entered the service of Cardinal Odoardo Farnese in Rome, and it was he who was responsible for exporting to the first city of Christendom the Carracci's reformed style of painting, which Annibale continued to develop with reference to the canonical Roman models of an idealized ancient and Renaissance art. Annibale remained with Cardinal Farnese for ten years, producing his greatest work, the frescoes in the gallery of the Palazzo Farnese, between 1597 and 1601. In 1605, he suffered a nearly complete mental breakdown, and four years later he died miserably, but not before having developed—with the help of his students—a final synthesis of warm, naturalistic Northern color and light with a highly abstract and classical formal vocabulary.

It was Caravaggio, already in Rome when Annibale first arrived there, who first grasped the full illusionistic potential of Bolognese techniques of handling color and light. Both Caravaggio and Annibale were perceived in the seventeenth century as exponents of a North Italian or "Lombard" tradition of naturalism that was opposed to the excessive aestheticism of Mannerist practice then prevalent in Rome. Even before Annibale came to the city, Caravaggio's style was recognized as a product of the naturalistic conventions of the Veneto-Lombard culture in which he had been raised; the full power of Caravaggio's mature style emerged after Annibale's arrival in Rome—first in the Contarelli Chapel, and then in his definitive statement, the Cerasi Chapel, where Annibale painted the altarpiece. The effect of Caravaggio's work was shocking, as we know from the rejection of his original version of the Conversion of Saint Paul, and it was at once apparent that the naturalistic illusionism of Lombardy, even though anti-Mannerist, had produced sharply divergent tendencies—tendencies that stood in a dialectically polemical relationship. Already in 1603, van Mander reports that Caravaggio scorned the principle of artistic selection, with its goal of realizing a perfected ideal of nature, insisting upon absolute faith to the individual model, depicting the truth of particular experience. Annibale, on the other hand, sought to give naturalistic verisimilitude to a perfected ideal that was deducible from experience, to represent not what is but what might be and what ought to be, and, in so doing, to inspire the viewer to virtue. His altarpiece for the Cerasi Chapel, in contrast to Caravaggio's two paintings on the side walls, emphasizes in the strongest possible way the divergence between the two artists' conceptions of the problem of reality. They are strictly antithetical, and were immediately understood to be so by their contemporaries. In that antithesis—not in the opposition of naturalism to Mannerism—appears the fundamental problem of Counter-Reformation culture.

23. The Dead Christ

Oil on canvas, 27 7/8 x 34 15/16 in. (70.8 x 88.8 cm.) Staatsgalerie, Stuttgart

The painting is perhaps earliest mentioned in an inventory of the contents of Annibale's house, made at the time of his death in 1609, although this identification is problematic. The picture is again cited in an inventory of the Palazzo Chigi-Odescalchi, Rome, following the death of Cardinal Flavio Chigi in 1693: "A painting on canvas measuring four *palmi* with a dead Christ in foreshortening taken down from the cross, with the crown of thorns and nails . . . by the hand of Carracci."

The painting is among the earliest surviving works by Annibale, and rightly has been seen as exemplary of the militant return to naturalism that characterizes the early stages of the Carracci reform. The Mannerist painters Prospero Fontana, Denys Calvaert, and Bartolomeo Passarotti, for example, denounced this style—as exemplified by Annibale's *Crucifixion*, which he signed in 1583—as limited to the conventions of the *accademia del nudo* but not suitable for altarpieces, noting that it was easy to copy a naked workman but not something that required great ingenuity. Freedberg (1983, p. 6), in his most recent discussion of the *Dead Christ*, finds it typical of the young Annibale's desire to avoid rhetoric and to confront the truth bluntly. Freedberg suggests, moreover, that the religious subject of the picture is not its primary meaning, but may be only a pretext for a *tour de force* of realism conceived in the manner of a still life or genre piece. There is no question of the painting's naturalistic force, and yet the related questions of Annibale's concurrent preoccupations with the traditions of art and its purpose as a technique for persuasion are not so easily dismissed. The Mannerist painters who criticized Annibale were themselves censured by Counter-Reformation critics for using subject matter only as a pretext for an artistic *tour de force*, and this same criticism equally censured Caravaggio—not Annibale—for an excessive display of naturalism at the expense of his subject matter. Accordingly, Caravaggio's *Death of the Virgin* was removed from

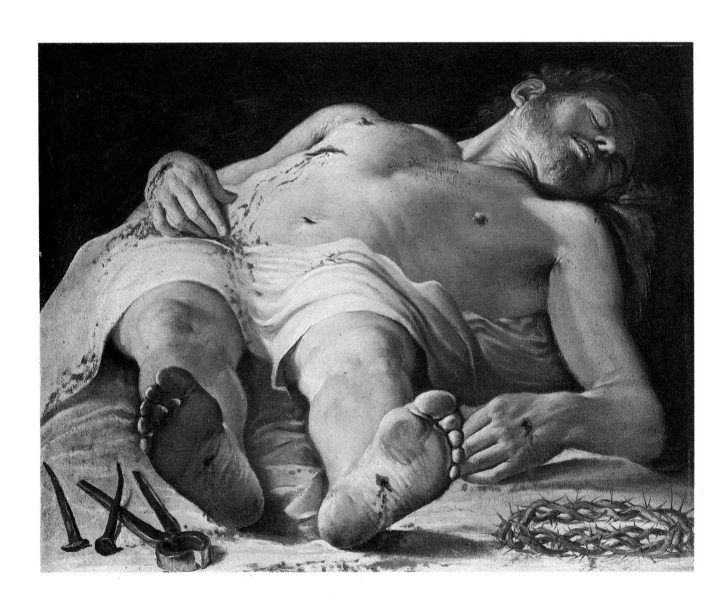

its altar because he had not represented the Madonna but, according to Bellori, instead copied too faithfully the swollen corpse of a dead woman, the model for which—Mancini had claimed some fifty years earlier—was simply a prostitute.

It is easy to see how such Mannerist artists as Fontana and Calvaert—who, as Malvasia points out, had known Michelangelo—might find a painting like the *Dead Christ* excessively natural. At the same time, Annibale's naturalism seems muted when contrasted to the particularity of Caravaggio's vision. The very poignancy of Caravaggio's image of the dead Virgin derives from its reversal of our expectations, from the fact that we do not see an artistic type of the Madonna but a pathetic and very individualized young woman, such as we have known, and so are brought face to face not with an idea of Christian triumph but with the ineluctability and finality of human mortality. Annibale's dead Christ, on the other hand, however naturalistically conceived, is nevertheless unmistakably the dead Christ. The painting belongs to a tradition of images of similarly foreshortened figures in North Italian art that can be traced to Mantegna's *Dead Christ* and includes versions of the subject by Lelio Orsi, Orazio Borgianni, and possibly even by Annibale's cousin Ludovico. Moreover, Annibale's treatment of the theme is virtually incomprehensible except in the context of Counter-Reformation devotional painting, the conventions of which the Carracci reform did much to stabilize and refine. The body of Christ, his terrible wounds, the infernally twisted nails with which his flesh was pierced, the cruel thorns that were pressed into his brow, the blood that he shed, each is presented *seriatim* as an object of particular meditation intended to touch and to move the affective sensibilities of the viewer. Annibale's painting is naturalistic, certainly, but it is arranged in the manner of a spiritual exercise, and in this respect prefigures the persuasive devices employed to brilliant effect in his mature and astonishing *Pietà* (in the Museo Nazionale di Capodimonte). Each object, for all its convincing illusionism, is an emblem of salvation.

C. D.

24. The Butcher's Shop

Oil on canvas, 73 13/16 x 106 11/16 in.
(190 x 271 cm.)
The Governing Body, Christ Church, Oxford

The painting is almost certainly the "beccaria opera del Caratio" cited in a 1627 inventory of the Gonzaga collection, Mantua. The theme is not especially novel, for market scenes had become popular in Italy in the previous generation through the work of Northern painters such as Pieter Aertsen, and then were variously adapted by Italian painters, among them the Bassani in Venice, the Campi in Cremona, and Bartolomeo Passarotti in Bologna. Nevertheless, Annibale's painting is distinguished from this diffuse tradition both in iconography and in style. Consensus has been reached about neither, but by far the most persuasive analysis of the iconography is the old explanation that the painting contains portraits of the three Carracci: Ludovico behind the counter; Agostino to the left, weighing meat on a lanyard; and Annibale slaughtering a lamb in the foreground. Existing portraits of the Carracci support these identifications, as does the fact that Ludovico, the nominal head of the Carracci Accademia degli Incamminati, was the son of a butcher and was nicknamed "the ox" in his student days. It would follow that the *Butcher's Shop* in some sense allegorizes the activities of the Carracci academy, which was founded in 1582—about the time that the picture must have been painted.

Moreover, Malvasia reports that the Carracci said of their initial style—the basis for their reform of the dry *maniera statuina* (literally, the "statuesque" style) of the previous generation—that it "assolutamente è da viva carne," a term that carries with it the simultaneous meanings of "living flesh" and "red meat." That the painting allegorizes the stylistic position adopted by the Carracci seems to be confirmed by the conspicuous naturalism of its representation, combined with the surprising—but obvious, once pointed out—compositional adaptation of High Renaissance models: notably, Michelangelo's and Raphael's versions of the *Sacrifice of Noah* (in the Vatican). The ridiculous halberdier to the left, who twists himself into a knot in the simple act of reaching for his purse, is clearly a caricature of Mannerist excesses in posturing, and his absurdly highlighted codpiece —which Montaigne in 1580 had already called a thankfully out-of-date affectation of the previous generation—suggests that patrons of the earlier, artistically affected style would now have to buy the *viva carne* of the Carracci.

In contrast to that affected style, the "living flesh" of the Carracci refers to the naturalism of their paintings: the verisimilitude created by the purity of their color (especially apparent in the undiluted reds of the *Butcher's Shop*) together with the illusionistic handling of light. Annibale appealed generally to a tradition of naturalism inherent in Emilio-Lombard painting, and, in particular, to the colorism of Correggio's work. Although the figure style of the *Butcher's Shop* differs from Correggio's characteristic morphologies, the nature of Annibale's color has its most direct antecedent in Correggio's work—specifically in the handling of the paint itself. The term employed by Bolognese painters to describe this handling, as reported by Malvasia, was *pastosità* ("pastiness"); its thickly saturated and oily effects were opposed to the unnaturally polished and harshly contoured quality of Mannerist painting, whose style they disparagingly called the *maniera statuina*. Annibale's *pastoso* effects may be compared, especially, to Passarotti's paintings, which are superficially similar because of their subject matter, but nevertheless are more tightly painted.

Caravaggio also grew up in the naturalistic traditions of Lombard painting, but his early work, as Bellori noticed, looks toward Venice and the colorism of Giorgione. Longhi rightly observed that Caravaggio must initially have become acquainted with the innovations of the Carracci as a youth passing through Bologna on his way to Rome. However, it was not until his work on the paintings for the Contarelli Chapel that he began to show that he had absorbed the lessons of Annibale's colorism and *pastosità*—for of Correggio's painting Caravaggio was apparently ignorant. Yet, from then on, Caravaggio, together with Elsheimer, may be said to have been the first to create a new, personal style, on the basis of the discoveries of the Carracci academy. Caravag-

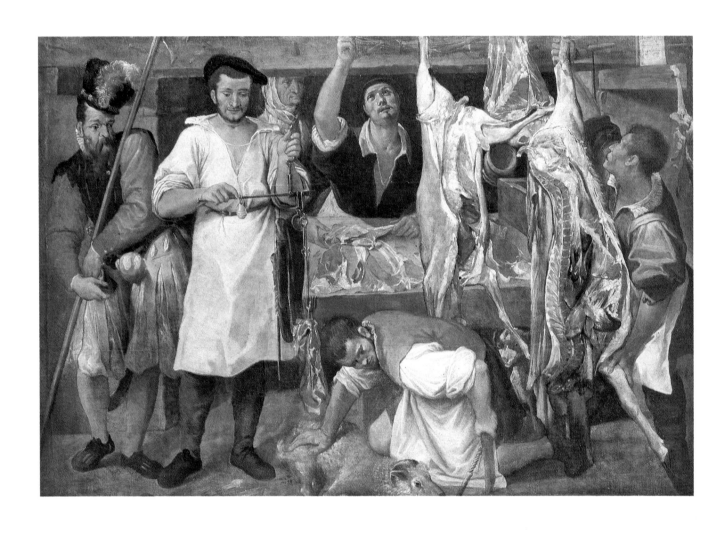

gio's colors and his depiction of light, although more limited in range, clearly derive from Annibale's after 1597, but Caravaggio's conception of naturalism is radically different. Bellori, who complained that Caravaggio had trampled down the majesty of art and initiated the imitation of vile things, seeking out filth and deformity, was clearly referring not only to Caravaggio and his immediate followers but also to the painters of genre scenes in Rome known as the Bamboccianti. He also was echoing the opinions expressed by Francesco Albani and Andrea Sacchi in the 1640s, when Annibale's *Arti di Bologna* was engraved and published, in order to show that pictures of common tradesmen and peddlers, like the butchers in the *Butcher's Shop*, could be represented with dignity and decorum.

C. D.

25. Hercules at the Crossroads

Oil on canvas, 65 3/4 x 93 5/16 in.
(167 x 237 cm.)
Museo Nazionale di Capodimonte, Naples

The painting originally was mounted at the center of the vaulted ceiling of Cardinal Odoardo Farnese's *camerino* (study) in the Palazzo Farnese, Rome. It is the keystone of an allegory of the young cardinal's virtues that Annibale elaborated in fresco on the remaining area of the vault. The story was invented by the philosopher Prodicus as an educational example to young men, warning them away from the pleasures of the senses and urging them toward virtue. The youthful Hercules is poised uncertainly between two female personifications of Virtue and Pleasure. Virtue stands to the left, next to a poet who is prepared to sing the hero's praises if Hercules chooses the arduous road up the mountainside—presided over by Pegasus—to which she points. To the right appears Pleasure, seductively dressed and coiffed—with playing cards, theatrical masks, and musical instruments by her side —who urges Hercules to follow her broad and easy path.

Stylistically, Virtue is represented as the essence of ancient Roman matronly dignity, while Pleasure, in her proportions and deportment, recalls the figures modeled on Venetian types (for example, the imposing woman in Tintoretto's famous *Presentation of the Virgin*) that Annibale had incorporated into his work just before he established himself in Rome in 1595. As long ago as 1924, Hess noticed the striking similarity between the figure of Pleasure and Caravaggio's violin-playing angel in the *Rest on the Flight into Egypt*, and, ever since, scholars have tried to determine whether Annibale's painting influenced Caravaggio, whether Caravaggio's influenced Annibale (depending on the date assigned to Caravaggio's picture), or whether both derive from some common prototype. The last hypothesis seems most likely, since the actions of the two figures vary greatly, and, more importantly, the style and handling of paint—Annibale's, generalizing; Caravaggio's, minutely descriptive—is radically different in each painting.

The sophistication of Annibale's manipulation of stylistic alternatives with expressive intent is striking, and was acknowledged in Sir Joshua Reynolds's *Garrick between Tragedy and Comedy*, which was based on this picture. Reynolds represented Comedy in the manner of Correggio, appropriate to her *allegrezza*, and invested Tragedy with the superior dignity of Annibale's Roman style. For Annibale, style itself possessed signification, and hence was part of the decorum of painting, while Caravaggio's canvases were notorious in the seventeenth century both for their lack of decorum and for the painter's refusal to adapt his naturalistic style to the demands of his subject matter. For this reason, as Bellori reports, Caravaggio's *Madonna dei Palafrenieri* was rejected, the painter having represented the Virgin and naked Christ Child in an unsuitable way. Caravaggio's treatment of classical subject matter is especially interesting. His *Amor Vincit Omnia*, for example, like Annibale's *Hercules at the Crossroads*, has a classical allegory as its theme. Its subject is a poetic fiction, but where Annibale adopted a style appropriate to sustain the fiction, Caravaggio represented his as reality, and thereby paradoxically deprived it of verisimilitude. It is for this reason that Caravaggio's mythological paintings still exercise their extraordinary power to shock, for it is not a classic or poetic idea of love that confronts us, but coarse reality masked by conventional fiction. The rendering of reality derives especial potency from the fact that, although Caravaggio's point of departure was the classic poetic theme, *omnia vincit Amor*, he painted it in a realistic manner, thus reversing convention and, consequently, the expectations of the viewer. In so doing, he revealed himself as no less a sophisticated thinker about style than Annibale, for, as Wittkower observed some time ago, Caravaggio's free choice to work within the traditions of mythology and allegory indicates his acceptance of a learned and literary heritage. If Annibale treated his themes with the grace of an Ovid, Caravaggio approached them with the savagery of a Martial or a Catullus, and for this reason his paintings were appreciated by such sophisticated collectors as Cardinal del Monte and Vincenzo Giustiniani.

C. D.

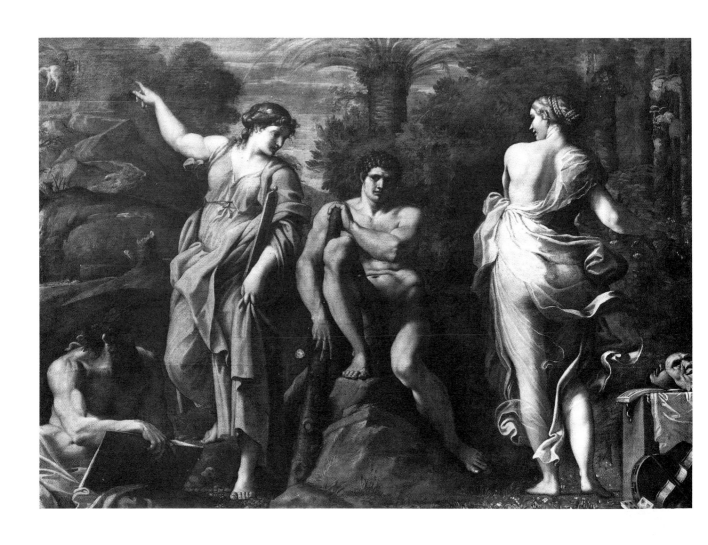

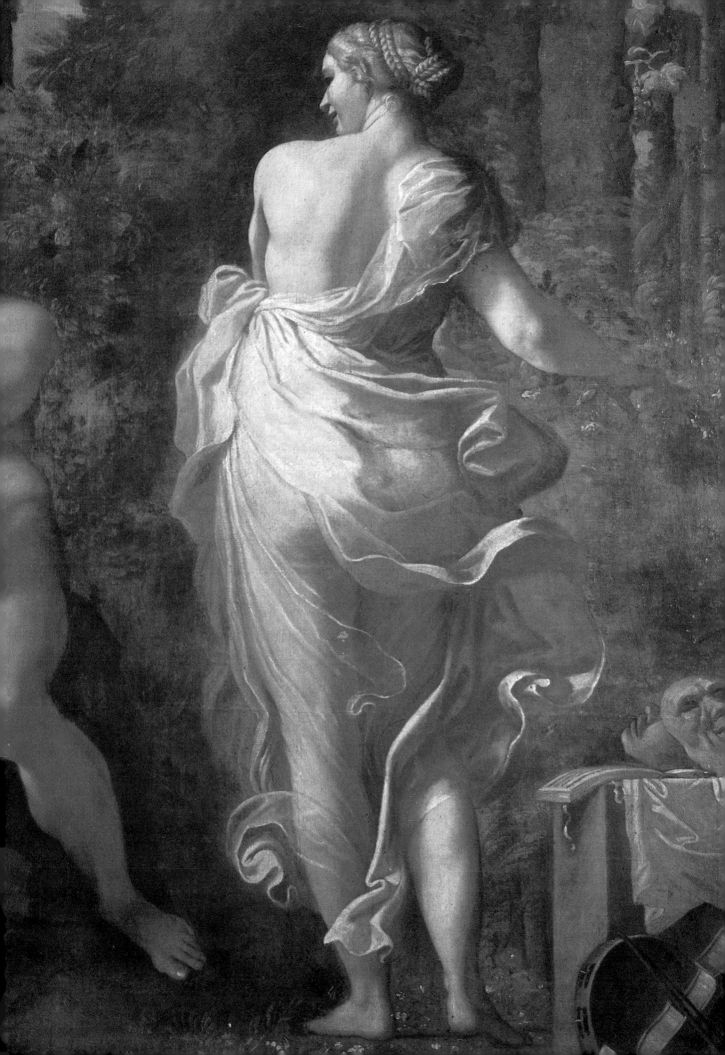

26. The Coronation of the Virgin

Oil on canvas, 46 3/8 x 55 5/8 in.
(117.8 x 141.3 cm.)
The Metropolitan Museum of Art,
New York

Bellori and Malvasia mention this painting in the Villa Aldobrandini, Rome; it is mentioned in Aldobrandini inventories as early as 1603. The dating of the picture is problematic, and is further confused by the existence of a related drawing in Dijon that Jaffé (1960, pp. 27 f.) published as by Annibale, and dated to the artist's final years in Bologna. However, the painting clearly seems to be from Annibale's Roman period, and according to Posner, dates from 1597.

The rational and severely geometric structure of Annibale's composition—notably, the spherical space in the background carved out by the bank of clouds upon which a host of angels sit in serried ranks, like spectators in an amphitheater built at the base of the dome of heaven—evince his study of Raphael's frescoes in the Vatican Stanze. The central group of the Madonna and the Trinity equally shows his mastery of the clarity and solidity of form characteristic of ancient art. The effect of severity is considerably softened, however, by Annibale's use of light and color, which derives in particular from his earlier study of the warm light and pure hues of Correggio, whose influence is especially apparent in the music-playing angels in the left and right foreground. These angels evoke the memory of Correggio's musical angels airily floating on soft and sun-dappled clouds in the dome of the cathedral of Parma, and it is indeed through Annibale and the students at the Carracci's Accademia degli Incamminati that Correggio's illusionistic conventions were to triumph in Rome.

The conventions that Annibale explores could hardly be more remote from those adopted by Caravaggio. Annibale's picture may usefully be compared with Caravaggio's *Martyrdom of Saint Matthew*, in which a boy-angel (actually more boy than angel) balances in a gingerly way upon a cloud and carefully lowers a palm frond into Saint Matthew's hand—"carefully," writes Hibbard (1983, p. 110), in a perceptive passage, "because Caravaggio's angel has not yet learned to fly." The clouds in the painting seem little more than stage props, barely concealing the box upon which Caravaggio's model was all too evidently posed. Hibbard (1983, p. 110) was correct in recalling the statement of the famous Realist painter, Courbet, who demanded, "Show me an angel and I will paint you one." To seventeenth-century painters in the tradition of the Carracci such practice indicated a failure of both imagination and knowledge. In a most interesting passage from Pietro Testa's notebook on painting, begun in the late 1630s, the painter and printmaker observed that a painter in this manner only appeared ridiculous because it was obvious that he had, in fact, delineated the footstool on which the model had placed his breast, pretending that it was the lightest of little clouds. "I have viewed with laughter and compassion," Testa wrote, "a painter who had to represent God the Father attach an old man into a leather waistcoat suspended by strings nailed to the ceiling, and when the contraption collapsed he wrecked his machine, the old man, and his poor painting." If a painter had trained his mind and hand in the principles of his art, Testa maintained, he would have no need of a model when called upon to represent the perfection of heavenly beings.

The Carracci reform of painting had been based on investigating and reconciling the perfections of nature through the observation of its effects, on the one hand, and, on the other, the perfections of art through the study of the styles of the canonical masters of antiquity and the Renaissance. For them, to imitate nature was merely to copy accidental appearances, while to imitate the style of another painter was equally empty of meaning—yet another form of copying. A painter following either path was a slave to practice, and his art uninformed by any understanding of theory without which he could not hope to attain his own style. Caravaggio's painting and his example polemicized the Carracci reform by elevating the imitation of appearances into a kind of artistic principle. Between that principle and its opposite, the imitation of the *Idea*, artistic thinking and practice in the coming century was poised.

C. D.

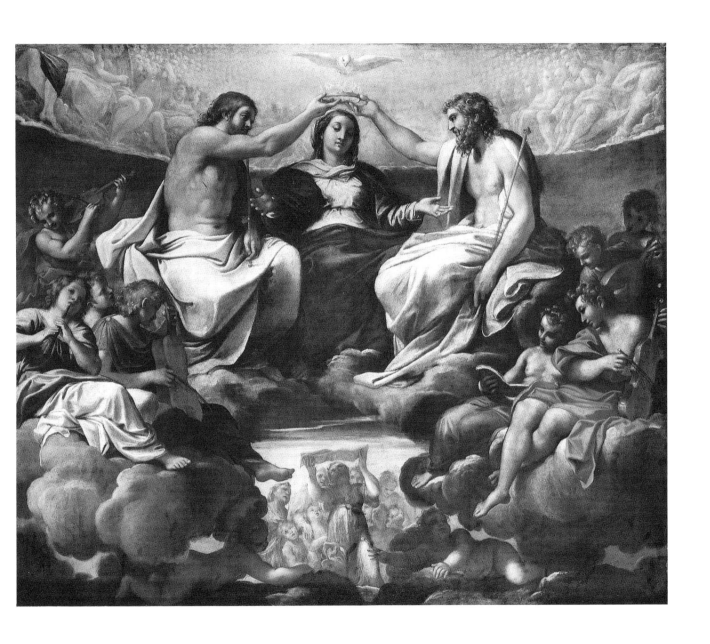

27. The Adoration of the Shepherds

*Oil on canvas, 40 9/16 x 33 1/2 in.
(103 x 85 cm.)*
Inscribed (on banderole, top center):
GLORIA.IN.EXCELSIS: DE[O]
Musée des Beaux-Arts, Orléans

The earliest mention of Annibale's *Adoration* is an inventory of the Ludovisi collection, Rome, made in 1633. By 1649, the painting was in Paris, where (as Annibale's biographers testify), it soon came into the possession of the Duc de Liancourt; in 1684 it was given to Louis XIV. In 1892, it was sent by the Louvre to the museum in Orléans. There is a splendid preparatory drawing in the Fitzwilliam Museum, Cambridge.

Although the subject is commonly encountered, the form in which it is presented—combining the Nativity with the Adoration of the Shepherds—is especially characteristic of post-Tridentine art. As Mâle has pointed out, by the seventeenth century the theme is rarely depicted otherwise because the Nativity and its concurrent Annunciation to the Shepherds, as opposed to a subject like the Adoration of the Magi, was incorporated into Rosary devotions to exemplify the mystery of the Incarnation. Also typical of post-Tridentine interpretations of the Nativity is the angel displaying an inscribed banderole with the words that announced Christ's birth to the shepherds. The same words form part of Rosary devotions upon the joys of the Virgin, and are, accordingly, included in such paintings as Domenichino's famous *Madonna of the Rosary* (in Bologna). Annibale's representation of the Madonna seated upon the ground is again typical and characteristic of the Counter-Reformation revival of Late Medieval devotional prototypes—in this case, of a type known as the Madonna of Humility. In contrast to the acknowledgment of Christ's kingship by the Magi, the shepherds behold God cloaked in the flesh of common humanity. This is emphasized by the Madonna's humble posture and by the simple bed of straw upon which the Child lies.

Caravaggio treated the same theme in the Messina *Adoration of the Shepherds* and again in the *Adoration of the Shepherds with*

Saints Lawrence and Francis (stolen in 1969 from the Oratorio di San Lorenzo, Palermo). Iconographically, his pictures do not differ fundamentally from the type exemplified by Annibale's painting, but conceptually the two artists are poles apart. As Longhi observed of Caravaggio's *Adoration* in Messina, the basket and tools in the foreground produce a still life of the poor, and the shepherds who gaze (with reverence or compassion [?]) at the heartbreakingly tiny young mother curled up with her baby on the stable floor are devastating portrayals of particularized human poverty and misery. Annibale's shepherds have lived in Arcady, and it does not occur to us to ask how it is that they enjoy such easy familiarity with angels, much less to wonder if it might be better never to have brought a child into such a world. That questions of this kind may be prompted by Caravaggio's painting illuminates Mancini's criticism, made within a decade of the artist's death, that by simply copying the truth of appearances ("ritrar il vero che tengon sempre avanti") Caravaggio and his school failed in "the composition of the story and in elucidating emotion, which depends upon the imagination and not on direct observation of things." The emotions portrayed in Annibale's painting—the wonderment of the shepherds, the joy of the angels, the prayerful attitude of the Madonna, and Joseph's air of dignified concern—are unambiguously orchestrated in order to give plausibility to the rendering of a clearly supernatural event. It could never be said of Annibale's figures, as Bellori said of Caravaggio's *Penitent Magdalen*, that "he painted a girl seated on a little chair, her hands in her lap, engaged in drying her hair, and by making a portrait of her in a room and adding a little ointment jar and some necklaces and gems on the ground he pretended that she was the Magdalen." Caravaggio's realism is based on particular observation and on an intense, individual psychological identification with the phenomena of immediate verity. We respond deeply to the emotions of his Magdalen and his shepherds, but we do not necessarily respond to her as the Magdalen or to them as the shepherds who received glad tidings, for, in their particularity, they stand apart from their own past, and indeed outside of

history. Annibale's naturalism is rooted in a generalizing sensibility canonized in the great tradition of art—a tradition that Caravaggio pointedly rejected. The lessons of Raphael's compositions, the clear and weighty forms of the art of antiquity, and the warmth and glow of Correggio's color have all been assimilated with a mastery that is simultaneously evident yet apparently spontaneously natural. The result has been to extend the particularities of reality into the permanence of history, and, at the same time, to endow history with immediate verisimilitude. Annibale's aim was neither to represent the Nativity as it might actually have been witnessed by a contemporary viewer, nor to depict it as it historically occurred, but, rather, to persuade the viewer of the permanent and unchanging truth of Christ's Incarnation.

C. D.

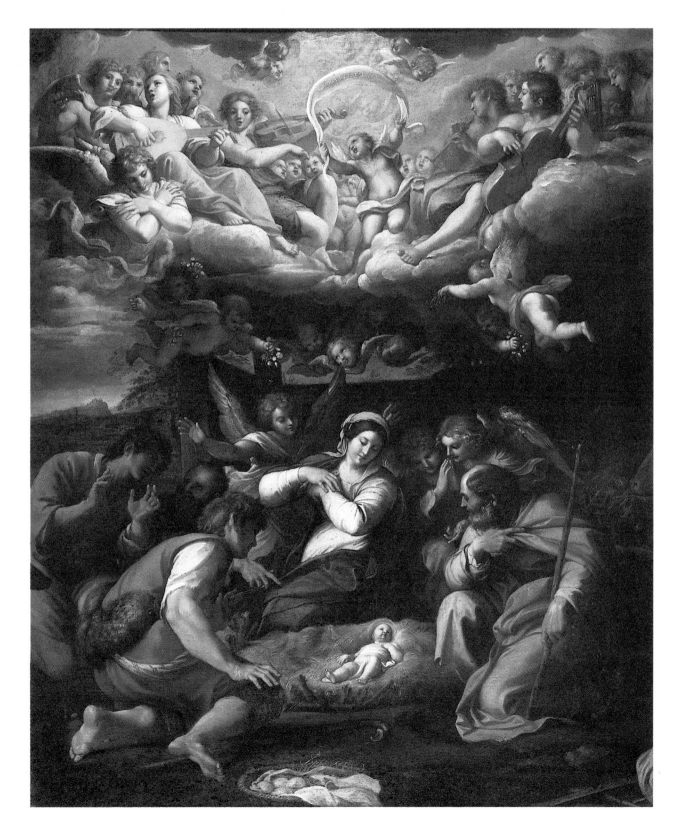

Ludovico Carracci

Born in 1555, Ludovico was the son of a butcher in Bologna. He received his earliest training with the Mannerist painter Prospero Fontana, after which he embarked upon a period of travel to study the works of the major North Italian artists, notably in Venice and in Parma, as well as in Florence, where already the climate of anti-Mannerist reform was beginning to be felt. By 1578, he was back in Bologna, where he became a member of the painters' guild. Bologna was, after Rome, the second city of the Papal States. Its Church, especially under the able administration of Cardinal-Bishop Gabriele Paleotti, was a major center for instituting the reforms enacted by the Council of Trent, which had met briefly in the city in 1547. It was the seat of an ancient and prestigious university, and the home of numerous music and literary academies.

In 1582, Ludovico, together with his younger cousins Agostino (1557–1602) and Annibale (1560–1609), opened in his rooms a private academy of art, first known as the Accademia dei Desiderosi and later as the Accademia degli Incamminati, which functioned simultaneously as a studio; a place where members of the university and of the academic, noble, theatrical, and artistic communities of Bologna met to discuss problems concerning the arts; and a training ground for the brilliant painters of the next two generations in Bologna. Whatever the individual roles played by each of the three Carracci, Ludovico, as the oldest, seems to have been the primary manager of the academy, remaining its guiding light after the departure of his two cousins for Rome. It was by way of the academy that the principles of the Carracci reform of painting were both articulated and put into practice, most notably in the series of monumental decorations initiated by the three Carracci upon completion of the Palazzo Fava frescoes in 1584, continued by them in such fresco cycles as that in the Palazzo Magnani, exported to Rome by Annibale with his frescoes in the Palazzo Farnese, and perpetuated in Bologna by Ludovico, as head of a team of academy artists, working on such commissions as the decoration of the octagonal cloister of San Michele in Bosco. Ludovico's art is not yet well understood. This is especially so—as a result of the lack of securely dated works—in its earlier phases,

when the principles of the Carracci reform were being defined and given their initial stylistic expression. His art, however, aggressively proclaims its origins in the traditions of North Italian naturalism, notably in the treatment of color and light, while at the same time rejecting the classical formulas of Florence and Rome, particularly as these were repeated in the maniera statuina adopted by Bolognese painters of the generation of Vasari. It is an art deeply impressed with the pietistic sentiment and didactic purposes of the Counter-Reformation, attempting to revive what Vasari (quoting Michelangelo) had sneeringly called the "devout manner" established in Bologna by Francia and by Bagnacavallo, but avoiding the "clumsiness" Vasari found in this manner by appealing to the more advanced style with which Correggio had cloaked the devotional sentiment characteristic of Emilian art. The Vision of Saint Francis and the Martyrdom of Saint Peter Thomas (cat. nos. 28, 29) dispense with the extravagant foreshortenings, elaborate perspectival constructions, and antique forms employed by Pellegrino Tibaldi and create, by contrast, an impression of directness, simplicity, and naturalness of representation. Yet, when the Carracci drew from the model in their academy, or studied the natural fall of drapery, it was not, as with Caravaggio, in order to reproduce the particular truth of that experience, but rather to test the techniques of the leading masters of the Renaissance against experience to eliminate the repetitious conventions, the true "eclecticism," of Mannerist practice. The naturalness of Ludovico's art is profoundly rhetorical, and the experience he represents is intentionally devotional, typical, exemplary. Unlike Annibale, he shunned the model of ancient art, being less concerned with a metaphysical ideal of natural perfection than with expressing a mystic experience of devotional intensity. Correggio's affective techniques were especially important to Ludovico's art, for, by appealing to the simple and natural sentiments of the viewer, Ludovico sought to identify those sentiments with generalizable religious experience, and, in so doing, to convert human passions into the pure love of God. Ludovico died in 1619.

28. A Vision of Saint Francis

Oil on canvas, 40 9/16 x 40 3/16 in.
(103 x 102 cm.)
Rijksmuseum, Amsterdam

The subject of this remarkable painting, which is not mentioned in any early sources, conventionally has been identified with a vision experienced by Saint Anthony, but it has been established beyond any doubt that the saint depicted is Francis. Saint Anthony's vision was indoors, and of the Child only, while Saint Francis was out walking when the Virgin appeared to him in a glory of light and placed the infant in his arms. The scene was witnessed by one of his companions, whom Ludovico has shown at the left. Confusion has arisen because the saint appears without wounds, but this is because the vision occurred before his stigmatization. The theme, in fact, was treated often by the Carracci and their followers. Ludovico's painting was closely imitated by Francesco Vanni in an oil sketch (now in the Uffizi), while Malvasia knew of a small painting by Agostino in Modena of "the Virgin with Saint Francis holding the Child in his arms," and another version by Ludovico in Rome showing the "Virgin and infant, Saint Francis, and an angel truly from Paradise." Annibale also depicted the subject, and yet a third version by Ludovico recently came to light in London. Alessandro Tiarini painted an impressive representation of the event for the chapel of Francesco Pagani (dedicated to his namesaint) in the Madonna della Ghiara, Reggio Emilia. Domenichino and Simone Cantarini both portrayed the story more than once, and Guido Reni and Guercino clearly incorporated it into their altarpieces for the Capuchin churches of Faenza and Parma, respectively.

As the provenance of the last two pictures suggests, the theme is especially to be understood in the light of the Capuchin reform of the Franciscan Observance. The Capuchin order, founded in 1529, became second in importance only to the Jesuits among the orders of the Catholic Reformation, or Counter-Reformation, after the Council of Trent. Capuchin devotion was rooted in a return to the practical austerity and spiritual unworldliness of Saint Francis

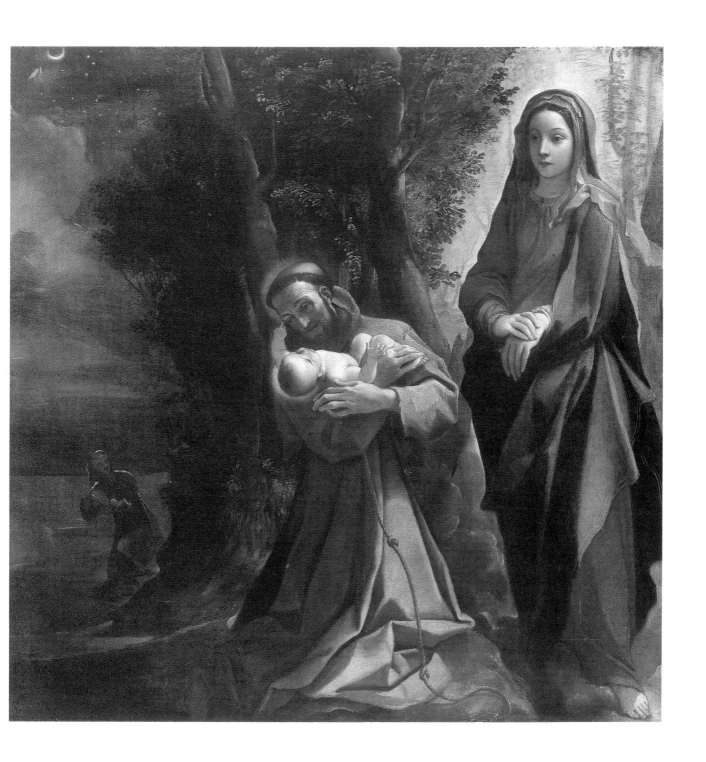

himself, and the directness and intensity of Ludovico's portrayal bespeaks an *anima naturaliter franciscana*, blending natural simplicity of representation with a powerful mysticism. Askew (1969, pp. 295 ff.) has stressed especially the fundamental role played by the Carracci in creating the new Franciscan imagery of the post-Tridentine era, and Longhi (1952, p. 12) was acutely sensitive to the particular psychological quality that characterizes their conception of such themes when he suggested that Caravaggio must surely have stopped in Bologna and studied their work on his way from Milan to Rome. Arcangeli (1956, p. 109), moreover, believed that Caravaggio probably was deeply impressed by the painting under discussion and carried the memory of it with him when he painted the Hartford *Stigmatization of Saint Francis* (cat. no. 68), one of the gentlest and most lyrical conceptions of a painter not normally given to gentleness and lyricism. The novelty of Ludovico's deeply human interpretation of a sacred theme in a decisively naturalistic style would not have been lost on Caravaggio, who, at the same time, would reject Ludovico's clear appeal to Correggio in his modeling (especially of the hands), and to Barocci in his coloring (especially in the *viva carne* of the flesh tones). Ludovico's wondrous light effects—the soft stillness of the moonlit night contrasted with the wood magically infused with light radiating from the Virgin—certainly would have been admired by Caravaggio, but it is not something that he ever attempted to emulate, with the single exception of the nighttime landscape of the Hartford picture. In the language of sixteenth-century art criticism, Ludovico aimed at verisimilitude, at rendering the probable outcome of supernatural experience in order to persuade the viewer of its universal reality. Caravaggio sought descriptive truth, rendering the actual physical and psychological results of an individual experience. Where Ludovico generalized by wedding natural effects to the great tradition of past art, Caravaggio particularized by seeming to locate his conception in nature, outside tradition.

C. D.

29. The Martyrdom of Saint Peter Thomas

Oil on canvas, 61 7/16 x 46 in.
(156 x 116 cm.)
Pinacoteca Nazionale, Bologna

Malvasia (1686, p. 97) mentions a "Saint Peter Thomas crucified to a tree," by Ludovico, in the chapter house of the Carmelite church of San Martino Maggiore, Bologna, together with a companion picture of the same saint meeting with Saints Dominic and Francis. Since these saints never actually met with Peter Thomas, but with another Carmelite, Saint Angelo, it has rightly been observed that Malvasia in a slip of the pen misnamed the second painting. That Malvasia also mistook the subject of the present painting has been wrongly inferred, however. Ludovico shows Saint Peter Thomas crucified on a tree trunk and pierced by a poisoned arrow, an event unsanctioned in his official hagiography but which derives from a legend—widely diffused in the sixteenth century—that he had earned sainthood by martyrdom at the hands of the Turks during the Battle of Alexandria. His ecclesiastical rank is correctly indicated by the bishop's miter and staff, to the left, while his special relationship to Bologna, where he was supposed to have attended the official inauguration of the faculty of theology at the University in 1364, is indicated by the lovely view of the city in the distance, to the right.

The painting is charged with an extraordinary passion. Longhi (1935 b, p. 128) found it an authentic expression of the nascent Baroque, filled with agitated pathos as the saint hangs weightless from the tree, his robes billowing like sails caught by a sudden gust of warm wind. His face is wasted, and the torments of the flesh are epigrammatically expressed by his heroically gnarled feet, but Saint Peter Thomas is unaware of, or indifferent to, this anguish and to the very arrow that pierces his breast. His spirit is focused elsewhere, on the vision of the Virgin who appears to receive him, and his heaving robes emblematize a soul in passionate ecstasy. The painting may be compared especially to Caravaggio's *Crucifixion of Saint Andrew* (cat. no. 99), in which the saint is shown at the outer limits of exhaustion and on the verge of death,

slipping into unconsciousness as his body collapses under its own weight. The physical experience of death is rendered with the same pathological clarity as the goiter on the neck of the woman looking on, and no vision of the eternal relieves Saint Andrew's suffering. Ludovico's Saint Peter Thomas dies an exemplary Christian death, and, in the painting, the visionary intensity of his faith is enhanced by a series of remarkable manipulations of scale. The disjunction, for example, between the foreground and the view of Bologna beyond makes the saint appear to hover in the air over the city, emphasizing his role as protector and intercessor; and the contrast between his size and the diminutive scale of the Virgin, so near to him yet so far from us, expresses the role of the saints in bringing together the hopes of the city with the promise of heaven. The latter contrast of scale reveals Ludovico's close study of the very similar manipulation of scale in Raphael's *Saint Cecilia* in Bologna, and it is part of a sequence of highly considered artistic strategies calculated to lead the viewer from a contemplation of particular events, represented with illusionistic verisimilitude, to an understanding of doctrinal or philosophical truth. Caravaggio paints the truth of individual experience. Around these two views of truth the artistic polemics of the coming century were to be fought.

C. D.

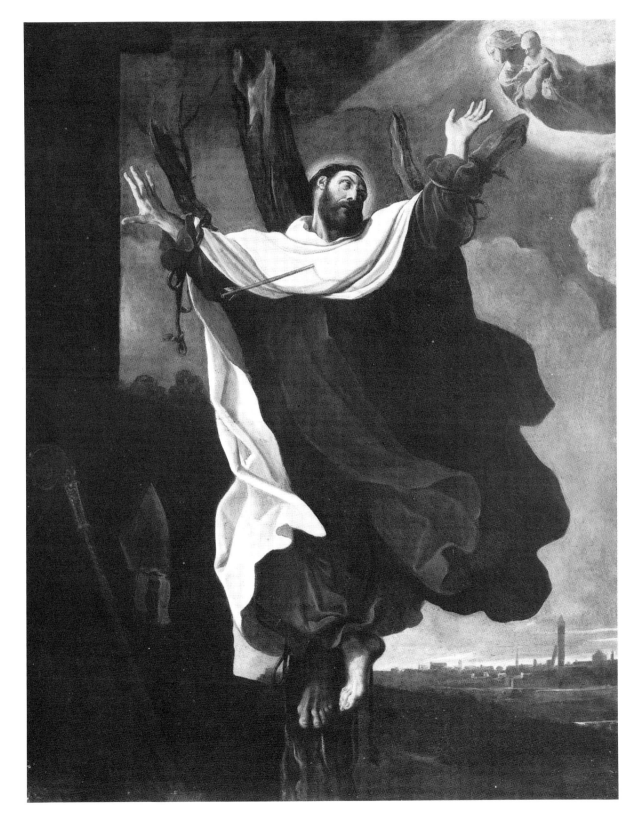

30. Saint Sebastian Thrown into the Cloaca Maxima

Oil on canvas, 65 3/4 x 91 3/4 in.
(167 x 233 cm.)
The J. Paul Getty Museum, Malibu

Saint Sebastian is conventionally shown pierced with arrows. He recovered from this attempted execution through the ministrations of Irene, whereupon Diocletian ordered that he be beaten to death and his body thrown into the Cloaca Maxima (this is the event shown here). The following night, the saint appeared in a dream to the Roman matron Lucina, told her where his body could be found, and requested that it be buried in the catacombs. She recovered the body from a drain called the Euripus Agrippae, alongside of which a church dedicated to the saint was later erected. It was razed in the sixteenth century for the construction of the Theatine church of Sant' Andrea della Valle. The Theatines were, however, obliged to perpetuate the cult of the saint by dedicating a chapel to him on the site of the former high altar. Since this site coincided with the position of the Barberini Chapel, Maffeo Barberini (later Urban VIII) became responsible for fulfilling the obligation. At the time he was papal legate to Bologna, and he commissioned the present picture from Ludovico for a subterranean chapel that he envisioned building beneath his family chapel (this was to prove impracticable). He refers to the commission in a letter of December 5, 1612, addressed to his brother Carlo in Rome: "I decided on a Saint Sebastian with regard to the Cloaca which is contiguous, and I had a Carracci here [in Bologna] make a painting of Saint Sebastian thrown into the Cloaca, but I shall keep this for my house because the light perhaps would not be suitable. . . . I would also prefer that Saint Sebastian be recovered from the Cloaca, because his being thrown in by the soldiers is a good representation of brute force [*forza*] but does not inspire very much devotion" (C. d'Onofrio, 1967, p. 419). Accordingly, Domenico Passignano, who had been charged with the decoration of the Barberini Chapel, was asked to paint Lucina recovering the body of Saint Sebastian from the Cloaca. Ludovico's *Saint Sebastian* en-

tered the Barberini collections, and is mentioned in four seventeenth-century Barberini inventories (M. Lavin, 1975, pp. 67, 207, 266, 403 ff.). In a highly interesting reference to the picture, Malvasia says that he owned a drawing (perhaps that now preserved in the Louvre, Inv. 7720) for a "Palinurus" by Ludovico in the Palazzo Barberini, "Which he made as a Saint Sebastian." Palinurus (*Aeneid* VI, 337 ff.), the helmsman of Aeneas, was overcome by Somnus and was washed overboard and brutally murdered by the Lucanians when he attempted to gain the shore. Like Sebastian, his body was contemptuously hurled into the water, and he, too, appeared in a vision to plead decent burial from Aeneas. Ludovico's invention thus begins by referring Sebastian to a classic exemplum of impiety (even as Palinurus himself invokes the unburied Elpenor in the *Odyssey*), for to the ancient or Christian mind nothing expressed greater contempt for religion than the denial of burial. It is Ludovico's characterization of the effects of impiety that accounts for the brutality of the work. While Maffeo Barberini admired this aspect of the painting, he nonetheless realized—in a manner typical of churchmen of the Counter-Reformation—that Lucina's pious recovery of the saint's body for burial was a more suitable subject for inspiring devotion than the subject he had originally commissioned. Although the brutal force of the executioners seems akin to such conceptions of Caravaggio's as the executioners in *The Flagellation of Christ* (cat. no. 92) or the gravediggers in *The Burial of Saint Lucy*, in fact the two painters started from radically different premises. Ludovico conceived the particular event in terms of the general virtue or vice it exemplified, which he then typified and abstracted through reference to canonical literary and artistic models. In the same way, Annibale Carracci's *Catanian Brothers* (in the Camerino Farnese) and Raphael's *Fire in the Borgo* (in the Vatican) both exemplify piety through metaphorical allusion to Aeneas saving his father Anchises from the flames of Troy. Caravaggio, by contrast, conceived the historical event from the point of view of a particular and individual experience; his *Beheading of Saint John the Baptist* (in Malta), for example, shows the violent and

pathetic death of a single, particularized human being with whose fate Caravaggio identified personally and psychologically, but not historically or morally—as expressed most poignantly in his macabre signature scrawled in the blood of the corpse. I am grateful to Gail Feigenbaum for sharing material from her recent dissertation with me.

C. D.

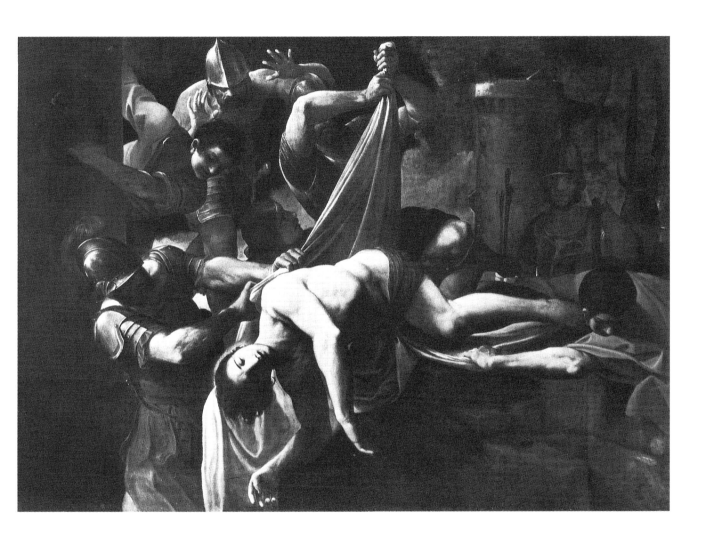

Bartolomeo Cavarozzi

According to Mancini (about 1617–21; 1956–57 ed., I, p. 256), Cavarozzi was born about 1590 in Viterbo, and as a child went to Rome, where he was first trained by the Viterbese painter Tarquinio Ligustri. Both Mancini and Baglione (1642, p. 186) state that he was raised, and lived for many years, in the household of the Marchese Virgilio Crescenzi so that he could study painting and drawing. Of Virgilio's six sons, it was Giovanni Battista Crescenzi (1577–1660) in particular who was the patron of Cavarozzi. Giovanni Battista was himself a painter (especially of still lifes), an architect, a collector and occasional art dealer, and, under Paul V, he was for some time "Superintendent of the Cappella Paolina in Santa Maria Maggiore . . . in charge of all construction and paintings" (Baglione). He also conducted famous academy of art (scuola di virtù) at his palace, which Cavarozzi attended, soon receiving the nickname Bartolomeo del Crescenzi. Only two dated or datable works by Cavarozzi are known: the early Saint Ursula, of 1608 (cat. no. 31), painted when Cavarozzi was working in the style of Cristoforo Roncalli (see cat. no. 53), and the Visitation, of 1622 (in the Palazzo Comunale in Viterbo), a work in his later, Caravaggesque style. Whether the young Cavarozzi was actually trained or merely influenced by Roncalli is not known. Certainly he was introduced to Roncalli's art, probably about 1605 (W. C. Kirwin, 1972, I, p. 199), by Giovanni Battista Crescenzi, who, according to Baglione, was a pupil of Roncalli's, as were his brothers. It is not known exactly when Cavarozzi changed his style (or, as Baglione put it, "cangiò gusto") and came under the influence of Caravaggio. Probably it developed concurrently with the new stylistic orientation of his mentor, Crescenzi—after Caravaggio's death in 1609 but before late 1617, when Cavarozzi accompanied Crescenzi to Spain, where Crescenzi had been invited to the court of Philip III to design the Pantheon of the Escorial. According to Baglione, Cavarozzi painted "many things" there; some paintings are thought to have been carried out in collaboration with Crescenzi (C. Volpe, 1973, pp. 25 ff.). In May 1619, both artists were back in Italy, where Crescenzi was to recruit artists to assist him with his work in Spain. When Crescenzi returned to Spain in 1620, Cavarozzi remained in Rome. He worked in both Viterbo and Rome, where he died in 1625 at the age of about thirty-five. The very smooth, lyrical style of his later, Caravaggesque phase was influenced by Gentileschi. Some of his paintings also show affinities with the work of the Genoese Domenico Fiasella, whom Cavarozzi could have met in Rome in 1615 or, according to Longhi, in Genoa in 1617 (R. Longhi, 1943 a, p. 31, no. 69; I. Faldi, 1970, p. 56; P. Torriti, 1971, II, p. 25).

31. Saint Ursula with Her Companions, Pope Cyriacus, and Saint Catherine of Alexandria

Oil on canvas, 110 1/4 x 86 5/8 in. (280 x 220 cm.)
Inscribed (at bottom): AVRELIVS. LVPATELLIVS. PERVSINVS. FIERI. FECIT. ANNO. DNI. M. DC. VIII. (Aurelio Lupatelli of Perugia had [this] made in the year of our Lord 1608)
San Marco, Rome

The picture was correctly identified by I. Toesca (1960, pp. 57 f.) with the high altarpiece of the church of Sant' Orsola in the Piazza del Popolo between the Corso and the Via di Ripetta (on the site now occupied by Santa Maria dei Miracoli). Baglione (1642, p. 187) describes it as follows: "In the church of Sant' Orsola in the Piazza of the Madonna del Popolo, where there is a company of secular brothers with red habits, [Cavarozzi] represented . . . the figures of Saint Ursula and her eleven thousand virgins." The "company of secular brothers" was the Confraternita delle Sante Orsola e Caterina, founded in 1599 in the church of Santa Maria della Pietà dei Pazzarelli in the Piazza Colonna. The confraternity purchased the site in the Piazza del Popolo in 1606, and moved into the newly completed church in 1608 (O. Panciroli, 1625, pp. 457 f.; [F. de Rossi], 1727, p. 576; I. Toesca, 1957, p. 44; C. Pietrangeli, 1975, pp. 58 ff.). The painting was commissioned by Aurelio Lupatelli of Perugia, probably a member of the confraternity; his name, in consequence, is inscribed on the picture. In 1658, Alexander VII initiated plans for two new churches in the Piazza del Popolo, Santa Maria di Monte Santo and Santa Maria dei Miracoli. Carlo Rainaldi's design for them was approved in 1661, and the confraternity was transferred to San Nicola de' Funari a Tor de' Specchi (a church affiliated with San Marco), which, upon its remodeling in 1663, was called Sante Orsola e Caterina (W. Buchowiecki, 1970, pp. 745 ff.; D. Angeli, 1903, p. 437). However, the altarpiece is described by Alveri (1664, II, p. 43) as being in the old church in the Piazza del Popolo, since that building was demolished only sometime after 1667 to make way for Santa Maria dei

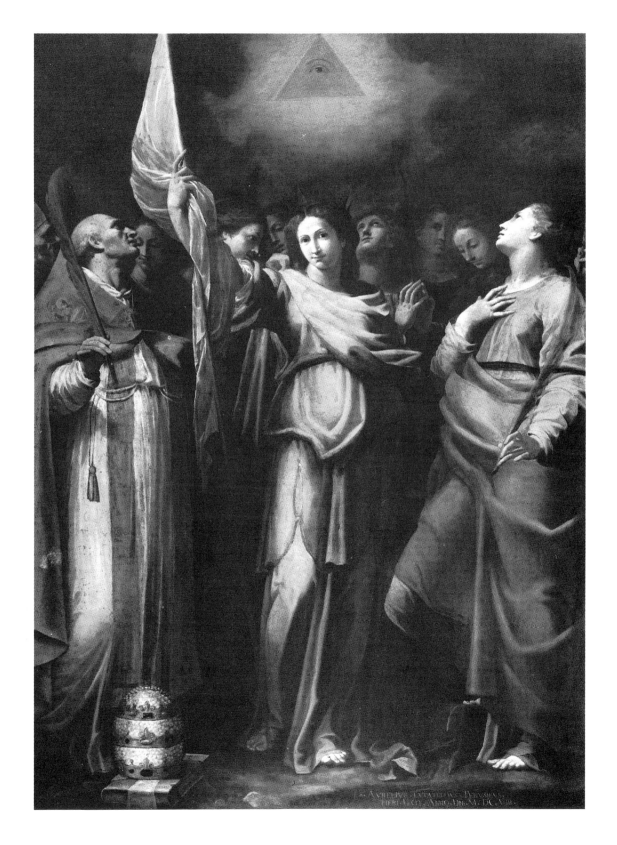

Miracoli. Alveri transcribed not only the inscription still legible on the painting but also one "above the said altar" with a dedication to "Divae Ursulae et Catharinae dicatum." In the confraternity's new church, the picture may have had to have been placed initially on the high altar, but eventually (after the redecoration, of 1745–47?) it was placed on the left side altar (D. Angeli, 1903, p. 437; C. Pietrangeli, 1975, p. 60); it was transferred to San Marco following the destruction of Sante Orsola e Caterina in 1929.

Saint Ursula, at the center, is flanked by Pope Cyriacus on the left and a female saint on the right, whom Toesca (1957, p. 44, n. 6, 1960, p. 58) plausibly identifies as Saint Catherine of Alexandria. (D. Angeli's, 1903, p. 437, and C. Pietrangeli's, 1975, p. 60, identification of her as the Dominican Saint Catherine of Siena is not tenable.) She wears a crown and holds the palm branch of a martyr in her left hand. It is not clear whether the object on which she sets her right foot is a fragment of her traditional wheel.

The symmetrical composition, with the strictly frontal pose of Saint Ursula, has justly been compared to its immediate model, Roncalli's altarpiece of Saint Domitilla, flanked by Saints Nereo and Achilleo, in Cardinal Baronio's church, Santi Nereo e Achilleo (1596–99; see cat. no. 53; I. Toesca, 1960, p. 58; W. C. Kirwin, 1972, p. 398; I. Chiappini di Sorio, 1983, p. 123). The prototype of Roncalli's picture was Raphael's *Saint Cecilia* in the Pinacoteca Nazionale, Bologna (P. Pouncey, 1952, p. 356; I. Toesca, in Attività . . . , 1969, p. 25; W. C. Kirwin, 1972, pp. 397 f.), which was also a direct model for Cavarozzi's altarpiece (A. E. Pérez Sánchez, 1964, p. 21). Cavarozzi could have known the composition through prints by Marcantonio Raimondi and Giulio Bonasone or through Reni's painted copy now in San Luigi dei Francesi, Rome. Cavarozzi's altarpiece, in fact, owes less to Roncalli's than to Raphael's, with its more rigid frontality. In Roncalli's painting, the two male saints at either side stand slightly more in the background, although equally parallel to the picture plane. In Cavarozzi's painting, the impression of a semicircle is produced by the secondary figures behind Saint Ursula. The two figures of Pope Cyriacus and Saint Catherine, strongly lighted and modeled, are separated from Saint Ursula by dark intervals of space. The other figures in the background, a bishop and six virgins, form a semicircular chain that links together the two figures on the sides.

Baglione's statement (1642, p. 187) that in this picture Cavarozzi was an imitator of Roncalli's style needs some qualification. Compared to the style of Roncalli's altarpiece of 1599, Cavarozzi's is obviously more advanced. The statuesque monumentality of Roncalli's late-Mannerist figure style and the static rigidity of his composition have been suppressed. Although the influence of Caravaggio is not visible in Cavarozzi's painting, some of the lyrical sweetness of his later Caravaggesque style can already be detected in the smooth modeling of the faces, in the softly flowing draperies, and in the chiaroscuro atmosphere, which at once separates the groups of figures and unifies the pictorial space. Toesca (1960, p. 58) was probably correct in seeing the influence of Reni in these features of Cavarozzi's early style.

While, in 1608, Cavarozzi retained the symmetrical frontal display of Raphael's and Roncalli's prototypes, which, shortly before had appealed also to Rubens (see cat. no. 55), fifteen years later this type of composition had become obsolete. Lanfranco abandoned it in his altarpiece of about 1623 for Santa Marta in Vaticano (now the property of an English private collection, on loan to the Picker Art Gallery, Colgate University, Hamilton, New York; see E. van Schaack, 1984, pp. 18 f., who gives too early a date). Lanfranco's Saint Ursula, who also holds a banner, is shown in an oblique position, stepping slightly forward.

E. S.

Giuseppe Cesari
called
the Cavaliere d'Arpino

Giuseppe Cesari was born in Arpino in 1568 into a family of painters (his father painted ex-votos and his younger brother was also an artist). He arrived in Rome in 1582, where he began work under the direction of Nicolò Circignani (Pomarancio) in the Logge of the Vatican. The following year, he was occupied with the decoration of the Sala Vecchia degli Svizzeri and the Sala dei Palafrenieri at the Vatican, and in 1586, in recognition of his precocious talents, he was admitted to the Confraternita dei Virtuosi del Pantheon. Thereafter began an extremely active career and a succession of works that included a fresco cycle for San Lorenzo in Damaso, Rome (in 1588–89; later destroyed); work for the Certosa di San Martino, Naples (in 1589, and 1596–97); the commission, in 1591, for the decoration of the Contarelli Chapel in San Luigi dei Francesi (Arpino completed only the vault in 1593, while Caravaggio later decorated the walls with his three canvases of the story of Saint Matthew); the decoration of the Olgiati Chapel in Santa Prassede, Rome (from 1593 to 1595); decorations (begun in 1595 and completed only in 1640) for the Palazzo dei Conservatori on the Capitoline; the direction of the decoration of the transept of San Giovanni in Laterano (from 1599 to 1601), for which Clement VIII made Arpino Cavaliere di Cristo; designs for the mosaics of the cupola of Saint Peter's (from 1603 to 1612); and the direction of the decoration of the Cappella Paolina in Santa Maria Maggiore (from 1610 to 1612). Indeed, under Clement VIII (1592–1605), the Cavaliere d'Arpino became the preeminent exponent of ceremonial and history painting in Rome. He was elected Principe of the Accademia di San Luca three times (in 1599, 1615, and 1629), and in 1630 Louis XIII granted him the cross of the order of Saint Michael. "Loved by princes and great personages" (Baglione, 1642, p. 374), he died in 1640.

Arpino's art, with its grace and its sentimental, erotic tendencies, is midway between Mannerism and Baroque, while, at the same time, it is representative of the sort of ceremonial history painting favored during the papacy of Clement VIII. The artist's predilection for symmetry and order is the most significant visual counterpart to a society that was itself based on a rigorous principle of order. Although he lived until 1640, Arpino was isolated from the developing Early Baroque, and after 1610 his work shows an increasing hardness. His reputation—at its height about 1600—suffered a corresponding eclipse. According to Bellori, Arpino paid no attention to nature and his art represented the extremes of fantasy. Perhaps the harshest censure is that of Adolfo Venturi (1932, pp. 923 ff.). However, during the last thirty years Arpino has been the subject of renewed interest.

In 1593, Caravaggio probably spent eight months in Arpino's workshop where, according to Bellori, he primarily painted flowers and fruits in the master's compositions (cat. no. 34). Later relations between the two were very strained. In the libel suit of 1603 Caravaggio stated that he was not on speaking terms with Arpino, although he considered him a "valenthuomo" (a good painter). The contrast between the two has certainly been exaggerated, and Arpino's influence on Caravaggio is evident (H. Röttgen, 1974).

32. Saint Lawrence Among the Poor and Infirm

Oil on canvas, 24 1/4 x 29 1/8 in. (61.5 x 74 cm.) E. V. Thaw and Co., Inc., New York

The picture, which was attributed to Joos van Winghe until Philip Pouncey recognized its true author, is one of Arpino's earliest extant small-scale pictures. Painted when the artist was twenty years old, it is a *modello* for one of the two large frescoes on the right wall of the nave of San Lorenzo in Damaso, Rome, which were destroyed in the nineteenth century. Early sources describe scenes by Arpino of "Saint Lawrence among the poor and the sick" and "Saint Lawrence accompanying Saint Sixtus to his martyrdom." On the other walls were frescoes by Nicolò Circignani and Giovanni de' Vecchi. The scenes, measuring seven to eight meters in width and painted to resemble wall hangings, were commissioned by Cardinal Alessandro Farnese and carried out between 1588 and the summer of 1589—prior to Arpino's commission on June 28, 1589, for the frescoes in the choir of the Certosa di San Martino, Naples. The scene nearest the high altar, to which the present picture is related, was the first to be completed, in 1588. Both scenes are known through copies carried out in Arpino's workshop (Ludovisi Boncompagni collection, Rome: see H. Röttgen, 1973, pp. 68 ff.). The only significant difference between the *modello* and the final composition is that the man at the left was naked in the *modello* and partly clothed in the fresco, in accordance with the proscriptions of the Council of Trent. A similar figure recurs in Caravaggio's *Seven Acts of Mercy* in the Pio Monte della Misericordia, Naples.

Four episodes from the saint's legend are represented in the picture: At the right, Saint Lawrence relieves the widow Cyriaca of headaches; at the center, a blind man—shown with a cane—is healed through baptism, and the feet of the poor are washed; at the left, those officials of the state who wished to confiscate the goods of the church are shown the poor and the sick and told that these represent the church's treasure (*Legenda Aurea* CXII; *Acta Sanctorum, augusti II*, 1735, pp. 485 ff.). The

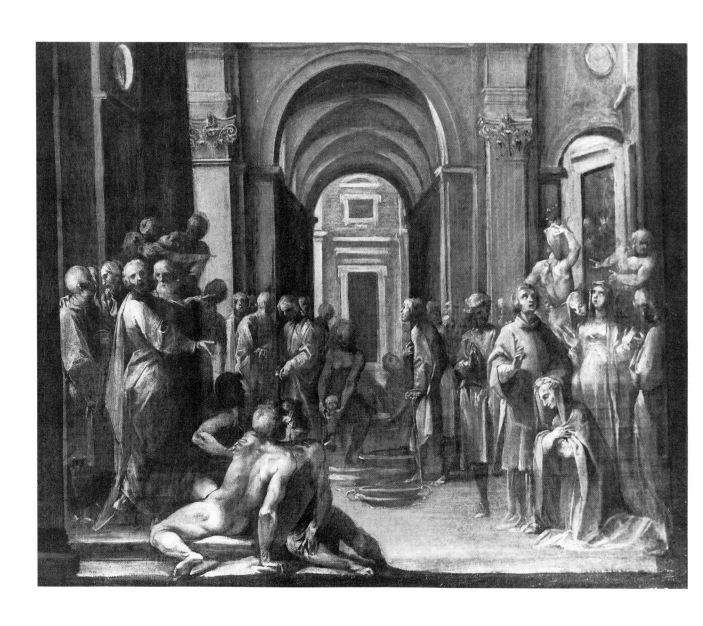

central figure at the left appears especially impressed by the saint's benediction and prayer. The composition is based on Raphael's *School of Athens* fresco in the Vatican. However, it has fewer figures and emphasizes the symmetrical arrangement of the groups with fewer prominent protagonists. Through a process of empathy the viewer participates in the scene, where the protagonist appears supported by a chorus. When Arpino undertook this work, his first major public commission, he may have had in mind Fra Angelico's fresco cycle of Saint Lawrence in the Chapel of Nicholas V in the Vatican. But the decisive factor was the example of the painters of the Catholic Reformation in the years around 1580—those artists who opposed the artistic license and intricacies of the Mannerists with the clarity, compactness, and symmetry of their compositions. Girolamo Muziano's work was especially important for Arpino, and Caravaggio's first composition for the *Martyrdom of Saint Matthew* (1599), in the Contarelli Chapel of San Luigi dei Francesi, Rome—which was laid out directly on the canvas and is known through X-rays—reveals that the same sort of compositions were important to him as well (H. Röttgen, 1974). What is at issue is the ceremonial style of history painting at the end of the sixteenth century (H. Röttgen, 1968, pp. 71 ff., 78 f.)—something that inspired even Guido Reni (H. Röttgen, 1973, pp. 68 ff.). The elongated figures, the luminous, transparent surfaces, and the elegant, faceted drapery folds of this masterly picture forecast the frescoes in the choir of San Martino, Naples, and reveal a tendency to idealization and spirituality. At the same time, there is a sensuous charm resembling the airy, vibrant work of Francesco Vanni. In the final analysis, this quality derives from the paintings of Beccafumi, Barocci, and Andrea Lilio. In the *Schilder-Boeck*, published in 1604, Carel van Mander described the frescoes as follows: "In these works one admires an ingenious handling of composition, a forcefulness of expression, and grace in the posing of the figures . . . whereby Arpino achieved fame and admiration." Even Bellori, who had a negative opinion of Arpino's work, wrote in the margin of his copy of Baglione's *Vite* that these frescoes were "very extravagant, but

also beautifully expressive" ("hanno una bella furia": see H. Röttgen, 1973, p. 71). The present picture was in the collections of D. A. Hoogendijk, Amsterdam, and Dr. E. Schapiro, London. It was exhibited as a work by Joos van Winghe both in Amsterdam in 1955 ("De trionf van het Manierisme") and in Rome in 1973 ("Il Cavalier d'Arpino," Palazzo Venezia). A study for the figures at the left is preserved in a drawing in the Fitzwilliam Museum, Cambridge.

H. R.

33. The Raising of Lazarus

Oil on canvas, 29 5/16 x 38 5/8 in.
(76 x 98 cm.)
Galleria Nazionale d'Arte Antica,
Palazzo Barberini, Rome

The painting dates from about 1593, and is contemporary with Arpino's frescoes in the Contarelli Chapel in San Luigi dei Francesi (H. Röttgen, 1973, p. 77, no. 9). Typical of Arpino's style at this time is the agitated, nervous, painterly treatment of the heads of the bystanders and of that of Lazarus. The figure of Mary Magdalen bears comparison with the same saint in the *Crucifixion* from San Martino, Naples; in both cases, her silhouette is clearly derived from the work of Federico Barocci (the *Noli me tangere,* of 1590, in the Uffizi, for example). As in the San Martino *Crucifixion*, the substantial, but finely faceted folds of the drapery are striking. The warm colors emphasize the tonal values, and their fluidity and freshness reveal a painterly style that Italo Faldi (1953, p. 54) related to Ludovico Mazzolino and to Scarsellino, arguing for a later date for the picture—about 1598. The almost exclusive reliance on color and light in painting was unusual in Rome. However, the faces of the apostles still show traces of Arpino's Sienese-Urbinate manner of about 1588/91, and the close affinity of the painting to the work of Francesco Vanni, with whom Arpino had much in common, supports an earlier dating.

Spear (1965, pp. 65 ff.) traced the composition to Cornelis Cort's engraving (Le Bl. 61) after Federico Zuccari's fresco in the Grimani Chapel in San Francesco della Vigna, Venice, and he has pointed out that Caravaggio's treatment of the subject also was influenced by such features in Arpino's pictures as the naked Lazarus—his arm stretched out toward Christ with his hand in the center of the picture, and his head turned upward rather than toward Jesus— and by the man with the tomb slab. In contrast to Zuccari and to Caravaggio, Arpino organized his composition with a rigorous symmetry quite in keeping with his own basic predilection for systematization: There are few protagonists, and the numerous spectators are grouped to either side. By contrast, Caravaggio placed Lazarus at

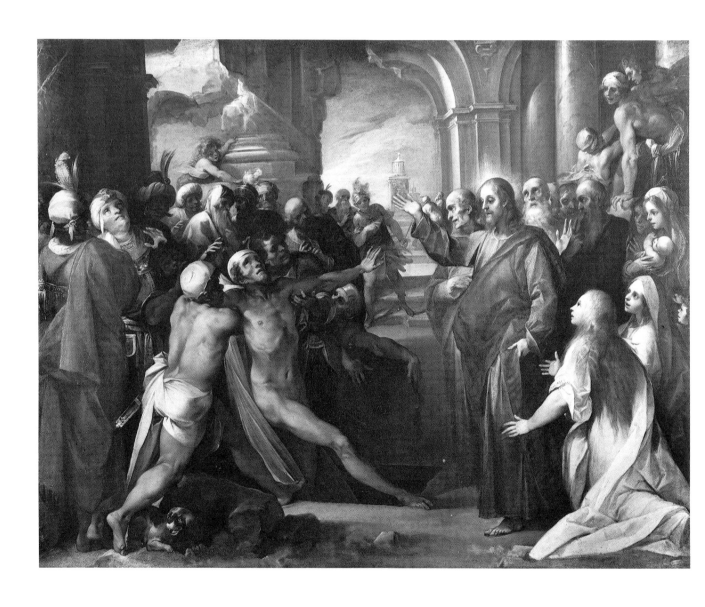

the center of his painting (H. Röttgen, 1974, pp. 100 f., 213 ff.). Arpino shows Lazarus, miraculously awakened, raising himself toward Christ with an almost ballet-like elegance, while Caravaggio's Lazarus is suspended between death and resurrection, and appears as though nailed in a cruciform position. Arpino's painting dispenses with all such subtleties. Rather, it is a typical example of the grand, epic style of history painting in which the action of a large yet ceremoniously well-ordered group of figures constitutes the expressive focus. This style developed in the 1590s, and was especially favored by the Church for the vast artistic undertakings in preparation for the Holy Year celebrations of 1600 (H. Röttgen, 1968, pp. 71 ff.). Arpino's typically systematic compositions made him one of the protagonists of Roman painting.

An earlier drawing of the subject, dating from about 1588/89, is in the Ashmolean Museum, Oxford (H. Röttgen, 1973, p. 149, no. 77); another, vertical in format, is in the Kupferstichkabinett of the Staatliche Museen, Berlin-Dahlem (K.d.Z. 15273). Replicas and copies of the painting are also known (H. Röttgen, 1973, p. 78).

H. R.

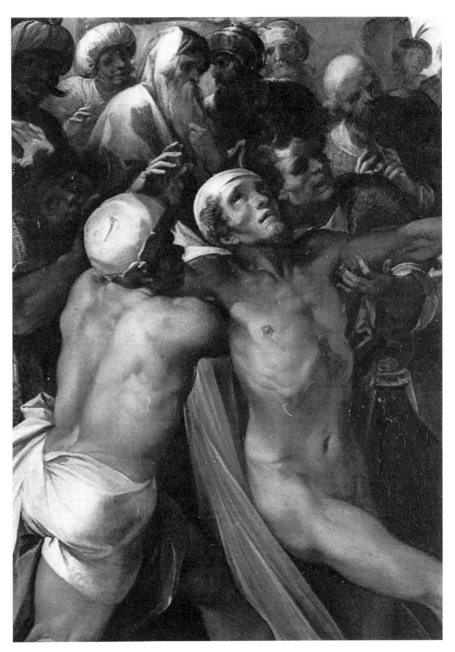

34. Saint Francis Consoled by an Angel Playing the Violin

Oil on canvas, 106 5/16 x 78 in.
(270 x 198 cm.)
Musée de la Chartreuse, Douai

This is one of the Cavaliere d'Arpino's most characteristic works from the time of his greatest artistic mastery and the period (about 1593) when Caravaggio spent eight months working in his studio. The tones are predominantly cool: gray, brown, blue, white, and violet. Particularly effective is the angel, with his white and violet drapery; set off against the blue sky and the yellow aureole, he contrasts pleasingly with the neutral colors of the saint. The combination of mystical asceticism and the sensuality of the vision may seem ambivalent to the modern viewer; certainly, the comparison with Caravaggio's *Stigmatization of Saint Francis* (cat. no. 68) is particularly striking. Whereas Arpino exalts the religious and sentimental aspects of the theme, Caravaggio describes the psychic experience of the unconscious saint with an intimate realism. Thus, we are presented with two different possibilities for the depiction of the mystical union of a saint with the object of his vision: on the one hand, an outwardly directed, theatrical pathos, and, on the other hand, an inner-directed portrayal of the body undergoing a spiritual experience. Yet, Caravaggio could doubtless have learned a great deal from the painterly qualities and naturalistic rendering of Arpino's picture, especially from the anatomy of the angel, which bears comparison with the *Bacchino Malato* and the *Boy with a Basket of Fruit* (cat. no. 66).

Mancini reports that Caravaggio painted the foliage in some of Arpino's pictures, but it would be difficult to determine in which. Still, the lushly painted leaves, with their broad yellow highlights, are certainly conceivable as by the hand of Caravaggio. The *Saint Francis* dates from the years in which Arpino's work exhibits its richest chromatic development and sensual brilliance. The angel recalls those in Arpino's paintings, of 1593–95, in the Olgiati Chapel in Santa Prassede, Rome, thus providing an approximate date for the Douai painting.

The picture was once in the Torlonia collection, Rome, and was acquired for the museum in Douai from Colnaghi, London, in 1964. A number of paintings among the Torlonia possessions at the Villa Albani were selected for confiscation by the French about 1797, and the "Terza nota" in the Biblioteca Vaticana (*Fondo Ferraioli* 969) lists a "S. Francesco che dorme, con un Angelo che suona il violino. Conventuali di Fano" (a Saint Francis who sleeps, with an angel playing the violin. Conventuals of Fano) [noted by Steffi Röttgen]. It is highly probable that the present picture is identical with this one, which formerly belonged to the Minorites in Fano. (The description of Saint Francis as asleep should not be taken as accurate, especially since, iconographically, it would be unusual.) As is known from other sources, Arpino had close ties with Fano.

The iconography of the Douai painting was widespread in the late sixteenth century. This was as a result of the heightened interest in Saint Francis—who had contributed to the renewal of the Church in the thirteenth century—that accompanied the Catholic reform, and of the new importance accorded the mystical and the visionary during the second half of the sixteenth century. The theme of the present picture was also the subject of paintings or drawings by Francesco Vanni, Cigoli, Antonio Tempesta, Annibale Carracci, and Lanfranco, and of an engraving by Agostino Carracci (H. Röttgen, 1973, p. 83 f., no. 14).

H. R.

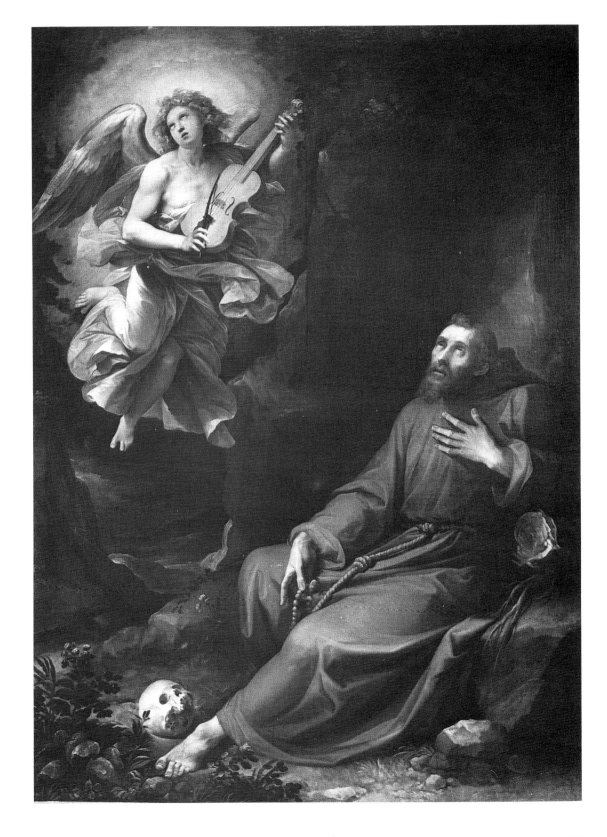

Ludovico Cardi
called Il Cigoli

Born September 21, 1559, in Castello di Cigoli near San Miniato al Tedesco, Cigoli was the major innovator in Florence in the last decades of the sixteenth century. With Gregorio Pagani and with Passignano, he led the way from the overzealous admiration of Michelangelo by such Florentine Mannerist artists as his own teacher Alessandro Allori, to a new, more believable and persuasive style based on a study of nature, a use of color largely inspired by Correggio, and the harmonious compositions of the High Renaissance. Baglione remarked on Cigoli's interest in the work of Andrea del Sarto, and Cigoli's principal biographer, Baldinucci, considered him a Florentine Titian and Correggio. Indeed, after the surprisingly proto-Baroque Saint Peter Martyr *and the* Martyrdom of Saint Stephen *(of 1597), Cigoli's paintings display an almost Renaissance sense of balanced composition. His "bella e leggiadra maniera"—as his nephew G. B. Cardi described it—was adopted by his followers Cristofano Allori and Giovanni Biliverti, and was a determining factor in the development of Florentine Baroque painting.*

Cigoli played an important role in Rome, although loss or damage to his principal works there makes it difficult to document his specific contribution. He was in the city from April to late July 1604, from May 1606 to mid-1607, and again from late 1608 until his death on June 8, 1613, and he received some of the most important commissions of the period: He painted the altarpiece of Saint Peter Healing the Cripple *(of 1604–6) in Saint Peter's, and* The Burial of Saint Paul *(begun in 1609), for the high altar of San Paolo; was responsible for designs for the elaborate funeral of Ferdinando I de' Medici in San Giovanni dei Fiorentini, and for the renovation of the Palazzo Firenze; frescoed the cupola of the Cappella Paolina in Santa Maria Maggiore; and decorated the Loggia di Psiche at the Borghese villa on the Quirinale. As a protégé of the Grand Duke of Tuscany, he was given lodgings in the Villa Medici and had access to the leading intellectual and artistic circles of Rome. In addition to his contacts with the most important collectors, he knew the physician-art amateur, Giulio Mancini, the theorist Monsignor Giovanni Battista Agucchi, and Galileo, whom he assisted with the newly perfected telescope*

and honored by including the first moonscape in his depiction of the Immaculate Conception (in the Cappella Paolina). He is known to have collaborated with Annibale Carracci on one occasion, and he also worked with Giovanni Baglione. He delivered a lecture at the Accademia di San Luca on the importance for painters of a foundation in disegno.

Intellectually and artistically Cigoli was Caravaggio's opposite, and his association with the Lombard was almost involuntary. "He would accompany Passignano and Caravaggio to the taverns in order not to criticize the actions of the former or suffer the persecutions and very strange mind of the latter," reports Baldinucci (1681–1728; 1846 ed., III, p. 277). Despite their cool personal relationship, artistic exchange between Caravaggio and Cigoli is evident, at least in the latter's work.

35. Ecce Homo

*Oil on canvas, 68 7/8 x 53 3/8 in.
(175 x 135.5 cm.)
Galleria Palatina, Palazzo Pitti, Florence*

The *Ecce Homo* is Cigoli's one commission directly connected with Caravaggio, and the principal instance of artistic exchange between these two very singular artists. The story of the commission as told by Baldinucci (1681–1728; 1846 ed., III, pp. 266 f.) is based on the account by Cigoli's nephew, G. B. Cardi (A. Matteoli, 1980, p. 31), according to which a Monsignor Massimi set up a competition between Caravaggio, Passignano, and Cigoli in such a manner that none knew of the others' involvement. Massimi kept Cigoli's picture for himself and gave the two remaining ones away; according to Bellori, Caravaggio's painting was sent to Spain. Longhi has recognized Caravaggio's picture (cat. no. 25), but Passignano's is lost (J. Nissman 1979 a, no. 55)—although Matteoli (1980, no. 29) has attempted to identify it.

Cigoli's painting, long regarded as one of his major works, is the key to the history of this "competition." The provenance of the *Ecce Homo* begins with Massimi. Later, the painting belonged to the musician G. B. Severi, and, at the time of Cardi's account (about 1628), to the Medici; it may be the picture described in 1621 among the effects of Don Antonio de' Medici (M. Chappell, 1981 a, p. 65). The "competition" is generally regarded as having taken place between April 1604, when Cigoli arrived in Rome for four months, and late May 1606, when Caravaggio fled the city (M. Cinotti, 1983, p. 439). A date of 1606 is often proposed (G. Cantelli, 1983, p. 33) although the most precise dating would be between April and July 1604, when Cigoli was in Rome and all three artists could have participated in the contest contemporaneously (M. Chappell, 1971, p. 21, n. 8 a). The *Ecce Homo* would seem to be one of Cigoli's first Roman works. The artist—perhaps filled with new artistic impressions—here combined Caravaggio's selective lighting, verism, the spatial device of the proximity of forms to the viewer, and the use of engaging gazes with his Florentine sense of harmonious design, refined color, and ennobled expression.

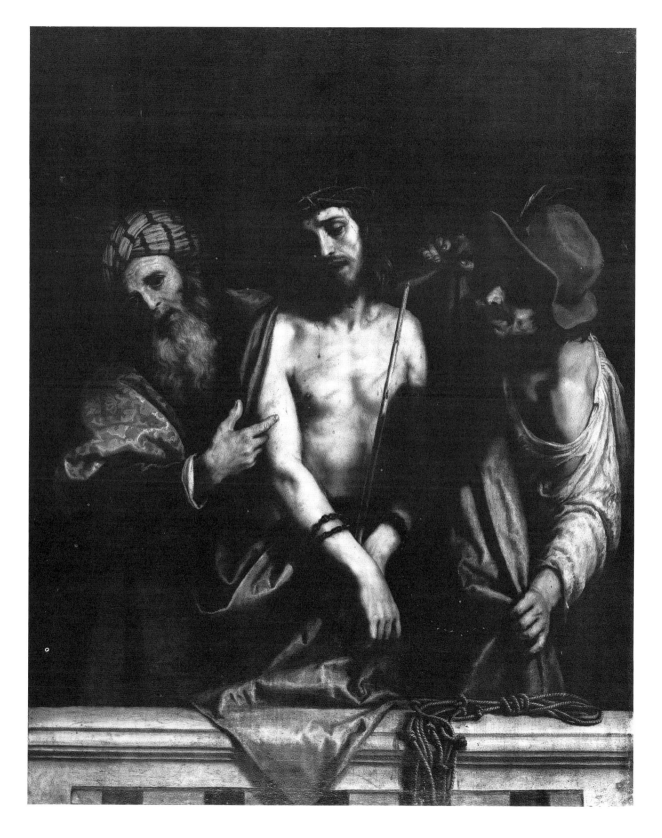

In contrast to Caravaggio, Cigoli placed great value on the Florentine tradition of elaborate preparatory studies. A drawing in the Louvre (inv. 915) combines rapid pen sketches for the figures with a preparatory compositional study making free use of washes to establish the light and dark areas (R. Bacou and J. Bean, 1958, no. 27). In an unpublished cartoon, squared for transfer, which has recently appeared on the art market (Hôtel Drouot, Paris, November 6, 1980, no. 136), the light and atmosphere that play a particularly expressive role in this painting are carefully defined by the pen line and the use of brown wash. The play of light and color was particularly important to Cigoli—especially in this painting, where he was attempting to surpass Caravaggio with his own version of Lombard color. Cigoli's avowed idol was Correggio, whom he called the "maestro del colore." Correggio's works exemplified Lombard color to such writers as Baldinucci—according to whom Cigoli's goal was to rival Correggio's Ecce Homo. Indeed, Cigoli's centralized composition with half-length figures owes much to Correggio—or to Agostino Carracci's engraving of Correggio's composition.

The immediacy of the figures in Cigoli's painting—the jailer lost in thought, the remorseful Pilate, and the Christ—is enhanced by the raking light, which creates a strong contrast with the atmospheric background where the soldiers are shown. This delight in perfected form and refined color could be considered Cigoli's Florentine alternative to the various tendencies toward realism, classicism, and nascent Baroque expressionism in Rome. Cigoli's pictorial, or Baroque, lyricism is perhaps the reason that he won the competition, and his lessons were not lost on Caravaggio. The balanced grouping of the figures, their eloquent gestures, and the manner in which those that are subordinate fill the background contributed to Caravaggio's late vocabulary of compressed yet structured relief-like scenes. Both The Raising of Lazarus and The Burial of Saint Lucy seem to reflect Caravaggio's own interest in disegno.

That Cigoli's painting was admired is proven by the numerous extant copies (M. Bucci, 1959, no. 33) and by its influence on Cigoli's contemporaries—such as the young Rubens (M. Jaffé, 1977, p. 51)—and on his pupils and followers. Giovanni Biliverti, who accompanied Cigoli to Rome in 1604, did a number of drawings of the Ecce Homo (M. Chappell, 1979, nos. 116–119). Domenico Fetti and Sigismondo Coccapani both treated the subject in a Cigolesque manner (E. Borea, 1970, no. 63), and Jacopo Vignali and Carlo Dolci (the latter painted a particularly derivative Christ as the Man of Sorrows) imitated Cigoli's transposition of Caravaggesque devices into the refined key that is typical of Florentine Baroque painting.

M. C.

Domenico Zampieri
called Domenichino

Born in Bologna in 1581, Domenichino ("little Domenico") first studied the humanities before joining the studio of Denys Calvaert. About 1595, he transferred to the Carracci's Accademia degli Incamminati, where Ludovico became his primary teacher; along with a crucial emphasis on drawing as the foundation of art, he received important education in such fields as theory, music, and architecture, all of which he continued to pursue seriously for the rest of his life. In 1602, he moved to Rome, and shortly after won the support of the Agucchi brothers: first, of Giovanni Battista, who was to become one of his principal advocates and whose Treatise on Painting, *the seminal statement of classic-idealist art theory, reflects Domenichino's own ideas on art; and second, of Cardinal Girolamo, who mistook Domenichino's dramatically lit* Liberation of Saint Peter from Prison *(of 1604) for a work by Annibale, which indicates that, at the time, intense chiaroscuro was not necessarily equated with a Caravaggesque style (Domenichino's own sources were Raphael, and Ludovico Carracci). During this formative period, which corresponds with Caravaggio's final years in Rome, Domenichino collaborated on the completion of the frescoes in the Galleria Farnese, learning there Annibale Carracci's working procedures of beginning with a compositional sketch that was developed by way of numerous life studies to a finished full-scale cartoon—a kind of methodical preparation that was entirely antithetical to Caravaggio's preference for working* alla prima.

Domenichino's first independent commissions were frescoes for a garden loggia at the Palazzo Farnese (1603–4) and for Sant'Onofrio (1604–5); at the time that Caravaggio fled from Rome (1606), Domenichino was working in the Palazzo Mattei with Albani, Lanfranco, and other young painters from the Carracci circle. Domenichino emerged as Annibale's "favorite," and it was through Annibale's persuasion that Cardinal Odoardo Farnese hired Domenichino rather than Lanfranco to decorate the chapel of Saint Nilus at the Abbey of Grottaferrata, near Rome (in 1608–10); Guido Reni subcontracted Domenichino to paint the Flagellation of Saint Andrew *in the Borghese-sponsored chapel adjacent to San Gregorio Magno, Rome (in 1608–9); and Albani probably was responsible for securing him a share in decorating the Odescalchi villa at Bassano di Sutri (1609).*

Thus, although occupied during the final years of the decade, Domenichino did not establish an independent reputation until after Annibale's and Caravaggio's deaths (in 1609 and 1610, respectively). This he achieved through the decoration of the Polet Chapel (1612–15) in San Luigi dei Francesi (the church in which Caravaggio had worked fifteen years earlier), a paradigm of neo-Raphaelesque "baroque classicism" and arguably Domenichino's masterpiece; and through his first Roman altarpiece, the Last Communion of Saint Jerome *(signed and dated 1614). Domenichino left Rome in 1617 to decorate the Nolfi Chapel in the cathedral of Fano and then settled in Bologna, where he painted some of his largest and most important altarpieces. Upon the election of his compatriot, Alessandro Ludovisi, to the papacy (Gregory XV, 1621–23), Domenichino returned to Rome, where he served as Papal Architect while beginning his most extensive Roman fresco cycle, the* Four Evangelists *(of 1622–25) and* Scenes from the Life of Saint Andrew *(of 1622–27) in Sant'Andrea della Valle. In 1625, he received his only commission for Saint Peter's. At the end of the decade, having completed or begun other projects in various Roman churches (plus a large* Saint John the Evangelist *that Caravaggio's celebrated patron, Vincenzo Giustiniani, owned and may have commissioned as part of a series of Evangelists to complement Caravaggio's "first"* Saint Matthew), *Domenichino moved to Naples to decorate the city's most prestigious chapel, the Treasury of San Gennaro at the Cathedral. There he was constantly tormented by jealous local artists; by resistance to his chilly, classicizing style from Ribera and his quasi-Caravaggesque circle; and by pressure to work for the Viceroy of Naples. He nevertheless managed to complete nearly all of the frescoes and altarpieces for the chapel before he died in 1641, perhaps from poison. Unlike Caravaggio, Domenichino was retiring by nature, deliberative, a family man, and bookish. He believed that the most significant stage of art-making resides in perfecting the* invenzione *— or the imaginative conception of the work—first in the mind and then through drawings; and that the ultimate end of art-making is the ordered depiction of themes of moral significance that, through rational as well as sensory processes, elevate the soul of the beholder.*

36. Christ at the Column

Oil on canvas, 81 1/2 x 40 1/8 in.
(200.7 x 100.2 cm.)
Dated (lower left): M.CIII
Private collection

Emphatically incarnate, yet spiritually absorbed, Christ is shown bound to the short column that allegedly was used for his flagellation. Ever since the thirteenth century, the column at the monastery of Santa Prassede, Rome, has been venerated, although it was not commonly represented in art until the late sixteenth century, when the Church put new emphasis on the importance of authentic relics (É. Mâle, 1932, pp. 262–67). Domenichino painted this picture in 1603, while he lived with his compatriots Guido Reni and Francesco Albani at Santa Prassede (see R. Spear, 1982, pp. 129–30, no. 7, for the painting's provenance and attribution); the arrangements for the quarters that the young artists shared were made by Cardinal Sfondrato. Reni also depicted Christ isolated from his tormentors, and tied to the same short column, in a picture (now in Frankfurt) probably painted for Sfondrato himself in the autumn of the following year. Rejecting the traditional conception of the scene as one of physical and mental punishment—as is the *Flagellation* (at Santa Prassede) attributed to Giulio Romano or to Simone Peterzano, Caravaggio's Milanese teacher (M. Calvesi, 1954), wherein Christ stands against a column between scourgers—Domenichino and Reni present the beholder with a quasi-iconic image, not the usual narrative scene from Christ's Passion, like Caravaggio's painting dating from 1607 (cat. no. 93).

Reni's Christ is more pathetic than Domenichino's punctiliously rendered, athletic nude, but their two pictures have more in common with one another than with Caravaggio's powerfully realistic work—above all, because the Bolognese painters' propagandistic aim of arousing pious sentiments refutes the efficacy of the prosaic means adopted by Caravaggio: his earthen palette, tough characters, and momentary postures. Typically, and tellingly, Domenichino's picture was tightly yet slowly executed, whereas Caravaggio's is broadly and quickly done. Domenichino's is a paradigm of the idealized devotional image; of methodically studied, yet unindividualized anatomy; of reliance on the persuasive power of the *affetti* (those expressions that convey the soulful feelings of the senses, and that de Piles thought were completely lacking in Caravaggio's art; see p. 23); and of clarity and correctness of drawing (*buon disegno*)—all of which are revealed through a steady, enhancing light.

Like Raphael, whose *Saint Cecilia with Saints* Domenichino studied as a youth in Bologna (*Christ at the Column* was painted shortly after Domenichino arrived in Rome), and like Poussin later, Domenichino believed that the artist's mission was the persuasive imitation of human actions in noble activities of moral significance, which have the potential of uplifting the spectator spiritually. It certainly could be said that Caravaggio's *Flagellation* has *more* action—that it "concentrates on process," as Hibbard perceptively writes (1983, p. 224). Yet action, in Caravaggio's un-Bolognese, un-Aristotelean vision, is punishment meted out in fits and starts, in kicks and hair-pulling, in naturally awkward movements —the sum of which conflicts with Christ's incarnate perfection (the central message of Domenichino's work), and constitutes a breach of classical decorum because this kind of unembellished world precludes the beauty and order deemed befitting of God. Domenichino undoubtedly would have seen Caravaggio's *Flagellation* as inexcusably realistic, even pointless, for, rather than conveying ideas, it transcribes phenomena, whereas Caravaggio would have found Domenichino's *Christ at the Column* insufferably affected. Decades later, Ribera articulated the Caravaggesque point of view when he complained that "Domenichino was not a painter, because he did not paint from nature . . . " (R. Spear, 1982, p. 69), which of course was not so, literally, but was true, conceptually.

Lest one doubt that, for Domenichino, nature and style were determined by meaning, as they had been for the Carracci (cf. Annibale's *Hercules,* cat. no. 25), it should suffice to compare *Christ at the Column* with the *Portrait of a Young Man* (cat. no. 37), since the two were painted only months apart and yet are markedly different. In the latter, secular work, there are a freshness of technique and an effortlessness of mien that create an engaging, mundane, temporal mood, whereas the posture of the religious image, and the brushwork, establish a cool, timeless, spiritual presence suited to an invulnerable Christian exemplum.

R. E. S.

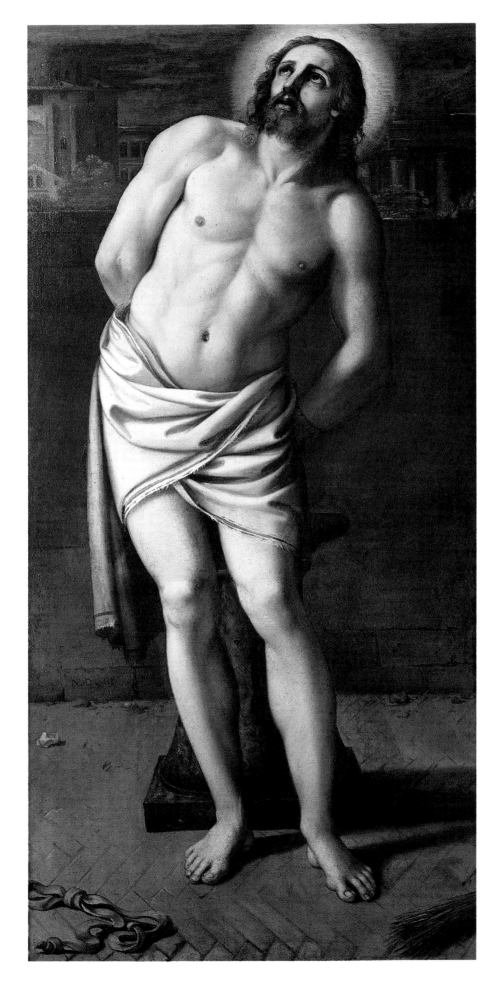

37. Portrait of a Young Man

Oil on canvas, 27 3/16 x 22 1/16 in.
(69 x 56 cm.)
Inscribed (upper left): A DI XII. / APRILE. /
M.DC.III. / IN / ROMA.
Hessisches Landesmuseum, Darmstadt

Seventeenth-century documents prove that Domenichino, like Caravaggio, painted more portraits than are known today, although neither artist seems to have been particularly devoted to the genre nor especially innovative in designing likenesses of his sitters. (It should be noted that Baglione, 1642, p. 139, reports that Caravaggio, "was paid more for his portraits [*teste*] than others received for their history paintings.") There is, however, one notable exception— for, if Domenichino's portraits usually conform to the well-established norms introduced by Raphael's circle (R. Spear, 1982, I, p. 137, no. 14, p. 187, no. 46, p. 227, no. 74), this is not true of his remarkable *Portrait of a Young Man* inscribed, "12 April 1603 in Rome."

Identification of this portrait's inscrutable subject, who stands—dressed in black and holding a tall floppy hat—in front of an expansive landscape, might shed light on the painting's unusual ness of conception, but efforts to identify him so far have failed. What we know regarding Domenichino's appearance precludes the otherwise attractive notion that this is a self-portrait (see R. Spear, 1982, pp. 128–29, no. 6, for further references). The only alternative suggestion, that the sitter is Domenichino's compatriot and collaborator, Giovanni Battista Viola (A. Harris, 1984, p. 167), a specialist in landscape painting, is entirely hypothetical.

There was nothing new *per se* in representing a full-length figure out-of-doors, silhouetted against a doorway—Veronese's illusionistic frescoes at Maser provide the best parallels (H. Keller, 1968, I, pp. 409–10)—yet, earlier examples tend to be as large as life and part of grander decorative programs. By contrast, the monumentality of Domenichino's image belies what are its unusually small dimensions for a full-length portrait: partly because of its low point of view (Velázquez's later innovations may come to mind or, within the Caravaggesque circle, Georges de La Tour's small, full-length "portraits," in the Fine Arts Museums of San Francisco); partly because of its firm, geometric conception (the youth bears the rationally ordered relationship to the picture plane and has the axial steadiness of Christ in Annibale Carracci's *Domine Quo Vadis?*, which was painted about a year earlier); partly because of the highly effective play of shadows on the enframing walls; and, finally, partly because of the restricted palette of blacks, browns, and blues, which allows so little spectral color to vie with the figure and with the continuity of the brownish setting.

A drawing by Barocci (Bologna, 1975, p. 200, no. 242) that may be a preparatory study for the *Marchese Ippolito della Rovere*, of 1602 (see cat. no. 19), also depicts a full-length standing man staring at the viewer as he holds a similar floppy hat against his body. Yet, while the traditional, relaxed pose in Barocci's design finds its closest parallels in Venetian art—notably, in the "state portrait"—the stance of Domenichino's youth is conceptually more allied with Moroni's "Lombard portraits," such as his stunning *Bernardo Spini* (M. Gregori, 1975 b, p. 227, no. 19, colorplate p. 204), in which the inner tension of a comparably statuesque form is uncompromised by the sitter's engagingly natural ease. Technically, too, one senses in Domenichino's fresh brushwork his "Lombard" or Passarottian heritage, by way of Bologna, as transmitted through Annibale's own early portraits, although it must be stressed that compositionally there are no Carracci precedents at all for this design. Precisely because of its originality as a small, full-length portrait, whose roots are in the North rather than in Italy, the most severe skeptic familiar with Domenichino's youthful imitations of his teacher's work could question the attribution of the picture, which rests on firm, although not incontrovertible, stylistic grounds.

As in Domenichino's first landscapes, the North Italian ideas that underlie this portrait have been "Romanized" through the artist's keen sense of classic order, and thus there are significant parallels with Caravaggio's own "Romanization" of his Lombard style about 1600. Domenichino's religious paintings of this period (cat. no. 36) tend to be coldly academic by comparison, suggesting that as early as 1603 a modal distinction already existed in the painter's mind between religious and secular styles (see R. Spear, 1981, on Domenichino's modal brushwork and decorative systems).

R. E. S.

Adam Elsheimer

Adam Elsheimer was born in Frankfurt in 1578, the son of a tailor. He was a pupil of Philipp Uffenbach, a local painter and printmaker. About 1568, he traveled via Bavaria to Venice, where he worked with Hans Rottenhammer. From 1600 until his death ten years later, Elsheimer lived in Rome, where, in 1606, he became a member of the Accademia di San Luca.

Elsheimer was close to the circle of intellectuals that comprised Johannes Faber, physician and botanist to the pope; the philosopher Justus Lipsius; and the brothers Philip and Peter Paul Rubens. After converting to Roman Catholicism, he married a woman of Scottish descent. The "Henrico pittore," who, according to existing documents, lodged in his house, has been identified as the Dutch artist Hendrick Goudt. Goudt appears to have acted both as pupil and patron, and it was through his seven masterly engravings (of 1608–13) after Elsheimer's paintings that the works of the German artist became known all over Europe. Goudt is said to have had his master thrown into debtor's prison—which seems to have been the cause of Elsheimer's early death—probably because Elsheimer was unable to deliver his works quickly enough. An inventory of Elsheimer's possessions, drawn up by his widow eight days after his death, testifies to the poverty in which he must have lived.

Elsheimer is often referred to as "Adamo Tedesco" in the early sources. Although not famous in his own day beyond a small circle of friends, the influence of his two dozen small pictures, all on copper, became widespread, especially in the North—in particular, on such artists as Claude, Rembrandt (who owned Goudt's engravings), and Elsheimer's close friend Rubens.

38. The Stoning of Saint Stephen

Oil on silvered copper, 13 5/8 x 11 1/4 in. (34.7 x 28.6 cm.)
National Gallery of Scotland, Edinburgh

Before this painting, which illustrates Acts 7:50–60, came to light in a Scottish private collection in 1965, its existence was completely unsuspected. It seems to have belonged early on to the Flemish painter Paul Bril, also resident in Rome and a close friend of Elsheimer (for further provenances, see K. Andrews, 1977, cat. 15, p. 145), and was, apparently, known in the circle of Elsheimer's Roman contemporaries, since direct quotations from it appear in the works of David Teniers the Elder, Jacob Pynas, and, through them, Frans Francken II and the young Rembrandt (specifically, the *Saint Stephen*, of 1625, in Lyons). The most direct derivation occurs in a drawing by Rubens (in the British Museum) in which figures are taken at random from the Elsheimer painting. Rubens's drawing, usually referred to as *The Departure of the Sultan* because of the central turbaned equestrian figure (see K. Andrews, 1977, p. 146), was subsequently engraved by Pieter Soutman (in three states; the first two captioned "Adam Elshamer Inven.," the third "P. P. Rub. pinxit"). It was the recollection of this drawing that enabled the late Ingrid Jost-van Gelder to propose the correct attribution of the Edinburgh painting.

The Roman ruins in the right background alone suggest that the painting dates from Elsheimer's early years in Rome, about 1603/4. Stylistically, the picture seems to follow the *Saint Lawrence Being Prepared for Martyrdom* (in the National Gallery, London), also including a similar Caravaggesque floating angel. Yet, the semi-nude boy directly behind Saint Stephen, who throws a stone, is even closer to an almost identical figure in Caravaggio's contemporary *Martyrdom of Saint Matthew* (in San Luigi dei Francesi, Rome).

In the past, when a putative influence from Caravaggio on Elsheimer has been discussed, it has been in terms of the dramatic, even theatrical, use of contrasting light and shade in the German artist's work. That Elsheimer did make use of stark chiaroscuro is not in question, but the source for this lay well within the German tradition in which he grew up (Albrecht Altdorfer's nocturnal scenes are a good example). If there was also an Italian influence, it would have come from the Tenebrist compositions of the Bassani with which Elsheimer undoubtedly became familiar during his stay in Venice—before he had the opportunity to see Caravaggio's paintings in Rome.

There is one essential difference in the handling of light and dark by these two artists. Whereas with Caravaggio the source of light is not depicted and remains mysterious, it is almost invariably shown by Elsheimer—whether it be the sun, moon, fire, a torch, or, as in the *Saint Stephen*, the heavenly rays. Caravaggio used light like a spotlight on a stage, whereas Elsheimer's light plays over the figures and the forms, modeling each of them, in turn. (The same differences, incidentally, also apply to the settings devised by each painter: Caravaggio's are minimal and often, again, mysterious; those of Elsheimer are always explicit and often detailed.) Yet, both, indisputably, were the major artists in seventeenth-century Italy who manipulated light in a novel and influential way—ultimately, in order to create the powerful atmosphere that emanates from their pictures.

K. A.

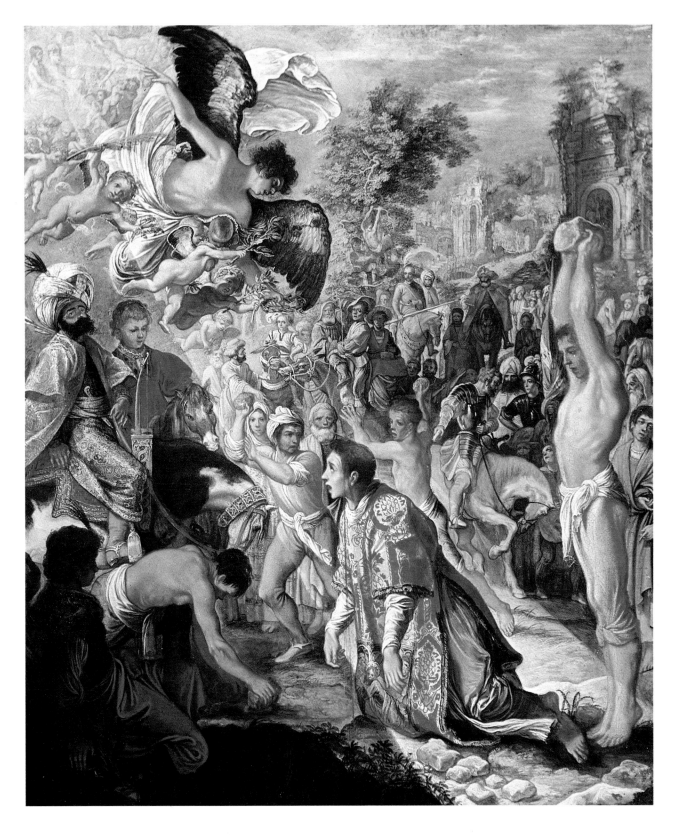

39. Tobias and the Angel
(The Small Tobias)

Oil on copper: overall, 4 7/8 x 7 9/16 in.
(12.4 x 19.2 cm.); painting, 4 9/16 x 7 1/4 in.
(11.6 x 18.4 cm.)
Historisches Museum, Frankfurt am Main

This was, and probably still is, Elsheimer's most popular painting, as attested by the numerous copies and adaptations to which it gave rise (see K. Andrews, 1977, p. 150, no. 20). Of the various versions presently known, the Frankfurt one appears to be the best and is very likely the original. Sandrart (1675; 1925 ed., p. 160), an early biographer of Elsheimer, reports that it was this composition that established the artist's name in Rome. However, Elsheimer's celebrity may not have been due to the original painting itself, but rather to Hendrick Goudt's masterly engraving of it. The engraving, dated 1608, and hence made under Elsheimer's direct supervision, was the first of Goudt's superb series of prints after Elsheimer compositions. Elsheimer himself had attempted to make an etching of the *Tobias* (K. Andrews, 1977, no. 58), probably following a preliminary drawing (now in Berlin; see K. Andrews, 1977, no. 47). There exists an earlier version of this subject that is part of the series of ten small biblical paintings on copper (K. Andrews, 1977, no. 17 F).

The subject, from the Book of Tobit 6:1–3 (in the Old Testament Apocrypha), obviously fascinated Elsheimer, as it had numerous other artists—in particular, Rembrandt. Apart from the *Small Tobias,* Elsheimer also painted a larger version of the composition, about 1609 (called the *Large Tobias*); although the original is now lost, there is a contemporary copy in Copenhagen (K. Andrews, 1977, no. 25). What intrigued Elsheimer, no doubt, was the possibility of combining his incomparable rendering of nature, in the form of the lakeside setting—which he adopted for this scene—and the two figures that he silhouetted against this background, not forgetting the ubiquitous dog, which is specially mentioned in Tobit 5:16, but is often omitted in depictions of this subject. While the landscape does much to create the atmosphere, as is so often the case with Elsheimer, it is always the figures that were of prime consequence for him. Whether forming part of the background, pitted against it, or enveloped in the surrounding nature (frequently peopled with other tiny staffage figures), they are the chief objects of the narrative—for Elsheimer was a supreme storyteller—yet they never overshadow it. It is intriguing to speculate on what Caravaggio would have made of such a theme, had he been induced to tackle it. The only painting by him in which landscape plays a significant role, and which is in any way comparable, is *The Rest on the Flight into Egypt,* but there the figures truly dominate and almost overpower the fragment of somewhat similar, idyllic landscape, to the right.

However original and inimitable Elsheimer's composition appears today—and was judged by his contemporaries and followers—it is firmly rooted in the German tradition in which he was brought up. Dürer's pupil Georg Pencz (Bartsch, no. 17), who made an engraving of the same subject, might be cited as a good example of such a predecessor.

K. A.

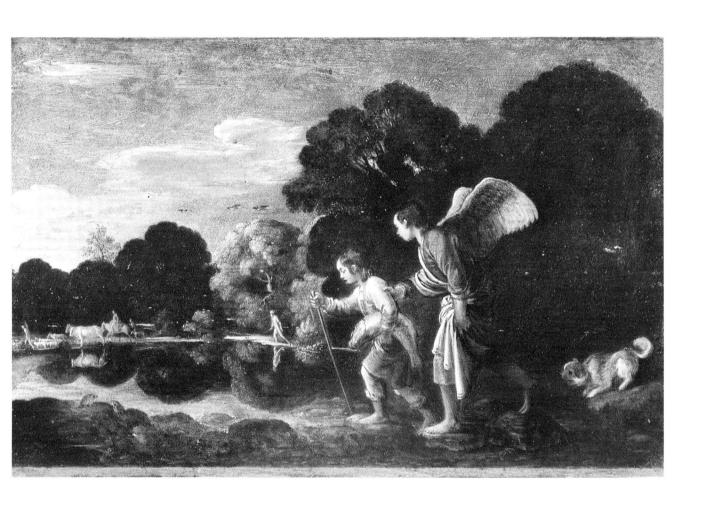

Orazio Gentileschi

The son of a Florentine goldsmith, Giovanni Battista Lomi, Orazio was born in Pisa in 1563, where his elder brother, Aurelio Lomi, became a respected painter. Orazio moved to Rome in 1576–78, living with a maternal uncle named Gentileschi, who was a Captain of the Guards at the Castel Sant'Angelo and from whom Orazio took his name. Gentileschi was a late starter. He is first documented as a painter in 1588–89, when he worked in the Biblioteca Sistina at the Vatican under Cesare Nebbia's direction. His earliest surviving work, one of the frescoes in the nave of Santa Maria Maggiore, dates from 1593, when he was already thirty years old; it reveals little of his talent and nothing of his future artistic genius. Indeed, Gentileschi was then only a rather undistinguished follower of such late Mannerist Roman painters as Niccolò Circignani, Cesare Nebbia, Giovanni Battista Ricci (da Novara), and Paris Nogari. His fresco (of 1600) of the Apostle Thaddeus, in the right transept of San Giovanni in Laterano, shows little advance over these works, whereas his earlier altarpieces and frescoes (of 1597–99) in Farfa—however awkward their general style—contain passages that presage some of the refinement and elegance of his later paintings. The turning point in Gentileschi's career came in about 1600, when he first saw paintings by Caravaggio, whose early style exercised a decisive influence on him. Although Gentileschi was personally acquainted with Caravaggio by about 1600, in September 1603 the Lombard denied that he and Gentileschi were still friends. The first signs of Gentileschi's Caravaggesque style can be detected in the frescoes (of 1599)—only recently recognized as his—in the dome of Santa Maria dei Monti, Rome, and, more clearly, in such altarpieces as the Baptism of Christ (of 1600–5) in Santa Maria della Pace, Rome; the Madonna in Glory (of about 1605), in the Museo Civico, Turin; and the Circumcision (of about 1605), now in the Museo Civico, Ancona; and formerly in the Chiesa del Gesù. In these pictures, the impact of Caravaggio's style is combined with features of Roman late Mannerism and elements recalling Gentileschi's Tuscan background (for example, his familiarity with the work of Santi di Tito). Caravaggio's influence

reached its peak from 1605 to 1613, at the same time that Gentileschi's fully formed personal style found expression in such masterpieces as the Saint Michael (of about 1607–8) in San Salvatore, Farnese; the two versions of David and Goliath (of about 1608) in the National Gallery of Ireland, Dublin, and the Galleria Spada, Rome (see cat. no. 42), which show a debt to Caravaggio's early paintings; as well as the Crowning with Thorns (cat. no. 43) and the various compositions of Judith and Holofernes, which reveal the impact of Caravaggio's mature and late works. Like Saraceni, but to a lesser degree, Gentileschi was briefly influenced by Elsheimer—specifically, in some small paintings on copper (see cat. no. 41)—and he also painted murals (in 1611, in the papal palace on the Quirinale, and, in 1611–12, in collaboration with Agostino Tassi, for Scipione Borghese's Casino delle Muse, also on the Quirinale). Between 1613–14 and 1616–19, he also worked in Fabriano, and he probably visited Florence between 1615 and 1616.

In 1621, when artistic life in Rome was increasingly dominated by such Emilian painters as Lanfranco, Domenichino, and Guercino, Gentileschi accepted an invitation to Genoa from Giovanni Antonio Sauli, for whom he painted several large canvases. From Genoa he established ties with the court of the Duke of Savoy in Turin in 1623. In the summer of 1624, he finished the frescoes in the loggia of the casino of Marcantonio Doria in Sampierdarena (near Genoa), but later in 1624 he joined the French court at the request of Maria de'Medici. From 1625 until his death in 1639, Gentileschi was court painter to Charles I of England. Already in his later Marchigian works—in which occasional affinities with Lotto can be detected—Caravaggio's influence had begun to wane. It was supplanted by a greater refinement and elegance, especially in the rendering of draperies. In his later years—from 1620 on—Gentileschi frequently repeated his major compositions for clients, although he varied the color schemes.

40. Saint Francis Supported by an Angel

Oil on canvas, 49 5/8 x 38 9/16 in.
(126 x 98 cm.)
Museo del Prado, Madrid

This picture—formerly in the Spanish royal collections and, previously, perhaps owned by Carlo Maratta—was recognized as the work of Gentileschi by Pérez Sánchez (1965 b, p. 504), who pointed out its close relationship to Orazio's painting of the same subject, of almost identical size, in the Galleria Nazionale d'Arte Antica, Rome. Longhi (1916) first attributed the latter work to Gentileschi, placing it before 1605; Bissell (1981, p. 140, no. 8) dates it between about 1600 and 1603. An inscription on the canvas in Rome indicates that it was a devotional image in a chapel or church (although by 1703 it was in a private collection); the Prado picture could originally have served an analogous function. Pérez Sánchez (1965 a, p. 504; 1970, no. 85) and the present writer (1970, p. 342) placed it a few years after the Roman painting, and Previtali (1973, p. 360, no. 17) dated it about 1605, contemporary with the Madonna in Glory (Museo Civico, Turin), as did Bissell (1981, p. 141, no. 9). This date is further suggested by the picture's affinity with the altarpieces of the Circumcision, of about 1605, from the Gesù in Ancona, and the slightly earlier Baptism of Christ, in Santa Maria della Pace, Rome. The facial types of the angel in the Madrid picture and of those in the Circumcision are extremely close, and, in the two paintings of Saint Francis, there is an archaic rigidity and tension that also characterizes the two altarpieces—a reflection of Gentileschi's late Mannerist phase of the 1590s. Some of the studied intricacy of the composition of the Ancona altarpiece is found in the Madrid Saint Francis. In these pictures, the impact of Caravaggio's work is not yet as strongly felt as in the Farnese Saint Michael (of about 1607–8), the Dublin David (of about 1608), and the David, of about 1610 (cat. no. 42). Bissell's suggestion that the Capuchin habit and a pair of wings—lent by Gentileschi to Caravaggio in 1603—were used by Gentileschi for the two paintings of Saint Francis, is very appealing. The large wings are, indeed, very similar in both works, as is the position of the left hand. As in so many of-

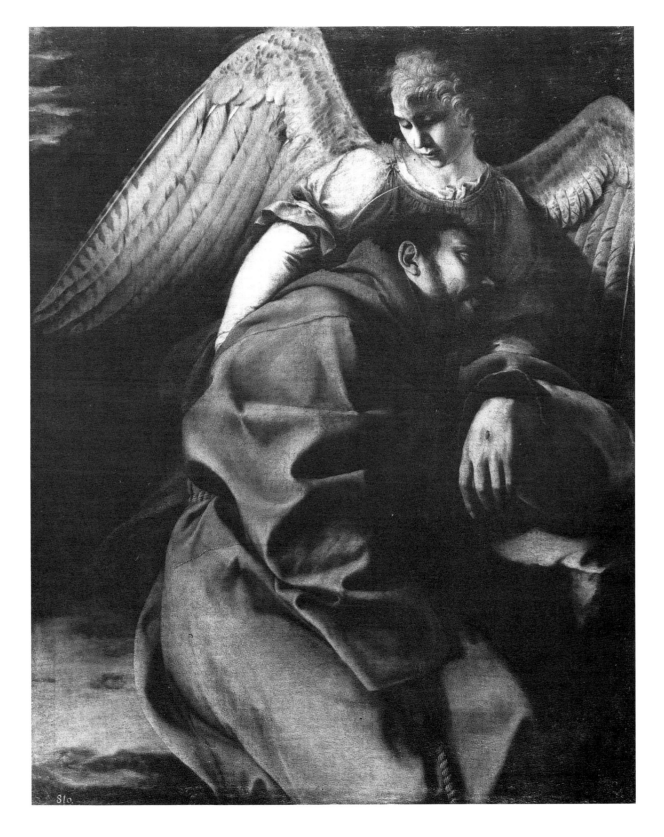

Gentileschi's paintings, the picture in Rome is lit from the right, while the one in the Prado is lit from the left—like the majority of Caravaggio's. Bissell correctly rejected Moir's theory (1976, pp. 62, 124) that the picture in Rome derives from a lost Caravaggio.

As Askew (1969, p. 295) has shown, Gentileschi's two paintings of Saint Francis supported and consoled by an angel belong to one of the three post-Tridentine iconographic types for showing this popular saint: Saint Francis in ecstasy supported by angels, Saint Francis adoring the crucifix, and Saint Francis's vision of an angel playing the violin (see cat. no. 34). Caravaggio's painting in Hartford (cat. no. 68), was the most important and innovative interpretation of the theme in Rome, and it had a catalytic effect in spreading the new imagery. However, in contrast to Caravaggio's painting—and especially to Baglione's *Saint Francis in Ecstasy*, of 1601 (Davidson collection, Santa Barbara), in which the saint appears in a reclining position—Gentileschi's conception seems to have been inspired by the devotional image of the dead Christ in a tomb, supported by angels, a type that originated about 1400, but gained renewed importance in the later sixteenth and early seventeenth century (see the examples by, among others, Taddeo and Federico Zuccari, Cherubino Alberti, and Veronese). In the present *Saint Francis* he "is transformed into an analogue of Christ"; the artist depicts "the mystical theme of St. Francis' spiritual and bodily transformation into Christ by means of love" (Askew). The Venetian representations of the subject (such as those by Veronese) are closer to Gentileschi's approach than are the Central Italian ones, in that they contain half-length figures. As Askew has demonstrated, another of Gentileschi's sources was the Agony in the Garden, with an angel showing Christ the chalice; Veronese's painting of this scene (Brera, Milan), in which Christ is supported by an angel, is particularly relevant (P. Askew, 1969, pl. 41 d). Bissell's assertion that there is a connection between the present picture and the story as told in Matthew 4:11, where Christ is served by angels in the wilderness, is, however, not correct.

E. S.

41. Saint Christopher Bearing the Christ Child

Oil on copper, 8 1/4 x 11 in.
(21 x 28 cm.)
Staatliche Museen Preussischer Kulturbesitz, Gemäldegalerie, Berlin-Dahlem

When Wilhelm von Bode acquired this small cabinet picture on copper for the Kaiser-Friedrich-Museum, Berlin, in 1913, he believed that it was by Elsheimer. Longhi (1927 d; 1967 ed.) recognized it as a work by Gentileschi and, later (1943 a), dated it within the first decade of the seventeenth century. While Drost (1933) still maintained the attribution to Elsheimer, and Weizsäcker (ed. H. Möhle, 1952, pp. 71 ff.) even believed that the picture dated from the beginning of the nineteenth century (and that it was an early work by Waldmüller, whose name had been mentioned in 1913 by Frimmel and by Bode), Longhi's attribution soon found authoritative support from Voss (1929). The picture was exhibited as a Gentileschi in Milan in 1951 and was reproduced as such by Moir (1967), Longhi (1967), and Ottani Cavina (1968). In 1971, the attribution, surprisingly, was dismissed by Bissell (p. 287, n. 33) because of the "Germanic physiognomy and the sinewy figure type" of the saint. Although Waddingham (1972, p. 611, n. 56), the present writer (1975; 1978), Salerno (1977–80; 1981), and Nicolson (1979) rejected his view in favor of Longhi's attribution, Bissell (1981, pp. 207 f., no. X–21) has recently reaffirmed his earlier rejection (without, however, referring to it, or to Waddingham's dismissal of it), calling the picture the "work of a Northern 'Little Master,' who moved in the Elsheimer-Saraceni circle in Rome." Yet, both the figure style and the landscape elements are compatible with Gentileschi's other works and seem to point unmistakably to his authorship. It is true that the Elsheimerian conception of the scene as a whole is unique in Gentileschi's œuvre (there are no other known representations of this subject by him), but the rocky formations on the riverbank—especially in the left foreground, where they are painted in a characteristically cool, gray tone, and are interspersed with

some foliage and half-bare tree trunks—are almost a signature of the artist, and can be found in many of his other pictures: in the *Magdalen*, in Santa Maria Maddalena, Fabriano; the Berlin *David*; the *Saint Francis*, in San Silvestro in Capite, Rome (also the small version, once in the Colonna collection, Rome, and now in Switzerland); the *Madonna and Child* at Burghley House, England; the various versions of *Lot and His Daughters* (those in the ex-Teophilatos collection, Genoa; in the Thyssen-Bornemisza collection, Lugano—contrary to the affirmations of Bissell and others, these two pictures are not identical; in Berlin; and in the National Gallery of Canada, Ottawa); and in the versions of the reclining *Magdalen* (Richard L. Feigen collection, New York, and the Kunsthistorisches Museum, Vienna). The distant landscape in the background at the right, near the horizon, can be compared with that in the left background of the Berlin *David*.

Saint Christopher's facial features—the high cheekbones, puffy cheeks, furrowed brows, and pronounced jaw—are close to those of the Fabriano *Magdalen*, the Farnese *Saint Michael*, and the two paintings of David (in Dublin, and in the Galleria Spada, Rome; see cat. no. 42). The face of the small *David* on copper (in Berlin) is only an ennobled version of that in the Spada picture. If one compares the general effect of the Berlin *David*, it must be admitted that the forms are more Caravaggesque, the modeling rounder, and the surface of a greater polish, but the more painterly and sketchy handling of the *Saint Christopher* does occur in the small Burghley *Madonna* (R. W. Bissell, 1981, no. 39, pl. 84). Bissell argues that, while the David in the Berlin picture "would not suffer from increased scale" (see the large Spada version), the Saint Christopher would—but so, too, would the figures in the Burghley *Madonna* and the Incisa *Christ Appearing to Saint Francis*, an equally unique invention in Gentileschi's oeuvre.

The intensity of the light, the luminosity of the space, and the range of tones from gray to intense sky blue are not found in the works of any of Elsheimer's Northern followers, but the same tonality occurs in the Berlin *David*. The realism with which the cool, brisk atmosphere is rendered, the

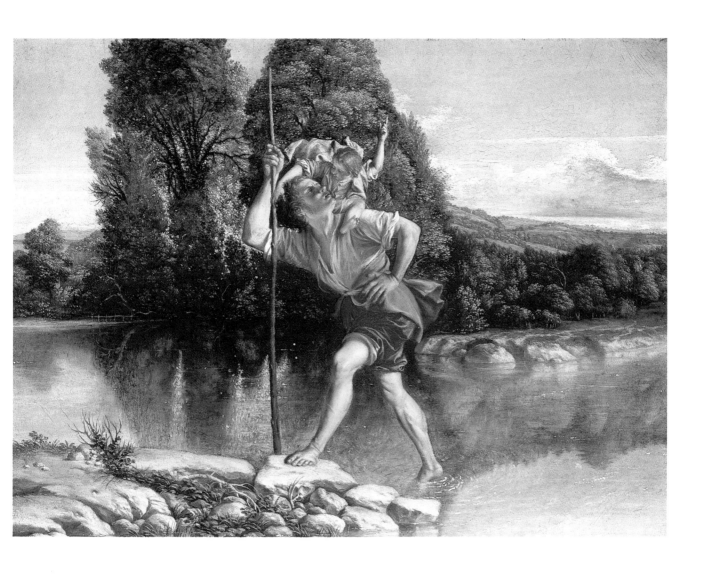

grandeur of conception of the landscape, and the airiness of the space transcend Elsheimer's potential and intentions. The picture also bears little similarity to Saraceni's Elsheimerian landscapes (cat. nos. 58–59), nor is it plausible that the author of the painting "was first and foremost a master of landscape rather than essentially a figure painter" (R. W. Bissell, 1981, p. 201). Saint Christopher is prominently—almost awkwardly—placed in the foreground, the artist apparently having had difficulty unifying figure and landscape; Saraceni, and Elsheimer and his Northern followers were more successful in this respect, as evidenced by comparison with the etching by Jan van der Horst, which, according to the inscription, AElshamer pinxit, reproduces a lost composition by the German master. Weizsäcker (1936, I, pl. 36), Holzinger (1951, p. 223), Jutta Held (1966, p. 61), and Salerno regarded the inscription as trustworthy and considered Elsheimer the author of the composition. Salerno (1977–80, I, p. 132; 1981, p. 459) even saw the painting as the source of Gentileschi's. Andrews (oral communication), however, does not believe that the composition is by Elsheimer, and did not mention the etching in his Elsheimer monograph, regarding the etching as based on two paintings, of about 1620, by Poelenburgh—which Jutta Held, conversely, claimed derived from the etching. However, the predilection for this subject in Rome at the beginning of the seventeenth century apparently originated with Elsheimer, as his nocturnal composition, in a vertical format (there are various versions, the best one in the Hermitage) proves, and from which a similar nocturnal composition by Orazio Borgianni is directly derived. Borgianni's composition also exists in at least two painted versions (the best is in Edinburgh; see cat. no. 21) as well as in an etching. In this composition and in an earlier painting by Borgianni from his first Spanish sojourn (ex-Milicua collection; sold at Christie's, London, July 6, 1984, no. 29), the Christ Child looks at Saint Christopher as he raises his right arm in blessing, a gesture similar to that in Gentileschi's painting, where the Child points to the sky. The gesture of pointing or blessing is missing in Elsheimer's vertical composition (and in van der

Horst's etching). It is not certain whether Gentileschi could have known Borgianni's etching, but if one dates Gentileschi's painting to the second half of the first decade of the seventeenth century—close to the Fabriano *Magdalen*, the Farnese *Saint Michael*, and the two paintings of David (in Dublin and in Rome), Gentileschi's *Saint Christopher* would precede Borgianni's etching (which seems to date from about 1615). Gentileschi's idea of using the huge poplars as a foil for the figure in the foreground is a device not uncommon in paintings executed in Rome in these years; one example is Lanfranco's small panel of *Juda and Thamar*, painted for Cardinal Montalto about 1608 (Galleria Nazionale d'Arte Antica, Rome).

E. S.

42. David in Contemplation after the Defeat of Goliath

Oil on canvas, 68 1/8 x 55 7/8 in.
(173 x 142 cm.)
Galleria Spada, Rome

As far as can be judged from Gentileschi's extant oeuvre, he treated the subject of David and Goliath twice, giving two totally different interpretations to the theme: David decapitating the giant Goliath, whom he had killed with his sling, and David in meditation over the decapitated giant's head. The first interpretation, showing David in action, follows a Cinquecento tradition upheld by Raphael, Pordenone, and Daniele da Volterra. In Gentileschi's painting in Dublin, however, he did not emphasize the violent, brutal side of the event, as his contemporary Orazio Borgianni did (see cat. no. 20), but presented a heroic image of the triumphant David, not dissimilar to the *Saint Michael* (in Farnese) painted about the same time (1607–8).

The present picture, in which David, contemplating the giant's death, is "lost in a mood of reverie" (D. S. Pepper, 1971, p. 337), is radically different from the decapitation scene. As Pepper pointed out, Gentileschi followed and interpreted a new iconographic type, which Caravaggio had introduced into Seicento painting (see cat. nos. 77, 97).

It has been assumed that the Spada picture, which was cleaned in 1967, has been cut at the bottom, and that, originally, David was depicted full length, in analogy to the almost identical full-length figure in Gentileschi's small version of the subject on copper (in the Gemäldegalerie, Berlin-Dahlem), where, however, the landscape in the background and the position of the head of Goliath differ. The height of the picture would then have been about 215–220 centimeters, instead of 173. The canvas would have had to have been cropped before 1759 because in the Spada-Veralli inventory of that year the picture is already listed with its current dimensions (F. Zeri, 1954, p. 87). Strangely enough, the small version on copper seems to have become more widely known and more popular than the large canvas: There are at least three extant copies—a variant, with a dark back-

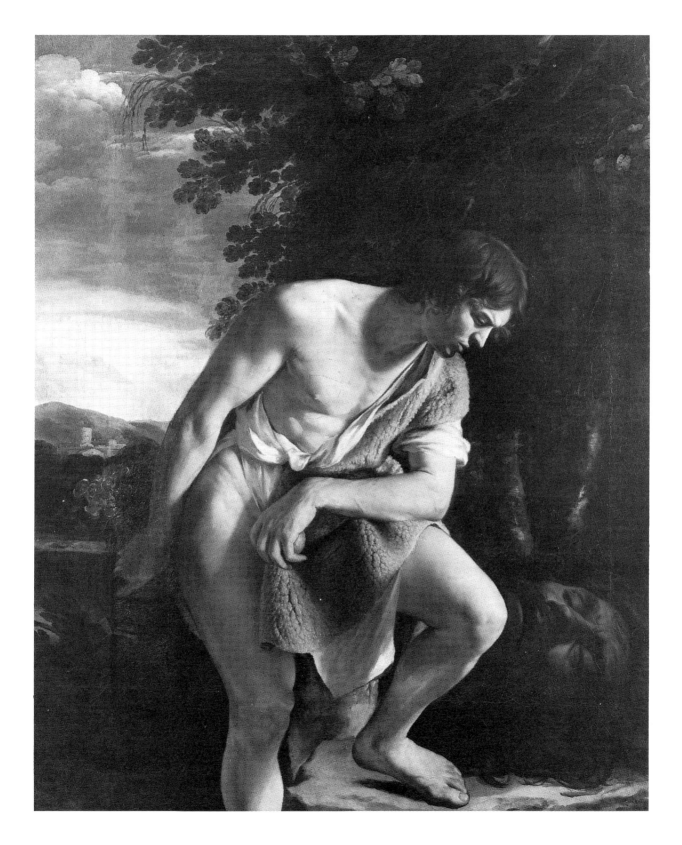

ground, on touchstone (in the Galleria dell'Arcivescovado, Milan), by a contemporary Italian (R. Longhi, 1916, attributed it to Orazio's daughter, Artemisia Gentileschi); another contemporary, but perhaps Northern, copy, on oak (in a private collection, Berlin); and a weak, late copy, of about 1700, on canvas (in Braunschweig). On the other hand, only one copy of the Spada picture (without the landscape, but in which David is apparently also cut at the knees), reported by Nicolson (1979) as on the Roman art market in 1977, is known. Whether the overdoor painting, which Ratti (1780, I, p. 265) and Lanzi (1795; 1834 ed., I, p. 214) describe as in the Palazzo Brignole, Genoa, in the collection of Carlo Cambiaso, was a variant or a replica is uncertain; the present picture came to the Spada palace with the dowry of Maria Veralli, who, in 1636, married Orazio Spada (she was the sole heir of the important collector Cardinal Fabrizio Veralli, who died in 1623; see L. Neppi, 1975, p. 144). The most significant differences between the Berlin painting on copper and the Spada canvas are obviously the landscape backgrounds, the disposition of Goliath's head, and the completion of David's figure to full length. The landscape in the Berlin picture —with the gray rocks at the right that serve as a foil for David; the deep blue sky, with small white clouds; and the distant hills behind a river—is typical of Gentileschi. The landscape in the Spada picture is less so, although Bissell (1981, p. 149) has rightly noted that wooded backgrounds do appear in some of Gentileschi's pictures. Longhi (1916, pp. 270, 311) attributed the landscape in the Spada picture to Agostino Tassi (he also believed that the head of Goliath was not by Gentileschi), but his opinion has been implicitly challenged by Pugliatti (1977, p. 10). Characteristic of Gentileschi's compositions is the rocky platform at the bottom, on which David places his left foot, but the two thick, shimmering tree trunks in the dark background —the dense foliage of which serves to set off the figure—are, on the other hand, unusual. Another difference is the horizon line at the left, which, in the Spada picture, is much higher than in the Berlin painting. Here, David's right hand and the hilt of the sword appear against the dark landscape, instead

of the sky, as in the Berlin picture. In consequence, Gentileschi painted a richly decorated hilt of shining gold, while, in the Berlin picture, it is black and unadorned. The change in the background of the Berlin picture also entailed a change in the position of Goliath's head, which lies face down on the rocky platform. In the Spada painting, David's legs are farther apart.

The 1967 cleaning (see L. Mortari, 1968, pp. 12–13) revealed that the Spada painting consists of a large, rectangular canvas with a herringbone pattern, to which strips of ordinary warp-and-weft canvas were added on all sides: a narrow one (about 11 centimeters wide) at the right, with wider strips (of about 23 centimeters) at the top and bottom, and one at the left 19 centimeters wide. These are clearly visible in old photographs and in the large colorplate reproduced by Neppi (1975, pl. XVII). In addition, there appears to be another seam running through the figure's right elbow. Whether this is simply damage where the canvas was folded over for a time (something that does not seem likely), or whether it indicates an actual seam between two sections of canvas, is not clear. However, unlike the other four strips of canvas, this one (16 centimeters wide) has the same herringbone pattern as the center portion, and certainly belonged to the original conception: While the other additions on all four sides seem both illogical and unusual, it was quite normal to join two or more pieces of canvas of similar weave to obtain the size desired (this is the case with Gentileschi's *Lot and His Daughters* in Berlin and the *Danaë* in Cleveland). The hypothesis that the artist first painted only the area comprised by the inner two pieces of canvas is a tempting one. If this were so, then David's right hand would have touched the edge of the picture, with only part of the grip of the sword visible; his left foot and the rocky plateau on which it rests would not have been included; the shirttail that hangs between his legs would have extended almost to the bottom of the canvas; and Goliath's head would have appeared almost to be lying on the frame of the picture in a much more plausible fashion (the way that the head presently seems to sit unnaturally on a mass of black hair is quite unconvincing, and is the likely result of an adjustment

necessitated by the enlarged picture field). David would have appeared even closer to the viewer, and the direction of his gaze (however unfocused and inward) toward Goliath's head would have been stronger, creating a more intense and stringent relationship between them. The viewer's attention would thus have been drawn exclusively to David, undistracted by the distant landscape.

It should be mentioned that there are pentimenti along the contours of the figure's right arm and shoulder, and left leg, while a pronounced craquelure in the dark area of the background above the right shoulder and the head indicates that the artist made some changes there, too. In the portion that the present writer believes made up the original canvas, a piece of the lambskin is visible behind the shirttail and the left leg. Sharply divided between light and shadow, the pelt has a characteristic flocky texture. However, when Gentileschi added the 23-centimeter strip at the bottom, he elongated the lambskin without imitating its flocky texture (a clear sign that the strip was added after a lapse of time), delineating it against the dark background. The resulting shape almost has the appearance of a tree stump beside which David is propped. Interestingly, Gentileschi eliminated precisely this detail in the small, copper version of the composition in Berlin. Yet another detail that would otherwise seem curious is the dark sword, almost indiscernible from the background—a departure from Gentileschi's normal emphasis on formal and spatial clarity.

Gentileschi adapted the enlarged composition of the Spada picture for the small picture on copper in Berlin, painting the figure of David full length in a grotto of cool, gray rocks, such as occur in the *Saint Francis* (in San Silvestro in Capite, Rome), the *Lot and His Daughters* (in Berlin), and the *Magdalen* (in Santa Maria Maddalena, Fabriano). At the left, he lowered the horizon line considerably so that the contour of David's right hand holding the sword is set clearly before the grayish clouds; the blade of the sword is brightly lit from the right. Whereas in the Berlin painting on copper the view into the distance is uninterrupted, in the Spada picture there is a sort of balustrade in the middle ground on which there

are a few stones. The pose of the David in Berlin has been slightly modified: The contours have been smoothed and streamlined, and the position of the left leg and foot has been shifted somewhat to the left, closer to the right leg. The features of David's face also appear smoother in the Berlin version. Pepper's characterization of David as "lost in a mood of reverie" applies much more to the Berlin figure than to the Spada David, where he seems to brood over the result of his act, his eyes half closed, in a trance, the brows furrowed, the mouth slightly open. The strained expression on the face, with its swollen forms, is paralleled by the weighty, muscular body, lit from the right side. The figure, which is light, pale, and pellucid, is similar to Saint Michael, in Farnese, but it is very different from the darker, more somber color of the *Crowning with Thorns* (cat. no. 43)—although both pictures belong to the same period. While the *Crowning with Thorns* seems to show the impact of the mature, late works of Caravaggio, the figure of David embodies more of Gentileschi's personal style: an amalgamation of Caravaggio's early works and the components of Gentileschi's Tuscan heritage.

E. S.

43. The Crowning with Thorns

Oil on canvas, 47 1/16 x 58 1/2 in.
(119.5 x 148.5 cm.)
Herzog Anton Ulrich-Museum,
Braunschweig

This is the prime version of a composition of which at least one replica exists. The picture belonged to Cardinal Fesch (died 1839) in Rome, where it was sold in 1867; it did not reappear until 1977, first in an English private collection and then on the art market. Prior to that time, the only known version was one published by Longhi (1943 a, p. 22); then in a private collection in Milan, it was exhibited at the "Mostra del Caravaggio e dei Caravaggeschi" there in 1951, when it belonged to the Lizza-Bassi collection in Varese. Sold in 1951 to Professor Cepellini of Nervi, it was inherited by the present owners in Genoa after his death in 1961. In addition, a related but distinctly different composition by Gentileschi is known (it was at the Galerie Fischer, Lucerne, in 1963; see R. W. Bissell, 1981, no. X–4, fig. 153).

A chronology for Gentileschi is still far from established; various phases of his career—for example, the first decade of the seventeenth century—are scarcely documented and the dating of many pictures remains controversial. However, there is a basic agreement on a date soon after 1610 for the *Crowning with Thorns* (R. Longhi, 1943 a, p. 22, proposes 1611; A. Emiliani, 1958, p. 50, suggests a date of about 1610; and R. W. Bissell, 1981, p. 152, dates it about 1610–15), as well as on the fact that it "belongs to the most Caravaggesque phase of Orazio's career" (R. W. Bissell circumscribes this phase within the years 1606–12). As Longhi wrote, "il Gentileschi si cimenta persino nell'azione repentina, e come sorpresa dalla luce, del Caravaggio tardo." Klessmann (1978, p. 106) called the Braunschweig picture Gentileschi's most Caravaggesque work and compared it to Caravaggio's *Flagellation*, of 1607 (cat. no. 93); the pose of Christ's head, his facial type, and his expression are, indeed, similar in both pictures, although the chiaroscuro modeling is, of course, much more violent in Caravaggio's painting. However, Gentileschi is not known to have

visited Naples, and he may, in fact, never have seen Caravaggio's altarpiece.

Within Gentileschi's oeuvre, the *Crowning with Thorns* represents the earliest surviving example of a horizontal composition with several three-quarter-length figures. This type of composition derives from such works by Caravaggio as the Casa Coppi *Judith and Holofernes* (cat. no. 74), the *Incredulity of Saint Thomas* (Bildergalerie, Potsdam), the *Flagellation* (in Rouen; cat. no. 91), and the *Martyrdom of Saint Ursula* (cat. no. 101). Other works by Gentileschi belonging to this category are the two versions of the *Judith and Holofernes* (in the Pinacoteca Vaticana and the Wadsworth Atheneum, Hartford), dated about 1611–12 by Bissell, but considerably later by D. S. Pepper (1984, p. 316); and the *Martha and the Magdalen* (in the Alte Pinakothek, Munich), dated about 1620 by Bissell, but about 1611–12 by Pepper. These paintings—to which the vertical composition of the *Judith and Holofernes* (Colnaghi, New York; see D. S. Pepper, 1984, p. 316) should be added—exhibit pronounced chiaroscuro contrasts that are stronger than in many of Gentileschi's other works, and a virtually neutral, dark background from which the figures seem to emerge.

In evaluating the relative merits of the Braunschweig and Genoa versions of the *Crowning with Thorns*, it should be borne in mind that Longhi was unaware of the Braunschweig picture, while Bissell was unable to examine the version in Genoa. The Braunschweig picture has a number of important pentimenti, some of which are visible to the naked eye, while the Genoa version has only one, where Christ's red garment shows through the mock scepter. One major difference between the two versions is the fact that in the one in Genoa there is considerably more space around the figures—especially above them, but also at the sides. In fact, the picture in Genoa is sixteen centimeters taller than the one in Braunschweig, which, however, has not been cut (stretcher marks on the canvas are visible on all sides: this was confirmed by Knut Nicolaus, the restorer at the museum in Braunschweig). In the Braunschweig picture, the figures—particularly the two tormentors, with their diagonal movements—are compressed into the picture space: The

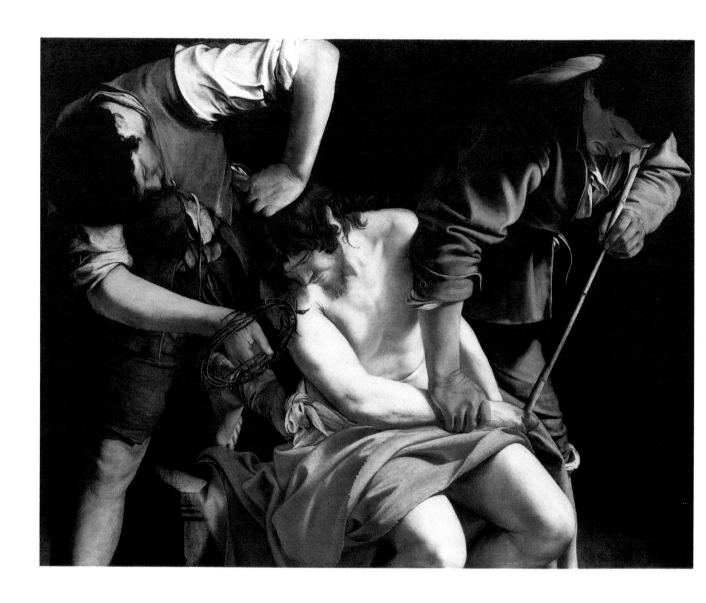

left elbow of the stiffly posed tormentor at the left just touches the upper edge of the canvas (the plates in R. Klessmann, 1978, and in R. W. Bissell, 1981, are cropped). Parallels for this compressed effect occur in such paintings by Gentileschi as the early *Way to Calvary*, in Vienna (R. W. Bissell, 1981, no. X–25, fig. 152); here, it emphasizes the rigidity of the poses of the figures and the strenuous, tense action of the tormentors (which is balanced by the calm figure of Christ at the center)—characteristics that are typical of a number of Gentileschi's works (for example, the Ancona *Circumcision* and the *Saint Francis* in San Silvestro in Capite, Rome), but are quite alien to Caravaggio's. In the Genoa *Crowning with Thorns*, the tormentors are not confined by the edges of the picture field—with the result that the composition has lost some of the tension, stringency, and logic of the Braunschweig version. However, it is worth noting that Gentileschi sometimes altered the relationship between figures and background in later replicas of a picture (see R. W. Bissell, 1981, figs. 40, 41).

As far as the sheer pictorial quality of the two versions is concerned, Bissell valued the painting in Genoa more highly. Yet, a direct examination of each leaves no doubt—at least for the present writer—that the Braunschweig picture is superior to that in Genoa in virtually every detail, even allowing for the fact that the latter does not share the advantage of the former's recent (1977) cleaning. As is frequently the case with his replicas—especially those from the 1620s and 1630s—Gentileschi altered the color scheme: The blue-green cloak and trousers of the tormentor at the left in the Braunschweig picture were changed to a brown for the cloak and a deep blue for the trousers in the Genoa version, while the olive-brown cloak of the tormentor on the right became a lighter gray-to-beige-to-olive in the Genoa picture. Another difference concerns the bench (a sort of antique base) on which Christ sits and on which the tormentor at the left braces his left knee. In the Braunschweig picture, the oblique line of the upper edges of the bench leads more deeply into space, while the bench in the Genoa version has been altered, its foreshortening differs, and the front profile has been eliminated. It is also notable that only

in the Genoa version do tufts of Christ's hair appear between the fingers of his tormentor. The curls that fall onto Christ's left cheek as well as his beard are also markedly different in the Genoa version, where, moreover, Christ's lips are broader, with downturned corners that create a bitter and disdainful expression. In the Braunschweig picture, Christ's expression is more tender, sensitive, and calm. These changes seem to confirm the status of the Genoa picture as an autograph replica—and, indeed, the subtle modeling of certain areas also supports this conclusion. Nevertheless, the simplified design of the draperies and the uncharacteristically soft treatment of other areas raise doubts. The Genoa version is not only inferior to the Braunschweig picture but, in many respects, it is also inferior to the standard of known replicas dating from Gentileschi's Genoese, Parisian, and English periods. A number of features speak against its being a copy, but some uncertainty remains.

The most important pentimenti in the Braunschweig *Crowning with Thorns* occur in the figure of the tormentor at the right and in Christ's body. Instead of turning away from Christ while placing the mock scepter in his right hand, the tormentor originally faced in the opposite direction, toward Christ, in a pose that closely resembled that of the tormentor in the variant sold in Lucerne in 1963 (contrary to Bissell's opinion, this variant seems to be a replica of a lost original by Gentileschi: while the position of the tormentor's head, his left shoulder, and his upper arm resemble the original conception of the Braunschweig picture, the right arm is bent differently). Originally, Christ's body was not intersected by the tormentor's right arm, and Christ's left arm was positioned differently, so that his left hand was hidden behind his right lower arm and rested in his lap (the mock scepter was apparently only introduced when the pose of the tormentor was modified).

The treatment of Christ's salmon-colored loincloth may recall Caravaggio's work, but the refined and elegant linear precision in the rendering of the facial types and of the details of the garments, the subtle *controluce* effects in the faces of Christ and of the tormentor at the right, and the frozen quali-

ty of the action are Gentileschi's alone. As in many of Gentileschi's paintings, the figures are lit from the right, whereas Caravaggio preferred a light source at the left, unless a different solution was required by special circumstances (for example, the natural source of light in a chapel). There is a parallel for the awkward stiffness of the pose of the tormentor at the right in the figure of the executioner in Gentileschi's contemporary *Executioner with the Head of Saint John the Baptist* (in the Prado). Despite some restorations, the Prado picture is neither "considerably repainted" nor a "partially redone copy," as Bissell (1981, p. 150, no. 20) suggests; this rigidity of pose may reflect the late Mannerist style of Gentileschi's earlier years.

Whether the Braunschweig original or the replica in Genoa can be identified with the painting described in the 1650 inventory of the Savelli collection, Rome, is a matter of conjecture. As Bissell noted, Soprani (1674, p. 316) mentions that Gentileschi worked for the Savelli; a letter of March 27, 1615, from Pietro Guicciardini to Andrea Cioli in Florence indicates that the artist was then living and working in Savelli's house.

Gentileschi's fresco, of about 1616, in the vault of the Chapel of the Crucifixion in San Venanzo, Fabriano—which depicts the Mocking of Christ with full-length figures (see R. W. Bissell, 1981, p. 163, no. 32 d)—is related to both the Braunschweig picture and the hypothetical, lost prototype of the painting formerly in Lucerne.

E. S.

Giovanni Lanfranco

Lanfranco was born in Parma in 1582. After the death there of his first teacher, Agostino Carracci, in 1602, he moved to Rome with his fellow student Sisto Badalocchio, joining the workshop of Annibale Carracci in the Palazzo Farnese. His first independent work was the decoration of the Camerino degli Eremiti in the Palazzetto Farnese (about 1605), after which he was employed by the Marchese Sannesi (about 1606–7) and then by Cardinal Alessandro Peretti-Montalto (about 1607–8). He worked under the direction of Guido Reni for Cardinal Scipione Borghese in the Oratorio di Sant'Andrea (1608–9), adjacent to San Gregorio Magno; in the Cappella dell'Annunziata in the Palazzo del Quirinale (1610); and at San Sebastiano fuori le Mura. The predominant influence in these works was that of his master, Annibale Carracci, but Lanfranco's paintings already showed a greater freedom than those of his former companions Francesco Albani and Domenichino. In 1610, a year after Annibale's death, Lanfranco moved to Piacenza, where he stayed about two years, receiving several commissions for altarpieces, some of which he painted only after returning to Rome in the latter half of 1612. In Emilia he was markedly influenced, if only briefly, by Ludovico Carracci and Bartolomeo Schedoni.

It took Lanfranco two years to reestablish himself in Rome, where Guido Reni dominated the artistic scene and Domenichino received important commissions between 1610 and 1614. Lanfranco painted frescoes in the Palazzo Mattei in 1615, but his first public commission was in the Buongiovanni Chapel (1616) in Sant'Agostino, where he created the first Baroque decorations of a dome—although on a relatively small scale. His work there reinforced his reputation and won him the attention of the papal court, which employed him, together with Agostino Tassi and Saraceni, to decorate the Sala Regia (1616–17) in the Palazzo del Quirinale. By this time Lanfranco had abandoned the Ludovichian character of his paintings from the years in Piacenza and had developed a very delicate, elegant style, employing subtle controluce effects and a magical chiaroscural atmosphere that has parallels in the work of Borgianni and such "caravaggisti nobilitati"

as Gentileschi, Saraceni, and Alessandro Turchi.

After the departure from Rome of the Bolognese painters Reni, Albani, and Domenichino, and also of the Tuscan Passignano, Lanfranco became the favored artist of Paul V, receiving the most important papal commission, the decoration of the vault of the Benediction Loggia at Saint Peter's toward the end of the second decade. However, Paul V died in 1621, and Lanfranco had no official position under the short reign of Paul's successor, Gregory XV. Nonetheless, in the early twenties he achieved a powerful, dynamic, and truly Baroque style, employing more violent chiaroscuro contrasts and allowing forms to expand more freely within the pictorial space (for example, in the Sacchetti Chapel in San Giovanni dei Fiorentini, of 1623–24). Lanfranco's most celebrated works in Rome, the fresco in the dome of Sant'Andrea della Valle (1625–27) and the Navicella altarpiece in Saint Peter's (1627–28), mark the artist's mature style. His participation in the neo-Venetian trend in Roman painting of the later 1620s is exemplified by the high altarpiece of Santa Maria della Concezione (I Cappuccini), commissioned by Urban VIII. In 1631, Lanfranco was Principe of the Accademia di San Luca. However, eclipsed by the leading younger artists of the Barberini era—Pietro da Cortona and Andrea Sacchi—Lanfranco accepted the invitation of the Jesuits to paint the dome of the Gesù Nuovo in Naples, where he arrived in the spring of 1634. He stayed twelve years, obtaining important commissions, mostly for extensive fresco decorations—San Martino, Santi Apostoli, and the Cappella del Tesoro di San Gennaro in the cathedral. In 1646, a year before his death, Lanfranco returned to Rome, where he painted his last work, the fresco in the apse of San Carlo ai Catinari.

44. The Adoration of the Shepherds ("La Notte")

Oil on canvas, 49 x 70 1/2 in.
(124.6 x 179.2 cm.)
His Grace the Duke of Northumberland,
K.G., Alnwick Castle, Northumberland

The Adoration of the Shepherds is the only surviving work by Lanfranco commissioned by the Marchese Clemente Sannesi, Maestro di Camera to Cardinal Pietro Aldobrandini, and his brother Giacomo, who was named Cardinal by Clement VIII in 1604 and Bishop of Orvieto by Paul V (see G. B. Passeri, 1670–80; 1934 ed., p. 141, and Bellori, 1672, p. 367). The two brothers owned at least three small paintings by Annibale Carracci and a copy of Caravaggio's Cardsharps (formerly in the Colonna di Sciarra collection, Rome), and Giacomo bought the first versions of Caravaggio's two lateral paintings for the Cerasi Chapel in Santa Maria del Popolo, Rome. Lanfranco's paintings for the Sannesi —his first commission after leaving the workshop of Annibale—followed his decoration of the Camerino degli Eremiti in the Palazzetto Farnese and constituted his second group of works in Rome. Annibale had recommended his pupil to the Marchese, who had built a casino on the Borgo above Santo Spirito in Sassia for which Lanfranco painted scenes from the Old Testament on the ceilings of seven rooms (see E. Schleier, 1983, p. 27); these perished when the Palazzino was demolished shortly before 1829. In addition, he painted "a number of oil paintings in different sites of various narrative subjects" (Passeri), of which only the Adoration was described in detail. The picture also has a more or less continuous provenance, enabling it to be identified with certainty once it was located (E. Schleier, 1962, pp. 246 ff.).

Together with the two surviving canvases from the Camerino degli Eremiti (now in the Museo Nazionale di Capodimonte, Naples) and the small Annunciation, of about 1607–8 painted for Cardinal Montalto (in the Hermitage, Leningrad), the Adoration, of about 1606–7, is the most important of the few extant easel paintings from Lanfranco's early, Annibalesque period, prior to 1610. Of these, it is the largest, and, with

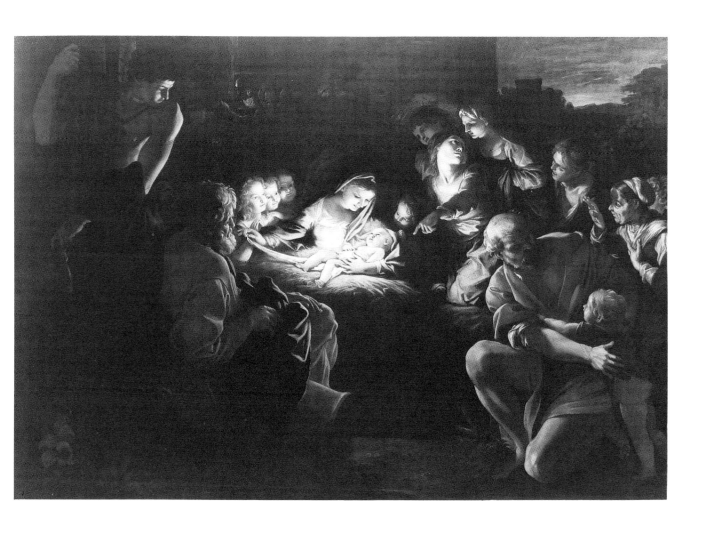

its multitude of figures, has the most complex composition.

As Bellori writes, it was painted "in imitation of Correggio's *Notte*." However, Lanfranco's direct model was not Correggio's altarpiece for San Prospero, Reggio (now in the Gemäldegalerie, Dresden), but a lost painting by Annibale, which was itself inspired, as Bellori notes, by Correggio's prototype. The dating of Annibale's lost picture, whose composition is known through a copy or variant by Domenichino (in the National Gallery of Scotland, Edinburgh), is controversial. Spear (1982, I, p. 101) dates Domenichino's picture to about 1607–8. Annibale's has been dated to about 1598–99, or shortly before 1606 (see E. Schleier, 1983, p. 29). Annibale's prototype also inspired a composition by Sisto Badalocchio known both in a horizontal and a vertical version (in the Galleria Nazionale d'Arte Antica, Rome, formerly in the Museo Provinciale, Bari; and in the Patrizi collection, Rome, respectively). There also existed a closely related composition by Lanfranco that is, again, known only through copies (see E. Schleier, 1983, p. 29).

Compared to the paintings by Badalocchio —which follow Annibale's prototype much more closely—and by Domenichino, Lanfranco's composition shows a relative boldness and independence: It is much less stable and solidly structured, more open and fluctuating. Lanfranco's picture is based exclusively on chiaroscuro contrasts and on the movement of the figures. The placement of the angels in relation to the Madonna and Child is reversed, and the Virgin's right arm is extended more dynamically. The bagpiper, who appears in Domenichino's picture as well as in the paintings by Badalocchio, and in Lanfranco's second *Notte*, is here replaced by the figure of a young shepherd who holds a ram by the horn and looks over his shoulder toward the central scene. Only his left arm and his face are illuminated by the light emanating from the Christ Child in the center. The accentuated chiaroscuro contrasts in the modeling of the body, as well as the facial type, make this figure almost Caravaggesque.

Unlike Domenichino's *Adoration*, Lanfranco's two compositions and Badalocchio's two paintings omit the singing angels above the stable.

On the basis of a preparatory drawing for Domenichino's *Adoration* (in Windsor Castle, inv. no. 5700 v.), Brigstocke (1973, pp. 525 f., 1978, pp. 39 f.) has plausibly suggested that Domenichino invented the figure of Saint Joseph carrying hay in the back of the stable, and altered his position relative to that in Annibale's lost painting. Whether, in Annibale's picture, Joseph was on the right (where he would have conflicted with the adoring peasants) or, as in the present picture, in the left foreground (where he would have interfered with the bagpipe player) is uncertain. Brigstocke's subsequent idea (1978, pp. 39 f.)—based on a study for the bagpipe player on the recto of the Windsor drawing—that Domenichino "either invented the figure [of the bagpipe player] . . . or at least gave it a much more prominent position than it held in the lost picture by Annibale Carracci" has been questioned by Spear (1982, I, p. 151). In the two pictures by Badalocchio and in Lanfranco's second, lost composition, the bagpipe player appears on the left and Joseph is in the right foreground; Badalocchio eliminated the kneeling peasant, while Lanfranco moved him farther back. In the present picture, Lanfranco retains the motif of the kneeling peasant and infant son from Domenichino's *Adoration* (although in a somewhat different form) and places Joseph in the left foreground, where he is seen from the back. Lanfranco therefore had to omit the bagpipe player, introducing instead the shepherd looking over his shoulder: His unusual pose creates the space necessary for the figure of Joseph.

E. S.

Bartolomeo Manfredi

There is little documentation on Manfredi's life and career. He is reported to have been born in southeastern Lombardy, in the little town of Ostiano near Mantua, perhaps as early as 1580 but more likely a few years after, even as late as 1587 (Mancini, about 1617–21; 1956–57 ed., I, p. 251, II, p. 151). After training in the neighboring centers of Cremona, Brescia, and Milan, he went to Rome, presumably soon after 1600 and certainly before 1606. There, according to Baglione (1642, p. 159), he studied with Roncalli. He came into contact with Caravaggio, conceivably as a servant-assistant (A. Moir, 1967, I, pp. 40 f.). Both Caravaggio and Roncalli left Rome in 1606, when Manfredi was at least nineteen, so he must then have begun his career as an independent master.

His career was exceptional. Manfredi was perhaps Caravaggio's closest follower, although he is the least known. None of his paintings is signed and none is dated, either on the canvas or by document, so his hypothetical evolution is based entirely on stylistic analysis. Furthermore, although he did paint a number of religious subjects, he had no known public commissions. Nonetheless, he achieved a considerable reputation, and his work was included in important private collections, notably those of the Marchese Giustiniani and the Grand Duke of Tuscany, Ferdinando de' Medici. Limited as his activity was, his work was very influential, particularly on younger painters from the Netherlands—so influential that the German painter-historian Joachim von Sandrart (1675; 1925 ed., p. 170) referred to the style of the group as the Manfredi manier.

These younger painters responded to Manfredi's mature work, from the second decade of the century. Characteristically, many of these late paintings appear to derive from Caravaggio's Roman masterpiece, the Calling of Saint Matthew, *in the Contarelli Chapel in San Luigi dei Francesi—specifically, the group seated around the table with the saint. They are easel pictures, most of them horizontal in format and frieze-like in character, with three-quarter-length figures veiled in heavy shadow gathered around a central space or figure. Whether religious or secular, these pictures are portrayed as contemporary genre*

subjects. When the younger artists returned to their native cities, they took with them the Manfredi manier, *with the result that Manfredi's influence became pan-European. We have no exact record of Manfredi's death, but he probably died in Rome about 1621.*

45. Cupid Punished by Mars

Oil on canvas, 67 x 48 1/4 in.
(175 x 130 cm.)
The Art Institute of Chicago

Writing in about 1620–21, Giulio Mancini (1956–57 ed., I, p. 251) mentioned an otherwise unspecified work—"perhaps the best thing [Manfredi] had made"—in the collection of the Cavaliere Agostino Chigi in Siena. It is now possible to identify this work as the *Cupid Punished by Mars*, since in the inventory made of the Cavaliere's possessions at the time of his death, in 1644, the picture is described so precisely as to allow no mistake (see A. Moir, 1985). We do not know exactly what disposition was made of the painting in 1644, but it appears—again described in convincing detail—in an inventory, made during 1657, of the possessions of the Cavaliere's cousins in Rome. They had followed their kinsman Fabio Chigi to the papal city about a year after his election to the papacy as Alexander VII in 1655. Until the 1930s, the picture remained in the Chigi family collections in Rome, unnoticed except for a reference to it in 1776 in the journal of an English traveler, Lady Anne Miller, as "an extravagant painting by Caravaggio" (R. Spear, 1971, p. 128). By 1937, still attributed to Caravaggio, it had passed into the hands of a Roman dealer-collector, Armando Brasini, from whom it was sold to the Art Institute of Chicago by Wildenstein and Company. Longhi (1943, p. 25) was the first to recognize it as a work by Manfredi.

None of Manfredi's works is dated by documentation, but for stylistic reasons the *Cupid Punished by Mars* can be placed in the late years of the first decade of the century, soon after Caravaggio's flight from Rome in May 1606. Hints of the continuing influence of Roncalli (see cat. no. 53), who, having also left Rome in 1606, did not settle there again until 1610, still appear, notably in the smooth, glossy handling of the paint, the somewhat turgid composition, the rather clumsy figures with their wooden movement, and in such details as Cupid's bright blue sash and the physiognomy of Venus. Yet Caravaggio's influence is dominant: The arrangement of the figures, rotating around the focal point of Mars's left

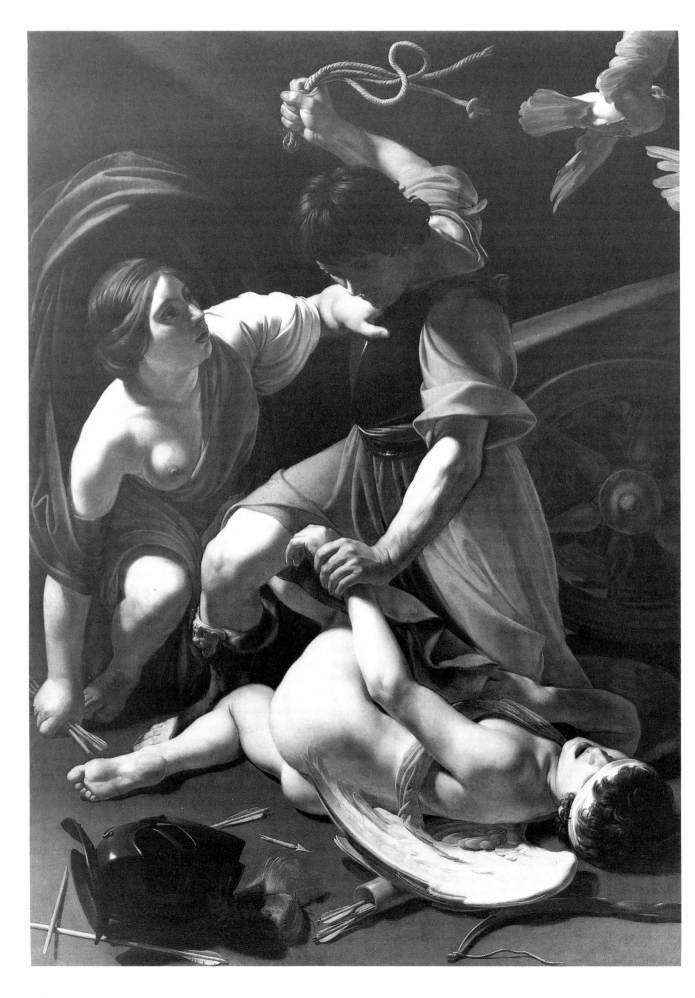

hand grasping Cupid's wrist, recalls his *Crucifixion of Saint Peter*, painted during 1601–2 for the Cerasi Chapel (see fig. 8, p. 38). Although the foreground is more fully illuminated than in most of Caravaggio's works, the contrast between the shadowy background and the foreground, with the light cutting across it from the left, striking the figures, can be related not only to the *Crucifixion of Saint Peter* but also to such slightly later works by the master as the Kansas City *Saint John the Baptist* (cat. no. 85). Perhaps we can also suspect some deliberate plagiarism of Caravaggio's *Sacrifice of Isaac* of 1603–4 (cat. no. 80), not only in the crucial gesture of Mars's restraining hand but also in the conception of the writhing, screaming boy.

Manfredi was also indebted to Caravaggio for his attitude toward the subject matter. Caravaggio is reported to have painted a similar subject, *Divine Love Conquering Profane Love*, for Cardinal del Monte (Baglione, 1642, p. 136). If this is true (and some scholars doubt it), his *Divine Love* may be reflected in the present painting, as well as in Baglione's *Divine Love* (cat. no. 15), but neither Caravaggio nor Manfredi painted many subjects from classical mythology. We know of only one other by Manfredi, the *Bacchus and a Drinker* (in the Galleria Nazionale dell'Arte Antica, Rome), while during his Roman years Caravaggio painted—after the *Bacchus* (cat. no. 71) and one or two other early works—only the *Amor Vincit Omnia* (cat. no. 79) and perhaps the *Divine Love*. In contrast to Baglione's more typical ennobled presentation of classical mythology in the *Divine Love*, both Manfredi's and Caravaggio's paintings seem mock-heroic. Their actors may be costumed *all'antica*, but they are plebeian, and they are motivated by ordinary human passions—triumph, annoyance, resentment, resistance—rather than by divine power and wisdom.

This painting is quite possibly Manfredi's earliest surviving picture, and, as far as we know, he painted no other picture quite like it. It marks his acceptance of Caravaggio's inspiration, but also his modification of it to suit his own artistic personality and the changing tastes of his patrons and public. He was not alone; the same process of modification of Caravaggio's style can be re-cognized in Gentileschi's *Crowning with Thorns* (cat. no. 43), Borgianni's *David and Goliath* (cat. no. 20), and Caracciolo's *Baptism of Christ* (cat. no. 22). Clearly derivative of the master's style, these paintings also clearly demonstrate the emergence of individual variations on it. Although the practitioners of the *Manfredi manier* did not respond directly to the *Cupid Punished by Mars*, they did respond to its end product—Manfredi's mature Caravaggesque style and his personal adaptation of Caravaggio's legacy.

A. M.

Domenico Cresti
called Il Passignano

That Passignano (1559–1638), a leader of the counter maniera *in Florence, was also one of the artists who received the most patronage in Rome has only recently gained attention (J. Nissman, 1979 b, pp. 83 ff.). Like Gregorio Pagani and Cigoli, he was dedicated to combining the North Italian tradition of warm, naturalistic color with the Florentine tradition of* disegno*. After a long and influential period in Venice, from 1581 to 1589, Passignano returned to Florence; there, with Pagani and Cigoli, his work took on a new naturalism and colorism that contributed much toward the development of Florentine Baroque painting. His art found particular expression in large-scale decorations and historiated cycles—a type of commission that he continued to obtain in Rome (J. Nissman, 1979 a, pp. 375 ff.). Passignano was already known in Rome for his painting, of 1599, in the Mancini Chapel of San Giovanni dei Fiorentini (Longhi considered the canvases by Passignano and by Cigoli in the chapel novel precedents for Caravaggio's work—on canvas rather than in fresco—in the Contarelli Chapel of San Luigi dei Francesi; see M. Cinotti, 1983, p. 527), prior to his arrival in the city in late 1602 to begin the* Crucifixion of Saint Peter *for Saint Peter's (M. Chappell and W. C. Kirwin, 1974, pp. 162 ff.). Soon Passignano joined the Cavaliere d'Arpino, Gaspare Celio, Cherubino Alberti, Giovanni Baglione, and others as one of the artists awarded the patronage of the papal establishment (see R. Wittkower, 1958, pp. 8 ff.). His reputation and achievement can be measured not only by his patrons—Popes Clement VIII and Paul V, and Cardinals Maffeo Barberini, Scipione Borghese, Pompeo Arrigoni, and Pietro Aldobrandini—but also by the prestige of his commissions; these included the decoration of the Barberini Chapel (of 1604–6) in Sant'Andrea della Valle (see cat. no. 30), and the ceiling frescoes (of 1608–10) for the Sacristia Nuova and the sacristy of the Cappella Paolina in Santa Maria Maggiore (J. Nissman, 1979 a, pp. 374 f.). He was active in the Accademia di San Luca and received the honor of being nominated* Cavaliere di Cristo *(F. Baldinucci, 1681–1728; 1846 ed., III, p. 438). After 1616, he worked mainly in Florence, except for one commission in Rome for Pope Urban VIII.*

Passignano's relationship with Caravaggio was twofold. On the one hand, they met in taverns with the somewhat reluctant Cigoli, while, on the other, Passignano's curtained work pavilion in Saint Peter's was slashed by the angry and jealous Lombard (F. Baldinucci, 1681–1728; 1846 ed., III, pp. 277, 447). The three artists participated in the competition sponsored by Monsignor Massimi to paint an Ecce Homo *(cat. nos. 35, 86)—probably in early 1604. Moreover, Passignano experimented with Caravaggesque lighting and verism, although he remained true to his personal synthesis of Venetian and Florentine traditions (M. Gregori, 1959, p. 206). Passignano's friend, the Roman physician and critic, Giulio Mancini (about 1617–21; 1956–57 ed., I, p. 110), who divided the painters of his day into four schools, categorized Passignano not as a follower of Caravaggio, Annibale Carracci, or the Cavaliere d'Arpino, but as a leader of the "quarta schuola"—those artists with their own individual style ("più tosto . . . [di] . . . ordine e grado che schuola"). Mancini's appraisal of Passignano as having a style both Florentine and Venetian in character, showing great knowledge, strong resolution, and the good color of a master ("di maniera fra la natione fiorentina e venetiana; ha gran prattica, risolutione e buon colorito da mastro") aptly applies to* The Burial of Saint Sebastian *at Capodimonte (cat. no. 46).*

46. The Burial of Saint Sebastian

Oil on canvas, 68 1/2 x 49 in. (174 x 124.5 cm.) Signed and dated: Dominici Passignani MDCII.
Museo Nazionale di Capodimonte, Naples

Whether this work of markedly classicizing naturalism was painted in Florence or in Caravaggio's Rome cannot, at present, be resolved, due to the picture's scant history. The painting was in the collection of Pietro Vitali, Rome, in 1802, and was acquired that year from the Galleria di Francavilla, Naples, by the King of Naples (Museo di Capodimonte files); it was identified in 1803 by the artist Tommaso Conca as a work of "Cav. Papignano" depicting Saint Sebastian being cured ("S. Sebastiano curato dalle ferite;" see A. Filangieri di Candida, 1902, p. 317, n. 105). Notwithstanding the identification, the painting was ascribed to Palma Giovane until this century, when it was correctly attributed to Passignano on the basis of the inscription (A. De Rinaldis, 1928, n. 102).

Its date corresponds to the important point in Passignano's career when he left Florence for Rome in late 1602. It is known that he painted a "Saint Sebastian" for Cardinal Pompeo Arrigoni before 1612, and Nissman (1979 a, p. 108) has suggested that this might be the present painting—perhaps a trial piece submitted before Arrigoni's recommendation of Passignano to the Fabbrica of Saint Peter's to decorate one of the altars in the crossing. Indeed, Passignano could have painted the *Saint Sebastian* in Rome between late 1602 and spring 1603 if, as a Tuscan, he dated the painting according to the Florentine calendar, which changed the year on March 25.

The present painting, which is a fine example of Passignano's strong Venetian colorism (A. Venturi, 1934, p. 646) and Florentine compositional design, bears a somewhat more tangential relationship to Caravaggio's verism. Martini's observation (1959, p. 56) that Passignano's work contains expressive, naturalistic passages that are, however, far removed from Caravaggesque specificity, aptly applies to the definition and the modeling of the very corporeal figure of the saint. What predomin-

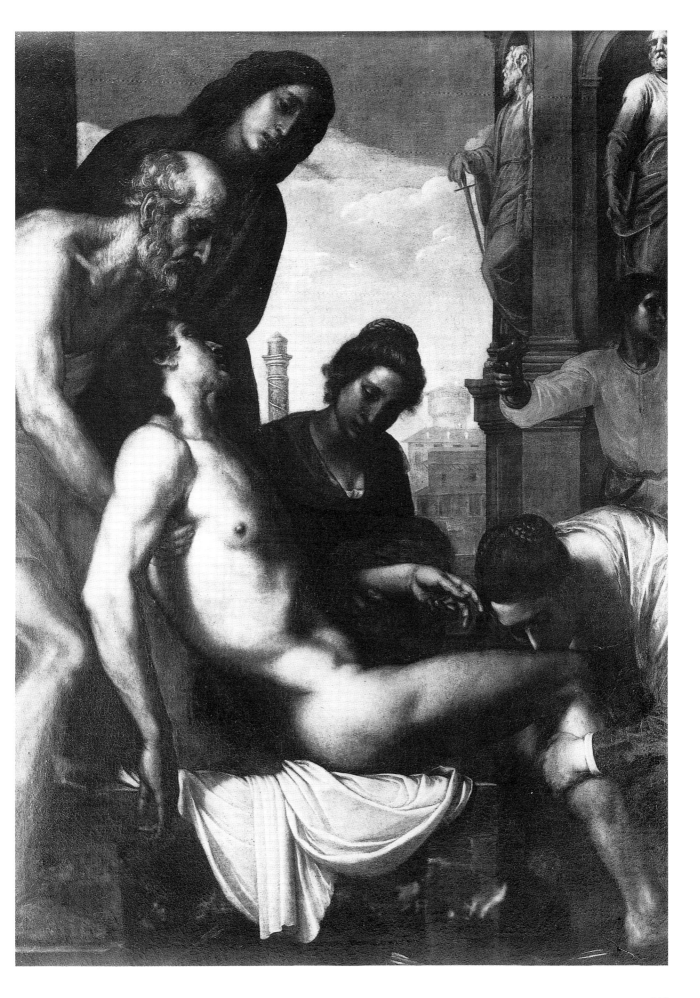

ates in the painting are the vividness of its color—which contributed to the picture's early attribution to the Venetian Palma Giovane—and the grandeur of the design, composed of eloquent figures reminiscent of those found in paintings of the Florentine High Renaissance.

That the composition is derived from portrayals of the *Entombment* by Andrea del Sarto, Fra Bartolommeo, Pontormo, and especially Cigoli (in particular, his painting, of 1599, in the Kunsthistorisches Museum, Vienna), is aptly demonstrated by Nissman (1979 a, pp. 109–10). In fact, the scene looks more like the burial of a Roman martyr rather than like his "curing" (as it was described in 1803), and the tomb and the attention to appropriate Roman details compares with the setting of Passignano's painting of the same subject, of 1616, for the Barberini Chapel of Sant'Andrea della Valle, Rome. The ennobled figures of the women and of the elder, and the eloquent gestures and the compressed grouping of the protagonists seem to have been inspired specifically by Michelangelo's two *Pietà* then in Rome (one at Saint Peter's and the other then in a garden on Monte Cavallo and now in Florence Cathedral). Thus, with its combination of veristic figures, its warm colorism, and its perfected Michelangelesque design, the Capodimonte *Saint Sebastian* bespeaks Passignano's origins, and may have served to introduce his art into Rome.

M. C.

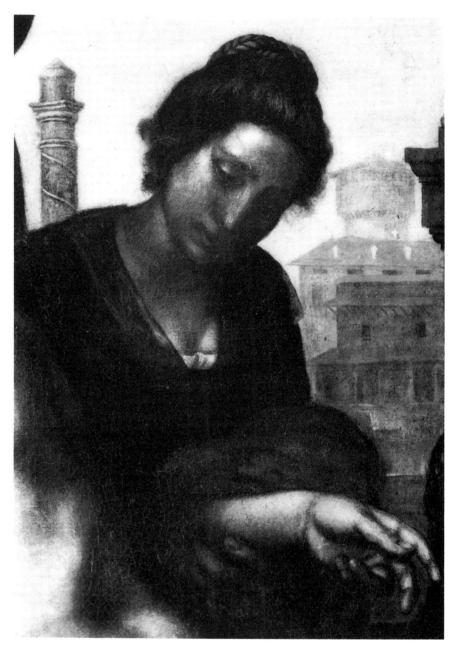

The Pensionante del Saraceni

In 1943, Longhi included under the sobriquet of the Pensionante del Saraceni a number of pictures close in style to those of Carlo Saraceni, but which were distinguishable from the works of the master by "a certain intonation, a certain French accent." Since then, the pictures attributed to the Pensionante have increased to six (one of which is known in several versions: see cat. no. 47), but if agreement has been reached as to the artist's nationality—French—none of the attempts to identify him with a documented personality (Jean Leclerc, Guy François, and even Georges de La Tour) has been successful.

Two facts are indisputable. The first, mentioned by Baglione, is that Saraceni was a Francophile: He adopted a French mode of dress, "though he had never visited France nor knew a word of that language," and he readily surrounded himself with French pupils. The second is that the pictures grouped under the name of the Pensionante, whether religious subjects, genre scenes, or still lifes, are stylistically coherent and display a direct knowledge of Caravaggio's early works. The charming originality of the Pensionante's mysterious personality resides in his smoothly executed paintings, with their soft lighting, delicate and tranquil poetry, and melancholic reserve.

47. The Denial of Saint Peter

Oil on canvas, 38 9/16 x 50 5/8 in.
(98 x 128.5 cm.)
Musée de la Chartreuse, Douai

A number of versions of this composition are known (A. Brejon de Lavergnée and J. Cuzin, 1974, p. 250; B. Nicolson, 1979, pp. 77 f.), but the painting in the Vatican and the present picture are the only ones that can be considered original (P. Rosenberg, 1983, p. 355). Even the version in the National Gallery of Ireland, Dublin, is merely a very good workshop replica.

The subject of the painting has caused some discussion. Nicolson and the present author (1982, p. 298), for example, have interpreted the scene as Job being mocked by his wife, but comparison with Georges de La Tour's famous canvas (in the museum in Épinal)—in which the physical suffering of Job, as it is described in the Bible, is mercilessly portrayed—makes this hypothesis rather unlikely. The simpler hypothesis, held by Longhi (1943 a) and Pigler (1956, I, p. 334) as well as by J. Montagu (personal communication), that the painting shows the denial of Saint Peter, is the more probable, especially since, in one of his last works, Caravaggio himself dealt with the subject in an analogous manner (cat. no. 100). The Douai picture is certainly by the Pensionante. If the disposition of the half-length figures and their large, eloquent hands was inspired by Caravaggio, the lost profiles, wide-open mouths, and rich colors are characteristic of the Pensionante.

The two protagonists are isolated in a cell, against a wall marked by candle smoke. Saint Peter's face, with its troubled and hypocritical expression, is in shadow, while the light strikes the lovely white turban, the red dress with its bottle-green sleeves, and the face of the servant girl. The dialogue between Peter, whose denial is without conviction, and the servant, who obstinately questions him, is conveyed as much by their glances as by their gestures. Yet, what is most striking about this work is its daring use of color, the simplicity of its composition, and its overall dramatic force.

P. R.

48. Still Life with Melons and a Carafe of White Wine

Oil on canvas, 20 1/16 x 28 3/8 in.
(51 x 72 cm.)
National Gallery of Art, Washington, D.C.

First published by Longhi, in 1928–29, as by Caravaggio, the picture carried this attribution for quite some time because of its analogy to Caravaggio's famous still life in the Pinacoteca Ambrosiana, Milan, and because of an old label on the reverse of the canvas (reproduced by Longhi, 1928–29; 1968 ed., p. 113). The attribution eventually was questioned both explicitly (see C. Sterling, 1952 b, p. 53) and implicitly, through the omission of the work from Caravaggio's oeuvre. However, Baumgart (1954, p. 201, no. 28) was the first to specifically ascribe the painting to the Pensionante del Saraceni; since Longhi's death in 1970, agreement on this has been universal (see F. R. Shapley, 1979, I, pp. 112 ff.; II, pl. 77). The picture is one of the rare French Caravaggesque still lifes of quality. It was probably painted in Rome between 1615 and 1620, and shows a knowledge of the works of Caravaggio of some twenty years earlier. On a table covered with a white tablecloth the artist has set a dish of fruit, a carafe of wine, a melon, a pear, and a slice of watermelon. Two flies underscore the trompe-l'œil effect of the picture and accentuate its anecdotal aspect. The harmony of the malachite green of the leaves, the pink of the watermelon, and the golden yellow of the wine testify to the Pensionante's abilities as a colorist. Contrary to the handling of light in the early work of Caravaggio, here the light is soft, almost velvety in some areas, dissolving the forms and multiplying the luminous reflections in the shadows.

As Spike (1983, p. 48) has justly noted, the Washington canvas forms a link between the still lifes in paintings by Caravaggio and by his direct imitators, and those Baroque still lifes, from mid-century, with their more complex and dynamic compositions.

P. R.

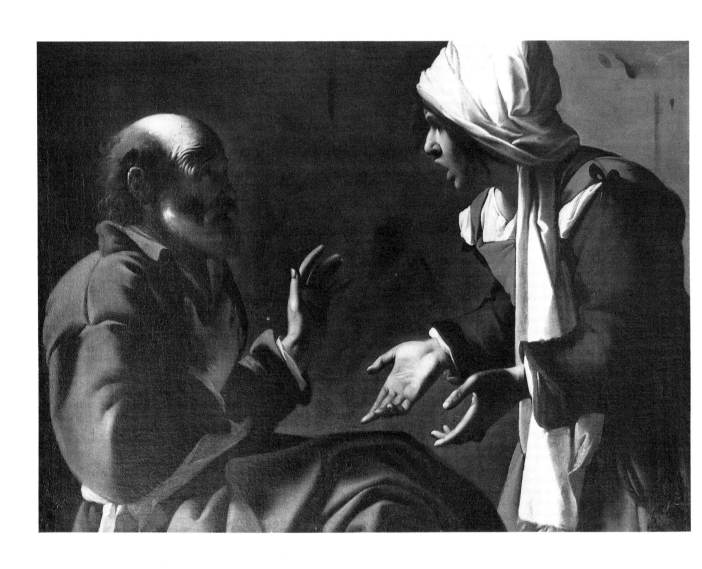

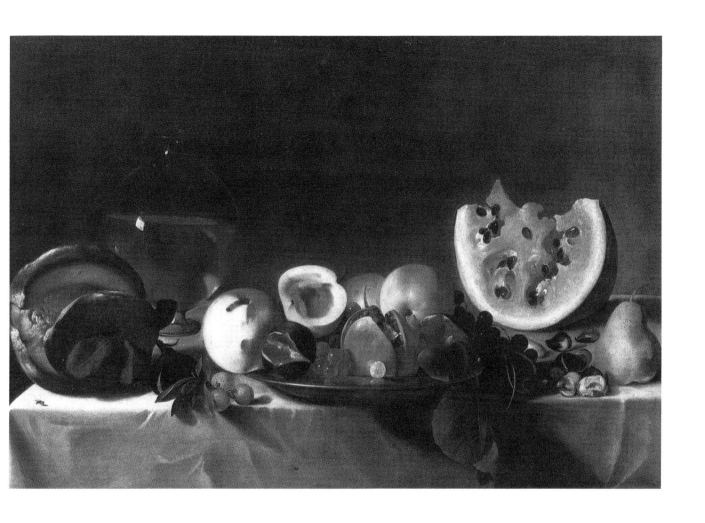

Scipione Pulzone
called Il Gaetano

There is little available biographical information on Scipione Pulzone. He was born in Gaeta about 1550 and, according to early sources, worked with Jacopino del Conte. Nevertheless, his first works reveal a predominant interest in the sort of "international" portraiture that had its origins in Flemish painting—in particular, in the work of Anthonis Mor. Pulzone had probably already been living in Rome for some time when he signed and dated his portrait of Cardinal Ricci in 1569. A member of Roman artistic institutions, he became consul of the Accademia di San Luca in 1578 and reggente of the Confraternita dei Virtuosi del Pantheon in 1582. In the same year, however, Pulzone left Rome to return temporarily to Gaeta.

His extraordinary ability to paint portraits from life so "that they appear alive" ("che paiono vivi"), as Borghini noted, made Pulzone one of the most popular painters in Rome—in demand by the "Signori principali di Roma, e tutte le belle donne" (the most important gentlemen of Rome and all of the beautiful women)—and spread his fame throughout the major courts of Italy. Among his initial patrons were those members of the College of Cardinals of greatest prominence, as well as, later, Pius V and Gregory XIII. In the Farnese household, in addition to Cardinal Alessandro Farnese, a number of noblewomen vied to have their portraits painted by Pulzone. The Colonna family also commissioned numerous portraits and religious paintings from him, and Marcantonio I Colonna had a Christ on the Road to Calvary *by Pulzone sent to Sicily; it is possible that Pulzone's other Sicilian commissions, like the altarpieces in Milazzo (of 1584) and in Mistretta (of 1588), were also due in some part to the same family. About 1581, he painted for the Marchese di Riano the Capuchin altarpiece now in Ronciglione—a work that reveals Pulzone's strong ties to the artistic traditions in Rome of the preceding fifty years. In 1583, the Spanish ambassador included Pulzone's name among the candidates under consideration for the decoration of the Escorial. The following year, Pulzone went to Naples and to Florence, where he was called by Cardinal Ferdinando I de' Medici (he returned there in 1587). To some degree, the composition of his* Assumption *in San*

Silvestro al Quirinale, Rome, with its refined Raphaelesque qualities and its Venetian color, is indebted to Florentine art.
At the Gesù in Rome, Pulzone and the Jesuit architect and painter Giuseppe Valeriano collaborated closely on the chapel of the Madonna della Strada and on two altarpieces (later removed) for the Cappella degli Angeli and the Cappella della Passione (cat. no. 50). Pulzone died on February 1, 1598, before completing his Assumption *for Santa Caterina de' Funari, Rome.*

49. Portrait of a Lady

Oil on canvas, 46 7/8 x 36 5/8 in.
(119 x 92.2 cm.)
Walters Art Gallery, Baltimore

This painting, from the Masserenti collection, Rome, dates from about 1590 or just before, when Pulzone had begun to turn away from Mannerism toward his own brand of classicism. Despite the picture's remotely Titianesque character, the pose of Anthonis Mor's portrait of Elizabeth of Valois, in Eindhoven, (F. Zeri, 1976, p. 361), with its aristocratic composure, is Scipione's immediate source. Such typical elements of Pulzone's portraiture as the effectively precise rendering of the silk and lace sleeves, blend with an accentuated realistic treatment of the physiognomy. Like the *Portrait of a Woman*, of 1591, formerly in the Klein collection, New York, it marks the transition from Pulzone's earlier, heraldic portraits (the "personaggio stemma") to a more individualized portraiture in which, as Zeri (1957; 1970 ed., p. 93) has noted, he "rediscovers the qualities of a humanity that is alive and always changing." Moreover, the Baltimore painting marks Pulzone's further departure from conventional formulas: he shows the figure almost full-length in all her bodily presence, accentuated even more by the three-quarter view. Thus, conformity to a rigid formula gives way to a characterization of the person and the personality—as exemplified by the features of this noblewoman. Within a few years, these changes were to culminate in the extraordinary achievements of Pulzone's last portraits, in which Scipione reduced accessories to essentials, abandoning mere representation for a vivid and lifelike interpretation of the sitter. The most eloquent example is the so-called *Lucrezia Cenci*, of 1594 (formerly in the Galleria Barberini). Her severe attire, the transparent veil that crowns her head, the small prayer book in her hands, and her responsive glance are reminiscent of a Virgin Annunciate. Nevertheless, these details mark the emergence of a new conception of society and of a more complex person, one who is aware of her own limitations and her own potential.

It has been suggested that Caravaggio stud-

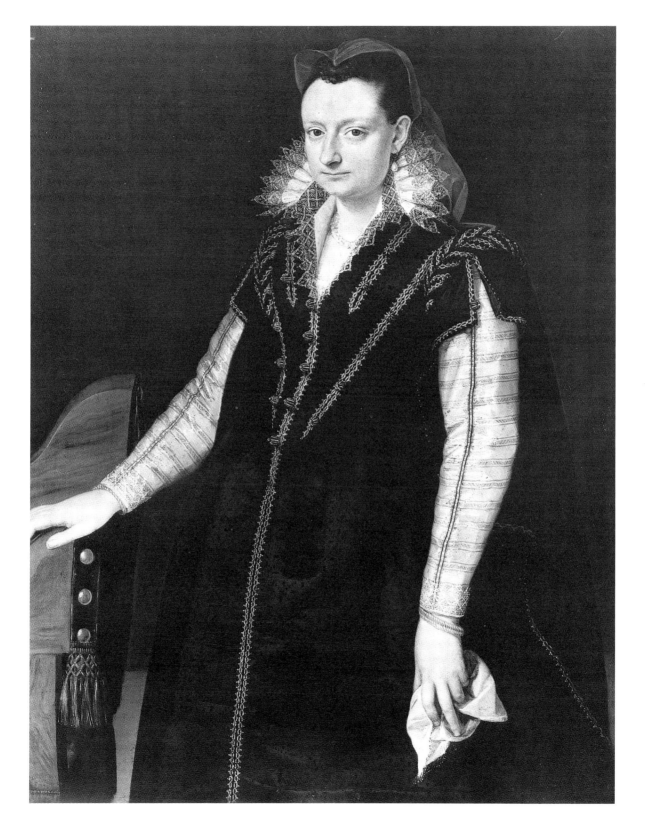

ied the portraits by Pulzone and drew inspiration from them for his own paintings. Voss (1923, p. 81) has correctly pointed out that the stylistic sources for Caravaggio's *Portrait of the Courtesan Phyllis* are to be found in Pulzone's portraiture. It is worth noting, moreover, that Caravaggio could even have seen various works by Pulzone in the residence of his patron, Cardinal Francesco Maria del Monte. According to the inventory published by Frommel (1971 b, pp. 31–32, 37–38), the Cardinal had four paintings by Pulzone in his collection: an unidentified portrait, two heads ("teste") of the Madonna, and "a portrait of the most illustrious and reverend cardinal del Monte" that can be dated after December 1588, when Del Monte was elected Cardinal. The Cardinal's choice of Scipione to paint his portrait is not only indicative of Del Monte's tastes; it also accorded with the interests of Caravaggio, whom he had taken under his protection. It should be mentioned that Caravaggio's *Portrait of the Courtesan Phyllis* was painted about 1598 (M. Cinotti, 1983, p. 411), some time after he had enjoyed the hospitality of Cardinal del Monte.

A. Z.

50. The Lamentation

Oil on canvas, 114 x 68 in.
(289.6 x 172.7 cm.)
Signed and dated (at right, on the cloth held by Joseph of Arimathea): SCIPIO CAIET[A]/ NVS FACI[E]/BAT AN[NO] DNI / MD.XCI
The Metropolitan Museum of Art, New York

The picture, identified and published by F. Zeri (1957; 1970 ed., pp. 90–93), was painted as the altarpiece for the Cappella della Passione in the Gesù, Rome, where it remained in place until the seventeenth century. On February 9, 1590, the Jesuit artist Giuseppe Valeriano received from Bianca Mellini, patron of the chapel, a first payment for Pulzone's work. Valeriano, who was in charge of the decoration of the chapel, had conceived a complex figurative program, furnishing designs that were carried out in fresco and on canvas by Gaspare Celio. Careful study of the paintings and inscriptions reveal that the entire cycle was to be a meditation on the mysteries of the Passion based on the relevant portions of the *Spiritual Exercises* (notes 290–96) of Saint Ignatius. The presence of the four Evangelists in the pendentives of the vault alludes to Saint Ignatius's synthesis of the four canonical versions of the *Passio Christi*. Moreover, the ceiling fresco emphasizes the desire of Ignatius to place his Christian "milites" (soldiers) "sotto il vesillo della croce" (under the standard of the cross), which, in fact, appears in the center of the oval vault. That Pulzone adhered to Valeriano's program is proven by his faithfulness to the passage from the Gospel of Saint John (19: 38–42) that was selected in the *Spiritual Exercises* for the "mysteries from the cross to the sepulchre" (n. 298). In fact, only the fourth Gospel mentions the presence of Nicodemus in addition to Joseph of Arimathea, who removes the body of Christ from the cross. Caravaggio's *Entombment,* contrariwise, is apparently based on the Synoptic Gospels, which do not include Nicodemus. Nonetheless, Nicodemus has frequently been identified with the figure supporting the legs of Christ, on the basis of an unsubstantiated statement by Bellori. (It seems more likely that Joseph, who owned the sepulcher, would have carried the body

of Christ to the tomb.) In his *Lamentation,* Pulzone appears to have followed Ignatius's method of the *compositio loci*: The background landscape is seen from an elevated spot—Golgotha—and the clouds are dispersing after having darkened the sky at the moment of Christ's death; Christ is taken down "in the presence of the grieving Virgin" and his women followers, while Joseph of Arimathea removes the ladder after having carried out his task.

The accurate representation of various realistic details (for example, the deathly pallor of Christ's feet and of the arm hanging at his side), is related to the "reformed" painting of Santi di Tito, and, in a certain sense, prepares the way for the realism of Caravaggio. Likewise, Pulzone's preference for the pure colors of the elegant but simple garments foreshadows some of Caravaggio's color schemes. The intense red and blue of the cloaks of Saint John and the Virgin in Caravaggio's *Entombment* are not dissimilar from those colors used by Pulzone in the *Crucifixion* in the Chiesa Nuova (it should be recalled that this picture would have been familiar to Caravaggio when he worked on the altar of the Pietà in the adjacent chapel). A like feeling of religious calm inspired both compositions, which, although they illustrate two distinct and successive moments of the Deposition and are based on two distinct conceptions, show the aftermath of the death of Christ. Scipione, however, followed another path that approximated Annibale Carracci's classicism, but its achievement was cut short by his premature death.

A. Z.

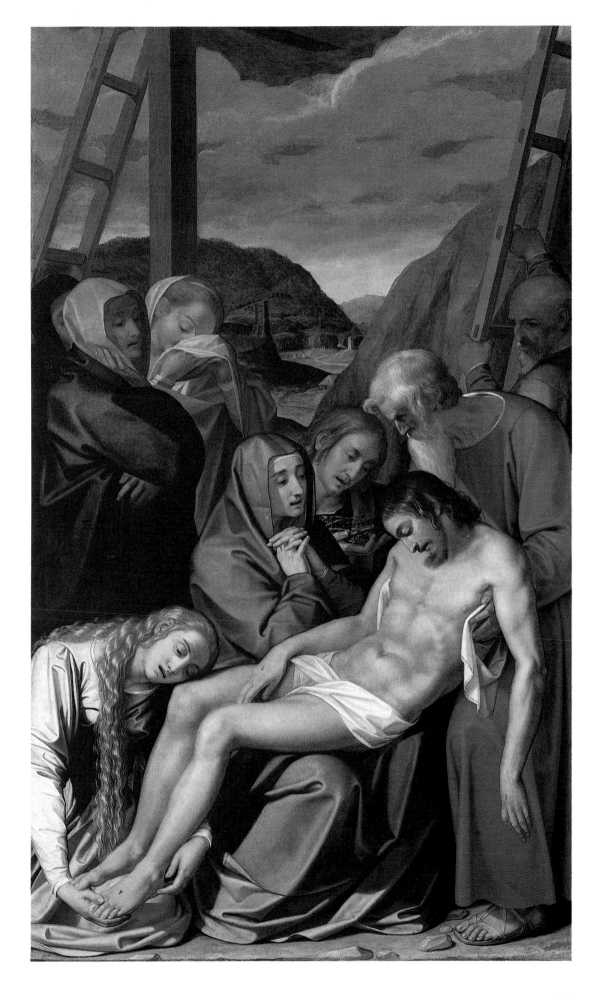

Guido Reni

Guido Reni was born in Bologna in the Jubilee Year 1575. He apprenticed with the Fleming Denys Calvaert for ten years, but broke with him in 1595 to join the Accademia degli Incamminati founded by the Carracci.

In 1601, Reni traveled to Rome, where he painted two works, commissioned by Cardinal Paolo Emilio Sfondrato (the nephew of Gregory XIV), for the Cappella del Bagno, in Santa Cecilia in Trastevere. Sfondrato was a member of the circle that revived Early Christian rites and cults; its leader was the celebrated Church historian Cardinal Cesare Baronio. Reni's activity for the Sfondrato continued until 1606. At this time, evidence of Reni's encounter with Caravaggio's Roman works is attested by The Crucifixion of Saint Peter (in the Vatican) that he painted in 1605–6 for Cardinal Aldobrandini, the Brera Saints Peter and Paul, and The Martyrdom of Saint Catherine, of 1605–6 (in Albenga). Caravaggio's departure from Rome in 1606 and Reni's brief absences from that city in 1603 and 1604 mark the end of his Caravaggesque phase. Even during this period, Reni's relationship to Caravaggio was ambiguous. According to Malvasia, Reni's principal seventeenth-century biographer, the Bolognese artist replaced Caravaggio in undertaking the commission for the Crucifixion of Saint Peter. Caravaggio accused Reni "of stealing his style and his color." However, as W. Friedlaender has pointed out, Reni may very well have chosen to employ aspects of Caravaggio's style to "correct" and surpass it. Indeed, in the small group of pictures that can legitimately be said to make up Reni's Caravaggesque period, there is an elegance and a concern for decorum that set these works in deliberate contrast to orthodox Caravaggism. Nevertheless, it would be wrong to assume that Reni simply employed Caravaggism for his own ends; he was clearly touched by the power of this new naturalism. From 1604 to 1606, Reni experienced hardships of his own—he was saved from debtor's prison with the help of the Marchese Facchinetti—that may have inclined him to appreciate the realistic elements in Caravaggio's art, and he was too sensitive a painter simply to manipulate these features. Further, despite the brevity of this intense Caravaggesque phase, Reni was affected for decades by the force and the volume of Caravaggio's figural style, which influenced works ranging in date from the Massacre of the Innocents, of 1611, to the Apollo and Marsyas (now in Munich), of 1621–22. Only with the development of his late, "silvery" style (during the decade of the 1630s) does Reni leave behind such modeling.

What marks Reni's oeuvre is the quality his contemporaries called "grazia"— a refinement seemingly inspired by heaven: So impressed were they by it that it was said that while other painters were endowed with human talents, his was the hand of an angel. This quality applies to Reni's Caravaggism as well.

51. David with the Head of Goliath

Oil on canvas, 93 1/4 x 53 7/8 in. (237 x 137 cm.) Musée du Louvre, Paris

The picture has been associated with the following two passages in Malvasia (1678; 1841 ed., I, p. 96, II, p. 37): "The beautiful standing David, companion to the afore-mentioned Judith with the head of Holofernes, who is shown with the left arm resting on a half column, holding the sling, while he grasps the head of Goliath— placed on a pedestal—and contemplates it. At his feet is the sword," and, "The beautiful Judith and the companion David painted for Monsù Criquì, and today, I am told, the property of his most Christian Majesty, which was praised by Marino." In 1619, Giovanni Battista Marino had dedicated a poem in *La Galleria* (p. 62) to a painting of this subject by Reni; although the description certainly suits the present picture, a number of factors make the identification problematic.

The Louvre *David* was first listed in the royal inventories in 1706, when it was in the Palais du Luxembourg (N. Bailly, 1709–10; 1899 ed., pp. 160 f.); it does not appear in Charles Le Brun's royal inventory of 1683. Moreover, according to Mariette (1727; 1857–58 ed., p. 361), the Louvre painting was from the collection of the Duc de Liancourt (1598–1674), and Mariette does not mention the Duc de Créqui. It is, nonetheless, possible that Charles III, Duc de Créqui (1623–1687)—the most probable candidate for Malvasia's Monsù Criquì —owned the *David* at one time and sold it to the Duc de Liancourt: He is known to have acquired paintings in Rome in the 1650s and was later ambassador to the city (see D. Wild, 1962, pp. 244 f.). Indeed, the *David* does not appear in the inventory made at his death in 1687, where five other works attributed to Reni are listed (see E. Magne, 1939, p. 190).

However, this hypothetical provenance still would not account for Malvasia's reference in 1678 to the king of France. One fact is reasonably certain: Contrary to what is commonly believed, the Louvre picture was never owned by Cardinal Mazarin. The painting of this subject in the Cardinal's

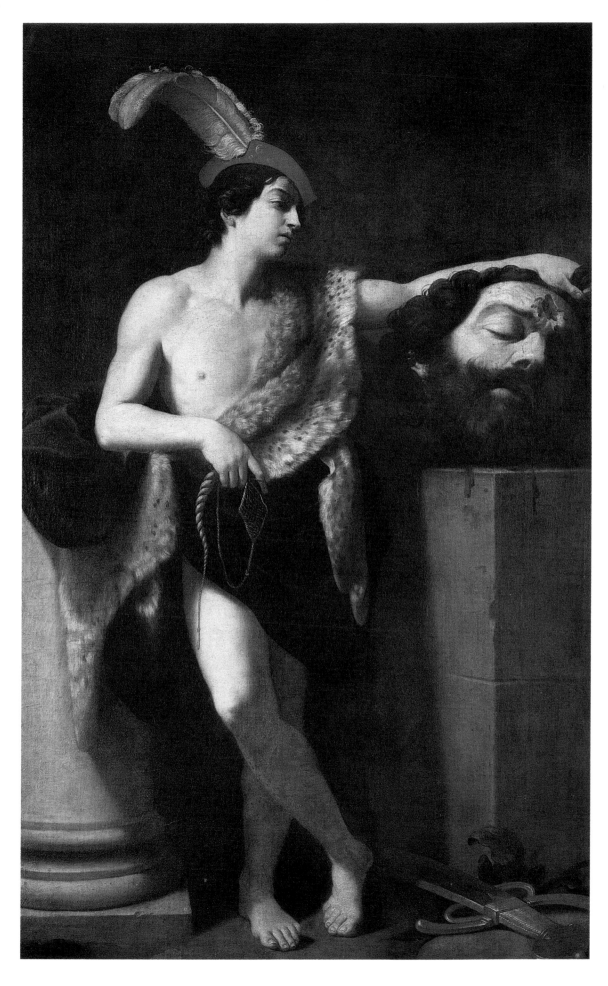

collection is described in his inventories of 1653 and 1661 as a "David holding in his hands the head of Goliath." The picture is shown in an engraving of Mazarin in his gallery; it conforms to the description in the inventories and differs considerably from the composition of the Louvre *David* (see R. A. Weigert, 1961, nos. 447, 464).

Concerning Malvasia's notion that the *David* was the pendant to a *Judith with the Head of Holofernes*, it should be noted that Reni's composition of that subject—known in a mediocre copy in the Galleria Spada, Rome, and in a superior version in the Sedlmayer collection, Geneva (a picture that has a Spanish provenance and may be identical with a work cited in the Spanish royal inventory of 1686)—dates no earlier than 1625. Interestingly, however, in the manuscript of the *Abécédario*, Mariette (1969 ed., p. 473) describes just such a painting before citing two version of the *David and Goliath*, so that it is possible that the two compositions were hung as pendants at some point.

What cannot be doubted is that the Louvre *David* is an autograph work of 1605–6. As such, it is an outstanding example of Reni's brand of Caravaggism. The figure of David wears a hat jauntily adorned with a feather, similar to those that appear in such works by Caravaggio as the *Calling of Saint Matthew* (in San Luigi dei Francesi, Rome). Indeed, this youthful type may be said to be one of the hallmarks of Caravaggio's style. Yet, Reni's David differs significantly from Caravaggio's, for all his obvious reliance on the latter's painting (cat. no. 97). Reni has used a classical source—a faun—for his David, and by presenting David in profile his composition becomes a more traditional one. Most important, he has totally avoided the highly personal associations that characterize Caravaggio's rendering of the subject, in which Caravaggio even reproduces his own features for the severed head of Goliath. Where Caravaggio's David seems to suffer from such ambiguous emotions as remorse, Reni's David is so untroubled a hero that his insouciant pose seems almost to border on the satirical.

The present painting reveals Reni's highly ambivalent attitude toward Caravaggio's art. As Friedlaender has suggested, Reni "improves" on Caravaggio from the standpoint of classical composition, but he is clearly attracted to the provocative, unclassical side of Caravaggio's paintings, as well: Reni's youthful David and the cavelike setting attest to this attraction. Nevertheless, Reni eschews the direct psychological engagement of the viewer that is the principal feature of Caravaggio's composition, with the result that the picture conveys the attraction and repulsion that Reni obviously felt toward his rival's powerful expressive style (W. Friedlaender, 1945; D. S. Pepper, 1971).

D. S. P.

52. The Agony in the Garden

Oil on copper, 26 3/8 x 16 15/16 in.
(67 x 43 cm.)
Musée Municipal, Sens

Malvasia (1678; 1841 ed., I, p. 97) mentions the *Agony in the Garden* among those paintings by Reni after which engravings were made (this picture was engraved by Jeremias Falck). The picture is listed in the 1653 inventory of the collection of Cardinal Mazarin as follows: "Our Lord praying in the garden of Olivet with a group of angels carrying the instruments of the Passion, a work of little figures, on copper" (*Inventaire de Tous les Meubles du Cardinal Mazarin . . .*, 1861 ed., p. 325, no. 276). The dimensions (one *pied* nine *pouces* high, one *pied* four *pouces* wide) are given in the 1661 inventory drawn up after the Cardinal's death, along with the incorrect information that the picture is on canvas (G.-J. Cosnac, 1885, p. 319, no. 1106). The painting was given by Mazarin's heir, the Duc de Mazarin, to the Duchesse de Chevreuse, who eventually sold it; it was purchased by Louis XIV in 1668 from the sculptor Gaspard Marsy (F. Villot, 1872, pp. 202 f., 302), and appears in a number of the royal inventories (N. Bailly, 1709–10; 1899 ed., pp. 156 f.). In 1895, the picture was transferred to the museum in Sens.

The *Agony in the Garden* marks the end of Reni's Caravaggesque phase. Stylistically, it is at the other end of the spectrum from the *David* (cat. no. 51). The jewel-like surfaces, the crumpled folds of Christ's drapery, and the intricate garland-like pattern created by the angels suggest the influence of the Cavaliere d'Arpino, instead of Caravaggio. This is not surprising, since Malvasia (1678; 1841 ed., II, p. 13) reports that Arpino was responsible for Reni's entry into the service of the reigning pope, Paul V, and of his nephew, Scipione Borghese, a passionate patron of the arts.

In fact, this elaborate drapery marks a return to an earlier manner rather than a new departure for the artist. Malvasia (1678; 1841 ed., II, p. 55) relates that, under the aegis of his first teacher, the Fleming Denis Calvaert, Reni studied prints by Dürer, and the accumulation of folds at Christ's feet and the marvelous layering of the angel's

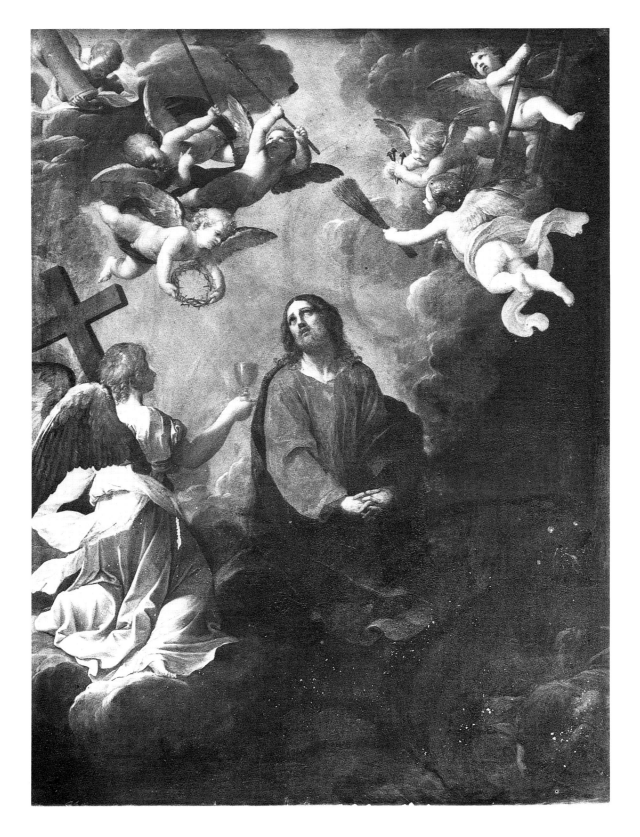

draperies attest to the reassertion of this earlier influence.

We can reconstruct Reni's passage from a Caravaggesque style to this new elegance: In the *Martyrdom of Saint Catherine* in the tiny parish church of Consciente, near Albenga, the influence of Caravaggio is combined with a Dürer-like treatment of the folds of the drapery (P. Matthiesen and D. S. Pepper, 1970, pp. 452 ff.). At least two other small paintings on copper, the *Ecstasy of Saint Francis* (in the Mahon collection, London) and the *Coronation of the Virgin* (in the National Gallery, London)—the latter work now magnificently cleaned—must date from about the same time as the Sens painting. Indeed, the London National Gallery picture is so close in date and size, as well as complementary in subject, that it could easily be a pendant to the present painting. An engraving by Reni, dated 1607, after a design by Luca Cambiaso showing a glory of angels, has analogies with the Sens picture and helps to establish its date more precisely.

One cannot help but feel that Reni abandoned his Caravaggesque manner—however adulterated it might have been—with a sense of relief. In temperament, he was never suited to Caravaggio's style, although the Lombard's work certainly touched upon some of Reni's emotional concerns. Nonetheless, Reni's experience with Caravaggism had an enduring effect on his figures and on his expressive use of chiaroscural effects. This is evident even in the *Agony in the Garden*: in the contrast between the dark, massive figure of Christ and the light, airy forms of the angels.

D. S. P.

Cristoforo Roncalli
called Il Pomarancio

The son of a Bergamask merchant, Giovanni Roncalli, Cristoforo was born at Pomarance, near Volterra, probably in 1552. Both Mancini, his first biographer, and Landi state that he was trained in Florence, although neither mention with whom. He is first documented in July 1576, when he was commissioned to paint the altarpiece of Saint Anthony in the cathedral of Siena. His study of the work of Domenico Beccafumi, as well as the various important commissions that he received while in Siena, made his stay especially profitable. Pomarancio may have arrived in Rome as early as 1578, although his residence there is documented only from 1582. Thereafter began his rapid rise in the difficult Roman art world. In 1583, he worked with Niccolò Circignani on the decoration of the Oratorio di San Marcello, subsequently obtaining both public and private commissions. One of these proved to be among his foremost works: the frescoes in the Mattei Chapel of Santa Maria in Aracoeli. He joined the Accademia di San Luca, becoming sindaco in 1593 and, six years later, one of the candidates for Principe (president). During the last decade of the century, Pomarancio established ties with Saint Filippo Neri's Oratorian circle, to which he was linked through his friendship with the priests of the community and with the Crescenzi brothers—the Abbot Giacomo and Cardinal Pier Paolo, his future patron and protector. He participated in the decoration of the transept of San Giovanni in Laterano, under the supervision of the Cavaliere d'Arpino, for the Jubilee celebrations of 1600, and he received the commission to decorate the Cappella Clementina in Saint Peter's. Asdrubale Mattei engaged Pomarancio to oversee the decoration of his palace. In 1605, Pomarancio replaced Leonello Spada in carrying out the designs for the new sacristy of the Santuario della Santa Casa, Loreto, but he had scarcely begun work when, in March 1606, he was invited to accompany the Marchese Vincenzo Giustiniani on a six-month tour of Europe. The success of his work in the sacristy earned Pomarancio his most prestigious and challenging commission: to fresco the cupola of the Santuario (now almost completely destroyed). His relationships with the Gonzaga dukes of Mantua—partly as a result of being recommended by Rubens— and with Cardinal Antonio Maria Gallo, protector of the Santa Casa, Loreto (who employed Pomarancio in his palace at Osimo) are also worth mentioning. Pomarancio died on May 14, 1626, at the age of seventy-four. His death certificate refers to him as "florentinus insignis pictor et nobilis eques."

53. Saint Domitilla, with Saints Nereus and Achilleus

Oil on canvas, 108 1/4 x 66 15/16 in. (275 x 170 cm.)
Santi Nereo ed Achilleo, Rome

Of the "four schools of living artists" distinguished in his *Discorso di pittura*, Giulio Mancini (about 1617–21; 1956–57 ed., I., p. 303) placed Cristoforo Roncalli after the Carracci, Caravaggio, and the Cavaliere d'Arpino, and with "those who had no following but who, however, have had and still have success and praise in their profession," singling out the present picture among the most representative of the artist's works. Elsewhere Mancini (p. 237) adds that after Pomarancio had followed a certain "variety of styles . . . he discovered his own," exemplified by the *Saint Domitilla,* and *The Baptism of Constantine* in San Giovanni in Laterano. The principal characteristic of these works is their refined classicism, which has been grafted onto a solid, "orthodox," Raphaelesque matrix. Indeed, as has been noted, Pomarancio's Saint Domitilla, who emerges from a gloomy darkness brightened by a burst of heavenly light, derives from Raphael's *Saint Cecilia.*
The painting—whose importance was recognized by Mancini—owes its fame to its stylistic purity as well as to the "primitivism" of its iconographic scheme, which made it a much imitated model for religious paintings of the early Seicento. Rubens was among the first to be inspired by the picture, when at work on his paintings for the Chiesa Nuova (cat. no. 55), and numerous artists followed suit, above all those who, like the Cavaliere d'Arpino, resurrected archaicizing compositions in the wake of the well-known revival of interest in early Christian and Medieval culture spearheaded by Cardinals Cesare Baronio and Federigo Borromeo. In fact, it was Cardinal Baronio who commissioned the painting for his titular church and suggested to Pomarancio the historicizing configuration of the three standing saints, which is based upon an early Medieval fresco of Gregory the Great flanked by his parents (A. Zuccari, 1981, p. 184). The commission probably dates from late 1596 (or shortly thereafter), when the decoration of the nave and

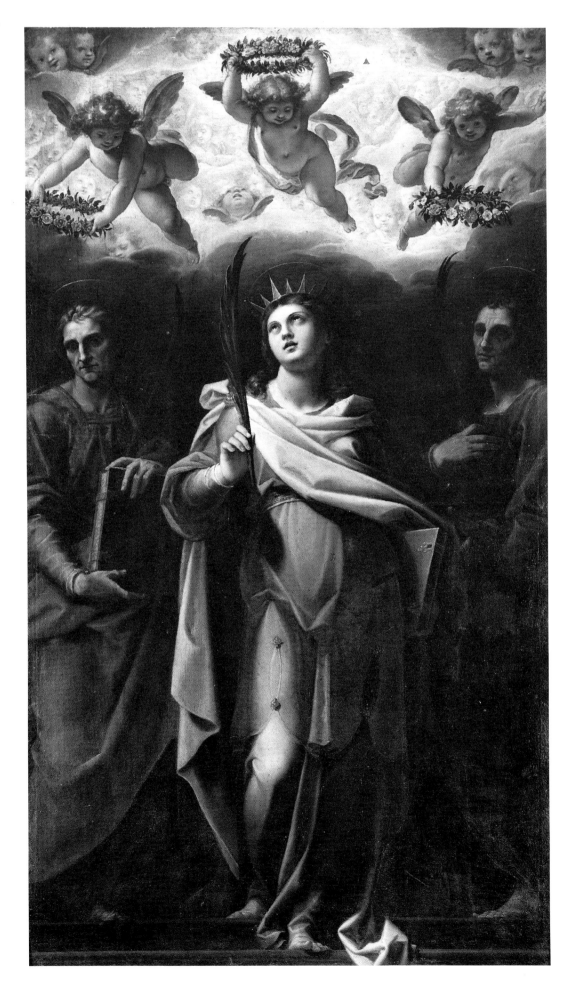

apse of the church was under consideration. In that year, Pomarancio was working on a series of canvases portraying the life of Saint Filippo Neri for the room dedicated to the saint in Santa Maria in Vallicella (the Chiesa Nuova); the paintings were finished in 1598. The artist's interest in the effects of light in these small canvases—which seems inspired by Tintoretto—is also apparent in the *Saint Domitilla,* but with a less vibrant result, due to a cooler light dictated by classicistic bias. It seems likely that Pomarancio's accentuated light was influenced by the Oratorians—his friends and patrons—and that he interpreted it according to the Augustinian theory of "enlightening Grace." This is a rare convergence between the cultural background of Pomarancio and that of Caravaggio—in whose work Calvesi (1971, pp. 113 ff.) has distinguished the evidence of "Augustinianism" in the symbolic use of light. Indeed, the stylistic differences between the two artists do not altogether preclude a mutual esteem—at any rate, on the part of Caravaggio, who listed Pomarancio among the "valenthuomini" in his libel suit of 1603. Moreover, Pomarancio was in contact with Caravaggio in 1599, when charged with examining the ultramarine blue furnished for the Contarelli Chapel canvases, and probably again at the Chiesa Nuova shortly after 1600, when Caravaggio painted the *Entombment*. Chiappini di Sorio (1983, pp. 11 ff.) has disproved their presumed competition for the commission to fresco the sacristy of the Santuario at Loreto by identifying Pomarancio's rival as Leonello Spada, called the "scimia del Caravaggio" (the ape of Caravaggio). It should be noted that Pomarancio attentively studied Caravaggio's work, as is obvious from the relationship that his *Resurrection* in San Giacomo in Augusta, Rome, bears to Caravaggio's *Conversion of Saint Paul* (see H. Röttgen, 1969, p. 70, n. 92, and I. Chiappini di Sorio, 1983, pp. 46, 114 f.).

A. Z.

Peter Paul Rubens

Rubens (1577–1640) was born in Westphalia, where his parents were in exile; his father, Jan, Catholic by upbringing, had had to flee Antwerp in 1568 with his wife and four children, his name having appeared on a list of Calvinists. In Cologne, Jan became agent and adviser to the second wife of William the Silent. A pregnancy revealed her intimacy with Jan and, although she obtained some clemency from William, the former alderman of Antwerp was under house arrest in Siegen when the future artist and his elder brother Philip were born. Maria Rubens returned to Antwerp only after her husband's death in 1587, bringing up her children as Catholics. Peter Paul, whose education had begun with his father, doctor utriusque juris, *attended the Latin school of Rumoldus Verdonck with Philip. His schooling ended with his appointment as a page to the Countess de Lalaing. His apprenticeship to painting began with a kinsman, Tobias Verhaecht; continued with Adam van Noort; and concluded with the most distinguished of the Antwerp Romanists, Otto van Veen, a specialist in emblems, who, in Italy, was an admirer of Barocci and of the strictly Roman tradition. Rubens's earliest independent works resembled the style of van Veen.*

On May 9, 1600, with two years' seniority in the Antwerp Guild of Saint Luke, Rubens and Deodat van der Mont—his own first pupil and constant traveling companion for eight years—set out for Italy to study the works of the ancient and modern masters. In Venice, Rubens was engaged as a "pittore fiammingho" by the Duke of Mantua to paint portraits, perhaps landscapes, and to copy Italian masterpieces. That October, he went to Florence with the Gonzaga retinue for the marriage-by-proxy of Maria de' Medici, his future patron, and Henry IV. From summer 1601 to spring 1602, Rubens was in Rome, recommended to Cardinal Montalto by Vincenzo I Gonzaga, for whom he was to copy paintings. His first public commission came through a family friend, agent of the archdukes regnant in Brussels, to supply altarpieces for the crypt chapel of Saint Helen in the archduke's former basilica of Santa Croce in Gerusalemme. A letter written by Philip Rubens in December 1601 indicates that Peter Paul had found opportunities to see the sights of almost every Italian city.

From March 1603, Rubens was again absent from Mantua for nearly a year on his first diplomatic mission: He had been entrusted by the duke with presents for Philip III and the Habsburg court. His Duke of Lerma, *painted at Ventosilla as captain-general of the Spanish cavalry, is the first of his masterpieces of equestrian portraiture and inaugurates the Baroque achievement in this genre. His fruitful association with the Genoese plutocracy began with his return to Mantua early in 1604. He then met Niccolò Pallavicini, Vincenzo I Gonzaga's banker, who would be godfather to Rubens's second son, and who, by the wishes of his own younger brother, P. Marcello Pallavicini S.J., commissioned from Rubens* The Circumcision *(delivered in 1605) and the* Saint Ignatius Healing a Woman Possessed *(delivered in 1620) for the new Gesù in Genoa. Through Niccolò Pallavicini's brother-in-law, Monsignor Giacomo Serra, Rubens was to obtain the coveted commission at the Chiesa Nuova, Rome, followed by another Oratorian commission for a* Nativity *for San Filippo, Fermo. During this second, longer stay in Rome, Rubens induced Vincenzo Gonzaga to buy Caravaggio's* Death of the Virgin, *and broadened his own earlier interest in the artist (manifest in Rubens's drawings at Chatsworth) so that it now included not only Caravaggio's* The Supper at Emmaus *(cat. no. 78) and* The Calling of Saint Matthew, *but also the more recent altarpieces at the Chiesa Nuova and at Sant'Agostino. However, not until a year or so after his return to Antwerp was Rubens's own work overtly Caravaggesque—for example, the* Cain Slaying Abel *(in the Courtauld Institute, London) and* The Supper at Emmaus *(known through Willem Isaaksz. Swanenburgh's engraving, of 1611). After Caravaggio's death, Rubens was a subscriber to the purchase of the* Madonna del Rosario *for Saint Paul's, the church of the Antwerp Dominicans. Despite this interest in Caravaggio's work, the art of Raphael, Correggio, Barocci, and the Venetians—as revived by Annibale Carracci— was ultimately of more importance to Rubens.*

54. Equestrian Portrait of the Marchese Giovanni Carlo Doria (1577–1629)

Oil on canvas, 104 3/8 x 74 in.
(265 x 188 cm.)
Palazzo Vecchio, Florence
(deposited by the Delegazione per le Restituzioni del Ministero Affari Esteri)

Since its rediscovery in Naples by Longhi (1939, pp. 123–30), this spectacular portrait of a *Cavaliere di San Giacomo* has been accepted as a masterpiece painted by Rubens in Italy. The eagle perched in the tree is a vivid reference to the Doria badge. The cross of Saint James on the breastplate helps to identify the painting as the one known to Ratti (1780, p. 332) in the Palazzo di Marcantonio Doria, Genoa: "un bel ritratto d'un Signore a cavallo, figurato per S. Giacomo, del Rubens." It remains the only example known of the class of work praised by Baglione (1642, p. 263): "[Rubens] depicted a number of Genoese noblemen from life mounted on horseback, in various canvases, lifesize, executed with love and very similar; and in this genre he had few equals."

Modern discussion has turned mainly on which son of Agostino Doria is portrayed, either Giacomo Massimiliano or his elder brother Giovanni Carlo, and, to a lesser extent, on dating—either 1602, as suggested by Müller Hofstede (1965), who would thus confine chronologically the interest of Rubens in Leonardo's *Battle of Anghiari*, or, following Longhi, 1606, as supported by Burchard (1950), Jaffé (1966), Bodart (1977), and Huemer (1977), all of whom note its congruity with Rubens's *Brigida Spinola Doria* (in Washington, D.C.), dated 1606, and with other documented activity related to his portrait commissions for Genoese families (see the letter from Paolo Agostino Spinola to Annibale Chieppio of September 26, 1606). Müller Hofstede is unpersuasive in proposing the Doria *Cavaliere* as the earliest known equestrian portrait by Rubens. Its flamboyant invention and its manner of execution can hardly antedate the *Duke of Lerma* (in Madrid), which is documented, signed, and dated 1603. Longhi identified the subject as Giacomo Massimiliano, partly onomastically, partly because the portrait

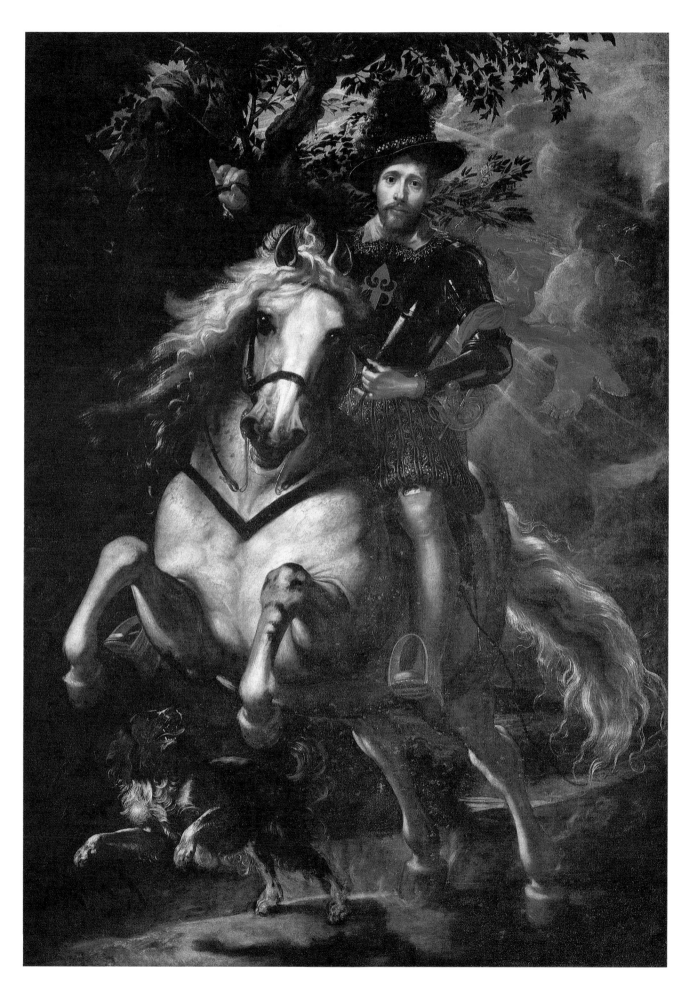

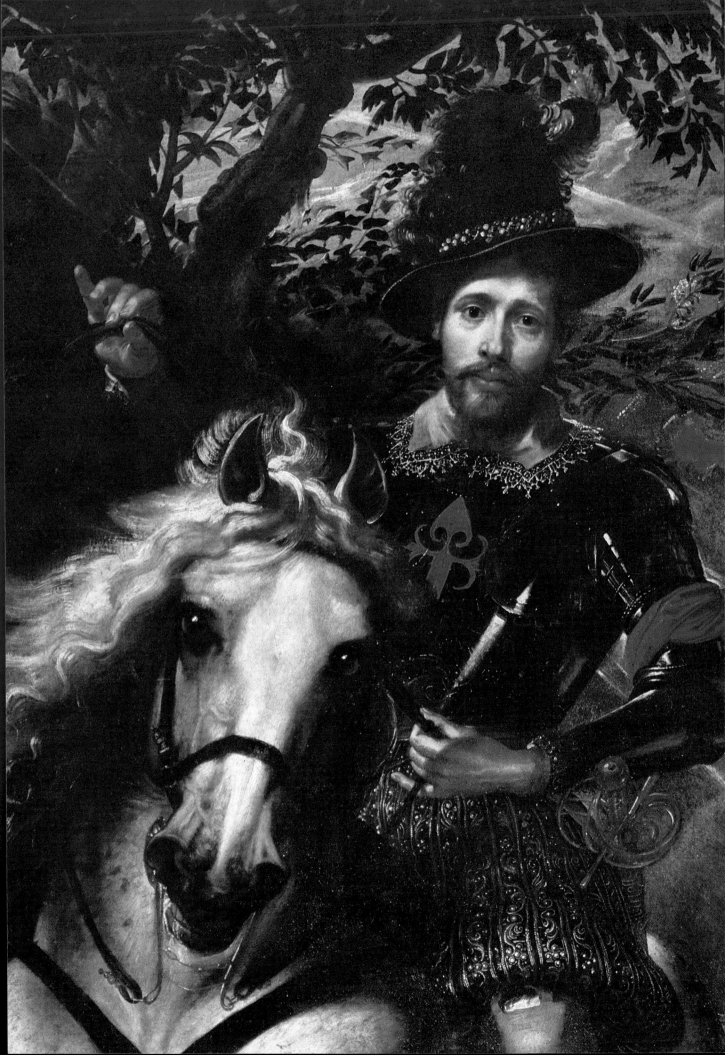

could then be taken as the pendant to that of Giacomo's wife, Brigida (originally also full-length), in the way that van Dyck, presumably following Rubens's example, was to pair the equestrian portrait of Anton Giulio Brignole Sale with the standing portrait of his wife, Paolina Adorno (both in the Palazzo Rosso, Genoa). However, the Doria *Cavaliere* is as likely to represent Giovanni Carlo, whose wife, Veronica, a daughter of Ambrogio Spinola, was also portrayed by Rubens (in the painting in the Staatliche Kunsthalle, Karlsruhe), about 1606, but seated. Longhi himself called attention to the will of Marcantonio Doria, in which an equestrian portrait of Giovanni Carlo was bequeathed to Giovanni Francesco: "Lascio al secondogenito Gio. Francesco oltre ad altri dipinti il seguente ritratto del quondam Gio. Carlo Doria a cavallo del Rubens." Burchard (1950) first accepted the identification of the sitter as Giacomo Massimiliano, but, according to Huemer (1977), later came to favor Giovanni Carlo, as did Müller Hofstede (1977, pp. 84–85). Giovanni Carlo, born the same year as Rubens, would have been twenty-nine in 1606, which is not discordant with this portrait. While the only certain guide to his appearance is an engraving after a lost portrait by Simon Vouet, made by Michel Lasne in 1620 (when the sitter was forty-three), a Vouet portrait of a *Cavaliere di San Giacomo*, a man of distinct Doria features, does exist (in a private collection). He is reputed to be Marcantonio, another brother of Giovanni Carlo and Giacomo Massimiliano, although he could as well be the man portrayed *a cavallo* by Rubens (G. Frabetti, 1977, pp. 210–11, figs. 75–76). Since the will of Marcantonio, father of Giovanni Francesco, mentions no other such equestrian portrait, it is reasonable to assume that the present Doria portrait represents Giovanni Carlo at the age of twenty-nine or thirty, and that it was painted in Genoa.

In Italy, Rubens was aware of the inventions disseminated from Florence by Antonio Tempesta. Müller Hofstede (1977, pp. 84–85) has demonstrated how, in reverse, Tempesta's 1593 etching of Henry IV of France anticipates formal elements in Rubens's painting: the diagonal movement of horse and rider bounding toward the spectator;

the excitement of the wind-blown mane and tail, and commander's scarf; and the display of the action against a cloudy sky. However, the writhing of the limbs of the tree, the silhouetting of the foliage, and the dramatic illumination of the clouds (boiling cumulus in the overall agitation of the painting, as opposed to freezing cirrus in the patterned schema of the print) all point to the more profound effects of Rubens's self-schooling in Venice. What is properly to be taken as a tribute to Caravaggio rather than to Tintoretto in the *Giovanni Carlo Doria* is the almost overwhelming sense of the physical proximity of the horse and rider. The composition of the *Lerma* was organically closer to the manner of Tempesta, its distant landscape animated by the Spanish cavalry wheeling in a cloud of dust. In the *Doria*, Rubens did not allow the compacted assault on the eye to be diffused beyond the foreground. The chiaroscuro of the tree and sun-rayed sky, which occupy the upper right-hand quadrant, and the placement, in the lower corner, of the forward-bounding spaniel, whose action echoes that of his master's charger, may owe nothing to Caravaggio, but the emotive thrust and the glances of the main figures confirm that Rubens studied the altarpieces in the Cerasi Chapel of Santa Maria del Popolo, as well as Tintoretto's work at the Scuola di San Rocco. The calculated risks of chiaroscuro in the modeling of the figures are more overtly Caravaggesque in the present portrait than in the horse and rider in Rubens's *Duke of Lerma*.

This brilliant advance in portraiture, achieved by Rubens through his experience of the painting of Florence, Rome, and Venice, did not go unnoticed in Genoa during the High Baroque: About 1645, Baldassarre Castiglione harked back to it in his altarpiece for the Oratorio di San Giacomo della Marina (M. Jaffé, 1977, p. 102), and so also did Valerio Castello in his *Rape of the Sabines* (formerly in the Palazzo Rosso, Genoa), as noted by G. Frabetti (1977, p. 214).

M. J.

55. Saint Gregory the Great, with Saints Domitilla, Maurus, and Papianus

Oil on canvas, 57 1/2 x 46 7/8 in.
(146 x 119 cm.)
Staatliche Museen Preussischer Kulturbesitz, Gemäldegalerie, Berlin-Dahlem

Plausibly the "Sinte Gregorius met dry figuren, van Rubens," listed in the 1668 inventory of Jan-Baptista Borrekens, Antwerp (J. Denucé, 1932, p. 255), this painting was first associated by Burchard (1926, p. 2) with the commissioning from Rubens of the principal altarpiece for Santa Maria in Vallicella, the Chiesa Nuova of the Roman Oratory. Burchard placed the picture at the beginning of the project. Evers (1943, pp. 111-16, 119, 327) tried to connect it with the painter's plans for the final phase of the work but, as Held (1980, p. 541) points out, this theory is generally rejected. Held supports the suggestion made by Jaffé (1963, pp. 209 ff.), upon the discovery of the documents, that Rubens, the protégé of Monsignor Giacomo Serra, painted the picture in Rome when asked by the Oratorians for an example of his prowess ("qualche opera fatta dal pittore nominando"). Rubens presumably welcomed this opportunity to demonstrate to the fathers both his promptness and his ability to work on an impressive scale—he had had no public commission in Rome since his altarpieces, of 1601–2, for the semi-subterranean chapel at Santa Croce in Gerusalemme, which may already have suffered visibly from the dampness. He made a spectacular bid for the coveted commission (which he refers to in a letter of December 2, 1606, to Annibale Chieppio, as "la più bella e superba occasione di tutta Roma") by submitting not a conventional subject, but a preliminary, if only approximate, formulation of what he gathered, or at least surmised, would eventually be required for the altarpiece. Saint Gregory's name had recently been added to that of the Madonna as co-patron of Santa Maria in Vallicella. Saint Domitilla, who was martyred with her eunuchs Saints Nereus and Achilleus (the subject was later to be included in the decorative program at the Chiesa Nuova), was venerated by the leading Oratorian, Cardinal Baronio, who had commissioned from

185

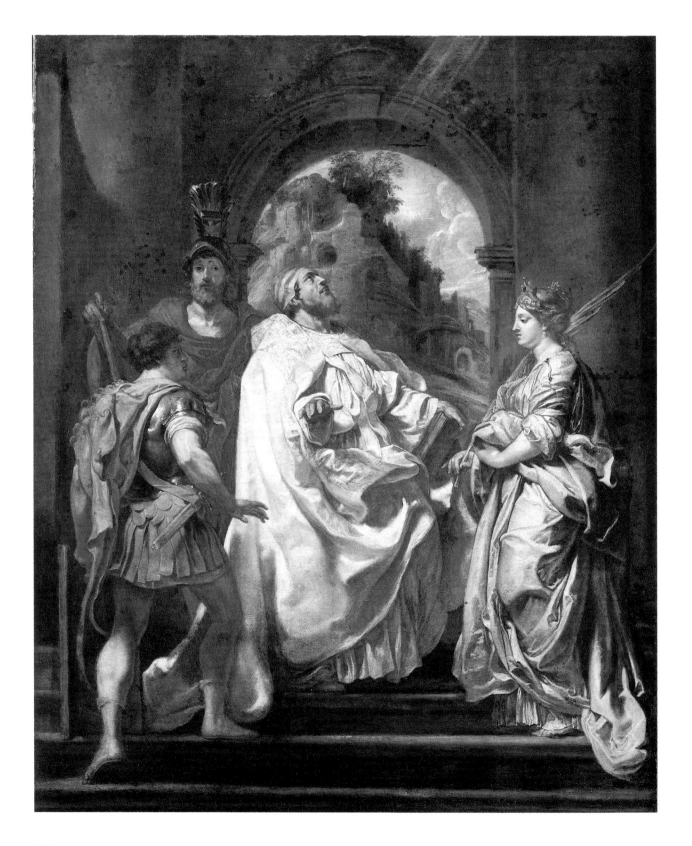

Pomarancio an altarpiece in the saints' honor for his titular church, Santi Nereo ed Achilleo (cat. no. 53); and silver reliquary heads of the Roman martyrs Saints Papianus and Maurus were already on the altar of the Chiesa Nuova (the entry for August 17, 1605, in the *Liber IV de' Decreti* indicates that the heads were in position). Foreknowledge of the likely program for the altar could well have been conveyed to Rubens by Serra, whose interest as a potential patron was represented within the Oratorian Congregation by P. Artemio Vannini (M. Jaffé, 1977, p. 86, n. 16).

The Berlin picture must just precede the congregation's acceptance, on August 2, 1606, of the offer of the painter—as yet unnamed but undoubtedly Rubens. Between August 2 and September 25, Rubens provided them with the "disegno o sbozzo" (now in Montpellier), a prerequisite for fulfilling the contract in full legal form. In the Berlin picture, Saint Gregory, as grandly Roman as Raphael's Aristotle, occupies the center, while Saint Domitilla, at the right, is like an antique statue in Venetian dress (M. Jaffé, 1977, p. 95). Her profile is cut with the sharpness of a cameo, but her staging and pose in relation to Saint Gregory echo those of Saints Catherine and Nicholas in Niccolò Boldrini's woodcut after Titian's *Madonna and Child, with the Holy Ghost and Two Angels*; Rubens had studied the actual altarpiece in San Nicolò dei Frari, Venice. Behind Saint Gregory, as though addorsed to the jamb of the archway, stands an antique Nerva in the guise of Saint Papianus, cloaked in the subdued but saturated red beloved by Bolognese painters. Saint Maurus in Roman uniform—and how pleased Rubens must have been with the authentic spirit this evokes—mounts the steps with elastic tread, the figure inspired by a like figure in Correggio's *Madonna with Saint George*, of which Rubens had penned a copy. The view of Roman ruins framed by the archway anticipates Paul Bril's landscapes of this sort, but the idea of introducing landscape into a religious subject—setting off large foreground figures against disproportionately small architecture that only emphasizes their visual order—derives from Agostino Carracci's *Last Communion of Saint Jerome*. Nothing was better calculated to please the metropolitan tastes of the first decade of the Seicento than this. As P. Flamminio Ricci, *Padre Superiore* of the Roman Congregation, was to write on February 23, 1608, recommending the services of Rubens to the Oratorian Congregation in Fermo, "E fiammingho ma da putto allevato in Roma" (He is Flemish, but as a boy was raised in Rome).

As Held has noted (1980, p. 542), the painting in the Siegerland-Museum, Siegen (inv. R-207), published by Müller Hofstede (1964, p. 445), is neither an autograph version of the Berlin picture nor likely to have been painted as a present for Monsignor Serra. The Berlin picture, not being a *bozzetto*, let alone a *modello*, for the Chiesa Nuova altarpiece, may have been acquired either as a gift, or purchased by Serra, without whom Rubens could not have had "un impresa ottenuta con tanta gloria contra le pretentioni di tutti li primi pittori di Roma" (a commission obtained with such glory against the pretensions of all the principal painters in Rome)—as Rubens described the *impresa* in a letter to Annibale Chieppio of December 2, 1606.

Only a few years before, one obvious rival, Caravaggio, had painted a masterpiece for the Vittrici Chapel at the Chiesa Nuova; its invention worked upon the imagination of Rubens for many years to come, but, conveniently for Rubens's chances in Rome, Caravaggio had had to flee the city at the end of May 1606.

M. J.

Carlo Saraceni

Born about 1579, Saraceni (also known as Carlo Veneziano, in deference to his native city) moved to Rome about 1598, and, according to Baglione, placed himself under the guidance of the Vicentine sculptor Camillo Mariani. Mancini, who was silent on the matter of Saraceni's initial training, emphasized instead his relationship to Caravaggio, although he expressed some reservations on the matter ("Carlo Veneziano . . . followed, to a degree, the manner of Caravaggio"). In point of fact, Saraceni's early work—which is known today through a group of pictures whose number has recently increased (A. Ottani Cavina, 1967, 1968, 1976; B. Nicolson, 1970; M. Waddingham, 1972; J. P. Cuzin-P. Rosenberg, 1978; R. Kultzen, 1978), following Longhi's (1913; 1943 a) fundamental contribution—proves that the formative influences on the young artist came from such Cinquecento masters as Jacopo Bassano, Romanino, Savoldo, and the Cavaliere d'Arpino. In Rome, however, Saraceni was quickly attracted by the most significant, modern, and even apparently contradictory styles: on the one hand, the incipient classicism of such Bolognese artists as Annibale Carracci and Domenichino; on the other hand, the naturalistic experimentation that Elsheimer carried out with such lucidity.

Although in a lawsuit instituted by Baglione in 1606 Saraceni was cited among the followers ("aderenti") of Caravaggio (L. Spezzaferro, 1975 b, pp. 53 f.), only later, in the second decade of the century, did he align himself decisively with the Lombard artist, joining Borgianni, Tanzio da Varallo, Marcantonio Bassetti, and Giovanni Serodine in reviving on a monumental scale the Caravaggesque tradition of religious painting. Saraceni's altarpieces for provincial churches in Gaeta, Palestrina, and Cesena, as well as his work in such Roman churches as San Simeone dei Lancellotti, Sant'Adriano, Santa Maria della Scala, and San Lorenzo in Lucina, date from this time; the Saint Benno Recovering the Keys of Meissen, of 1617-18 (in the German national church of Santa Maria dell'Anima), a work of intensely human and internalized religious feeling, marks his most Caravaggesque phase. In the first decade of the seventeenth century, by contrast, Saraceni—like

Elsheimer—preferred working on a small scale, depicting biblical and mythological themes with landscape backgrounds that dominate the scenes and that exhibit a strong naturalistic bent. Precisely because of his fascinating and autonomous achievement as a petit-maître—so alien to Italian traditions—Saraceni's workshop became one of the most significant channels for the exchange of motifs between Italy and the North, and his work was an obligatory point of reference for the circle of artists who gravitated around Elsheimer (among them Pieter Lastman, Jacob and Jan Pynas, and perhaps Johann König) under the influence of Galilean empiricism (A. Ottani Cavina, 1976, I).

Called to Venice in 1619, Saraceni died in the house of his noble patrons, the Contarini, in June 1620, leaving the Lorraine painter Jean Le Clerc—his friend and collaborator, and without doubt one of the principal proponents of Saraceni's style in France (along with Guy François, the Pensionante del Saraceni, and Philippe Quantin)—the task of completing his prestigious commission in the Palazzo Ducale to paint Doge Enrico Dandolo Urging the Crusade, a task that Orazio Gentileschi had tried in vain to obtain (A. M. Crinò, 1960, p. 264).

56. Mars and Venus

Oil on copper, 15 3/4 x 21 3/8 in. (40 x 54.3 cm.)
Thyssen-Bornemisza collection, Lugano

This picture, which appeared on the New York art market in 1979, is an important addition to our knowledge of Saraceni's early activity in Rome. The Bath of Mars and Venus (formerly in the A. Clark collection, Minneapolis), datable to the early years of the seventeenth century—after the Andromeda in the Musée des Beaux-Arts, Dijon, still Saraceni's earliest known work —offers the best basis for a comparison. These three paintings shed a good deal of light on the Venetian artist at the moment of his encounter with the artistic world of Rome. His training, which had, in certain respects, been Mannerist—even international Mannerist—was now informed by a knowledge of the work of the Cavaliere d'Arpino. This is most evident in the Andromeda, but it is perceptible even in the Rest on the Flight into Egypt, of 1606 (in the Eremo dei Camaldolesi, Frascati). Furthermore, in such pictures as the present one, there is a clear recourse to Raphaelesque classicism in the crisp, profiled, cameolike treatment of the forms and in the intentionally all'antica composition.

The iconography of the two paintings dealing with Mars and Venus can be traced to the decoration of the Palazzo Madama, Rome, and to Giulio Romano's decorations in the Sala di Psyche at the Palazzo del Te, Mantua—the Bath of Mars and Venus derives directly from this cycle, where the motif of the animated statues in architectural niches recurs (see Giulio's Adonis Fleeing the Wrath of Mars): However, Saraceni's interpretation is very different. It is both anti-heroic and anti-monumental: in a word, non-Mannerist. The classicistic ideal of well-defined forms predominates— as, for example, in the neo-Greek elegance of Cupid, who is mirrored in the shield of Mars, and in the ivory-like purity of the nudes, set off against the white linens of the nuptial bed. It was this return to a Raphaelesque heritage that permitted Saraceni to create a modern idiom with a more fluid, cursive manner, thereby leaving behind his Mannerist training. This

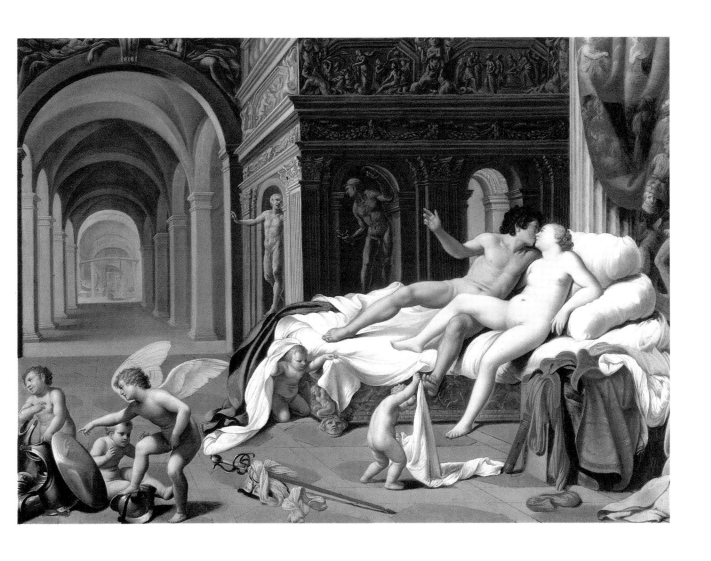

Raphaelesque revival, a common denominator in the evolution of other, contemporary artists—such as Annibale Carracci, Francesco Albani, and Guido Reni—is also apparent in the Alexandrian interpretation of the Mars/Venus love theme (Ovid, *Metamorphoses* IV, 167–189). The clandestine meeting of the god of war and the beautiful wife of Vulcan (a natural elaboration of the story of Cupid and Psyche) is enriched by the Hellenistic motif of putti "innocently" playing among the armor and the bedclothes in the sumptuous setting of the mythic palace of Vulcan, whose deserted forge is visible at the rear of the loggia (the god had pretended to leave in order to surprise the lovers).

Was this revival productive and modern, and did it lead to new developments? If we compare the present picture with the later version of the same theme in the Museu de Arte, São Paulo, which is contemporary with the Ovidian series in Naples (cat. nos. 58, 59), it is obvious that if Raphaelesque classicism enabled Saraceni to free himself from Mannerism, this classical background (so evident in the predilection for subjects foreign to the Caravaggisti) did not prevent him from giving the forms greater naturalism or from painting landscape and the nude on the model of Caravaggio and Elsheimer. Nonetheless, in the present picture, Caravaggio's influence is not yet felt. Rather, the fancifully storiated tapestry and the feigned stuccos in monochrome are painted more in the tradition of the *accademie alla veneziana*: The rich surface is typical of this school and it recurs in the work of the young Domenico Fetti and Marcantonio Bassetti (see Bassetti's letter from Rome to Palma Giovane, dated May 6, 1616, in G. Bottari-S. Ticozzi, 1822, II, p. 485).

Also worthy of note is the monumentality of the interior setting—the mysterious recession of the architecture and the flawed beauty of the terra-cotta pavement, with the careful description of every nick and every worn spot: From the outset there was in Saraceni's work a Northern component that he perhaps assimilated in Venice by way of Hans Rottenhammer.

A. O. C.

57. Paradise

Oil on copper, 21 3/8 x 18 7/8 in.
(54.3 x 48 cm.)
The Metropolitan Museum of Art,
New York

This picture, which, prior to its sale in London (Sotheby's, April 7, 1932, no. 55; July 16, 1969, no. 128), belonged to the Earl of Harewood at Chesterfield House, London (see F. Zeri, 1973, pp. 49 f.), attracted the attention of Nicolson (1970, p. 312, fig. 53), who noted its relationship to the treatment of the subject by the Venetian masters Veronese, Titian, Tintoretto, and Jacopo Bassano. It may be added that the iconographic scheme derives from much older and more popular representations of the *Coronation of the Virgin*, in which concentric circles serve as the basis for the composition. The last link in the chain of sixteenth-century paintings of the Coronation that served as prototypes for the newer series showing Paradise, is Johann Rottenhammer's version of 1598 (now in the National Gallery, London). This use of the same compositional scheme to illustrate a different doctrinal concept is worth mentioning, for the Glory of Paradise tended to be interpreted as a visual expression of the mystical presence of Christ's body, a doctrine that received new emphasis during the Counter-Reformation (see A. Ottani Cavina, 1974, pp. 41 ff., 49 ff.). In fact, the new representations of *Paradise* by Saraceni, the young Rubens (in the Museum Boymans van Beuningen, Rotterdam), Scarsellino (formerly at Goudstikker, Amsterdam), Marcantonio Bassetti (in the Museo Nazionale di Capodimonte, Naples), J. Heinrich Schönfeld (formerly in the Graetz collection, Vincigliata), Scipione Compagni (by whom there are numerous versions), and, it may be added, even by Elsheimer—whose *Exaltation of the Cross* (in the Städelsches Kunstinstitut, Frankfort) is a variation of sorts on the theme—seem motivated by precise theological considerations codified in the catechism of the Council of Trent in 1564 and later by Cardinal Bellarmino in 1598 and 1616. It is against this background of religious controversy that the treatment of the theme in the early seventeenth century becomes intelligible as a response to Protestant iconoclasm by representing the spectacular glories of the Blesseds and of the Saints, in a clear and recognizable fashion. In Saraceni's picture, the four doctors of the Church—Gregory the Great, Augustine, Ambrose, and Jerome—as well as Saints George (?) and Christopher, and King David, are identifiable in the foreground, while in the upper register are Moses and Saints Cecilia, Peter, Paul, and Lawrence.

It is evident, however, that such a doctrinal interpretation depends upon the knowledge that the painting was commissioned by an orthodox Catholic patron. Precisely this knowledge is lacking for Saraceni's *Paradise*, although Zeri (1973, p. 50) has aptly suggested that the patron is probably shown at the extreme left in the guise of Gregory the Great. Nevertheless, an analogous case is provided by the *Paradise*, painted for just such a patron—Cardinal Pietro Aldobrandini—by Saraceni's collaborator in Rome, Bassetti.

With the evolution of the iconography, the formal characteristics also changed. The majestic scheme of the Venetians, still apparent in the altarpiece that Francesco Bassano the Younger painted about 1591 for Il Gesù, Rome, is translated—as Longhi emphasized—into the "lower case, cursive script" typical of the circle of Northern *petits maîtres* in Rome, to which the young Saraceni belonged.

The Metropolitan Museum's *Paradise*, which dates from early in Saraceni's career, furnishes precious indications about his artistic formation. It underscores the northern origin of his colors—the vibrant reds, greens, and gold, and the harmony of the lilacs and sharp pinks—and it contains figure types that recur in Saraceni's later work: The Saint Christopher at the right will become the Saint Roch in the canvas in the Museo Nazionale, Naples, and the virgin martyrs, with their lost profiles, will reappear as Saraceni's mythical heroines. It is as though Saraceni, from the outset, was seduced from his Venetian heritage by the cold luminosity of Northern painting: first in Venice by Rottenhammer, who is documented there from 1596, and then in Rome by Elsheimer.

A. O. C.

58. The Flight of Icarus

Oil on copper, 15 3/4 x 20 11/16 in.
(40 x 52.5 cm.)
Museo Nazionale di Capodimonte, Naples

59. Ariadne Abandoned by Theseus

Oil on copper 15 3/4 x 21 1/16 in.
(40 x 53.5 cm.)
Museo Nazionale di Capodimonte, Naples

The Flight of Icarus and *Ariadne Abandoned by Theseus*, together with four other pictures also at Capodimonte (formerly in the Farnese collection, Parma, and, before that, in their residence in Rome, even though the series does not appear in the 1662 inventory published by Filangeri in 1902), have assumed a crucial importance in defining Saraceni's historical identity as a landscape painter. Longhi (1913) took the decisive step of disassociating Elsheimer's name from the series, but, in fact, in the inventory of paintings in the Palazzo del Giardino, Parma (Archivio di Stato, Parma), which dates from about 1680 and was published by Campori in 1870 (p. 235), the six paintings are listed in the "settima camera" in unequivocal terms: "Tutti segnati et a una misura, di Carlo Veneziano." Confusion, however, has been perpetuated by the unacceptable proposals of Moir (1967, II, pp. 99 ff.) that the pictures represent a collaboration between Saraceni and Elsheimer, and of Andrews (1977, p. 44), who attributes the figures to Saraceni and the landscapes to Jacob Pynas—this at a date when a good deal of light had already been shed on the diverse characteristic and historical roles of these artists. The present writer has projected a reconstruction of the youthful activity of Saraceni as a landscape painter based on the documented Farnese series (A. Ottani Cavina, 1968, pp. 60 f.), which was among the first shipments of paintings sent to Naples after the arrival of Charles III in 1734, and has used these works to evaluate Saraceni's leading position in Elsheimer's circle (Pynas seems, by contrast, to have occupied a secondary place). More recently, Salerno (1977–80, I, p. 134) has cautiously revived the notion of an ill-defined collaboration between Saraceni and Pynas. Actually, as with a number of Elsheimer's pictures, the series was inspired by Ovid's *Metamorphoses* and was certainly known to Pynas, who painted a version of the Capodimonte *Salmacis and Hermaphroditus* (inv. C 448; Pynas's picture, now lost, is known through a 1623 engraving by Magdalena de Passe, inscribed Jc Pynas pinxit). This engraving allows us to draw two important conclusions: First, that 1608, the year in which Pynas returned to Amsterdam from Rome—where he had been since 1605—is a *terminus ante quem* for the execution of Saraceni's series, and, second, that Pynas radically altered the figures in a Romanist fashion, while he treated the landscape in archaicizing terms reminiscent of the work of Paul Bril. In other words, Pynas's picture shows a regression in the coefficient of nature and truth that Saraceni had already achieved.

In Rome, where he was associated with Saraceni, Pynas assimilated a repertory of vegetal and geological forms. The Italian poplar, with its compact foliage dappled with light, for example, became the leitmotiv of many of the landscapes that he painted after his return to Holland. Nevertheless, in his early panel paintings (panel was the most preferred support; Pynas resorted to copper more rarely), which date from the first decade of the century—and thus are of the greatest interest for the problem at hand—the landscape shows a hardness that differs from the breadth and the luminous, atmospheric unity of the Capodimonte landscapes. Pynas employs a more minute and insistent technique, with the branches of the trees arranged in an artificial fashion against the sunny horizon—as in a painting of a biblical scene (in the Kurhessische Hausstiftung, Worms) and in the *Rest on the Flight into Egypt* (in the Stiftung Kunsthaus Heylshof, Worms). Where a detail appears somewhat heavy-handed in the Capodimonte landscapes it is due to the restoration of flaking—an endemic problem of paintings on copper. As Oehler (1967) has demonstrated, although Pynas certainly worked in a vein similar to that of Saraceni, he only approached Saraceni's prototypes in a demonstrable fashion in the second decade of the century, when his trees conform less exclusively to Bril's typology and the narrative content becomes somewhat less excessive.

These points should be kept in mind when evaluating the Ovidian series in Naples. The paintings, datable to about 1606–7, seem far more naturalistic and modern than such contemporary, large-scale works by Saraceni as *The Rest on the Flight into Egypt*, in the Eremo dei Camaldolesi, Frascati (the date of 1606 on the rock to the right has been verified in response to the doubts voiced by J. Thuillier, 1982, p. 21); there, the contours that define the pebbles and foliage in the foreground serve to isolate and separate the forms.

The Flight of Icarus, whose theme is taken from *Metamorphoses* VIII, 183 ff., and *Ariadne Abandoned by Theseus*, inspired by *Metamorphoses* VIII, 169 ff., underscore the autonomy and richly expressive language of Saraceni (Pynas also plagiarized the *Ariadne*; see L. Oehler, 1967, fig. 21). These works represent the apex of Saraceni's investigative, Elsheimerian realism, while revealing an emotivity that presages the Vergilian poetry in the paintings of Claude Lorrain. The imploring Ariadne, who stands on the shore while Theseus's ship sets sail on the rippled waters of the gulf, is an invention of great pathos, embodying the antique acceptance of both the heroic and the tragic. The elegiac poetry of her abandonment prevails over the searing passion of betrayal, and the femininity of Ariadne—sublimated in Saraceni's image of an ordered yet benign Nature—is a paradigm of the artist's sentimentality. Indeed, the intense lyricism evokes not the laconic passage in Ovid, but the lament of Ariadne in the *Carmine* of Catullus (LXIV, 60 ff.; trans. F. W. Cornish), which Saraceni's picture seems to follow almost to the letter:

> At whom [Theseus] afar from the weedy beach with streaming eyes the daughter of Minos, like a marble figure of a bacchanal, looks forth, alas! looks forth tempest-tost with great tides of passion. Nor does she still keep the delicate headband on her golden head, nor has her breast veiled by the covering of her light raiment, nor her milk-white bosom bound with a smooth girdle; all these, as they slipt off around her whole body, before her very feet the salt waves lapped.

Perhaps the notion of illustrating these lines

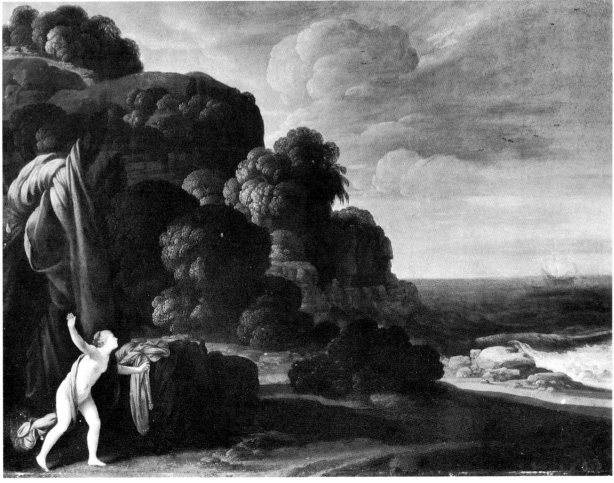

was suggested by the literary bent of the patron.

By contrast, *The Flight of Icarus* marks Saraceni's closest approximation of Elsheimer's preference for "irregular" compositions: syncopated and asymmetrical structures that are diametrically opposed to the melodic scansion of classic space in Bolognese painting (for example, Elsheimer's *Aurora,* in the Herzog Anton Ulrich-Museum, Braunschweig). The unexpected darkness of the wooded ravine and the opalescent water in the distance establish a dramatic counterpoint to Icarus's reckless flight against the light of the sun. The tension created between the landscape and the figures, underscored by the dark hill in the foreground, is the most dramatic and Caravaggesque passage in Saraceni's landscapes. Among Italian painters, only Gentileschi attained a comparable effect—without the use of a *repoussoir* device—in his luministic rendition of the river landscape that extends behind Saint Christopher (cat. no. 41).

A. O. C.

60. Saint Roch and the Angel

Oil on canvas, 75 x 50 1/4 in.
(190.5 x 127.5 cm.)
Galleria Doria-Pamphili, Rome

For Saraceni's capabilities as a follower of Caravaggio to be fully revealed, it would be necessary to examine his altarpieces of the second decade of the century (his masterpieces are in Santa Maria dell'Anima, Rome), which place him among the most original interpreters of religious themes. Compared to the populist art of Borgianni, Marcantonio Bassetti, and Serodine, Saraceni employs a more sentimental and intimate means of expression, underscoring the humanity of his figures with moral gravity. As Arcangeli has remarked (1967), Saraceni's accent is elegiac rather than dramatic. But if his public works are touched by a sweet and affecting grace, the dominant feeling underlying a number of his smaller altarpieces intended for private devotion—such as the present *Saint Roch* —is a languid, unconstrained tenderness. Indeed, although only an exhaustive examination of the archives of the Doria-Pamphili (the picture has belonged *ab antiquo* to the family, and was attributed to Bartolomeo Schedoni until corrected by Voss in 1924) can furnish concrete information on the picture's original location, its dimensions leave little room for speculation. Did it decorate the altar of a private chapel or an oratory—or perhaps a confraternity of Saint Roch, like the one documented as annexed to the hospital at the Porto di Ripetta, just a short distance from Saraceni's living quarters in the strada di Ripetta in the parish of Santa Maria del Popolo, Rome? This last hypothesis is tempting, considering the continuous history of the cult of Saint Roch, propagated by the Franciscans and the Capuchins with the cyclical return of the plague.

The iconography is both traditional and orthodox: There is the angel who was sent by God into the forest of Piacenza to cure the bubo of the pilgrim, and the faithful mongrel who guards Roch's daily ration of a morsel of bread. By contrast, Saraceni's interpretation is highly individual, mysteriously combining the two foremost aspects of his background at the beginning of the second decade: on the one hand, a neo-Giorgionism and, on the other, a new naturalism. In fact, it was during his Roman years more than in his actual Venetian period (1619–20) that an atmospheric quality that can be traced back to Giorgione, and the saturated colors of Veronese's paintings were most in evidence in Saraceni's work. One may note the dark green of the forest; the beautiful range of browns, violets, and blues; and the pale color of the angel's wing against the hyacinth blue sky. Nonetheless, the fluid and pictorial rendering of the forms does not diminish the brilliance of the colors (the *pittura di valori,* to apply Longhi's expression and the distinctions that he made in his 1916 article on Gentileschi) that is the proof of Saraceni's awareness of Caravaggio. The use of whites and the luminous transparency of the garments, which echo the blue sky, are enough to assure us of Saraceni's study of nature, although such tendencies were rarely either radical or exclusive in his subsequent work. On the whole, it is impossible not to reaffirm the judgment of Saraceni's contemporary, Mancini, who, despite the artist's striking naturalistic experimentation, nonetheless stressed that Saraceni could only be considered a follower of Caravaggio "in parte"—to which Bellori (1672) added that his work "fu meno tinto" "was less strongly colored").

Beyond its narrative pretext, the nocturnal setting may be interpreted as a romantic, crepuscular embodiment of a spiritual state of exhaustion, solitude, and abandon. At the same time, the picture's extraordinarily direct appeal lies in its typically Caravaggesque way of narrating the story in a straightforward fashion, underscoring the actuality of the event.

A copy of the picture appeared on the art market in Venice, and another is in the picture gallery at the Château de Beloeil, Belgium. The latter picture confirms that the clearly visible vertical strips on the left- and right-hand sides of the Doria canvas are later additions.

A. O. C.

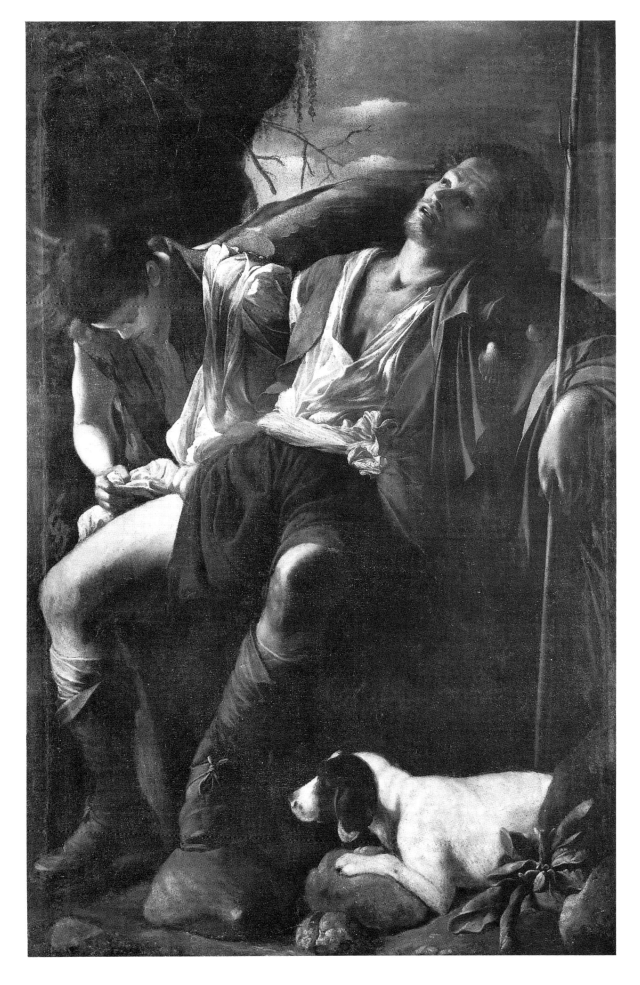

Caravaggio
*Paintings by, after, or attributed
to Caravaggio*

Michelangelo Merisi da Caravaggio
A Documentary Survey of His Life

1571

Michelangelo Merisi da Caravaggio is born—probably in Milan—to Fermo di Bernardino Merisi and his second wife, Lucia Aratori, both natives of the town of Caravaggio, east of Milan. According to Baglione (1642, p. 136) and Bellori (1672, p. 202), Fermo was a mason. However, Mancini (about 1617–21; 1956–57 ed., I, p. 223) states that he was majordomo and architect ("mastro di casa et architetto") to Francesco I Sforza, Marchese di Caravaggio. The marchese was a witness at Fermo's second marriage, and their relationship seems to have been a close one. Michelangelo's only brother to reach adulthood was born the following year and took holy orders in 1583. The family resided principally in Milan until 1576, when they returned to Caravaggio, probably to escape the plague. Fermo died the following year.

1584

Caravaggio returns to Milan to be apprenticed for four years to the Bergamask painter Simone Peterzano, a pupil of Titian (the contract is dated April 6, 1584).

1589

The young artist is documented in Caravaggio. His mother dies there in 1590.

May 11, 1592

Michelangelo ("habitans Caravaggii") and his brother are in Caravaggio for the division of their inheritance. There is no further notice of the artist until 1599. Bellori (1672, p. 202) reports that Caravaggio fled from Milan because of some quarrels ("alcune discordie") and visited Venice before going to Rome. Mancini (about 1617–21; 1956–57 ed., I, p. 224), Caravaggio's earliest biographer, states that the artist arrived in Rome "at about the age of twenty," living first with a beneficiary of Saint Peter's, Monsignor Pandolfo Pucci (nicknamed by Caravaggio Monsignor Insalata, since salad was all that Pucci gave him to eat), for whom he painted copies of devotional pictures, and then joining the workshop of the Cavaliere d'Arpino for eight months. According to Baglione (1642, p. 136), Caravaggio was associated with a Sicilian painter prior to working for Arpino, by whom "he was employed painting flowers and fruit"

(Bellori, 1672, p. 213). Other colleagues mentioned in early sources are Mario Minnitti, Antiveduto Grammatica, and Prospero Orsi (Prosperino delle Grottesche). The stay with Arpino was evidently concluded by Caravaggio's illness and hospitalization (Mancini, in a marginal note, about 1617–21; 1956–57 ed., I, pp. 226 f.). Mancini (p. 224) further states that, after leaving Arpino's workshop, Caravaggio stayed with Monsignor Fantino Petrignani, which, if correct, would probably have occurred in 1595. Such half-length compositions as the Boy Peeling a Fruit, *the* Boy Bitten by a Lizard, *and* The Fortune Teller *(cat. nos. 61, 70, 67) are said by Caravaggio's three biographers to have been painted in these first years in Rome. It should be noted that Caravaggio's uncle was a priest in Rome, and his brother was in the city from 1596 to 1599.*

According to Baglione (1642, p. 136), a French dealer, Maestro Valentino, whose shop was near San Luigi dei Francesi, brought Caravaggio's work to the attention of the cultivated Cardinal Francesco Maria del Monte, who, upon purchase of the Cardsharps (i "Bari"), *provided Caravaggio with quarters in his palace near San Luigi (Caravaggio was still living there in November 1600). The 1627 inventory of Del Monte's collection, in fact, lists eight paintings by Caravaggio (see cat. nos. 67, 68, 69, 72). It was doubtless through Del Monte that Caravaggio gained access to an elite clientele, and through him, also, that—so Baglione says—he received his first public commission at San Luigi dei Francesi.*

July 23 and August 1, 1599

Caravaggio is contracted for 400 scudi to paint two canvases, The Calling of Saint Matthew *and* The Martyrdom of Saint Matthew, *for the lateral walls of the Contarelli Chapel in San Luigi dei Francesi (figs. 4, 5, pp. 34 f.). The commission to decorate the chapel, the rights to which were acquired by Matteo Contarelli (Matthieu Cointrel) in 1565, initially went to Girolamo Muziano. At Contarelli's death in 1585, work had not yet begun. His executor, Virgilio Crescenzi, commissioned a marble group of Saint Matthew and an angel for the altar in 1587, and fresco decorations for the walls and the vault from the Cavaliere*

d'Arpino in 1591. Arpino finished the vault by June 1593, but work came to a stop; only through repeated petitions by the congregation of San Luigi to the Fabbrica of Saint Peter's—with which Del Monte was associated—was pressure brought to bear on the Crescenzi to complete the chapel's decorations. Caravaggio's two pictures, which established his fame (Baglione, 1642, p. 137), were completed by July 1600.

April 5, 1600

Caravaggio is commissioned to paint a large canvas for Fabio de Sartis in Siena, for which he furnished a modello ("sbozzo"). *The picture was paid for that November, but is not traceable.*

September 24, 1600

Caravaggio, "egregius in Urbe Pictor," receives a commission to paint The Conversion of Saint Paul *and* The Crucifixion of Saint Peter *on the lateral walls of the Cerasi Chapel in Santa Maria del Popolo—for which preliminary* modelli *and drawings were required (figs. 8, 9, pp. 38, 40). Two versions of each picture were painted: The first, on panel, "did not please the patron, and Cardinal Sannesio took them" (Baglione, 1642, p. 137). Final payment for the two canvases (still in place) was made on November 10, 1601. The altarpiece,* The Assumption of the Virgin *(on panel), was commissioned from Annibale Carracci.*

November 19, 1600

Caravaggio is accused of assault.

February 7, 1601

A case against Caravaggio for having wounded a sergeant of the guards of the Castel Sant'Angelo is dropped after the two parties make peace.

February 7, 1602

Caravaggio is commissioned to paint "Saint Matthew writing his gospel with the angel on the right dictating" for the altar of the Contarelli Chapel in San Luigi dei Francesi. (The marble group—unfinished—had been rejected.) Two versions were produced. The first, "which pleased no one" (Baglione, 1642, p. 137), was purchased by Caravaggio's patron Vincenzo Giustiniani, who, according

to Bellori (1672, p. 206), paid for the second version (still in place). Caravaggio received payment on September 22, 1602. A frame was paid for on October 5, 1602, and again in February 1603.

May 20, 1603
Maffeo Barberini makes the first of several payments for an unspecified painting (see cat. no. 80); the last is dated January 8, 1604.

August 28, 1603
Giovanni Baglione brings a libel suit against Caravaggio, Onorio Longhi, Orazio Gentileschi, and Filippo Trisegno for derogatory verses about his altarpiece in Il Gesù (cat. no. 16). Caravaggio is arrested September 11 and freed September 25. His testimony on September 13 contains some of his few recorded views on painting and on his contemporaries.

April 24 and 25, 1604
Testimony against Caravaggio for insulting a waiter and throwing a plate of artichokes in his face.

September 1, 1604
Caravaggio's altarpiece of the Entombment *for Santa Maria in Vallicella (the Chiesa Nuova) is referred to as finished. Reconstruction of the chapel had begun in 1602.*

October 19 and 20, 1604
Caravaggio is imprisoned for throwing stones.

November 18, 1604
Caravaggio is in prison for insulting an officer.

May 28, 1605
Caravaggio is arrested for illegal possession of arms.

June 6, 1605
Caravaggio is mentioned as living in the Campo Marzio.

July 20, 1605
Caravaggio is again in prison for having offended a woman and her daughter, who sued him. Some friends, including Prospero Orsi, stand surety.

July 29, 1605
Caravaggio is denounced for assaulting a notary following a dispute about a certain Lena, "donna di Caravaggio." The artist flees to Genoa, leaving unfinished a painting for Cesare d'Este, the Duke of Modena, and returns to Rome the following month, making peace with the notary on August 26.

September 1, 1605
Caravaggio's landlady brings charges against him for breaking a window shutter: Caravaggio's rent was six months in arrears and the landlady had seized his furniture.

October 12, 1605
The painting for the Duke of Modena is still unfinished.

October 24, 1605
Caravaggio, questioned about wounds that he received, states that he fell on his own sword.

October 31, 1605
The Arciconfraternita di Sant'Anna dei Palafrenieri (the papal grooms) decides to substitute a new altarpiece for its old one in Saint Peter's. Caravaggio received a first payment on December 1, 1605, and completed the work by April 1606. On April 16, it "was removed by order of the cardinals of the Fabbrica" (Baglione, 1642, p. 137) because "the Virgin was shown in a vulgar manner with the nude Christ Child" (Bellori, 1672, p. 213).

March 2, 1606
The fathers of Sant'Agostino decide to give an old image of the Pietà to Scipione Borghese after replacing it with Caravaggio's Madonna di Loreto *(still in place). Rights to the chapel had been acquired in September 1603.*

May 28, 1606
In a dispute over a wager on a tennis match, Caravaggio kills his opponent, Ranuccio Tommasoni, and is wounded.

May 31, 1606
The Duke of Modena's ambassador in Rome reports that Caravaggio has fled the city, leaving the duke's picture still unfinished.

September 23, 1606
Caravaggio is reported to be in Paliano, east of Palestrina, awaiting a pardon. In Palestrina, Baglione (1642, p. 138) says that Caravaggio painted a Mary Magdalen (cat. no. 89); Mancini (about 1617–21; 1956–57 ed., I, p. 225) and Bellori (1672, p. 208) record that the half-length Magdalen and a Christ at Emmaus (cat. no. 87) were painted in Zagarolo, near Palestrina, where Caravaggio found refuge with Duke Marzio Colonna.

October 6, 1606
Caravaggio is in Naples, where he is paid 200 ducats for a large painting of the Madonna and Child surrounded by angels, with four saints (not traceable).

January 9, 1607
Caravaggio is paid for the Seven Acts of Mercy *by the Pio Monte della Misericordia in Naples (fig. 13, p. 44).*

May 11, 1607
Caravaggio is paid a residual 100 ducats from the account of Tommaso di Franco (de Franchis) for a work identifiable with the Flagellation *(cat. no. 93). A further payment was received on May 28.*

July 13, 1607
Caravaggio is in Malta.

August 20, 1607
The Duke of Modena's ambassador in Rome reports that a pardon is being sought for Caravaggio, but there is no hope that the duke's altarpiece will ever be completed.

September 25, 1607
The Flemish artist Frans Pourbus the Younger writes to Vincenzo I Gonzaga, the Duke of Mantua, that a Madonna of the Rosary *and a* Judith and Holofernes *(not cat. 74) by Caravaggio are for sale in Naples.*

July 14, 1608
Caravaggio is made a Knight ("miles obedientiae") of the Order of Malta by the Grand Master, Alof de Wignacourt, in recognition of the portrait(s) that Caravaggio painted of him (Baglione, 1642, p. 138; Bellori, 1672, p. 209; see cat. no. 94).

October 6, 1608

In Malta, two men are charged to seek Caravaggio, who had escaped from prison where he had been placed following "some sort of disagreement with a Cavaliere di Giustizia" (Baglione, 1642, p. 138), "a quarrel with a noble knight" (Bellori, 1672, p. 210). According to both Baglione and Bellori, Caravaggio escaped at night and fled to Sicily.

December 1, 1608

Caravaggio is expelled from the Order of Malta.

June 10, 1609

The fathers of the Crociferi in Messina note receipt of the Raising of Lazarus, *commissioned from Caravaggio after December 6, 1608, by Giovanni Battista de' Lazzari. Prior to August 1609, Caravaggio had also been commissioned by another patron to paint four stories of the Passion, one of which—a* Christ Carrying the Cross—*had already been delivered.*

May 11, 1610

Prince Marcantonio Doria's procurator in Naples writes his master in Genoa that the varnish on Caravaggio's Martyrdom of Saint Ursula *(see cat. 101) has been ruined, but he will have it repaired by the artist. The picture was sent to Genoa on May 27.*

July 18, 1610

Caravaggio dies at Porto Ercole of a fever. Baglione (1642, pp. 138 f.) relates that Caravaggio's enemies had caught up with him in Naples, slashing his face so badly that he was almost unrecognizable. Caravaggio then boarded a boat for Rome, where his pardon was being negotiated by Cardinal Gonzaga. Upon landing, he was mistakenly identified and thrown into prison for two days. He resumed the trip on foot, caught a fever, and "within a few days died as miserably as he had lived." Bellori tells essentially the same story.

K. C.

61. Boy Peeling a Fruit

Oil on canvas, 25 5/8 x 20 1/2 in.
(65 x 52 cm.)
Private collection

The subject of the picture corresponds to Giulio Mancini's description in the *Considerazioni sulla pittura* (about 1617–21; 1956–57 ed., I, p. 224) of one of the first works painted by Caravaggio after his arrival in Rome, when he was staying with Monsignor Pandolfo Pucci (see cat. no. 70), for whom he painted copies of devotional pictures; he produced at the same time, "for the market, a boy who cries at being bitten by a lizard that he holds in his hand, and afterwards a boy who peels a pear with a knife" ("e per vendere, un putto che piange per essere stato morso da un racano che tiene in mano, e dopo pur un putto che mondava una pera con il cortello"). In the Palatino manuscript of the *Considerazioni* the fruit is called an apple ("una mela"), indicating Mancini's uncertainty about the fruit's identity. Isarlov (1935, pp. 116–17) identified the subject described by Mancini in a copy at Hampton Court, and Longhi (1943, p. 10) subsequently identified it in a copy in his own collection. Numerous other copies have since come to light, testifying to the popularity of the picture (see M. Marini, 1974, pp. 84 ff., 332 f., no. 2; A. Moir, 1976, pp. 104 f., no. 50).

The Bergamot oranges, peaches, cherries, and ears of grain on the table, and the citrus fruit—a Seville or Bergamot orange—held by the boy are depicted with particular attention. Recently a number of symbolic interpretations have been proposed for the picture, which had previously been considered, like Caravaggio's other early, secular pictures, a work of pure genre—one of Longhi's "anti-subject" paintings—and the novel outcome of the artist's Lombard training. Bauch (1956, p. 260), who thought that the picture was inspired by Northern prints, generically linked it and other youthful paintings such as the *Boy with a Basket of Fruit* and the *Boy Bitten by a Lizard* (cat. nos. 66, 70) with the five senses. Costello (1981, pp. 375 ff.), pointing out the correspondence with the *Five Senses* by Frans Floris, engraved by Hieronymus Cock in 1561, believes that the two pictures men-

tioned together by Mancini were painted as companion pieces—an unlikely conjecture, given their stylistic disparities—and that they represent Touch (the *Boy Bitten by a Lizard*) and Taste (the *Boy Peeling a Fruit*). Wind (1975, p. 72, n. 4) related the present picture to a series on the Seasons. Calvesi (1971, pp. 95 f.) has attributed a Christological significance to the picture, seeing in the boy who peels an apple a reference to Christ redeeming Man from Original Sin. (The recent identification of the fruit as an orange would, in effect, relate the picture to a tradition exemplified by van Eyck's *Ghent Altarpiece*, in which Eve holds a citrus fruit: see J. Snyder, 1976, pp. 511 f.; M. Levi d'Ancona, 1976, pp. 658 f.) For Mahon (see B. Nicolson, 1979, p. 34) the bitter fruit (like the reptile in the *Boy Bitten by a Lizard*) may allude to the surprises that await inexperienced youth. According to Posner (1971 b, p. 306), who proposed a homoerotic interpretation of Caravaggio's early works, the picture does not yet have the explicitly erotic significance of the paintings done for Cardinal del Monte. Röttgen (1974, pp. 186, 251, n. 126) explains the painting in the light of a popular proverb.

Confronted by such diverse interpretations, one wonders if, after all, the *Boy Peeling a Fruit* has no significance beyond the intrinsic interest of genre painting. In this regard we may recall the representations current in North Italian painting of half-length figures of youths playing musical instruments or performing domestic tasks. Sometimes these pictures are endowed with a poetic quality of Neoplatonic or Giorgionesque inspiration, while at other times they seem to be exercises in naturalistic imitation, based on anecdotes reported by Pliny. Chronologically the most pertinent examples of this genre are Annibale Carracci's two paintings of a *Boy Drinking*, one at Christ Church, Oxford, and one in the R. van Buren Emmons collection at Hamble, near Southampton.

If Mancini's "boy who peels an apple" is to be identified with no. 89, "un putto in tavola con un pomo in mano," in the list of paintings confiscated from the Cavaliere d'Arpino in 1607, it would seem at first to follow that the original picture was painted on panel (*tavola*) rather than canvas. Saler-

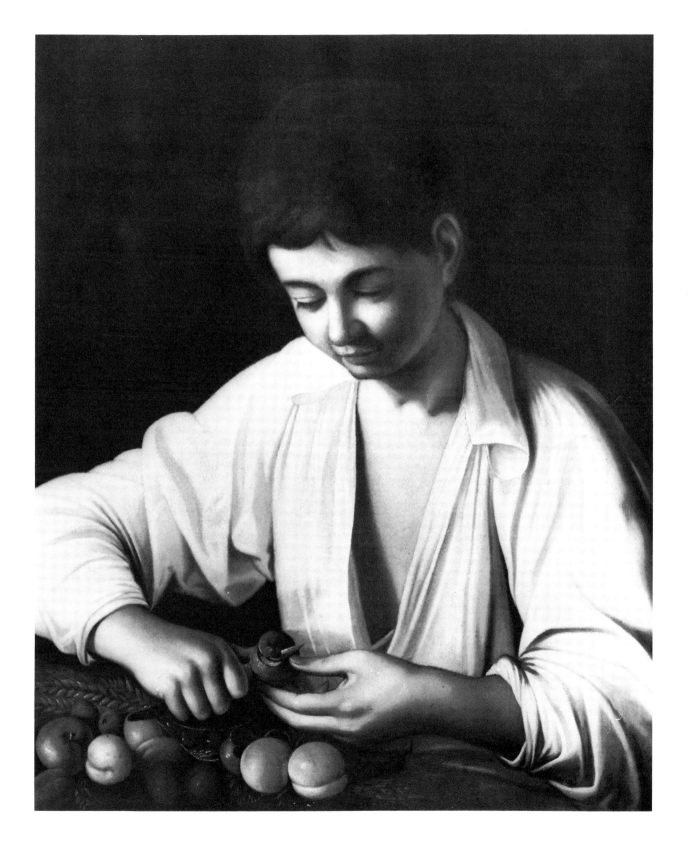

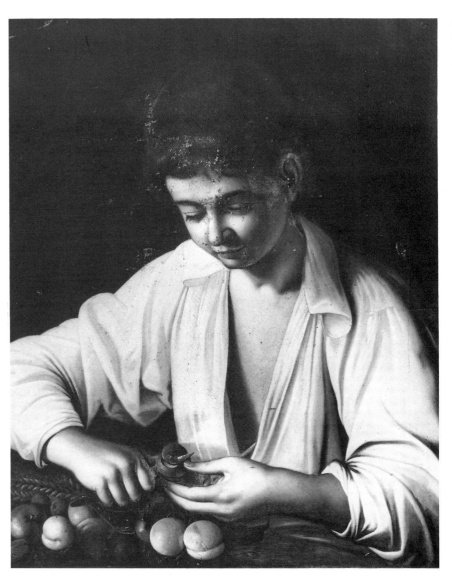

no (1984, p. 439), however, noting that Caravaggio never painted on panel (with the single documented exception of the Odescalchi *Conversion of Saint Paul*), has recently maintained that there are only two tenable alternatives: One must either reject the identification of the sequestered picture (the author of which is not mentioned) with the one described by Mancini, or one must interpret "in tavola" not as a reference to the support of the picture but as part of the description of the subject—"a boy at a table"; the position of the words "in tavola," in the middle of the description, would seem to support the latter hypothesis. But if this painting entered Scipione Borghese's collection along with the other confiscated pictures, it must have remained there only a short time, since it is not listed in the 1693 inventory.

The version that is included here belonged to Sir Joshua Reynolds and was shown at 28 Haymarket in 1791 with an attribution to Murillo; this fact suggested to Wagner (1958, p. 20) that the painting came from Spain. In the sale of Reynolds's collection in 1795 it appeared with the same attribution. (D. Mahon has informed the present writer, through L. Salerno, that the Hampton Court copy was attributed to "Michael Angelo" in 1688–89 and, from the early eighteenth until the early nineteenth century, to Caravaggio; the attribution was then changed to Murillo by analogy with Reynolds's picture.) Two labels on the reverse of the present picture indicate that in 1805 it belonged to the Earl of Inchiquin, who may have acquired it through marriage to Reynolds's niece, and in 1897 to the Marquise de Plessis-Bellières. It then entered an English private collection, and appeared in a London sale (Hart collection, Christie's, November 28, 1927, no. 125) as "attributed to Le Nain." In 1952 it belonged to S. F. Sabin and was exhibited at Park House, London, with the attribution to Caravaggio (London, 1952, pp. 6 f., fig. 5). In the following year, Hinks (1953, p. 93) stated that the Sabin version could well be the original. More recently, Nicolson (1979, p. 34) has maintained that it is the original version, as have Gash (1980, pp. 17, 23, n. 4) and Salerno (1984, pp. 438 f.). Spear (1979, p. 318), who has not himself examined the picture, has recommended caution; Hib-

bard (1983, p. 269) rejects the attribution. Cinotti (1983, p. 442) has published the picture as a copy, since she believes that the original was painted on panel (see above). Hibbard (1983, pp. 15 f.), who knows the picture only in photographs, considers another version recently mentioned by Marini (1978, p. 76, n. 5) to be either the original or an old copy; it is larger (29 1/2 x 25 5/8 in.; 75 x 65 cm.) and has on the reverse the eighteenth-century seal of Cardinal Tiberio Borghese. This picture, however, unlike all the other known versions, completes the boy's arms and shows two additional fruits. These differences exclude it as the prototype of the other copies. An echo of the Cavaliere d'Arpino's manner (M. Cinotti, 1971, pp. 88 f.; M. Marini, 1974, p. 14) is perceptible in, for example, the broken folds of the boy's shirt, and it is likely that this famous and much-copied picture was painted in Arpino's workshop, which Caravaggio joined after his initial, disappointing experiences in Rome. (In the present version, which exhibits a greater softness than some of the others, the Arpino-like qualities seem somewhat less prominent.) Since a number of features—such as the rather tentative and awkward forms of the head, the right hand, and the shirt collar—suggest that this is Caravaggio's earliest known work, the conclusion that we know no paintings prior to the period when he lived with the Cavaliere d'Arpino seems inescapable; there remains, however, the difficulty of explaining the heightened Lombard character and the more evident influence of Peterzano in such early but more accomplished paintings as the so-called *Bacchino Malato* (in the Galleria Borghese, Rome; see fig. 1, p. 39) and the *Boy with a Basket of Fruit* (cat. no. 66). The early date of the *Boy Peeling a Fruit* has never been doubted. Friedlaender (1955, p. 145) noted the similarity, in figure type and in the position of the head, of the boy in this painting to the angel in the *Stigmatization of Saint Francis* (cat. no. 68) and to the figure of Eros at the far left in the *Musicians* (cat. no. 69).

The boy's head is the least well-preserved part of the picture. The white shirt is firmly modeled—this is especially evident in the photograph of the painting in its stripped state—and in such areas as the left shoulder

and arm the shadows create curious forms; a transverse band of light is clearly visible in the background. The foreground is somewhat better preserved, and it is difficult to believe that such typically Lombard passages as the carefully rendered fruit and the hands, with their naturalistic pinkish color and their varied light effects, could be the work of a copyist. The illusionistic treatment of the skin of the hands, in the tradition of Northern "Romanist" artists, relates directly to Peterzano, who had completed his work at Garegnano shortly before 1584, the year in which Caravaggio—then only twelve years old—was apprenticed to him. The comparison of the present picture with the uncontested originals in this exhibition will provide an opportunity to evaluate the probability of Caravaggio's authorship and to establish the painting's superiority over the other known versions.

M. G.

62. Boy with a Vase of Roses

Oil on canvas, 26 1/2 x 20 3/8 in.
(67.3 x 51.8 cm.)
The High Museum of Art, Atlanta

The significance of this picture, which has generally been associated with the youthful, half-length compositions of Caravaggio (to whom it was initially attributed), is not easy to gauge. Although it is only a copy and its condition is far from excellent, and although it has not been possible to decipher all of its iconographical and iconological elements, a number of readings have been proposed.

The picture has, incorrectly, been considered a self-portrait made with the aid of a mirror (H. Voss, 1951 c, pp. 410 ff.; A. Czobor, 1954–55, p. 213, n. 21), and the subject has been variously interpreted as symbolizing love (M. Calvesi, 1966 a, pp. 287 f.; L. Salerno, 1966, p. 110); as containing a moral admonition (D. Posner, 1971 b, pp. 316 f., 324); as an allusion to the transiency of youth, expressed by the withered rosebud and the gesture of the youth, who originally pointed to himself with his left hand (see below); and as an allegory of Smell from a series illustrating the Senses (R. Spear, 1971, pp. 470 f.). According to this last hypothesis its pendant, standing for Touch, would have been the *Boy Bitten by a Lizard* (cat. no. 70), which has very close dimensions and in which we find the same androgynous model, a comparable vase with flowers, and a similar light striking the background wall diagonally. Röttgen, however, has correctly noted (1974, p. 253, n. 157) that two pictures belonging to the same series would not resemble each other as closely as these two, but would be more varied in their imagery. He interpreted the *Boy with a Vase of Roses* as the antithesis of the *Boy Bitten by a Lizard* and saw in it the representation of untroubled youth. According to him, the prototypes of this picture and the Korda and Longhi versions of the *Boy Bitten by a Lizard* were painted as variations of a single idea and were intended to be sold singly.

A painting with this subject is listed as no. 213 in the Borghese inventory of 1693: "a picture measuring two *palmi* with a portrait of a youth with a vase of roses, on canvas . . .

with a gilt frame, by Caravaggio" ("un quadro di due palmi con un ritratto d'un Giovane con un Vaso di rose in tela . . . con cornice dorata del Garavaggi": P. Della Pergola, 1964 a, p. 453). Della Pergola notes (p. 463) that in other inventories the picture is associated with the *Boy with a Basket of Fruit*; the latter, however, has different dimensions. Whether or not it corresponds to one of the pictures in the inventory of works confiscated from the Cavaliere d'Arpino in 1607 is less evident; Della Pergola (1964 b, pp. 253, 256, n. 1) suggests identifying it with no. 99, while Marini (1974, p. 338) identifies it with no. 59.

Prior to its acquisition by the High Museum of Art in 1958, the present picture was in an English private collection; in the Moussali collection, Paris; and at Wildenstein, New York. It had an expertise by Lionello Venturi, dated 1949, attributing it to Caravaggio, and it was published as a Caravaggio by Voss (1951 c, pp. 410 ff.). It has been affirmed by a number of critics as an autograph early work. Subsequently, the idea that it is a copy of a lost original has gained wide acceptance; the alternative view is that it is merely derived from the *Boy Bitten by a Lizard* and other youthful works of Caravaggio (for the opinions of various critics, see M. Cinotti, 1983, p. 557, no. 72). Röttgen (1974, p. 253, n. 157) and Hibbard (1983, p. 284) believe the Atlanta picture to be by Baglione, regardless of whether or not it is a copy of a lost Caravaggio, while Marini, who at one time (1974, p. 339) thought that the author was a painter trained in Rome in the circle of Antiveduto Grammatica, Baglione, and Angelo Caroselli and was possibly identifiable as Tommaso Salini, has recently (1983, pp. 123 ff.) proposed that the work may be a ruined, much repainted original by Caravaggio (see below). For Moir (1967, I, p. 27, n. 20), it is by the author (now identified as the Pensionante del Saraceni) of the still life in the National Gallery of Art, Washington (cat. no. 48). The picture is not mentioned by Hinks (1953) or Friedlaender (1955).

Another version of the composition, from the collection of Mrs. Borenius, Coombe Bissett, Wiltshire, was sold at Sotheby's, London, on June 7, 1950 (no. 120, as "School of Caravaggio," 26 x 20 in.; it was bought by Lambert). It reappeared at Christie's, London, where it was sold on December 14, 1983 (no. 21, as "After Michelangelo Cerisi [*sic*] called il Caravaggio," 25 3/4 x 20 1/4 in.). It is now in a private collection in Milan (I thank M. Cinotti for this information). Spear (1971 c, p. 473) considered this version the superior copy. Cinotti (1983, p. 557) observed that the author of the Milan version has reduced the figure slightly to adapt it to the pictorial space, as copyists frequently do. Marini (1974, p. 339) dated this version to the late seventeenth century. The present writer has not examined it personally and can therefore express no judgment.

Following Marini's reappraisal of the Atlanta picture and its X-rays (1983 b, pp. 123 ff.), it was examined in detail by the conservation staff of the Metropolitan Museum, and its status as a crude copy—possibly even of the eighteenth century (since lead-tin yellow was employed, it is unlikely to date any later)—has been confirmed. Indeed, although the eyes and mouth of the figure have been reinforced, and the contour of the left cheek and jaw have been gone over, the head is, on the whole, in good condition. Likewise, the general appearance of the sleeve is only minimally affected by the reinforcement of the shadows, and the roses are almost free of repainting. The vase and foliage, by contrast, have been heavily overpainted, hiding the boy's left hand and finger, which pointed back to himself. The X-rays show a technique and lack of sensitivity not found in any autograph work by Caravaggio. However, it remains an open question whether the picture is a copy of a lost work by Caravaggio, a free derivation from the *Boy Bitten by a Lizard* (to which it is closely linked, as has been noted), or, more generically, a copy of a work inspired by Caravaggio's youthful paintings and done as an exercise by an artist who knew him when he worked for Arpino—perhaps even a fellow member of Arpino's shop. Whichever is the case, the artist had difficulties in reproducing the foreshortening of the head, which is viewed from a slightly *di sotto in su* position (an idea hinted at in the *Boy Bitten by a Lizard*, but resolved there in a better fashion). Although the defects of the picture lead one, at first, to doubt that it could derive from an original by Caravaggio, it is probable nevertheless that we are dealing with an unfaithful copy; the same is true of the ex-Borenius version. The existence of two copies makes one think that there was in fact a prototype by Caravaggio, a work of great novelty—although not mentioned by Caravaggio's biographers—whose spatial quality the copyists perhaps did not understand, since it was foreign to the principles upheld by Roman workshops.

Since the boy is less well articulated than the corresponding figure in the *Boy Bitten by a Lizard*, it is probable that the prototype was an earlier work, datable to Caravaggio's very first years in Rome. The Arpinesque character of the drapery and the schematic treatment of the light on the neck relate the picture to the *Boy Peeling a Fruit* (cat. no. 61); Mancini's reference serves as support for the attribution to Caravaggio. These stylistic features, which distinguish both works from Caravaggio's other early paintings, may perhaps be explained by the not unlikely hypothesis that the young artist was obliged to accommodate his manner to the practices of Arpino's workshop.

M. G.

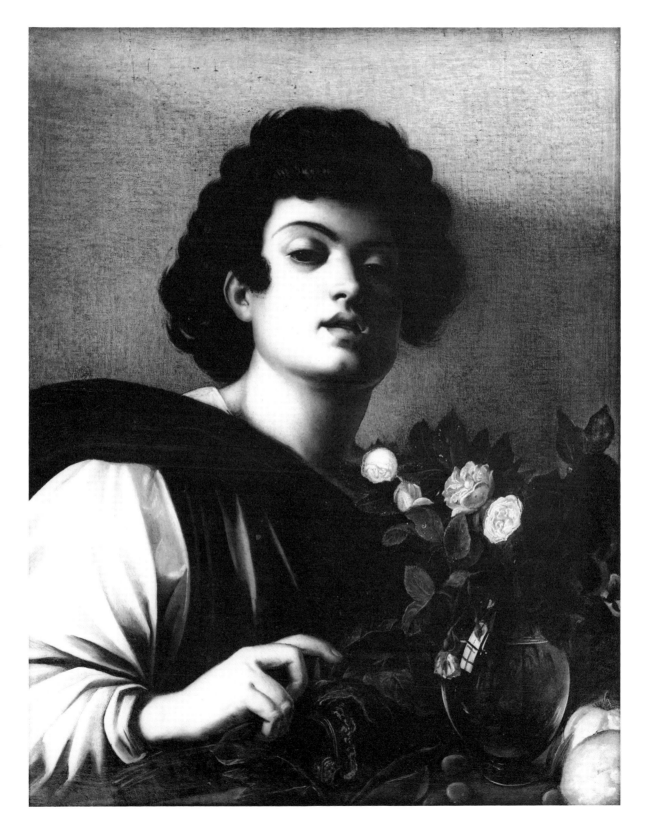

63. Still Life with Flowers, Fruits, and Vegetables

Oil on canvas, 41 1/4 x 72 7/16 in.
(105 x 184 cm.)
Galleria Borghese, Rome

64. Still Life with Birds

Oil on canvas, 40 3/4 x 68 1/8 in.
(103.5 x 173 cm.)
Galleria Borghese, Rome

For the designation of the *Still Life with Flowers, Fruits, and Vegetables* (cat. no. 63) as a Flemish painting in the late-seventeenth-century Borghese inventory and in the fideicomissum, and then as a work by Karel van Vogelaer, see Della Pergola (1959, p. 191, no. 287). Zeri (1976 a, p. 93) attributed it to the anonymous author of the *Still Life with Flowers and Fruit* in Hartford (cat. no. 65) through a series of incontrovertible comparisons, noting that this painting, in its studied objectivity, reveals a naturalistic approach that is somewhat more archaic than what we would expect of Vogelaer, with his Baroque vision. Zeri went on to associate the *Still Life with Flowers, Fruits, and Vegetables* with the *Still Life with Birds*, correcting the dimensions of the latter given in the Borghese catalogue (P. Della Pergola, 1959, p. 170, no. 248; see F. Zeri, 1976 a, p. 94). The *Still Life with Birds*, which had also been catalogued as a Flemish work, was assigned by A. Venturi (1893, p. 154) to Arcangelo Resani; this attribution was rejected by Longhi (1928; 1967 ed., p. 346). Having reunited the two pictures, Zeri demonstrated that they are mentioned in the inventory of paintings sequestered from the Cavaliere d'Arpino in 1607: The *Still Life with Birds* is described (as Della Pergola had already noted) under no. 38 as "un quadro con diversi uccellami morti senza cornici," while the *Still Life with Flowers, Fruits, and Vegetables* is listed under no. 39 as "un altro quadro con diversi frutti et fiori senza cornici." According to Zeri, the Hartford still life (cat. no. 65) and a *Still Life with Figures* formerly in the Galleria Manzoni, Milan (see C. Volpe, 1972 a, p. 74), were probably also among the paintings sequestered in 1607. These proposals have been more or less accepted by scholars (M. Rosci, 1977, pp. 92, 95, 166, n. 67; J. Spike,

1983, p. 44) along with the consequent early date—of great importance for the history of seventeenth-century still-life painting in Italy.

Within the group of pictures associated by Zeri with the Hartford still life, the Borghese paintings date from a relatively advanced stage: after a painting formerly in the Galleria Lorenzelli, Bergamo, one formerly in the Mont collection, New York, and two exhibited at Finarte, Milan, in 1972 (all illustrated in M. Cinotti, 1983, p. 632, figs. 1, 2, 4, 5), and before the Hartford painting, which in turn is followed by the ex-Manzoni still life; the last was left unfinished—because of a rift between its author and the workshop in which it was painted?—and completed by Saraceni after 1607 (see cat. no. 65). According to Zeri (1976, pp. 99 ff.), this expanded group of pictures is what remains of Caravaggio's work from the time when, having arrived in Rome and finding himself in a difficult position, he joined the workshop of the Cavaliere d'Arpino, "who employed him painting flowers and fruits, which are so well executed that in them he achieved that greater beauty ("vaghezza") that so delights us today. He painted a vase of flowers, showing the transparency of the water and glass and the reflections from the window of a room, scattering fresh dewdrops on the flowers. And he painted excellently other pictures with a similar mimetic effect" (Bellori, 1672, p. 202); this description seems to refer to a picture similar to the ex-Manzoni still life. Bellori then alludes to Caravaggio's unhappiness in doing this sort of painting, saying that he "took the opportunity, when he met Prospero, a painter of grotesques, to leave Giuseppe [Cesari's] house." Read properly, Bellori's passage is extremely important, since it describes the conditions in which the still lifes—probably destined for a minor market—were painted by Caravaggio for the Cavaliere d'Arpino.

As Zeri observes, the Borghese *Still Life with Flowers, Fruits, and Vegetables* shares with the Hartford still life the even distribution of the objects; the use of a triangular spatial device (marked in the Borghese painting by the cabbage in the left foreground, the majolica vase aligned on a perspectival diagonal, and the basket in the right middle ground); the type of lighting;

and the uncommon knowledge revealed in the choice of botanical specimens. To judge from their somewhat disjunctive and additive compositions—Marini (1978, p. 43, n. 128) suggests that the Borghese pictures were conceived as compendia of birds and vegetables—there seems little doubt that the painter was inspired by the scientific curiosity and the urge to classify that had such an impact on intellectual life in the late Cinquecento, even though the still lifes he created were modest, rustic, "everyday" ("feriali," an expression of Longhi's), with parallels in the Cinquecento painting of Lombardy. Because of these characteristics, the still lifes here considered—and especially the Borghese *Still Life with Flowers, Fruits, and Vegetables* and the Hartford picture—distinguish themselves from the majority of contemporary Northern paintings and constitute the earliest examples of the phase of Italian still-life painting that developed in the Seicento.

Although the two Borghese pictures lack what one could call unified compositions, this is in itself an indication of their early date and their still Cinquecentesque spirit. However, the present writer cannot agree with Marini (1978, p. 43, n. 128; 1981, p. 359; 1983 a, p. 5; 1984, pp. 11 f.) that the *Still Life with Flowers, Fruits, and Vegetables* and other pictures in the group were collaborative efforts by more than one artist, of whom the most important was the author of the Hartford still life (tentatively identified by Marini as Francesco Zucchi), with the limited participation of Caravaggio. A more careful analysis would take into consideration the areas of intense illumination on the fruits, vegetables, and birds alike, and the extremely realistic passages—Zeri calls attention in particular to the painterly quality of the squash—that have analogies only in the work of Jacopo Ligozzi, although here (and in the Hartford still life) the crudeness of a pattern-book arrangement is tempered by a light that binds the composition together. Moreover, the chromatic variety of the fruit and the delicate, lovingly painted plumage of the birds reveal the hand of a far from commonplace artist.

Another significant aspect of the *Still Life with Birds* is the coloristic character of its carefully painted details—what Baglione

called the "diligenza" of the youthful Caravaggio's paintings of fruits and flowers. The rocks in the foreground, enveloped in a limpid light that transforms them into abstract shapes, are almost identical to the rocks scattered on the ground in the *Rest on the Flight into Egypt* (see fig. 3, p. 33) in the Galleria Doria-Pamphili. (The Cavaliere d'Arpino also included such details in his work and, it may be added, Gentileschi displays the same interest.)

The Borghese pictures were exhibited in Rome in 1979 (C. Strinati, pp. 62 ff.) as "attributed to Caravaggio," and in New York in 1983 (J. Spike, pp. 41 ff.) as the work of a "follower of Caravaggio." While this is not the place to examine the conceptual significance of Caravaggio's naturalism or the role of still life within it, we must nonetheless weigh the evidence for the assumption that Caravaggio did, in fact, paint still-life paintings—evidence that is far from "problematic" or "scant" (J. Spike, 1983, pp. 39, 41). The hypothesis raised in the 1950s, that the *Basket of Fruit* in the Pinacoteca Ambrosiana, Milan (cat. no. 75), is only a fragment of a larger composition (W. Friedlaender, 1955, pp. 80, 142 ff.) is now a figment of the past; it is precisely this work, together with the important still-life passages in his other youthful paintings, that leads one to conclude that, especially in his early years, Caravaggio painted independent still-life pictures. The earliest positive testimony is the reference to a statement by the artist himself in the letter from Vincenzo Giustiniani to Teodoro Amayden, written in the 1620s (see G. Bottari and S. Ticozzi, 1822–25, VI, p. 121): "And Caravaggio said that it required as much diligence to paint a good picture of flowers as a picture of figures." The information furnished by Bellori is more detailed, but it is also later in date. Bellori, as we have seen, is the only one of Caravaggio's biographers to speak of the still lifes; this is because, writing in the years 1660–70, he was in a better position than his predecessors, of about 1620–40, to appreciate both the importance that still-life painting had acquired and the significance of Caravaggio's revolutionary effect in Italy. Bellori's credibility, doubted by Friedlaender (1955, p. 80) and Salerno (1970, p. 236), seems to be confirmed by

the discovery, in the inventory of Cardinal del Monte's property dated February 21, 1627, of a still life: "un quadretto nel quale vi è una Caraffa di mano del Caravaggio di Palmi dua" (c. 575 *r.*; see C. L. Frommel, 1971, p. 31). The picture was sold, along with the *Musicians* (cat. no. 69), on May 8, 1628, and has disappeared (see W. C. Kirwin, 1971, p. 55; M. Marini, 1984, p. 13). This notice corresponds to Bellori's briefer mention of "una caraffa di fiori," which he says Caravaggio painted while working for the Cavaliere d'Arpino, even though it is far from certain that the two references are to the same picture. There are also later and, consequently, less reliable references to still-life paintings by Caravaggio: "Un quadro di p.mo 4 e 3—rappresentante Diversi frutti porti sop'a Un Tavolino di Pietra in Una Canestra mano di Michel Angelo da *Caravagio*" in the inventories of Cardinal Antonio Barberini's collection (M. Lavin, 1975, pp. 309, 342); a picture with "frutta, caraffa di fiori e farfalle" mentioned in the inventories of Nicolas Regnier's property in Venice in 1666 (M. Marini, 1984, p. 12)—a still life that, given its constituent elements, would seem to be an old-fashioned one; "Sei rose e un fiore bianco," measuring about 2 x 2 *palmi*, in the 1666 inventory of the collection of Gaspar de Haro, Viceroy of Naples (M. Marini, 1974, p. 482); and two other still lifes, one cited in 1689 in the collection of Cassiano dal Pozzo (M. Marini, 1984, p. 17, n. 24) and one owned by Prince Giacomo Carlo Capece Zurlo (R. Ruotolo, 1973, p. 149). These later citations, even though they are probably erroneous, provide evidence of a widely diffused notion that Caravaggio painted still lifes.

Bellori's affirmation that in Arpino's workshop Caravaggio was employed painting flowers and fruit reflects the division of labor which was then current and which had its source in the prototypical Roman workshop: Raphael's. To examine Arpino's figurative compositions for evidence of Caravaggio's contribution—for example, in the trees and grass of *Saint Francis Consoled by an Angel Playing the Violin* (cat. no. 34)—does not seem to this writer to be a very fruitful enterprise. Although one may be tempted to conclude that, partly because of his profoundly different training, Cara-

vaggio was employed only in painting "naturalia," a note—difficult to decipher—in the Codex M of Mancini (about 1617–21; 1956–57 ed., I, pp. 226 f., II, pp. 124 ff., n. 905) should not be forgotten. Mancini seems to imply that Caravaggio collaborated with Arpino on a "Death of Saint John." The only work with this subject by Arpino recorded in the sources was begun in 1597 and cannot, therefore, be relevant. Nonetheless this notice, taken together with van Mander's (albeit erroneous) affirmation that Caravaggio worked on the frescoes in San Lorenzo in Damaso, leads one to believe that perhaps Caravaggio did collaborate on some of Arpino's paintings.

Zeri (verbal communication) notes that in the ex-Mont still life there is the trace of a signature: M di Cara.

M. G.

65. Still Life with Flowers and Fruit

Oil on canvas, 29 1/8 x 39 3/8 in.
(74 x 100 cm.)
Wadsworth Atheneum, Hartford

The table is shown from slightly above, with two vases (*caraffe*) aligned perspectively on a diagonal. The flowers are varied and carefully chosen; they include irises—which frequently occur in early still lifes because of their association with the Virgin—and a branch of rosemary in bloom. The same can be said of the fruits and nuts from various seasons, among which are medlars, hazelnuts, and arbutus berries. A pink flower in the vase in the left foreground has begun to lose its petals, some of which lie scattered on the tablecloth. X-rays made at the Metropolitan Museum have revealed that originally there was, in the right background, a curtain drawn back. Possibly because of severe damage this was later painted out, although it is still faintly visible.

The picture was acquired in New York in 1942 and was attributed to Fede Galizia (*Art News*, May 1944). It was included in the exhibition "La Nature morte de l'antiquité à nos jours" in Paris in 1952 (C. Sterling, 1952 a, pp. 87 f., no. 66) as the work of an anonymous Italian artist, datable no later than 1615–20. Sterling emphasized the Caravaggesque character of the work as well as its Flemish influences, and in the same year (1952 b, p. 54) he wondered whether it might not be a copy of an unknown original by Caravaggio; later (1959, fig. 55) he attributed it to the circle of Caravaggio. A number of other pictures, forming a homogeneous group, have been associated with the Hartford still life (see H. Hüttinger, 1964, p. 36, no. 33; F. Bologna, 1968, no. 10; C. Volpe, 1972 a, p. 74, 1972 b, pp. 9, 22). In 1973, the present writer (M. Gregori, 1973 a, pp. 41 ff.) proposed a somewhat earlier date than Sterling's for the Hartford picture and, for the rest of the series, dates beginning in the first decade of the seventeenth century. She also identified the artist hypothetically as Giovanni Battista Crescenzi, a contemporary of Caravaggio's, a dilettante, and the founder of an academy where young artists practiced painting "fruits, animals, and other bizarre things" from life (Baglione, 1642, p. 365).

A turning point in the discussion occurred in 1976, when Zeri (pp. 92 ff.) added to the group two still-life paintings then kept in the storerooms of the Galleria Borghese —the *Still Life with Flowers, Fruits, and Vegetables* and the *Still Life with Birds* (cat. nos. 63, 64)—and another still life, with flowers and fruit, formerly the property of Frederick Mont, New York. Describing the relative place of the two Borghese paintings within the group, Zeri suggested identifying cat. no. 63 with one of the works sequestered from the Cavaliere d'Arpino in 1607; Della Pergola (1959, p. 170) had already linked cat. no. 64 with a picture mentioned in the 1607 inventory of Arpino's property. Zeri also proposed that the Hartford picture was no. 47 in that inventory ("Un quadro pieno di frutti, et fiori con due Caraffe") and a *Still Life with Two Female Figures* (in the Galleria Manzoni, Milan, in 1967) was no. 96 ("Un quadro con una Caraffa di fiori et altri fiori non compito"). The flowers in the ex-Manzoni picture were painted by the same artist, while Saraceni probably added the figures between 1607 and 1610 (C. Volpe, 1972 a, p. 74).

Zeri having thus established that the group of still lifes (to which he peripherally related two oblong paintings formerly in the Galleria Lorenzelli, Bergamo, although these certainly do not form part of the group) originated in the workshop of the Cavaliere d'Arpino along with the two Borghese pictures, dated them to the end of the sixteenth century and reopened the question of their authorship. He excluded Crescenzi for chronological reasons, as well as Floris Claesz. van Dyck, who is known to have been in Rome and to have frequented Arpino's workshop, but who never abandoned his basically Northern style. Zeri put forward a number of arguments for identifying the author as Caravaggio and dating the pictures in question to the months that the young artist spent in Arpino's workshop, where he was "employed painting flowers and fruit" (Bellori, 1672, p. 202). Among the elements that Zeri adduced in favor of his attribution are the Lombard influences, especially in the color range of the earliest picture in the series, a still life also formerly in the Galleria Lorenzelli (J. Spike, 1983, p. 44, denies the Lombard connection, seeing in these paintings exclusively Roman, late

maniera traits); the variety in the choice of botanical specimens (which also supports the hypothesis of an early date); and, even more importantly, such specific qualities as the optical lucidity and the exceptionally acute, naturalistic precision of the pictures. Incontrovertible morphological comparisons advanced by Zeri link this group of still lifes to an unquestionable youthful work by Caravaggio, the *Boy with a Basket of Fruit* (cat. no. 66), which was also among the pictures sequestered by Paul V: The wicker baskets in that work and in the Hartford, ex-Mont, and Borghese (cat. no. 63) pictures, for example, are almost interchangeable. The scattered flowers in the still life completed by Saraceni, moreover, approximate those in the *Lute Player* in Leningrad. Zeri emphasizes the difficulties inherent in any attempt to attribute this large but homogeneous group of works to a follower or to a copyist operating during the months that Caravaggio worked for Arpino, and it is well to keep his observations in mind in the face of contrary or uncertain opinions (see M. Rosci, 1977, pp. 92, 95, 166, n. 67, who underscores the importance of a "humble" production of still lifes by 1607; R. Causa, 1978, pp. 40 f.; M. Calvesi, 1979, pp. 75 f.; and J. Spike, 1983, pp. 41 f., who considers them the work of an anonymous follower of Caravaggio's and the expression of a first reaction by Roman still-life specialists to Caravaggio's influence. Spike follows R. Causa, 1972, p. 1033, no. 6; 1978, p. 41, who had emphasized the high quality of the Hartford picture but classified it nonetheless as a naïve work; A. Harris, 1983, p. 514; and M. Cinotti, 1983, p. 568, who rejects Caravaggio's authorship of a number of the pictures in the group). Posner's observation (1971, pp. 315 f.; see also J. Spike, 1983, p. 44) that the more than one hundred paintings sequestered from Arpino were probably not all products of his workshop but rather his stock-in-trade as an art dealer— Nicolò Pio (about 1724; 1977 ed., p. 107) speaks of the "many beautiful paintings by famous masters that [Arpino] possessed"— can be applied to the paintings in question only with difficulty. Marini, in the course of several articles (1978, p. 43, n. 128; 1981, p. 359; 1983, p. 5; 1984, pp. 12 f.), has come to distinguish at least two hands, in addition to Caravaggio's, in the most important pic-

tures in the group: that of Arpino's brother, Bernardino Cesari, and the Florentine Francesco Zucchi, who collaborated first with his brother Jacopo and then with Arpino (Baglione, 1642, p. 62, says in his biography of Francesco that he "was very good at painting flowers and fruit"). Marini's attributions, however, are not easy to accept. For Harris (1983, p. 514), these paintings "remain fascinating evidence of the early impact of [Caravaggio's] art in Rome." For Sterling (1981, p. 17), the attribution to Caravaggio "is to be considered very seriously, and its historical implications are far reaching."

The suggestion that these still lifes were painted by the young Caravaggio has encountered resistance, both because of their general character—they seem to reflect a mentality different from his—and because of their relatively modest quality. Our doubts, however, may well turn out to be merely the products of our prejudices. Caravaggio's biographers, especially Bellori, make it clear that until he entered the household of Cardinal del Monte, Caravaggio was obliged to accept workshop assignments of a modest nature; these were distinct from the pictures that, at the same time, he painted for himself and for the art market.

The most striking feature of the Hartford *Still Life with Flowers and Fruit* is its clear, variable luminosity, calculated to bring out the vegetable forms. This quality—which a recent cleaning has accentuated—is one that recurs in all of Caravaggio's secure early works. The painting is conceived according to an analytic scheme, of Northern origin, showing a well-provisioned table.

The most accurate and penetrating discussion of the cultural and stylistic components of the present work is Sterling's (1952 a, pp. 87 f.).

M. G.

66. Boy with a Basket of Fruit

Oil on canvas, 27 1/2 x 26 3/8 in.
(70 x 67 cm.)
Galleria Borghese, Rome

This picture—along with the so-called *Bacchino Malato*, also in the Galleria Borghese (see fig. 1, p. 29)—was among the paintings in the studio of the Cavaliere d'Arpino that were sequestered in 1607 by Paul V's prosecutor (it is cited in the list of sequestered objects, with no author indicated, under no. 56: "un quadro di un Giovane che tiene un canestro di frutti in mano senza cornice"). A nearly illegible passage in Mancini (about 1617–21; 1956–57 ed., I, p. 224; II, p. 112, n. 885), recording among Caravaggio's works painted for the art market ("per vendere") a portrait of a peasant ("un ritratto di un vilico" [?]), probably also refers to this work.

More than any other painting, the *Boy with a Basket of Fruit* testifies to the iconographic novelties that the young Caravaggio introduced into Rome from Northern Italy and to the originality of his interpretation of them (H. Wagner, 1958, p. 19, has opportunely mentioned the Galleria Borghese *Pastore Appassionato*, as Longhi christened it, which P. Della Pergola, 1954, pp. 27 ff., attributed to Giorgione; B. Wind, 1975, p. 71, related Caravaggio's picture to Dosso Dossi's *Boy with a Basket of Flowers* in the Fondazione Longhi, Florence, a work that G. Galli, 1977, pp. 54 ff., correctly associated with the so-called *Poet with a Muse* in the National Gallery, London). The realism of Flemish genre painting, as adapted by Vincenzo Campi, Bartolomeo Passarotti, and the young Annibale Carracci in the second half of the sixteenth century, is here surpassed by Caravaggio's fusion of pictorial means with an allusive poetic quality that echoes the half-length compositions of Giorgionesque painting. Caravaggio gave a greater focus to this Giorgionesque tradition by invariably using youths as models and choosing themes linked to youth. The subject of the present picture is probably exactly what it appears to be: A young fruit vendor offers his merchandise—the veracity of which is underscored by the marvelously brilliant colors—displaying it in a basket among leaves that are still fresh.

If it is recalled that Caravaggio probably painted this picture in the workshop of the Cavaliere d'Arpino (but see D. Posner, 1971 b, p. 316, who thinks that Arpino could have purchased the work a short time before it was sequestered), and that, according to a practice that had its origins in Raphael's workshop, he was employed there principally as a genre painter (M. Gregori, 1972 a, pp. 34 ff.)—"painting," Bellori noted, "flowers and fruits"—then this work may be seen as a sort of urgent and implicitly provocative manifesto.

The true subject of the picture—its conceptual basis—is the exaltation of naturalistic painting (*imitazione naturale*), which was given a new impetus in Northern Italy in the sixteenth century through the reading of Pliny and other ancient sources (on these matters, see C. Sterling, 1959, pp. 11, 40 f.; J. Białostocki, 1956, pp. 591 ff.; and H. Hibbard, 1983, pp. 17 f.). However, the significance of the *Boy with a Basket of Fruit* has been interpreted in other ways. Although the notion that it is a self-portrait has been rejected, leaving the identity of the model uncertain, the painting has been variously construed as a representation of the sense of Taste; as Autumn, symbolizing transience (this hypothesis is improbable for the simple reason that the fruits shown are not all autumnal); as a symbol of love—ranging from profane to sacred—expressive of a homosexual orientation (L. Lanzi, 1795–96; 1968–74 ed., I, p. 359, referred to the painting as *La Fruttaiola*, thereby mistaking the sex of the model, as did M. Marangoni, 1922 a, p. 788); and as an evocation of Horatian simplicity and frugality (see C. Del Bravo, 1974, p. 1574).

The painting, given by Paul V to his nephew Scipione Borghese, is described in an inventory of the Borghese collection in 1693 as "un quadro di tre palmi con un Giovane che tiene la canestra de frutti con due N[u]m[e]ri, uno 606 e l'altro 475 con cornice dorata di Michelan Garavagni," and in an inventory of 1790 as "un giovane con canestra di frutti, Caravaggio" (the two inventory numbers were uncovered in the 1964 cleaning of the picture). As Della Pergola noted (1959, p. 75), an "Uomo con canestro di fiori, Caravaggio"—possibly identifiable with the prototype of the Atlanta painting (cat. no. 62) and the version

211

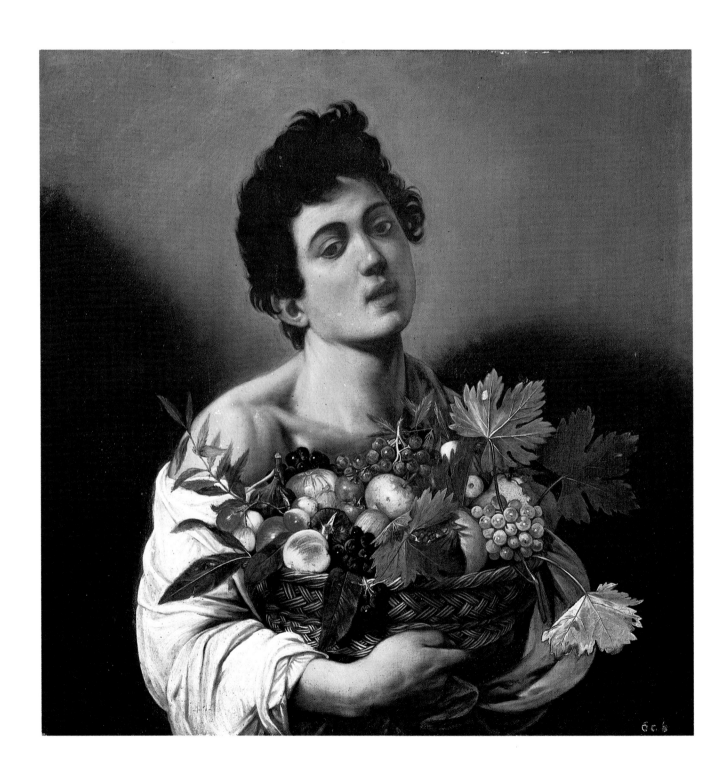

formerly in the Borenius collection—is also mentioned, but it was not given to the Galleria Borghese along with the rest of the estate. The attribution to Caravaggio is repeated in successive nineteenth-century inventories until 1891, when the Piancastelli inventory was completed. There it is called a copy, and this opinion has been taken up by various critics.

The authorship of the picture, along with that of the *Bacchino Malato* and the *Magdalen*, in the Galleria Doria-Pamphili, Rome, has been questioned by Arslan (1951, pp. 444 ff.; 1959, pp. 194 f., 211 f., nn. 3, 4, 6, 8, 11) on the basis of X-rays and the reports of the Istituto Centrale di Restauro, which underscore the affinities, as well as the differences, among the X-rays of these three works and the X-rays of the Uffizi *Bacchus* (cat. no. 71), the Doria *Rest on the Flight into Egypt* (see fig. 3, p. 33), and the Metropolitan Museum's *Musicians* (cat. no. 69). Friedlaender (1955, p. 145, no. 3, p. 148, no. 5) judged the still life to be by Caravaggio, but not the figure, which he thought was possibly by another artist in Arpino's workshop. In general, however, scholars have confirmed Caravaggio's authorship of the *Boy with a Basket of Fruit*, which indeed seems indisputable. In 1927, Longhi (1927 b; 1967 ed., p. 301) declared that it was due to his familiarity with the Borghese picture that, about 1916, he had come to recognize Caravaggio's authorship of the *Bacchus*, which at that time was kept in the storerooms of the Uffizi, in poor condition and with no attribution.

This painting should certainly be dated shortly after Caravaggio's arrival in Rome, as the majority of critics have acknowledged. From a recently discovered document proving that Caravaggio was still in Lombardy on May 11, 1592 (M. Cinotti, 1973, p. 32), we now know that his early Roman paintings were executed after that date, even though there is no sure way of determining when his activity in the city began or when he joined Arpino's workshop.

Although the *Bacchino Malato* and the slightly later *Boy with a Basket of Fruit* are more individual than the *Boy Peeling a Fruit* and the *Boy with a Vase of Roses* (cat. nos. 61, 62), and closer to the Lombard roots of the young artist, they were, nonetheless,

probably painted in the workshop of the Cavaliere d'Arpino, and they ought to be considered together, even though their different dimensions indicate that they were not conceived as pendants. Both pictures invite comparison with works by Caravaggio's master, Simone Peterzano; this relationship was first taken into account by R. Longhi (1928–29; 1968 ed., p. 131, who specifically mentioned the *Boy with a Basket of Fruit*; see also M. Calvesi, 1954, pp. 129 f.; 1978, pp. 486 f., 489; for the particular importance of Peterzano's work at Garegnano, see M. Gregori, 1973 b, pp. 17 f.). These analogies surface at precisely the moment when Caravaggio applied himself to the representation of the nude, with its inherent difficulties (perhaps it is not by chance that in the two earliest pictures—the *Boy Peeling a Fruit* and the *Boy with a Vase of Roses*—the model is fully dressed). Just as there is a close and well-noted relationship between the *Bacchino Malato* and Peterzano's *Persian Sibyl* in one of the spandrels beneath the dome of the Certosa di Garegnano and also to the preparatory drawing for that fresco, so in the *Boy with a Basket of Fruit* there is an obvious link between Caravaggio's approach and the hedonism of his master's style in the way in which the shirt has slipped down the boy's arm, leaving his shoulder bare—a recurring motif in Caravaggio's youthful, half-length figures and one that has captured the attention of scholars who have stressed the homoerotic character of the figures. Any schematic effect has been avoided by dividing the background into zones of light and shadow, and the head is placed with great subtlety at the center of the fan-shaped, illuminated area. The purely pictorial aspects of the painting are thus emphasized in a way that prefigures Seicento painterly techniques: Especially extraordinary is the optical and tonal vividness that Caravaggio obtains, on the one hand, by contrasting the mass of dark hair with the illuminated wall, and, on the other, by setting the white shoulder against the shadowed area. This solution, in which the light playing on the background gives the figure an illusionistic appearance, derives from the experiments carried out in Lombardy in the Cinquecento by Savoldo, Moretto, and Moroni (it is, in fact, fre-

quently encountered in Moroni's portraits). In the representation of the neck, which is too muscular for the small head and which is attached to the clavicle according to a formula that the young artist had learned from Peterzano's example, Caravaggio's empirical approach to painting—direct and without preparatory drawings, as he himself affirmed and as van Mander reported—is evident. The robustness of the transitions from full illumination to shadows to the refracted light along the right-hand side of the neck reveal that Venetian, Tintorettesque features had filtered down to Caravaggio through his teacher and were then transposed in terms of the Lombard luministic vision. The lighting of the boy's left eye, seen in half shadow, is the result of extremely subtle observation, possibly inspired by a painting by Lorenzo Lotto; the effect was, perhaps, hinted at in the *Bacchino*, but here it is realized with greater perspicuity. Yet, there is nothing comparable to this figure in contemporary Lombard painting: neither the spirit that animates the youth, which recalls the poetry of Giorgione (whose work Caravaggio had certainly come to know during his peregrinations in Northern Italy), nor the figure's impressive, existential presence, which presupposes Caravaggio's knowledge of the experiments with realism that the young Annibale Carracci had conducted in Bologna.

The still life is the focal point of the picture; it is painted in the "somewhat dry manner" ("maniera un poco secca") that Baglione (1642, p. 136) noted in the *Bacchus*, which, according to him, Caravaggio painted when he left the workshop of Arpino and "attempted to strike out on his own." Zeri (1976, p. 101) has cited the close similarities among the baskets containing the fruit in this painting, in the still life in Hartford (cat. no. 65), and in two others—one formerly owned by F. Mont, New York (F. Zeri, 1976, fig. 96), and the other in the Galleria Borghese (cat. no. 63)—belonging to a group of works attributed to the Master of the Hartford still life; Zeri identifies this group with the still lifes painted by Caravaggio in Arpino's workshop.

M. G.

67. The Fortune Teller (La buona ventura)

Oil on canvas, 45 1/4 x 59 in.
(115 x 150 cm.)
Pinacoteca Capitolina, Rome

Caravaggio treated the subject of a gypsy telling the fortune of a young man, twice: in the present canvas and in a version in the Musée du Louvre, Paris (fig. 1). Bellori (1672, p. 203), making a comparison with the ancient painter Eupompos, tells the following anecdote to illustrate Caravaggio's naturalistic method: Caravaggio "took nature alone as his model for painting. Thus, when shown the famous statues of Phidias and Glykon as objects worthy of study, his only answer was to stretch out his hand toward a crowd of men, affirming that nature had provided a sufficient number of teachers. And to give his words greater authority, he called aside a gypsy who happened to be passing by in the street, and took her to an inn, where he painted her in the act of fortune-telling He showed in the same picture a youth . . .; and in the two half-length figures [Caravaggio] transcribed reality so exactly as to give substance to what he had said."

Like the *Cardsharps* (fig. 2), the *Fortune Teller* presented Caravaggio with the new task of describing the relationship between two or more figures shown in three-quarter length, in accordance with a tradition originating in Venice (P. Francastel, 1938, pp. 51 f.; H. Wagner, 1958, p. 26). Although the subject of the picture is taken from contemporary street life, its treatment differs significantly from the realism of the Flemicizing scenes of Vincenzo Campi and Annibale Carracci (for example, cat. no. 24). In his *Rime*, published in 1603, Gaspare Murtola included a madrigal about a painting of a gypsy ("cingara") by Caravaggio, expressing his admiration both for the lifelike appearance of the figure ("viva si vede") and for Caravaggio's mimetic abilities (G. Murtola, 1603, no. 472; D. Mahon, 1951 a, p. 229, n. 65; L. Salerno, 1966, pp. 109 f.; 1974, pp. 20 f.). Murtola mentions only the gypsy, since the verse turns on a comparison between the magic of the gypsy and that of the artist, but he probably had in mind the two-figure composition of the *Fortune Teller*. Even the inventory of Cardinal

del Monte drawn up after his death (C. L. Frommel, 1971 b, p. 31) describes the Capitoline picture simply as "a gypsy by Caravaggio" ("Una Zingara del Caravaggio"). Whether Murtola is referring to this version or to the one in the Louvre is, however, uncertain.

With the *Fortune Teller* and the *Cardsharps*, Caravaggio abandoned the themes of his earliest paintings in favor of a new type of genre picture, one that presented a clear moral message—for there can be no confusion about the interpretation of these two pictures. In a lively and allusive fashion that makes no concession to the coarse burlesque typical of Dutch genre painting (C. L. Frommel, 1971 b, p. 25), he depicts the pitfalls that a youth might encounter. Mahon (1951 a, p. 229) had pointed out that the success of the *Cardsharps* marks the beginning of Caravaggio's celebrity; Bellori (1672, p. 212) tells us, in fact, that Cardinal del Monte's interest in, and protection of, the artist began with his acquisition of that much-copied work. The theme of the *Fortune Teller* was also widely imitated; Friedlaender (1955, p. 84) found echoes of it in the *Novelas ejemplares* of Cervantes. Moreover, both canvases have been connected with the *commedia dell'arte* (B. Wind, 1974, pp. 31 ff.). This type of theater, which was frequently performed at fairs and in other outdoor locations, drew inspiration from everyday life, freely mirroring its customs and characters while at the same time pursuing a didactic purpose; in the opinion of the present writer, an investigation of the relationship of the *Cardsharps* and the *Fortune Teller* to the *commedia dell'arte* sheds light on certain peculiarities of these paintings as well as on other aspects of Caravaggio's naturalism, including those passages with representations of contemporary life in the two Saint Matthew scenes in San Luigi dei Francesi (see figs. 4, 5, pp. 34 f.) and in the later *Seven Acts of Mercy* in the Pio Monte della Misericordia, Naples (see fig. 3, p. 33).

Contrary to what Bellori suggests by his account and by his comparison of Caravaggio with Eupompos, the *Fortune Teller* and the *Cardsharps* are not simple evocations of everyday life. They belong, rather, to a tradition of theater-related genre painting, the intellectual basis of which was the Aris-

totelian comparison of the various arts as revived by Cinquecento theorists. The mental process by which an artist approached reality through the conventions of the theater may strike us today as both complex and artificial, but it was inevitable in Caravaggio's day. In any case, it should be mentioned that the artist probably deliberately exploited an ambiguity that his contemporaries would easily have recognized, for the characters he portrayed—even in their fictional, theatrical roles—were also part of everyday life in the streets.

Caravaggio's interest in the *commedia dell'arte* probably also stems from his familiarity with the places that the actors frequented and his sympathy—even in matters of dress—with the life that they led (see van Mander, 1604, p. 191; Bellori, 1672, p. 214). A number of elements in the *Fortune Teller* and the *Cardsharps* relate directly to the *commedia dell'arte*, especially the theme of deception, which had been a *topos* in the theater since antiquity. In the *Fortune Teller*, the representation of figures in three-quarter length, close to the viewer and seemingly occupying an extension of his space, suggests that Caravaggio knew late-sixteenth-century Flemish and French paintings that depicted episodes and actors of the *commedia dell'arte*, and that he employed the same scheme: See the examples illustrated by Sterling (1943–44, pp. 22 f.) and the well-known picture (fig. 3) in the John and Mable Ringling Museum of Art, Sarasota, in which Pantaloon is robbed by gypsy women (J. P. Cuzin, 1977, p. 22 f.). The Sarasota picture is the only known representation in which a victim's encounter with gypsies is treated as an isolated incident (the theme of the *Fortune Teller*, however, appears as an episode, usually associated with seduction and robbery, within larger narrative contexts as early as the Quattrocento: see J. P. Cuzin, 1977, pp. 16 f., *passim*); it is therefore likely that the theme of the *Fortune Teller* was suggested to Caravaggio by a painting illustrating skits of the *commedia dell'arte*. It seems significant that an analogous compositional scheme, derived from the above-mentioned works, was used by Georges de La Tour, for his *Fortune Teller* in the Metropolitan Museum (fig. 4), which strikes us today as decidedly archaic for its time.

1

2

The play of hands is of special importance in Caravaggio's two pictures. It, too, is an essential element of this typically Italian form of theater, and is almost always a feature in visual transcriptions of *commedia dell'arte* scenes. Even the old question regarding Caravaggio's use, for the first time in these scenes, of gaudy but attractive costumes for his male protagonists—costumes which certainly did not correspond to popular dress and which, according to some scholars, were even then out of date (see, however, S. M. Pearce, 1953, pp. 147 ff., for the contrary thesis)—may find an explanation in the characters and the ambient of the *commedia dell'arte*, which was known throughout Europe. The same considerations help to explain the widespread similarities with engravings—by Callot, for example—of contemporary scenes and characters.

Wind (1974, pp. 31 ff., fig. 7) has identified the probable source for the *Fortune Teller* as a French engraving in the Recueil Fossard that was inspired by the *commedia dell'arte*. The story illustrated combines eroticism and the art of magic, and the elegant attire and attitude of the protagonist, "Julien le débauché," as well as the gesture with which he receives money from a woman called Peronne, anticipate the two versions of the *Fortune Teller*—except that in these the moral intent seems to count for less than the attractive, ironic presentation. Even in the *Cardsharps*, where the moral intent—the condemnation of gambling—is perhaps more obvious, the costumes underscore the roles of the three protagonists: the older cardsharp, his accomplice, and the naïve young gambler. The two cardsharps are characterized as "bravi," familiar types —Captain Spavento was the most famous of them—in the *commedie* of the late sixteenth and early seventeenth centuries (B. Wind, 1974, pp. 33 f.). The two youths in the *Calling of Saint Matthew* are similarly distinguished from the other personages by their dress, and their dissipated life-style would have been recognized by contemporary viewers because of their conformity to a type of character that the *commedia dell'arte* had popularized. For the *Cardsharps* and the *Calling of Saint Matthew* (see fig. 4, p. 34) Caravaggio drew on Northern prints of the early Cinquecento; Sandrart

(1675; 1925 ed., p. 102) correctly mentions a print by Holbein as a source for the *Calling of Saint Matthew*. Caravaggio's interest in the costumes of German mercenaries (*Landsknechte*) was certainly a product of his Lombard training: Brescian and Cremonese painting of the late sixteenth century is enlivened by figures in multicolored costumes and feathered caps (N. Pevsner, 1928–29, p. 283; D. Mahon, 1951 a, p. 229, n. 64). This interest, combined with a neo-Giorgionesque sensibility, is probably the origin of the apparently archaic costumes of the youths in the *Fortune Teller* and the *Cardsharps*.

Mancini (about 1617–21; 1956–57 ed., I, p. 109) describes a painting of the *Fortune Teller* by Caravaggio that showed a gypsy surreptitiously removing a ring from a youth's hand. This detail is visible in neither the Louvre version nor in the Capitoline picture—at least in its present, poorly preserved state. Nevertheless, the gypsy in the Capitoline *Fortune Teller* exhibits the "cunning" and seductiveness Mancini ascribed to her, and the youth his "simplicity and attraction to the gypsy's beauty"; these traits are related to the theme of the picture as well as to particular characters and typical situations of the *commedia dell'arte*. The moral significance of the picture, which is reflected in its realistic, "comic" style, is more clearly expressed in a well-known engraving, sometimes erroneously attributed to Caravaggio—it is actually later; possibly French, about 1620 (by Claude Vignon?)—of which there is a copy, in oil, in the Galleria Pallavicini, Rome, paired with a companion concert scene that has no relation to Caravaggio's (F. Zeri, 1959, pp. 73 f., nn. 107 f.; J. P. Cuzin, 1977, pp. 28 f.). Probably connected with Caravaggio's inventions, the engraving bears a dedication to the Cavaliere d'Arpino and an inscription: "Fur demon mundus . . . tria sunt haec fugienda viro" ("The thief, the demon, and the world . . . these three a man should flee"). The moral, one favored by the young Caravaggio, takes up the recurrent theme of deception and the disillusionment of youth (L. Salerno, 1966, pp. 109 f.). As we have seen, an analogous theme is found in the *Cardsharps* (the original, much-copied version of which also belonged to Cardinal del Monte; it then passed to Cardinal Antonio

Barberini, and later to the Colonna di Sciarra family; in 1899, it was allegedly sold to a Baron Rothschild, after which it disappeared). It has been proposed that the two pictures were pendants (A. Ottino della Chiesa, 1967, p. 88, no. 14); Frommel (1971 b, p. 16) notes that in the 1627 inventory they were listed together, with the same measurements and identical frames. The dimensions of the *Cardsharps* cannot be verified, however, and the hypothesis that they are companions seems unlikely both for stylistic reasons and because the pictures were sold separately by Del Monte's heirs (see H. Hibbard, 1983, p. 273). Marini (1974, p. 351) and Anderson (forthcoming) have suggested that the two pictures, certainly related through the moral that they express, refer to episodes in the life of the Prodigal Son (Luke 15:11–32); but this idea seems dubious, for the same reasons. For other interpretations of the theme of the *Fortune Teller*, see Marini (1974, p. 351), Cuzin (1977, pp. 25 f.), and Cinotti (1983, p. 486).

Like the *Saint John the Baptist*, also in the Pinacoteca Capitolina, the *Fortune Teller* was owned by Cardinal del Monte; it is mentioned, among the Cardinal's pictures, by Baglione (1642, p. 136), who notes its "bel colorito." Mancini (about 1617–21; 1956–57 ed., I, pp. 109, 140, 224) alludes a number of times to a *Fortune Teller* by Caravaggio but he was not familiar with Del Monte's collection and was certainly referring to another version—he states, in fact, that at the time of his writing the *Fortune Teller* was owned by Alessandro Vittrici. In another place he notes that the "Zingara" was sold by Caravaggio for eight *scudi* in time of need; this again may not refer to the present painting. The Vittrici canvas (fig. 1) was subsequently owned by the Pamphili, in whose collection it is recorded by Scannelli (1657, p. 199). In 1665, the painting was given by Camillo Pamphili, through the agency of Bernini, to Louis XIV; it is now in the Louvre. It corresponds almost exactly to the description in Bellori (1672, p. 203), which must be based on memory, since the painting had already left Rome at the time Bellori wrote. (For the history of the Louvre version, see J. P. Cuzin, 1977, pp. 3 ff.) The early mentions of both versions are reported by Frommel (1971 b, p. 16) and

Hibbard (1983, p. 273).

The Capitoline *Fortune Teller* is listed as a picture by Caravaggio in the inventory drawn up after Cardinal del Monte's death on February 21, 1627 (C. L. Frommel, 1971 b, p. 31) and was sold as Caravaggio's work on May 5, 1628 (W. C. Kirwin, 1971, p. 53, n. 1, p. 55) along with other paintings—the *Saint John the Baptist* by Caravaggio, a *Saint Sebastian* by Guido Reni, and an *Orpheus* by "Bassano"—for 240 *scudi*. Although the purchaser is not recorded, it was almost certainly Cardinal Pio: Scannelli (1657, p. 199) does not mention the picture specifically (he does note the *Saint John the Baptist*), but he probably meant to include it among the "alcuni Quadretti" by Caravaggio in Cardinal Pio's collection. In the inventory of the Pio di Savoia collection drawn up by Francesco Trevisani in the 1740s, the picture was attributed to Annibale Carracci, but in Panini's inventory of 1749, compiled when the collection was about to be sold to Benedict XIV Lambertini for his newly founded Pinacoteca Capitolina, it is again listed as an original by Caravaggio and valued at three hundred *scudi* (E. Battisti, 1955, p. 182). It is attributed to Caravaggio in an eighteenth-century engraving by Giuseppe Perini, the only known engraving after the picture (M. Cinotti, 1983, p. 519).

The history of the Capitoline picture, therefore, provides compelling evidence for its provenance in Del Monte's collection and for its attribution to Caravaggio. In the opinion of the present writer, the version that belonged to Alessandro Vittrici and that is now in the Louvre was painted by Caravaggio a few years later, when he lived with Del Monte; this conclusion is suggested by the Louvre painting's stylistic affinities with the *Lute Player* and with the *Bacchus* in the Uffizi (cat. no. 71). The existence of two versions of the *Fortune Teller* has given rise to misunderstandings and to conflicting opinions about the authorship of both, though the greatest number of reservations concern the Capitoline painting. The most authoritative negative judgment was expressed by Mahon (1951 a, p. 234, n. 112); Nicolson (1977, p. 597) proposed that the Capitoline picture was painted by another artist as a pendant to the *Cardsharps*. These reservations have not been

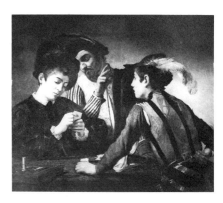

2. Caravaggio. *The Cardsharps* (i "*Bari*").
Formerly Sciarra collection, Rome
3. French (?). *Scene from the Commedia
dell'Arte*. The John and Mable Ringling Museum
of Art, Sarasota, Florida

entirely eradicated even by the discovery of the documents showing that in 1627 and 1628 the work was attributed to Caravaggio, or by the fact that the picture can be traced from Del Monte's collection to its present location (for various opinions, see M. Cinotti, 1983, pp. 520 f.). Of those who have upheld its autograph status—among them Longhi (1943, p. 9, and repeatedly thereafter)—some have considered it later than the Louvre version and others earlier; the latter opinion seems to prevail among recent writers (see M. Cinotti, 1983, p. 520).

The present writer shares, on grounds of style, the view that the Capitoline picture must predate the Louvre version, and has proposed that Caravaggio painted it prior to joining Cardinal Del Monte's household (M. Gregori, 1976, p. 868). Mancini (about 1617–21; 1956–57 ed., I, p. 224), in fact, states that it was during the time that Caravaggio worked with the Cavaliere d'Arpino that he painted the *Fortune Teller*. This information is not necessarily accurate (see M. Cinotti, 1983, p. 485), and, as we have seen, Mancini probably did not know the Capitoline picture. However, when it was X-rayed at the Istituto Centrale del Restauro in Rome in 1977, another painting in the style of the Cavaliere d'Arpino was revealed beneath the present image of the fortune teller. The earlier painting, showing the Virgin with her hands clasped in prayer, is certainly not by the same hand. It has been correctly related by Cordaro (1980, pp. 103 f., 106, n. 13) to the *Coronation of the Virgin* in the Chiesa Nuova, commissioned from Arpino in 1592 but not completed before 1615 (H. Röttgen, 1973, pp. 125 f.), and to other works painted by Arpino in the last decade of the sixteenth century. Since the Capitoline *Fortune Teller* belonged to Del Monte, it is conceivable that he purchased it, just as, according to Bellori (1672, p. 204), he purchased the *Cardsharps*. The *Musicians*, on the other hand, was painted expressly for him, and in it the change in intellectual climate is evident. Baglione (1642, p. 136), furthermore, seems to connect the prelate's discovery of the young prodigy with pictures sold by the dealer "Mastro Valentino a S. Luigi dei Francesi"—although the passage in question is not altogether clear. While it cannot

be ruled out that the *Fortune Teller* was painted at the beginning of Caravaggio's residence in the palace of his principal protector, rather than earlier, the Arpinesque Virgin revealed by the X-rays would in that event be difficult to explain.

The *Fortune Teller* in the Louvre more clearly dates from the late Del Monte period. The model who posed for the youth —Frommel (1971 b, p. 25) identifies him as the painter Mario Minnitti, who came to Rome at a very early age and who was, according to Susinno (1724; 1960 ed., p. 117), a friend of Caravaggio; however, the suggestion requires further investigation— also posed for the *Lute Player*, the *Bacchus*, and the *Calling* and the *Martyrdom of Saint Matthew*. These last-mentioned paintings are closely related to the Louvre *Fortune Teller* in style and, consequently, are close in date; the Louvre picture must be contemporary with them or slightly earlier. The most probable date for the Louvre version is, therefore, no earlier than 1597.

The condition of the Capitoline *Fortune Teller* remains poor, even after the 1963 restoration, and the picture is therefore difficult to read (see M. Cordaro, 1980, p. 104). The X-rays, made on the occasion of the Paris exhibition (J. P. Cuzin, 1977, p. 11), reveal a paint surface that is worn and abraded; it is particularly thin on the youth's hand and on those of the gypsy. The sleeve of the gypsy and the left hand and sleeve of the youth are better preserved. The brushstrokes in the flesh areas and in the white drapery are continuous and rapid —especially in the head of the youth (which is shown in profile in a schematic manner derived from Arpino); this seems to confirm Caravaggio's authorship and to belie the theory that the picture is the result of a collaboration (C. Brandi, 1972–73, pp. 27 ff., 1974, pp. 9 f.; J. P. Cuzin, 1977, p. 11). The surface appears overcleaned and granular, with losses of color and, perhaps, heavy retouches. A major pentimento in the mantle of the youth is visible at the lower right beneath the background pigment, which seems to have been laid on after the figures were painted, as in other works by Caravaggio.

Once it is noticed that the two versions differ considerably from each other, it also becomes evident that, in comparison to the

version in the Louvre—with its refined composition, its uniformly high quality of execution, and its more acute description of the psychological relationship between the figures—the Capitoline version is (as C. Brandi, 1972–73, and M. Cordaro, 1980, pp. 102 f., have noted) the expression of a substantially different idea, one that seems to represent the artist's first thoughts on a theme he later developed further. In the Louvre painting the two figures are standing still, as though posed (the same is true in other, related works that are contemporary with this painting). In the Capitoline picture, on the other hand, the encounter clearly has the more instantaneous, fleeting character of a street scene captured on canvas by Caravaggio as a demonstration of his method of painting directly from nature. The gypsy, apparently, has only just arrived and is still in motion. The restless play of light and shadow—sharply focused on the wonderfully observed ear, more diffused elsewhere—emphasizes the turn of her head. The head, moreover, lacks the geometric regularity of the gypsy's head in the Louvre version, a regularity accentuated by the band of cloth (or gorget) under her chin. Caravaggio's use of light to describe the simply constructed head, which appears to be painted directly from life rather than carefully drawn (a similar procedure was anticipated in the Galleria Borghese *Bacchino Malato*, fig. 1, p. 29), derives from the Lombard tradition represented by Lotto and Savoldo—the Savoldesque quality is particularly evident in the X-ray—and appears to be a variation on the more recent example of Sofonisba Anguisciola, who experimented with the relationship of two figures in the well-known drawing of the *Boy Bitten by a Crayfish* (in the Uffizi, Florence). A painting on paper showing two girls (fig. 5), perhaps also by Sofonisba Anguisciola, should also be cited. The connection among these works confirms that the *Fortune Teller* had its genesis in portraiture (this is also true for its format: see E. Bardon, 1978, p. 51). Three-quarter-length figures whose action is directed parallel to the picture plane—as in the *Fortune Teller*—would be revived in such religious works for private collectors as the *Supper at Emmaus* (cat. no. 78), the *Incredulity of Saint Thomas*, the *Calling of Saints Peter and Andrew*, and the *Taking of Christ*. The use of large areas of contrasting colors in the gypsy's simple costume and the boy's doublet recalls the Venetian character that Bellori (1672, pp. 202, 204) saw in the youthful paintings: They reminded him of Giorgione, "the purest and most straightforward in representing natural forms with few colors." The *Cardsharps* in particular, according to Bellori, is painted "in that pure manner of Giorgione, with a restrained use of darks."

M. G.

68. The Stigmatization of Saint Francis

Oil on canvas, 36 7/8 x 50 5/16 in.
(92.5 x 127.8 cm.)
Wadsworth Atheneum, Hartford

Saint Francis lies on the ground, supported by an angel. As the wound on his breast indicates, he has just received the stigmata. There are, however, no visible wounds on his hands, and, indeed, despite the contrary report of Askew (1969, pp. 280 f.), who is the author of an important study of this picture and of the significance of the subject in post-Tridentine painting, examination and cleaning at the Metropolitan Museum in 1983 revealed that the stigmata were never shown on the right hand (what has, in the past, been interpreted under ultraviolet light as the wound is instead a small damage). Likewise, contrary to Mahon's assertion (1952 a, p. 7, n. 24), there is no pentimenti around this hand—in fact, there are practically no pentimenti at all in this composition, which Caravaggio laid on the canvas with great sureness (however, the contour of the angel's right arm was painted first and the draper superimposed over it, a typical feature of Caravaggio's early work). The presence of the wound in a copy of the picture in the Museo Civico, Udine, must, therefore, signify an attempt to further clarify the subject of the picture.

The stigmatization occurred on the summit of Mount La Verna, and Caravaggio has, accordingly, shown the background landscape lower and at a considerable distance from the principal figures. Two shepherds can be seen gesticulating toward something, while a third figure, near a fire and a hut, apparently gazes at the sky, which, in the absence of the seraph who is traditionally represented appearing to Saint Francis, is streaked with light.

In 1894, Joppi (IV, p. 41) published the will of Ruggero Tritonio da Udine, Abbot of Pinerolo, which provided that a painting by Caravaggio showing Saint Francis was to be left to the abbot's nephew, Francesco: "divi Francisci signum a Caravagio celeberrimo pictori summa cum diligentia affabre pictum, quod mihi d. Octavius Costa civis Januensis nobilissimus, mutui amoris incomparabilisque amicitiae ergo donavit. . . . " This statement indicates that the picture had been given to Tritonio by Ottavio Costa. Tritonio died on July 13, 1612, but, according to Joppi, the will was dated October 25, 1597. Joppi identified this reference with a painting in the church of San Giacomo, Fagagna, of "the death of Saint Francis," which had been owned by the Fistulario family and given to the church by Conte Francesco Fistulario in 1582. The date of the will was long considered an important *terminus ante quem* for Caravaggio's first religious painting and an early indication of his fame. However, in 1974 Spezzaferro (1975a, p. 113) discovered the will of Ottavio Costa, drawn up in Rome on August 6, 1606, providing for Tritonio's choice of one of two pictures by Caravaggio, a "Saint Francis" or a "Saint Martha and the Magdalen" (cat. no. 73); the remaining picture was to go to Costa's banking associate, Giovanni Enriquez de Herrera, who later commissioned Annibale Carracci to decorate his chapel in San Giacomo degli Spagnoli, Rome. Spezzaferro reexamined Tritonio's will in Udine and corrected Joppi's reading of the date to October 25, 1607—a year after Costa's will was drawn up. Costa was not to die until 1639. Presumably, having recovered from the illness that had led him to make his will, he gave the "Saint Francis" to Tritonio, probably shortly after August 1606. Tritonio, in turn, left the picture to his nephew. In 1928, A. Venturi (pp. 58 f.) published a version of the present picture (in the Museo Civico, Udine), recalling the painting that had been mentioned in Tritonio's will (the Udine picture may, in fact, be the Fagagna "death of Saint Francis"). Although he attributed the Udine version to Caravaggio, Longhi (1928–29; 1968 ed., p. 120, n. 17) considered it only a good copy. Marangoni (1929, pp. 34 f.) was the first to call attention to the present work, which has a Maltese provenance, and belonged to the Grioni collection, Trieste, at the time. The picture was subsequently exhibited in Naples in 1938, and then was sold the following year to A. Seligmann, Rey and Co., New York, who, in turn, sold it to the Wadsworth Atheneum in 1943. Marangoni attributed this picture to Caravaggio, and he explained its relationship to the "Saint Francis" mentioned in Tritonio's will— assuming that it had a direct bearing on the version in Udine—by suggesting that an exchange of paintings had taken place at an uncertain date.

The Hartford picture is now universally recognized as an early work by Caravaggio, although some reservations were raised by a number of scholars in the 1950s (for example, by H. Wagner, 1958, pp. 226 f., who believed that it was by a follower of Caravaggio from the circle of Saraceni) and even more recently (see M. Cinotti, 1983, p. 441). No painting of this subject is mentioned by Caravaggio's biographers. However, in the inventory of the possessions of Cardinal del Monte (C. L. Frommel, 1971 b, p. 34) there is listed on f. 580 *r*.: "un' S. Francesco in Estasi di Michel Agnolo da Caravaggio con Cornici negre di Palmi quattro." The measurement given coincides with the height of the Hartford picture, and the subject also corresponds. It is known that the painting owned by Cardinal del Monte was sold by his heirs on May 25, 1628, for 70 *scudi* (see W. C. Kirwin, 1971, pp. 54 f., who erroneously thought that the picture was acquired by the Barberini), but nothing more was heard of it until its rediscovery in 1929.

These facts have occasioned a reconsideration of the painting's history. On the one hand, Spear (1971 a, p. 68) and Spezzaferro (1974, p. 580; 1975a, pp. 113 f.)—modifying somewhat the accepted viewpoint— have proposed that in 1612 Tritonio's heirs sold the original (the Hartford picture) to Cardinal del Monte, retaining a copy (identifiable with the painting in Udine) that they had made on this occasion. A second, less complicated hypothesis follows logically from Frommel's discovery (1971 b, pp. 8 f., 24) of the Del Monte inventory: The picture by Caravaggio was painted for Cardinal del Monte, who bore the saint's name (Frommel's idea that the saint has the features of the Cardinal is less convincing). Costa's painting would have been only a copy, which he gave to Tritonio (C. Volpe, 1972 a, pp. 57 f.; R. Spear, 1972, p. 68), and Frommel (1971 a, p. 15, n. 61) has questioned whether it might not be by Mario Minnitti. This proposed reconstruction of the picture's history seems to accord with what is known of Costa, a man "strongly attached to his possessions" (Spezzaferro), and with the particular attention given in his succes-

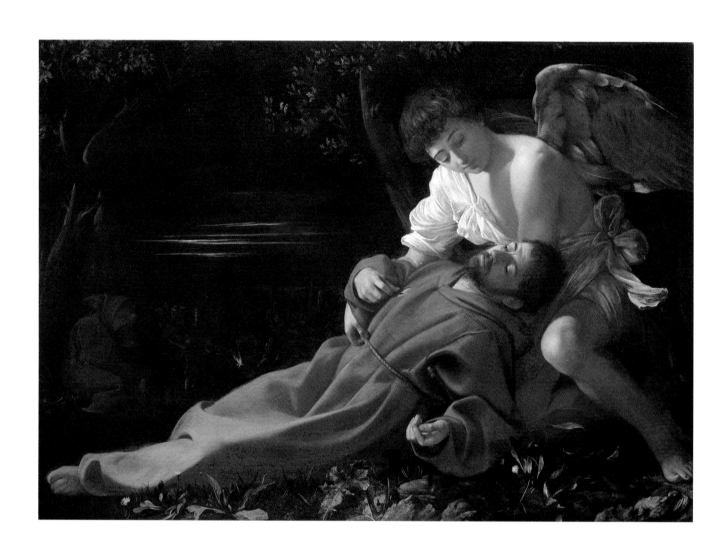

X-ray

sive wills to the paintings in his collection by Reni, Arpino, and Caravaggio—especially the *Judith and Holofernes* (cat. no. 74)—the sale of which he forbade in order that they remain the unalienable inheritance of the family. Costa was one of Caravaggio's admirers and protectors, and it was probably through his good offices and those of his relative, Ippolito Malaspina, that Caravaggio went to Malta (see J. Hess, 1958; 1967 ed., pp. 339 ff.; P. Matthiesen and D. S. Pepper, 1970, pp. 452 ff.; L. Spezzaferro, 1974, p. 580; 1975 a, pp. 103 ff.).

Our understanding of the artistic (or stylistic) importance of the present picture is due to Longhi and to Mahon, and to the debate in the 1950s that focused on the date of the San Luigi dei Francesi canvases and on the chronology of Caravaggio's youthful paintings. Longhi (1928–29; 1968 ed., pp. 114, 120) noted the relationship between the lucidly described leaves and flowers in the foreground—very similar to those in the Doria *Rest on the Flight into Egypt*—and the treatment of the sky, and works by Moretto and by Savoldo. Although Longhi (1952, p. 24) proposed that the date of the picture coincided with that of the lateral paintings in San Luigi dei Francesi—calling attention to the existence within the same picture of two contrasting tendencies, one toward a youthful, elegiac clarity, and the other toward a crude, almost bloody brutality ("[contrasto] fra lucida inclinazione elegiaca di adolescenza e impulso quasi sanguigno verso la più cruda brutalità in diretto contrasto in uno stesso dipinto")—he emphasized the importance of Caravaggio's Lombard heritage (especially the influence of Savoldo) and its transmittal to Elsheimer through the present work. Longhi saw the nocturnal landscape, in which the shepherds have lit a fire and appear to be surprised by the light-streaked sky, as a brilliant conception for the description of a night scene. The dense nocturnal ambience in which the miracle takes place is manifest even in the soft light that falls across the figure of the saint and highlights the nose, foot, and knee of the angel in a way that recalls the work of Lorenzo Lotto. Calvesi (1954, p. 131) has noted the similarity between a drawing (in the Castello Sforzesco, Milan) by Simone Peterzano for the angel in a *Pietà*, and the angel in the present picture,

thereby establishing yet a further Lombard context.

To Mahon (1951 a, p. 227, n. 49, p. 233, n. 155), who believed that the date of the Hartford picture was contemporary with the *Musicians* (cat. no. 69) and the *Cardsharps* (fig. 2, cat. 67), is due the perception of the difficulty encountered by Caravaggio in dealing with a religious subject for the first time, and of those characteristics of the artist's early works (these had already been noted by R. Oertel, 1938, p. 230, who thought it possible that the picture dates from Caravaggio's Lombard period). Mahon's early dating of the picture to perhaps shortly after Caravaggio's acquaintance with Del Monte was based on his recognition of a lack of volume in the sleeve of the angel's garment, the rigidly abstract folds of which have been superimposed over the bare arm, and the artist's timid approach toward representing the nude. It should nonetheless be mentioned that the illuminated knee of the angel prefigures a motif that recurs later in the *Saint John the Baptist* in Kansas City (cat. no. 85). These observations have led other scholars (see M. Cinotti, 1983, pp. 440 f.) to observe, correctly, the analogies among the angel, with his head inclined forward, the youth in the *Boy Peeling a Fruit* (cat. no. 61), and the Eros in the *Musicians*, as well as the physiognomic resemblance of the saint and the companion in the *Cardsharps*. The depiction of the light, projected from the left, and a similar morphology of the hands of the figures further relates the Hartford painting to the *Cardsharps*. It has also been pointed out that the picture's naïve features clearly differentiate it from the "charm" and the facility that characterize the Doria *Rest on the Flight into Egypt*.

The inclusion of this painting among the artist's youthful works makes it appear even more disconcerting and revolutionary. While its simple compositional structure—based on intersecting diagonals—anticipates Caravaggio's later religious pictures (R. Spear, 1971, pp. 68 f.), the novel figurative conception is closely tied to the theme. As observed by Askew (1969, pp. 280 ff.), from whose article only the most important points will be noted here, the subject is not the ecstasy of the saint but his stigmatization, an event that marks the consummation

of Francis's mystical experience and of his identification with Christ. Quite apart from the possibility that the subject was selected on account of its reference to Del Monte's first name, the choice was motivated by the fact that, more than any other saint, Francis of Assisi represented a paradigm of the ideals of spiritual life in the post-Tridentine period because of the conformity of his life to Christ's, his conception of life as love, and his mystical experience—to which the figurative arts devoted especial attention, and which had a profound influence on Saint Francis de Sales's writings, published in the first two decades of the seventeenth century. (De Sales was a student in Padua from 1588 to 1592, and Askew has queried whether Caravaggio—who, Bellori says, visited Venice—might not have known him.) Caravaggio's treatment of the subject was without precedent, and it was certainly the most complex interpretation in the post-Tridentine period. The saint, lying on the ground in a state of ecstasy while he receives the stigmata, and the angel, who tenderly supports him, are two diverse expressions of love—the dominating spiritual theme of the picture. As affinities with the ideas of Saint Francis de Sales suggest, Caravaggio's depiction of the event was certainly based on literary descriptions of mystical experiences (toward the end of his life, Cardinal del Monte delivered a *laudatio* on the occasion of the canonization of Saint Teresa of Avila: see C. L. Frommel, 1971 b, pp. 24, 51).

According to Saint Bonaventure's life of Saint Francis (of 1262), it was revealed to the saint at the time of his stigmatization that his identification with Christ was more a function of a seraphic spirit (love) than of physical deprivation. When the vision disappeared, the stigmata appeared. Following Saint Bonaventure's exposition, which describes an inner experience of the mystical vision, "love precedes the stigmata" (P. Askew, 1969, p. 283). In the *Saint Francis*, Caravaggio confronted for the first time the task of representing a crucial moment in the spiritual life of a saint. The *Conversion of Saint Paul* (fig. 9, p. 40) is a later conception of an even more acute interpretation of such a moment.

As Askew has shown, in the Hartford painting Caravaggio approached the theme by

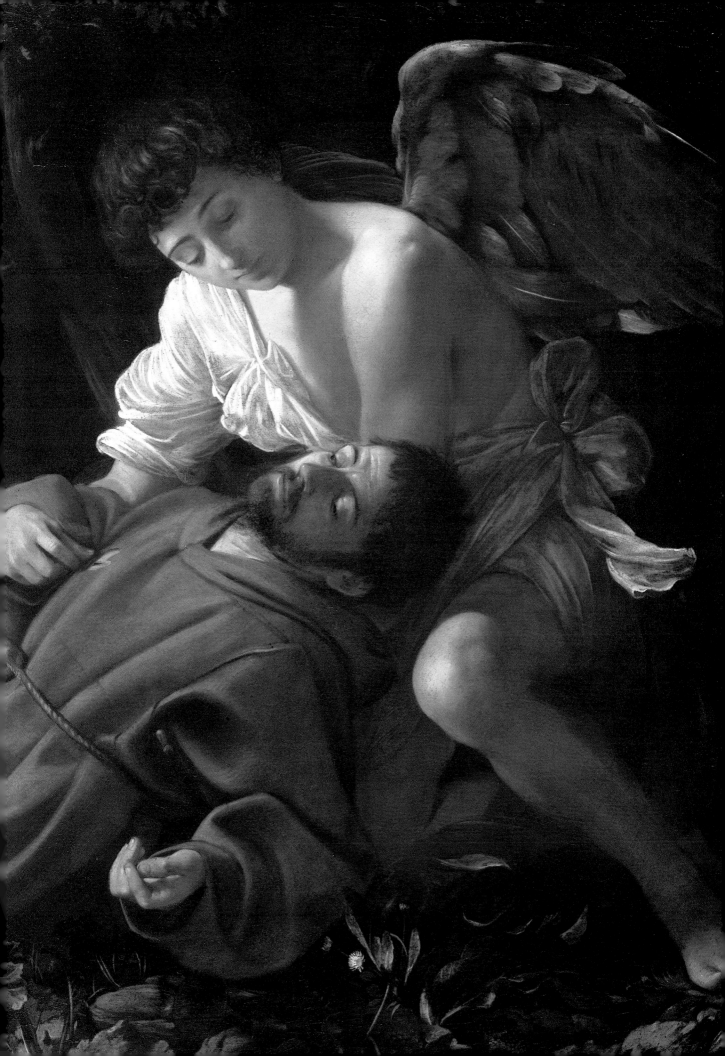

way of important iconographic innovations that derive from other, non-Franciscan subjects (such as a recumbent saint supported by an angel), and he described it with an extreme attention to significant details that should be understood in the context of Christological allusions. The artist arrived at his conception of the subject through a profound consideration of the mystical and theological significance of the theme (for example, the interpretation of light as both a natural and a spiritual phenomenon), and a faithful description of the event (as was required by the rules of suitability, or "convenienza"). By so doing, Caravaggio took the radical path of an "imitatore della natura," since, according to his revolutionary conclusions, this was the only route by which to produce narrative paintings. Nonetheless, he encountered difficulties in preparing himself for such a task. The angel, still close to his early, poetic half-length figures, contrasts markedly with the almost brutal, portrait-like truthfulness of the saint.

The following observations, taken for the most part, from Askew's article, are intended simply to call attention to the painting's salient iconographic novelties. The shepherds, who are mentioned in the description of the stigmatization in the *Fioretti*, rarely appear in representations of the subject (see, however, cat. no. 18). The fact that Caravaggio did not show the stigmata on Saint Francis's hands confirms that he placed greater importance on the saint's inner experience than on his physical suffering. The recumbent position of the saint presents ecstatic love as a metaphor for death; the two are frequently associated in mystical literature. And it should not be forgotten that the episode is analogous to Saint Paul's conversion on the road to Damascus (Caravaggio himself later recalled this analogy)—even on a figurative plane (Askew alluded to Michelangelo's fresco of the *Conversion of Saint Paul* in the Cappella Paolina). The motif of the angel supporting the saint has been intentionally adopted from images of Christ supported by an angel—as in certain episodes of the Passion—in order to give visual form to Saint Francis's identification with Christ (the analogy of the stigmatization and the death of Christ is also found in Saint Francis

de Sales's *Traité de l'amour de Dieu*, and the derivation of the angel from Peterzano's drawing seems to confirm this analogy in Caravaggio's painting). Landcastle (1961, pp. 58 f.) notes the connection with scenes of the Deposition showing the Virgin holding her son; indeed, it is probable that Correggio's *Deposition*, which Caravaggio could have seen in the church of San Giovanni Evangelista, Parma (the picture is now in the Galleria Nazionale, Parma), was one of the models for this painting. The manner in which the body of Saint Francis extends along a diagonal—Correggesque in origin—is the earliest example of the revival of a paradigmatic scheme for representing a mystical state (not by accident does the configuration of Saint Francis's habit suggest analogies with Parmesan paintings, of the early Seicento, by Bartolomeo Schedoni and Sisto Badalocchio). Later, the scheme was frequently adopted for depictions of saints in ecstasy. Prior to Bernini's *Ecstasy of Saint Teresa* (according to C. L. Frommel, 1971 b, pp. 24, 51, the Hartford picture anticipates this work), Lanfranco followed Caravaggio's example in the *Saint Margaret of Cortona* (in the Palazzo Pitti, Florence).

Another, more specific, association between Caravaggio's *Stigmatization of Saint Francis* and Christ with an angel is suggested by the parallel drawn by Saint Bonaventure between Saint Francis and the prophet Elijah, who was consoled by an angel while he slept. It is significant that, in Brescia, this subject was painted twice by Moretto—for San Giovanni Evangelista and for the cathedral. Since the episode was interpreted as a prefiguration of Christ's Agony on the Mount of Olives (L. Réau, 1955–59, II, pt. 2, p. 353), Caravaggio may have intended the same Christological meaning in the episode that he represented from the life of Saint Francis. He may have recalled Veronese's *Agony in the Garden*, which he probably saw in Venice in Santa Maria Maggiore (it is now in the Pinacoteca di Brera, Milan). Yet a further association of the work with post-Tridentine ideas stems from Arcangeli's observation (1956 a, p. 35; 1956 b, pp. 109 f.) that Ludovico Carracci's *Vision of Saint Anthony* (actually the *Vision of Saint Francis*; see cat. no. 28), datable to 1585–86, is a prelude to Cara-

vaggio's picture. Caravaggio may have seen Ludovico's painting in Bologna before his arrival in Rome.

In the *Stigmatization of Saint Francis* there is a hole in the angel's head (see X-ray), and the surface of the painting was burned somewhat during a past relining. Of the five copies that are known, the one in Udine has almost identical dimensions (see M. Cinotti, 1983, p. 440).

M. G.

69. The Musicians

Oil on canvas, 34 5/8 x 45 5/8 in.
(87.9 x 115.9 cm.)
The Metropolitan Museum of Art,
New York

The picture, discovered by David Carritt, was identified by Mahon (1952 a, pp. 3 ff.) with a concert scene of half-length figures that, according to Baglione (1642, p. 136) and Bellori (1672, p. 204), was painted for Cardinal Francesco Maria del Monte. Baglione writes: "Because of his interest in painting, [Del Monte] took [Caravaggio] into his house, where, having a place and provisions, [the artist] took heart and made for the cardinal a music piece ["una musica"] of some youths painted from nature ["ritratti dal naturale"]." Bellori recounts essentially the same story: Caravaggio "made for this gentleman a concert of youths painted from nature in half length." The lutenist in the center tunes his instrument, his eyes veiled with emotion. The boy in the background turns his head and holds a cornetto. Longhi (1952, p. 9) identified the latter figure as a self-portrait of Caravaggio; Czobor's proposal (1954–55, pp. 206, 208, 210) that the lutenist is also a self-portrait has not been widely accepted. The youth at the right, whose task it will be to sight-read, looks attentively at the score he holds. At the left another, evidently younger boy leans over to pluck a bunch of grapes; the cleaning of the canvas in 1983 has uncovered the wings and quiver that identify him as Eros. These attributes were painted out at an unknown date; Mahon (1952 a, p. 4, n. 15) supposed that they were eliminated by Caravaggio himself. Yet their presence in old copies leaves no doubt that they were visible when Caravaggio consigned the picture (for the opinions of R. Spear, 1971 a, C. Volpe, 1972 a, and V. Scherliess, 1973, with regard to this problem see M. Cinotti, 1983, p, 477). The same conclusion is suggested by Pietro Paolini's *Concert* in the J. Paul Getty Museum, Malibu (fig. 1), in which the figure of the young winged Amor is clearly inspired by Caravaggio's picture.
As the vaguely *all'antica* costumes and the presence of Eros indicate, the picture was conceived as an allegory translated into ideal terms. Pictures like the *Cardsharps* (see fig. 2, cat. no. 67) and the *Fortune Teller* (cat. no. 67), on the other hand, were conceived as scenes of everyday life, since their moralizing significance accorded with a realistic, "comic" interpretation.
There were important North Italian precedents for the theme of a concert, especially in Venice, and Caravaggio certainly intended a reference to them. Among Giorgionesque examples one may cite the *Concert* at Hampton Court, the *Three Ages of Man* and the *Concert* in the Palazzo Pitti, and the *Fête Champêtre* in the Louvre (the last two by Titian); the ample red mantle of the lutenist in Caravaggio's picture recalls the last-mentioned work (see H. Wagner, 1958, pp. 22, 178, nn. 68–71; E. Waterhouse, 1962, pp. 22 f.). Salerno (1966, pp. 108 f.) and Kinkead (1966, p. 112) have cited the precedent of Callisto Piazza's *Concert* in the John G. Johnson Collection, Philadelphia Museum of Art, in which, however, the Venetian theme is presented in realistic, genre-like terms: Caravaggio's crowded composition, with the figures wedged together and the one player shown in the foreground in three-quarter view, may reflect acquaintance with this work. Baglione's assertion that the *Musicians* was the first work that Caravaggio produced in the Cardinal's service is borne out by its style, which retains youthful features despite the artist's evident intention of surpassing his earlier paintings of individual half-length figures by creating a multifigure composition.
Longhi (1952, p. 19) maintained that the present picture, with its "insolente allegorismo pagano," was unlikely to be the work mentioned by Baglione and Bellori. He conceived of Del Monte's "musica" as a painting with figures in contemporary dress, a companion piece to the famous *Cardsharps* acquired by the Cardinal. His opinion has, however, found little favor. Neither the inventory of the collection made at Del Monte's death in 1627 nor the list of his paintings sold between October 1627 and June 1628 supports Longhi's hypothesis. In the inventory the "musica" is described as "di palmi cinque in circa" (about 44 inches), which approximates the width of the Metropolitan picture—even allowing for the fact that it has been cut down slightly at the left side. We know, moreover, that the "musica" cited in the sources hung in the "prima stanza dell'appartamento nuovo," whereas the *Cardsharps* ("un gioco di mano del Caravaggio") was in another room, the gallery adjacent to the "galleria nova stretta," where it was perhaps paired with the *Fortune Teller*, even though the two were not painted together (see C. L. Frommel, 1971 b, pp. 31, 35). The sale document (see W. C. Kirwin, 1971, p. 55) also suggests that the "musica" and the *Cardsharps* were not paired, since they were sold separately (as was the *Fortune Teller*). The *Lute Player* in the Hermitage, Leningrad (fig. 2), which has sometimes been associated with the *Musicians* because of their affinities of subject and style and their nearly identical dimensions (see M. Calvesi, 1971, p. 110; S. Vsevolozhskaya, 1975, figs. 1–4) also hung in a different room, together with two concert scenes by Gerrit van Honthorst and Antiveduto Grammatica; it is indeed difficult to imagine the *Lute Player* as a pendant to the *Musicians*, given their compositional differences (see also M. Marini, 1974, p. 344). Baglione's statement that the youths in the "musica" were "ritratti dal naturale" actually tends to confirm the identity of Del Monte's picture with the *Musicians*, for rather than indicating that the figures were shown in contemporary dress, that expression may mean simply that they were painted (not drawn) from nature, in accordance with Caravaggio's usual practice—or, according to current norms, that the models were almost nude. This did not prevent Caravaggio from conceiving a sophisticated work evocative of the poetry of Giorgione and of ancient eroticism. But it was precisely the representation "from nature" in a picture of this sort that must have seemed a novel and bewildering provocation.
The fact that Baglione says the picture was the first work painted by Caravaggio for Del Monte has caused the *Musicians* to be related more or less explicitly to the Cardinal's personality (see L. Spezzaferro, 1971, pp. 57 ff.) and the new cultural climate in which, as a result of the prelate's protection, Caravaggio found himself. Calvesi (1971, p. 110) has characterized the youths in the *Musicians* as possessing the perfection of the androgynous. The theme of Music—

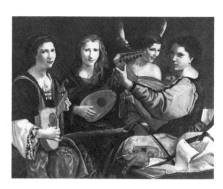

also treated in Del Monte's *Lute Player*, which Bauch (1956, p. 254) has understood in terms of a *vanitas*—has occasioned various interpretations, many of them overly elaborate: as a symbol of love; of harmony (see C. Ripa, 1603, p. 344); of the divine, based on cabalistic and Pythagorean considerations; or of artistic inspiration (see M. Calvesi, 1971, pp. 110 f.; L. Spezzaferro, 1971, p. 87, n. 147; M. Marini, 1974, p. 343). Others (C. L. Frommel, 1971 b, p. 23; D. Posner, 1971 b, p. 306; H. Röttgen, 1974, pp. 173 ff.) have emphasized a homoerotic significance, seeing a close relationship between the painting and Del Monte's supposed homosexual inclinations. But these suppositions are based on a tendentious and not very reliable source (Teodoro Amayden's biography: see L. Spezzaferro, 1971, p. 60) and on an inexact interpretation of a notice reported by Orbaan (1920, p. 139) and taken up by Haskell (1963, p. 29). According to this notice, Del Monte attended a banquet in the Palazzo della Cancelleria given "in the usual fashion" by Cardinal Montalto "for Cardinals Aldobrandini, Monte, and Peretti, as well as other gentlemen . . . with extremely beautiful festivities and, for recreation, dancing after dinner in which the best dancing masters took part. And because there were no women, many youths took part, dressed as women, providing not a little entertainment." This event should not be given a homosexual interpretation, considering the importance and the official nature of the occasion and the widespread custom, in ecclesiastical circles and religious communities, of staging festivities without mixing the sexes.

The first iconological interpretation of the picture was proposed by Friedlaender (1955, p. 148), who called attention to the presence of the wings on the youth at the left and saw the work as an allegory of Music and Love. Egan (1961, p. 193), Salerno (1966, p. 108), Posner (1971 b, pp. 303, 322, n. 39), and Scherliess (1973, pp. 141 ff.) have followed along the same lines. In contemporary thought, Music and Love were frequently associated because of the role of music as entertainment during the Renaissance (see A. P. de Mirimonde, 1966 –67, pp. 320 ff.); indeed, Vasari (1568; 1906 ed., VI, p. 373) affirmed that Love is

born of Music. His comment was occasioned by Veronese's *Music* in the Biblioteca Marciana, Venice: "Close by the women [musicians] is a Cupid without wings, . . . showing that Love is born of music . . . ; and since he never parts company with it, he is shown without wings" (this interpretation would have explained the absence of Eros's wings in Caravaggio's painting were it not that the recent restoration has revealed that the artist intended them to be present). The Bacchic motif of the grapes is also consonant with a representation of Love and Music; it is found in Pietro Paolini's *Concert* in the Hoblitzelle Foundation, Dallas, which illustrates to the letter Ripa's observation (1603, p. 345) that music and wine, according to the ancient authors, belong in the company of Bacchus.

The *Musicians*, like the half-length figures that Caravaggio painted before meeting Cardinal del Monte, indubitably displays his early penchant for depicting androgynous youths in ambiguous costumes, for whom he probably used both himself and his friends as models. Traditionally, representations of Music showed women (as in Paolini's picture in Malibu; fig. 1), and Hibbard (1983, p. 33) has therefore seen in Caravaggio's treatment a deviation from the norm and an indication of a perverse tendency. Part of the picture's iconographic novelty may be explained by the free, experimental climate at the end of the sixteenth century. Despite its allegorical intention, the painting also drew inspiration from portraiture; there are North Italian portraits, of the late Cinquecento, for example by Bartolomeo Passarotti and Leandro Bassano, in which youths play the lute. The theme was certainly stimulated by the great musical innovations of those decades. Del Monte was the intimate friend of Ferdinando de' Medici. Both were great music lovers, and there seems little doubt that paintings like the *Musicians* and the *Lute Player* represent the newly acquired power of music to express the human passions.

The badly damaged musical scores in the *Musicians* are no longer legible, but at one time they were; the text set to the music could also be read in at least one of them. Although there are precedents for the transcription of music in Northern and North Italian painting (see F. Camiz and A. Ziino,

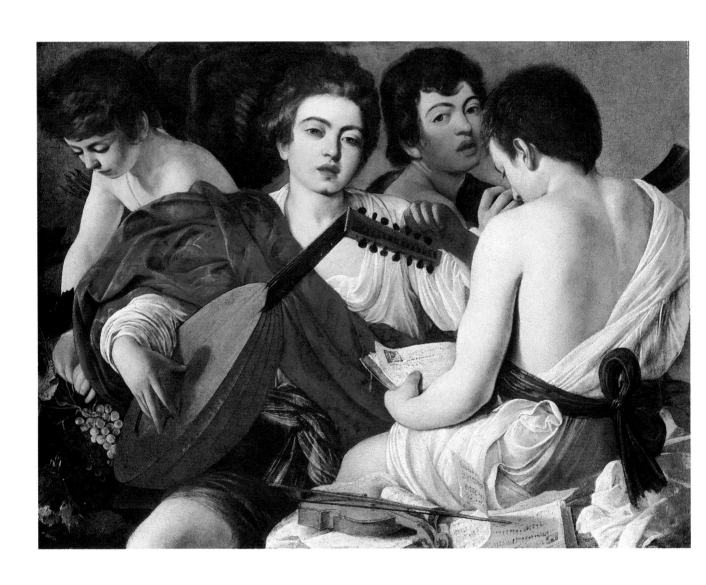

1983, pp. 67 f.; F. Camiz, 1983, pp. 99 f.), in the *Musicians* the scores call attention to the musical interests of the artist or patron and contribute at the same time to the content of the picture. Caravaggio also transcribed music in the *Lute Player* and in the *Rest on the Flight into Egypt* in the Galleria Doria-Pamphili; the latter, though it was not commissioned by Del Monte, was certainly painted while Caravaggio lived with the Cardinal. In both pictures, the music whose scores are included has been identified (see M. Cinotti, 1983, p. 449; F. Camiz and A. Ziino, 1983 pp. 68 f.). In the *Lute Player* the bass part of four madrigals by Jacques Arcadelt (about 1505–1568) is shown: *Chi potrà dir, Se la dura durezza, Voi sapete ch'io v'amo, anzi v'adoro*, and *Vostra fui*. Obviously, Caravaggio was responding to a patron such as Del Monte, with a refined musical background, who could recognize the madrigals by their first words. The amorous content of the musical texts must have intensified the emotional response of the patron to the image of the young musician. Caravaggio certainly tried to achieve the same kind of appeal in the *Musicians* through the figure of the young lute player, absorbed by the music. One is reminded, as was Giovanni Testori (1980, p. 3), of the opening invitation in *Twelfth Night*: "If music be the food of love, play on." The music shown in the *Rest on the Flight into Egypt* is the *cantus* of the motet in honor of the Virgin, *Quam pulchra est*, by the Franco-Flemish composer Noel Bauldeweyn (about 1480–1520), a work that had also been published in Italy. The text for this is taken from the *Song of Songs* and was used in liturgical celebrations in honor of the Virgin. Camiz (1983, pp. 101 ff.) has observed that these compositions were already old when Caravaggio transcribed them; although they do not conform to monodic practice, they are represented as solos. Caravaggio's treatments of musical themes established a genre and created a market among patrons who loved and supported music—men such as Del Monte and Vincenzo Giustiniani, for whom Caravaggio painted the *Amor Vincit Omnia* (cat. no. 79). The new musical genre, which also became popular among Caravaggio's followers, retained the evocative power he had endowed it with.

The theme of music, introduced in the *Musicians* and in the *Lute Player* (see L. Salerno, 1966, p. 108), enriched the world of Caravaggio, thanks to the Cardinal and to the circle that, through him, Caravaggio could now frequent. It is almost certain that one of the string instruments that Caravaggio painted "dal naturale"—the lute (which was used for improvisation)—belonged to his protector ("quattro leuti diversi" are mentioned in the 1627 inventory: see C. L. Frommel, 1971 b, pp. 44 f.), and it is possible to situate historically his way of representing the instrument. In both the *Musicians* (the foreground of which is, however, badly damaged: see the photograph of the painting in its stripped state) and the perspectively more refined *Lute Player*, the violin is foreshortened. In the *Lute Player*, however, it projects from the table toward the viewer, establishing a proper distance; an analogous idea, anticipated in the Hartford still life (cat. no. 65), may be observed in the Ambrosiana still life (cat. no. 75) where the basket projects illusionistically. The foreshortening of the lute is more accentuated in the Leningrad painting, where the lighting brings out the abstract beauty in the curved ribs of the instrument's body. This interest in the form of musical instruments viewed in perspective was a feature of intarsia work (C. Sterling, 1959, pp. 30 ff.; E. Winternitz, 1967, pp. 110 ff.), but Caravaggio certainly also knew the late-sixteenth-century treatises in which the regular forms of musical instruments were used as demonstrations of perspective theory. These treatises, with their illustrations, were also a source for Evaristo Baschenis (M. Rosci, 1971, pp. 34 f.), who is generally considered Caravaggio's continuator in his paintings of musical instruments. These illustrated treatises, like the intarsia representations, gave pride of place to the lute, there having been the authoritative precedent of Dürer's woodcut for his treatise on geometry, the *Underweysung der Messung mit dem Zirckel uñ Richtscheyt* of 1525. While he was with Del Monte, Caravaggio turned his attention once again to the study of perspective, which had certainly been an important part of his training in Lombardy. This is demonstrated by the ceiling of the *camerino* of the Cardinal's casino (see fig. 2, p. 30)—Caravaggio's most important

youthful work, both for its dimensions and its invention (a study of this ceiling, by the present writer, is forthcoming).

The perspectival experimentation evident in the *Musicians* and the *Lute Player* as well as in the decoration of the barrel vault of Del Monte's casino reached a climax in the lateral canvases of the Cerasi Chapel in Santa Maria del Popolo (see figs. 8, 9, pp. 38 f.), where Caravaggio employed an oblique point of view; for these last he probably drew upon Lombard, Leonardesque precedents (L. Steinberg, 1959, p. 180). Del Monte and his brother Guidubaldo, who was particularly interested in the theory of perspective, certainly encouraged Caravaggio in his experiments, but Caravaggio must also have been stimulated to reconsider and to utilize what he had learned of perspective practice in Lombardy by his natural desire to create provocative images.

Spezzaferro (1971, pp. 83 ff.) has noted that during Caravaggio's stay with Del Monte—the scholar terms this stay, somewhat groundlessly, as Caravaggio's "tutelage"—he gradually achieved mastery over figural space, in part as a result of his use of light and partly by relating the figures to one another more successfully; this new mastery is especially evident in the works that Caravaggio painted for Del Monte. (To Spezzaferro's observations may be added others.) During the period in question Guidubaldo del Monte must still have been working on his treatise on perspective, which he had begun in 1588 or earlier (L. Vagnetti, 1980, p. 469) and which Loria (1950, p. 361) has called a "gem of Italian mathematical literature." Although at present it cannot be established precisely, it is likely that Caravaggio knew other late Cinquecento treatises, such as the *Prospettiva, ossia Trattato matematico sopra i modi di mettere varie cose in perdimento ossia scurto, dichiarato con le figure*, which shows, on folio 65 *v.*, a lute in three different positions, one very similar (but in reverse) to that of the lute in the *Lute Player*. The text was probably known to Francesco and Guidubaldo del Monte, since the manuscript preserved in the Biblioteca Ambrosiana, Milan, belonged to Vincenzo Pinelli (1535–1601), who, in Padua, was in touch with Guidubaldo and with Galileo (M. Rosci, 1971, p. 55, n. 13); it would be interest-

ing to compare this treatise with Guidubaldo's. Also significant, perhaps, was the publication, in Venice in 1596 (prior, that is, to the publication of Guidubaldo's *Perspectivae libri sex* in Pesaro in 1600) of the *Pratica di prospettiva del Cavalier Lorenzo Sirigatti*. Some of the illustrations in this treatise, in which the exact projection of shadows is shown, reproduce string instruments foreshortened in much the same way as the violins in the *Musicians* and the *Lute Player* (see M. Rosci, 1971, pls. XV, XVI). Caravaggio's interest in perspective is further evidence of how false and tendentious is the assertion that he rejected contemporary culture. Such an assertion, which reflects to some extent the modern interpretation of Caravaggio as a realist precursor of Courbet and of the Impressionists, leaves unexplained his own working method, nourished as it was by theoretical premises current in the Veneto and in Lombardy.

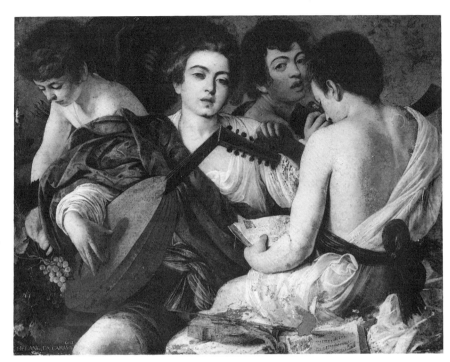

Taking into account the foregoing considerations, there can be no doubt that the *Musicians* was painted in Del Monte's house and that it demonstrates Caravaggio's assimilation of the intellectual environment into which he had been introduced. The interest in perspective manifest in the musical instruments of the *Musicians* and, in a more evolved fashion, in the *Lute Player*, relates these two works to the casino ceiling, which was painted no earlier than 1597. Thus, the *Musicians* can be dated about 1595 and the *Lute Player* about 1596. Caravaggio's meeting with Del Monte and his move to the Cardinal's palace must have taken place in late 1594 or early 1595 (C. L. Frommel, 1971 b, pp. 8 f.; L. Spezzaferro, 1971, p. 84). Indeed, in the *Musicians* we find, in addition to features and ideas common to the *Lute Player*, an evident difficulty in composing the group of figures, as well as a relationship to the early half-length compositions. The casino ceiling, with representations of Jupiter, Neptune, and Pluto, is a work that belongs to Caravaggio's early phase, and its firm attribution to him makes it possible to establish the years 1593–95 as the period of Caravaggio's first Roman works and 1595–96 as the date of the works that he painted for the Cardinal (see M. Cinotti, 1983, p. 477, for the various dates proposed for the *Musicians*).

The *Musicians* shares ideas and pictorial

solutions with the *Stigmatization of Saint Francis* (cat. no. 68). The figure of Eros may be more highly evolved, but it bears comparison with the angel supporting the saint in the Hartford picture as well as with the youths in the *Cardsharps*. Caravaggio's interest in *profil perdu* is first seen in the latter, and it is further developed in the figure at the right in the *Musicians*, whose ear is foreshortened more successfully than that of his counterpart in the *Cardsharps* and the curve of whose eyebrow is ingeniously made to coincide with the contour of his rounded forehead—a solution of great geometric clarity (D. Mahon, 1952 a, p. 23). This pursuit of simplification and formal abstraction, together with the already noted interest in perspective (evinced in the representation of the instruments), will be further developed in the Uffizi *Bacchus* (cat. no. 71) and in several related pictures. The right-hand musician in the Metropolitan picture will become the angel in the *Rest on the Flight into Egypt* in the Galleria Doria-Pamphili (see fig. 3, p. 33), which is a more mature, more fully realized work, close in date to the casino ceiling. Yet, if the *profil perdu* of the angel in the *Rest on the Flight* evolved out of that of the musician, it is nonetheless integrated with the continuous, undulating line—derived from the antique —of the rest of the figure. A realistic, detailed treatment of the physiognomy has, moreover, been modified by a concern for beauty that seems to parallel Annibale Carracci's contemporary ideals (H. Voss, 1924, p. 494, first compared the angel to the figure of Pleasure in Annibale's *Hercules at the Crossroads*, cat. no. 25, painted for the Farnese in 1596; his comparison seems entirely valid in light of the date of the *Rest on the Flight into Egypt*). One may also note that the foreshortened left arm of the right-hand figure in the *Musicians*—bent at the wrist, with an abbreviated modeling derived from Lorenzo Lotto, Simone Peterzano, and other Lombard painters—anticipates the foreshortened arm of the Uffizi *Bacchus* (D. Mahon, 1952 b, p. 23). The figure's hand, too, is summarily but tellingly modeled—not drawn—in accordance with a procedure that goes back to Romanino and Moroni. Mahon (1952 a, p. 10, n. 48; 1952 b, p. 24) has rightly noted that this figure recalls Moretto's *Prophet Micah* in

the Cappella del Santissimo Sacramento in San Giovanni Evangelista, Brescia. The relationship of the head of the lutenist to that of the Korda *Boy Bitten by a Lizard* (cat. no. 70), where the highlights on the nose and above the lips are painted with a like delicacy, is one more feature in the execution of the picture that ties it to other works by Caravaggio.

Although the composition of the *Musicians* has precedents in Venetian painting, the means by which the figures are related one to the other reveals a limited compositional capacity. Each figure in pose seems to have been studied in isolation, and, individually, they recall Caravaggio's early half-length figures (Friedlaender's notion that the painting might be a pastiche executed by some young artists in Arpino's workshop is, in this sense, understandable, although unacceptable). The *Musicians* is one of Caravaggio's first compositions with more than two figures; in it he probably adopted a practice, common in the Brescian tradition of Moretto and Moroni and also encountered in naturalistic Seicento genres such as still-life painting, by which features taken from nature, or cartoons for individual elements or figures, are patched together or conflated to create a new composition. This practice probably explains the use of lines impressed into the ground, usually to indicate the contours of a figure or a specific detail, in many of Caravaggio's paintings after his early period.

The head of the lutenist in the *Musicians* is relatively well preserved, but the overall state of the picture is not good (see the stripped-state photograph). The effect of the damages—some due to old restorations (see D. Mahon, 1952 a, pp. 21 f.; 1952 b, pp. 3 f.; T. Rousseau, in D. Mahon, 1953 b, p. 45)—has been greatly alleviated by the recent cleaning, but the picture has lost much of its original quality. Acquired by the Metropolitan Museum in 1952, the picture was restored in London by Sebastian Isepp. It was relined in the Metropolitan in 1953. In the recent cleaning (1983) most of the repainting was removed, including that affecting the grapes and vine leaves at the lower left—which are, however, damaged. X-rays have revealed numerous changes that lend added support to the view that this is one of Caravaggio's first multi-

figured compositions, painted at the beginning of his stay with Del Monte. The most important pentimenti are in the lutenist's ample, brocaded drapery (which was painted over a nude arm, visible in the X-ray), in his sash, and in the drapery folds of his shirt. The head of the youth with a cornetto was moved. An inscription at the lower left, now painted out, was probably added after a relining; according to a common practice mentioned by Mahon (1952 a, p. 22), it probably records an inscription once on the reverse of the original canvas. The picture has been cut down at the left, as the letters missing from the later inscription prove, but not elsewhere. Because of its poor condition, Caravaggio's authorship has been doubted or denied: Longhi (1968, p. 14) considered it a copy, as did, for a time, Marini (1974, p. 342), who later (1980, p. 12), came to regard it as autograph. However, the manner of highlighting the folds of the white drapery, the presence of pentimenti, the evidence of the X-rays, and, above all, the quality of the areas that are best preserved lead one to conclude that this is the "wraith of an extremely beautiful original" (M. Cinotti, 1983, p. 477).

After the sale in 1628 following the death of Cardinal del Monte (W. C. Kirwin, 1971, pp. 53, 55), all trace of the "musica" was lost. In the 1920s the Metropolitan picture belonged to David Burns of Fernacre, Whitehaven, Cumberland. Between 1941 and 1947, it was in the possession of a dealer, J. Cookson, in Kendal, Westmorland. It was then sold to Surgeon Captain W. G. Thwaytes of Maulds Meaburn, Penrith, from whom it was purchased by the Museum (D. Mahon, 1952 a, p. 3; D. C. Burns, 1952, pp. 119 f.). It is not certain whether nineteenth-century descriptions of the composition refer to the original or to a copy. A "Scuola di musica" by Caravaggio measuring 6 by 7 *palmi* is mentioned in an export license requested by Prince Scipione Lancellotti on July 1, 1789 (A. Bertolotti, 1877, II, p. 35; M. Marini, 1974, p. 344). Moir (1976, p. 123, n. 183) identified the Metropolitan picture with one that appeared as lot 94 in the sale of Henry Fulton's property at Christie's on June 20, 1834. Moir maintained that the same picture had been sold by Christie's as lot 57 on

June 3, 1815, at which time it was described as "Love and Harmony, a beautiful group of four figures, painted with great sweetness and delicacy." The Poniatowsky sale at Christie's on February 9, 1839, included "a Bacchanalian concert, a grand composition," believed by Busiri Vici (1971, pp. 330 f.) to be the original; the contrary opinion has been expressed by Haskell (1973, p. 549).

M. G.

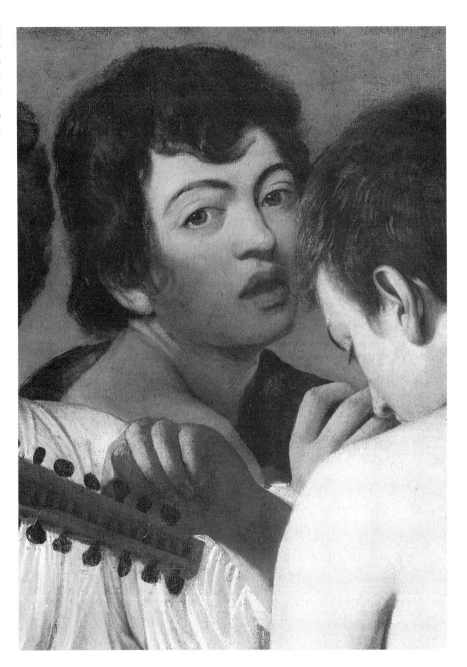

70. Boy Bitten by a Lizard

Oil on canvas, 26 x 19 1/2 in.
(66 x 49.5 cm.)
Private collection, London

Mancini, in the second part of the *Considerazioni sulla pittura* (about 1617–21; 1956–57 ed., I, p. 224), after referring to Caravaggio's arrival in Rome "at the age of about twenty," records that the artist stayed with Monsignor Pandolfo Pucci, a beneficiary of Saint Peter's and the majordomo of Camilla Peretti. Mancini states: "At this time [Caravaggio] painted for [Pucci] some copies of devotional pictures, which are now in Recanati, and, for the market, a boy who cries at being bitten by a lizard that he holds in his hand, and afterward a boy who peels a pear with a knife" ("In questo tempo fece per esso alcune copie di devotione che sono in Recanati e, per vendere, un putto che piange per esser stato morso da un racano che tiene in mano, e dopo pur un putto che mondava una pera con il cortello"); to this he adds, in the Palatino manuscript, "which was why, having sold it and being encouraged that he could support himself, he left that ungenerous master and patron" ("che fu causa che, vendutolo e preso animo di poter vivere da sé si partì da quel suo così scarso maestro e padrone"). In the first part of the *Considerazioni* Mancini notes that out of necessity—"setting aside fame"— Caravaggio sold the *Boy Bitten by a Lizard* for fifteen *giulii*; in the Palatino manuscript the sum given is twenty-five *giulii* (G. Mancini, about 1617–21; 1956–57 ed., I, p. 140). Even Baglione (1642, p. 136), after recording the months that Caravaggio spent with the Cavaliere d'Arpino, says that "he tried to strike out on his own, and made several small pictures after his reflection in a mirror" ("provò a stare da sé stesso, e fece alcuni quadretti da lui nello specchio ritratti"). After the *Bacchus*, Baglione describes a "boy bitten by a lizard emerging from among the flowers and fruits, and his head seems truly to cry out, and the whole is painted with diligence" ("un fanciullo, che da una lucerta, la quale usciva da fiori, e da frutti, era morso, e parea quella testa veramente stridere, & il tutto con diligenza era lavorato"). Another imprecise mention was made by Sandrart (1675; 1925 ed., p.

276), who confused elements from this work with others from the *Boy with a Basket of Fruit* (cat. no. 66). There are some discrepancies in the descriptions by Mancini and Baglione, as well as in their chronological placement of the painting (some scholars —J. Clark, 1951, p. 49; R. Longhi, 1952, pp. 13 f.; W. Friedlaender, 1955, p. 154— thought that they were referring to two different paintings). The subject of the picture described by Baglione seems best to correspond with that of the present picture, which is one of the two principal versions known; the other, in the Fondazione Longhi, Florence, is not included here. Manilli (1650, p. 71) mentions "a child bitten by a crab" ("un fanciullo morso da un granchio"), by Caravaggio, in the Borghese collection, but this cannot be identified with the subject described by Baglione and Mancini. There are other pictures, all of more or less poor quality, on this and related themes, suggesting that there may have been a prototype by Caravaggio; at the end of the Cinquecento the subject would certainly have been a novelty (see L. Salerno, in Mancini, about 1617–21; 1956–57 ed., II, p. 111, n. 882; D. Posner, 1971 b, p. 317; P. Della Pergola, 1973, pp. 53 f.).

The picture was intended to depict reactions of surprise and pain as though captured instantaneously. As Longhi (1928–29; 1968 ed., p. 124) noted, the closest analogy is with a drawing by Sofonisba Anguisciola sent by Tommaso Cavalieri to Cosimo I de' Medici and recorded by Vasari (1568; 1906 ed., V, p. 81) as a singular work in which "a little girl . . . laughs at another child, who cries because he has been bitten on the finger by a crayfish in a basket that the little girl has set before him, and it would be impossible to see anything more delightful ["graziosa"] or more true to life ["simile al vero"] than that drawing." The drawing is now in the storerooms of the Museo Nazionale di Capodimonte, Naples; a later derivation, painted on canvas, is in the Musée Magnin, Dijon. The subject of Caravaggio's painting should be understood in terms of the attempts to depict psychological reactions—both of laughter and of pain—that were carried out in Lombardy in the sixteenth century, and which, according to Lomazzo, had been of interest to Leonardo. Lomazzo's own theory of

emotions is described in the first chapter of book two of the *Trattato dell'arte della Pittura, Scoltura et Architettura* (of 1584), which Caravaggio must have pondered. Indeed, the contents of this chapter make it clear that Caravaggio's effort to capture the boy's reaction to the lizard's bite was motivated by an investigative and mimetic intent. The picture was a first step toward his later treatment of narrative subjects: It is almost as though Caravaggio were preparing himself for those more ambitious tasks through his use of an experimental method whose origins may be traced to Leonardo, and which—as van Mander (1604, p. 191) tells us, and as the *Judith and Holofernes* (cat. no. 74), for example, demonstrates— was the only approach to painting that he considered valid. Lomazzo, in fact, wrote (1584; 1974 ed., II, p. 97) that "all the great inventors, for the most part, were extremely subtle investigators into natural effects" ("tutti i grandi inventori, per il più, sono stati sottilissimi investigatori de gl'effetti naturali"). These remarks support Frommel's observation (1971 b, p. 51) that the attempt at imitation in this picture has transformed it into a drama, and they are also relevant to the dating of the picture, which is fairly advanced within the group of youthful works.

Nonetheless, the choice of a pretty, effeminate boy (H. Wagner, 1958, p. 23, suggested that the curly-haired youth was inspired by Michelangelo's *David*, but it is more likely that the type is loosely derived from ancient sculpture), dressed in an affected way, in a shirt that leaves his shoulder bare, and with a rose stuck behind his ear, justifies the hypothesis that the picture has other meanings as well. While, with its rich folds, the shirt—which is not of the sort then in fashion—is reminiscent of the costumes found in Savoldo's Giorgionesque work, it is probable that, from his earliest years in Rome, Caravaggio had become sensitive, through sculpture, to the art of antiquity (for L. Salerno, 1966, p. 108, the silhouette of the lizard recalled the lizard of the Apollo Sauroktonos; he noted that the "aulic, classical appearance established the atmosphere for the metaphor"—the same atmosphere found in the poetic conceits of the early Seicento). For various interpretations of the picture involving symbolic,

moral, and amorous-erotic themes of youth, redolent with subjective implications, see Cinotti (1983, pp. 436 ff.) and the introductory essay (pp. 25 ff. above) by Richard Spear, who notes that both the *Boy Bitten by a Lizard* and the *Bacchus* were painted to be sold and are therefore unlikely to have elaborate iconographic programs. The supposition that the present painting is a self-portrait results from an erroneous interpretation of Baglione's remark (1642, p. 136) that Caravaggio "made several small pictures after his reflection in a mirror," and the proposal (J. Costello, 1981, p. 377) that the *Boy Peeling a Fruit* (cat. no. 61) and the *Boy Bitten by a Lizard* are companion pieces—signifying, respectively, Taste and Touch—is unacceptable on a number of counts, among which is the stylistic and chronological disparity between them. Slatkes (1972 a, p. 24) believes that the picture is a personification of the choleric temperament, and Hibbard (1983, p. 284, n. 25) proposes that it is to be interpreted essentially as an allegory of *vanitas*, referring to a passage in Lucretius (*De rerum natura*, IV, 1134 f., trans. W. H. D. Rouse): " . . . but all is vanity, since from the very fountain of enchantment rises a drop of bitterness to torment amongst all the flowers" (" . . . nequiquam, quoniam medio leporum / surgit amari aliquid quod in ipsis floribus angat").

The dewdrops on the flowers and the vase with the reflection of the window require comment. Van Mander (1604, pp. 142 f.) mentions still lifes by Lodewijck van den Bos (active in the second half of the sixteenth century) that showed fruit with flowers in a glass of water and dewdrops on the flowers; Friedlaender (1955, p. 142), who has emphasized the Northern origin of this sort of representation—which goes back to the time of van Eyck—notes that Caravaggio could have known these pictures. In tracing the origins of Caravaggio's vision, furthermore, the importance attached by the Lombards—both in treatises and in paintings—to the problem of representing light should not be forgotten; the interest in light is in turn but one aspect of the relationship that begins in the Quattrocento, if not earlier, between the artistic ideas of Lombardy and those developed north of the Alps. Leonardo's still influen-

tial example, for evidence of which we need only recall Lomazzo's *Trattato*, also helps to explain these motifs. Caravaggio certainly knew what Vasari wrote (1568; 1906 ed., IV, p. 25) of Leonardo's youthful works: "Leonardo then made most excellently Our Lady in a painting that belonged to Pope Clement VII; and among the things shown in it was a vase filled with water and some flowers, in which, besides the marvelous vividness, he had imitated the dewdrops so that the picture seemed more real than life." However, Caravaggio's most direct source for these details in his youthful works was certainly the still lifes painted by Flemish artists active in Italy in the late sixteenth century. Indeed, there are compelling similarities between the vases or carafes, with or without the reflected window, in Caravaggio's paintings: in the *Boy with a Vase of Roses* (cat. no. 62), the *Boy Bitten by a Lizard*; and in the still life described by Bellori (1672, p. 248), possibly on the basis of Baglione's description of the *Lute Player*—to which should be added the group of still lifes related to the Hartford picture (cat. nos. 63–65) and a small painting in the Galleria Borghese (inv. no. 362) of flowers in a similarly shaped vase with the reflection of a window, in the style of Jan Brueghel. This last may have been among the pictures sequestered from the Cavaliere d'Arpino in 1607, or it may have been purchased by Scipione Borghese in 1613; as Della Pergola (1959, p. 155) suggests, it was probably seen by Caravaggio.

Despite the immediate fame of Caravaggio's *Boy Bitten by a Lizard*, we do not know its first owner, and after Baglione's reference all trace of it is lost. We have already seen that, contrary to the opinion of some critics, it cannot be identified with the painting in the Borghese collections mentioned by Manilli in 1650. Two principal versions are now known. The present picture, first published by Borenius (1925, pp. 23 ff.), has the following provenance: Lord Methuen (attributed to Murillo); Dr. Jones, Bishop of Kildare; Viscount Harcourt, Nuneham Park; Vincent Korda, London (acquired at Christie's, London, June 11, 1948). The second version, measuring 25 3/4 x 20 1/2 in. (65.6 x 52.3 cm.), was in the d'Atri collection, Paris, and then in a private collection, Rome. Published by Longhi

(1928–29; 1968 ed., pp. 85 f.), who later acquired it, it is now in the Fondazione Longhi, Florence. Three other, inferior versions have been recognized as copies: one was formerly in the Katz Gallery, Dieren, The Netherlands, and then sold at auction; another is known from a photograph in the Fondazione Giorgio Cini (see A. Moir, 1976, p. 104, fig. 3); the third was on the Roman art market (M. Marini, 1974, p. 341).

The version included here was at first accepted as the picture mentioned by Mancini and Baglione. Subsequently, the Longhi version obtained a greater consensus. Shown in the Milan exhibition of 1951, it was regarded as the original by Baroni (1951, p. 17), Mahon (1951 a, p. 233), Calvesi (1969, p. 408), and Frommel (1971 b, p. 18), but considered a copy by L. Venturi (1951, p. 61), Arslan (1951, p. 446), and Wagner (1958, p. 19). Mahon confirmed his favorable impression of the Longhi version in a later article (1953 a, p. 214) and in a recent verbal communication; he considers the Korda picture a copy from the very early seventeenth century. According to Salerno (1970, p. 235) and Röttgen (1971, p. 253), both versions are originals; Marini (1974, pp. 94 f., 339 ff.) is undecided between the two pictures. More recently, the Korda picture has been reevaluated. Nicolson (1979, p. 34) tentatively accepted it as the original, followed by Spear (1979, p. 318), Marini (1981, p. 355, n. 8), and Hibbard (1983, p. 284, no. 25), while Posner (1981, p. 388), and Cinotti (1983, pp. 435 ff.) have upheld the authenticity of the Longhi version.

Although it is badly damaged and, in many places, also skinned, the Korda picture is painted with a sensitivity worthy of Caravaggio; details such as the rose in the boy's hair and the one in the vase are meticulously rendered. The youth's expression, however, is less savage—although it is still horrific—than in the Longhi version. In X-rays, the whites in the shirt bear comparison with passages in X-rays of the Doria *Magdalen* (see E. Arslan, 1959, fig. 93 a), and there are small pentimenti in the drapery around the boy's right shoulder and in the leaves of the flowers in the vase—whereas X-rays of the Longhi version show virtually no pentimenti. The execution of the Longhi picture (which is in excellent condition) seems

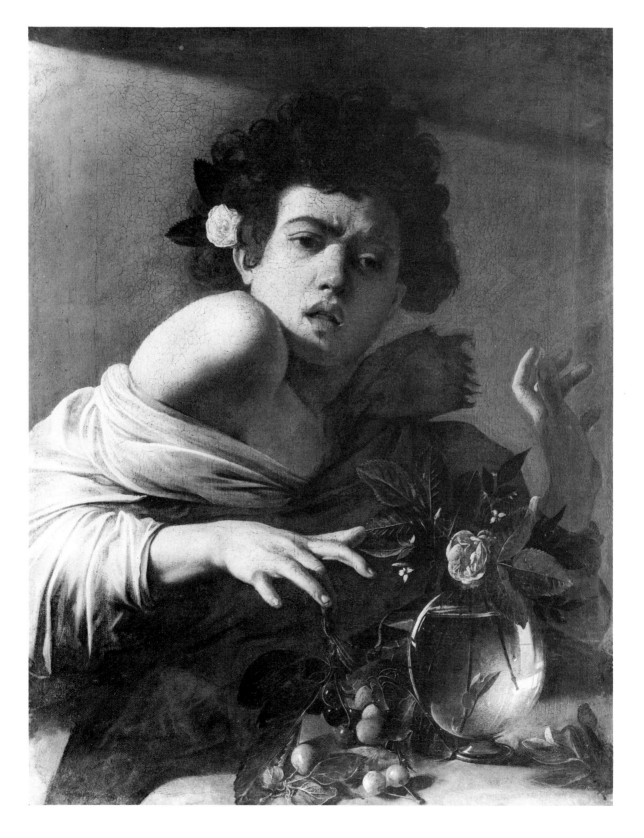

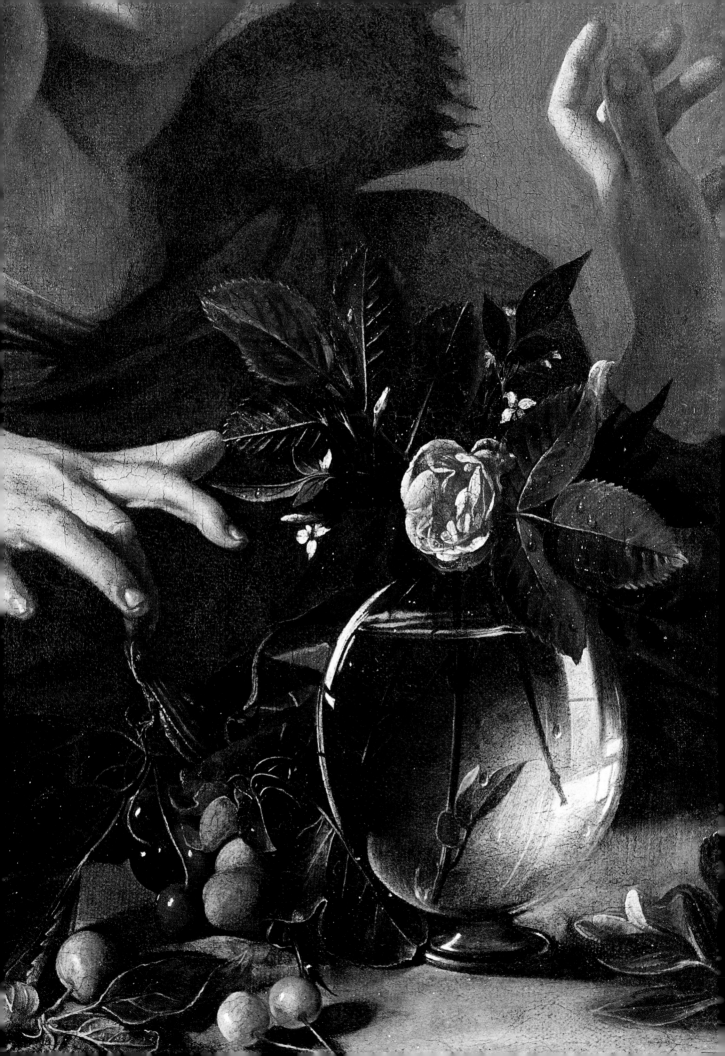

more incisive and cursory, and, in fact, almost aggressive; Longhi (1928–29; 1968 ed., pp. 85 f.) described it as "così vivace e dipinto tanto alla prima da poter avere servito di ispirazione al Velázquez per la testa del dio Bacco nei 'Borrachos.'" Mahon (1953 a, p. 214, n. 16) has noted that in the handling and consistency of the paint the present picture differs from other securely youthful works of Caravaggio. Moreover, he finds it difficult to believe that passages of reflected light—so characteristic of Caravaggio—on the shoulder, chest, and neck of the boy, in the Longhi version, could derive from the equivalent (and, for that matter, almost nonexistent) passages in the Korda version. Marini (1974, p. 341) notes that the craquelure of the Florence picture is very similar to that of the Hartford *Stigmatization of Saint Francis* (cat. no. 68) and the Doria *Rest on the Flight into Egypt* (see fig. 3, p. 33), while that of the Korda painting seems atypical of Caravaggio's autograph works. The exclusion here of the version in the Fondazione Longhi has denied us a unique occasion for the sort of comparisons that would permit a better—perhaps a definitive—evaluation of the two pictures.

There have also been differences of opinion about the dating of the picture: For Longhi (1928–29; 1968 ed., pp. 85 f.), it is unlikely to be earlier than the *Medusa* in the Uffizi and thus would be from the period when Caravaggio was with Cardinal del Monte; for Mahon, it is earlier, as Mancini's account suggests (1951 a, p. 233: 1594–95, after the *Stigmatization of Saint Francis* and the *Lute Player* and before the *Medusa*; 1952 a, p. 19: 1592–93, after the *Boy with a Basket of Fruit* and before the *Cardsharps*, the *Magdalen*, and the Louvre *Fortune Teller*; 1953 a, p. 204: among the earliest works); for Frommel (1971 b, p. 51), it is datable to 1597; for Posner (1971 b, p. 323, n. 45), it belongs to the same period as the ceiling painting (rightly attributed to Caravaggio by Bellori, 1672, p. 214) for the casino of Cardinal del Monte in the Villa Ludovisi—that is, after November 26, 1596, the date the building was acquired; for Hibbard (1983, p. 284), the *Boy Bitten by a Lizard* dates from about 1597.

M. G.

71. Bacchus

Oil on canvas, 38 9/16 x 33 1/2 in. (98 x 85 cm.)
Galleria degli Uffizi, Florence

Bacchus is shown as a soft, fleshy youth, crowned with vine leaves and grapes, his left shoulder covered with drapery *all'antica*. Seated on a sort of triclinium (an ancient couch used when dining), he seems to offer the viewer a goblet of wine. In the foreground, next to the carafe from which he has just poured the wine—Marini (1974, p. 358) has noted that the bubbles on its surface are the result of the movement of the liquid—is a molded white Faentine bowl containing grapes and fruit, a reference to Bacchus's traditional role as overseer of the growth of fruit and vegetation.

The picture, assigned an inventory number designating it among the lowest class of paintings in the Uffizi, was discovered in the gallery's storerooms and identified as the work of Caravaggio by Longhi (see M. Marangoni, 1917, p. 13, who published it as a copy). After its restoration for the "Mostra della pittura italiana del Seicento e del Settecento" at the Palazzo Pitti, Florence, in 1922, Marangoni (1922, p. 794, n. 1) also recognized the picture as by Caravaggio. The *Bacchus* was long associated with a picture that, according to Baglione (1642, p. 136), Caravaggio painted after leaving the workshop of the Cavaliere d'Arpino: "[Caravaggio] then struck out on his own, and made several paintings from his reflection in a mirror, the first being a Bacchus with assorted grapes, made with great care but somewhat dry in style" (" . . . un Bacco con alcuni grappoli di uve diverse, con gran diligenza fatte; ma di maniera un poco secca"). Consequently, it was considered one of Caravaggio's earliest works (H. Voss, 1923, p. 78; 1924, p. 437; N. Pevsner, 1927–28, p. 390; L. Schudt, 1942, p. 43; R. Longhi, 1943 a, p. 8; 1951 a, pp. 12 f.; L. Venturi, 1951, p. 47). However, Mahon (1951 a, p. 234, n. 110; 1952 a, p. 19) considered it a work of the mature phase of Caravaggio's youthful period, dating it first about 1596–97 and then 1595–96, after the early, half-length figures.

Mahon's opinion has been widely accepted (see especially C. L. Frommel, 1971 b, p. 51, who dates it 1596). Mahon also (1953 a, p. 215, nn. 22–23) called attention to a marginal note in Mancini's *Considerazioni* (about 1617–21; 1956–57 ed., I, pp. 226 f.) that evidently refers not to the Uffizi *Bacchus* but to the so-called *Bacchino Malato* in the Galleria Borghese, which was among the pictures sequestered from the Cavaliere d'Arpino in 1607: "Among other things he painted a very beautiful and beardless Bacchus in the Borghese collection" ("Fra tanto fa un Bacco bellissimo et era sbarbato [?] lo tiene Borghese, l'haveva . . . "). Baglione's remark is almost certainly about the Borghese picture, too. There is, therefore, no circumstantial reason to place the picture among Caravaggio's earliest works. Stylistically, it must date from the time when Caravaggio lived with Cardinal del Monte. Most likely, it was sent by Del Monte as a gift to Ferdinando de' Medici shortly after its completion; it was apparently unknown in Rome (C. del Bravo, 1974, p. 1572 f.). Scannelli (1657, p. 199) describes the *Toothpuller* (cat. no. 98) in the Medici collections, but does not mention the *Bacchus*. Like the parade shield showing the head of Medusa, which was first reproduced in an engraving in the *Galleria di Firenze Illustrata* in 1819 (A. Moir, 1976, pp. 85 f.), no copies of the *Bacchus* are known—probably because it was kept in a private apartment.

The cleaning of the picture in 1922 revealed a small head reflected in the carafe. Marangoni (1922–23, pp. 224 ff.) believed it to be a self-portrait and records Carlo Gamba's comparison of it with the *Boy with a Basket of Fruit* (cat. no. 66). The reflected head is that of a male, who wears a contemporary costume with a white collar; there also seems to be a painting seen from the back, as though on an easel. Bacchus himself was at first thought to be a freely interpreted self-portrait. This identification, later revived by a number of scholars (H. Voss, 1951 b, p. 289; A. Czobor, 1954–55, pp. 206 ff.; R. Wittkower, 1958, p. 22) who accepted an early date for the picture, introduced the theory that Caravaggio frequently was his own model. This notion was based on a misinterpretation of Baglione's account, cited above ("fece alcuni quadretti da lui nello specchio ritratti . . . "). What Baglione records is the widespread practice

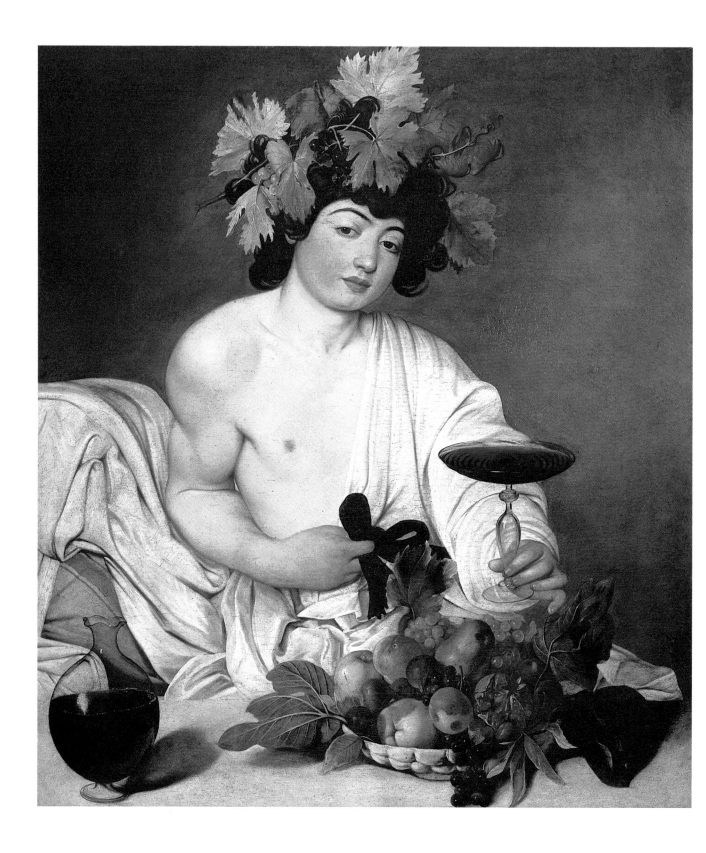

X-ray

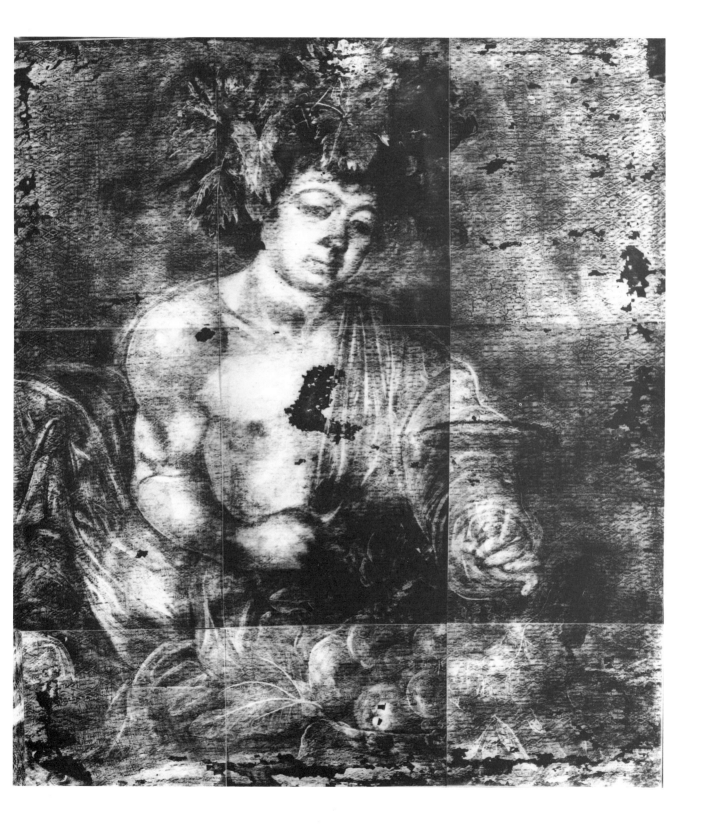

of employing a mirror as an aid in achieving a realistic representation—a method that, as a painter, he was certainly familiar with (R. Longhi, 1943, p. 35, n. 7). The identification of the Borghese *Bacchino Malato* as a self-portrait is, contrariwise, based on physiognomic comparisons with known representations of Caravaggio (see R. Longhi, 1927 b; 1967 ed., pp. 304–5, and, most recently, R. Spear, 1983, p. 165). The model for the Uffizi *Bacchus* was also used by Caravaggio for a group of pictures, related in style, that date from the end of his youthful period—among them the *Lute Player* (in the Hermitage) and the *Fortune Teller* (in the Louvre)—as well as for the lateral canvases in the Contarelli Chapel in San Luigi dei Francesi. Hess (1954, pp. 280 f.) proposed that he was actually the painter Lionello Spada. Frommel (1971 a, pp. 43 ff.; 1971 b, pp. 25 f.) identified the model with the Sicilian artist Mario Minnitti, who, as a youth, lived with Caravaggio in Rome at the end of the sixteenth and the beginning of the seventeenth century (F. Susinno, 1724; 1960 ed., p. 117). The identification was based, in part, on the figure's resemblance to Minnitti's engraved portrait—possibly after a painting by Caravaggio—in Grosso Cacopardi (1821, p. 82).

When the picture was discovered, it was found to have suffered a number of large losses at the bottom, and in the body of the figure (see R. Longhi, 1943, fig. 1; the photographs published by M. Marangoni, 1917, fig. 1; 1922 a, p. 785, seem to have been retouched to mask these losses). The canvas was poorly relined and a number of retouches were made, altering the appearance of the picture (see R. Longhi, 1943 a, figs. 1, 2). The *Bacchus* was properly restored first in 1947 and again in 1978. X-rays (see illustration, and also M. Cinotti, 1975, p. 218 f., n. 107; L. Berti et al., 1979, pp. 64 f., figs. 12 a, b) reveal both the damages and the finely patterned Flemish linen support—similar in type to the linen used for the Doria *Rest on the Flight into Egypt*. The head of Bacchus can also be seen to have been changed during the course of execution, a fact that makes one wonder whether the figure type in this and in related paintings by Caravaggio was the result of stylization—by which Caravaggio achieved regular, volumetric forms of an abstract beauty

comparable to that found in the work of Scipione Pulzone (H. Voss, 1923, pp. 85 ff., cited Pulzone, considering Caravaggio's background more Roman than Lombard)—rather than of the use of a specific model.

The picture has been variously interpreted as a *vanitas*, or as either homoerotic, Christological, or Horatian in theme (see M. Cinotti, 1983, p. 432). Hibbard (1983, p. 40) mentions "the peculiarly ambivalent nature of Caravaggio's realism." Classical antiquity held a fascination for all North Italian artists who made the trip to Rome (M. Gregori, 1972 a, pp. 45 ff.), and this fascination informs the present picture, whose mythological associations are evoked by the *all'antica* guise of Bacchus and by the historical device of the triclinium (for an analogous representation in 1596, by Cigoli, see M. Gregori, 1972 a, p. 46). The sensual features of Caravaggio's Bacchus may recall Hadrianic images of the god and of Antinous (W. Friedlaender, 1955, p. 85), but the nude body is rendered with exceptionally acute, almost embarrassing, perceptiveness: The reddened skin of the hands and wrists is described with the same realism as the swollen lips—with little attention for conventional ideas of drawing—and the dirty fingernails ill befitting the young deity. Bacchus's identifying attributes—the leaves and grapes that crown his head, the carafe and goblet, the bowl of fruit (some bruised and spoiled)—are portrayed with equal clarity and optical precision.

Rather than giving life to the composition, the almost frontal lighting freezes those details that have been introduced to enhance the effect of instantaneousness (for example, the ripples on the surface of the wine in the goblet), and it accentuates the regularity of the features of the face and the firm contours of the shoulder and arm—which are painted with the same consummate mastery that recurs in the angel in the Doria *Rest on the Flight into Egypt*. The rich whites of the toga and the sheet, the unexpected foreshortening of the worn, striped cushion—creating an exquisite, subdued tonal variation that anticipates similar effects in the work of such later painters as Greuze—the sensuous, intertwining pattern described by Bacchus's body (for

which there are analogies, too, in the *Rest on the Flight into Egypt* and in the ceiling painting in Del Monte's casino), recall certain works by Canova and by Ingres in which the figures manifest a like equivocation between idealization and realism and a similar quality of subtle, sensual solicitation. Precisely these two artists were mentioned in conjunction with the *Bacchus* in the 1920s, when an attempt was made to interpret Caravaggio's work in idealistic terms (M. Marangoni, 1922 a, p. 784). A comparison of the picture with Dosso Dossi's mature, jovial, bust-length *Bacchus* (in the Galleria Estense, Modena), which Friedlaender (1955, pp. 84 ff.) called attention to and which Caravaggio was probably familiar with, underscores the sophistication of the Uffizi canvas. Caravaggio's practice of painting directly from nature ("dipingere dal naturale") raises another, apparently contradictory, issue. The practice grew out of a specific artistic tradition that was responsible not only for his empirical approach, but for certain formal and technical matters that pertain to stylistic questions. Perhaps more than any other work, the *Bacchus* demonstrates Caravaggio's ties with Cinquecento traditions in Brescia, for the tridimensional and illusionistic effects of the picture are indebted to techniques employed by such sixteenth-century painters as Moretto, Savoldo, and Moroni—techniques that were still valid for Giacomo Ceruti in the eighteenth century (M. Gregori, 1982 b, pp. 24 f.). Among these is the use of contrasting colors and a dark contour—in part, the exposed ground—to enhance the volumetric quality of the objects and to define their position in space (for example, the hand shown against the chest, and the carafe viewed in front of the cushion and the sheet). The ground was also left exposed in the area of the blue stripes on the sheets (see F. Cummings, 1974, p. 568, n. 8). The foreshortening of the figure and the emphasis on surface appearances rather than on underlying structure derive from Moretto, while the clarity of the light—devoid of pictorial and atmospheric effects—may be traced to Moroni's work. Even the interest in genre-like details—the "naturalia" commented upon by Bellori (1672, p. 202), who recognized in Caravaggio the founder of a new

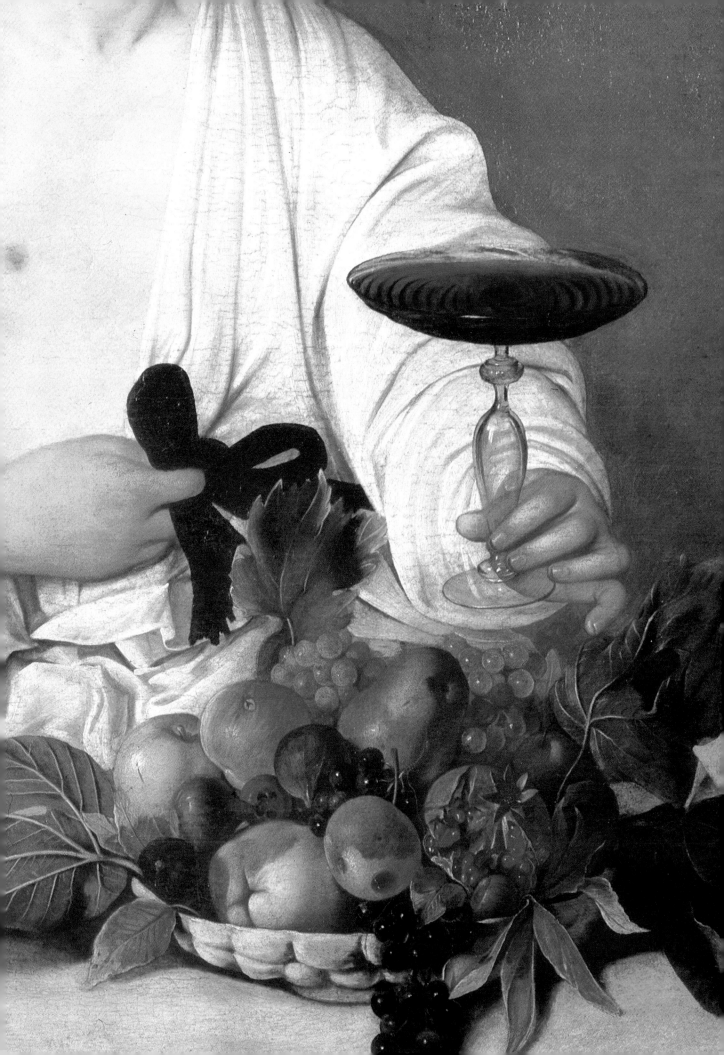

phase of still-life painting—are an out-growth of Caravaggio's Lombard training. This was demonstrated by Longhi (1928–29; 1968 ed., pp. 113 f.), who made pointed comparisons with details from the work of Moretto, such as the bowl of fruit in the altarpiece in Sant'Andrea, Bergamo, and the vines in the *Drunkenness of Noah* (in the Bressi Fenaroli collection, Turin), where both the variety of greens and the botanical description recall the vine leaves that crown Caravaggio's Bacchus.

The *Bacchus* may be dated about 1596–97. The fruit is painted in a freer manner than in the *Boy with a Basket of Fruit* (cat. no. 66), in which an almost Flemish dryness is apparent; this in itself suggests a date toward the end of Caravaggio's youthful period. There are analogies between the still life of the bowl of fruit in the foreground and the still life of a basket of fruit (cat. no. 75) in the Pinacoteca Ambrosiana, Milan, and in the still life in the London *Supper at Emmaus* (cat. no. 87). The near-stereoscopic effects in the *Bacchus* demonstrate how much visual faculties had sharpened in the late Cinquecento, as noted by Lucien Febvre; the representation of the fruit presupposes the diffusion of scientific illustrations, and, indeed, those by Jacopo Ligozzi seem to have been the immediate precedent for Caravaggio.

The majolica fruit dish suggests further comparisons. The gray shadows in the indentations of the dish are similar to the cast shadows on the tablecloth in the *Supper at Emmaus*. Since this type of fruit dish is also found in the earliest Lombard still lifes, Caravaggio was probably relying upon a tradition already widespread in Lombardy; or, possibly, he used as a prototype some still life—whether independent or part of a larger picture—that he completed before leaving for Rome. It is, in any event, likely that he painted still lifes while still in Lombardy.

X-rays of the picture reveal that the contours of the shoulders of Bacchus, and of the goblet that he holds, were reduced by Caravaggio somewhat when he laid in the background. In accordance with a typically Lombard practice that he adopted in other paintings as well, this part of the background was painted in last, and the brush-work there differs from that in the rest of the picture. Also worthy of note is the experimental approach revealed by the variety of techniques employed in the execution of the picture, ranging from the mixture of colors in the nude body of the Bacchus to the decisive and apparently rapidly delineated form of the goblet: Caravaggio certainly was familiar with Tintoretto's rapid, summary manner of execution—obtained either through his training in Peterzano's workshop or during a visit to Venice. Bacchus's sash, aligned along the vertical axis of the picture, is painted "à plat" and without any glazes. In the works of Moroni there is a comparable variety and experimentation with technical procedures (M. Gregori, 1982 b, p. 25).

M. G.

72. Saint Catherine of Alexandria

Oil on canvas, 68 1/2 x 52 3/8 in.
(173 x 133 cm).
Inscribed (lower right): F. 12.
Thyssen-Bornemisza collection, Lugano

Saint Catherine is shown with her traditional attributes: the palm; the wheel, by which her martyrdom was first attempted; and the sword with which she was killed. She does not wear a crown, but Caravaggio has depicted her with a halo, a feature that he omitted in the Hartford *Saint Francis* (cat. no. 68). In narrative pictures, the artist usually—but not always—dispensed with haloes, reserving them for depictions of the Madonna and for more explicitly devotional images, especially of single figures. (In the *Agony in the Garden* —now destroyed; formerly in Berlin— the halo served to identify the protagonist.)

Saint Catherine's mundane appearance has been much commented upon. This impression is due in large measure to the silk cushion on which she kneels and to the beauty of her costume, enriched by the ample, almost encumbering, floral-patterned mantle that cascades over the pin of the wheel—a remarkably convincing motif that Caravaggio favored in his work at this time. (In the *Conversion of the Magdalen* —cat. no. 73— the saint's velvet mantle is draped over her left arm in a way that emphasizes its sumptuous beauty.) With such elements, Caravaggio doubtlessly intended to allude to Catherine's royal parentage. He has intentionally contrasted them with the crude appearance of the broken wheel, which is, like the other attributes, shown life-size rather than reduced to the scale of a mere symbol. It is worth noting that the veining in the wood of the wheel recurs in the tabletop in the *Conversion of the Magdalen*, and in the cross in the *Crucifixion of Saint Peter* in Santa Maria del Popolo. The attributes also help to define the space (see C. L. Frommel, 1971 b, p. 19; F. Bardon, 1978, p. 61, has noted their "pouvoir spatialisant"). As Hibbard (1983, p. 64) points out, the light enters from the right, an exception in Caravaggio's work. The choice of a lightweight sword rather than a more common, heavier one was probably dictated by the sex of the saint.

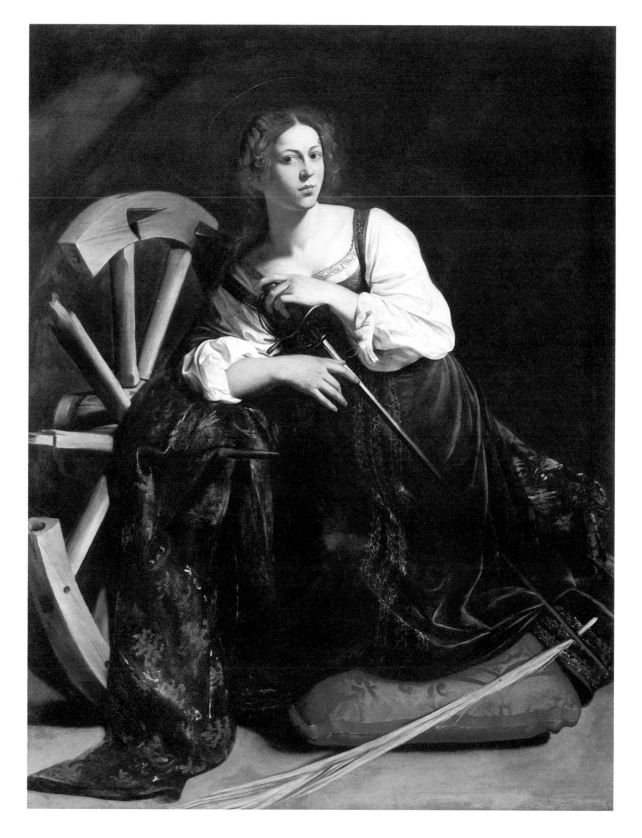

This type of sword does not occur in other pictures by Caravaggio, with the possible exception of the Capitoline *Fortune Teller* (cat. no. 67; see D. Macrae, 1964, p. 416, and, for other observations on the sword, M. Marini, 1974, p. 365). There can be no doubt that Caravaggio used the same female model for the *Conversion of the Magdalen* and for the lost portrait formerly in Berlin; the costumes, too, are almost identical. Whether she was also the model for Judith in the *Judith and Holofernes* (cat. no. 74) is not certain.

Voss (1923, p. 81) and other scholars have proposed that Caterina Campani, the wife of Caravaggio's friend, the architect Onorio Longhi, may have sat for both the ex-Berlin portrait and the *Saint Catherine*, noting that the coincidence of her name with that of the saint could support such an identification. Portraits by Caravaggio of both Caterina and Onorio are recorded in an inventory of July 31, 1656, of the possessions of their son, Martino Longhi the Younger (A. Bertolotti, 1881, II, p. 126). However, this cannot be a reference to the ex-Berlin portrait since that picture is listed in a 1638 inventory of the Giustiniani collection as a "portrait of a courtesan called Phyllis [Fillide]" (L. Salerno, 1960, p. 136, n. 12); she is named "Taïde" in verses by G. M. Silos (1673, p. 92), as well as in an anonymous madrigal (see G. Fulco, 1980, p. 80). The most likely hypothesis is that the model for these pictures—datable to the last years of the sixteenth century—was a courtesan.

The *Saint Catherine* is described in the inventory of Cardinal del Monte's collection (f. 580 *r*.), made in 1627, after the deaths of the Cardinal and of his heir, Uguccione: "A Saint Catherine with the wheel, a work of Michelangelo da Caravaggio, with a gilt frame ornamented with arabesques, seven *palmi*" ("Una S. Caterina della Ruota opera di Michel Agnolo da Caravaggio con Cornici d'oro rabescate di Palmi sette"; see C. L. Frommel, 1971 b, p. 349). On December 12, 1626, the Cardinal's second heir, Alessandro del Monte, was authorized to sell whatever objects were necessary to meet estate debts. An inventory was drawn up, and on May 7, 1628, "a Saint Catherine and a game of cards by Caravaggio, a Saint Jerome by Guercino of Cento, a youth who plays a clavichord ["clevo"], 13 small paint-

ings on copper by Brueghel ["Bruchel": Jan Brueghel the Elder], four landscapes by the same, and ten pieces of cosmographic books" were sold for 500 *scudi* (see W. Kirwin, 1971, p. 55). Although proof is lacking, the purchaser must have been Cardinal Antonio Barberini, since the *Saint Catherine* is listed in the Barberini inventories of April 1644, and of 1671 (M. Lavin, 1975, pp. 167, 296; see M. Cinotti [1983, p. 419] on the disparities between the actual dimensions and those given in the Del Monte and Barberini inventories).

Bellori (1672, p. 204) mentions among the pictures that belonged to Del Monte "a Saint Catherine leaning on the wheel," and notes "a more saturated use of colors, [Caravaggio] having already begun to strengthen the darks" (for L. Spezzaferro's untenable interpretation of this passage, 1971, p. 57, n. 3, see M. Cinotti, 1983, pp. 418, 448). The painting remained in the Barberini collection until 1935, when it was sold to the present owner's father (the F. 12. in the lower right-hand corner is the inventory number of the fideicommissum ordered by Cardinal Pacca on August 8, 1817, and undertaken by Vincenzo Camuccini; see F. Mariotti, 1892, p. 127, n. 12, cited by R. Spear, 1971 a, p. 72).

The picture was attributed by Longhi (1916; 1961 ed., p. 278) to Orazio Gentileschi, and was exhibited as "school of Caravaggio" at the Palazzo Pitti, Florence, in 1922 (no. 206). Marangoni (1922, p. 44, pl. XLIV; 1922–23, p. 222), however cautiously, was the first to suggest Caravaggio's authorship, underscoring the elegant configuration created by the crossing of the sword and the palm, the beauty of the hands, the chiaroscuro of the neck and bust—"sober and decisive" as in the *Madonna dei Palafrenieri*—the snow-white sleeves, and the same type of azurite blue, now much altered through age, as in the Borghese *David* (cat. no. 97). It has further been noted that the prominent designs on the red damask pillow recur in other paintings by Caravaggio dating from his early period or slightly later: in the *Magdalen* in the Galleria Doria-Pamphili, the *Fortune Teller* in the Pinacoteca Capitolina (cat. no. 67), the *Narcissus* in the Palazzo Corsini (cat. no. 76), and in the two lateral *Saint Matthew* scenes in the Contarelli Chapel in

San Luigi dei Francesi. Voss (1923, pp. 80 f.; 1924, p. 439) supported the attribution to Caravaggio, comparing the work to the *Lute Player* in Leningrad; he was followed by Zahn (1928, p. 38) and by Longhi (1928–29; 1968 ed., pp. 90, 125). Caravaggio's authorship cannot, in fact, be doubted, and is almost universally accepted: see M. Cinotti (1983, p. 418) for the various opinions.

Bellori's pointed remarks would situate the *Saint Catherine* at the moment of transition between Caravaggio's early period and a new phase best represented by the lateral canvases in the Contarelli Chapel, which are now known to date between July 23, 1599, and July 4, 1600. Longhi (1943, p. 11) remarked on the stylistic relationship of the *Saint Catherine* to the *Conversion of the Magdalen*, as well as on the use of the same model, when he recognized the latter composition—known to him through three versions that he considered to be copies (the original, now in Detroit, is the same picture that Longhi believed to be in the Manzella collection: see cat. no. 73)—as an invention of Caravaggio. Mahon (1952 a, p. 9) has noted other details typical of Caravaggio's work during this period: the saint's silken hair, which occurs for the first time in the angel in the Doria-Pamphili *Rest on the Flight into Egypt*; and the sleeves, similar to those of Judith in the *Judith and Holofernes* and, later, of the angel in the first version of the *Saint Matthew and the Angel* (now destroyed; formerly in Berlin). For the slight variations in the proposed dating of the *Saint Catherine* just prior to the San Luigi dei Francesi lateral canvases—between 1597 and 1599—see M. Cinotti (1983, p. 419). The most widely accepted sequence is: the *Saint Catherine*, the *Conversion of the Magdalen*, and the *Judith and Holofernes*. Mahon (1952 a, p. 19) believes that the *Conversion of the Magdalen* preceded the *Saint Catherine*.

While, as Marangoni remarked, the saint's dress does not reveal the position of her body, Caravaggio has overcome his difficulties by means of the splendid clothing. The juxtaposition of the violet tone of the dress and the blue of the mantle is evidence of the artist's adherence to the coloristic traditions of Northern Italy. The large gold and silver designs woven into the cloth of the mantle

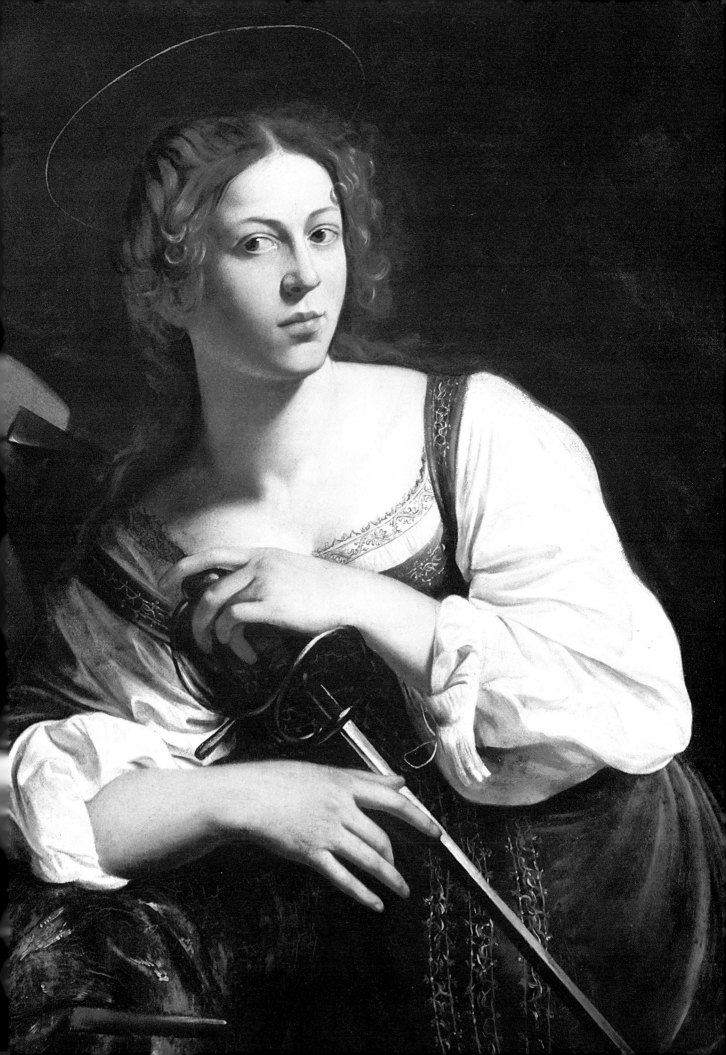

recall similar passages in the work of Romanino, and it is difficult to accept the proposal of Arslan (1959, pp. 214 f., n. 43) that they are later additions, even though the craquelure of the mantle varies in certain areas. Although only laboratory tests can provide the final answer, it is worth considering whether what is at issue is not, rather, a pentimento or an autograph addition, as Marini (1974, p. 365) conjectured. The freedom with which the designs have been painted have reminded Hibbard (1983, p. 65) of the late work of Velázquez. The rich color scheme of the costume echoes Dosso Dossi, as does the manner in which Caravaggio has strongly lit part of the face conferring on it a certain flatness (as in the ex-Berlin portrait). Through this effect, Caravaggio attempted to accentuate the contrast between light and shade. Saint Catherine's reddish-blonde hair, enhanced by the lighting, is a feature that can be traced back to Savoldo's work (for example, the *Saint Margaret* in the Pinacoteca Capitolina) and remained an attribute that Caravaggio favored for his feminine figures as late as the *Saint Ursula* (cat. no. 101). The tender humanity implicit in the gesture of the saint's elegant right hand seems to call the viewer's attention to the sharp blade of the sword, still tinged with the blood of her martyrdom. Longhi (1928–29; 1968 ed., p. 125) recognized in the pose of the hand a derivation from the "superplastico" gesture of the figure in Antonio Campi's *Saint Jerome* in the Prado.

When the paintings were exhibited in 1922 at the Palazzo Pitti, Marangoni (1922–23, p. 226) was able to detect incisions along the contours of the figure in the *Saint Catherine* as well as in the first *Saint Matthew*, in the *Conversion of Saint Paul* (from Santa Maria del Popolo), and in the *Madonna dei Palafrenieri*. These incisions, similar to those found in frescoes, were made when the priming was still damp and have since been noted in other works by Caravaggio (see R. Longhi, 1960, p. 27; R. Spear, 1971 a, p. 76; M. Cinotti, 1983, p. 418). According to Marangoni, this phenomenon raises the possibility that Caravaggio worked from cartoons.

An old copy of the picture was noted by Voss (1924, p. 439; see also J. Ainaud de Lasarte, 1947, pp. 387 f., and A. E. Pérez Sánchez, 1970, p. 124, no. 33) when it was still in the Prado (it is now in the sacristy of San Jerónimo el Real, Madrid). Marini (1974, p. 365) recorded another copy, of mediocre quality and poorly preserved, in San Pietro, Castel San Pietro (Palestrina).

M. G.

73. The Conversion of the Magdalen

Oil on canvas, 38 1/2 x 52 1/4 in.
(97.8 x 132.7 cm.)
The Detroit Institute of Arts

In the Middle Ages and the Renaissance, Mary Magdalen was widely believed to have been the sister of Martha and Lazarus. The present picture shows her at the moment of her conversion, enlightened by divine love and grace—a central theme of post-Tridentine spirituality. Martha, who is dressed modestly, reproves Mary and enumerates the miracles of Christ (see the vernacular life of Saint Mary Magdalen in Domenico Cavalca's *Libro chiamato specchio di croce*, an edition of which was printed in Venice in 1540). Cummings (1974, pp. 572 ff.) is responsible for the principal iconological interpretation of the painting. He has noted the brief description in Cardinal Roberto Bellarmino's hymn, *Pater superni luminis* (of about 1597–99), which alludes to the softening of the Magdalen's hardened soul. In the *Stigmatization of Saint Francis* (cat. no. 68), Caravaggio had already represented the theme of spiritual enlightenment, and he later returned to it in the two, successive versions of the *Conversion of Saint Paul* for the Cerasi Chapel in Santa Maria del Popolo. The stress that Caravaggio places on the young Magdalen—her beauty was part of patristic tradition—vis-à-vis her sister implies that her conversion coincided with the assumption of her new spiritual role, and may refer to the words spoken by Christ when he visited the two: "Martha, Martha, thou art anxious and troubled about many things. But one thing is needful, and Mary hath chosen that good part, which shall not be taken away from her" (Luke 10:41–42).

Traditionally, Martha and Mary symbolize the two types of religious life—the active and the contemplative. The theme was a popular one in Lombard painting of the Cinquecento, and the source of Caravaggio's painting was probably a work by Bernardino Luini, in Cardinal del Monte's collection, then attributed to Leonardo (A. Moir, 1976, p. 139, n. 237; see C. L. Frommel, 1971 b, p. 37, for the inventory of 1627, f. 584 *v.*). The picture, later purchased by the Barberini, was identified by

Cummings (1974, p. 575, n. 9) with the version in the Fine Arts Gallery of San Diego (but see M. Cinotti, 1983, p. 427). Caravaggio has accentuated the "contrapposto" (on which, see cat. no. 74) between the two figures, alluding to both a narrative ("azione") interpretation of the subject and to a new, subtle dialogue of the emotions ("affetti"). The use of a table to define the foreground is a common device in sixteenth-century Flemish painting, and one much diffused in Northern Italy as well. On the table are a comb—realistically shown with missing teeth—an ointment jar in which there is a sponge (in Venetian dialect, a *sponzarol*) for applying cosmetics, and a convex mirror on which the saint rests her hand. Like the ointment jar ("il vasello d'unguenti": Bellori) and the jewels in the Doria *Magdalen*, these objects refer to the saint's sinful life. The light emphasizes the objects, imparting to them a lifelike quality like that in a *vanitas*, familiar in Northern and in Venetian painting (as, for example, in Giovanni Bellini's *Woman at Her Toilette* in the Kunsthistorisches Museum, Vienna, and Paris Bordone's *Courtesan at Her Toilette* in the collection of the Earl of Spencer at Althorp). The symbolic nature of the objects provides confirmation that in Caravaggio's youthful paintings such details possess not only a new, naturalistic message, but a symbolic and poetic meaning as well. The significance of the mirror is complex. It, too, derives from Venetian paintings of a woman at her toilette, such as the picture by Bellini cited above and Titian's *Woman at Her Toilette* in the Louvre. These pictures, in addition to their splendid affirmation of the sensual world, contain allusions to the vanity of earthly things and of physical beauty (Titian's *Vanity* in the Alte Pinakothek, Munich, showing a young woman with a mirror, is less to the point in that the mirror was painted over at a later date). A late-sixteenth-century copy of the Louvre picture (in a private collection) probably Lombard—or possibly Brescian—includes a comb alongside the ointment jar on the foreground ledge, while the back of the woman is clearly reflected in the mirror. However, in the visual arts the mirror is associated not only with the theme of Vanity, but also with Prudence, and in that regard what Dante has to say seems more

relevant. In the *Purgatorio* (Canto XXVII, 101–8), he introduces the mirror and the theme of the toilette to contrast Leah and Rachel, the first of whom dedicated herself to the active life while the second sought truth through perpetual contemplation. In Caravaggio's picture, the light striking the mirror from a rectangular opening or a window probably has some significance related to divine enlightenment, to a property of the contemplative life, and to a knowledge of the divine, which, according to Saint Paul (II Corinthians 3:18), we behold "as in a glass." The Magdalen wears no jewels, only a golden ring on her left hand. In her right hand she holds an orange blossom (L. Salerno, 1974, p. 589, has seen in the gesture, as in that in Caravaggio's portrait of a lady formerly in Berlin, an echo of Leonardo). These details are probably symbols of mystic love.

The novelty and wealth of meaning in the *Conversion of the Magdalen* are arguments in favor of Caravaggio's invention of the theme, and they explain the success of the picture, evidence of which is provided both by the known copies (R. Longhi, 1943, p. 11, mentioned the earliest copies, deducing that they derived from a work by Caravaggio, although no such work is mentioned by his biographers), and by later treatments of the subject by artists not necessarily from Caravaggio's close circle (Orazio Gentileschi, Saraceni—the author of the most important derivation, known through copies and possibly identical with a picture in Gaspar Roomer's collection in Naples —and also Simon Vouet, Valentin, Antiveduto Grammatica, Rubens, and Pietro Paolini: see F. Cummings, 1974, p. 578; L. Spezzaferro, 1974, p. 582; L. Salerno, 1974, pp. 590 ff.; A. Moir, 1976, pp. 107 ff., nos. 56 a–p, pp. 139 ff., nn. 237–238).

For the Magdalen, Caravaggio employed the same female model that he had for the *Saint Catherine* (cat. no. 72) and for the lost Berlin portrait. Even the embroidered costumes in these three pictures are closely analogous, lending support to a date for the *Magdalen* in the last years of the sixteenth century, just prior to the lateral canvases in San Luigi dei Francesi (D. Mahon, 1952 a, p. 19: dates it 1596–97, before the *Saint Catherine* and the *Judith and Holofernes*; C. L. Frommel, 1971 b, pp. 19, 51: 1598–99;

E. Šáfařík, 1972, p. 30: before or in 1599– 1600; M. Marini, 1974, p. 365, 1978, p. 16: 1597; L. Salerno, 1974, p. 588: 1598–99; M. Cinotti, 1983, p. 426: 1598, after the *Saint Catherine* and prior to the *Judith*). This is the period in which Caravaggio's vision underwent a profound transformation: He sought to construct his figures more solidly, and to achieve a greater contrast between light and shadow, something that, inevitably, led him to the opposite extreme—to a negation and a nullification of the forms. The different ways in which the figures of Mary and Martha are lit presents the earliest example of this new interest, which is closely tied to Vasari's description of Leonardo's use of chiaroscuro (M. Gregori, 1972 a, pp. 32 f.; H. Hibbard, 1983, p. 61). These innovations are accompanied by a change in execution: The care ("diligenza") taken in the first works is replaced by an impetuous speed and technical experimentation that presupposes an interest in Venetian art, the influence of which was much diffused at the close of the Cinquecento. However, in the *Conversion of the Magdalen*, as in the other works from this moment of equilibrium, the transformation is not yet definitive. The subtlety with which the reflections in the mirror are studied derives from Caravaggio's youthful works. The green velvet mantle that is draped over the Magdalen's left arm (an accessory, although of a different fabric and color, that recurs in the *Saint Catherine*), is unique in Caravaggio's work for its Venetian—or, more precisely, its Dosso-like —tonality. The purplish color of the Magdalen's dress is enriched in accordance with Venetian fashion of the Cinquecento. What interested Caravaggio most, however, is the rendering of the sheen of the red silk sleeve, inspired by those youthful portraits by Titian that had so attracted Vasari's admiration, and by such artists on the Venetian mainland as Moretto da Brescia and Bernardino Licinio, who both remained faithful to such details in their own work. If, however, Caravaggio's picture is compared to the paintings of these artists, the novelty of the chiaroscural depth and density that he achieves becomes evident. This is part of the explosive—almost Courbet-like—vitality through which Caravaggio gives a new, brutal force to the timeworn subject of

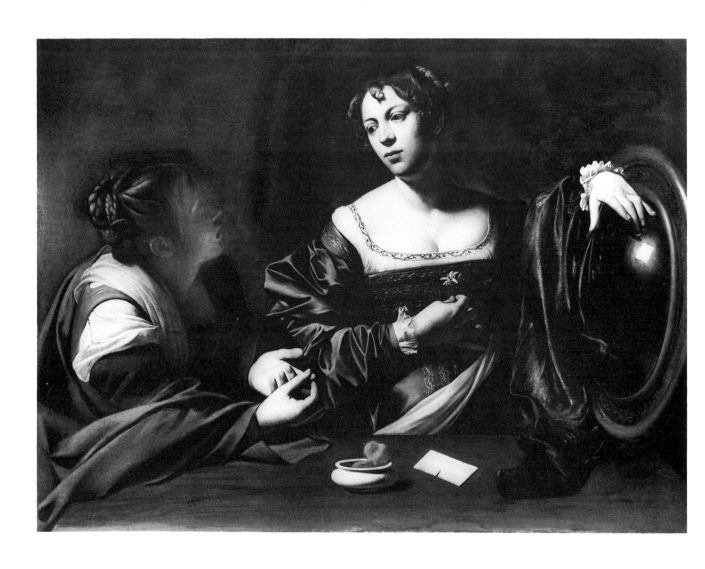

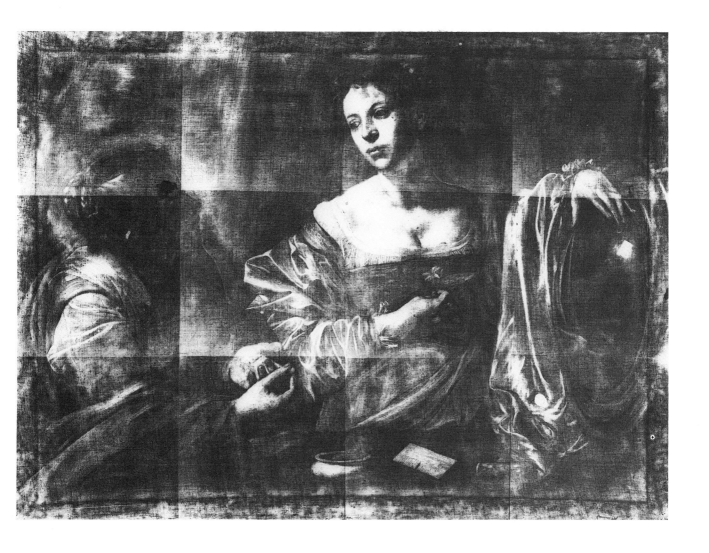

the *vanitas* (R. Longhi, 1943, p. 11).

The contrast between the Magdalen's costume and the modest dress of her sister is emphasized in a way that seems to announce one of the most fundamental and obvious aspects of Seicento painting, and there is no doubt that during the period when Caravaggio painted the *Conversion of the Magdalen*, the *Saint Catherine*, and the *Judith and Holofernes* he created his first truly innovative works, laden with consequences for the following century. Although he continued to live with Cardinal del Monte—who would soon procure for him the commission at San Luigi dei Francesi—Caravaggio began to interest other collectors as well, such as the banker Orazio Costa and the Marchese Vincenzo Giustiniani (the lost portrait of a lady, formerly in Berlin, was from the same period). The use of the lights and shadows, creating clearly legible images, allowed these works to be more easily imitated than those later paintings in which the artist would adopt a more radical descriptive method. Saraceni was indebted to the *Judith* and to the *Conversion of the Magdalen* for a number of stylistic features: especially for the novel representation of Martha—partly in light and partly in shadow, with reflected light illuminating her face from below—and for her physiognomic type. The brilliantly rendered silken sleeve of the Magdalen attracted Vouet and Lanfranco. However, the new manner in which the shadows are treated and the play of reflected light (M. Cinotti, 1983, p. 427) mark a significant advance over Caravaggio's youthful works.

In his will of August 6, 1606, Ottavio Costa left to the Abbot Ruggero Tritonio the choice of a painting of Saint Francis (cat. no. 68) or one of "Saints Martha and the Magdalen." Although the author(s) of the two pictures is not mentioned, the second picture obviously showed the same subject as the present one, and the reference may well be to the Detroit picture itself. Tritonio chose the *Saint Francis*, and in his will of October 25, 1607, he states that the picture was given to him by Costa and is the work of Caravaggio, "celeberrimo pittore." The logical conclusion is that the "Saints Martha and the Magdalen" was equal in value and importance to the *Saint Francis*; it is, moreover, difficult to believe that in 1606

this rare subject was treated by someone other than Caravaggio (L. Spezzaferro, 1974, p. 581). According to provisions in Costa's will, the "Saints Martha and the Magdalen" would have been given to the other beneficiary, Costa's friend and banking associate Giovanni Enriquez de Herrera. Although there is no mention of the picture in the inventory of Herrera's property made after his death in 1610, the picture must have been visible for a time in Rome—possibly in the house of one of Herrera's sons—as attested by the numerous extant versions. However, in the event that the *Saint Francis* that Costa gave to Tritonio was a copy rather than an original (see cat. no. 68), the same possibility should be entertained for the "Saints Martha and the Magdalen" mentioned along with it in the 1606 will. In that case, Costa may have kept the original—although no picture with that subject is recorded in the 1639 inventory of his possessions. Alternatively, the original by Caravaggio may have been owned by someone else altogether.

It was Longhi (1943, p. 11) who, on the basis of his knowledge of three versions that he considered copies of a lost original—a mediocre copy with the dealer Simonetti, in Rome; another at Christ Church, Oxford; and a picture that was said to have been owned by Comm. Manzella of Rome, but which, in reality, is identical to the Detroit picture (a photograph of it is at the Fondazione Longhi, Florence)—recognized the conception as Caravaggio's. Longhi's proposal was accepted by Berenson (1951, p. 17), Mahon (1952 a, p. 19), and Hinks (1953, pp. 54 f., 101, no. 18).

The present picture was acquired by The Detroit Institute of Arts in 1973. It had previously been offered at auction (Christie's, London, June 25, 1971, no. 21) by its owner, Ambassador Carlos Gómez-Alzaga, following Martin S. de Alzaga's and David Carritt's favorable opinions of the attribution, but the painting was bought in. (Between 1904 and 1909, the picture had been acquired in Paris by Indalecio Gómez; after his death in 1920 it was taken by his heirs to a family estate in the province of Salta, Argentina, where it remained until about 1965.) Seven wax seals on the canvas and frame establish that the picture was exported from Italy on January 21, 1897,

while on the eighteenth-century(?) relining are inscribed in what appears to be an early-nineteenth-century hand the names of Niccolò Panzani, Emilia Panzani, and Anna E. Panzani (a member of this Aretine family, Monsignor Gregorio Panzani, was linked to the circle of Urban VIII, but there is no proof that he was a direct ancestor of the owners: see L. Spezzaferro, 1974, pp. 582 f.). Following the abortive sale in 1971, the picture was again cleaned (it had been cleaned in Buenos Aires). Mahon and Salerno were the first to support its autograph status, followed by Nicolson, Cummings, Spear, Posner—an opinion later modified—Gregori, and Cinotti. The picture has not been accepted by Moir (1976, pp. 107 f., nn. 56 a; 1982, p. 27, fig. 31), who thinks it a copy from the circle of Valentin; Marini (1974, pp. 365 f.; 1978, pp. 15 ff.; 1980, p. 28, no. 20; 1981, p. 362); or Hibbard (1983, pp. 61 f., 288, no. 33), who believes that its attribution to Caravaggio is uncertain.

After its purchase by The Detroit Institute of Arts, the *Conversion of the Magdalen* underwent another restoration as well as a series of examinations by the museum's conservation department that proved to be of great interest for the still debated attribution (see J. L. Greaves and M. Johnson, 1974, pp. 564 ff.). Examination under infrared and ultraviolet light revealed pentimenti (those in the figure of Martha are the most significant). Long lines had been incised, probably with the end of the brush, into the wet paint (not into the ground, as in other paintings by Caravaggio) to define the bodice of the Magdalen's dress that was to receive embroidered decoration (contrary to Hibbard's observation, these lines are visible in photographs). The ground seems at times to have been left exposed between zones of color, especially around the flesh areas (sometimes a color similar to the ground was laid on to mark the division of the two zones). This corresponds to the practice of painting "alla prima"—rapidly and without a preliminary drawing, juxtaposing passages of different colors while they are still wet, yet leaving a subtle division between them. The effect is similar to—and may sometimes be confused with—that produced by the incisions found in many of Caravaggio's paintings. It

has not been noted in studies dealing with Caravaggio that this is essentially a Lombard technique that can be found in paintings by Moroni, as well as in the work of Carlo Ceresa and of Giacomo Ceruti (see M. Gregori, 1979 a, p. 36; 1982 b, pp. 24 f.). In the present painting, the reddish brown preparation was also occasionally used for the middle tones. This corresponds to what Bellori (1672, p. 209) reports about the *Beheading of the Baptist* (in Malta), in which Caravaggio "left the priming of the canvas exposed in the middle tones." The technique was widely employed in the late works, but it sometimes occurs in earlier paintings close in date to the *Conversion of the Magdalen*, such as the Uffizi *Bacchus* (cat. no. 71), where both uses of the ground noted above can be seen.

Analysis of a cross section of the paint has revealed an unusual mixture of egg tempera and oil in the flesh areas and in the highlights of the whites. The egg tempera seems to have been applied while the underlying oil medium was still wet (similar analyses of paintings by Orazio Gentileschi and by the Pensionante del Saraceni, in Detroit, showed a different application of this mixed-media technique). From these various analyses, the author of the Detroit picture reveals himself to have been an accomplished but impatient painter (for example, in the painting of wet on wet; the way in which the design was laid directly on the reddish-brown ground with a brush, without resorting to preliminary drawings; and the use of the ground as a middle tone). These methods accord with Caravaggio's singular temperament and his irregular, impulsive manner of working, as recorded in such sources as Van Mander and Bellori, and should also be considered within the context of sixteenth-century traditions in Bergamo and Brescia. It is, on the one hand, difficult to believe that the incisions and the uses of the ground according to traditional Lombard practices could be attributable to a copyist in Rome: These features are encountered in other works by Caravaggio, and, when taken together with the pentimenti, they provide evidence for his authorship. On the other hand, there is not enough information available on the application of egg tempera on wet oil paint to determine whether it is characteristic of

Caravaggio. Yet, examination of the London *Supper at Emmaus* (cat. no. 78) seems to provide support for this supposition. Moreover, the X-rays of the London *Supper at Emmaus* and those of the Kansas City *Saint John the Baptist* (cat. no. 85) compare convincingly with X-rays of the Detroit picture (J. L. Greaves and M. Johnson, 1974, figs. 12, 13). Nonetheless, further laboratory comparisons with other works—particularly with the contemporary *Saint Catherine* and the *Judith and Holofernes* (cat. nos. 72, 74)—are desirable.

Even such critics as Posner (1975, p. 302), who has proposed that the picture may be the product of a collaboration, accept the figure of Martha as by Caravaggio. And indeed, the pentimenti and the subtle lines in the whites of the drapery revealed in the X-rays (see J. L. Greaves and M. Johnson, 1974, fig. 12) weigh in favor of Caravaggio's authorship. They recur in other youthful works—in the Doria *Magdalen*, and in the Korda *Boy Bitten by a Lizard*, the Uffizi *Bacchus*, and the Capitoline *Fortune Teller* (cat. nos. 70, 71, 67)—and were probably introduced to obtain an effect of greater luminosity. In the body color, lead white is less prevalent and is mixed with other colors, while the crests of the drapery folds are painted exclusively with lead white and show up with a distinct appearance in the X-rays (these remarks are the result of a valuable exchange of ideas with Maurizio Seracini).

The folds of Martha's shawl, created by long, resolute brushstrokes; the highlighting of the profile of the face and of the neck with a few touches that describe the reflected light (a technique derived, in part, from Tintoretto); the circular brushwork and the broad, dark areas with which the hair is built up, revealing an extreme economy of means as well as a tenderness of approach—these are details absolutely worthy of Caravaggio and are certainly autograph.

No change in technique is noticeable in other parts of the canvas—either to the naked eye or in X-rays. The folds of the yellow sash of the Magdalen and the two moldings of the frame of the mirror display the same decisive execution, and the same attenuated brushstrokes. While the mirror has a function similar to that of the wheel in

the *Saint Catherine*, its perspective could be faulted, for it was certainly drawn freehand. There are other perspectival uncertainties: in the objects on the table and in the face of the Magdalen (which seems hardened by the loss of glazes). Such awkwardnesses contrast with the beauty and richness of the paint. The most apparent defect is in the right eye of the Magdalen, which is depicted in incorrect perspective. Yet, the fact that this detail (for which no sophisticated explanation need be given) recurs in the Oxford copy suggests that it was present in Caravaggio's original, from which it was borrowed by the copyist. The Magdalen's silk sleeve and green velvet drapery also appear similar in X-ray. However, while the brushstrokes in the sleeve are preserved intact, and variations in intensity and freedom of handling are evident—features that cannot be attributed to a copyist—abrasion in the area of the drapery has altered its appearance markedly.

M. G.

74. Judith and Holofernes

Oil on canvas, 57 1/8 x 76 3/4 in.
(145 x 195 cm.)
Galleria Nazionale d'Arte Antica,
Palazzo Barberini, Rome

The subject of the picture is taken from the book of Judith in the Apocrypha (13:7–8): "And [she] approached to his bed, and took hold of the hair of his head, and said, Strengthen me, O Lord God of Israel, this day. And she smote twice upon his neck with all her might, and she took away his head from him." Traditionally, the Jewish widow Judith, who saved her nation from the Assyrians by slaying Holofernes, is a symbol of fortitude. As the savior of her people, she also prefigures the Madonna, and is invoked on the feast of the Immaculate Conception. In his depiction of the scene, Caravaggio has accentuated the significance of her victory by contrasting the acerbic, proud beauty of the young Judith with the brute obtuseness of Holofernes. Calvesi (1971, p. 111) interprets the picture as symbolic of virtue overcoming evil, while Marini (1974, pp. 25 f.), noting the pertinence of certain sacred texts, interprets it as antiheretical.

Caravaggio has chosen the moment when Judith decapitates Holofernes, rendering the act at the instant of its execution, just as on the parade shield in the Uffizi he portrayed Medusa's head immediately after it had been severed. The *Judith* thus confronts us with Caravaggio's interpretation of action and narrative painting ("istorie") in accordance with his practice of working directly from nature, a method that could not but favor a representation emphasizing both the temporal and the physical present. More than once Caravaggio felt impelled to include himself as one of the spectators. The portrayal of a dramatic and violent event at its expressive and physical climax, already essayed in the *Boy Bitten by a Lizard* (cat. no. 70), had its roots in Northern Italy. Lomazzo records one of Leonardo's admonishments (which were still valid in the late Cinquecento) that combines a preference for bloody deeds with an insistence on studying from life (E. Săfărík, 1972, p. 32, recalls the recommendation—which, however, he attributes to Lomazzo—of

"going to see the reactions of those condemned to death when they are led to their execution, in order to study those archings of the eyebrows and those movements of the eyes"). For both Leonardo and Lomazzo, study from nature was associated with the representation of expressions ("affetti": see B. W. Meijer, 1971, p. 266). This was not the simple imitation of appearances found in Venetian painting, but a method that aimed at a different and more efficacious empathic relation with the viewer: "A picture . . . in which the emotions ["moti"] are imitated from life will, without doubt, stimulate laughter with him who laughs, thought with him who thinks, sadness with him who weeps, happiness and joy with him who is happy" (G. P. Lomazzo 1584; 1974 ed., p. 95). When Caravaggio abandoned his carefully painted half-length figures, through which he had deepened his perception of the visual world, and undertook for the first time paintings that represent action, he certainly had these ideas in mind; indeed, he was their most radical interpreter.

There was a persistent tradition in Lombardy and the Veneto for the portrayal of violent action without the constraints of Mannerist artifice—even among those artists whose work attempted to reconcile the drama of Raphael's Roman paintings with the realism of German painting. These artists included Pordenone, Romanino, and even Lorenzo Lotto. In the lunettes of the loggia of the Castello del Buonconsiglio in Trent, Romanino depicted scenes in which classical themes alternate with violent subjects taken from the Bible and history: Tarquin and Lucretia, the death of Cleopatra, and Judith and her maid furiously stuffing Holofernes's head in a sack. Although Caravaggio probably did not travel as far afield as Trent, he was certainly familiar with Romanino's work in and around Brescia. Indeed, Romanino ought to be counted among Caravaggio's predecessors, though a distinction should be made between his work and that of Moretto, Savoldo, and Moroni, from which Caravaggio derived the stylistic premise for his own paintings. It is very likely that Caravaggio also knew Pordenone's frescoes of the Passion in the cathedral of Cremona—turbulent scenes of physical violence carried out with an empir-

ical approach that underscores their brutality and that was later adopted by local artists.

The importance of the *Judith*—which seems to precede the *Martyrdom of Saint Matthew* in the Contarelli Chapel—lies in its being the first work in which Caravaggio ventured to undertake a dramatic scene with violent action. The painting exemplifies the attention given by Caravaggio to such themes, which eventually led him to explore, with a profundity that—as Săfărík (1972, p. 32) has noted—is paralleled only in Shakespeare's tragedies, the perennial conflict between the persecutor and the victim, the tragic meaning of life, and the omnipresence of death. In the *Judith and Holofernes*, however, Caravaggio, still portrays, as in the *Medusa*, mere physical cruelty. Subjective implications, the artist's identification with the suffering of the victim, his stoic conception of grief—all this is absent. Analogies to contemporary events in Rome, however, immediately come to mind: the sordid history of the Cenci family (Francesco Cenci was murdered on September 9, 1598, by the daughter and second wife he had abused, and they were beheaded a year later) and the burning of Giordano Bruno on February 17, 1600 (R. Longhi, 1951 c, p. 11, refers to these events indirectly, as does E. Săfărík, 1972, p. 32). For the various iconographic interpretations of the picture, see Cinotti (1983, p. 516).

Săfărík (1972, p. 32) has noted a precedent for the composition in Paolo Veronese's treatment of the theme (two versions are known, in the Galleria di Palazzo Rosso, Genoa, and the Kunsthistorisches Museum, Vienna), and Moir (1982, p. 90) has cited a sixteenth-century fresco in monochrome in the Palazzo Massimo alle Colonne, Rome. However, the qualities of immediacy and actuality that so engage the viewer in Caravaggio's picture have no real precedent. These features seem to correspond to the classical unity of time, place, and action, observed in contemporary theater. Even the drapery in the background, which has been compared to prototypes in Venetian paintings and has been thought lacking in narrative significance, is, to the contrary, faithful to the text, since the event took place in Holofernes's tent. Although

the drapery does not describe the setting, its very suggestiveness constitutes a theatrical element. Caravaggio's choice of a dynamic horizontal format—a constant feature of his three-quarter-length pictures (see the *Sacrifice of Isaac*, cat. no. 80)—reveals a hesitation to undertake more complex compositions, not only because they would have required a traditional representational technique but also because they presented compositional difficulties for the artist.

In accordance with the biblical text, Caravaggio focuses attention on the beauty of the victorious young Judith, the fulfillment of the promise in his earlier work. The model for the figure is usually thought to be the same as for the *Saint Catherine of Alexandria* and the *Conversion of the Magdalen* (cat. nos. 72, 73), although Salerno (1974, p. 589, n. 15) has correctly expressed reservations about this. Longhi (1951 c, pp. 10 ff.), who published the picture after its discovery and restoration by Pico Cellini (it was exhibited in Milan in 1951 toward the conclusion of the "Mostra di Caravaggio e dei Caravaggeschi"), has brilliantly described the heroine and the contrast between the picture's ingenious conception and the ghastly episode that it illustrates. In Judith's servant, Caravaggio has painted, for the first time, an old woman, whose face is marked by the signs of age and her horror at the bloody deed at which she assists. The accomplice in the earlier *Cardsharps* (see fig. 2, cat. 67) provides a precedent for her bulging eyes and for her caricatured face (R. Longhi, 1951 c, p. 12). The careful analysis of the servant's features is reminiscent of Leonardo's studies of grotesque people (E. Săfărík, 1972, p. 32), while the contrast between the servant and Judith plays on the classical tradition in rhetoric and poetry of contrapposto, a concept that had great currency in the figurative arts of the Renaissance (H. Hibbard, 1983, p. 67; see D. Summers, 1977, pp. 336 ff.). Gregorio Comanini, in his treatise *Il Figino*, of 1591—certainly familiar to Caravaggio because of its Lombard setting—recommends that painters juxtapose figures of different sex, age, and appearance to achieve an effect of contrapposto. In particular, he speaks of pairing a beautiful maiden and an old hag. Here the aged woman, whose appearance in Cinquecento theater and painting was frequently associated with repugnant and despicable characters (B. Wind, 1974, p. 31), acts as a foil, enhancing not only Judith's beauty but her moral endowments as well. The currency of these ideas in Lombardy is further confirmed by many Lombard and especially Cremonese examples. Caravaggio had perhaps intended to contrast youth and old age in the *Rest on the Flight into Egypt*, as Hibbard (1983, p. 67, n. 10) suggests, but this became a more frequent leitmotiv in his mature work: In the late pictures of Salome with the head of John the Baptist, in London (cat. no. 96) and in Madrid, the heads of the young protagonist and her aged servant seem almost to belong to the same body, as though to suggest the effects of the passage of time and to allude to the theme of Vanity.

The *Judith and Holofernes* was acquired by the Galleria Nazionale d'Arte Antica in 1971 from the collection of Dr. Vincenzo Coppi in Rome (for its earlier history—its possible ownership by the Montaguti and its certain presence in Rome in the nineteenth century, where it was engraved—see A. Moir, 1972, p. 128; and the excellent entry by E. Săfărík, 1972, pp. 24 ff.). A derivative drawing, signed by Conca (perhaps, as Faldi suggests, Giacomo Maria Conca), and an engraving and engraving plate in the Calcografia Nazionale, Rome, were discovered by Salerno. Although there is no proof, it is very probable that the painting is identical with the one described as the "Judith who cuts off the head of Holofernes," which Baglione (1642, p. 138) said was painted by Caravaggio "per li signori Costi." The member of this family to whom the picture most likely belonged was Ottavio Costa, a Roman banker and one of Caravaggio's first patrons, who owned houses and property in Liguria, Naples, and Malta (see P. Matthiesen and D. S. Pepper, 1970, p. 452; E. Săfărík, 1972, p. 26; L. Spezzaferro, 1975 a, pp. 106 ff.). Costa's will, of 1606, lists both a "Saint Francis" (given by Costa to the Abbot Ruggero Tritonio; see cat. no. 68) and a "Saints Martha and the Magdalen" (cat. no. 73). His attachment to Caravaggio's paintings is evident in a later will, of 1632, in which he forbade his heir to dispose of "the paintings by Caravaggio, particularly the *Judith*." The same prohibition is expressed in his will of January 18–24, 1639, where "a large painting showing Judith painted by Michelangelo Caravaggio" is listed (L. Spezzaferro, 1975 a, p. 118). Also among his pictures by the artist was a "Saint John the Baptist in the desert," identifiable with the painting in Kansas City (cat. no. 85). Other paintings corresponding to themes treated by Caravaggio are listed with no indication of their author. However, Mancini (about 1617–20; 1956–57 ed., I, p. 225) mentions a "Christ on his way to Emmaus" that was bought by Costa in Rome (for its identification, see cat. no. 78).

The 1639 mention of the *Judith* is the last known reference to the picture, although sources and documents mention other paintings of the same subject attributed to Caravaggio. According to Frans Pourbus the Younger, a *Judith* was sold in Naples in 1607 together with the *Madonna of the Rosary* (in the Kunsthistorisches Museum, Vienna); this *Judith* is probably the same picture recorded in 1617 in the will of Louis Finson, who, with Abraham Vinck, had acquired the *Madonna of the Rosary*. That this *Judith* could be identical with the Costa *Judith*, as Friedlaender (1955, p. 159) tentatively suggests, is impossible. A "Judith who cuts off the head of Holofernes" (in the Palazzo Zambeccari, Bologna; now in the Pinacoteca Nazionale, Bologna), which was cited by various visitors to the city, is a replica—possibly autograph—of Artemisia Gentileschi's *Judith and Holofernes* in the Uffizi, and it is possible that other references to pictures of the subject attributed to Caravaggio result from a confusion of paintings that actually depict Salome. The theme of Judith and Holofernes was quite popular among Caravaggio's followers, confirming the importance of his prototype (see especially E. Săfărík, 1972, p. 28; M. Cinotti, 1983, pp. 515 f.).

The attribution of the *Judith* has not been seriously questioned (for opposing opinions—among which is an unjustified one by P. Della Pergola, 1973, p. 52—see M. Cinotti, 1983, p. 516), and today it is universally accepted as a work by Caravaggio. It is generally dated to the end of the century, along with related works (D. Mahon, 1952 a, p. 19 proposes: 1597–98; C. L. Frommel, 1971 b, pp. 19, 51: 1598–99; E. Săfărík, 1972, p. 30: 1599–1600; M. Cinotti, 1983,

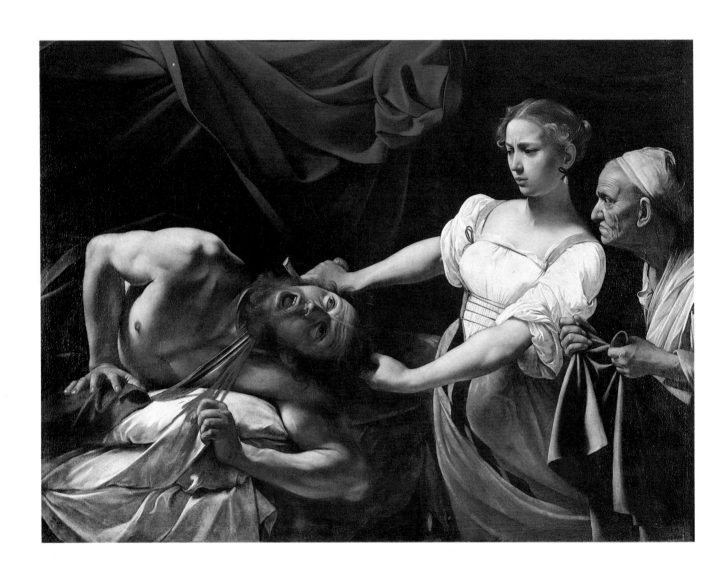

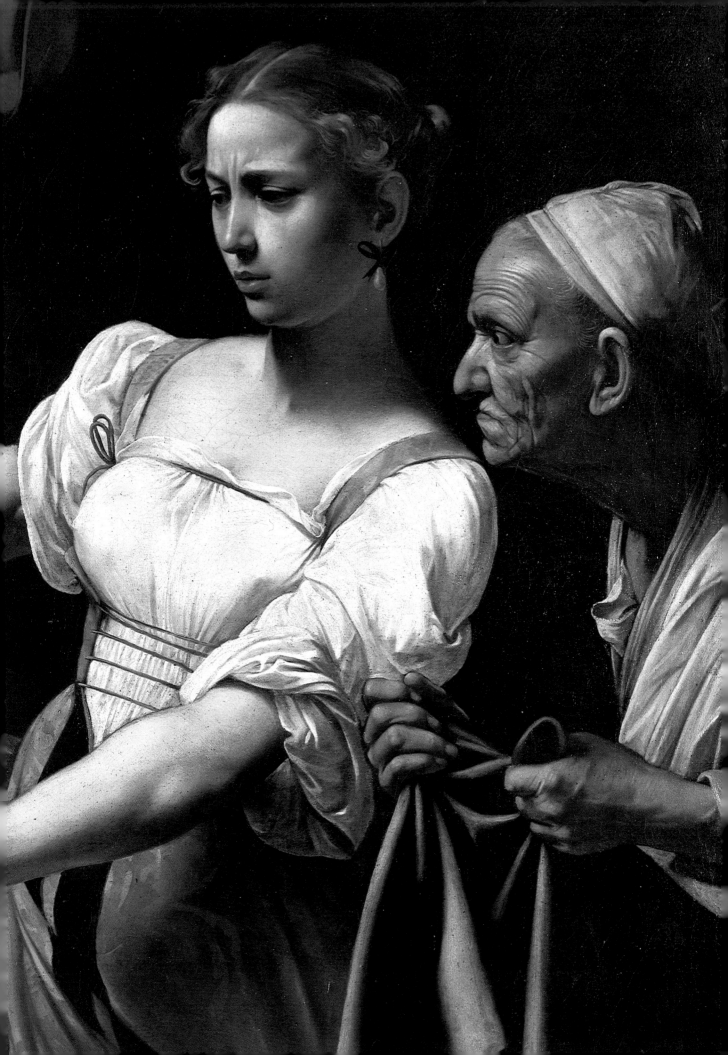

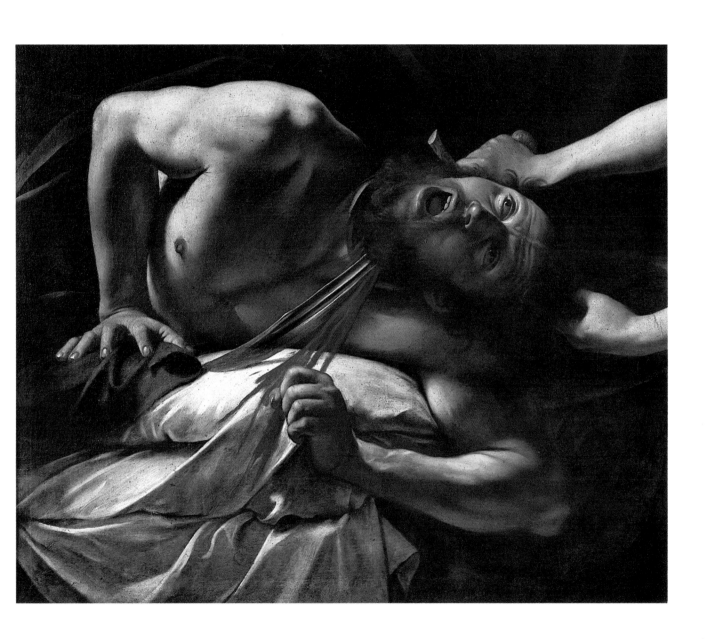

p. 516: the first months of 1599). A number of characteristics relate it to paintings usually associated with the end of Caravaggio's youthful period—the concern for the regular, almost abstract beauty of Judith, for example, and the pearl earrings, similar to those of the *Magdalen* in the Galleria Doria-Pamphili, Rome. However, the dark background marks the first appearance of the "closed room" setting of which Bellori speaks and which Caravaggio employed when he began "to strengthen the darks." Indeed, the artist's visualization of the scene results not from an attempt to re-create the historical setting, but from a desire to give the picture an immediacy by emphasizing the foreground and the contrasts of light and dark. Caravaggio's interest in the effect of shadow is especially evident in the irregular patterns of light and shade on the chest of Holofernes; the curious shape created by the shadow on his shoulder is similar to the shadow projected by the basket of fruit onto the tablecloth in the *Supper at Emmaus* in London (cat. no. 78).

The picture has not been relined, and the back of the original frame is inscribed "D'Orazio"—probably the record of an attribution to Orazio Gentileschi—with the number 36 (M. Marini, 1974, pp. 379 f.). Mahon, in a letter that he wrote to F. Cummings (January 20, 1973) while engaged in research on the Detroit *Conversion of the Magdalen* (cat. no. 73), pointed out the presence of incised lines in the *Judith*; for this peculiarity, see cat. no. 80.

M. G.

75. Still Life with a Basket of Fruit

Oil on canvas, 12 3/16 x 18 1/2 in.
(31 x 47 cm.)
Pinacoteca Ambrosiana, Milan

Contrary to what has sometimes been proposed (L. Borgese, 1950; E. Arslan, 1951, p. 448), this picture was conceived as an independent still life, and was not excised from a larger work, such as the London *Supper at Emmaus* (cat. no. 78). It is first cited, as a still life, by Ratti ([A. Ratti], 1907, pp. 27, 58, n. 8, p. 136; R. Longhi, 1928–29; 1968 ed., p. 94) in the 1607 codicil by which Cardinal Federigo Borromeo willed a number of paintings as the nucleus of a projected academy of painting, at the Biblioteca Ambrosiana—only recently founded by him. The *Still Life* is described in the Cardinal's legacy to the picture gallery of the Ambrosiana, dated April 28, 1618, as follows: "a basket of fruit by Michelangelo da Caravaggio, on canvas, one *braccio* wide and three-fourths *braccia* high, without a frame" ([A. Ratti], 1907, p. 136; L. Venturi, 1910, pp. 198 f.; A. Bellu, 1969, p. 295; M. Cinotti, 1971, p. 162, F 97). As Calvesi (1975 b, p. 80) has suggested, Cardinal Borromeo may have purchased the picture in Rome, where he lived prior to 1595, and again from 1597 to 1601, when his residence was close to that of his friend Cardinal Francesco del Monte (see H. Hibbard, 1983, p. 381, n. 19, who cites the relevant bibliography). It is also possible that the painting was a gift from Del Monte. Longhi (1928–29; 1968 ed., p. 94) conjectured that the picture could be identified with a reference in a letter of February 29, 1596, from Del Monte to Borromeo, but he later (1952, pl. IV) abandoned the hypothesis, which Calvesi (1973, p. 3; 1975 b, p. 80) has shown to be incorrect.

Borromeo was an enthusiastic collector of still lifes by Jan Brueghel of Velours, and he recorded his interest in and admiration for Caravaggio's still life—albeit in rhetorical terms—in the *Musaeum* (1625, pp. 32 f.; M. Cinotti, 1971, p. 165, F 116), which was probably written about 1618, although it was not published until 1625, along with his treatise *De Pictura Sacra*: "Of not little value is a basket . . . with flowers [*sic*] in lively tints. It was made by Michelangelo da Cara-

vaggio who acquired a great name in Rome. I would have liked to place another similar basket nearby, but no other having attained the beauty and incomparable excellence of this, it remained alone" ("Nec abest gloria proximae huic fiscellae, ex qua flores micant. Fecit ea Michael Angelus Caravagensis Romae nactus auctoritatem, volueramque ego fiscellam huic aliam habere similem, sed cum huius pulchritudinem, incomparabilemque excellentiam assequeretur nemo, solitaria relicta est").

X-rays of the picture, made in 1951 (R. Longhi, 1952, no. IV), revealed beneath the present surface a decoration of grotesques that Hope Werness (reported by A. Moir, 1976, p. 124, n. 185) has shown to be a copy after the base of an ancient candelabrum in the Museo Laterano, Rome. However, the fact that the still life is painted over another image does not mean that this was carried out as an exercise by Caravaggio, as Salerno (1970, p. 236) has suggested. Salerno (1966, p. 107) has plausibly identified the author of the grotesques as Prospero Orsi, known as Prosperino delle Grottesche, who, according to a deposition of September 13, 1603, at the libel suit of Baglione, was a friend of Caravaggio (A. Bertolotti, 1881, II, pp. 58 ff.; M. Cinotti, 1971, p. 155, F 52). Bellori (1672, p. 202) also refers to Prosperino as Caravaggio's friend.

This is the only still life that can be ascribed with certainty to Caravaggio; the one in the National Gallery of Art, Washington, D.C.—on the back of which is an old label with an attribution to Caravaggio—has now been recognized as a work by the Pensionante del Saraceni (see cat. no. 48). It is, however, probable that Caravaggio painted other, earlier still lifes (see cat. nos. 63–65), perhaps when he was still in Lombardy, where there are contemporary examples (R. Longhi, 1967, pp. 18 ff.; M. Rosci, 1977, pp. 90 f.; J. Spike, 1983, pp. 12 ff.), and almost certainly when he was a member of the workshop of the Cavaliere d'Arpino. Concerning this activity (see L. Venturi, 1910, p. 197), it is Bellori (1672, p. 202) who gives the most extensive information, although what he has to say is frequently accorded less weight than it merits. Bellori writes, "So that, from necessity, Caravaggio worked for the Cavaliere d'Arpino, who employed him painting flowers and fruits,

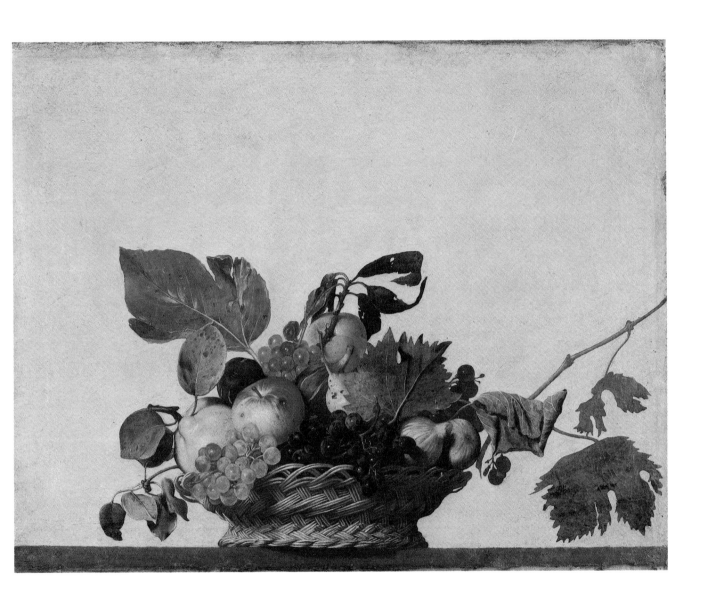

which are so well executed that in them he achieved that greater beauty ["vaghezza"] that so delights us today. He painted a vase of flowers, showing the transparency of the water and glass and the reflections from the window of a room, scattering fresh dew-drops on the flowers. And he painted excellently other pictures with a similar mimetic effect." A work with this subject, "Un Quadretto nel quale vi è una Caraffa di mano del Caravaggio di Palmi dua," cited in the 1627 inventory of Del Monte's property (C. L. Frommel, 1971 b, p. 31, fol. 575 r.), is probably identical to the picture mentioned by Bellori—who, however, does not state that it was painted in Arpino's workshop. The Marchese Vincenzo Giustiniani (1620 –30; 1675 ed., p. 111, no. LXXXV) records that Caravaggio declared that it required as much skill to paint a picture of flowers as one of figures. That Caravaggio painted still lifes, judging them to be equal to figure painting (R. Longhi, 1928–29; 1968 ed., p. 94; 1950, pp. 34 f.), cannot be doubted (for the contrary position, see W. Friedlaender, 1955, p. 80; L. Salerno, 1970, p. 236). By giving pride of place to the way in which a picture is painted rather than to its subject or content, Caravaggio overturned the established hierarchy (M. Gregori, 1972 a, p. 35). Indeed, in his deposition during the libel suit of 1603, Caravaggio took his Lombard bias a step further, asserting that "for me a good man ["un valenthuomo"] knows how to practice his art well, and a good painter ["un pittore valenthuomo"] is one who knows how to paint well and to imitate nature ["le cose naturali"] well."

In a fashion typical of Caravaggio, the Ambrosiana still life repeats, with variations, the representation of fruits in a basket that is the focus of the *Boy with a Basket of Fruit* (cat. no. 66; as R. Longhi, 1928–29; 1968 ed., pp. 94 f., noted, the *Boy with a Basket of Fruit* is certainly an earlier picture), and of the still life in the foreground of the Uffizi *Bacchus* (cat. no. 71). The accentuated areas of shadow on the basket, and their strong contrast with the pale background, which contributes to the emphasis on the leaves and to their optically acute description, suggest that the Ambrosiana still life dates from the last years of the sixteenth century, either slightly before or contemporary with the lateral canvases in

San Luigi dei Francesi (see M. Cinotti, 1983, p. 464). The background was painted after the execution of the basket of fruits, and Longhi (1952, pl. IV) explained this as an attempt to "enhance the fiction of a back wall." (The assertion by D. Mahon, 1951 a, p. 233, n. 108, and by others, that the background was added by another artist is not convincing.) The picture is earlier than the London *Supper at Emmaus* (cat. no. 78), in which the basket of fruit lacks a comparable intensity. This slight difference may be due to the fact that in the London picture the still life is only a detail in a narrative, but it also serves to confirm that the Ambrosiana picture was conceived as an independent still life. Its importance as such has been emphasized first by L. Venturi (1910, pp. 199 f.) and then by Marangoni (1917, pp. 13 f.), Longhi (1928–29; 1968 ed., pp. 94 f.), Waterhouse (1962, p. 22), and Causa (1972 b, pp. 1997–99), both within the context of the career of Caravaggio—"The first great master of modern painting to paint an autonomous still life" (C. Sterling, 1952 b; 1959 ed., p. 57)—and the history of still-life painting. The formal plenitude of the fruits, heightened by their intense colors and by their arrangement in the basket—at once compact yet casual, not frozen like the offerings of fruit and flowers in Counter-Reformation painting—became the basis for the most important tendency in Italian still-life painting of the seventeenth century. This tendency was developed especially by painters in Caravaggio's circle and by artists of the Neapolitan school.

In the light of what we now know, the Ambrosiana *Still Life with a Basket of Fruit* may be regarded as the synthesis of Caravaggio's early interest in Nature ("naturalia"). It marks his mastery over the precedents offered by Lombard and Flemish painting, as well as over his own, earlier experiments—reflected in the still lifes in the Galleria Borghese (cat. nos. 63, 64) and in Hartford (cat. no. 65) and in the still-life details in his early half-length figure compositions, up until the *Boy Bitten by a Lizard* (cat. no. 70). In this transition from an analytic to a synthetic vision based on a lucid, optical naturalism, Caravaggio repudiated the formulas of Mannerism and aligned himself directly with the most genuine values of the Renaissance (F. Zeri, 1976, p.

103). In fact, although Caravaggio's acute, probing mimesis would seem directly related to Jacopo Ligozzi's botanical illustrations (E. Battisti, 1962, p. 464, n. 65; M. Gregori, 1972 a, p. 39), it is from the naturalistic tradition of North Italy that he derived the intense, synthetic vitality that distinguishes his various baskets with fruit from analogous compositions by Dutch and Flemish artists, which are the product of an analytic vision. Giovanni da Udine was one of the founders of this North Italian tradition, which took root in Brescia and in Ferrara—even in religious painting, and in pictures having a "moral" theme, as demonstrated by the work of Moretto (R. Longhi, 1928–29; 1968 ed., pp. 112 f.) and of Dosso Dossi.

The illusionistic way in which the basket projects over the ledge on which it rests, into the viewer's space—"like a decorative trompe l'oeil comparable to motifs in ancient art" (C. Sterling, 1952 b; 1959 ed., p. 56)—also stems from a classical and humanistic background. This illusionism, whose function in Caravaggio's paintings is far from decorative, contributes a feature to the Ambrosiana picture that is found in other early still lifes by artists such as Juan Sánchez Cotán, Georg Flegel, Floris Claesz. van Dyck, and Nicolaes Gillis. This picture has always been recognized as exceptional, and a variety of interpretations—of a religious nature (M. Calvesi, 1971, pp. 97 f., 128 f.; 1973; L. Spezzaferro, 1981, pp. 262 f.), or directed more toward characterizing the cultural climate in which the work was produced (C. del Bravo, 1974, pp. 1568 f., 1575 ff.)—have been put forward. However, the ethical significance of the picture resides, in Longhi's words (1928–29; 1968 ed., p. 94), in its representation of "a humble biological drama," or, according to Sterling (1952 b; 1959 ed., p. 56), in the expression of "the natural wear and tear of life." The means Caravaggio employs have their roots in the empiricism of Brescian–Bergamask painting. One may take the observations of Longhi and Sterling still further and assert that, in its depiction of the fruit and leaves, the picture represents decay and death, an implicit theme in Caravaggio's work after a certain date (G. C. Argan, 1956, pp. 36 f.). The deeper meaning of the Ambrosiana still life—the transience, or vanity, of earthly

things (M. Fagiolo dell'Arco, 1968; 1969 ed., p. 21; and M. Marini, 1974, p. 361, n. 19)—is inherent in the picture itself, since the sensory pleasures stimulated by any still life are illusory, not real (E. Gombrich, 1963, p. 104; H. Hibbard, 1983, pp. 82 f.); this is especially true in the present case.

M. G.

76. Narcissus

Oil on canvas, 43 5/16 x 36 1/4 in.
(110 x 92 cm.)
Galleria Nazionale d'Arte Antica,
Palazzo Corsini, Rome

This infrequently treated subject is inspired by Ovid's *Metamorphoses* III, 407 ff. The picture is not mentioned in the early sources, but a "Narciso in tela d'imperatore di mano di Michelangiolo di Caravaggio" was sent to Savona by G. B. Valtabelze (from where is not stated) on May 8, 1645, together with other pictures, including a landscape on canvas "di quattro palmi di Grosseto" (A. Bertolotti, 1876, p. 121; cited by M. Marini, 1974, p. 387).

Narcissus is shown on his knees, gazing into the dark water that reflects the dolorous expression on his face. The figure and his reflection describe a circle at the center of which is the illuminated knee; a similar function is fulfilled by the highlighted knee of the angel in the *Stigmatization of Saint Francis* and by Saint John's knee in the Kansas City *Saint John the Baptist* (cat. nos. 68, 85). In accordance with Caravaggio's figurative language and his unique way of interpreting the tragic myth, Narcissus's concentrated gaze is described with extraordinary intensity and endowed with a human urgency: Fatally infatuated with himself, he is destined for imminent death and transformation into the flower that bears his name. The interpretation of the theme as much as stylistic comparisons with other works have led a number of critics to accept the attribution to Caravaggio made by Longhi (1916; 1961 ed., pp. 229 f.: see R. Hinks, 1953, pp. 60, 90, 104, no. 24; H. Wagner, 1958, pp. 84 f., 91, 203, nn. 373–376). The present picture shares a number of similarities with the lateral canvases in the Contarelli Chapel in San Luigi dei Francesi: The pose and the profile of Narcissus's bowed head recall that of the youth counting the money in the *Calling of Saint Matthew*, and the sleeveless doublet with its large-scale decoration recurs in the figure with his back to the viewer in the left background of the *Martyrdom of Saint Matthew*. The way in which light and paint are fused support a date for the picture of about 1599–1600 —contemporary with the San Luigi can-

vases. It is significant that at the moment when Caravaggio undertook an important public commission, he returned to the type of subject treated in his early, half-length compositions, endowing it with more profound psychological and human implications—almost as if he identified his own unhappy experiences with those of the mythological figure.

In the seventeenth century, Narcissus was sometimes depicted after his death (see D. Panofsky, 1949, p. 114). In literature, the water in which he sees his reflection is frequently associated with the Styx. The dangers, as opposed to the utility, of water alluded to in the myth were illustrated by Domenichino in a fresco (in the Palazzo Farnese) in which a man in a boat is shown on the distant sea while, in the foreground, Narcissus gazes at himself in a pool; his pose resembles that of the figure in the present picture. As D. Panofsky (1949, pp. 115 f.) noted, even Poussin's Narcissus in the *Kingdom of Flora* in Dresden, with his inclined head seen in strict profile, is closely analogous in pose. As an engraving published by G. L. Mellini (1977, p. 410) suggests, Caravaggio, Domenichino, and Poussin were probably all inspired by a sixteenth-century prototype—although the latter two artists most likely knew Caravaggio's painting as well. The engraving, by the sixteenth-century publisher in Rome, Tommaso Barlacchi, who was the cultural heir to Marcantonio Raimondi and Enea Vico, shows Narcissus in a similar fashion—even down to the disheveled lock of hair. The subject had also been treated by Leonardo's circle (for example, the two panels, close to Boltraffio in style, one in the National Gallery, London, the other in the Uffizi, Florence: see H. Bodmer, 1931, pl. 98; W. Suida, 1929, pl. 227). Maselli has compared the pose of Narcissus to that of figures in an engraving by Marcantonio Raimondi after the nudes in Michelangelo's *Battle of Cascina*. More convincing is the proposal of Marini (1974, pp. 388 f.) that the source was the ancient bronze statue of the *Spinario* (in the Palazzo dei Conservatori, Rome); it was well known in the Cinquecento, and a replica was listed in the inventory of Cardinal del Monte's possessions. Such obvious derivations from the picture as Orazio Gentileschi's *David in Contemplation after the*

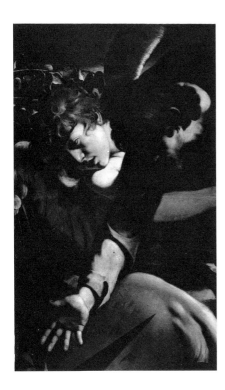

Defeat of Goliath (cat. no. 42; the *Narcissus* had been attributed to Orazio) and Nicolò Tornioli's *Astronomers*, both in the Galleria Spada, Rome (F. Zeri, 1954, pp. 136 ff., fig. 187), indicate that Caravaggio's canvas was in Rome at least until the middle of the seventeenth century.

The most immediate—as well as the principal—attraction of Caravaggio's picture is his depiction of the human vicissitudes of Narcissus. However, a variety of diverse iconological interpretations has been suggested by scholars. The painting has been thought to represent the sense of Sight, in a series devoted to the five senses (K. Bauch, 1956, p. 259; M. Fagiolo dell'Arco, 1968, pp. 50, 58 f., n. 32). It has been considered an illustration of the theme of "Conosce te ipsum" (L. Salerno, 1970, p. 235), or, in its exemplification of the knowledge of oneself and of God, as an allegory of a Christian (M. Calvesi, 1971, p. 136). To the present writer, Marini's reference (1974, p. 388) to Neoplatonic texts on the relationship of Man and Nature carries considerable weight, although the dolorous mood of the painting does not seem to accord with the final description of *Pimander* (*Corpus Hermeticum* I) of Nature embracing in itself the Lover (Man): "Man, having seen a form similar to his in nature—reflected in water—fell in love with it and wanted to live with it."

Numerous penetrating analogies with securely autograph works by Caravaggio are suggested by the pose of the youth. Not by chance does he recall the Doria-Pamphili *Magdalen*, where the broad curve of the shoulders and folded arms marks the first use of this circular motif, containing and focusing the tension implicit in the figure's mood of sadness and meditation. The closed, circular composition of the *Narcissus*, in turn, prefigures the pose of Saint Paul in the *Conversion of Saint Paul* in the Cerasi Chapel in Santa Maria del Popolo. Although there are analogies with the second *Saint Matthew and the Angel* in the Contarelli Chapel, the *Sacrifice of Isaac* (cat. no. 80), the Capitoline *Saint John the Baptist*, and the *Incredulity of Saint Thomas* in Potsdam, it is closest to the first version of the *Conversion of Saint Paul* in the Odescalchi collection, Rome. The head of Narcissus is almost interchangeable with that of

Christ in the Odescalchi picture. The representation of the hair—even its length and the manner in which it is arranged on the neck—is identical, as is the manner in which the ear emerges from the dark mass of hair on the nape of the neck into the light. These comparisons suggest a more precise dating of the *Narcissus*, to 1600—as has been proposed by some scholars: in relation both to the lateral canvases in San Luigi dei Francesi and to the inception of the Cerasi Chapel paintings, commissioned on September 24, 1600.

The *Narcissus* was discovered in a private collection in Milan (it belonged to Paolo d'Ancona) in 1913 by Longhi, who published it in 1916 (1961 ed., pp. 229 f.). It was acquired by B. Kwhoshinsky and given by him to the Galleria Nazionale d'Arte Antica in 1914. The attribution of the picture to Caravaggio, first proposed by Longhi (see also 1943, p. 8; 1952, p. 23), has been accepted, *inter alia*, by Marangoni (1922 b, p. 43, pl. XLIII; 1922–23, p. 220), by Berenson (1951 a, p. 35), and, after initial doubts, by Mahon (1951 a, p. 234; 1953 a, p. 219, n. 35). Nonetheless, this attribution has encountered reservations and opposition, due, in part, to the poor state of the painting as well as to an overly superficial consideration of those specific qualities that link the picture with Caravaggio's work. Following the rejection by Schudt (1942, p. 54, no. 78) and by D. Panofsky (1949, p. 115), who tentatively ascribed the picture to Orazio Gentileschi—an idea taken up by Baumgart (1955, p. 113) and, with reserve, by Bissell (1981, pp. 205 f., no. x–18)—as it has been dismissed by such "restrictionist" critics as L. Venturi (1951, p. 41) and Friedlaender (1953, p. 316, n. 1, who proposes that the picture is perhaps by a Tuscan imitator of Caravaggio for whom the youth in the *Calling of Saint Matthew* was a point of departure; and 1955, p. 139), on the basis that it is not mentioned in the sources. Among others who have rejected it are Arslan (1951 a, p. 446; 1959, p. 214: He calls it possibly a seventeenth-century copy), Moir (1961, pp. 3 ff.; 1967, I, p. 85, n. 54, II, p. 61; 1976, p. 119, no. 116, p. 138, n. 235: He attributes it to Manfredi or a follower of Manfredi), and Posner (1971, p. 323, n. 46). Those who have remained uncertain include: Pevsner (1928, p. 131),

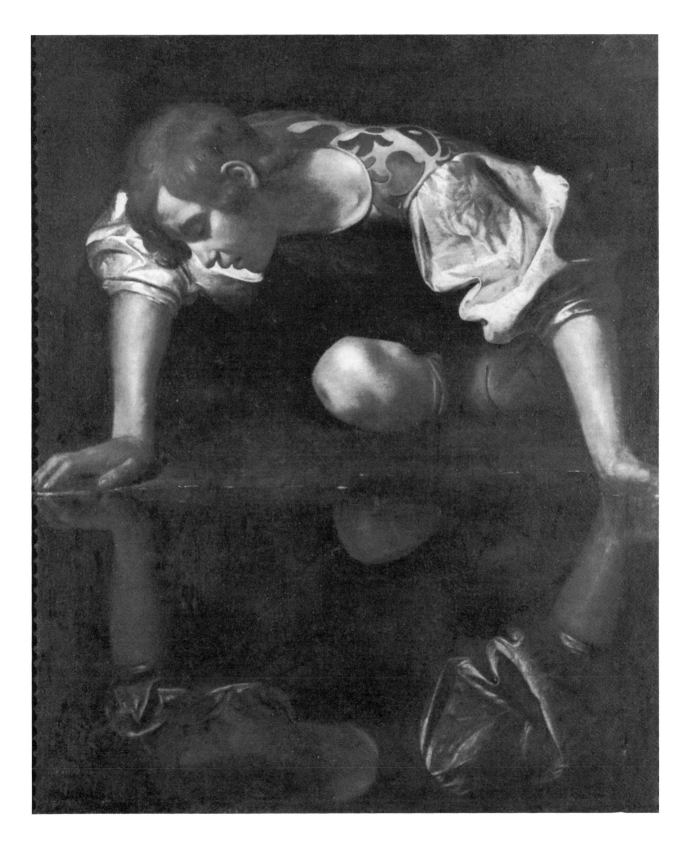

Voss (1951 a, p. 168), Cinotti (1971, p. 102), Spear (1971 a, p. 78), Nicolson (1979, p. 31), and Hibbard (1983, p. 334). The most recent favorable opinions are those of Marini (1974, pp. 162 f., 387 ff.; 1980, p. 36, no. 37), Bardon (1978, pp. 94 f., 99, 108) and Cinotti (1983, pp. 518 f.).

The proposal that the *Narcissus* is by Orazio Gentileschi or by Manfredi cannot be sustained on stylistic grounds—nor if one considers the Lombard, Savoldo-like interpretation of the theme. The refracted quality of the image and the obvious pleasure taken in describing the luminous effect of the sleeves and their reflection in the water recall the work of Savoldo (R. Longhi, 1928–29; 1968 ed., p. 120, plates 168–169, cited especially the *Tobias* in the Galleria Borghese).

The picture has suffered from abrasion and from old restorations, although it has not been worked on since 1914, or examined scientifically. For a discussion of the old stretcher and the state of the picture, see Cinotti (1983, p. 518).

M. G.

77. David and Goliath

Oil on canvas, 43 1/4 x 35 7/8 in. (110 x 91 cm.)
Inscribed (lower right): 1118
Museo del Prado, Madrid

The subject is taken from the biblical account of David's victory over Goliath (I Samuel 17:49–54). David is shown bending over the giant, his knee on the corpse, intent on binding the hair of the severed head. David's attitude—not yet triumphant, but informal and humble—conforms to the biblical description (R. Spear, 1971, p. 78). As in a number of Cinquecento paintings, so here the episode illustrated refers to antecedent events—David's slaying of the giant with a stone that pierces his forehead, and the subsequent decapitation—but the mood is profoundly different. In his two late pictures of the theme, in the Kunsthistorisches Museum, Vienna, and in the Galleria Borghese, Rome (cat. no. 97), Caravaggio, showing the victorious David in three-quarter length holding his unsheathed sword and displaying the head of Goliath, made a significant iconographic innovation by eliminating the narrative element. The artist apparently attached a private emblematic significance to the subject, in response to the tragic psychological situation of his last years. The close adherence of the Prado picture to its biblical source seems far removed from such concerns, demonstrating by comparison the enormous change in Caravaggio's personal life in the space of a few years.

The painting probably served as a prototype for the earliest Caravaggesque treatments of the theme— those by Borgianni (cat. no. 20) and by Orazio Gentileschi (cat. no. 42, and in the National Gallery of Ireland, Dublin). Since David is shown full figure, the identification of the picture with a painting of the same subject by Caravaggio but with David shown half length, owned by the Conte di Villamediana (Bellori, 1672, p. 214), is not tenable (see X. de Salas, 1974, p. 31; and A. Moir, 1976, pp. 138 f., who believes that the picture, the dimensions of which are identical with those of the *Narcissus*—cat. no. 76—has been reduced). Nonetheless, there are early copies in Madrid of the picture (R. Longhi,

1951 d, p. 21), which must have arrived in Spain in the seventeenth century: It is first cited in the inventories of the Buen Retiro in 1794 (A. Pérez Sánchez, 1970, p. 122, n. 32: the inventory number still appears in the lower-right corner), and it entered the Prado from the royal collections. Marini (1980, p. 30, with a reference to E. Battisti, 1955, pp. 174 ff.) has suggested that the picture was taken to Spain in 1617 by the painter Giovanni Battista Crescenzi, and confiscated with other paintings about 1635, but there is no proof of this.

The painting was published as an autograph work by A. Venturi (1927, p. 369). However, doubts have persisted: both Ainaud de Lasarte (1947, p. 385) and Berenson (1951, p. 37) considered it a copy. Longhi (1943 a, p. 39), who at first believed it to be by Saraceni or his school, revised his opinion, attributing it to Caravaggio upon examining the reproductions published by Ainaud de Lasarte after the picture was cleaned. Longhi (1951 d, pp. 21 ff.) judged the quality too high for a copy and dated the painting just prior to the *Martyrdom of Saint Matthew* in the Contarelli Chapel—at that moment of "alternation between delicate idyll and savage drama that is typical of Caravaggio's work." This phase is represented by the slightly earlier *Judith and Holofernes* (cat. no. 74), which may precede the *David* by only a few months, and the *Sacrifice of Isaac* (cat. no. 80). Longhi's restitution of the picture to Caravaggio has been accepted by a number of scholars, beginning with Mahon (1952 a, p. 18), who, in an important revision of Caravaggio's chronology, dated the work to 1598–99. Nonetheless, several critics remain skeptical (see M. Cinotti, 1983, p. 454). The most discerning exponent of this position is Spear (1971, p. 78), who states that although the picture is certainly by the same hand as the *Narcissus*, a specific attribution is complicated by the contradiction inherent in the work: The tender, almost sentimental treatment of the protagonist, who appears still to belong to the world of Caravaggio's early pictures, seems irreconcilable with the principle of style, tied more closely to later works—the *Supper at Emmaus* (cat. no. 78), the Cerasi Chapel *Conversion of Saint Paul*, and even the *Adoration of the Shepherds* in Messina (?). In fact, an analysis

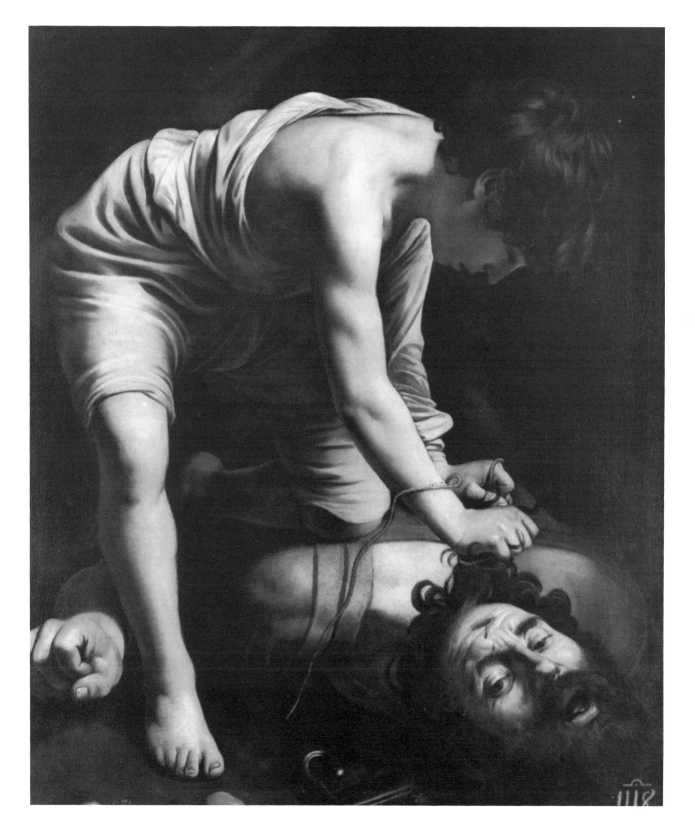

of the Prado *David* underscores the difficulty of placing it stylistically or chronologically within the artist's oeuvre. And while the present writer is firmly convinced that Caravaggio conceived the picture, she cannot at present decide whether it is autograph or—what seems less likely—a copy. A number of factors weigh strongly in Caravaggio's favor, but Spear's observations concerning the banality of the body and head of Goliath cannot be dismissed—even thought it might seem possible to attribute the notable drop in quality in the lower part of the picture to the exigencies of Caravaggio's many commissions. We know from Caravaggio's late work for private patrons that his execution could be neglectful and hurried—but the result was always moving. The relative chronological position of the *David* and its dating to the first years of the seventeenth century are clarified by its relationship to securely autograph works. When Mahon (1952 a, p. 18) accepted the picture as a work by Caravaggio, he compared the head of David, shown in full shadow (almost a visual counterpart to the humble attitude of the figure described in the Bible) with touches of light on his hair and profile, to the apostle on the left in the London *Supper at Emmaus*, whose face is shown in *profil perdu* illuminated by reflected light. Many of the reservations since expressed might have been avoided had even "nonconnoisseurs" attentively weighed the consequences of this comparison. The "delicate transparency" of the near *profil perdu* (R. Longhi, 1951 d, pp. 22 f.) and white-to-gray range of colors—heightened only by the green of Goliath's costume—may be understood in terms of Caravaggio's search for transparency and variety within a more complexly conceived space, as evident in the first version of the *Saint Matthew and the Angel* (see fig. 7, page 37) for the altar of the Contarelli Chapel.

Recent documentary findings have affected the dating of the first *Saint Matthew*, long thought to be Caravaggio's earliest work for the Contarelli Chapel. Consequently, pictures whose character would otherwise be difficult to explain in the context of his activity in the early years of the seventeenth century—when he achieved sudden fame—may now be seen in a new light. The lateral canvases in the Contarelli Chapel were painted—despite the extensive revisions in the *Martyrdom of Saint Matthew*, revealed in X-rays—in the short space of one year, from July 1599 to July 1600. The four pictures for the Cerasi Chapel in Santa Maria del Popolo—the two panels that were rejected and the two canvases that were installed—were painted between September 1600 and November 1601. The two successive altarpieces for the Contarelli Chapel showing Saint Matthew and the angel seem to have been executed from February 1602 to September of the same year—or to February 1603, following Hibbard's reasoning (1983, pp. 144, 302 f.)—unless Salerno (1974, p. 587) is correct in suggesting that the first altarpiece of Saint Matthew was painted shortly after completion of the lateral scenes in July 1600. The altarpiece was intended to replace a sculpture group of the saint and the angel by the Flemish sculptor Jacob Cobaert, and the conception of the first version in terms of a sculptural relief against a dark background—with the transparency of his early style—may reflect to this fact.

Caravaggio's work reveals an alternating interest between light paintings and paintings that employ strong contrasts, such as the lateral scenes in the Contarelli Chapel. This phenomenon is evidently due to the difficulty the artist encountered in adapting the highly finished style of his early pictures to scenes with many figures in action; in fact, the contrasted style is usually associated with a more painterly execution. This alternating interest not only distinguishes the two versions of *Saint Matthew and the Angel*, it also marks the two successive versions of the *Conversion of Saint Paul*. It is by no means impossible that what impelled Caravaggio to take up a more painterly style was in part the necessity of finishing these works speedily. Other considerations lead to the conclusion that at that time, occupied with a number of important and disparate public commissions, he was still experimenting with a variety of approaches. He must gradually have come to reject the raw, optical lucidity of his Lombard heritage, which had been the object of serious criticism, in favor of a manner that was less suited to the imitation of natural effects but which was still within the bounds of Leonardesque precedent. As Bellori (1672, p. 204) writes, Caravaggio used colors "reinforced with vigorous darks, employing much black to give relief to the figures." The dating of the first version of the *Saint Matthew* to Caravaggio's early maturity has necessarily affected the dating of other paintings formerly thought to be youthful works. This is the case with the *Sacrifice of Isaac* (cat. no. 80), which is now correctly associated with payments in 1603–4 for 100 *scudi*, and the same is true of the *David*. A dating in these years would resolve the contradictions noted by Spear. In fact, a number of stylistic and interpretive aspects of the picture relate it to Caravaggio's ideas of the first years of the seventeenth century. The kneeling figure defines a space no less deep than that in the second *Conversion of Saint Paul* or the *Amor Vincit Omnia* (cat. no. 79). The *David* is further associated with the latter picture and to the Cerasi Chapel *Crucifixion of Saint Peter* by the intensely pictorial effect of the drapery folds, as well as by the somewhat squat illuminated leg (the light, however, comes from the right rather than from the left). The description of the muscles of David's right arm, silhouetted against the shirt, reveals the same illusionistic method—even in the use of a dark contour—employed for the angel in the *Sacrifice of Isaac*. The way David holds the cord twisted around his hand (here to bind Goliath's hair, which has been painted "alla prima") is studied from nature; the same sort of observation occurs in the *Crowning with Thorns* (cat. no. 81) and the *Crucifixion of Saint Peter*. In the motif of David's inclined head and in the mood of the picture, an affinity with the *Narcissus* has been noted, but for the present writer the *David* is not earlier but slightly later. If the *Narcissus* was conceived at the moment Caravaggio was engaged in painting the lateral canvases for the Contarelli Chapel and the first version of the *Conversion of Saint Paul*, then the *David* would seem to be contemporary with the definitive versions of the canvases for the Cerasi Chapel and the London *Supper at Emmaus*—which is Mahon's point of departure.

M. G.

78. The Supper at Emmaus

*Oil on canvas, 55 1/2 x 77 1/4 in.
(141 x 196.2 cm.)
Inscribed (lower right):* N I
National Gallery, London

The episode illustrated in this picture is taken from the Gospel of Saint Luke (24: 30–31): "And it came to pass, as [Jesus] sat at meat with them, he took bread, and blessed it, and brake, and gave to them. And their eyes were opened, and they knew him; and he vanished out of their sight." The gospel refers to one of the disciples as Cleophas. The second is traditionally identified as the author of the gospel, Luke, or, alternatively, as Peter. The pilgrim's shell on the mantle of one of the disciples in the painting is an allusion to the journey that the two men were making when they met Jesus.

Following a tradition well established in Italy, Christ is seated at the center of the table. The gesture of his right hand, which is raised in blessing, is clarified, through the position of his left hand as directed toward the bread in front of him; this action is immediately understood by the two disciples, who react in surprise. The disciple at the right flings his arms outward along a diagonal axis so that one hand is directed inward while the other extends outward toward the viewer. The disciple seated at the left grasps the armrests of his chair, as though to rise; the immediacy of his reaction contrasts with that of the other disciple, whose gesture expresses a recognition that is already complete. These gestures have their source in such sixteenth-century Venetian representations of the Supper at Emmaus as Titian's (in the Musée du Louvre, Paris, and in the collection of the Earl of Yarborough, Brocklesby Park, Lincolnshire) and Veronese's (in the Musée du Louvre, Paris; the Gemäldegalerie, Dresden; and the Museum Boymans-van Beuningen, Rotterdam). In Caravaggio's picture, however, they have an effect of greater immediacy, involving the viewer directly through the closeness of the figures to the picture plane and through the use of a number of perspectival devices. As Wittkower (1958, p. 24) has noted, "In keeping with the tradition stemming from Alberti and Leonardo, Caravaggio, at this stage in

his development, regarded striking gestures as necessary to express the actions of the mind." In Lombardy, Lomazzo, in his treatises, had taken up Leonardo's ideas, paying especial attention to their naturalistic, empirical basis. Nonetheless, so startling is Caravaggio's truthfulness in this picture—his "tremenda naturalezza" (F. Scannelli, 1657, pp. 198 f.)—that he goes far beyond any such theoretical premises, putting them completely out of mind. The surprised figure of Cleophas on the left, whose pose is frozen by a brilliant light that comes from behind him, invading the room and accentuating the perfect illusionism of his foreshortened chair, marks the summit of Caravaggio's achievement in this vein.

The representation of figures gathered around a table in a small interior, viewed close to the picture plane, may be traced, as Friedlaender (1955, pp. 164 ff.) observed, to Romanino's *Supper at Emmaus* (in the Pinacoteca Tosio Martinengo, Brescia) and to his *Christ in the House of Simon* (in San Giovanni Evangelista, Brescia), as well as to Moretto's paintings of those subjects (in the Pinacoteca Tosio Martinengo and in Santa Maria in Calchera, Brescia). The objects and the food on the perspectively defined table are represented in an informal but veristic fashion analogous to that of Moretto's *Christ in the House of Simon*. As in Moretto's picture, the concentrated composition, the description of the furnishings, and the differentiation between the unenlightened innkeeper (who has the appearance and dress of an ordinary person) on the one hand, and Christ and the two disciples on the other, evoke a monumental genre scene ("scena di genere": R. Longhi, 1928–29; 1968 ed., p. 113); the closeness of the table to the picture plane presupposes Caravaggio's interest in the representation of pure still life. The tablecloth spread over a carpet is a motif taken from Venetian painting (see H. Potterton, 1975, p. 6, who cites examples by Titian, Veronese, and, above all, by Jacopo Bassano); Caravaggio employed it in the later *Supper at Emmaus* in the Brera and in the *Toothpuller* (cat. nos. 87, 98). The designs on the carpet, viewed in half-shadow; the curious forms of the shadows cast upon the white tablecloth; the basket of fruit that projects over the table in an unstable

fashion, creating yet another illusionistic motif—all of these details mark a return to Caravaggio's early interest in naturalistic effects ("naturalia") and in optical and illusionistic experiments. The basket of fruit recalls the one in the still life in the Ambrosiana (cat. no. 75), as well as earlier experiments with the motif, as evidenced by the Hartford still life (cat. no. 65).

The significance of the subject of the picture and of the choice of foods depicted has aroused a good deal of interest. The subject alludes to the institution of the Eucharist at the Last Supper: It is through Christ's repetition of the same gesture that the disciples now immediately recognize him. The bread and the wine are the material means through which Christ's sacrifice is renewed. Although it is not necessary to attach a specific meaning to each item, the fruit—which, as Bellori (1672, p. 213) pointed out, consists of varieties that are not in season at Easter time—represents, according to Christian tradition, fruitfulness and hope. The pomegranate is a symbol of resurrection and of immortality. It is more difficult to assign a meaning to the roasted bird, though the thaumaturgic, vivifying power of Christ's sacramental gesture is certainly intensified by the contrast between his hands and the fowl's scrawny, inert claws. Christ's head is youthful and beardless, and it is impossible not to remark upon the sensuality and ambiguity of his appearance. This head perhaps represents a recollection of that of Christ in Leonardo's *Last Supper* (R. Longhi, 1952, p. 24). There are precedents for it in other Lombard paintings (W. Kallab, 1906–7, p. 289, notes examples by Luini and by Boltraffio) and especially in representations of the youthful Christ, such as the *Salvator Mundi* commissioned from Leonardo by Isabella d'Este, the *Christ Among the Elders* by Luini (in the National Gallery, London), and the *Christ Blessing* by Marco d'Oggiono (in the Galleria Borghese, Rome). Calvesi (1971, p. 99) and Scribner (1977, p. 380) have suggested that Caravaggio's Christ is derived from the Early Christian beardless type. A closer point of reference is Michelangelo's Christ in the *Last Judgment*, from which Caravaggio has adopted not only the physiognomic type but also the orchestrated gesture of the two hands; according to Scribner (1977, p.

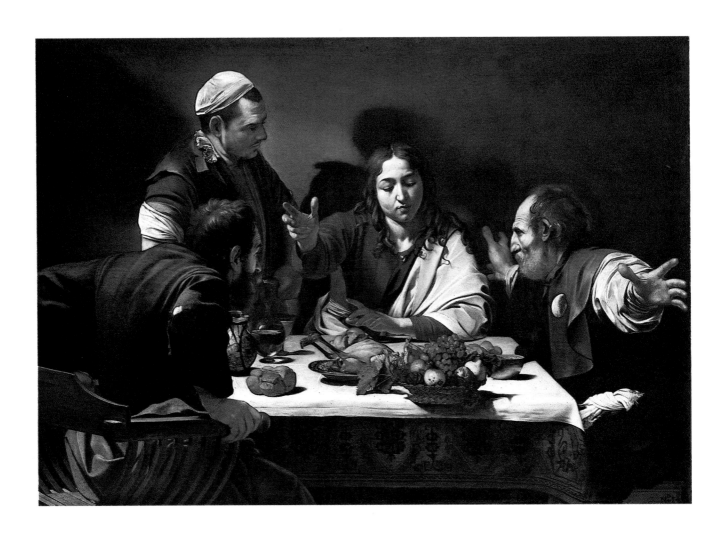

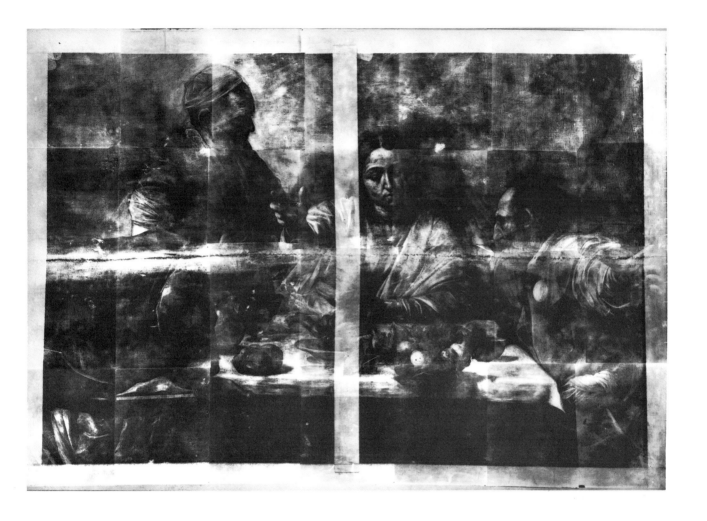

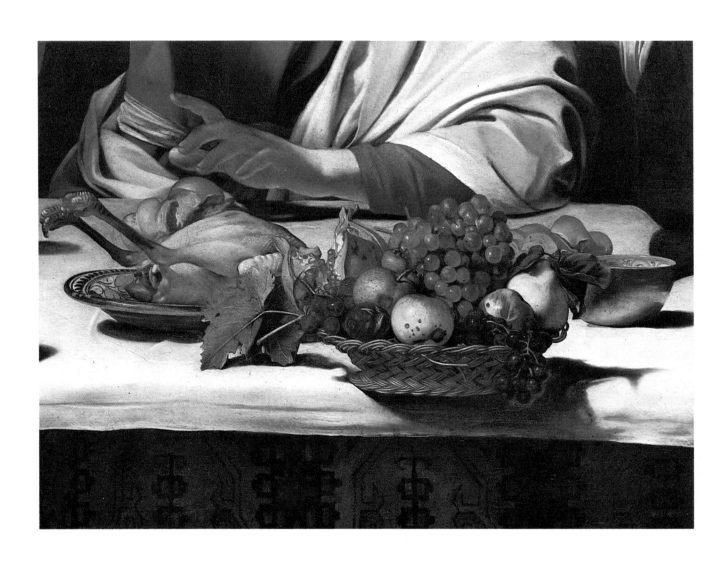

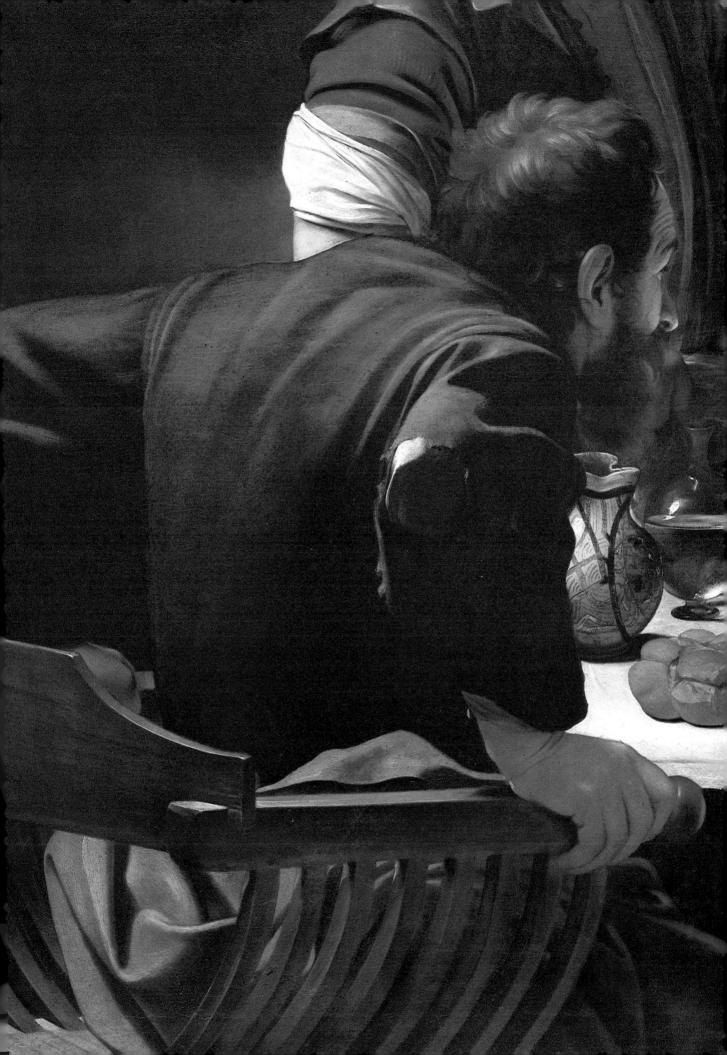

381), the allusion to Michelangelo suggests the idea that Christ's appearance to the disciples at Emmaus anticipates his coming at the Last Judgment.

The attribution of the picture is beyond dispute, but the history of its provenance is controversial. Manilli (1650, p. 88) records it as in the Villa Borghese: It had probably belonged to Cardinal Scipione Borghese. Yet, it cannot have been painted for him, as Bellori (1672, p. 208) says it was, since Scipione only returned to Rome, summoned by his uncle, Paul V, on May 16, 1605—and by then the picture had certainly been in existence for several years. Bellori mentions both this *Supper at Emmaus* and another one that, he says, was painted for the Marchese Patrizi—the second was probably the same picture that, according to Mancini (about 1617–20; 1956–57 ed., I, p. 225), was painted at the Colonna estates (see cat. no. 87)—praising them for their "imitation of natural color," even though "they are lacking in decorum, [Caravaggio] having frequently degenerated into common and vulgar forms." Writing long before Bellori, Jusepe Martínez (about 1650; 1934 ed., p. 40; see also J. Ainaud de Lasarte, 1947, p. 368, who dates the paragraph dedicated to Caravaggio to about 1625) referred even more disparagingly to what was probably the London *Supper at Emmaus*, although where he saw the picture cannot be said for certain. He criticized the Christ for having the common features of a workshop apprentice and said of the disciples that they are painted "with so little decency that it may be said that they look like a couple of knaves."

The picture is listed in the Borghese inventory of 1693 (P. Della Pergola, 1964, p. 453, no. 261): "Beneath the cornice nearby a large painting with the Supper at Emmaus, on canvas No. 1, with a carved and gilded frame, by Caravaggio" (the number is still visible in the lower right-hand corner of the London picture). It is mentioned again, in the Palazzo Borghese, in 1700 (G. B. Montelatici, 1700, p. 221) and in 1787 (F. W. B. von Ramdohr, 1787, I, p. 299). It was sold in 1801 by Camillo Borghese to a certain Durand, who was presumably an antiquarian or a French agent. The picture later belonged to George Vernon, who attempted unsuccessfully to sell it at auction (Christie's, London, April 16, 1831, no. 35), and it was given by Lord Vernon to the National Gallery in 1839.

Before Bellori, Baglione (1642, p. 137) mentioned a painting that showed "when our Lord went to Emmaus" ("quando N. Signore andò in Emaus"), painted by Caravaggio for Ciriaco Mattei. Despite this description, which would suggest a representation of the Road to Emmaus (a theme treated in North Italy in the sixteenth century by artists such as Altobello Melone in Cremona, whose work Caravaggio could have seen), Hinks (1953, pp. 102 f., n. 21) has plausibly suggested that the picture described by Baglione—whose life of Caravaggio seems to have been written about 1625—is the same one that was subsequently owned by Scipione Borghese. Levey (1971, p. 50) has expressed the contrary opinion, basing it principally on the fact that Celio (1638, p. 134, in a passage that seems, however, to have been written in 1620) cites three pictures in the Palazzo Mattei: the *Taking of Christ*; the *Saint John the Baptist* (now in the Pinacoteca Capitolina, Rome), left by Ciriaco to Cardinal del Monte in his will of 1623–24; and an "Emmaus" ("Quella de Emaus"). If, indeed, this "Emmaus" was still in the Mattei collection in 1638, then it cannot be the *Supper at Emmaus* owned by Scipione Borghese, who died in 1633. However, as Cinotti (1983, p. 451) suggests, it is probable that Celio did not update his *Memoria* after 1620 and that the picture was acquired by Scipione Borghese sometime after that date.

A date of about 1601 or, at the latest, early 1602, is suggested by the painting's analogies with the first version of the *Saint Matthew and the Angel* (fig. 7, p. 37), where the same Savonarola chair appears; with the *David* in the Prado (cat. no. 77); and with the *Amor Vincit Omnia* (cat. no. 79), which is probably a bit later. For various opinions, see Cinotti (1983, p. 451).

The picture was cleaned in 1961. X-rays show no significant pentimenti, save in the outline of the hat and profile of the innkeeper (M. Levey, 1971, p. 49). Technical analysis has revealed the use of tempera over still-wet oil on the tablecloth, as in the Detroit *Conversion of the Magdalen* (cat. no. 73).

For the numerous copies and derivations, some of which show Christ with a beard, see Friedlaender (1955, p. 167), Marini (1974, p. 375), and Moir (1976, pp. 87 f.).

M. G.

79. Amor Vincit Omnia

Oil on canvas, 75 1/4 x 58 1/4 in.
(191 x 148 cm.)
Gemäldegalerie, Staatliche Museen
Preussischer Kulturbesitz, Berlin-Dahlem

It was during the libel suit brought by Giovanni Baglione against Caravaggio, Orazio Gentileschi, Onorio Longhi, and Filippo Trisegno in 1603 that the subject of this picture was first mentioned. In his deposition on September 14, Gentileschi stated that "in competition with a picture of Earthly Love [*un Amor terreno*] by Michelangelo da Caravaggio" Baglione had painted one of "Divine Love [*un Amor devino*], . . . dedicated to Cardinal [Benedetto] Giustiniani" (A. Bertolotti, 1881, II, p. 62; M. Cinotti, 1971, p. 156, F 54). Baglione's painting is in the Gemäldegalerie, Berlin-Dahlem (for a second version, see cat. no. 15). It is quite probable that Caravaggio's picture, which enjoyed instant celebrity, inspired two madrigals written by Gaspare Murtola prior to 1603 on the subject of "l'Amore, pittura del Caravaggio" (G. Murtola, 1603; see M. Cinotti, 1971, p. 164, F 110 a, b); these madrigals do not appear in the 1601 edition of Murtola's *Rime* (M. Cinotti, 1983, p. 409). A Latin distich by Marzio Milesi (see M. Cinotti, 1971, p. 162, F 93), entitled "On Michelangelo da Caravaggio, Who Painted Love Subduing All" ("De Michaele Angelo da Caravaggio, qui Amorem omnia subigentem pinxit"), is undated but inserted among the epitaphs on the death of Caravaggio. It recalls the picture in words that evoke Vergil's line in the *Eclogues* (X, 69) "Love conquers all: let us, too, yield to love" ("Omnia vincit Amor: et nos cedamus amori"): "Love conquers all, and you, too, painter, conquer all; he indeed conquers souls, while you conquer souls and bodies" ("Omnia vincit amor, tu pictor, et omnia vincis, / Scilicet ille animos, corpora tuque animos").

The painting is described as follows in the inventory drawn up in 1638 after the death of Cardinal Giustiniani's brother, the Marchese Vincenzo Giustiniani, for whom it was painted: "A picture of a laughing Cupid who shows his contempt for the world, which lies at his feet in the guise of various instruments, crowns, scepters, and armor; known, because of its fame, as the Cupid of Caravaggio" ("Un quadro con un Amore ridente in atto di dispregiar il mondo, che tiene sotto con diversi stromenti, Corone, Scettri, et Armature, chiamato per fama il Cupido del Caravaggio": L. Salerno, 1960, p. 135, n. 9).

Baglione (1642, p. 137) calls it simply "a seated Cupid painted after life," and Scannelli (1657, p. 199) is no less brief. By contrast, Bellori (1672, p. 207) writes of "victorious Cupid who raises an arrow in his right hand while at his feet there lie arms, books, and other instruments as trophies." Silos (1673; 1979 ed., I, p. 91, no. 144) gives a similar interpretation in an epigram of which it is sufficient to quote the title: "Cupido Celebratissimus ridet, & coronas calcat, & arma. Eiusdem Caravaggi apud eundem Principem Justinianum" ("The most celebrated Cupid, [who] laughs and tramples underfoot crowns and arms: by Caravaggio, owned by Principe Giustiniani"). The enormous wings, which are not the white ones of the angel in the first version of the *Saint Matthew and the Angel* in the Contarelli Chapel (fig. 7, p. 37) but the dark wings of an eagle or a vulture, identify the youth as Cupid. So, too, do the arrows, one red-tipped and the other black: They are possibly, as Friedlaender (1955, p. 91) suggested, an allusion to the two wounds of love accepted and love rejected. Understandably, the picture has been interpreted in terms of eroticism and homosexuality on account of the figure's expression of laughter, his attitude of self-satisfaction, and his unwonted, impudent nudity (see C. L. Frommel, 1971 a, pp. 49 ff.; D. Posner, 1971 b, p. 314; H. Röttgen, 1974, pp. 197 f.). The affinity of Cupid with the angel in the first version of the *Saint Matthew* underscores the ambiguous relationship of the secular to the sacred in Caravaggio's works of this date. This ambiguity was certainly not lost on his contemporaries, who were well aware of the erotic allusions encountered in mystical literature: There is no figure more closely analogous to this triumphant Cupid than Bernini's smiling angel who directs his arrow toward Saint Teresa (M. Praz, 1977, p. 81).

The primary significance intended by Caravaggio was that of Vergil's verses quoted above, which had been diffused in literature and the figurative arts through Petrarch's *Triumphs* (C. L. Frommel, 1971 a, p. 48). Sandrart (1675; 1925 ed., pp. 276 f.), who saw the picture in Giustiniani's palace between 1629 and 1635, records that it was hung in a gallery so that it was the last picture a visitor would come upon, and that it was covered by a curtain, probably not only for reasons of decency and morality, but also to enhance the surprise aroused in the spectator by this provocative nude painted from life: "This work hung in a room near a hundred and twenty other paintings by the most famous artists . . . but at my suggestion it was covered with a dark green curtain and only after the other pictures had been seen was it shown, since it made all the other rarities seem insignificant."

Modern interpretations of the *Amor* are more complex than those cited above, and they are sometimes contradictory. It is generally assumed that the patron specified the elements to be represented, although Caravaggio was certainly responsible for the homoerotic slant. Friedlaender (1955, pp. 91 ff.), who first studied the picture's symbols in detail, found that they relate to man's highest endeavors, over which Love has triumphed. Music is represented by a lute, a violin, and a musical score; geometry, by a carpenter's square and compasses; astronomy, by the globe behind Cupid's right leg. In the center are shown a manuscript volume, a quill pen, and a wreath of laurel. To the right is some armor and, on the bed, a crown and scepter. The mocking, lascivious youth has the same iconographic function as a skull in a *vanitas*: He scorns these symbols of man's ambition and fame. The same symbols recur in an engraving (A. P. de Mirimonde, 1966–67, p. 319, fig. 1), which has been erroneously dated to the end of the fifteenth century but which actually dates from well into the seventeenth. De Mirimonde (1966–67, pp. 320 f.) sees the musical instruments and the armor as attributes of Venus and Mars —the goddess who generates and creates, on the one hand, and the god who kills and destroys, on the other. The blue globe, which, as a recent cleaning has shown, was not originally planned, may be the symbol of Love's power.

Enggass (1967, pp. 13 ff.) has examined the relationship of the theme of Love triumphant to Vincenzo Giustiniani's interests in architecture, music (symbolized by the instruments and the musical score, which is for mezzo-soprano: see M. Cinotti, 1983, p. 410), and the other arts. According to Teodoro Amayden (about 1640; 1914 ed., p. 455), Giustiniani's friend and the person for whom his essays were intended, the marchese was graced with "virtue and incomparable merit" (for Vincenzo Giustiniani and his brother Benedetto, see L. Salerno, 1960, pp. 21 ff.; H. Hibbard, 1971, p. 11, and *passim*; and Giustiniani's own *Discorso sulle arti e sui mestieri*, 1981 ed.). Even the armor relates to Giustiniani, whom Amayden refers to as a knight. The crown and the scepter, less prominently placed, are a reference to the dominion of the Giustiniani family over the island of Chios, which they had lost to the Turks in 1560. Thus, a second interpretation would explain the picture and the impudently triumphant pose of the winged boy in terms of a parallel: "omnia vincit Amor" and "omnia vincit Vincentius."

The concept of Earthly Love should not be confused with that of Sensual (or Bestial) Love. According to Neoplatonic thought—whose currency in aristocratic circles dates from the sixteenth century—the former was the source of inspiration for the arts and the virtues, while the latter, as Marsilio Ficino maintained, was a sort of madness. Calvesi (1966 b, p. 302, n. 1), commenting on the relationship between Earthly Love and Divine Love, saw in Caravaggio's picture the triumph of the former over the latter. Later (M. Calvesi, 1971, p. 108), he reversed the relationship, making Divine Love the victor. But this explanation is contradicted by the explicitly erotic content of the picture.

Numerous paintings testify to the influence of the *Amor.* There is a copy in the Musée des Beaux-Arts, Dijon, and another, signed by Andrea Vaccaro, in a private collection in Rome (M. Marini, 1974, p. 397); for other derivations see Mirimonde (1966–67, pp. 321 f.), Gregori (1972 b, pp. 49 f., 63, n. 66), Moir (1976, pp. 128 ff., n. 208), and Cinotti (1983, p. 409). Of the prototypes and models for Caravaggio's picture, the earliest in date is Michelangelo's sculpture group, the *Victory,* now in the Palazzo Vecchio, Florence. Friedlaender (1955, p. 91) saw the *Amor* as an intentional parody of Michelangelo's work. Others have emphasized the Cupid's relationship to homosexual images by Michelangelo such as his drawing of Ganymede for Tommaso de' Cavalieri (see K. Clark, 1966, pp. 17 f.) as well as to the Saint Bartholomew in the *Last Judgment* in the Sistine Chapel.

These references on Caravaggio's part may be explained by an interest in his namesake (H. Hibbard, 1983, pp. 157, 159) and his desire to react against the sublimated homosexuality of Michelangelo by unveiling the truth (S. J. Freedberg, 1983, p. 59). Wagner (1958, pp. 82, 201, n. 351) cited another precedent in Parmigianino's *Cupid Carving His Bow* (in the Kunsthistorisches Museum, Vienna), which Caravaggio has radically transformed by means of his own provocative, naturalistic vision. Calvesi (1966 b, p. 302, n. 1; 1971, pp. 93, 108, fig. 32) has cited Agostino Carracci's engraving of an old man and a courtesan, with the inscription "Ogni cosa vince l'oro" ("Gold conquers everything"), in which the pose of the female figure is similar to that of Caravaggio's Cupid.

As Wagner (1958, p. 81) and the present writer (M. Gregori, 1972, p. 38) have noted, Caravaggio's source for the representation of the musical instruments and other symbolic objects at the feet of Cupid was certainly Raphael's *Saint Cecilia* altarpiece (fig. 1), which, in his time, was still in its chapel in San Giovanni in Monte, Bologna. According to Vasari (1568; 1906 ed., VII, p. 551), the instruments in Raphael's altarpiece, carefully arranged on the ground and carrying symbolic, Neoplatonic connotations that Caravaggio and his patron would probably have been aware of, were painted by Giovanni da Udine (see A. Mossakowski, 1968; 1983 ed., pp. 61 f.).

Baglione (1642, p. 138) mentions that Caravaggio had earlier painted for Cardinal del Monte a picture of "Divine Love overpowering Profane Love," and this theme was taken up by Baglione himself. Marini (1974, pp. 100, 346 f., no. 10) has convincingly identified Caravaggio's invention in a copy, in a private collection, which has no relation to Baglione's later treatment of the theme: His hypothesis is supported by the

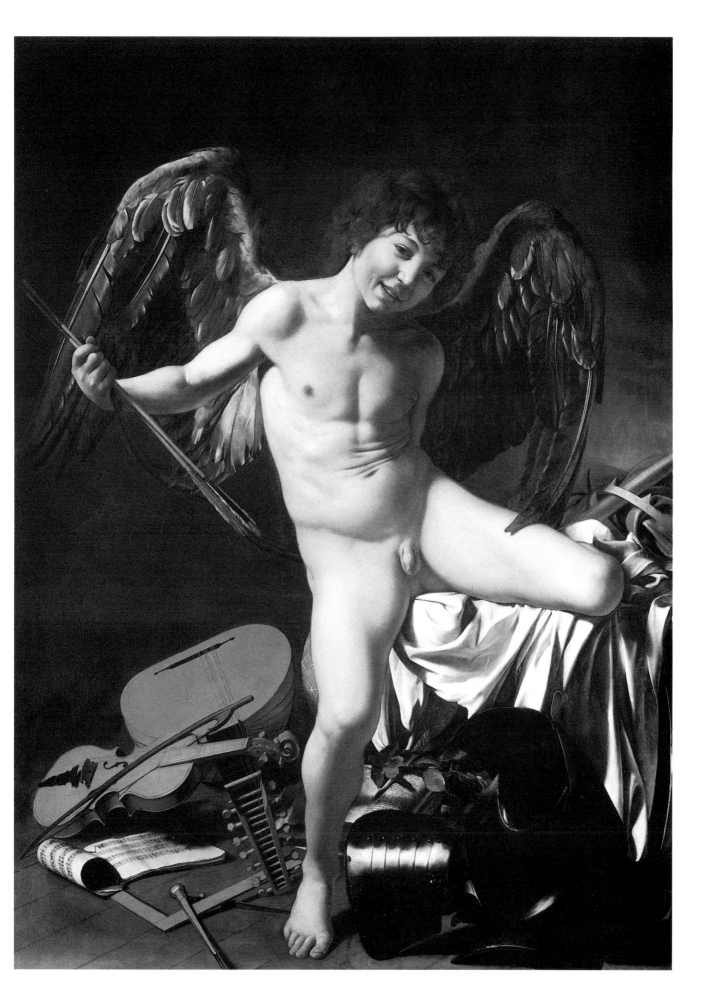

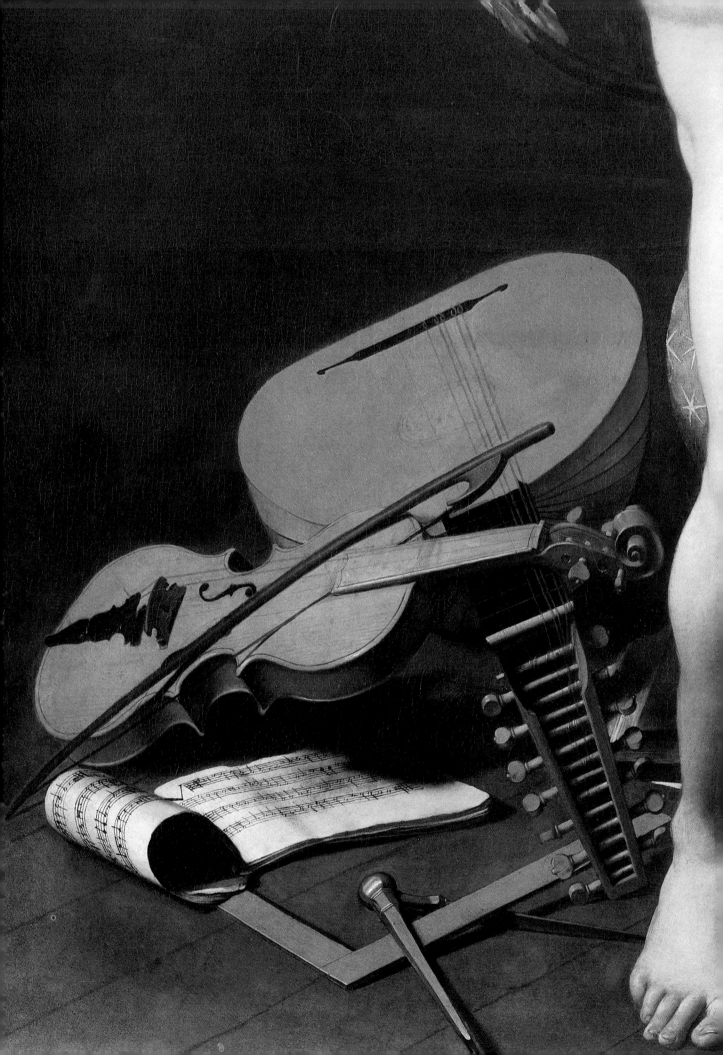

fact that the subject, like that of the *David* in the Prado (cat. no. 77), is interpreted as a narrative; by the possible derivation of the figure of Divine Love from a model that Caravaggio used later, the Hellenistic statue (in the Uffizi, Florence) of a Scythian slave sharpening his knife; by the typically Caravaggesque pose of the two figures; by the open-mouthed cry of the Divine Love; by the description of the patterned fabric of his costume, which recalls, in its precision, the doublet worn by the Corsini Narcissus (cat. no. 76); and by the rope looped around his hands so as to give greater force to his action, a detail that also occurs in the Prado *David*, the Cerasi Chapel *Crucifixion of Saint Peter* (fig. 8, p. 39), and the Prado *Crowning with Thorns* (cat. no. 81).

The dating of the *Amor Vincit Omnia*, between 1602 and 1603 (for various opinions, see M. Cinotti, 1983, p. 409), has always been based on Gentileschi's reference in his deposition of September 14, 1603, to the "Amor devino" that Baglione painted in competition with—and therefore not much later than—Caravaggio's "Amor terreno," as well as on the fact that about six to eight months earlier Gentileschi had lent Caravaggio a pair of wings. Gentileschi's story seems to refer to recent events, though the wings need not have been used for this picture—especially if Bissell's observations (for which, see below) are valid. It is, moreover, logical to assume that Murtola's madrigals were composed shortly after the picture was painted, even though they imply that it had already become famous. Some weight should also be given to Sandrart's report (1675; 1925 ed., p. 277) that Caravaggio's success, apparently as a result of the *Amor*, played a part in his liberation from prison. Sandrart was very likely referring to Baglione's libel suit; Caravaggio was released on September 25, 1603, the French envoy having intervened and provided surety (A. Bertolotti, 1881, I, p. 64; M. Cinotti, 1971, p. 156, F 55). Gentileschi states in his deposition that Baglione exhibited his "Amor devino" at San Giovanni dei Fiorentini, opposite a painting of Gentileschi's showing the Archangel Michael. Bissell (1974, pp. 116 ff.) has pointed out that the occasion referred to was the annual exhibition held in the courtyard of San Giovanni Decollato (not San Giovanni dei

Fiorentini), in this instance on August 29, 1602; Caravaggio's *Amor* should thus date to mid-1602; Bissell's arguments for dating it before 1602 are not convincing.

Stylistic evidence supports the same dating. Although Caravaggio's work has not been sufficiently subjected to morphological-stylistic analysis, the application of this method to the *Amor* reveals a sculptural structure in the strongly illuminated folds of the sheet on which Cupid sits; the drapery to the right falls like a lance in simple vertical folds. This type of drapery is directly inspired by ancient art, and it represents a novelty in Caravaggio's evolution; this fact contributes to the establishment of a fairly precise order for the pictures that he painted in the first years of the seventeenth century. The Capitoline *Saint John the Baptist* (fig. 1, cat. no. 85), which is frequently—and correctly—associated with the *Amor Vincit Omnia* (F. Scannelli, 1657, p. 199, was the first to do so), belongs to the Cerasi Chapel phase so far as the conception of the drapery is concerned. In the first version of the *Conversion of Saint Paul* (fig. 10, p. 41), as well as in the two paintings that were eventually installed in the chapel (figs. 8, 9, pp. 39, 40), the folds of the drapery, with their slow rhythms, create elegant repeating curves on the ground. Even in the first version of the *Saint Matthew and the Angel* (fig. 7, p. 37) there are vestiges of this undulating, convoluted type of drapery. In the second version (fig. 6, p. 36), however, Caravaggio adopts the long sculptural folds of the *Amor*. It was this version of the *Saint Matthew* that inspired Francesco Mochi's marble *Virgin Annunciate* for the cathedral of Orvieto: The sculptor even adopted the motif of the unstable *sgabello*, or stool, which nicely translates the surprise of the protagonist at the appearance of the angel. The *Sacrifice of Isaac* (cat. no. 80), which can be associated with payments made in 1603, is related in a number of ways to the second *Saint Matthew*. In it, too, the treatment of the drapery adheres fully to the new formula. All of these considerations support a dating of the *Amor Vincit Omnia* to 1602–3.

The picture remained in the Giustiniani collection until 1812, when it was sent to Paris along with a large number of other paintings from the collection, which was

purchased by a painter, the Chevalier Féréol Bonnemaison, exhibited, illustrated in the two volumes of Landon (1812; the engraving of the *Amor*, by Mme. Soyer, appears in vol. I, p. 33, pl. 43), and acquired *en bloc* in 1815 by the king of Prussia for the Berlin museum (L. Salerno, 1960, p. 26). The picture is in good condition—even the gold of the crown and of the stars on the globe is intact. Brushstrokes of the same color as the background follow the contours around the figure and the objects: This procedure is typical of Caravaggio. Some pentimenti have been revealed by X-rays and by the cleaning carried out in 1984: The most important are in the drapery at the right, in the pen (the position of which was changed), and in the stone bench on which Cupid's leg rests. Originally, Caravaggio showed the bench extended to the left of Cupid, but he then painted this part out; all that is visible today is a horizontal strip somewhat lighter than the background (E. Schleier, 1978, p. 91). Further down there is a division between a gray-blue zone below and a brown zone above: Whether this was intentional is not clear. The division was apparently more evident in 1812, since the engraving shows it demarcated by a line. There are also incision-like impressions on the surface; some of them seem to have been intentional, such as those that mark a different position for Cupid's left wing, the line along the principal axis of the lute, and the two shorter lines made at the scroll of the violin, apparently to determine its foreshortening (I wish to thank Erich Schleier and Keith Christiansen for communicating these observations).

M. G.

80. The Sacrifice of Isaac

Oil on canvas, 41 x 53 1/8 in.
(104 x 135 cm.)
Galleria degli Uffizi, Florence

The subject is taken from the book of Genesis (13:10–13), which tells how God, in order to test Abraham's obedience, commanded him to sacrifice his son. Abraham is shown at the moment when, about to carry out the order, he is stopped by an angel. He presses Isaac's head against a rock that serves as an altar while immediately above, in poignant contrast, there appears the head of a ram, miraculously sent to take Isaac's place. Caravaggio used the ram rather than the traditional lamb as a symbol of Christ's sacrifice again, in his two paintings of Saint John the Baptist in the wilderness (in the Pinacoteca Capitolina, fig. 1, cat. no. 85; and in the Galleria Borghese). The picture is described by Bellori (1672, p. 208) as follows: "In addition to a portrait, [Caravaggio] painted for Cardinal Maffeo Barberini, later Pope Urban VIII, the sacrifice of Abraham, with Abraham holding his knife against the throat of his son, who cries out and falls" ("Al Cardinale Maffeo Barberini, che fu poi Urbano VIII, Sommo Pontefice, oltre il ritratto, fece il sacrificio di Abramo, il quale tiene il ferro presso la gola del figliuolo che grida e cade"). Instead of calling from the heavens, as in the biblical text, the angel is next to Abraham, seemingly admonishing him with one hand, while with the other he vigorously grasps the patriarch's arm in a gesture similar to that of the executioner in the *Martyrdom of Saint Matthew* in the Contarelli Chapel (see fig. 5, p. 35). More than surprise, Abraham's face seems to register incomprehension, even diffidence (H. Wagner, 1958, p. 48). The relationship between Abraham and the angel is described in human rather than supernatural terms, like the analogous relationship of Saint Matthew and the Angel in Caravaggio's first *Saint Matthew and the Angel*, a picture for which there were precedents in Lombard and in Northern painting.

The *Sacrifice of Isaac* was long thought to date from Caravaggio's youth or early maturity, and its unprecedented iconography and the realistic presentation of the theme were seen as paradigms of the artist's novel approach to subject matter. Abandoning Cinquecento models (H. Wagner, 1958, p. 188, n. 201), Caravaggio arrived at a conception of the divine more akin to that found in Northern painting. As in the *Judith and Holofernes* (cat. no. 74), he has chosen to illustrate the most brutal moment in the story. Rather than allude to events leading up to that moment or its aftermath, he focuses the viewer's attention on the action itself (R. Longhi, 1951 c, pp. 10 ff.). Bellori understood quite well the tragic essence of the scene—"a tragedy without a framework, without a logical development, without catharsis" (G. C. Argan, 1956, p. 31). Caravaggio has chosen a horizontal format with three-quarter-length figures in order to center attention on the protagonists. The same format was employed in the *Judith and Holofernes* as well as in such pictures from the early years of the seventeenth century, with Christological subjects, as the *Incredulity of Saint Thomas* in Potsdam, the *Supper at Emmaus* (cat. no. 78), and the *Taking of Christ* (known through copies). The action develops in a chain-like sequence parallel to the picture plane, a favored scheme of Caravaggio's that obviated complex, preparatory designs. Yet, the continuous, rhythmic line created by the juxtaposition of the angel's right arm with Isaac's body (M. Marangoni, 1922 a, p. 793) reveals just how much Caravaggio was concerned with composition. In this case the motif may have been inspired by Correggio (a similar effect is already present in Caravaggio's *Martyrdom of Saint Matthew*, where the pattern of the angel's right arm and palm is echoed by the raised arm of the prostrate saint).

The "affetti," or expressions, are not those of a standardized repertory adapted to suit the story. Rather, their realistic character is the result of an experimental, Leonardesque intention (see cat. no. 74) that may seem at odds with the religious nature of the event (H. Röttgen, 1969; 1974 ed., p. 121, no. 80). This seems, in any case, to have been the opinion of contemporaries, to judge from a letter of 1603 in which Cardinal Ottavio Paravicino refers to Caravaggio as the author of pictures "halfway between sacred and profane" (M. Cinotti, 1971, p. 153, F 45; the letter is exactly contemporary with the *Isaac*: see below).

A privileged place is given to the landscape, which, far from serving as a backdrop for the main scene, underscores Caravaggio's lifelike interpretation of the event. This tranquil landscape, broadly painted "alla veneta" and redolent with Giorgionesque echoes (for R. Longhi, 1928–29; 1968 ed., p. 120, it recalled Savoldo; for B. Berenson, 1951, p. 25, Palma Vecchio), has no proper perspectival relationship to the foreground. However, the two indistinct figures, Carraccesque in type, in the light area above the ram's head are probably intended to represent the servants whom Abraham left at the foot of the mountain (A. Moir, 1982, p. 116). There is nothing in this landscape —neither the meteorological occurrences, the rustic houses along the path, nor the city with its church and tower—that Caravaggio could not have seen in the countryside surrounding Rome. Whereas in the first version of the *Conversion of Saint Paul* in the Odescalchi collection (which is not a youthful work but one that dates three years before the *Sacrifice of Isaac*) we can see unimpeded as far as the distant horizon, streaked with clouds and animated by the setting sun, here the mountains close off the view and the brilliant light measures the distance. In its morphology this landscape does not seem closely related to sixteenth-century North Italian traditions; it is possible, given the probable date of the *Sacrifice of Isaac*, that it stems from Caravaggio's recognition of Annibale Carracci's important contribution to landscape painting in these years (see C. Brandi, 1972–73, pp. 34 ff., who, however, based his notion on the supposed contemporaneity of the *Sacrifice of Isaac* and Carracci's lunettes in the Galleria Doria-Pamphili, which are datable to 1605 but which may have been commissioned in 1603, and also M. Marini, 1974, p. 401). Nonetheless, it should be emphasized that Caravaggio has conceived his landscape not as a historical setting but as a humble, everyday view, which has no precise models.

According to Saint Paul and to Saint Augustine, the sacrifice, of Isaac prefigures Christ's sacrifice, while Abraham symbolizes obedience and faith; the picture has been interpreted in terms of the theme of Christ's grace by Calvesi (1971 b, pp. 132 f.), who points out that allusions of this sort

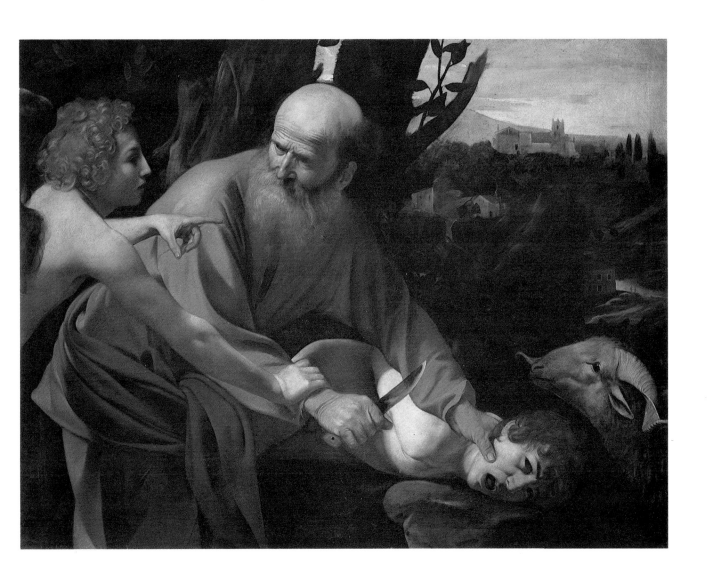

recall elements of contemporary spirituality that are paralleled in Federigo Borromeo's *De pictura sacra.* Argan's comment (1974, p. 22) that here, just as in the *Rest on the Flight into Egypt* and in the two versions of the *Saint Matthew and the Angel*, a youth in the guise of an angel instructs an old man, also seems pertinent. Marini's suggestion (1974, p. 400), on the other hand, that elements in the picture refer to the virtues and to heraldic devices of the Barberini, is not convincing.

Marangoni (1922 a, p. 794), approaching the picture from a completely different point of view, called attention to the "hedonistic" features of the angel, whose profile resembles that of his counterpart in the second altarpiece for the Contarelli Chapel. The model for this figure has been identified (see M. Cinotti, 1983, p. 430) with the aggressive-looking youth—so different from the pretty boys of Caravaggio's early work—of the Capitoline *Saint John the Baptist* and the Berlin *Amor Vincit Omnia* (cat. no. 79). According to this hypothesis he could be the "vago Giulietto" praised in a madrigal by the poet Gaspare Murtola in 1603 (see M. Cinotti, 1971, p. 164, F 110), or else Caravaggio's and Gentileschi's "bardassa" (the term, which can signify either a prostitute or simply a youth, in this case means servant: see M. Cinotti, 1983, p. 242), Giovanni Battista, who is cited by Tommaso (Mao) Salini in a deposition of August 28, 1603, in conjunction with Baglione's libel suit (the youth evidently distributed some of the defaming poems for which Caravaggio was sued).

That the theme of the sacrifice of Isaac responded to a new interest in Augustinian texts—Calvesi (1971, p. 132) has noted that a chapter of the *De civitate Dei* is entitled "The Obedience and Faith of Abraham"—is suggested by the critical fortune of the picture in the early Seicento. Three copies have been reported: One is in a private collection in Florence (M. Marini, 1974, p. 401), and there are possibly two in London—one, which differs in some details from the Uffizi version, seen in 1971 by Moir (1976, p. 86, n. 15), and another, perhaps identical to the picture in the A. Rosenthal collection; a photograph of this last picture, in the Witt Library, was mentioned by Marini (1978, p. 77, n. 11). Lon-

ghi (1951 a, pp. 18 f.; 1951 d, pp. 25 f.; 1952, p. 31), moreover, plausibly argued from the existence of copies (see fig. 1) that there was another version of the theme by Caravaggio (this hypothesis had been advanced by J. Ainaud de Lasarte, 1947, pp. 383 ff., and has been accepted by M. Marini, 1974, pp. 122, 366 f., and B. Nicolson, 1979, pp. 31, 37). The Barberini *Sacrifice of Isaac* is generally considered to be contemporary with the *Incredulity of Saint Thomas* in Potsdam and with a lost *Calling of Saints Peter and Andrew*, known through a damaged copy (see R. Longhi, 1943 a, p. 12, fig. 15); these, too, are compositions in which figures are represented in the midst of uncompleted actions ("figure passanti": R. Longhi, 1952, p. 31). If this dating is correct, the lost version would be somewhat earlier. Marini (1974, p. 122) dates it close in time to the *Saint Catherine* and the *Conversion of the Magdalen* (cat. nos. 72, 73); he identifies as the original a picture cited, with a high valuation, in an early-eighteenth-century inventory of the dowry brought to Don José Fuentebuena by Antonia Cecilia Fernandez de Hijar. There are a number of derivations or free variants of one or the other picture dating from the first two decades of the seventeenth century. One, in the Rapp collection, Stockholm (A. Moir, 1976, p. 125, no. 187, n. 15 v.), is based on both versions (Isaac is shown with his torso raised, as in the earlier example). The author of the Rapp picture is the Lombard painter Giuseppe Vermiglio, who painted the Sacrifice of Isaac several times; his work may be an indication of the popularity of the subject in Lombardy (the present writer is preparing a study on these paintings by Vermiglio).

The *Sacrifice of Isaac* was given to the Uffizi in 1917 by John Fairfax Murray as a work by Caravaggio. When Marangoni first published it (1922 a, 793 f.; 1922 b, pp. 26 f.), he associated it with the passage in Bellori but was uncertain as to whether it was a copy or the original (he later inclined to the belief that it was a copy). Both Voss (1924, p. 38) and Longhi (1928–29; 1968 ed., p. 120) accepted it as an early work by Caravaggio, while Mahon (1952 a, p. 19) dated it after the first version of the *Saint Matthew and the Angel*, during the artist's early maturity, at the very end of the sixteenth century.

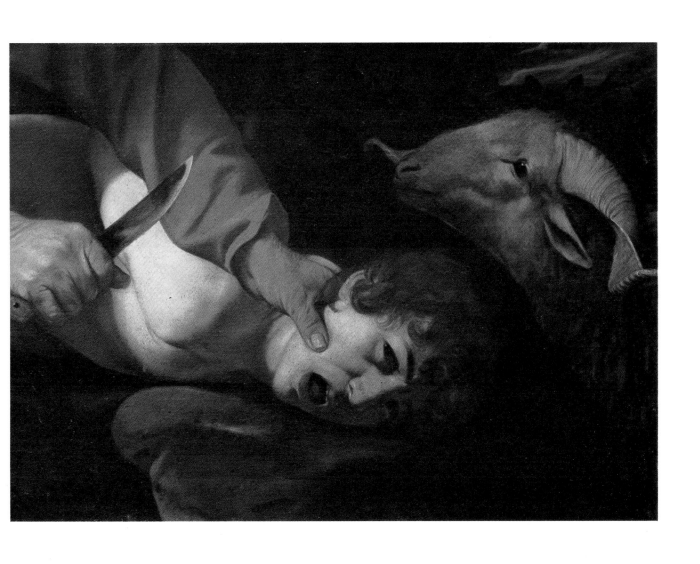

The reservations expressed by Marangoni (1922 a, p. 794) were prompted primarily by the "stylistic anachronism of the various sources" for the picture—for example, the head of Isaac is related to such youthful works as the *Medusa*; the hedonistic appearance of the angel recalls the *Saint John the Baptist* (the original of which was then thought to be the Doria, not the Capitoline, version); the figure of Abraham has parallels in the two lateral canvases in the Contarelli Chapel as well as in the second version of the *Saint Matthew and the Angel* (see figs. 4, 5, 6, pp. 34 ff.)—and were echoed, until quite recently, by other scholars (L. Schudt, 1942, p. 54; F. Baumgart, 1955, p. 97; W. Friedlaender, 1955, p. 160, who argued that it was a pastiche; M. Cinotti, 1971, p. 126). However, the dating of the work to 1603, in the light of recently discovered documents, clarifies these apparent anachronisms. Lavin (1967, p. 473) and D'Onofrio (1967, pp. 60 f., 429, n. 128) have associated the *Sacrifice of Isaac* with a picture of an unspecified subject for which Monsignor Maffeo Barberini—he became a cardinal only in 1608—made payments to Caravaggio on May 20, 1603 (25 *scudi*: possibly, but not necessarily, the first payment), on June 6 of the same year (10 *scudi*), on July 12 (10 *scudi*), and on January 8, 1604 (50 *scudi*). The interruption between July 1603 and January 1604 was due to Baglione's libel suit; Caravaggio was arrested on September 2 and released on September 25 through the offices of the French ambassador (in 1610 the same ambassador asked Cardinal Barberini to have a copy made of the *Sacrifice of Isaac*: see C. D'Onofrio, 1967, p. 61; this notice sheds some light on the problem of contemporary copies). He then went to Tolentino in the Marches to paint the altarpiece (which was either lost or never executed) for the high altar of the Capuchin church of Santa Maria di Costantinopoli (in a letter of January 2, 1604, Lancellotto Maurizi, a citizen of Tolentino then residing in Rome, mentions the work and speaks of Caravaggio as the "best painter at present in Rome": G. Benadduci, 1888, p. 7; R. Longhi, 1913, pp. 163 f., n. 2; M. Cinotti, 1971, p. 157, F 57). The *Sacrifice of Isaac* is mentioned in a number of Barberini inventories (see M. Lavin, 1975, p. 64, no. 3, p. 69, no. 126, p.

386, no. 587, p. 403, no. 203), confirming the information provided by Bellori. In the inventory of December 7, 1608, of the furnishings of Marchese Salviati's house, where Cardinal Barberini—then Archbishop of Spoleto—lived when he was in Rome, the picture is listed (with no indication of an author) under no. 3: "a painting showing Abraham, with a black frame." In the 1623 inventory, known as the Seconda Donazione, undertaken when Maffeo Barberini was elected pope, it is listed under no. 126: "The Sacrifice of Isaac, with a black frame." In an inventory made after 1672 for Prince Maffeo Barberini it is described, this time in a gold frame, as a work by Caravaggio, with dimensions matching those of the Uffizi picture, under no. 587: "a horizontal painting with the Sacrifice of Abraham and Isaac, 5 1/2 *palmi* long, about 4 1/2 *palmi* high." The same information, but with the height given as 4 *palmi*, is registered in Maffeo Barberini's 1686 inventory under no. 203. According to Fairfax Murray, the picture belonged to the Sciarra di Colonna family; it was probably obtained by them from the Barberini in 1812, when they also acquired the *Cardsharps* (see M. Cinotti, 1983, p. 555). The later date now given to the *Sacrifice of Isaac* conforms to a general shift in Caravaggio's chronology, and it casts light on his intense, often complex activity between 1599 and 1603. What we now know of Caravaggio's activity in the first years of the seventeenth century supports the identification of the *Isaac* with the 1603–4 payments, although reservations have been expressed (A. Moir, 1976, p. 125, n. 187; M. Cinotti, 1983, p. 430). In the first version of the *Conversion of Saint Paul* for the Cerasi Chapel in Santa Maria del Popolo and in the first version of the *Saint Matthew and the Angel* (probably datable after the lateral canvases for San Luigi dei Francesi: see p. 39), we find the transparent luminosity that scholars, until recently, considered characteristic only of Caravaggio's earlier work; indeed, Bellori (1672, p. 203) suggests that in his mature paintings Caravaggio abandoned this brightness, "reinforcing the darks." So much does the Abraham in the *Sacrifice of Isaac* resemble the Saint Matthew in the second altarpiece for the Contarelli Chapel that it seems that the same

model was used for each; Moir (1982, p. 116) also compares him to one of the apostles in the *Incredulity of Saint Thomas*. At this time in his career it would appear that Caravaggio fixed upon a standard type for the apostles in his biblical paintings, conferring on them a gravity and an air of human dignity that complement their rustic physiognomies. He seems not only to have been aware of prototypes in the work of Ludovico and Annibale Carracci but to have returned to the examples of Moretto and of Savoldo.

The impetuous, twisting pose of Abraham is more accomplished than that of his counterparts in the *Incredulity of Saint Thomas*; in this, he prefigures the Nicodemus in the Vatican *Entombment*. Similarly, the drapery of his knotted cloak, whose long, clearly constructed folds fall with a measured, classical rhythm, reflects a new, grander conception that is also found in the second *Saint Matthew*, and which marks Caravaggio's final Roman period of 1603–6. The same, later, date is suggested by the painterly treatment of Abraham's aged, peasant's hands and the painterly, somewhat schematic description of his furrowed brow.

The picture was cleaned in 1954. As in many of Caravaggio's paintings, lines have been incised with a stylus or with the end of the brush; here, they delineate the details of Isaac's face, the basic contours of the figure of Abraham (his left arm, but not his drapery, is indicated), and the elbow, the back of the head, and the chin of the angel. There are light impressions along the sides of the altar as well as along the contour of Abraham's right arm, where they continue into his hand and then disappear. These shallow impressions were probably incised into the ground and then covered by the paint surface, which would explain why only some have reappeared with the passage of time (K. Christiansen, verbal opinion). This is but one of the technical features that support the attribution of the *Isaac* to Caravaggio. Another is the fact that Abraham's knife was painted over the nude Isaac—just as the sword in the *Judith and Holofernes* was painted over the sheets: A copyist would not have done this. The illusionistic relief of the right arm and hand of the angel is achieved by means of their subtle, variable dark contours—perhaps formed by

the ground, left exposed, or a color similar to the ground; there are precedents for this feature in Bergamask and Brescian painting (M. Gregori, 1982 b, p. 23). The patriarch's robe is lighter in color where it adjoins the angel's left hand: This could be the result of a pentimento (M. Marini, 1974, p. 40; X-rays, however, would be necessary to verify this assertion), or, more likely, it could indicate that Caravaggio reinforced the contours to better define them. The latter practice is common both in his paintings (see the *Bacchus*, cat. no. 71) and in the work of Lombard painters. That the paint surface is not thick and the forms are not densely painted can be attributed to the circumstances that accompanied the picture's execution (the libel suit and Caravaggio's trip to the Marches), as well as to the necessity of finishing it rapidly.

M. G.

81. The Crowning with Thorns

Oil on canvas, 70 1/8 x 49 1/4 in.
(178 x 125 cm.)
Cassa di Risparmio e Depositi, Prato

The two most famous treatments of this theme are Titian's paintings in the Alte Pinakothek, Munich, and in the Louvre. The Louvre picture was painted for Santa Maria delle Grazie, Milan, and must have been familiar to Caravaggio. Rubens's picture for Santa Croce in Gerusalemme, Rome (now in the Hôpital du Petit-Paris, Grasse), is datable to 1601–2. In the present picture attention focuses on Christ, who occupies a prominent place in the foreground, but whereas in the pictures mentioned above the action of the torturers is generic, here each is assigned a specific role. The figure in armor, evidently the leader, sets the crown of thorns in place upon Christ's head with the aid of a stick while with his other hand he grasps a shock of reddish hair; the latter motif recurs in the Naples *Flagellation* (cat. no. 93). Another torturer holds Christ firmly by the left arm and ribs, while the third torturer, crouching at the lower left, has just finished binding Christ's hands and holds the rope tightly. The taut arm may echo an idea in the Cavaliere d'Arpino's *Ecce Homo* in the sacristy of San Carlo ai Catinari, Rome. (H. Röttgen, 1973, pp. 101 f., dates Arpino's picture to about 1598. Another autograph version is currently on the market.) The motif of derision, frequently encountered in representations of this subject, is absent here; it would have conflicted with the stoic, focused effect that Caravaggio sought to achieve by contrasting the resignation and suffering of Christ with the brutality and physical violence of the torturers. The scene, reduced to essentials and described with an almost maniacal exactitude, is extremely moving; the moral effect is similar to that of the Cerasi Chapel *Crucifixion of Saint Peter*, which Caravaggio had probably already completed. Indeed, the physiognomy of the chief torturer recalls that of the man raising the cross in the Cerasi Chapel picture. In the earliest three-quarter-length compositions of scenes from the life of Christ that he painted for private collectors, Caravaggio employed a horizontal format, as in the *Incredulity of Saint Thomas* in Potsdam, the *Taking of Christ* (a copy is in the State Museum, Odessa) and the *Supper at Emmaus* (cat. no. 78). Only slightly later does he seem to have adopted the vertical format employed here and, later, in the *Ecce Homo* (cat. no. 86). Bearing in mind Caravaggio's normal working habits, it seems probable that this new format was an outgrowth of his vertical compositions in the Cerasi Chapel. The stylistically related Cerasi Chapel compositions share with the Prato picture a calm arising from the analogous use of a tightly closed group of figures; this device reached its climactic formulation in the supremely orchestrated ceremony of the Vatican *Entombment* (see fig. 11, p. 42), painted for the Chiesa Nuova between the close of 1601 and 1604. The Prato picture fits naturally into this evolution, and it marks yet another aspect of Caravaggio's tragic style. Since tragedy resides in the actual occurrence of an event, Caravaggio opposes ideal types and an exciting alternation of tone with an emotive resonance culled from reality. Like Shakespeare, he shows that event in all its fatal logic.

The body of Christ is clearly derived from the *Belvedere Torso* in the Vatican, which was believed to represent the ancient hero Hercules. A similar interest in antiquity is manifest in the *Entombment*, where the naturalistic details are the basis of a composition that resembles an ancient bas-relief. Curious and highly cultured, Caravaggio has in this painting provided his own interpretation of antiquity, stimulated by the presence in Rome of Annibale Carracci and Rubens. Such an interpretation necessarily entailed an ethic dimension, and Caravaggio found one in the grave Stoic conception of grief and human suffering. This he translated into his own lifelike vision.

Judging from its conception and style the *Crowning with Thorns* dates from 1602 or 1603. With the figure of the torturer to the left there appears, for the first time in Caravaggio's work, the motif of a hand pressing into Christ's flesh. This motif recurs in the *Entombment*, where Saint John's hand supports Christ's body, and, in a more tender form, in the *Madonna di Loreto*, in the gesture of the Virgin who holds her son while she shows him to the two pilgrims; it is

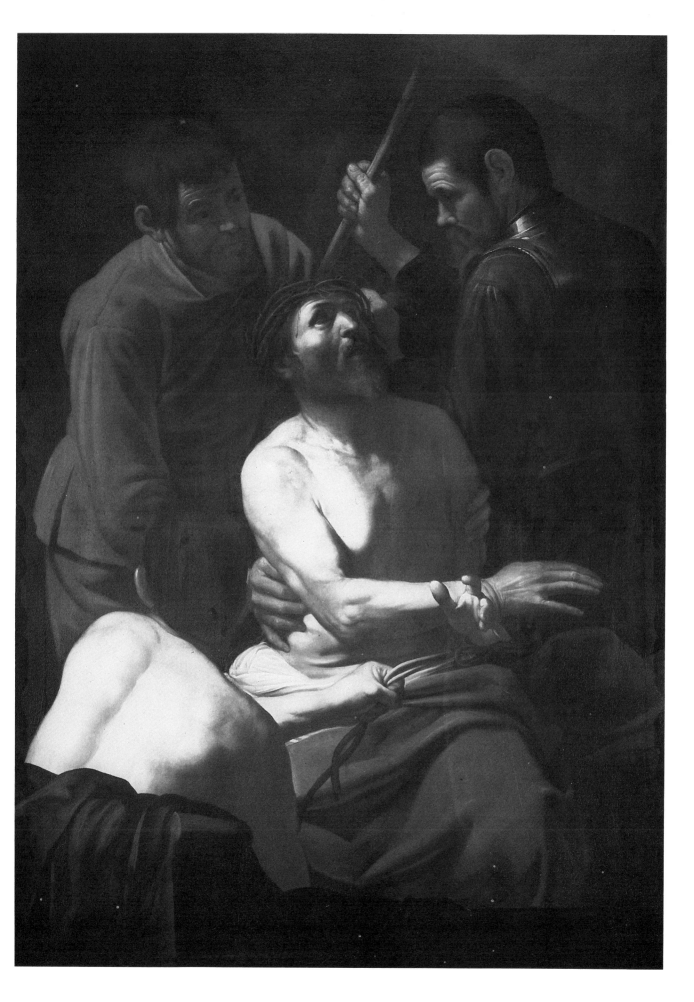

289

arguably related to current theological ideas concerning Christ's incarnation.

There are no documents that can be associated with the picture. It was purchased in 1916 by Angelo Cecconi, who was one of the earliest collectors of Seicento painting in this century and who was also well known as a writer, under the pseudonym Thomas Neal; at that time, Longhi recognized it as Caravaggio's invention, although he believed it to be a copy (see R. Longhi, 1928–29; 1968 ed., p. 93; 1943, p. 6). It was discussed by Marangoni (1922 b, pp. 51 f.), who erroneously thought it might be a copy of the painting of the same subject that Bellori (1672, p. 207) says was executed for Vincenzo Giustiniani; that work was later shown to have had a horizontal format (see cat. no. 90). In 1951, the picture was included in the "Mostra del Caravaggio e dei Caravaggeschi" in Milan as "attributed to Caravaggio" (probably at the request of the owner, who believed it to be an original), but with the qualification in the catalogue that it was derived from a work by Caravaggio and was datable to about 1598 (R. Longhi, 1951 a, p. 38, no. 49). Longhi's opinion that it is a copy was accepted by Mahon (1951 a, p. 234), who believed the lost original might be a late work; by Hinks (1953, p. 119), who related it hypothetically to the four stories of the Passion that Caravaggio is known to have been painting in Messina in 1609 for Nicolao di Giacomo; by Ottino della Chiesa (1967, p. 107) and Kitson (1967, p. 109), who also gave the lost original a late date; and by Jullian (1961, p. 96) and Marini (1974, pp. 392 f.), who followed Longhi's dating—contemporary with the lateral canvases in San Luigi dei Francesi. Another group of scholars rejected the picture's direct relationship to Caravaggio (L. Venturi, 1951, p. 41; W. Friedlaender, 1954, p. 150, n. 66; F. Baumgart, 1955, p. 116). It should, however, be recalled that for many years all trace of the picture was lost, and that the two reproductions published by Longhi (1943 a, pl. 21; 1951 a, p. 49) showed two quite different-looking images, raising further doubts. On the basis of these reproductions it was possible to argue that the painting had been restored and considerably repainted on at least two occasions, most recently prior to the 1951 Milan exhibition. It is also possible that the repro-ductions were touched up. A new restoration, undertaken by the owners in 1974 on the advice of the present writer and the restorer, Thomas Schneider, was motivated by the high quality evident in passages such as the arm of Christ. Cleaning revealed that the picture had been extensively repainted—perhaps with the intention of modifying its essential character, which may have been considered too realistic—and that damages are limited to unimportant areas. The head of Christ is in excellent condition, and both the quality and the technique employed are consonant with Caravaggio's autograph works. Following the cleaning an attribution to Caravaggio was accepted by Denis Mahon, Benedict Nicolson, and Pierre Rosenberg. The picture has since been accepted by Marini (1978, pp. 15, 17 ff., 34, nn. 32–37, p. 45, n. 44; 1979, p. 34, 1980, p. 38); by Nicolson (1979, p. 32); apparently by Bardon (1978, p. 119); by Cinotti (1983, pp. 491 ff.); by Spear (1984, p. 165), who, however, considers it "uninspired"; and, with reservations, by Hibbard, (1983, pp. 291 ff.). Moir (1976, p. 147) rejected the work, disputing Longhi's hypothesis that Caravaggio ever painted a *Crowning with Thorns* with a vertical format; he makes no mention of the picture in his recent monograph (A. Moir, 1982). Borea (in G.P. Bellori, 1672; 1976 ed., p. 222, n. 3) considers the attribution to Caravaggio disputable.

The restoration also sheds light on the history of the picture's execution, furnishing information of a sort that is rare where Caravaggio's paintings are concerned. The background, now freed of old repaint, is composed of three areas illuminated with varying intensity. The construction of Christ's head does not differ significantly from that of the head of Saint John the Baptist in the Capitoline canvas or that of Amor in the *Amor Vincit Omnia* (cat. no. 79). The flesh is densely painted. The cheek and eye are shown swollen, though without disfiguring the face. The coloristically varied crown of thorns and the reddish beard are painted with an extremely fine, subtle brushwork. The light striking the furrowed brow of Christ forecasts a similar detail in the late *Magdalen* (cat. no. 89). In Christ's torso and arm the realistic quality of the flesh is achieved through a variation of color, even in the densely painted areas, while the use of a contour line the same color as the preparation helps create an effect of volume and relief. The folds of the stomach are defined by a stronger shadow than is found in comparable passages in the two later canvases of Saint Jerome, in Montserrat (cat. no. 84) and in Malta. The portion of Christ's chest that is deepest in shadow has a completely flat appearance—the same is true of the arm of the crouching torturer—but a reflected light on Christ's breast is sufficient to suggest the modeling: This technique, already noted in the *Conversion of the Magdalen* (cat. no. 73), has its origin in the work of Tintoretto. Through cleaning, the drapery regained a characteristic brick-red color. Its surface, enhanced by beautiful effects of light, is broken by luminous folds.

The focused light and the actual density of execution set in relief the figure of Christ and the back of the crouching figure in the foreground. In other areas, form and light are described in a rapid, more summary fashion: Note especially the hands of the figure at the right, seemingly painted, without drawing, in an additive manner; the foreshortened hand of Christ, a hieroglyph of flesh and light; and that of the torturer holding the rope; and the rope itself, which is described with the long, concise brushstrokes characteristic of Caravaggio. A number of important pentimenti were discovered in the course of restoration (see T. Schneider, 1976, pp. 679 f.). Some were corrections made "alla prima," when the paint was still wet, such as the reduction in size of the fingers of Christ's right hand and of the earlobe of the torturer at the upper left (which is not sufficiently foreshortened—a common feature with Caravaggio), and the change in the position of the ear of the man at right. Other adjustments, such as the reduction in size of Christ's shoulder and arm, were made after the paint had dried. Most significantly, it was revealed that initially the back of the figure in the foreground and the red robe of Christ continued to within three or four inches of the lower edge of the canvas; before the picture was consigned Caravaggio would seem to have added the balustrade and the mantle that is draped over it (cross sections of the surface have revealed no signs of

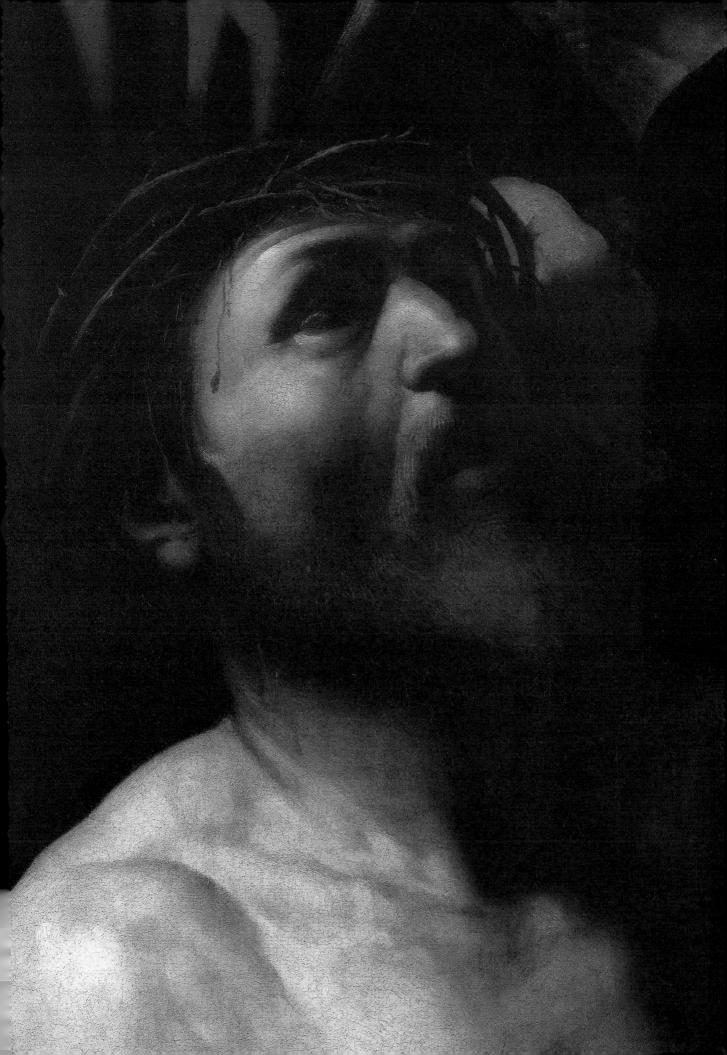

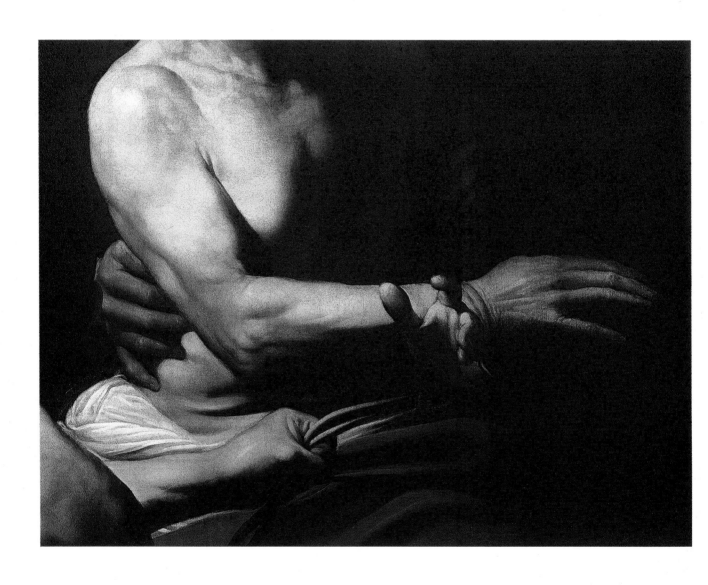

varnish or dust between the layers of pigment such as might indicate that the balustrade and mantle were added later). This change was probably made to reduce the prominence of the brilliantly lit back of the torturer and to focus attention on the illuminated body of Christ—or perhaps the patron requested Caravaggio to make the change for reasons of "decorum."

The apparent speed with which the picture was painted—the execution seems almost violent in some areas—as well as the character of the pentimenti weigh against Marini's theory (1978, pp. 17 f.) that the picture was carried out gradually over a two-year period, between 1600 and 1602. There were, rather, two distinct phases of execution. Although the Prato canvas has not been cut down, its composition is enlarged in a copy, of poor quality, in the sacristy of San Bartolomeo della Certosa, Rivarolo, on the outskirts of Genoa. The anonymous painter was certainly a Genoese, active in the second quarter of the seventeenth century. In the copy the back of the man at the lower left is shown as far as his waist, and he wears rustic trousers. (A similar figure appears in Giovanni Battista Carlone's fresco, the *Disembarkation of the Ashes of the Baptist*, in the Palazzo Reale, Genoa, as well as in the *bozzetto* for the fresco in the Groppallo collection.) Another copy, in a private collection in Bologna, called to my attention by Dr. Eugenio Busmanti, is nearer in size to the original, but its author was plainly incapable of dealing with the difficulties of Caravaggio's style. Yet, in this copy, too, the balustrade and the mantle are absent and the nude body of the torturer at the left continues to below the waist. These copies could suggest that, despite the evidence mentioned above, the balustrade is, after all, a later addition.

The existence of a copy of the picture in Genoa as well as echoes of it in Genoese painting indicate that the *Crowning with Thorns* was in Genoa in the seventeenth century. Marini (1979 b, p. 34) has validly suggested that the picture may have been painted in Rome for a Genoese patron. Caravaggio had important ties with a number of Ligurians, including Vincenzo Giustiniani and Ottavio Costa in Rome, Ippolito Malaspina (who was not himself a Ligurian but who was related to Costa) in Naples,

Giovanni Battista de' Lazzari in Messina, and, during his last years in Naples, Marcantonio Doria. It was probably Doria who requested Caravaggio to fresco a loggia during the artist's flight from Rome to Genoa in 1605. The *Crowning with Thorns* was probably in a Neapolitan collection before it was acquired by Angelo Cecconi, but communication between Naples and Genoa was frequent in the seventeenth century (the *Martyrdom of Saint Ursula*, cat. no. 101, presents a case in point).

Longhi (1928–29; 1968 ed., p. 93; 1943 a, p. 16), who dated the picture to the last years of the sixteenth century, about 1598, inferred that both Ludovico Carracci, in his painting in San Gerolamo della Certosa, Bologna, and Rubens, in his painting for Santa Croce in Gerusalemme, Rome, took the motif of Christ's hands bound at the wrists, with one seen in profile and the other strongly foreshortened, from Caravaggio's picture. It is more likely that Rubens and Caravaggio derived the motif from Ludovico's picture, which Caravaggio may have known either in the original or from an engraving after it (there is no exact date for either). Caravaggio was probably also familiar with Rubens's picture, which predates the Prato *Crowning with Thorns* (for the probable influence of Rubens's antiquarian interests on Caravaggio, see M. Gregori, 1976 a, pp. 676, ff.); but the two works differ profoundly. Caravaggio invests the figure of Christ with a composure that seems to echo an archaic feature of Northern painting, and, indeed, the unusual device of showing Christ with his head raised suggests that Caravaggio was familiar with a version of the subject by Aert Mytens (the best known is in Stockholm). According to Van Mander (1604, p. 264), Mytens began a picture on this subject in Naples; he brought it, unfinished, first to Aquila and then to Rome shortly before his death on September 28, 1601 (G. Hoogewerff, 1942, p. 191, gives the notice of Mytens's death; I thank D. Bodart for calling it to my attention). Mytens evidently attached a great deal of importance to the picture, which enjoyed a certain fame and even attracted the attention of Rubens.

The compositional scheme of the Prato picture, with its simplicity and symmetrical arrangement, has an archaic regularity that

seems to stem from early-sixteenth-century Venetian painting—especially works from the circles of Giorgione and of the late Bellini. The figure at the right, posed so that the light is reflected on the shoulder and on the back of his armor, is inspired by such prototypes as Giorgione's *Warrior* and Titian's *Bravo*, both in the Kunsthistorisches Museum, Vienna.

M. G.

82. Saint Francis in Meditation

Oil on canvas, 51 3/16 x 38 9/16 in.
(130 x 98 cm.)
Santa Maria della Concezione
(Chiesa dei Cappuccini), Rome

83. Saint Francis in Meditation

Oil on canvas, 48 7/16 x 36 5/8 in.
(123 x 93 cm.)
San Pietro, Carpineto Romano (on deposit
in the storerooms of the Galleria Nazionale
d'Arte Antica, Palazzo Barberini, Rome)

In the late Cinquecento, there was a new interest among private collectors in acquiring paintings of penitential or praying saints, especially of Saint Francis in prayer or in meditation before a crucifix or a skull. The cult of Saint Francis enjoyed a resurgence, even among common people, following the renewal of the Franciscan order and its various branches during the Counter-Reformation. Although Muziano was responsible for the earliest images of Saint Francis in meditation, there are numerous interpretations of the theme by such painters in Rome as, for example, Francesco Villamena, and in Bologna by Bartolomeo Passarotti and, above all, by the Carracci—whose early representations are characterized by great expressive and iconographic novelty. The subject was diffused in Tuscany by Cigoli, Cristofano Allori, and Francesco Vanni, and in Lombardy by Cerano. There are even examples of the theme by artists in the Veneto, including Leandro Bassano's three-quarter-length figure of Saint Francis (in the Kunsthistorisches Museum, Vienna)—a pendant to a painting, with an equally mystical theme, of Saint Giuliana Falconieri. Chappell (in A. Moir, 1976, p. 122, n. 180 vi) has correctly noted that Bassano's picture was the prototype of Pieter Soutman's etching, which bears the inscription, "Cum Privil Michael Agnolo Caravaggio." For another example of the theme, formerly in Sant'Anna dei Lombardi, Naples, see M. Stoughton (1978, p. 406). El Greco's representations of the saint derive from Italian art, and his numerous pictures find parallels in contemporary mystical literature and in Spain's staunch support of the Counter-Reformation.

In the present composition, the two most important known versions of which are included here, Saint Francis meditates on a skull rather than on the crucifix. This was something of an iconographic innovation. One of Caravaggio's sources was probably Annibale Carracci's engraving, of 1585, showing the saint with a skull on his lap (fig. 1, cat. no. 88). The same print influenced Caravaggio's *Saint Francis in Prayer* in Cremona (cat. no. 88). In both the Cappuccini and Carpineto Romano pictures, Saint Francis holds a skull, while the cross rests on a stone in the foreground. One wonders whether Caravaggio may have been familiar with a picture by El Greco, frequently repeated in his Spanish period, showing Saint Francis, viewed frontally, meditating on a skull with a companion nearby. Two such pictures date from the eighth or ninth decade of the sixteenth century (see J. Gudiol, 1983, p. 108, for the paintings at Monforte de Lemos and in the Pidal collection). Even if Caravaggio did not see them, at the very least they testify to the prior existence in art of the theme, which would be taken up later in Spain by Zurbarán; the latter's treatment of the saint viewed in profile probably depends, in part, on Caravaggio's composition. It is possible that the focus on a dialogue or meditation on death relates to the specific concerns of the Capuchins (see R. Manselli, 1982, p. 19; C. Strinati, 1982, p. 76, no. 16), but Caravaggio has given the picture a subjective, autobiographical slant, transforming it into a meditation on human destiny and on the vanity of the world. In this, his conception shares a significant analogy with Hamlet's famous soliloquy, as Wagner (1958, p. 110) has noted.

In Annibale's engraving and in Caravaggio's composition, there are intentional references to the theme of Vanity as well as obvious connections with the iconography of subjects dealing with meditation and melancholy. Giulio Campagnola represented a youth with a skull (see G. F. Hartlaub, 1925, pl. 24), and this image may have served as a model for one of Caravaggio's meditative—not sleeping—apostles in the *Agony in the Garden* (formerly in Berlin; now destroyed). Parmigianino's etching of the penitent Saint Thaïs (B. 15) portrays a religious subject in terms of meditation and melancholy; the print was the source—with some iconographic changes (the elimination of the motif of the saint resting her chin on her hand, an age-old symbol of meditation)—for Caravaggio's *Magdalen* in the Galleria Doria-Pamphili (P. Toesca, 1961, pp. 114 f.). By introducing the skull—either on the saint's lap or in his hands—as the object of his meditation, Annibale and Caravaggio probably contributed to a Seicento formula that fused the iconography traditionally associated with Melancholy and that associated with Vanity, thereby providing the symbolic figure of Melancholy (whose origins go back to Dürer) with a concrete object upon which to direct her attention (on this, see R. Klibansky; E. Panofsky; F. Saxl, 1964, pp. 389 ff.). Domenico Fetti, in particular, made wide use of this interchange of, on the one hand, objects symbolizing meditation and, on the other, religious themes (see his *Magdalen* in the Galleria Doria-Pamphili). In the *Melancholy*, which is known in a number of versions (one is in the Gallerie dell'Accademia, Venice, and another in the Musée du Louvre, Paris), Fetti seems to have relied on Caravaggio's *Saint Francis* for his portrayal of the young woman contemplating a skull. The tear in the shoulder of the saint's habit is an allusion to the virtue of Poverty that Francis practiced and preached. In contrast to the *Saint Francis* in Cremona, which reflects a later moment in Caravaggio's stylistic and personal development, the figure is virile and impassive. In the Cappuccini version, the long folds of the habit define the saint's pose (in the Carpineto Romano picture, the treatment of these folds is different and confused). The ethical and emotive world to which this composition belongs is that of Caravaggio's late Roman paintings, of 1603–6: the *Entombment* (fig. 11, p. 42), the Corsini *Saint John the Baptist* (fig. 2, cat. no. 85), and the ex-Berlin *Agony in the Garden*. The picture marks a new humanism in Caravaggio's work, laying bare not only the ancient dignity of man, but also his grief and his tragic destiny. In the Cappuccini version of the composition, the saint's habit has the pointed hood characteristic of the Capuchins; in the Carpineto Romano version, the hood is rounded in form, although cleaning has uncovered a pointed hood (the explanation of this modification requires further analysis).

Cantalamessa (1908, pp. 401 f.) first attributed the *Saint Francis* in the Chiesa dei Cappuccini to Caravaggio, recording the following, apparently seventeenth-century, inscription on a piece of paper pasted onto the back of the canvas (the paper is lost): "Il S.re Francesco de Rustici da [que]sto / quadro a i padri Capucini con tale / . . . nd . . . [comando?] che / n . . . n [non] si possi dare a nisuno" ("Francesco de Rustici gives this picture to the Capuchin fathers with the stipulation that it cannot be given to anyone"). Brugnoli (1968, pp. 13 f.) has noted that the picture was presumably brought from the Capuchin monastery at Monte Cavallo, from whence the monks transferred to Santa Maria della Concezione, founded by Urban VIII in 1626. According to Brugnoli, Francesco Rustici could be a descendant of the Rustici family who died at the age of seventy-three in 1617, or he could be the painter, called Rustichino, who was active in Rome in 1617–19. Brugnoli suggested that Rustichino may be the author of the Cappuccini *Saint Francis*, but this must be incorrect, for it is surely the Cappuccini version that is Caravaggio's original. If one of these two men was the donor of the picture, then it cannot be identified with the "Saint Francis . . . painted by the same Caravaggio" in the 1639 inventory made after Ottavio Costa's death (L. Spezzaferro, 1975, p. 112). For the possible identification of another picture with this reference, see cat. no. 88. Cantalamessa's attribution of the Cappuccini *Saint Francis* was accepted by Posse (1911, p. 573); by Longhi (1918, p. 239; 1961 ed., p. 418), who cited it as a precedent for Gerrit van Honthorst's picture in the Capuchin church in Albano; and by Marangoni (1922 b, p. 50), who knew of a copy in the Cecconi collection (now in a private collection in Rome; see M. Marini, 1978 a, p. 77, n. 19). The picture was exhibited in the "Mostra del Sei e Settecento" at the Palazzo Pitti, Florence, in 1922. Pevsner (1928, p. 132) associated the work with Gentileschi's testimony at Baglione's libel suit on September 14, 1603, that he had lent Caravaggio a Capuchin habit: "[Caravaggio] requested from me a Capuchin habit and I lent it to him along with a pair of wings, and he must have returned that habit to me some ten days ago" (A. Bertolotti,

1881, pp. 62 f.; M. Cinotti, 1971, p. 156, F 54). Subsequently, the attribution has been doubted (by L. Zahn, 1928, p. 42, and H. Voss, 1951 a, p. 168) or rejected (by L. Venturi, 1951, p. 41; W. Friedlaender, 1954, p. 150 and A. Moir, 1967, I, p. 19, n. 27, who considers it to be by an anonymous follower of Caravaggio). Mahon (1951 a, p. 234), who believed the picture to be a copy after a lost work by Caravaggio, dated the composition to about 1603–5.
Brugnoli (1968, pp. 11 ff.) rediscovered the version in San Pietro, Carpineto Romano —the picture hung first in the sacristy and then in the choir—and had it summarily restored. The church was founded in 1609 by Cardinal Pietro Aldobrandini, who in that year was a considerable distance from Lazio (see M. Marini, 1974, p. 79, n. 406). The Carpineto Romano version had been catalogued for the Soprintendenza in 1930 by A. Santangelo as a copy of the Cappuccini picture (M. V. Brugnoli, 1970, p. 24). The version in Carpineto Romano—of slightly different dimensions—has been cut at the sides and at the bottom; originally, the rock on which the cross rests would have been shown in its entirety, as in the Cappuccini picture. Brugnoli (1968, p. 12) noted that the two versions exhibit technical differences—a thick medium, somewhat irregular in its application, and composed of a mixture of brown with yellow granules, was employed in the Carpineto Romano version, while a white preparation that is laid on in a thin, uniform layer, leaving the weave of the canvas exposed, was used in the Cappuccini picture. A like difference characterizes the use of white lead in the two paintings—and this, in itself, excludes the possibility that both are by the same artist. Brugnoli (1968, pp. 11 ff.) has attempted to demonstrate that the Carpineto Romano version was the original and the Cappuccini picture a copy. Her thesis has gained the support of Salerno (1970, p. 236), who has spoken of the possibility of both being original—as have Ferrari (1968, p. 372), Cinotti (1971, pp. 127 f., and, more decisively, 1983, pp. 417 f.), Marini (1974, p. 58, and *passim*, with some reservations), Spezzaferro (1974, p. 585; 1975 a, p. 113), and Nicolson (1979, p. 32). Brandi (1972–73, pp. 87 f.) is undecided, and Spear (1984, p. 165) has postponed a verdict pending the

juxtaposition of the two pictures in the present exhibition. The two paintings were exhibited together in "L'Immagine di San Francesco nella Controriforma" in Rome in 1982 (p. 91 f., nos. 82, 83), where the present writer examined them under good light. She is of the opinion that the Cappuccini picture is the original and the Carpineto Romano version is, without doubt, a copy. To the technical differences reported by Brugnoli—differences which support a conclusion contrary to that advanced, vindicating the Cappuccini picture as the original—one may add the greater subtlety and complexity in the foreshortening of the head in the Cappuccini *Saint Francis*. Barely perceptible variations in the head of the saint in the Carpineto Romano painting reveal the weaknesses of a copyist who, incapable of reproducing the foreshortened features, transformed the head into a semiprofile view, clumsily accentuating the contrasts of light and dark; in the Cappuccini *Saint Francis*, these passages have a marvelous transparency and variety of treatment. In the Cappuccini picture, the habit is defined by the light with an extraordinary clarity, quite in contrast to the confusion that characterizes the Carpineto Romano version. In the latter, moreover, the contour of the habit has been altered on the left, and in defining the folds the brushstrokes are continuous and fused in a manner typical of a copyist; some of the details even show a misunderstanding of structure. Indeed, there is in the picture no comparison to the forceful, attenuated brushstrokes visible in original works by Caravaggio. Finally, the cross in the Cappuccini picture, viewed in perspective, is lucidly and impeccably defined by the strong light in a way that the author of the Carpineto Romano version was not able to replicate.
Various factors have influenced the dating of the picture. A date of about 1603, first proposed by Pevsner in 1928 and taken up by a number of scholars, including, most recently, Cinotti, is based on the association of the painting with Gentileschi's loan to Caravaggio in that year of a Capuchin habit and a pair of wings; the two props could just as well have been used for a painting of Saint Francis and an angel (see the remarks of W. Bissell, 1974, p. 117)—although it is worth noting that in September Caravaggio

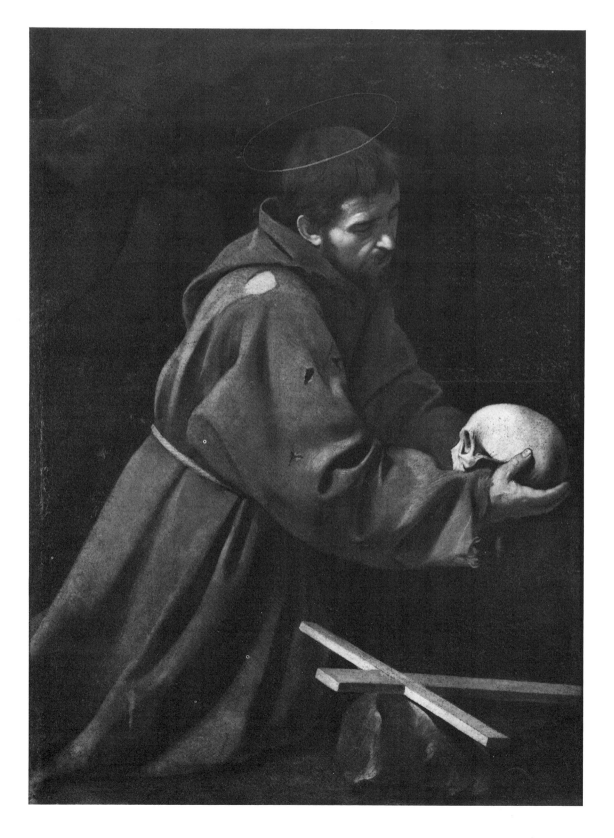

had returned only the monk's habit, not the wings. Brugnoli (1968, p. 12) placed what she considered to be the original version (that in Carpineto Romano) after Caravaggio's departure from Rome in 1606 and during his stay on the Colonna estates, noting affinities with pictures painted at that time. Marini (1974, pp. 56 f., 276, 454, no. 89) dated it in relation to the founding of the church in Carpineto Romano, during the artist's sojourn in Sicily in the summer and fall of 1609. The most convincing date is during Caravaggio's Roman period, in 1603 or a bit later.

M. G.

84. Saint Jerome in Meditation

Oil on canvas, 46 1/2 x 31 7/8 in.
(118 x 81 cm.)
Museu de Montserrat (Barcelona)

The impulse that Saint Jerome gave to the cult of the Virgin Mary and his recognition of Saint Peter's status as the first bishop of Rome made him an object of ridicule among Protestants and the focus of renewed interest and veneration by the Roman church (H. Hibbard, 1983, pp. 193 f.). The polemical side of his character, no less than his refusal to compromise his beliefs, for which he was forced to leave Rome, must have appealed to Caravaggio. However, this is scarcely a basis for asserting, as Kinkead (1966, p. 114) does, that Caravaggio turned to the subject of Saint Jerome in meditation only after his own flight from Rome in 1606. Even if the theme may be construed as referring to Caravaggio's exile, its primary significance was spiritual. Caravaggio's interest in themes of solitary penitence and meditation during his last Roman years is reflected in his depictions of Saint Francis and of Saint John the Baptist in the wilderness (cat. nos. 82, 85). The ascetic theme of the present picture, which carries an allusion to Vanity, is expressed not only by the saint's meditation but by the obvious physical deterioration of his body. In the Montserrat canvas, Caravaggio has eliminated any allusion to Saint Jerome's status as a Doctor of the Church, represented by the books and inkstand in the *Saint Jerome* paintings in the Galleria Borghese, Rome, and the museum of the Co-Cathedral of Saint John in La Valletta, Malta, and has focused exclusively on the theme of the saint's meditation. The analogy between Saint Jerome's bald head and the skull resting on his stack of books, which Longhi noted (1952, p. 41) in the Borghese picture, is repeated here—not as a kind of macabre dialogue, but as a poignant parallel that is made even more compelling by the similarities in the angle from which the skull and the saint's cranium are viewed, and in the lighting. Although it is possible that the canvas has been cut down somewhat, the compressed space is a recurring feature in Caravaggio's compositions with single, three-quarter-length figures.

The painting is not mentioned by Caravaggio's early biographers. Marini (1974, p. 408) has proposed identifying it with an item in the 1638 inventory of Vincenzo Giustiniani's possessions (see L. Salerno, 1960, III, p. 135, n. 5): "Another similar picture, of a half-length figure of Saint Jerome on canvas, about 5 [5 1/2 ?] *palmi* high and 4 [4 1/2 ?] *palmi* wide, by Michelangelo da Caravaggio" ("Un altro quadro simile, di mezza figura, di S. Ger.mo dipinto in tela alto pal. 5 [5 1/2 ?] larg. 4 [4 1/2 ?] in circa di mano di Michelang.o da Caravaggio"); the dimensions in Roman *palmi* are equivalent to 44 1/8 x 35 inches or 48 1/2 x 39 1/2 inches, depending on one's reading of the measurements in the inventory (for which, see H. Hibbard, 1983, pp. 280, 320). The seventeenth-century poet Giuseppe Michele Silos devoted an epigram to the Giustiniani painting, describing the saint as beating his breast with a stone even while engaged in reading and writing, torn between penance and his love of classical literature (G. M. Silos, 1673; 1979 ed., I, p. 89, no. CLX, II, pp. 88, 342). The identification is, therefore, problematic. L. Venturi's attempt (1951, p. 27) to identify the Montserrat picture with the "Saint Jerome with a skull, meditating on death" that Bellori (1672, p. 210) records in the palace of the Grand Master in Malta is improbable because of the date of the painting.

The *Saint Jerome* was studied by Longhi in 1913 when it was in the Magni collection in Rome (R. Longhi, 1943 a, p. 16). It was acquired by the monastery of Montserrat in 1917 (*Analecta Montserratensia*, 1917, p. 338). Longhi noted that the same model was used for the indisputably autograph Borghese *Saint Jerome*, and he dated the Montserrat painting approximately contemporary with the Borghese one, "perhaps about 1603." He also noted considerable repainting in the drapery at the right. In 1952, R. Longhi (plate XXXVII) stated that the picture had been overcleaned in the repainted areas. Ainaud de Lasarte (1947, p. 395, no. 33) suggested dating the picture to 1605–6, as did L. Venturi (1951, p. 27) and Longhi (1951 d, p. 29, n. 34). Mahon (1951 a, p. 234; 1952 a, p. 19) continued to favor an earlier date, about 1602–3 or 1602–4. The earlier dating is not convincing. However, Mahon's association of the

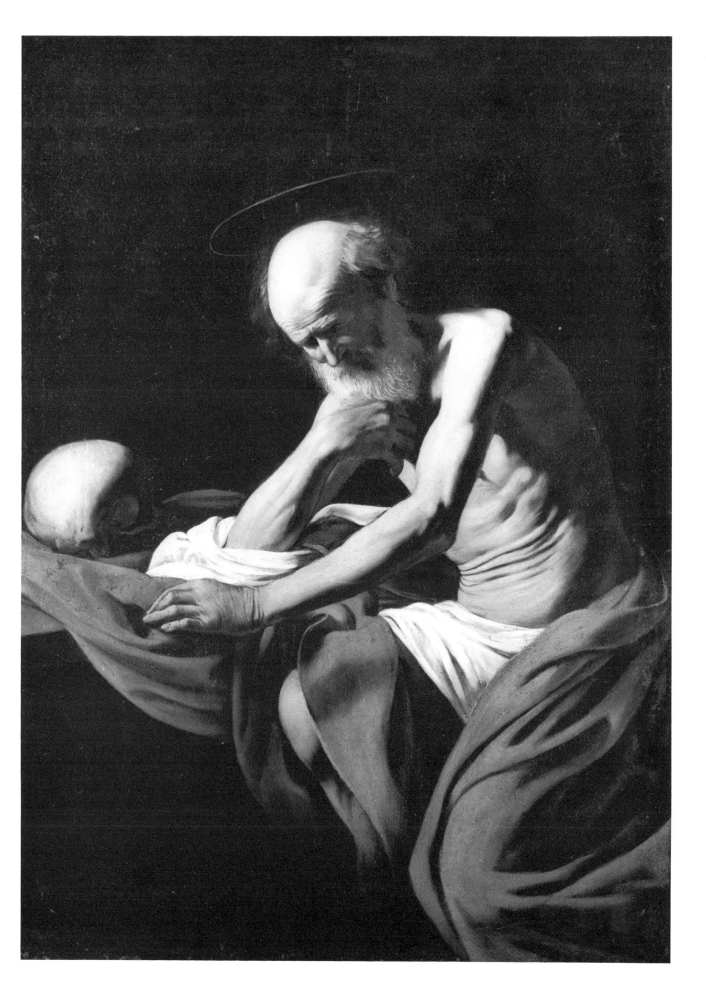

picture with Caravaggio's two paintings of Saint John the Baptist—in the Palazzo Corsini, Rome, and in Kansas City (cat. no. 85)—seems correct. The pose of the figure in these canvases and the position of the knee recur in the *Saint Jerome*, suggesting that the three were conceived contemporaneously. The arrangement of Jerome's arms parallel to each other is a motif that recurs in the Corsini *Saint John the Baptist*. The attribution of the picture to Caravaggio—which was rejected by such "restrictionists" of the 1950s as Arslan (1951, p. 446), Voss (1951 a, p. 168), Friedlaender (1955, p. 204), and Wagner (1958, p. 232, who considered it probably a copy of an original of the first years of the seventeenth century) has gained widespread acceptance, most recently by Nicolson (1979, p. 33) and Cinotti (1983, p. 446); Cinotti had previously expressed doubts (1971, p. 130); Rossi (1973, p. 89) rejects the attribution; Moir (1976, p. 161, n. 285) suggests the possibility that it is a youthful work by Ribera; and Hibbard (1983, p. 320) agrees with Friedlaender that it is "a clever imitation."

The comparisons suggested above confirm a date of 1605–6 for the *Saint Jerome*, although it was certainly painted after the Prato *Crowning with Thorns* (cat. no. 81), which, with its almost crude realism, manifest in the deep folds of the skin, forecasts a new stage in Caravaggio's representation of the nude. It immediately predates the Galleria Borghese *Saint Jerome*, which was probably painted for Scipione Borghese, who arrived in Rome in May 1605. While there are no known copies of the Montserrat picture, Caravaggio's interpretation of the saint—his body wasted and furrowed with wrinkles as a result of the rigors of penitence (B. Berenson, 1951, p. 39, admired the rendering of the body)—had an incalculable effect on later Seicento painting. Indeed, it may be argued that no other invention of Caravaggio's had a comparable impact. The old penitent, who personifies the experiences of life and the desire for expiation, became a prototype for Stoic-inspired painting and the model for Ribera's cruel, penetrating realism.

M. G.

85. Saint John the Baptist

*Oil on canvas, 68 1/4 x 52 in.
(173.4 x 132.1 cm.)
The Nelson-Atkins Museum of Art,
Kansas City*

Saint John the Baptist in the wilderness was one of the subjects on ascetic themes preferred by Caravaggio; he returned to it a number of times during the course of his career, as he did also to the themes of Saint Francis, Saint Jerome, and David. His earliest treatment of the subject is the *Saint John the Baptist* in the Pinacoteca Capitolina, Rome (fig. 1), which is related to the Cerasi Chapel scenes and thus is datable to about 1601. As Mahon noted (1953 a, p. 213, n. 7; D. Mahon and D. Sutton, 1955, pp. 20 ff., no. 17), the Capitoline picture is superior in quality to the version in the Galleria Doria-Pamphili, which the present writer considers a copy. The pose and the somewhat perplexing nudity of the youth (for which see S. J. Freedberg, 1983, pp. 53 f.) are difficult to reconcile with the ostensibly religious subject and have their closest analogies in the ambiguous early half-length compositions by the artist. Some scholars have indeed thought the subject a profane one, noting that the figure lacks a halo and the Baptist's traditional attributes, the cross and the scroll, and that a ram rather than a sheep is shown. Slatkes (1972, pp. 67 ff.) has interpreted some of the features of the Capitoline picture as attributes of the Sanguine Temperament. The red brushstrokes on the leaves in the lower left, which seem to represent blood, could also be an allusion to this temperament; such a layering of meanings might refer to the strong, polemical character of Saint John the Baptist as he is presented in the Bible.

The two other versions of the theme—the one in the Palazzo Corsini (fig. 2) and the present picture—postdate the Capitoline *Saint John* by a few years, and are related to each other compositionally. (The doubts that some scholars have raised about the attribution of the Corsini version are unjustified.) The youth in the Kansas City picture is older, and more adult in appearance than his Corsini counterpart, but in both paintings the saint's pose differs profoundly from that of the Capitoline *Saint John*.

Caravaggio has represented the meditative, melancholic figure with a troubled gaze expressive of the strongly subjective spirit proper to the saint, and he has done this with unprecedented intensity and clarity. In the Kansas City picture, the lamb has been omitted and the only traditional attribute shown is the saint's reed cross. The violent, focused light falling from the left seems to revive a device used in the *Martyrdom of Saint Matthew* in the Contarelli Chapel (fig. 5, p. 85). The leaves in the background, with their autumn colors, and the tufts of vegetation in the foreground evoke the wilderness to which John has retired.

The superbly conceived figure of the saint, whose pose expresses perfectly his psychological tension, was certainly inspired by ancient sculpture: the *Belvedere Torso* and, perhaps, the *Laocoön* in the Vatican. The large mantle has long, classically inspired folds of a type that Caravaggio had already adapted for his second version of the *Saint Matthew and the Angel* (fig. 6, p. 36); it is displaced to the left so that it takes on the autonomous character of the Hellenistic motif of a mantle draped over a support. With only a few scholars demurring (see M. Cinotti, 1983, p. 444), the attribution to Caravaggio is generally accepted. Longhi (1927; 1967 ed., p. 306) was the first to ascribe the composition, which he knew from a copy in the Museo Nazionale di Capodimonte, Naples, to Caravaggio. (The Naples copy, purchased in Rome as a work by Manfredi in 1802, was though by the painter Tommaso Conca to be by Caravaggio.) Later, Longhi (1943 a, pp. 14 f.) recognized the present picture as the original. He remarked that "the body is exposed to the most profound variations of shadow, as though entrapped in a cosmic joke; . . . the left leg is seemingly reduced to a knee that emerges in sharpened outline, like the moon during a partial eclipse; the pointed throat . . . seems almost to detach the head from the body, and the mocking shadow . . . devours the ribs."

According to information furnished to the museum by Geoffrey Agnew, the picture was purchased in Malta by James, fifth Lord Aston of Forfar (died 1751), and was housed at Tixall, Staffordshire. It was inherited by Aston's second daughter, Barbara, who married Thomas Clifford. Their

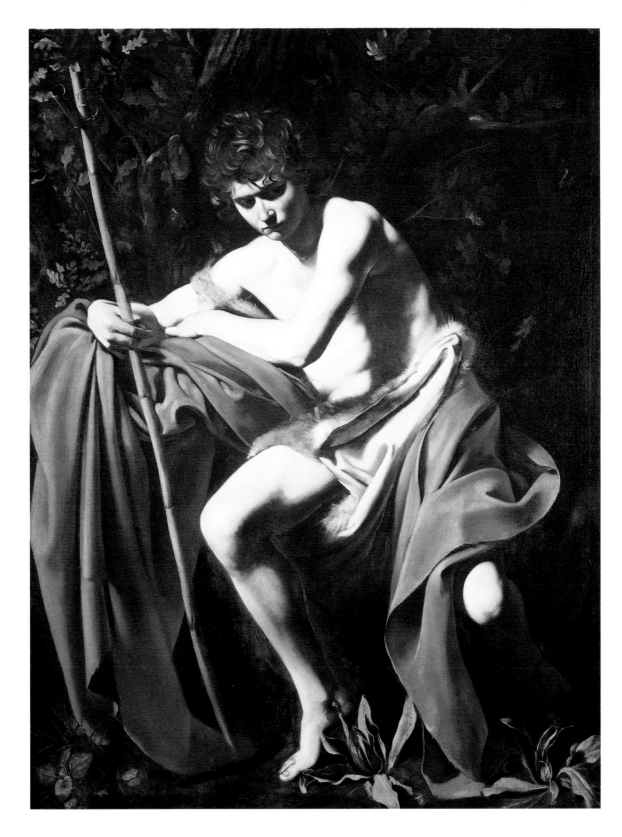

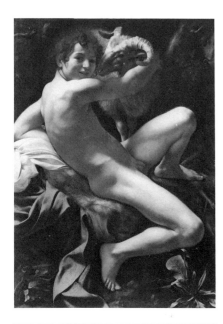

second son, Sir Thomas Hugh Clifford (1762–1829), inherited Tixall through his mother and, through his father, the estates of the Constable family. In 1844, the Clifford-Constable possessions in Tixall were moved to Burton Constable. Clifford's daughter, Mary Barbara Clifford-Constable (died 1876), married Sir Charles Chichester. The painting, discovered in Burton Constable in the 1940s, was sold in 1951 to Edward Speelman and Geoffrey Agnew by a descendant, Brigadier Raleigh Charles Joseph Chichester-Constable. It was purchased by the Nelson-Atkins Museum in 1952.

Paintings of this subject are mentioned a number of times by early sources—one was owned by the architect Martino Longhi, the son of Caravaggio's friend Onorio. However, the discovery (S. Torre, 1962, p. 9) of a copy of the present picture, now in the Museo Diocesano, Albenga, but originally in the chapel of the Confraternita della Misericordia in Conscente in Liguria, and later in the nearby church of Sant'Alessandro, built by the Costa family (P. Matthiesen and D. S. Pepper, 1970, pp. 452 ff.), suggested to Spear (1971 a, p. 75) that the Kansas City *Saint John the Baptist* was commissioned by Ottavio Costa, one of Caravaggio's principal patrons and the owner of other pictures by the master (cat. nos. 68, 73, 74 and possibly also 88). Just as Costa gave away a copy of the Hartford *Stigmatization of Saint Francis*, so in this case he probably sent a copy to Conscente, keeping the original for himself. (According to A. Moir, 1976, p. 97, the copy measures 170 x 107 centimeters, but R. Ward, in a 1984 letter, states that the difference between the copy and the original is a matter of millimeters. Another copy is in the sacristy of Santo Stefano, Empoli.) In the 1639 inventory drawn up after Costa's death there is described, after the *Judith*, "another picture with the image of Saint John the Baptist in the desert painted by the same Caravaggio" (L. Spezzaferro, 1974 c, p. 584, n. 36, 586; 1975, pp. 112, 117 f.). It is possible, although not very likely, that Costa sent the original to Conscente and later replaced it with a locally made copy. The fact that the picture was purchased in Malta is further evidence that Costa kept the original, for the Costa family had close ties with the Knights of Malta and owned property on the island. Spear's suggestion (1971 a, p. 76) that the original, sent to Conscente, was replaced by a copy when it was sold seems unlikely, although the date of the copy would have to be ascertained before the matter can be better resolved. The fact that the copy in Naples was purchased in Rome suggests that the original was there in the seventeenth century. Hibbard's thesis (1983, pp. 191, 319) that Caravaggio painted the picture in Genoa in the summer of 1605 is not acceptable.

Ward has furnished information that, together with that published by Matthiesen and Pepper (1970, pp. 452 ff.), also bears on the date of the picture. The Costa obtained the fief of Conscente from the Vatican by 1584. In 1588, the people of the village made a gift of their parish church, which was dedicated to Saint John the Baptist, to the abbot, Alessandro Costa. The Costa brothers, Pier Francesco, Alessandro, and Ottavio, then financed the building of a new, larger church, dedicated to Saint Alexander, on a higher site. Construction began in 1596. According to Ward, the old church became an oratory for the Confraternita della Misericordia and the new structure became the parish church on September 14, 1603. A papal bull of that date called for the acquisition of furnishings and relics to enrich the new church and to refurbish the old one. On November 5, 1603, the administration of the church was assigned to Ottavio Costa and his heirs. Thus, according to Ward, the *Saint John the Baptist* must have been commissioned after that date for the old church, in which an elaborate stucco frame of the requisite measurements still exists. This information accords with the date of 1602–5 generally proposed for the picture (D. Mahon, 1951 a, p. 234: 1603–4; 1952 a, p. 19: 1602–4; and A. Moir, 1965, pp. 25 f., n. 3, R. Spear, 1971 a, p. 75, and M. Cinotti, 1971, p. 128: 1604–5). Marini (1974, p. 160), by way of exception, dates the picture to 1600. The present writer dates it to 1604–5 and agrees with Cinotti (1983, p. 444) that it is somewhat earlier than the Corsini *Saint John the Baptist*, which may date from as late as 1606 (see M. Marini, 1974, p. 387).

X-rays have revealed no pentimenti but only slight adjustments—for example, along the right shoulder of the saint. The

execution is accomplished and "aggressive" (R. Ward). X-rays and raking light show that a thin line was impressed in the wet paint along the contours of the left leg, which is partly immersed in shadows, in order to fix its position. This practice, which takes the place of preparatory drawings, was noted by Longhi (1960, p. 27) in the *Conversion of Saint Paul* (fig. 9, p. 40) and in the Rouen *Flagellation* (cat. no. 91) and is encountered in other works as well (see M. Cinotti, 1983, p. 418); it is similar to the technique used in frescoes, where lines are drawn directly or transferred from cartoons onto the damp surface of the wall (see G. Martellotti and B. Zanardi, 1980, referred to by M. Marini, 1981, p. 356, n. 1, in his discussion of cartoons). In the *Saint John the Baptist* the incisions seem to have been made directly on the surface. Matthiesen and Pepper (1970, p. 456) have pointed out that in Guido Reni's *Martyrdom of Saint Catherine*, which was painted for the new church in Conscente (the church was consecrated, according to an inscription, in 1606, but it was dedicated only in 1621), the tuft of vegetation in the foreground, near an ancient architectural fragment, derives from the similar detail in the *Saint John the Baptist*; Reni's interest in Caravaggio's work in Rome is well known. The earliest mention of the composition is in a manuscript in the Curia Vescovile, Albenga, entitled "Sacro e vago Giardinello, e succinto Repilogo delle Ragioni delle Chiese, e Diocesi d'Albenga: In Tre Tomi chiuso; cominciato da Pier Francesco Costa, Vescovo d'Albenga dell'anno 1624" (I, pp. 367 f.), where Caravaggio's incomparably profound psychological portrayal of the saint is interpreted in a devotional sense: "Before ascending to the abovementioned church, in the narrow but fruitful valley, one comes upon a small, holy oratory . . . , formerly the parish church, restored in the modern style in honor of that mysterious nightingale who announces the coming of Christ, Saint John the Baptist. The image of him in the desert, mourning human miseries, was painted by the famous Michelangelo Caravaggio, and it moves not only the brothers but also visitors to penitence."

M. G.

86. Ecce Homo

Oil on canvas, 50 3/8 x 40 1/2 in.
(128 x 103 cm.)
Galleria Comunale di Palazzo Rosso, Genoa

The theme of the *Ecce Homo* derives from the Gospel of Saint John (19:5): "Then came Jesus forth, wearing the crown of thorns, and the purple robe. And Pilate saith unto them, Behold the man [*Ecce homo*]!" There were famous paintings of the subject by such Cinquecento masters as Titian and Correggio, but, in contrast to them, Caravaggio has employed a characteristically asymmetrical composition, placing Christ off-axis and creating a diagonal thrust into space by means of Pilate's position in the immediate foreground. Longhi (1954 b, pp. 211 f.) noted that this perspectival device of placing Pilate in a prominent position had been adopted by Titian in an *Ecce Homo* in the Escorial (prior to Longhi's attribution, the Escorial picture was ascribed to Tintoretto).

Before the present picture reappeared, the composition was known from a copy—which had an attribution to Caravaggio dating back to the mid-eighteenth century—in the Theatine church of Sant'Andrea Avellino, Messina. The copy was placed in the local museum before the earthquake of 1908 (for bibliography, see F. Negri Arnoldi, 1977, p. 33). It measures 194 x 112 centimeters, the parapet being considerably elongated in comparison to that in the present picture. There are drops of blood on Christ's chest, a feature that accords with Spanish taste. Mauceri (1921–22 a, p. 582) was the first to reject the attribution to Caravaggio; Longhi (1943, p. 37, n. 25) agreed, calling it a crude but faithful copy from the first half of the seventeenth century, and dating the prototype to the artist's late period (R. Longhi, 1954 a, p. 4).

The present painting was discovered by Caterina Marcenaro, director of the Musei Civici, Genoa, in storage in the Palazzo Bianco in 1953. Lionello Spada had catalogued it as a copy in 1921; it was placed in storage in the Palazzo Rosso in 1925, lent to the local naval school in 1929, recovered from the ruins after the war, and housed first in the Palazzo Ducale and then, in 1946, in the Palazzo Rosso. Following its

recovery in 1953, the picture was entrusted to Pico Cellini for restoration, which was completed in February 1954. The canvas had no stretcher and had been stiffened by a relining, perhaps dating from the late eighteenth century. The original, irregular canvas, measuring 118 x 96 centimeters, was enlarged on all sides to reestablish the relationship between the figures and space documented in the copy. The Christ had been disfigured by retouching, as well as by a tear in his right breast and a slight split passing through his hands and loincloth (see R. Longhi, 1954 a, figs. 2–5).

Longhi attributed the Genoa picture to Caravaggio, considering it the prototype of the Messina painting and also as of other copies, a good number of which are Sicilian. The restoration has underscored the violent execution of the picture. Caravaggio altered the contours of Christ's face by going over it a number of times, and there are pentimenti in the hands of Pilate. The height of Christ's shoulders was also modified, and there are further pentimenti in his arms, hands, and loincloth. Such changes, in and of themselves, provide strong evidence for attributing the work to Caravaggio; the technique is also characteristic of the master.

Bearing in mind the damaged state of the picture, the repairs to which its surface has been subjected in the course of restoration, and a recent, arbitrary varnishing (for which see P. Cellini, in M. Marini, 1974, p. 413, and M. Cinotti, 1983, p. 439), the work nonetheless bears the hallmarks of Caravaggio: the marvelously pictorial passages of naturalistic observation, in which Longhi (1954 a, p. 12) saw an extension of the "mysteries of the Venetian palette" (note, for example, the vibrant painting of the crown of thorns); the tridimensional illusionism and the succession of planes in the hands of Pilate and in the body of Christ, obtained by laying tone on tone; and the animation of those parts of the composition that emerge from the shadow—the hair and the ear of Christ, or the ear and bicolored feather of Pilate's henchman, for example. (For various opinions regarding the picture's attribution, see M. Cinotti, 1983, p. 439.)

Longhi later redated the *Ecce Homo* to Caravaggio's Roman years, convincingly associating it with the story told by Cigoli's

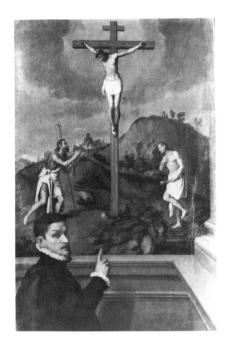

1. Giovanni Battista Moroni. *The Crucifixion, with Saints John the Baptist, Sebastian, and a Donor*. Sant'Alessandro della Croce, Bergamo

nephew, Giovanni Battista Cardi (before 1628; 1913 ed., p. 38), and by Baldinucci (1671–1728; 1846 ed., III, pp. 266 f.), concerning a Monsignor Massimi, who held a competition involving Caravaggio, Cigoli, and Passignano. According to Cardi, each artist was requested to paint an *Ecce Homo* "without knowing about the others; and when they had finished and the works were compared, [Cigoli's] pleased the most." Bellori (1672, pp. 207 f.) does not mention the competition, but he relates that "for the Massimi [Caravaggio] painted an *Ecce Homo* that was taken to Spain." Passignano's picture is lost; Matteoli's attempt to identify it (1980, p. 154) is not convincing (for a picture of this subject, in the Barberini collection, see M. Lavin, 1975, p. 307, n. 319). Cigoli's winning painting, however, has survived. It was acquired by Giovanni Battista Severi, musician to Lorenzo de' Medici, from Monsignor Massimi, and subsequently entered the grand-ducal collection in Florence (see cat. no. 35).

If the *Ecce Homo* in Genoa was the one painted for Massimi's competition, as appears to be the case, then it must have been executed between April 1604, when Cigoli arrived in Rome, and late May 1606, when Caravaggio fled the city following the murder of Ranuccio Tommasoni. An account of Cigoli's whereabouts narrows the period of execution still further, since Cigoli left Rome in late 1604, spent a year in Pisa and Florence, and returned to the city no earlier than April 1606; on May 12, 1606, he received payment for his altarpiece for Saint Peter's (M. Chappell, 1971 a, pp. 97, 103 f.; A. Matteoli, 1980, pp. 440 f.). If all three artists were present in Rome for the competition, then it can only have taken place in the summer of 1604 or, more likely, between April and May 1606 (but see cat. no. 35). Caravaggio would seem to have painted his *Ecce Homo* during this brief period in 1606, just after completing the *Madonna dei Palafrenieri*, to which the *Ecce Homo* has been compared on stylistic grounds (A. Ottino della Chiesa, 1967, pp. 100 f., n. 67; M. Marini, 1979, p. 32; A. Moir, 1982, p. 122; M. Cinotti, 1983, p. 439). Perhaps the very short lapse of time between the refusal of the *Madonna dei Palafrenieri* and the competition, as well as Caravaggio's subsequent flight from the

city, played a part in Massimi's choice of Cigoli's painting. It may also help to account for the recurrence of similar motifs in the two pictures—which cannot be entirely explained by the fact that Massimi probably gave the same instructions to the three artists, and which suggested to Longhi (1954 a, p. 8) that Cigoli saw his rival's painting. If this dating is correct, then the *Ecce Homo* would be the last work that Caravaggio painted in Rome, and the outcome of the competition would have been one more aggravating circumstance in his life during the time that led up to the murder of Tommasoni. His psychological stability had already been shaken by the rejection of his altarpiece for Saint Peter's, and the rejection of the *Ecce Homo* by Massimi may have coincided with the refusal of the *Death of the Virgin* by the Capuchins (this last defeat, however, may have been inflicted after Caravaggio had already fled the city). The rapid execution of the picture, and, specifically, the dark shadows in the folds of Christ's loincloth, in the turban of the torturer, and in the forehead of Pilate, are characteristic of Caravaggio's work at the time of the *Madonna dei Palafrenieri*. The demonstrative, not to say eloquent, part played by Christ's and especially Pilate's hands in addressing the viewer foreshadows similar passages in the *Madonna of the Rosary* (in the Kunsthistorisches Museum, Vienna). Other aspects of the *Ecce Homo* have analogies in the *Seven Acts of Mercy* (in the Pio Monte della Misericordia, Naples). In the *Ecce Homo*, Caravaggio exalts—as he does not in the Prato *Crowning with Thorns* (cat. no. 81)—the beauty of the protagonist-victim in a manner appropriate to the subject. As in the *Crowning with Thorns*, the gestures are both apposite and efficacious. The torturer removes from Christ's shoulders the purple mantle, whose long, rhythmic folds frame the figure as though he were an ancient cult object. Pilate's gesture, directed toward the viewer, accords with the aims of the religious art of the Counter-Reformation. There are parallels for it in the North Italian paintings by Moroni and by Passarotti; Caravaggio probably had in mind Moroni's *Portrait of a Donor Indicating the Crucifixion* in Sant' Alessandro della Croce, Bergamo (fig. 1), or the *Saint Martin and the Beggar, with a*

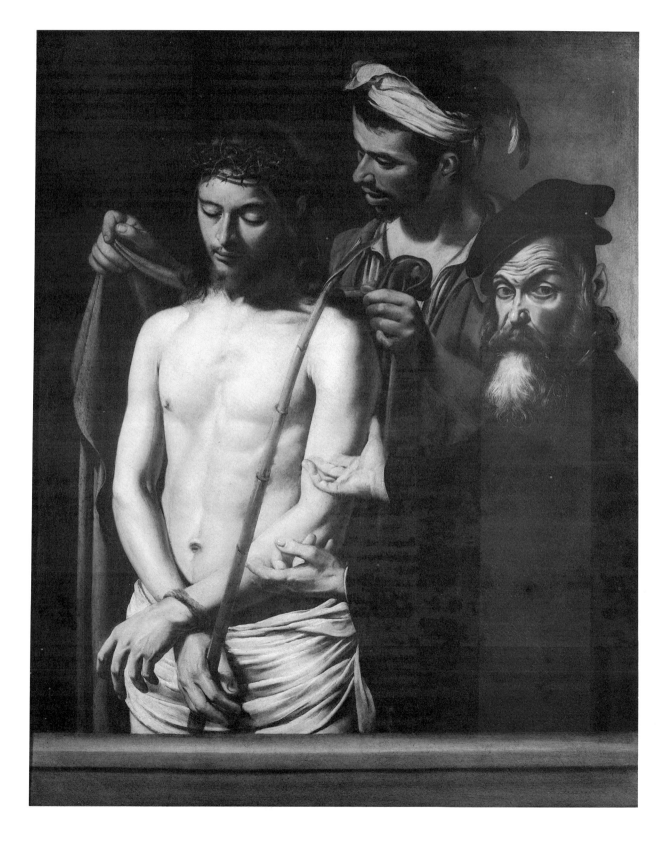

Donor in San Martino, Cenate d'Argon. The underlying scheme of the picture, with Pilate in the foreground gesturing toward Christ, and the emphasis on such illusionistic devices as the placement of Christ's hands, holding the mock-scepter in front of his body so as to emphasize the realism of the event, are related to Moroni's paintings showing donor-worshipers in the foreground with a sacred image behind—a superposition of the real and the visionary that may, perhaps, have been inspired by Ignatius Loyola's *compositio loci*, described in the *Spiritual Exercises*, whereby one attempts to re-create a concrete visual image of the object of meditation (see cat. no. 8). Even the portrait-like quality of Pilate's face may to some extent be associated with Counter-Reformation paintings of the kind mentioned above. Saccà (1906, pp. 66 f.) and Longhi (1943 a, p. 37, n. 25; 1954 a, p. 11) believed that Pilate was a self-portrait. While there is no basis for this assertion, it may be noted that Caravaggio frequently employed in his paintings figures of his own physical type—if not with his actual face. There is, for the time being, no satisfactory explanation for the evident resemblance, noted by Marini (1974, p. 318, C 19), between this Pilate and Sebastiano del Piombo's portrait of Andrea Doria (in the Galleria Doria-Pamphili, Rome).

Both Bellori (1672, p. 208) and Baldinucci (1681–1728; 1846 ed., V, p. 36) report that Caravaggio's *Ecce Homo* was taken to Spain. Longhi (1954 a, p. 9)—noting that among the Spanish copies after works by Caravaggio cited by Ainaud de Lasarte (1947, p. 368) none is after the *Ecce Homo*, while Sicilian copies "in the style of Minnitti and Rodriguez" exist—suggested that one ought, perhaps, to understand "Spain" as including Sicily, and that the picture found its way to that island, possibly to Palermo. There, sometime between 1640 and 1645, Matthias Stomer painted for the Oratorio del Rosario his *Christ at the Column*, in which the rendering of Christ's torso derives from that in Caravaggio's painting. According to Longhi, the *Ecce Homo* must have left Rome at an early date, since there is no echo of it in works by the second wave of Caravaggesque artists, mainly Northern in origin, active there from about 1615 to 1620. For the problem of the Sicilian copies, see Moir (1967, I, p. 184), who believes that those published by Longhi derive from another lost work by Caravaggio; Calvesi (1971, p. 123) would identify that hypothetical painting with one produced for the Massimi competition. Marini (1974, p. 318, C 23) also discusses the copies. Isarlo (1941, p. 210), and Negri Arnoldi (1977, p. 33) attribute the Messina copy to Alonso Rodriguez, who would have painted it in Rome in 1610; Caravaggio's picture thus need not have been in Sicily.

It is not known when the picture was brought to Genoa. Longhi suggested that, since there is no mention of it by Ratti (1780) in a Genoese private collection, it probably arrived in the nineteenth century. Moir (1976, pp. 131 f., n. 215), however, has raised the possibility that, already in the seventeenth century, Genoese artists were familiar with the picture, but this line of inquiry must be pursued.

The identification of Monsignor Massimi is still an open question. Ainaud de Lasarte (1947, p. 368, n. 41), in reference to Bellori's assertion that the picture was taken to Spain, called attention to an unpublished manuscript (cited earlier by A. Farinelli, 1920, p. 205) entitled "Viaggio di Monsig. Patriarca de' Massimi da Roma a Madrid, così per mare all'andare come per terra al ritorno, 1654–58." Matteoli (1980, p. 155) has suggested that Massimi be identified with Monsignor Innocenzo di Alessandro, who belonged to a branch of the Massimi delle Colonne family that died out in 1642: Innocenzo was Vice Legate to Ferrara in 1607, Bishop of Bertinoro from 1613, and Nunzio to Florence in 1621–22 and to Madrid in the following year; from 1624 until his death, he held the episcopacy of Catania. This interesting possibility, however, requires further investigation.

M. G.

87. The Supper at Emmaus

Oil on canvas, 55 1/2 x 68 7/8 in.
(141 x 175 cm.)
Pinacoteca di Brera, Milan

Caravaggio had represented this scene several years earlier (see cat. no. 78), but with notable differences, as Bellori (1672, p. 208) himself remarked. The gestures in the two pictures are the same, only in the Brera picture they are simplified and reduced to essentials, without the amplification found in the London *Supper at Emmaus*. It is almost as though Caravaggio purposely avoided the clear, efficacious distinctions he had sought previously, differentiating the various figures—Christ, the two disciples, the innkeeper, and the old servant—less sharply. Although the innkeeper and the servant are probably unaware of what is happening, they are not set apart from the disciples according to the contrasting logic (or "contrapposto": see cat. no. 74) that characterizes the earlier picture. They appear simply as witnesses, and they function as a supporting chorus—an idea that Caravaggio developed more fully in such late pictures as the *Beheading of Saint John the Baptist* in Malta (fig. 14, p. 45) and in works of the Sicilian and second Neapolitan periods. The old woman seems touched by the air of sadness that is the emotive core of the picture. Christ, in stricter accordance with the subject—an apparition after his Resurrection—is no longer the beardless, fleshy youth of the London version, but an adult who has undergone the experiences that come with age (Bartolomeo Manfredi depicted him in an analogous fashion in a *Christ Appearing to His Mother*, painted for the Giustiniani and now in a private collection). The moment represented follows immediately after that shown in the London *Supper at Emmaus*: The bread has already been broken (M. Calvesi, 1971, p. 97). Christ's benediction renews the significance of leave-taking that had already been present in the Last Supper, for in a moment he will disappear from the two disciples' sight (Luke 24:31).

This more profound interpretation of the subject, with greater attention given to its psychological aspects, is accompanied by a new objectivity and by an attempt to probe

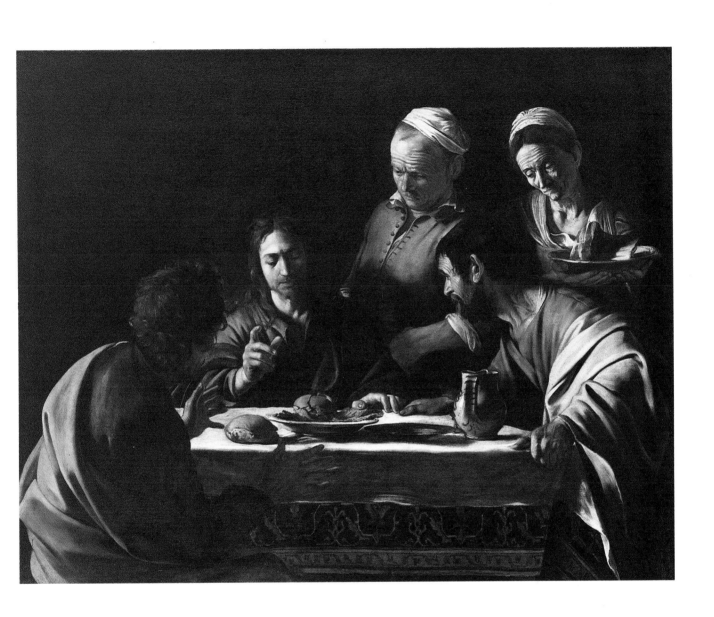

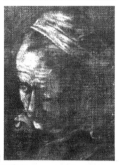

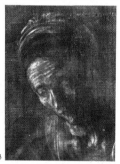

the essence of the story. And this change is reflected in the quick, spare, but magisterial execution of the picture; the darker shadows absorb the background, defining the constituent elements of the scene in a more summary fashion. The varying intensity of the light creates an effect of rapidity and instability: More than in any other work by Caravaggio, it prefigures Rembrandt's vision.

The picture was recognized as by Caravaggio, in 1912, when it was in the Patrizi collection, Rome, by Lionello Venturi (1912, pp. 1, 7 f.), whose attention had been drawn to it by Corrado Ricci and Giulio Cantalamessa. It is identifiable with a painting described in a Patrizi inventory of 1624: "Another large painting of a supper, when they recognized him in the breaking of the bread, by Caravaggio, with a gold frame, 300 *scudi*" ("Un altro quadro grande di una cena quando cognoveru[n]t eum in frattione panis mano del Caravaggio con cornice tocca d'oro, scudi 300"; R. Longhi, 1951 a, p. 30, no. 35). Bellori (1672, p. 208) states that "for the Marchese Patrizi [Caravaggio painted] the Supper at Emmaus in which, at the center, Christ blesses the bread; and one of the seated apostles, recognizing him, opens his arms, while the other grasps the table and stares at him in amazement. Behind [these] there is the innkeeper wearing a cap and an old woman who carries food" ("al marchese Patrizi [colorì] la Cena in Emaus, nella quale vi è Cristo in mezzo che benedice il pane, ed uno degli apostoli a sedere nel riconoscerlo apre le braccia, e l'altro ferma le mani su la mensa e lo riguarda con maraviglia: evvi dietro l'oste con la cuffia in capo ed una vecchia che porta le vivande"). Immediately after this description, Bellori refers to the London version, which he believed was painted for Scipione Borghese, noting that the Patrizi picture was darker ("più tinta"). It is probable, though not certain, that Bellori was also referring to this picture (which he would thus have mentioned twice) when he wrote of a "Christ at Emmaus between the two apostles" painted in Zagarolo. Mancini (about 1617–21; 1956–57 ed., I, p. 225) had written earlier of a "Christ going to Emmaus" ("Cristo che va in Emmaus"), painted by Caravaggio in Zagarolo after his flight from Rome in 1606, "which Costa

bought in Rome" (in the Palatino manuscript Mancini simply states that the picture "was sent to Rome to sell"). Friedlaender (1955, pp. 167 f.) believed that the picture described by Mancini showed not the Supper at Emmaus but the Road to Emmaus. Despite the discrepancies in the sources as to the moment represented and the name of the original owner, the style of the Brera *Supper at Emmaus* is that of Caravaggio's late Roman period, which by extension also included his immediately subsequent stay in Zagarolo. This fact lends support to the identification of the Patrizi-Brera picture with the painting bought by Costa—or, according to Mancini's variant manuscript, with the painting that Caravaggio "sent to Rome to sell." In the 1639 inventory of Ottavio Costa's collection there is described, without mention of the artist, a "large painting of when our Lord revealed himself to the two disciples" ("quadro grande quando Nostro Signore si dette a conoscere alli doi discepoli": L. Spezzaferro, 1975 a, p. 116). Perhaps, as Spezzaferro suggests, Costa never owned the original—or, if he did, he gave or sold it to the Marchese Patrizi before 1624 and had a copy made for himself.

Caravaggio's authorship is universally acknowledged (M. Marangoni, 1922–23, p. 218, at first doubted the attribution but later accepted it; H. Voss, 1924, p. 442, also expressed doubts). Cleaning of the picture, by Mauro Pellicioli in 1939, when the painting was purchased by the Brera, and by Pinin Brambilla Barcilon in 1978, has disclosed the rapid execution, the dynamic use of light, and the thin layers of color, through which the ground and the weave of the canvas are visible. Marangoni (1922–23, p. 218) had doubted Caravaggio's authorship of the picture because of this last feature, which is, however, characteristic of the artist's late works and which may be observed in the *Death of the Virgin* (fig. 12, p. 43). As in other paintings by Caravaggio (see cat. no. 101), a strip of canvas had been added at the top—it was removed in 1939, but appears in the old Alinari photograph —to counteract the effect of constricted space; the same sort of additions were frequently made to Moroni's portraits.

It has been suggested that the model who posed for the old servant was also used for

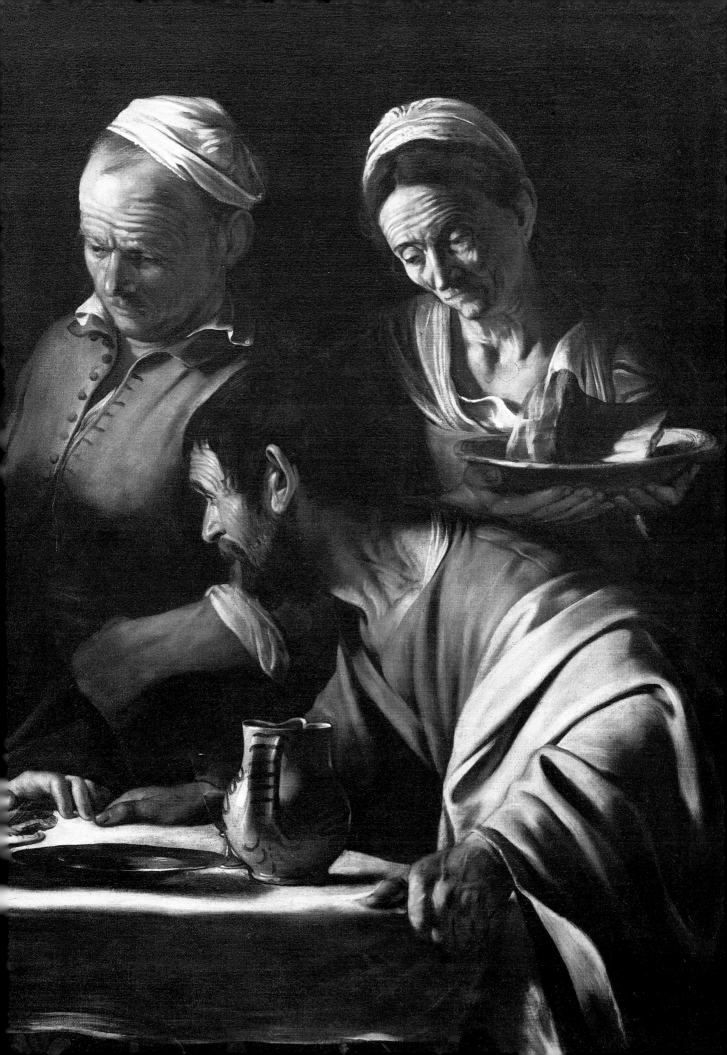

the figure of Saint Anne in the *Madonna dei Palafrenieri*, but Brandi (1972–73, pp. 91 f.) attributes the resemblance to Caravaggio's recollection of the figure in that work. The head of the young apostle, lit from behind, can be related to that of one of the two torturers in the *Christ at the Column*, a picture that is known through copies (fig. 1, cat. no. 90; R. Longhi, 1960, p. 31; M. Marini, 1974, p. 123, no. 25). The same motif reappears, in a more evolved form, in the torturer in the left foreground of the Naples *Flagellation* (cat. no. 93).

The picture's pensive, sorrowful intimacy, which replaces the demonstrative gestures and the attempt to engage the viewer manifest in the earlier *Supper at Emmaus*; the simplified treatment of the subject; the rapid, cursory ("sprezzato": R. Longhi, 1952, pl. XL) technique; the light, which is no longer the naturalistic light of Lombard tradition; and the "earthy brownish tonalities [that] are hard to name" (H. Hibbard, 1983, p. 212) are some of the characteristics that, today, seem to raise this picture to the level of the earlier London version, if not still higher. They have parallels in the concentrated meditative conception of Caravaggio's religious work of his last Roman phase.

As already noted, a copy of the picture probably belonged to Ottavio Costa. Another was in the Cecconi collection (M. Marangoni, 1922–23, p. 218), and two others, one at Tatton Park, Cheshire (with some changes), and one with the dealer O. Klein, in New York, are mentioned by Moir (1976, pp. 66, 100).

M. G.

88. Saint Francis in Prayer

Oil on canvas, 51 1/8 in. x 35 3/8 in. (130 x 190 cm.)
Pinacoteca del Museo Civico, Cremona

The saint kneels and contemplates a crucifix, his head resting on his folded hands, which recall those of the Magdalen (cat. no. 89). No stigmata are visible. In the dark, nocturnal background is the trunk of a tree and foliage—as in the destroyed *Agony in the Garden* (formerly in the Kaiser-Friedrich-Museum, Berlin) and in the two paintings of Saint John the Baptist (in the Palazzo Corsini, Rome, and in Kansas City; cat. no. 85). The saint's halo is barely indicated. The crucifix, the book—with the crucifix resting on it as though to keep it open—and the skull are studiously arranged in the foreground to create a still life, clearly defined by the play of light and shadow. The figure's intent expression and deeply furrowed brow do not correspond to the traditional type for Saint Francis; the saint is perhaps a self-portrait. He has an introspective, expressive force with few parallels in Caravaggio's oeuvre. The representation of Saint Francis in a wild, outdoor setting, kneeling in contemplation before a crucifix, an open book, and a skull on the barren ground—in exaltation of Humility—derives from a conception of Ludovico Carracci's that is known through his painting in the Pinacoteca Capitolina and through an engraving after it (F. Arcangeli, 1956 b, p. 105, n. 1; C. Strinati, 1982, p. 78, n. 23).

The saint's unkempt appearance and his dark beard are also Carraccesque. However, unlike Ludovico's painting, Caravaggio's omits Saint Francis's companion, showing the saint with his hands clasped in prayer. By so doing, Caravaggio emphasized an interiorized, meditative interpretation of the subject, which avoids the rhetorical eloquence—so typical of the Carracci's religious imagery—of the Capitoline picture, where the saint's arms are outstretched as in a representation of the stigmatization. The manner in which, in Caravaggio's picture, the hands are intertwined and the folds of the sleeves, with their frayed edges, are accented by broad patches of light recalls Annibale Carracci's engraving, of 1585, of Saint Francis absorbed in prayer, holding a roughhewn cross (fig. 1; see D. Bohlin, 1979, p. 343, n. 7). The position of the saint's head in Annibale's engraving seems to have inspired Caravaggio's conception of the saint, and it is possible that Caravaggio's version of the subject in the Chiesa dei Cappuccini, Rome (cat. no. 82), which shows Saint Francis contemplating a skull rather than a crucifix, also derives from Annibale's print.

The provenance of the picture, before it was given to the city by the Marchese Filippo da Ponzone, is not known. Longhi's tentative hypothesis (1951 d, pp. 31 f.) that it might be identifiable with a "Saint Francis receiving the stigmata" mentioned in 1666 by an annotator of Mancini (about 1617–21; 1956–57 ed., I, p. 340) is not acceptable, given the discrepancy between the precise description there and the subject of the present picture; the "Saint Francis receiving the stigmata" was in the now-destroyed Fenaroli Chapel in Sant'Anna dei Lombardi, Naples. The 1639 inventory of Ottavio Costa's property (L. Spezzaferro, 1975 a, pp. 112, 118) lists "another painting of Saint Francis painted by the same Caravaggio," but that description is not detailed enough to permit a definitive identification with either the picture in Cremona or the version of the theme in the Chiesa dei Cappuccini.

The idea of associating the painting in Cremona with Caravaggio's last phase is Longhi's (1943 a, p. 17; see also I. Camelli, 1930, p. 786, who notes, without verification, the existence of other copies of the picture, in Cremona). Longhi at first proposed that the Cremona *Saint Francis* was an "old, good copy," an opinion expressed again in the catalogue of the 1951 exhibition in Milan (pp. 41 f., no. 60). Later, Longhi (1952, p. 42) suggested that the Cremona painting might be a damaged original, but, subsequently (1960, p. 36, n. 12), he returned to his initial idea. His opinion has been shared by the majority of scholars (see M. Cinotti, 1983, p. 423). Recently, Hibbard (1983, p. 287) proposed that the painting is by a North Italian follower of Caravaggio. Mahon (1951 a, p. 234, n. 125) was the first to suggest that the Cremona *Saint Francis* was a damaged, although autograph, picture, painted "hurriedly . . . but a

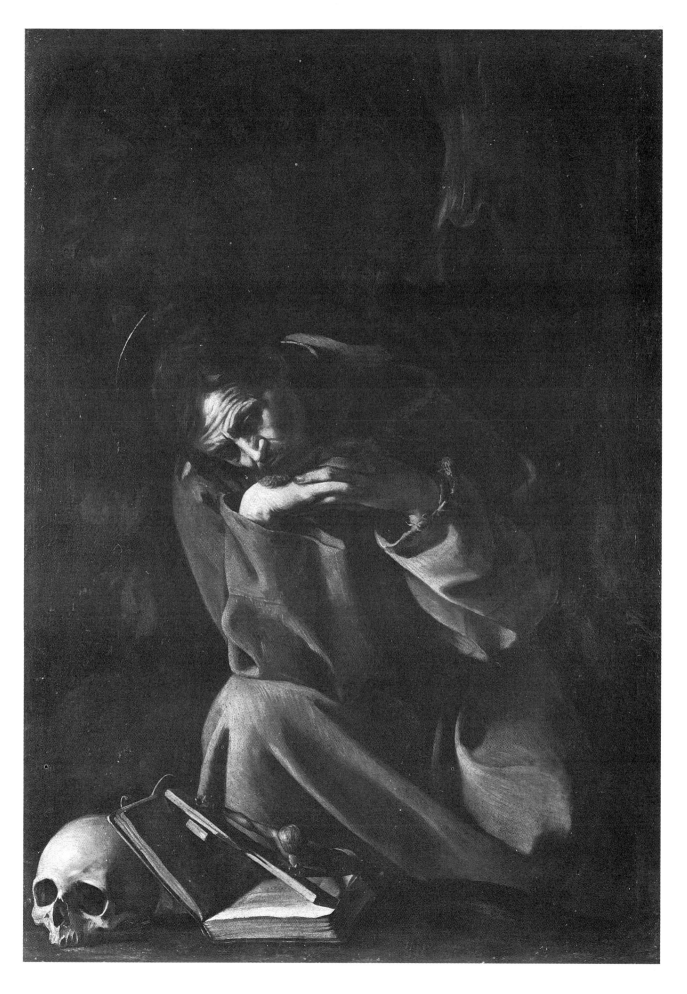

fine work." He noted that the treatment of the flesh areas has parallels in such Neapolitan paintings as the *Seven Acts of Mercy* (the *Samson*; see fig. 13, p. 44) and the *Flagellation* (cat. no. 93). Among those who consider the picture to be by Caravaggio are Baumgart (1955, pp. 44 f., 109, no. 62), Marini (1974, pp. 186, 401 f., no. 50; 1979, p. 36, n. 2, p. 74, n. 1, p. 76, n. 5), Röttgen (1974 b, pp. 208, 211, 213, figs. 86, 109), Nicolson (1979, p. 32), and Testori (1983, p. XVI). The most probable date for the *Saint Francis* is immediately after Caravaggio's flight from Rome, during his stay at the Colonna estates in Zagarolo in the summer of 1606 (R. Longhi, 1952, p. 42; and M. Cinotti, 1971, p. 132; 1983, p. 423), and at the beginning of his first Neapolitan period (D. Mahon, 1951 a, p. 234, n. 25). For other suggested dates, see Cinotti (1983, p. 423). It is worth recalling that Mancini (about 1617–21; 1956–57 ed., I, p. 225) refers to a "Christ on the way to Emmaus that was bought in Rome by Costa," which had been painted by Caravaggio at the Colonna estates. The Costa inventories mention no such picture, and Mancini's notice may, instead, indicate simply that Costa purchased pictures that the artist sent to Rome from his exile. These could have included the "Saint Francis" cited in Costa's 1639 inventory. Taking into consideration the likely date of the Cremona *Saint Francis*, its identification with the Costa picture is at least possible (see also M. Marini, 1979, p. 74, n. 1). The absence of copies suggests that the picture was not readily available to artists (F. Rossi, 1973, p. 94).

No satisfactory technical or stylistic analysis of the painting has yet been made, and the matter is certainly not helped by the yellowed varnish. The picture was restored in 1954: Although it was not overcleaned, restorations are visible—for example, in the hair. As in the Chiesa dei Cappuccini version of the subject, Caravaggio has turned his attention from the saint's stigmatization, depicted in the early, Hartford picture (cat. no. 68), to the saint meditating on a crucifix and on death. This "tragically autobiographical" theme (R. Longhi, 1943 a, p. 17) accords with Caravaggio's anxiety following the death of Ranuccio Tommasoni and the artist's subsequent flight from Rome. Toward the end of his Roman period, Cara-

vaggio returned to the theme of penitential saints, frequently representing them in a wild, outdoor setting to underscore their isolation. Here, however, he goes well beyond what he had heretofore shown, seemingly identifying himself emotively with Saint Francis, who is completely absorbed in meditation—almost as though the artist were transferring to the saint his own sense of guilt and his own wish to expiate his sins and do penance. The conception of Saint Francis's habit—and Caravaggio's brightly lit, unified rendition of it—is the counterpart to the still life of devotional objects, and here Caravaggio seems to transcend the classical gravity of the works of his last Roman years. Nonetheless, there are, both in the picture's constituent elements and in its execution, similarities with such late Roman works as the *Agony in the Garden* (destroyed) and the two versions of the *Saint John the Baptist* (one in the Pinacoteca Capitolina; the other in Kansas City, cat. no. 85). Saint Francis's head and hair recall the head and hair of the sleeping apostle at the right in the *Agony in the Garden* (M. Cinotti, 1971, p. 197, n. 481), and the dense painting of the habit and the brilliant highlights on its edges, as well as on the book, are not far removed from analogous passages in the above-cited works.

A fresh, in-depth examination of the picture confirms that it is an autograph work. The long, sure brushstrokes in the broad, luminous areas of the painting and in the curves of the drapery folds are characteristic of Caravaggio's style. The wrinkles on the saint's forehead and the highlights on his eyelids are painted in a new way, with a variety of tones, and the sharp nose is constructed with consummate conciseness in much the same manner as the physiognomy of the pilgrim in the *Seven Acts of Mercy* (see fig. 13, p. 44) and of Saint Jerome, in the painting in the museum of the Co-Cathedral of Saint John in La Valletta, Malta; the latter has close, often-noted ties with works from Caravaggio's first Neapolitan period. The skin on the bent wrist is described with dense touches of paint. Further evidence of the picture's autograph status is provided by the sparse beard, painted over the light tone of the hand.

M. G.

89. The Magdalen in Ecstasy

Oil on canvas, 41 7/8 x 35 7/8 in.
(106.5 x 91 cm.)
Private collection, Rome

The Magdalen is represented in three-quarter view, with her reddish-blonde hair untied; its heavy, compact mass is depicted with great efficacy. Her body and her head are thrown back, tears flow from her half-shut eyes, and tension is visible in her furrowed brow, her neck, and her hands—all of which express her grief, penitence, and the absorption of the senses in a state of ecstasy (F. Bardon, 1978, p. 207, n. 4). The subject has sometimes been described as the "dying Magdalen" (see D. Bodart, 1966, p. 125, n. 27, on ecstasy as fainting and agony). Cleaning of the picture has revealed a cave in the background, with vegetation growing from its crevices.

Longhi (1935 a; 1972 ed., p. 6) at first considered a version of the composition signed by Louis Finson (in the Musée des Beaux-Arts, Marseilles; published by A. von Schneider, 1933, p. 88) to be an original by Caravaggio, to which the Flemish artist put his name. Later (1943 a, p. 16), Longhi recognized that the Marseilles picture was a copy by Finson after a lost original, noting in it the "Caravaggesque inversion of the canonical values of sculptural chiaroscuro," which Caravaggio had already employed in the *sottinsù* raking light on the head of the Madonna in the *Death of the Virgin* (fig. 12, p. 43). Despite this precedent in his own work, it is probable that in the present painting of the Magdalen Caravaggio recalled a similar lighting effect in the *Dying Cleopatra*, an important Florentine invention deriving from Rosso (B. Fredericksen, 1984, pp. 323 ff.) that is known through a number of versions dating from the late sixteenth century; in one (illustrated in E. Camesasca, 1966, pl. xxi f.), a cross is included, transforming the subject into a penitent Magdalen. A version at Hampton Court seems to be identifiable with a picture mentioned in Van der Doorf's inventory of the collection of Charles I of England as a work painted in Naples by Aert Mytens. Benedict Nicolson brought this picture to the present writer's attention, noting its relationship to Caravaggio's *Mag-*

dalen (M. Gregori, 1976 a, p. 677, n. 27; 1983, p. 52). Mytens was interested in such lighting effects, as demonstrated by his *Crowning with Thorns*, known through a number of replicas. Caravaggio may have seen either the prototype or a derivation such as Mytens's while on a possible initial visit to Naples during the period of his refuge at the Colonna estates in 1606, or later—after his move to Naples.

Isarlo (1941, p. 132; 1956, p. 134) and Styns (1955, p. 8) both insisted that the composition of the *Magdalen* was Finson's, but Ainaud de Lasarte (1947, pp. 393 ff.) noted another version in the collection of Santiago Alorda in Barcelona, signed by Wybrand de Geest with an inscription that vindicated Longhi's hypothesis: Imitando Michaelem Angelum Carrava . . . / Mediolan. / Wybrandus de Geest / Friesius / A° 1620 (Wybrand de Geest "the Frisian," imitating Michelangelo da Caravaggio of Milan, 1620). Numerous copies (which vary in the representation of spatial relationships, in luminosity, and in the inclusion of details such as a skull, cross, or an ointment jar), as well as free derivations, have been cited by Longhi, Ainaud de Lasarte, Bodart, Marini, and Moir (see M. Cinotti, 1983, pp. 542 f.). These testify to the interest inspired by Caravaggio's *Magdalen*, the most frequently copied of any of his works (A. Moir, 1976, p. 140, n. 11) and "one of the most pregnant inventions of the entire Seicento" (R. Longhi, 1943, p. 17). In its profound visualization of a state of ecstasy, the *Magdalen* looks back to Caravaggio's early *Stigmatization of Saint Francis* (cat. no. 68). The picture has been seen as prefiguring Baroque, Berninian representations (see J. Thuillier, 1978, p. 69, n. 95; and H. Hibbard, 1983, p. 323, who cites an unpublished paper on Bernini and Caravaggio that he read at a colloquium in 1980). The invention—for which the mediocre Finson can scarcely have been responsible (G. Pariset, 1948, p. 378, n. 8)—gained currency in Italy and in southern France, where Saint Mary Magdalen was especially venerated. Among the copies is one signed by Finson and dated 1613, in a private collection in Saint-Rémy-de-Provence—perhaps the painting formerly owned by Michel Borrilly of Ventabren (D. Bodart, 1970, p. 96, n. 5).

It was Longhi (1943 a, p. 17) who first identi-

fied the picture with a *Magdalen* that, according to Caravaggio's early biographers, was painted at the Colonna estates in 1606, after the artist's flight from Rome; this hypothesis has been widely accepted. Mancini (about 1617–21; 1956–57 ed., I, p. 225) states that Caravaggio "stayed first in Zagarolo, where he was sheltered secretly by that prince, and where he painted a Magdalen and a Christ going to Emmaus that Costa bought in Rome . . . [and] with this money he went on to Naples, where he produced some works" ("di primo salto fu in Zagarola, ivi trattenuto secretamente da quel Prencipe, dove fece una Maddalena e Christo che va in Emaus che lo comprò in Roma il Costa . . . [e] con questi denari se ne passò a Napoli dove operò alcune cose"). The *Magdalen* is also mentioned by Baglione (1642, p. 138) and by Bellori (1672, p. 208); the latter records that the composition showed a half-length figure, and this, in itself, is a strong argument for identifying it with the present picture—of which so many copies are known.

It is more difficult to trace the subsequent history of the painting and to establish where it might have been available for copying. One hypothesis is that, unlike the *Emmaus*, which was sent to Rome to be sold, the *Magdalen* was kept by the Colonna. At Zagarolo—or, according to Baglione, at Palestrina—Caravaggio was taken in by Don Marzio Colonna, who was a relative of the Marchese di Caravaggio and who is mentioned by Bellori; Caravaggio may also have found shelter with one of the Colonna of Paliano, a locale mentioned by the Duke of Mantua's envoy in a letter of September 23, 1606 (see M. Cinotti, 1971, pp. 80, 160, F 77). According to another hypothesis (R. Longhi, 1951 d, p. 31), the *Magdalen* was sent to Rome, where it was possibly copied in 1620 by Wybrand de Geest. De Geest is documented in Rome between 1614 and 1618; he may not have returned to Holland until 1621. Longhi also believed that the picture was referred to in an epigram by Silos (1673, p. 90, no. 162) as in the collection of Vincenzo Giustiniani; Bodart (1970, p. 98), however, points out that in the Giustiniani inventory, published by Salerno (1960, p. 135), the picture is described as showing the Magdalen full-length. Moir (1976, p. 148, n. 247) has

noted derivations in the work of Caravaggesque painters in Rome (for example, the use of light in the two versions of Saraceni's *Saint Sebastian* in the Glasgow Art Gallery and the National Gallery, Prague), but he does not exclude the alternative hypothesis—now more generally accepted—that the *Magdalen* was in Naples, where Finson could have copied it. Finson was in Naples between 1604 and 1612 and could even have known Caravaggio personally (R. Longhi, 1935 a; 1972 ed., p. 6). Finson's copy of the picture, in the Musée des Beaux-Arts, Marseilles—according to Bodart (1970, p. 96), the picture was one of twenty sent there from Paris in 1804—does not bear the date 1612, contrary to what has been stated, and perhaps it never was dated. Finson may, therefore, have painted it in Naples, where De Geest might also have seen it. The provenance of the copy in the Cutolo collection in Naples—smaller and with variations—is Solofra, near Avellino (G. Scavizzi, 1963, p. 20), which tends to confirm the Neapolitan origin of the original. Oreste Ferrari has attributed this copy to Francesco Guarino, while Raffaello Causa ascribed it, more plausibly, to Niccolò de Simone (see G. Scavizzi, 1963, pp. 194 f.).

Longhi (1951 a, pp. 17 f., fig. 3) published and proposed as the original another version of the composition, which he knew through a photograph sent to him from Naples by Antonio de Mata several years earlier. (De Mata had restored the picture about 1940, when it was in a private collection in Palermo; about 1930, it had belonged to a German painter in Rome named Tannenbaum.) Longhi hoped that publication would lead to the discovery of its owner, but the picture is still untraced. Yet, even the knowledge of the photograph has provided a better and deeper understanding of this exceptional invention of Caravaggio's.

Some years later, at "Caravaggio e Caravaggeschi" in Naples (G. Scavizzi, 1963, pp. 19 f., n. 7, fig. 7 a), the present picture—which then belonged to Giuseppe Klain—was exhibited as a copy. In the nineteenth century, the painting, traditionally attributed to Caravaggio, was owned by the Principessa Carafa-Colonna of Naples who had inherited it. About 1873, it was sold to the canon Michele Blando; after his death in 1936, it

was inherited by Klain (M. Marini, 1974, p. 418; 1978, p. 45; B. Nicolson, 1974, p. 624). On the occasion of the exhibition, Scavizzi called attention to the picture, noting the drapery over the saint's legs (a detail that is not visible in the photograph of the version published by Longhi), the rapid execution of the white shirt, the taut curve of the neck, and "the reflections of light on the cheeks and in the eyes." At Marini's urging, the picture was cleaned by Pico Cellini in 1972 (see M. Marini, 1975, p. 420, no. 62). The canvas itself is of the Neapolitan "laziale" type, which Caravaggio used for the *Death of the Virgin* and for the Brera *Supper at Emmaus* (cat. no. 87: see M. Marini, 1974, p. 421, who also comments on the consequent craquelure). Following the restoration, Marini (1974, pp. 212 f., 418 ff., no. 62; 1978, p. 15; 1980, p. 52, no. 58; 1981, p. 416) published the picture as the original—an opinion shared by Cellini, Bodart (but see Bodart's subsequent, modified view, reported by M. Cinotti, 1983, p. 544), the present writer (M. Gregori, 1975, p. 28; 1976 a, pp. 676, n. 20, p. 677, n. 27; 1976 b, p. 869; 1983, p. 53), and Zeri (see M. Gregori, 1976 a, p. 676, n. 20). Nicolson (1974, p. 624, fig. 91) maintained doubts, but considers it the best known version (1979, p. 33). Bardon (1978, pp. 206 f., n. 4) rejects the picture, while Moir (1976, p. 112) proposes, without sufficient evidence, that its author is Angelo Caroselli. Cinotti (1983, p. 544) has suspended judgment pending the reappearance of the version published by Longhi.

Unfortunately, a comparison of the present picture with the version published by Longhi—of which there is only the one, not particularly good, photograph—is not possible. The case thus turns on the intrinsic qualities of the ex-Klain picture, an evaluation of which will be facilitated by the inclusion of the painting in the present exhibition. Cleaning has enhanced the effect of the raking light that strikes the Magdalen's forehead, and the severity, which results from the play of reflected light captured by means of the artist's indescribably acute perception. The light is the outgrowth of a procedure already experimented with in the Vienna *Crowning with Thorns* (cat. no. 90). The face and neck, silhouetted against the dark background, are powerful-

ly conceived. The variations in thickness of the surface of the paint along the neck, visible to the naked eye, are caused by a slight pentimento. The reddish colored hair, arranged in a thick, compact mass, is characteristic of Caravaggio's female models. An analogy for the long, rapid brushstrokes in the folds of the shirt is found in the white drapery in the Montserrat *Saint Jerome* (cat. no. 84). As Marini (1974, p. 212) has noted, there is a pentimento, apparent to the naked eye, but even more evident in X-rays: The index finger of the left hand has been raised, leaving its trace upon the middle finger of the right hand.

Generally, the work is dated to 1606 through its association with the half-length *Magdalen* Caravaggio is said to have painted at the Colonna estates. This seems the most acceptable hypothesis, although the picture has features in common with later paintings (see M. Gregori, 1976 a, p. 676, n. 20, p. 677). The motif of intertwined fingers, employed in the *Taking of Christ* (a copy is in the State Museum, Odessa) and in the Cremona *Saint Francis* (cat. no. 88), also approximates the gesture of a bystander in the *Burial of Saint Lucy* in Syracuse. The grief that devastates the Magdalen's features equals in intensity the emotion displayed by the David in the Borghese *David and Goliath* (cat. no. 97). It is also worth noting that the detail of the Magdalen's nearly closed eyes, which express her bewilderment in the face of death, recurs in a painting of the beheaded Saint Gennaro, in Sant'Antonio Abate, Palestrina. This would seem to confirm Marini's proposal (1971, pp. 57 f.; 1974, pp. 278, 456, no. 90) that the painting of Saint Gennaro is a copy of a lost original by Caravaggio, perhaps identifiable with the "bishop saint, his head decapitated . . . an original by Caravaggio" ("Santo obispo la cabeza degollada . . . original de Carabacho") mentioned in the 1653 inventory of paintings belonging to the Conde de Benavente (J. Ainaud de Lasarte, 1947, p. 381, n. 3; E. García Chico, 1946, pp. 393 f.; see also cat. no. 99).

M. G.

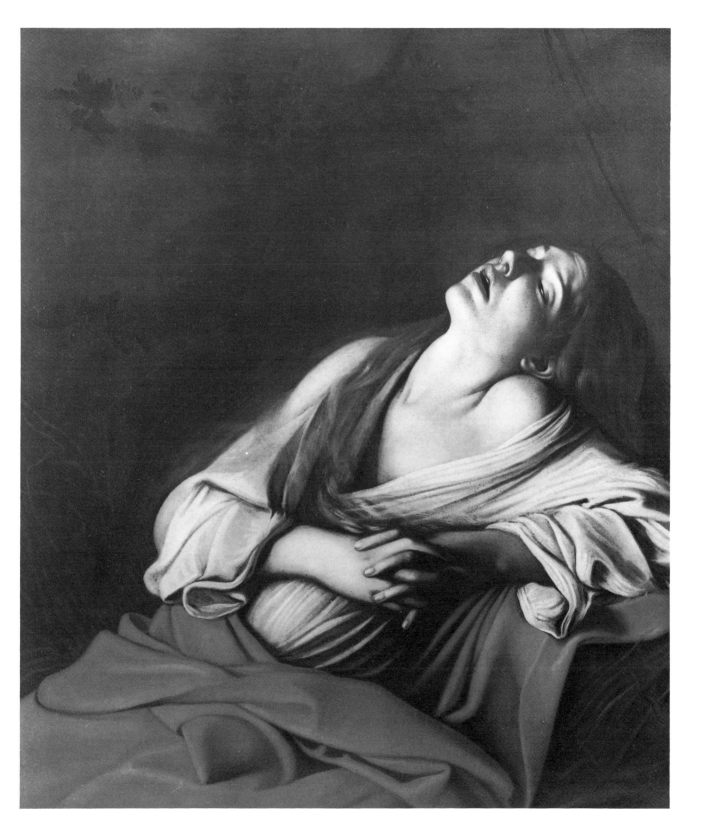

90. The Crowning with Thorns

Oil on canvas, 50 x 65 1/8 in.
(127 x 165.5 cm.)
Inscribed (lower left): 302
Gemäldegalerie, Kunsthistorisches
Museum, Vienna

The composition, consisting of four figures in a horizontal format, corresponds to a painting by Caravaggio described in the 1638 inventory of the property of the Marchese Vincenzo Giustiniani (1564–1637), where it is listed as number 3 in the *Stanza grande de quadri antichi*: "A painting over a door with Christ Our Lord crowned with thorns, [composed of] four half-length figures, painted on canvas, 5 1/2 *palmi* high, 7 1/2 *palmi* wide, from the hand of Michelangelo da Caravaggio, with a frame edged and decorated with gold" ("Un quadro sopraporta con la Incoronat.ne de spine di Xpo N. signore 4 mezze figure dipinto in tela alto pal. 5 1/2 lar. pal. 7 1/2 di mano di Michelang.o da Caravaggio con sua cornice profilata, e rabescata di oro": see L. Salerno, 1960, p. 135. Bellori (1672, p. 207) refers to a painting by Caravaggio for Giustiniani of *The Crowning with Thorns*, and Silos (1673, p. 88, no. 158) dedicated an epigram to it, the first two lines of which allude to a detail that is seen in the Vienna painting: "Behold here the Lord with his head crowned with thorns, and a stream of blood that flows over his cheeks" ("Aspicis hic Dominū redimitū tempora dumis, / Itque, per irriguas sanguinis unda genas"). The measurements of the Vienna picture correspond closely to those given in the Giustiniani inventory (see H. Hibbard, 1983, p. 291, no. 41, and M. Cinotti, 1983, p. 565, both of whom read the measurements in the inventory as 5 1/2 x 7 1/2 *palmi*—that is, as 48 3/8 x 66 inches; L. Salerno, 1960, p. 135, read the measurements as 5 x 7 *palmi*, and maintained that the Vienna painting was too large to be identified with the Giustiniani picture). The painting was purchased in Rome in 1816, about the time that the Giustiniani collection was dispersed (in 1812, a large part of the collection was sent to Paris, but the *Crowning with Thorns* is not mentioned in the published catalogues: see W. Friedlaender, 1955, p. 222): This is another indication that the Vienna and

Giustiniani paintings may be identical. That the Vienna *Crowning with Thorns* is the one referred to by Bellori, or a copy of it, is further suggested by the existence of many derivations of the composition by Caravaggesque painters active in Rome, such as Manfredi, Valentin, and Baburen (see E. Borea, 1970, pp. 16 f., no. 7, who traces these derivations to the Giustiniani canvas or to another, unidentified, original by Caravaggio; M. Marini, 1974, p. 369, no. 26; A. Moir, 1976, pp. 146 f., no. 245; and A. Brejon de Lavergnée, 1979, p. 306). Marini (1974, pp. 124, 369, no. 26; 1978, p. 36, n. 2; 1980, p. 28, no. 23, with greater decisiveness; 1981, p. 366) and Cinotti (1983, p. 565) accept both the identification of the Vienna picture with the Giustiniani canvas and its status as an autograph work by Caravaggio. Some have considered the painting in Vienna a copy of the Giustiniani picture.

The attribution of the Vienna *Crowning with Thorns* is still much debated; however, prevailing opinion relates it in some way to Caravaggio. Catalogued by the Kunsthistorisches Museum as the work of a follower, it was judged by Kallab (1906–7, p. 291) to be a copy after Caravaggio. Voss (1912, p. 62) published it, together with a *Way to Calvary* (also in the Kunsthistorisches Museum), as the work of a Roman follower. Longhi (1915; 1961 ed., pp. 182 f.) at first considered it to be by the young Caracciolo —"little more than a free copy, like the *Flagellation* of Catania, after Caravaggio's original in San Domenico" (cat. no. 93); later (1943 a, p. 18), he regarded the Vienna *Crowning with Thorns* as a copy of a painting from Caravaggio's Neapolitan period. Subsequently, Longhi (1960, p. 31) dated it shortly after the canvases in the Cerasi Chapel in Santa Maria del Popolo, Rome, and, ultimately (1968, p. 42), judged it to have been painted by Caravaggio in Naples. Longhi's vacillation is characteristic of the uncertainties that, in general, surround the picture's attribution, its date, and the identification of the place where it was painted. Among the various opinions, that of Mahon (1951 a, p. 234) should be mentioned: He believed the picture to be by an independent artist who had closely studied Caravaggio's Roman work after 1600 and who was also influenced by Gentileschi. The re-

	1	
2	3	4

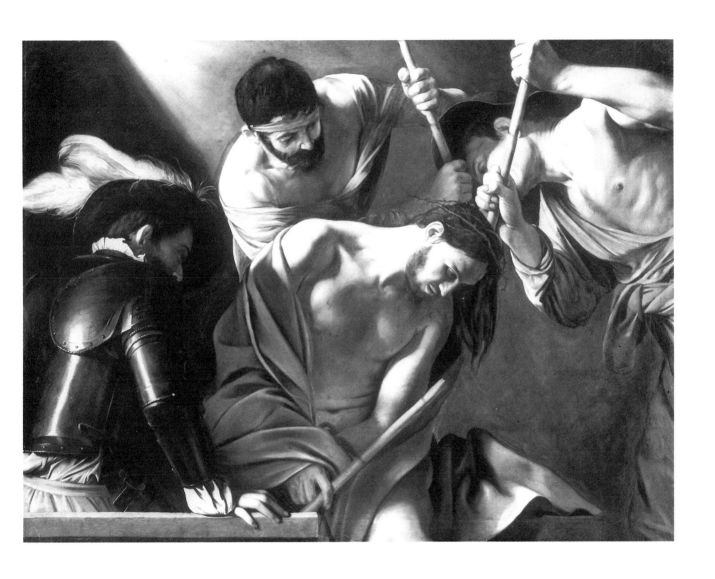

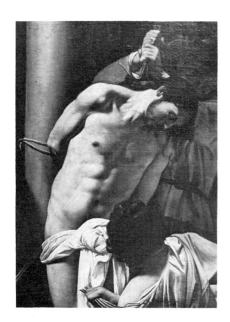

1. Copy after Caravaggio. *The Flagellation.*
Camuccini collection, Cantalupo Sabina (Rieti)

lationship to Roman paintings by Caravaggio was accepted by Hinks (1953, p. 111, no. 40), Kitson (1969, p. 105, no. 78), and, as noted above, by Longhi (1960, p. 31) and Marini (1974, pp. 124, 369, no. 26; 1981, p. 366, where he attributes it to Caravaggio and dates it 1598). Nonetheless, most critics consider it to be a Neapolitan work, regardless of whether they judge it to be a copy after a lost picture by Caravaggio (W. Friedlaender, 1955, p. 222; R. Jullian, 1961, pp. 175, 182, no. 40, p. 232; B. Nicolson, 1979, p. 32, who calls it either an original or an excellent copy, possibly by Caracciolo), an autonomous creation by a very good Neapolitan artist, such as Caracciolo (M. Cinotti, 1971, p. 136), influenced by the Naples *Flagellation*; or an original painting by Caravaggio (M. Gregori, 1976 a, p. 675, n. 17). Moir (1967, I, p. 158, n. 18) proposed, not convincingly, that it was an early work by Manfredi or (1976, p. 111, no. 65) by Biagio Manzoni. Implicit in Cinotti's argument, cited above, is the fact that the picture does not have the character of a copy, and this is decisive. Indeed, the picture exhibits neither Caracciolo's manner nor that of any other major Caravaggesque painter.

If one accepts the identification of the Vienna *Crowning with Thorns* with the Giustiniani painting, which seems plausible, it should be noted that the work was more likely to have been purchased in Naples than actually painted for the marchese, as Bellori would have it (the same sort of inexactitude occurs in Bellori's comments about the Caravaggios in Scipione Borghese's collection: see cat. nos. 78, 97). There are, in fact, a number of reasons for rejecting the idea that the picture was painted in Rome, and for dating it, instead, to Caravaggio's Neapolitan period: Foremost among them are the correspondences with the Naples *Flagellation* and with another *Flagellation* that is known through copies in the Pinacoteca Civica, Macerata, in the Museo Civico, Catania, and in the Camuccini collection in Cantalupo Sabina (fig. 1). The last work seems to stand midway between the Vienna *Crowning with Thorns* and the Naples *Flagellation*. The luminous setting of the Vienna picture, with the light falling from above, and the relatively thin handling (M. Marini, 1974, p. 369, no. 26, thought

the picture unfinished) recall similar features in the *Madonna of the Rosary* (in the Kunsthistorisches Museum, Vienna) and the *Seven Acts of Mercy* (fig. 13, p. 44). The distribution of light and shadow on Christ's forehead repeats the tragic characterization of the Magdalen's face (see cat. no. 89), but the picture's autograph status is revealed in less obvious passages as well: the refraction of the light in the half-shadows of Christ's armpits and chest, and of the chest of the torturer at the center, where the dark contours delineate the anatomical details; the rapid and powerful characterization of the inclined head of the figure at the center, modeled with variously colored touches; and the dense, pictorial shadows on the shirt of the soldier at the left. This soldier prefigures Aegeas in the *Crucifixion of Saint Andrew* (cat. no. 99) in the lighting of his armor by means of vertical bands that fade toward the edges, in the illusionistic projection of his elbow, and in his general compositional function. In the area around the right shoulder of the center figure, the background is painted somewhat differently for a space of several centimeters. Rather than a pentimento, this is probably a result of Caravaggio's technique of delimiting the contour of a nude figure in the final stages of execution. X-rays furnish further evidence in favor of the attribution of the picture to Caravaggio.

M. G.

91. The Flagellation

Oil on canvas, 53 x 69 1/8 in.
(134.5 x 175.5 cm.)
Musée des Beaux-Arts, Rouen

92. The Flagellation

Oil on canvas, 52 x 67 3/4 in.
(132 x 172 cm.)
Private collection, Switzerland

As is usual with Caravaggio, the theme of these two pictures is treated dynamically, with the figures shown three-quarter length and the action directed from right to left, parallel to the picture plane. Christ is placed to the left of the central axis, with the two torturers to the right. Thus, the central-ized scheme preferred in Cinquecento painting—the most important example is Sebastiano del Piombo's *Flagellation* in San Pietro in Montorio, Rome, which Caravag-gio's *Flagellation* in Naples (cat. no. 93) recalls—is not pertinent. Rather, such Northern representations as the scene—quite different, however—from Dürer's "Small Passion" series provided Caravaggio with a precedent. Dürer's treatment of the subject had been adapted in Northern Italy by Romanino, for example, in his fresco in the cathedral of Cremona. Typically, Cara-vaggio depicts the moment when the prepa-rations for Christ's torture are about finished and the actual flagellation has just begun: The torturer at the right ties the hands of Christ, as his companion grasps Christ's hair—a gesture that recurs in the Prato *Crowning with Thorns* (cat. no. 81) and in the Naples *Flagellation*—while hold-ing the whip in his raised hand. Although there are no clear signs of wounds on Christ's flesh, Longhi (1960, p. 26) rightly observed that in the Rouen picture Christ's torso is painted with a mixture of colors suggesting "injuries, and it begins to show the blood from the first lashes."

Longhi (1951 d, pp. 28 f.) was the first to recognize this composition as Caravaggio's, on the basis of a mediocre copy that he saw in Lucca in 1942, and which, later, was in a private collection in Rome. As in other, similar cases, his proposal raised a general methodological question, pointed out by Baumgart (1955, p. 112, no. 8), of identify-ing an original through a copy. Baumgart

denied that the composition was Caravag-gio's, noting—without basis—that it had a Bolognese flavor. Other scholars (R. Hinks; W. Friedlaender) passed the matter over, thereby implicitly denying the paternity of the composition; Mahon maintained an attitude of "wait and see." Subsequently, he (D. Mahon, 1956 a, pp. 25 ff.; 1956 b, pp. 225 ff.) published the privately owned ver-sion discussed here—of considerably high-er quality than the Lucca copy—as the orig-inal, approving Longhi's thesis and credit-ing the importance of his intuitive identi-fication. Mahon considered the picture to date well into the artist's mature phase, and he observed that in the half-lit features of the central figure the ground had been left exposed for expressive effect. According to Mahon, this technique was unusual for the time and was not imitated by Caravaggio's more conventional followers. It becomes noticeable, alongside fully painted areas, in the *Madonna dei Palafrenieri* (in the Galle-ria Borghese), which was completed in April 1606, and in other contemporary works: in the *David with the Head of Goliath* (cat. no. 97), which is now dated somewhat later; the Brera *Supper at Emmaus* (cat. no. 87); in the figure of Samson in the *Seven Acts of Mercy* (fig. 13, p. 44); and in the *Beheading of Saint John the Baptist*, of 1608 (fig. 14, p. 45), in which Bellori (1672, p. 209) had com-mented upon just this technical feature. The climax of this novel "impressionism" is the Messina *Raising of Lazarus* (fig. 15, p. 46), of 1609 (for earlier examples of the phenomenon in Caravaggio's work and the Lombard origin of this use of the ground, see cat. no. 71). Taking into consideration the dominant colors, Mahon (1956 a, p. 33, n. 20; 1956 b, p. 227, n. 20) dated the painting to 1605–7.

Longhi examined the privately owned ver-sion sometime after its publication by Mahon, and he was convinced that it, too, was not the original. In the meantime, in 1957, the Musée des Beaux-Arts in Rouen purchased another version of the *Flagella-tion*, which Mahon judged to be a copy of the painting he had published. Attributed to Mattia Preti, the Rouen picture was pub-lished by the director of the museum, Guil-let (1956, pl. 9), referring to Longhi's article of 1951, as a replica by Caravaggio or an old copy. The Rouen painting came from a pri-

vate collector, Jean Descarsin, who lived near Paris and who had purchased the pic-ture the preceding year from the restorer, Georges Zerzos. According to Rosenberg (1966, p. 174), it had been sold about 1950 at the Hôtel des Ventes, Paris, to M. Stuart de Clèves. Longhi studied this picture on December 17, 1959, and published it (1960, pp. 23 ff.) as the original version, noting that, in raking light, incisions are visible in various parts; Moir (1976, p. 158, n. 279) has specified that they occur along the con-tours of the right-hand torturer and around the head of the central figure. This technical feature would seem to be an attempt to fix the distance between the principal forms in the composition, in order—according to Longhi (1960, p. 27)—to "find in each place the proper pose for the models, viewed in a tone of light." For Longhi, the Rouen picture had neither the excessively forced anatomy of the Lucca copy, nor the excessive softness of the privately owned version published by Mahon (that picture, however, has been damaged in the body and the loincloth of Christ), and it is dis-tinguished for the severity of the shadows, the vibrant highlights, and for such percep-tively observed details as the shadow cast by the nipple on Christ's breast and the depic-tion of his ribs.

The Rouen *Flagellation* was exhibited in Paris in 1965–66 (P. Rosenberg, 1965, pp. 46 ff.), after cleaning, as the autograph ver-sion, and it has subsequently been exhib-ited in Cleveland; Spear (1971 a, pp. 76 f.) considered the incised lines proof of its autograph status. The painting has attracted both supporters and detractors: see Cinotti (1983, p. 545) for the various opinions. Most recently, Salerno (1984, p. 440) has come out in favor of the privately owned version, and Hibbard (1983, pp. 325 f.) seems to agree with the doubts previous-ly expressed by Moir (1976, pp. 158 ff., n. 279), believing only the right-hand figure to be by Caravaggio. Mahon, both while ex-amining the privately owned picture with the present writer, and in a letter to her on March 1, 1984 (see also H. Hibbard, 1983, p. 326, n. 145), maintains that it is the orig-inal, and that in the Rouen version the right-hand figure is modeled in a more approximative way that is lacking in force; the contours are also less eloquent. Mahon

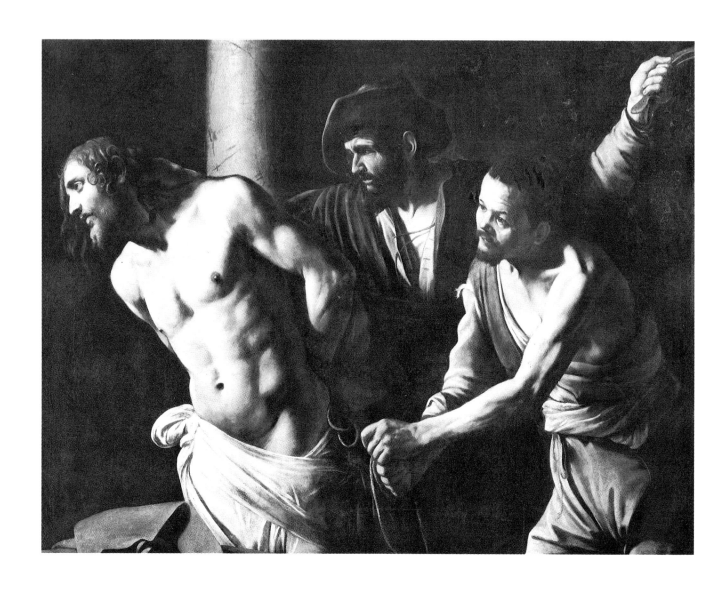

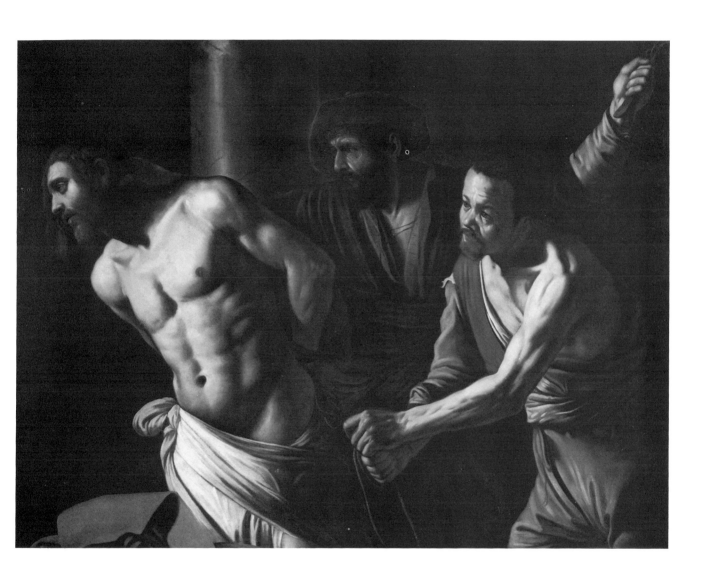

makes other observations concerning the central figure in the Rouen version: That it is more solidly painted, in contrast to the economy of means evident in the privately owned picture, which is more consonant with Caravaggio's mature style. Christ's torso, in places, lacks precise details, and his prettified head, with the curls and the lighting of the beard, are features that, Mahon notes, seem not to be repeated in either the Lucca copy or in another copy published by Marini (1974, p. 223, no. 65, E 3), and are at once singular and difficult to explain.

The presence of both versions here will make a comparison between the opposing positions of Mahon and Longhi possible. While the present writer recognizes the quality of the privately owned version, which was painted by an artist familiar with Caravaggio's late technique (the Neapolitan type of canvas might also be taken as an indication of this), she favors the Rouen picture as the autograph version. In it the emotive and vital power typical of Caravaggio is evident. Also typical of Caravaggio is the animated light that plays over the forms; the manner in which the whites are set off against the halftones of Christ's loincloth, painted with delicate brushstrokes that are even more noticeable in the shaded portion (in the privately owned version white is used more extensively); and the treatment of the trousers of the right-hand figure, and his dynamic silhouette. Although Christ's head is not attractive, the Tintorettesque curls, accented with light—Caravaggio painted the curl on the forehead of the Magdalen (cat. no. 89) with a similar emphasis—the delicate highlights and coloristic passages of his beard; the varied transparency of the half-shadows on his neck and his ear; the shape of the shadow where the neck joins the torso; his unforgettable, intense gaze; and the definition of the features in contrast to the dark tones, all indicate Caravaggio's authorship. The torturer at the center offers analogous characteristics. A pentimento is visible in the left side of this figure's jacket.

Neither version has a known provenance. Mahon (1956 a, p. 31; 1956 b, p. 227), recalling an observation of L. Venturi (1909, p. 39), noted that in the Borghese collection there was a "Cristo alla colonna" by Caravaggio that was referred to by Ma-

nilli (1650, p. 64) as in the Villa Borghese; by Sebastiani (1683, p. 23), as in the Borghese palace in the Campo Marzio; and again, by Montelatici (1700, p. 297), as in the Villa Borghese ("Nostro Signore flagellato da due manigoldi"). Cinotti (1983, p. 545) has shown that the picture is not listed in the 1693 Borghese inventory published by Della Pergola (1964), but there is no proof that the painting discussed by the above writers is the same as that under discussion (M. Marini, 1974, p. 123, n. 25, associates the Borghese picture with the *Flagellation* known through copies in the Museo Civico, Catania; the Pinacoteca Civica, Macerata; and one formerly in the Camuccini collection, Cantalupo Sabina; fig. 1, cat. 90).

Longhi regarded the date of the composition as contemporary with the lateral canvases in San Luigi dei Francesi—about 1595 (1951 d, p. 29) or the last years of the sixteenth century (1960, p. 27). Mahon (1956 a, p. 28; 1956 b, p. 227), basing his opinion on the privately owned version, dated the picture between 1605 and 1607, and he cited analogies in the execution of the *Madonna dei Palafrenieri*, as well as of the Brera *Supper at Emmaus* and of works from Caravaggio's Neapolitan period; his dating has been accepted by Spear (1971 a, p. 76). A date in Caravaggio's first Neapolitan period has found a number of adherents, including the present writer (M. Gregori, 1982, p. 39; and M. Cinotti, 1983, p. 545). Marini (1974, p. 223, n. 65, E 3) published another copy in a private collection in Naples that he considers indicative of the Neapolitan derivation of the original. Moir (1967, I, p. 54, n. 134), in reference to a passage in Baldinucci (1681–1728; 1845–47 ed., III, p. 745), points out that a "Cristo alla colonna" by Caravaggio was copied faithfully by Angelo Caroselli, and initialed. Among the various hypotheses is the suggestion—for which there is no proof—that this copy may be the same one that Longhi first saw in Lucca.

M. G.

93. The Flagellation

*Oil on canvas, 104 3/8 x 83 7/8 in.
(266 x 213 cm.)
Museo Nazionale di Capodimonte, Naples*

Berenson (1951, p. 38) was the first to identify the compositional source as Sebastiano del Piombo's mural in San Pietro in Montorio, Rome (see also W. Friedlaender, 1955, p. 206; G.A. Dell'Acqua, 1971, pp. 47 f.; H. Hibbard, 1983, p. 223). Analogies with a painting of the same subject in Santa Prassede, Rome—a work closely related to the art of Giulio Romano but attributed to Simone Peterzano (M. Calvesi, 1954, p. 131)—have also been noted. These recollections of sixteenth-century Roman prototypes are accompanied by classical echoes in the grandiose figure of Christ, which is inspired by an ancient Herculean torso, and in that of the foreground torturer, which Longhi (1952, pl. XLII) compared to the so-called Arrotino, the knife-sharpening Scythian slave in the Marsyas group in the Uffizi. However, in Caravaggio's Christ the heroic torso, with its majesty and sculptural beauty, has been transformed into a suffering, slightly heavy-set body not unlike that of the Christ in the Prato *Crowning with Thorns* (cat. no. 81). In stark contrast to the figure of Christ, on whom the light is focused, the torturers have a brutal aspect, transforming the representation of the event, which the Cinquecento had idealized, into a factual record of raw violence. Longhi (1928–29; 1968 ed., p. 127) noted an analogous, almost animalistic corporeality in the executioners of Antonio Campi's *Martyrdom of Saint Lawrence* in San Paolo, Milan.

Bellori (1672, p. 209) is the earliest of Caravaggio's biographers to describe the *Flagellation*, which he does immediately after his mention of the artist's arrival in Naples: "[Caravaggio] was commissioned to paint the flagellation of Christ at the column for the Di Franco chapel in the church of San Domenico Maggiore" ("Per la Chiesa di San Domenico maggiore gli fu data a fare nella cappella de' Signori di Franco la Flagellazione di Cristo alla colonna"). The picture is not mentioned by the anonymous annotator of Mancini (about 1617–21; 1956–57 ed., I, p. 340), who re-

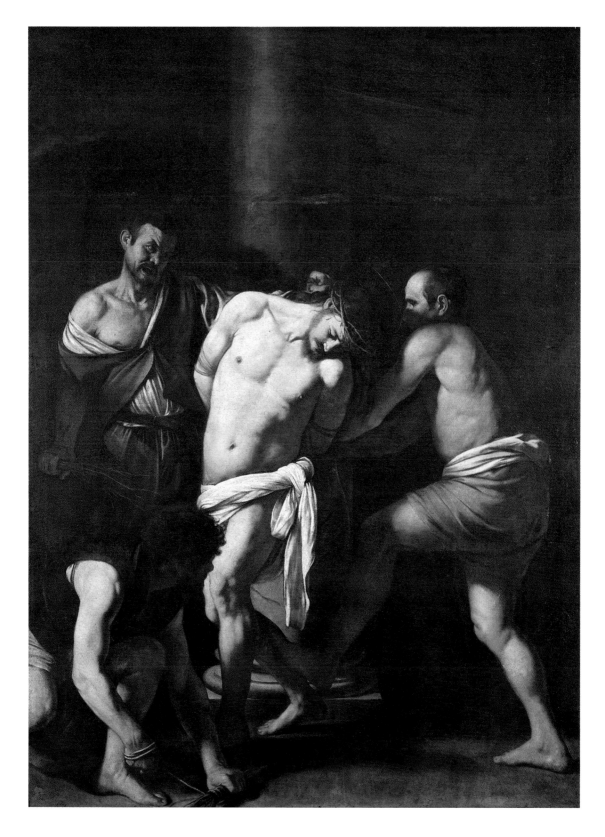

ports information furnished by Teofilo Gallaccini (died 1641) about Caravaggio's Neapolitan activity. Indeed, the *Flagellation* is not recorded in published Neapolitan sources prior to Celano's guidebook (1692, III, p. 458); it was probably not placed on view in the church until some time after Caravaggio had completed it. Baldinucci (1681–1728; 1845–47 ed., III, pp. 685 f.) repeats, inexactly, Bellori's information, but also adds that the *Flagellation* was the first work painted by Caravaggio upon his arrival in Naples. De' Dominici (1742–45, II, pp. 275 f.) provides an indication of the fame of the painting, which was much admired despite the "ignoble naturalism" ("naturale ignobile") of the figure of Christ. Dézallier d'Argenville (1745, p. 263) refers to it, but of far greater importance are the comments of Charles Nicolas Cochin (1763, p. 165), who, despite its darkened state, admired the picture's coloristic aspect (an area in which Caravaggio's merits were recognized) and considered it "bien composé" (a verdict that reflects Cochin's comprehension of features that modern scholars have also noted).

The *Flagellation* was painted for a chapel in San Domenico belonging to the Di Franco (or De Franchis), a well-to-do Neapolitan family (in the late sixteenth century, Giordano Bruno and Tommaso Campanella had stayed in the convent of the church, which was open to nonconformist cultural views: see R. Villari, 1967, pp. 76 f.). The picture was moved a number of times within the chapel and the church (see M. Marini, 1974, pp. 40, 58, 74, n. 307, p. 80, n. 417, pp. 297 ff., and, for more extensive information on these moves and on the building history of the chapel, V. Pacelli, 1977, pp. 823 ff.; 1978 b, pp. 59 ff.) prior to its removal to the Museo Nazionale di Capodimonte (R. Causa, 1972 a, p. 917; 1972 b, p. 963, n. 5). The first Di Franco Chapel, in which the altarpiece was probably placed, was given by Don Fernando Gonzaga, Prince of Molfetta, to the sons and heirs of the deceased Vincenzo di Franco in 1602. Beginning in 1632 the chapel was enlarged to include the neighboring one. Since construction went on for some time, the picture was probably kept in the house of the patrons, which could explain the absence of any mention of it in Naples before Celano

(1692). In 1652, the new chapel was dedicated to the "Flagellation of Our Lord"; it may be inferred that the picture was installed above the altar at that time. That it is not discussed by Carlo de Lellis, who gives an extensive description of the chapel in his *Parte seconda o'vero supplimento a Napoli Sacra di D. Cesare d'Engenio*, is explained by the fact that the book, published in 1654, had been completed earlier: It had been approved by the Curia on May 18, 1651, and by the Regia Camera on April 9, 1652 (V. Pacelli, 1977, p. 824; 1978 b, p. 61). In a later, still unpublished manuscript, of about 1672, in the Biblioteca Nazionale, Naples (XB 21, fol. 368), De Lellis describes the *Flagellation* as "the most beautiful work which that illustrious painter ever made," and he gives its dimensions as 12 by 8 *palmi* (about 106 x 71 inches).

In 1675, it was decided to move the *Flagellation* from its place above the altar to a lateral wall and to replace it with a statue of the Madonna by Pietro Cerasi; Celano (1692, III, p. 458) records that the picture hung on the Epistle side of the chapel. At the end of the eighteenth century or early in the nineteenth, the *Flagellation* was moved to the chapel of Saint Stephen and then to that of the Rosary, where De Rinaldis (1928–29, p. 54, n. 1) records it. Marangoni (1922 b, p. 50) and Voss (1924, p. 446) both noted its poor state of preservation, and several years later the picture was restored.

Pacelli (1977, p. 820; 1978 b, p. 59) has published two payments to Caravaggio, one by the Banco dello Spirito Santo and one by the Banco di Sant'Eligio, on behalf of Tommaso di Franco. The first, on May 11, 1607, was for 100 ducats—part of a total of 250 ducats for an unspecified work: "A Tomase di Franco ducati cento e per lui a Michelangelo Caravaggio dite ce li paga a compimento di ducati duecentocinquanta, atteso gli altri D. 150 l'have ricevuti contanti et sono in conto del prezzo di una [] che li havera da consignare a lui contanti ——D. 100." There is a lacuna in the document at the place where the nature of the commission was to have been specified, but given the sum involved it may be inferred that the picture must have been an altarpiece—probably the *Flagellation*. Contrary to the opinions of Marini (1978, p. 22) and

Hibbard (1983, p. 225), the payment was not a final one, since the work had not yet been consigned to the patron (Caravaggio had been paid 400 ducats for the *Seven Acts of Mercy*, fig. 13, p. 44). A second payment, for 40.09 ducats, was made on May 28, 1607 (and not May 29 or May 19, as V. Pacelli stated: see M. Marini, 1978, p. 40, n. 82, and M. Cinotti, 1983, p. 469): "Ducati 40,09 tramite Tomase de Franchis a Caravaggio." The payment was probably for the same work, though again there is no indication that it was the final payment; alternatively, it could have been for another painting (M. Marini, 1978, p. 23), although there is no trace of such a work in the inventory of Di Franco's paintings.

It is known that Vincenzo di Franco was president of the Sacro Regio Consiglio in 1590, and that after his death in 1601 a sepulchral monument was erected to him in the family chapel. His son Tommaso was Regio Consigliere and then president of the Regia Camera della Sommaria. Another son, Lorenzo, applied for admission, along with other nobles, to the Pio Monte della Misericordia on January 20, 1607, and his brother, Giacomo, requested—and obtained—a patent as Marchese di Taviano on May 22, 1612 (he had acquired the estate two years earlier). The commission for the *Flagellation* is likely to have been made through Lorenzo, since the Pio Monte della Misericordia had, some months earlier, commissioned the *Seven Acts of Mercy*, Caravaggio's first public work in Naples (for documentation, see V. Pacelli, 1977, p. 823, n. 14; 1978 b, pp. 59 f.).

The *Flagellation* was long considered a product of Caravaggio's first Neapolitan period. According to the chronology proposed by Longhi (1952, p. 42) and Mahon (1952 a, p. 19), it was the first work Caravaggio painted in Naples in 1607, while the *Seven Acts of Mercy* was the last—close in time to the *Beheading of Saint John the Baptist* in Malta. The affinities of the *Seven Acts of Mercy* with the *Beheading of Saint John* should not be underestimated, for they could indicate that the definitive execution of the *Flagellation* did not occur between the completion of one picture and the undertaking of the other. Longhi later (1959, p. 29) proposed hypothetically that

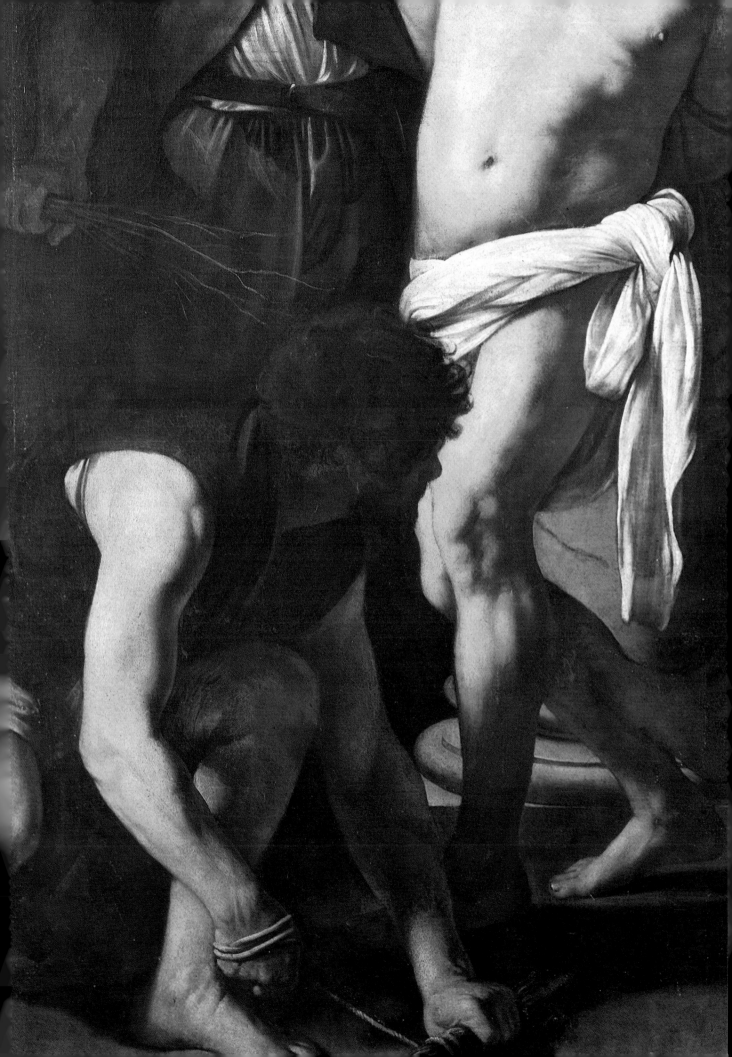

Caravaggio painted the *Flagellation* during his second Neapolitan period. This opinion has been followed by a large number of scholars, while others have held to the traditional dating (see M. Cinotti, 1983, pp. 469 f.). The publication of the Di Franco payments of May 1607 would seem to have solved the matter definitively by establishing that Caravaggio painted the picture at the conclusion of his first Neapolitan period. However, by July 13 or 14, 1607, Caravaggio had already been in Malta for some time (J. Azzopardi, 1978, pp. 18 f.), and it may be argued whether he would have had time to complete the Di Franco picture. According to Cinotti (1983, p. 470), Pacelli has proposed, orally, that Caravaggio may have returned to Naples from Malta shortly after July 1607 to finish the *Flagellation*. He has, moreover, suggested in print (1977, p. 820; 1978 b, p. 58), and promised to demonstrate in a future study, that the artist was in Naples for the rest of 1607 and even in the early months of 1608; after the July 1607 notice, Caravaggio is next documented in Malta on July 14, 1608, when he was made a Cavaliere.

By May 1607, Caravaggio had received from Tommaso di Franco's account the conspicuous sum of 250 ducats. This would seem to indicate that the execution of the *Flagellation* was at an advanced stage. The total amount must have been about 400 ducats, the price he received for the *Seven Acts of Mercy* and the sum requested for the *Madonna of the Rosary* (in the Kunsthistorisches Museum, Vienna) in 1607 (A. Luzio, 1913, p. 278; see W. Prohaska, 1980, p. 119, n. 34, for comparative fees of Caravaggio's altarpieces).

Bologna (1980, pp. 41 f., n. 8), taking up Longhi's hypothesis, considers the problem of dating an unresolved issue. He notes that the model for the left-hand torturer is the same man who appears as the executioner in the London *Salome* (which Bologna calls a *Herodias*, thus referring to Bellori and identifying the picture with the one said by that author to have been sent by Caravaggio to Malta, after his return to Naples, in order to placate the Grand Master: see cat. no. 96).

At the urging of the present writer (M. Gregori, 1982 a, p. 125), X-rays of the *Flagellation* were made in Paris in September 1983,

with unexpected results: They confirm the hypothesis that the picture was carried out in two phases, thus providing an explanation for its problematic appearance. Arnauld Brejon de Lavergnée will publish these X-rays in a forthcoming article, and the present writer would like to thank him for allowing her to examine them. With his consent, she is able to report that in addition to other pentimenti there appears, at the height of the shoulder of the right-hand figure, a male head, which seems to be that of the patron, turned passionately toward Christ. Caravaggio thus radically altered the content of the picture, for unknown reasons; there may well have been a lapse of time between the two phases of execution. Unlike Sebastiano del Piombo's treatment of the subject, in San Pietro in Montorio, Caravaggio initially showed torturers only on the left side, creating an asymmetrical composition that differed radically from any High Renaissance scheme (as H. Wagner, 1958, p. 142, pointed out, the column is not aligned with the central axis). This sort of asymmetry is a constant feature in Caravaggio's other paintings of the Flagellation, whether in a horizontal format (for example, cat. no. 91) or a vertical one (see the copies of a lost picture in the Pinacoteca Civica, Macerata; in the Museo Civico, Catania; and in a private collection, Cantalupo Sabina), and it also characterized his *Ecce Homo* (cat. no. 86). As always with Caravaggio, the gestures in the *Flagellation* are functional and sober. The violence is concentrated in the ferocious bestiality of the torturer to the left, who is about to begin the flagellation (Christ's body is still unblemished) and who grasps his victim by the hair (a gesture that also occurs in the Prato *Crowning with Thorns*, cat. no. 81), and in that of the foreground figure, who, lit from behind, bends over to fashion a scourge from a bundle of branches so that he, too, can begin his appointed task. The profile of the foreground figure is seen in shadow against the illuminated body of Christ, "as in a Rembrandt of some thirty years later" (Longhi, 1952, p. 42). The torturer to the right gains leverage by holding his left foot against Christ's right leg as he finishes tying Christ to the column. The difficulty that one encounters in reading this figure (see F. Bardon, 1978, p. 200)

is certainly the result of the change in the program of the altarpiece. The density of the paint in the flesh areas is due to the superposition of two layers and it suggests a date not of 1607 but of 1609–10, especially if the picture is compared to the *Martyrdom of Saint Ursula* (cat. no. 101). The summary, vehement execution, the rapidity with which the light is described—especially in the head and the chest of the standing, left-hand torturer, where X-rays reveal considerable changes—and the sobriety of the color and the shallowness of the space seem to be characteristics of Caravaggio's second Neapolitan phase.

A privately owned painting by Caracciolo, published by Mormone (1963, pp. 136, 139) and now in the Museo Nazionale di Capodimonte, is a free imitation of the *Flagellation*. Luca Giordano's *Flagellation*, in a private collection in Naples (to which Nicola Spinosa alerted the writer), is still closer, revealing a renewed interest in Caravaggio's picture, perhaps as a result of its relocation in a more advantageous position in San Domenico. In describing Caracciolo's copies after Caravaggio's painting, De' Dominici (1742–45, II, 743, p. 276) mentions a painting by either Caracciolo or Andrea Vaccaro of the *Flagellation* on a lateral wall of the choir of Santissima Trinità degli Spagnoli, Naples. No such picture is now in that church, although De Rinaldis (1928–29, p. 54, n. 1) thought that the painting was possibly identifiable with a faithful copy of Caravaggio's composition now in the chapel of San Domenico from which the original altarpiece was removed in 1972. Rejecting the attribution to Caracciolo, De Rinaldis espoused an undemonstrable attribution to Vaccaro, which has been accepted by scholars. Moir (1976, p. 132, n. 218) and Stoughton (1978, p. 408) have suggested an equally untenable attribution to Alonso Rodriguez. A *Flagellation* by Vaccaro in the Staatsgemäldesammlungen, Munich (A. Moir, 1976, p. 132, n. 218, fig. 93), while it is indebted to Caravaggio's painting, is but a free derivation. Cinotti (1983, p. 469) mentions other cited copies and derivations.

M. G.

94. Alof de Wignacourt, with a Page

*Oil on canvas, 76 3/8 x 52 3/4 in.
(194 x 134 cm.)
Musée du Louvre, Paris*

The Grand Master of the Knights of Malta is shown standing, holding the baton of a commander, his head turned to the right, gazing into the distance as is appropriate to a condottiere. He is serene and relaxed, in an "attitude and expression of kindly manliness" (B. Berenson, 1953, p. 46). There are precedents for the inclusion of the page holding the helmet and an outer garment (similar garments occur in Lionello Spada's frescoes in the Palace of the Grand Masters: see M. Gregori, 1974, figs. 49, 50) in Venetian and Lombard painting: for example, in Titian's portrait of the Marchese del Vasto addressing his troops (in the Museo del Prado, Madrid: see W. Friedlaender, 1955, p. 221), and in Giulio Campi's portrait of a condottiere (in the Museo Civico, Piacenza). The presence of such a figure is uncommon in early Seicento portraits, however, and may, perhaps, be explained by Wignacourt's habit of surrounding himself with a multitude of young pages (B. Dal Pozzo, 1703, pp. 570, 694). The full-length format belongs to a Venetian or Veneto-Lombard tradition, and as Hess (1958, p. 142) has noted, the composition is similar to that of the 1556 portrait of Pase Guarienti (in the Museo di Castelvecchio, Verona); this painting, formerly attributed to Veronese, has a plainness more consonant with the work of Domenico Brusasorci, to whom recent opinion tends to attribute it.

The identity of the sitter as Alof de Wignacourt, one of the most eminent grand masters in the history of the order (on his life, see the bibliography in M. Gregori, 1974 b, p. 594, n. 11), is confirmed by comparison of the picture with certified representations of him: on the medals and coins with his portrait in profile and in three-quarter view minted between 1601 and 1622, the period of his tenure in office (see M. Maindron, 1908, pp. 243, 247, n. 1; Versailles, 1961, p. 42, no. 33, p. 76, nos. 192–93, p. 84, nos. 243–46, p. 103, nos. 344–345; La Valletta, 1970, p. 227, no. 133, p. 229, no. 138, pp. 234–35, nos. 156–157); in engravings, including one by Philippe Thomassin datable to 1609 (M. Gregori, 1974, p. 597); and in paintings—some accompanied by inscriptions—still in Malta.

Baglione (1642, p. 138) is the first to mention a portrait of the Grand Master painted by Caravaggio in Malta. Bellori (1672, p. 209) records two portraits: "Caravaggio ... decided to move to that island where, upon his arrival, he was introduced to the Grand Master Wignacourt, a Frenchman. He portrayed him armed and standing, and seated, without armor, in the dress of the Grand Master. The first of these portraits is in the Armory at Malta." Baldinucci (1681–1728; 1845–47 ed., III, p. 686) and Susinno (1724, 1960 ed., p. 109) repeat this information. It is almost certain that the first of these two pictures is identifiable with the Louvre portrait, which was seen by John Evelyn on March 1, 1644, in the collection of the Comte de Liancourt in Paris. Evelyn (1644; 1906 ed., I, p. 86) describes it in his diary as a "Cavaliero di Malta, attended by his page, said to be of Michael Angelo [da Caravaggio]." The picture ("un portrait d'un grand-maistre de Malte faict par Michel Lange") was sold for 14,300 livres to Louis XIV in 1670, together with other paintings, a bronze, and some busts (E. Bonaffé, 1884, pp. 185 f., 240; M. Maindron, 1908, p. 246, n. 1). One of the sellers was Hoursel, secretary to the Duc de Vrillière and one of the most gifted *amateurs* of the time. There is a seventeenth-century copy, dating from after Wignacourt's death, in Santa Maria della Vittoria, La Valletta, Malta (E. Sammut, 1959; M. Marini, 1974, p. 437, E 1, ill. p. 237) in which the gesture of Wignacourt as well as other details are changed somewhat and the figure of the page is omitted. An engraving for Baudoin's *Histoire des chevaliers de Saint-Jean de Jérusalem* (of 1643) is derived in some way from the Louvre portrait. However, it cannot be said that the engraving was made directly from the portrait, since the fact that the sitter was Wignacourt seems to have been forgotten at that date (see above), although Caravaggio's authorship was not. Wignacourt's identity was probably recognized only after the publication of Bellori's and of Baldinucci's texts: Even Félibien (1688, II, p. 13) speaks generically of the portrait, praising it as a work of Caravaggio. Not until the eight-

eenth century was the picture reproduced in catalogues of the royal collections as a portrait of Wignacourt (the most famous engraving, with the composition reversed, is by Nicolas de Larmessin, made for the *Recueil d'estampes d'après les tableaux . . . dans le Cabinet du Roy . . . ,* 1729–42, I, p. 36, pl. 92). A further complication is raised by Bellori's statement that Caravaggio's portrait was in the Armory in La Valletta, whereas by 1644 it was in France (see M. Cinotti, 1983, p. 487, for various explanations).

The second portrait described by Bellori—Wignacourt shown "seated, without armor, in the dress of the Grand Master"—is probably reflected in a mediocre painting (in the Canon's College of the Grotto of Saint Paul in Rabat, Malta) signed by Gian Domenico Corso and dated 1617. Another version, with the figure shown full-length, in the church over the Grotto of Saint Paul, was published by Marini (to whose attention it had been brought by U. Bonelli and J. A. Cauchi; see M. Marini, 1971, p. 56, 1974, pp. 43, 236, 435, no. 73; J. Azzopardi, 1978, p. 56, no. 3; and also M. Cinotti, 1983, p. 562, who sees it as Caravaggio's invention). The 1609 engraving by Thomassin, cited above, seems to have been inspired by the prototype of this evidently official portrait—regardless of whether it was by Caravaggio or not. Another portrait, formerly in the Armory and now in the National Gallery, La Valletta, shows Wignacourt full-length and in armor; it was noted in Laking's catalogue of 1905. A second version, apparently by the same hand, is in the Palace of the Grand Masters (see M. Gregori, 1974, figs. 43, 44, p. 5). Maindron (1908, p. 251) believed—albeit with reservations—that this picture, extremely analytic in its execution, although flattened by a relining and restoration carried out in London in 1886, could be identified with the portrait mentioned by Bellori. Subsequently, attributions to Lionello Spada, Cassarino, and Mario Minnitti have been suggested (see M. Cinotti, 1983, pp. 487 f.). It is probable that the author of the portrait in the Armory, of which the version in the grand masters' palace is a replica, knew the present picture. Nonetheless, there are differences between them. In the Armory portrait, Wignacourt looks at the

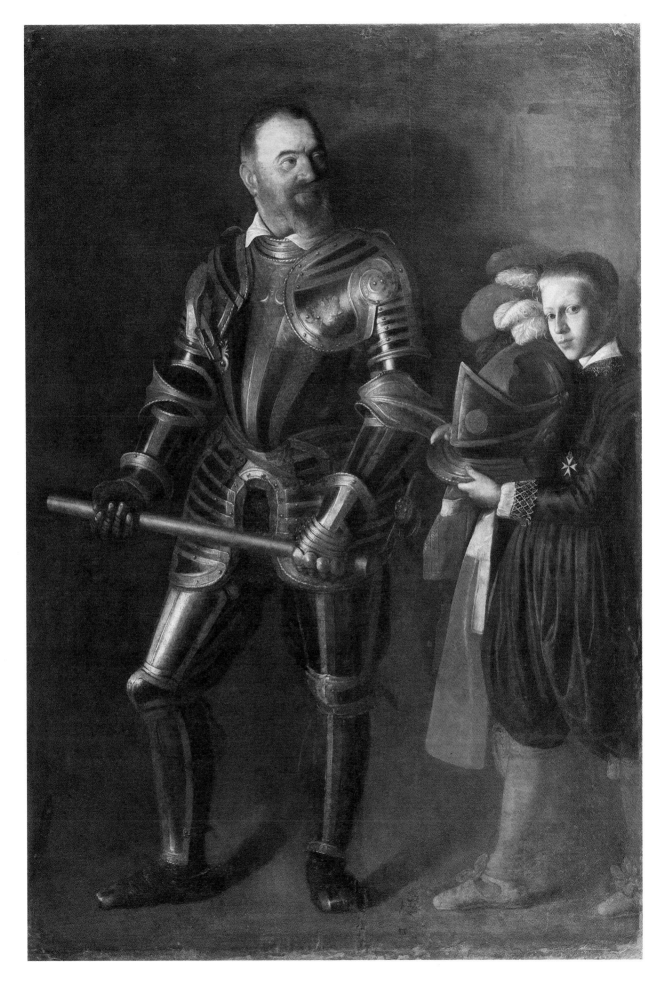

329

viewer; his armor is different and of a later date (about 1610–20, whereas the armor in the Louvre portrait is datable to about 1580), and he holds his baton in a more ceremonious fashion (see, for comparison, Titian's portrait in the Uffizi, Florence, of Francesco Maria della Rovere). In the Louvre portrait, Wignacourt holds the baton with both hands, as do the sitters in certain sixteenth-century portraits. However, one of his hands is held palm up: an informal and unusual gesture. This detail underscores Caravaggio's independence toward traditional iconographic conventions, and probably accounts for the presence of pentimenti in this part of the picture (see M. Marini, 1974, p. 437); in the copy in Santa Maria della Vittoria the gesture was, indeed, modified.

The Louvre portrait was relined in 1751 and restored by Godefroid between 1783 and 1786 (S. De Ricci, 1913, pp. 7 f., no. 1124). The restorer Picault (1973, pp. 54 f.; cited by A. Berne-Joffroy, 1959, p. 342) criticized the earlier treatment of the picture, noting that a hot iron had been used in the relining, and he characterized the picture as "perdu sans ressource"; it has in fact been flattened and skinned in places, especially in the background and in the lower portion. However, contrary to Hinks's assertion (1953, p. 118, no. 61), the head of Wignacourt has not been repainted, but is fully legible and in a relatively good state of preservation. In it are evident the unmistakable characteristics of Caravaggio's hand: The division of the head into light and dark passages; the highlighting of the earlobe; and the juncture between the neck, armor, and collar by means of a wide, dark area—perhaps consisting of the exposed ground. These details recur in the *Portrait of a Knight of Malta* in the Palazzo Pitti (see cat. no. 95), as the present writer has pointed out (M. Gregori, 1974, pp. 597 ff.; 1975, p. 36).

The pose of the Grand Master has affinities with that of the jailer in the *Beheading of Saint John the Baptist* (fig. 13, p. 44); the thinness of the paint surface gives him an almost phosphorescent appearance that anticipates Rembrandt's work. It should be noted that the picture belongs to the phase in which Caravaggio experimented, for the first time on a large scale, with leaving areas of the ground exposed or employing a color similar to it, and with modeling and highlighting by means of rapid, summary brushstrokes. The technique was employed in Caravaggio's most important Maltese work, the *Beheading of Saint John the Baptist*, as Bellori (1672, p. 209) himself noted: "In this work Caravaggio used the full power of his brush, having worked with such intrepidity, that he left the ground or *imprimitura* exposed in the middle tones." We cannot be certain whether this comment derives from Bellori's firsthand knowledge of the work or from hearsay.

The authorship of the portrait was called into question by Longhi (1943 a, p. 39, n. 25; 1943 b, p. 99; 1952 a, p. 43, and *passim*). To Mahon (1952 a, p. 19; 1953 a, p. 215, n. 20) the picture seemed problematic and unusual due to its state of preservation. The present writer considers it autograph (M. Gregori, 1974, p. 598; 1975, p. 34), as does Marini (1974, pp. 43, 237, 435 ff., no. 74), and Cinotti (1983, pp. 487 ff.). Hibbard (1983, p. 327) does not consider the figure of the page to be by Caravaggio. The present writer has noted that by comparison to the portrait in the Pitti, which she has identified as Wignacourt (but see cat. no. 95), the Louvre portrait is more idealized. This is due to the official nature of the commission.

In Bellori's comments on Caravaggio's activity in Malta, he mentions first the two portraits of Wignacourt, implying that the artist was granted his knighthood as a result of them (F. Ashford, 1935, p. 174). This sequence of events is generally accepted, along with a dating of the Louvre portrait to 1607–8. Cinotti (1983, p. 488) notes that Caravaggio is recorded in Malta in July 1607, and she dates the portrait to 1607 or, at the latest, to early 1608. Mahon, by contrast, places it after the *Beheading of Saint John the Baptist* and the *Saint Jerome* in the Museum of Saint John's Co-Cathedral (the present writer would reverse the sequence of these two works) and before the *Sleeping Cupid* in the Palazzo Pitti. The already noted affinities of the portrait with the *Beheading of Saint John the Baptist* (dated to 1608 in a pastoral visit of 1680; see J. Spike, 1978, p. 627), and the conception of light, which already anticipates the Sicilian works, suggest a date of 1608.

Even before the modern rediscovery of Caravaggio, the Louvre portrait of Wignacourt captured the attention of such nonacademic artists as Delacroix, who made a drawing of the page (in an album now in the Louvre, RF 9143, fol. 7 r: see A. Moir, 1976, p. 67). Perhaps, as G. de Vito has suggested to the present writer, the page inspired Manet's *Boy with a Sword* in the Metropolitan Museum.

M. G.

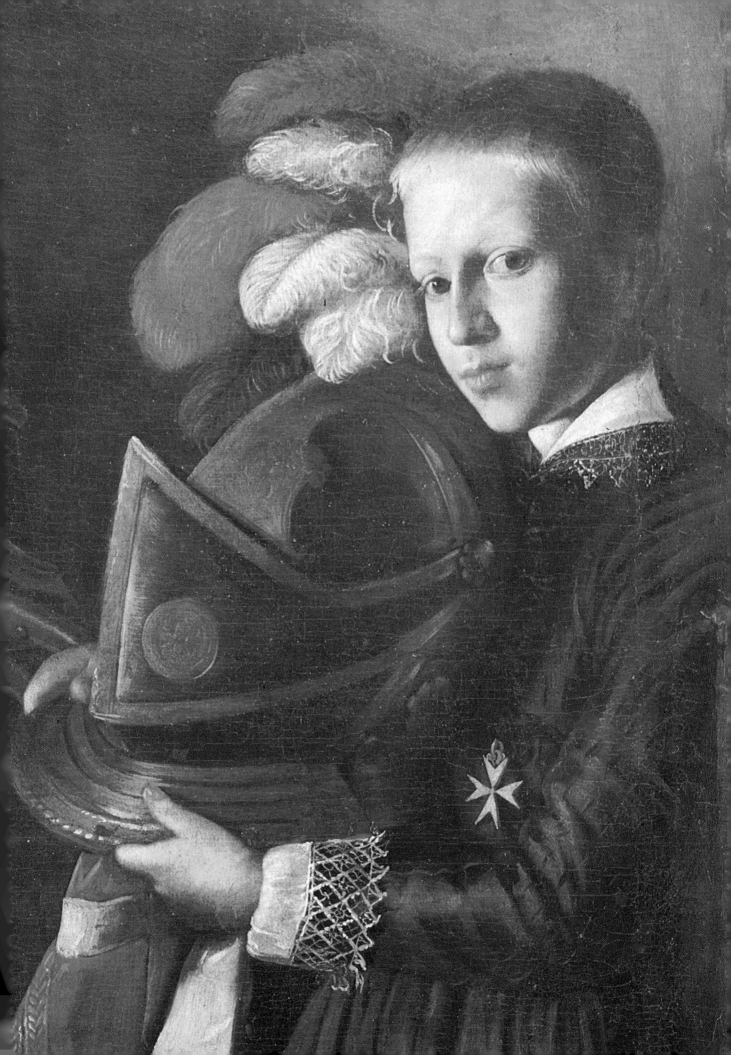

95. Portrait of a Knight of Malta (Alof de Wignacourt?)

Oil on canvas, 46 5/8 x 37 5/8 in.
(118.5 x 95.5 cm.)
Galleria Palatina, Palazzo Pitti, Florence

The picture shows a knight of Malta in customary dress, emblazoned on the chest with a Maltese cross. He holds his sword in his left hand, while in his right hand there is a rosary. The present writer (M. Gregori, 1974, pp. 594 ff.; 1975, pp. 34 f.) has noted physiognomical similarities to Caravaggio's patron and protector in Malta, the Grand Master of the Knights of Malta, Alof de Wignacourt. Bellori (1672, p. 209) tells us that Caravaggio portrayed the Grand Master twice, once "armed and standing" and once "seated, without armor, in the dress of the Grand Master," and that "the first of these portraits is in the Armory in Malta." The portrait formerly in the Armory is now in the Louvre (cat. no. 94), and the other is known from a copy in the Canons' College of the Grotto of Saint Paul in Rabat, Malta (see M. Marini, 1971, p. 56, fig. 2). Baumgart (1955, p. 107) had earlier proposed identifying as Wignacourt the sitter of the Pitti portrait, which he considered contemporary with the Louvre portrait, although by a different artist. The present writer's arguments have led scholars to accept the identification of the sitter as Alof de Wignacourt. However, Bologna (1980, p. 42, n. 8) has recently called attention to a nineteenth-century engraving published by Caracciolo di Torchiarolo (1939, p. 187), purportedly representing Niccolò Caracciolo di San Vito, who died in 1689. The engraving corresponds to the Pitti portrait, which was also engraved in 1838 by Gaetano Silvani with no identification of the sitter (Bardi, 1837–42, IV). Bologna himself has recognized the necessity for further proof of Caracciolo di Torchiarolo's information, which carries little historical weight, but with this as his point of departure he has doubted both the attribution and the date of the Pitti portrait and has called into question other matters that one would not have thought controversial. His views were followed by Hibbard (1983, p. 327).

As the present writer has stated (1975, p. 34), she arrived at her attribution of the picture to Caravaggio not through identifying the sitter as Alof de Wignacourt, but from a consideration of its style and technique. Firsthand examination of the picture—the writer has inspected it under optimal conditions, once with the technical consultation of Thomas Schneider (the restorer of the Prato *Crowning with Thorns*, cat. no. 81), and on numerous other occasions (most recently on September 9, 1984)—leaves no room for doubt that the work is from the early Seicento. The fine craquelure of the dark background; the application of the paint, and its thickness in such highlights as those on the belt buckle and the sword; and the speed with which the light areas (the collar and cross) were painted will be recognized by any connoisseur as characteristic of the early seventeenth century. Specifically Caravaggesque is the manner in which the figure is set off from the background, "as though caught unaware," by means of "a concise profile of light" (G. Testori, 1975, p. 3). The sitter makes a grandiose impression; his features are articulated with a freedom that has precedents in the portraiture of Moroni. The foreshortening of the arm, conceived in a synthetic rather than an orthodox manner, again recalls Moroni. Even disregarding the identity of the sitter, it would be difficult to deny the Caravaggesque structure of his head: The present writer has compared it not only with Wignacourt's in the Louvre portrait, but also with the head of one of the torturers in the Rouen *Flagellation* (cat. no. 91). Caravaggio's tendency to repeat certain archetypes should be emphasized; Mancini (about 1617–20; 1956–57 ed., I, p. 136) cites him as one of those "extremely valiant painters who do not make good likenesses." The division of the head into areas of light and dark and the depiction of the left eye and cheek in half-darkness are constant elements in Caravaggio's paintings. Further evidence of the picture's indubitable status as an autograph work by Caravaggio is provided by the manner in which the nostril and the wrinkle of the cheek are defined, by the directness with which the mouth is painted (Caravaggio's way of dispensing with corrections is in itself expressive of a profound humanity), by the highlights on the ear, and by the unflattering truthfulness with which the loose skin of the neck is

described. Other features typical of Caravaggio are the cursory hieroglyphic formed by the sword and the thick-fingered left hand, both touched sporadically by light and shade; and by the cross that, despite its regularity, follows the curve of the sitter's chest, its contours possessing their own, almost imperceptible, life, while the whites seem as though burnt at irregular intervals by shadow. Along the edges of the cross, in places, a brown tone is apparent, which may be that of the exposed ground of the picture. A line of the same tonality is more easily visible along the contour of the neck below the ear, where the ground seems to have been gone over with a color similar to it. This is a practice that originates in Lombard painting, and it is also found in the Louvre portrait; in the Pitti portrait it is certainly not an indication of a pentimento, as Marini (1974, pp. 250, 442) supposed. No less characteristic of Caravaggio is the left hand, with its reddish tonality and summary modeling (the almost formless appearance of this hand does not seem to be a result of the painting's state of preservation, as the present writer had earlier believed it to be; see also P. dal Poggetto, in E. Borea, 1970, p. 125).

Whether the present picture is held to be Caravaggio's first portrayal of Alof de Wignacourt, painted directly from life—the Louvre picture would be the more elaborated, official version—or a portrait of another knight, whom Caravaggio painted during his stay in Malta, it is probably not unfinished (for the contrary opinion, see M. Marini, 1974, p. 322). Van Mander (1604, p. 191 r.), in reporting information furnished by Floris Claesz. van Dyck, states that Caravaggio himself maintained that he painted directly from nature, without using preparatory drawings. This was a Giorgionesque method, and Caravaggio probably followed it when painting portraits, beginning work directly with oils on the canvas.

The Pitti portrait, which was painted with great speed, shares with the *Beheading of Saint John the Baptist* in Malta and the Sicilian paintings an abbreviated, summary execution, and it shares with Caravaggio's late paintings the use of the ground as the general tonality for the background of the picture. In the face and hands, reddish and

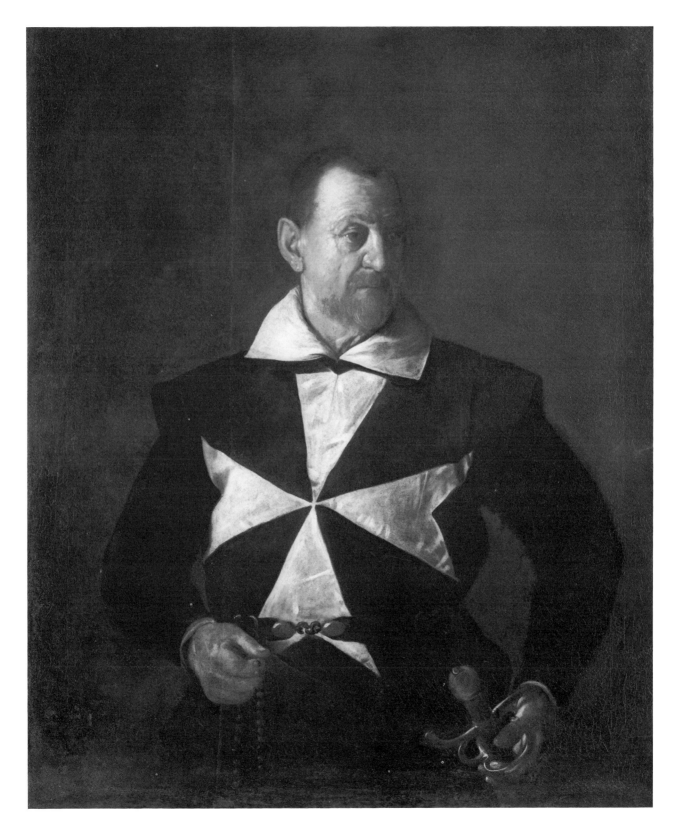

sulfur-yellowish tones blend together, but the surface does not have a finished appearance and the ground is visible throughout; it is probable that Caravaggio wished to leave it in this state. The two sections of canvas have been joined together much as they are in the Louvre picture.

The provenance of the Pitti portrait is not known, and no reference to it has been found in old inventories. Meloni Trkulja (1977, p. 49) has suggested that, as with Caravaggio's *Sleeping Cupid* (also in the Palazzo Pitti), the portrait was sent to Florence by Francesco dell'Antella, who was in Wignacourt's service in Malta and subsequently obtained the commendam of San Jacopo in Campo Corbolini in Florence. Dell'Antella may have commissioned the *Sleeping Cupid*, which was sent from Malta to Florence in July 1609 (L. Sebregondi Fiorentini, 1982, pp. 107 ff.). In return for his commendam he gave a portrait of himself to San Jacopo in Campo Corbolini (this has been identified with a work by Justus Sustermans, and it is therefore certain that Dell'Antella is not the sitter of the present picture), as well as another portrait of Wignacourt "from the hand of Caravaggio." The latter portrait was reduced to an oval (an "ovatino") in the eighteenth century. The present picture was formerly attributed —for example, in the 1838 engraving—to Niccolò Cassana, who worked for some time for the Medici. It is cited in the *Inventario Oggetti d'arte*, no. 717, as by Cassana, or, alternatively, by Francesco Bassano. These attributions certainly stem from an old inscription, on a piece of paper on the back of the canvas, which originally read "Ritratto de Cassana" and was later altered (in the nineteenth century ?) to read "Bassano." The picture was included in the 1911 exhibition "Il Ritratto italiano dal Caravaggio al Tiepolo," as well as in an exhibition at Versailles in 1961 dedicated to the Order of Malta.

Since the costume seems to date from the first half of the seventeenth century, Gamba (in G. Fogolari et al., 1927, p. 118) proposed attributing the portrait to Giovanni Francesco Cassana, the father of Niccolò, who was born in 1611 and was a pupil of Bernardo Strozzi. However, Fogolari (1927, p. 111) noted that there is no comparative basis on which to establish this

attribution definitively. In an article in *La Nazione* in 1966, Giorgio Batini reported the present writer's opinion that the portrait shows Alof de Wignacourt and should be considered a work by Caravaggio, or at least a copy of a work by the master. After cleaning (see P. dal Poggetto, in E. Borea, 1970, p. 125), the picture was included in the exhibition "Caravaggio e Caravaggeschi nelle Gallerie di Firenze" in 1970, at which time Borea, although she recorded the opinion of the present writer and noted affinities between the portrait and Caravaggio's late work, considered it close to a group of paintings associated with Manfredi. In general, scholars who saw the picture responded favorably, recognizing its importance and encouraging the present writer to publish the results of her research. Salerno (1970, p. 237) thought that the attribution to Caravaggio "should not be rejected, given the strength of the picture" (see also C. Volpe, 1970, p. 111; and M. Marini, 1971, p. 58, n. 5; 1974, pp. 442 f.), and Pérez Sánchez (1971, p. 85) referred to the portrait as "a very beautiful surprise, . . . a work of superb quality that can be attributed to Caravaggio himself, though it would be prudent to await the promised article and arguments of Mina Gregori." Schleier (1971, p. 88) called it "surprisingly close to the late, Maltese style of Caravaggio, like the *Toothpuller* [cat. no. 98]," while Cinotti (1971, pp. 137, 200, n. 527), Spear (1971, p. 110), and Brandi (1972–73, p. 103) remained doubtful. (The attribution to Caravaggio has received the verbal support of Federico Zeri, Pico Cellini, Carlo Volpe, Maurizio Calvesi, and John Cauchi.) Following the Convegno Internazionale di Studi Caravaggeschi in Bergamo in 1974, and an article by the present writer (M. Gregori, 1974, pp. 594 ff.; 1975, pp. 33 ff.), further support for the attribution to Caravaggio was given by Testori (1975, p. 3), Ferrari (1978, p. 372), Nicolson (1979, p. 33), Gash (1980, p. 112), Marini (1978, p. 75, n. 3; 1980, p. 64; 1981, p. 428), and Cinotti (1983, pp. 434 f.). Moir (1976, pp. 66, 133, n. 220), Whitfield (1978, p. 359), Spear (1975, p. 318), Bologna (1980, p. 42, n. 12), and Hibbard (1983, p. 327) have expressed negative opinions or maintained reservations about the picture.

Marini (1974, p. 442) called the Pitti por-

trait "the last known work of Caravaggio's Maltese period." Regardless of the identity of the sitter, the dating of the picture is closely connected with that of the Louvre portrait. The placement of the head and the position of the light source are very similar in both works, as are various features of the paintings' execution: the highlights on the earlobes, the breaks between necks and collars, the construction of the noses. The surface of the Louvre picture is more densely painted, possibly suggesting that it is the earlier of the two. However, its higher degree of finish (it was evidently painted at a slower pace) and the relaxed but vigorous expression—it is even possible to speak of an idealization—with its distant gaze, obligatory in the portrayal of a military captain, can be explained by the picture's official function. In contrast to these features is the pictorial rendering of the armor, bathed in light, which Caravaggio seems almost to intend as an ironic comment on the sinister, mannequin-like rigidity that the figure has assumed.

M. G.

96. Salome Receiving the Head of John the Baptist

Oil on canvas, 36 x 42 in.
(91.5 x 106.7 cm.)
National Gallery, London

Salome is mentioned in the Gospels of Saint Matthew (14:6–11) and of Saint Mark (6:22–28) simply as the daughter of Herodias; she is first cited by name by the Jewish historian Flavius Josephus in the *Antiquitates Judaeorum* (about A.D. 94). In his *Commentarius in Matthaeum*, Origen (about 185–254) gives her her mother's name, as do a number of later Christian authors (see E. Panofsky, 1969, p. 44). Thus, it is scarcely surprising that Bellori (1672, p. 211) should have referred to what was certainly a painting of Salome as "a half-length figure of Herodias with the Head of Saint John in a basin" (he committed the same error in describing the Malta *Beheading of Saint John the Baptist*). According to Bellori, the painting was sent by Caravaggio to the Grand Master of the Knights of Malta after the artist's return to Naples sometime before October 24, 1609. He had hoped to placate the grand master's anger and obtain his pardon.

Salome holds a charger, or basin, into which the executioner places the head of the Baptist. She turns her head away from the scene while an old servant woman behind her looks on, clasping her hands in a gesture of horror and compassion. Caravaggio contemplated showing the old female attendant in the *Crucifixion of Saint Andrew* in like fashion, but changed his mind (see cat. no. 99). The contrast between the attitudes of the two women, whose heads seem almost to belong to the same body (M. Calvesi, 1971, p. 135)—and the opposition of youth and old age—create a moving and profoundly human "contrapposto."

The inclusion of Salome's servant in the scene can be traced to Lombard sources, such as the panel by Bernardino Luini in the Uffizi. In a study on Titian's *Salome* (in the Galleria Doria-Pamphili)—a picture that, in the seventeenth century, belonged to the Salviati and was probably known both to Caravaggio and to the Cavaliere d'Arpino (A. Moir, 1976, pp. 134 f., n. 226)—Panofsky (1969, p. 42) noted that the servant's

presence is more proper to the subject of Judith and Holofernes. In the present picture, the outstretched arm of the executioner marks the perspectival axis of the composition and constitutes its dramatic focus, repeating in mirror image the foreshortened arm of David in the *David with the Head of Goliath* (in the Kunsthistorisches Museum, Vienna), datable to Caravaggio's first Neapolitan period. The gesture is closely associated with the theme of Salome. It occurs repeatedly in Leonardesque paintings of the subject (in the picture by Andrea Solario in the Kunsthistorisches Museum, Vienna, and in those by Luini in the Uffizi, in the Louvre, and in scattered replicas), suggesting that the invention was Leonardo's. The example with the closest analogy to the foreshortened arm in the present painting is the picture by Cesare da Sesto in Vienna.

Longhi (1927 a; 1967 ed., I, p. 124; 1952, p. 45) at first proposed identifying the picture described by Bellori with the *Salome* in the Palacio Real, Madrid—a work that he attributed to Caravaggio (when Longhi saw it, it was in the Casita del Príncipe at the Escorial). The present version was sold by a French private collector in Paris (Hôtel Drouot) in 1959. It was purchased by Major A. E. Alnatt from a Swiss private collection in 1961, and lent to the National Gallery, which acquired it in 1970. Upon its reappearance, Longhi (1959, pp. 21 ff.) reconsidered his earlier opinion. He identified the picture described by Bellori with the present *Salome*, and dated the Madrid painting to Caravaggio's Maltese period. He also correctly underscored the fact that, given the artist's preference for narrative treatments of such subjects, it was unlikely that Bellori's reference was to an isolated, half-length figure of Salome.

In his review of those works that Bellori assigned to Caravaggio's Neapolitan period, Longhi dated the London *Salome* to the artist's second sojourn in Naples. He placed the *Flagellation* (cat. no. 93) in the same period, noting the differences that distinguish it from the *Madonna of the Rosary* in Vienna and from the *Seven Acts of Mercy* in the Pio Monte della Misericordia (documents now date the commission of the *Flagellation* to the spring of 1607). That the London *Salome* was painted in Naples is

demonstrated by the models used for the figures, and by the existence of a copy of the picture, discovered by Causa, in the Abbey of Montevergine, near Avellino (G. Scavizzi, 1963, p. 21, n. 9), as well as by a number of derivations by Neapolitan artists and by Finson (A. Moir, 1976, p. 135). Some of these derivative works (for example, the painting by Caracciolo formerly in the Peltzer collection, Cologne) seem to have been based on the Madrid *Salome*. The model for the executioner in the London *Salome* was used as well for the tormentor at the left in the *Flagellation* (V. Pacelli, 1978 a, p. 493, also identified him with one of the figures in the *Crucifixion of Saint Andrew*). The model for Salome—a more austere figure than her counterpart in Madrid—is the same as for the Madonna in the *Madonna of the Rosary*, which dates from Caravaggio's first Neapolitan period. Longhi thought that she also appears as the figure of Pero, who suckles her imprisoned father, in the *Seven Acts of Mercy* (for which Caravaggio received payment on January 9, 1607). The model for the old woman may be the same one who reappears in the *Crucifixion of Saint Andrew*; Longhi was uncertain whether that picture belonged to the first or the second Neapolitan period. He believed that Caravaggio employed some of the same models during both periods. Others hold that the National Gallery *Salome* dates from the first Neapolitan period, including Kitson (1967, p. 109) and Cinotti (1971, pp. 82, 86, 143; 1983, pp. 453 f.); Marini (1973 a, p. 189; 1974, pp. 40 f., 226 ff., 429 f., no. 67; 1979, pp. 36, 47, n. 180) suggests the possibility that the *Salome* may be identifiable with the *Judith and Holofernes* sold in Naples together with the *Madonna of the Rosary*, as mentioned in a letter written by Frans Pourbus the Younger on September 25, 1607 (V. Pacelli, 1978 b, p. 57; A. Moir, 1982, p. 138, pl. 38).

Among those who accept a dating of the *Salome* to Caravaggio's second Neapolitan period are Jullian (1961, p. 230, with reservation), Spear (1971 a, pp. 14 f.), Röttgen (1974, pp. 202, 209 f.), Bologna (1980, p. 41, n. 8), and Hibbard (1983, pp. 329 f., n. 168). Numerous considerations support such a date. The first of these results from a comparison of the London *Salome* with the one in Madrid, an autograph work that

Mahon (1952 a, p. 19) convincingly dated to the first Neapolitan period, close to the *Madonna of the Rosary*. In the Madrid picture, the tragic subject is treated in a more severe, abbreviated fashion. In the National Gallery *Salome*, Caravaggio has probed the psychological reactions of the protagonists with a new depth—the cunning, sidelong glance of Salome; the horror of the servant; and the understanding face of the executioner and the fatality of his gesture. The painting of the London *Salome* is rapid and assured. At the same time, Caravaggio does not make a show of bravura, but presents an interiorized interpretation of the theme: The palette is sober, and so cursory is the execution that the ground has been left exposed in various areas (see the report of Joyce Plesters, principal scientific officer at the National Gallery, August 15, 1970, and below), leading some to conclude that the picture is unfinished—erroneously, to the present writer's mind. X-rays reveal no pentimenti, but variations along the contours of the shoulder of the executioner are visible to the naked eye. Caravaggio has focused attention on the brilliant play of light on the white drapery of Salome and on that of the executioner, which is seen in shadow (note also the light striking his shoulder), rather than on the rhythm of the folds and on their solidity, as in the Madrid *Salome*, where the curious forms of the shadows are studied with great care. A comparison of the picture with the *Martyrdom of Saint Ursula* (cat. no. 101), certainly from the very last phase of Caravaggio's career, supports the dating proposed here. In both pictures, the highlights are broken up into pools of light and the medium is comparable in density.

The compassionate, melancholic mood of the London *Salome* is characteristic of Caravaggio's late works, and both the attitude of resignation of the protagonists and the style of the picture relate it to the Borghese *David with the Head of Goliath* (cat. no. 97)—according to Spear (1971 a, pp. 14 f.), from the same period. Spear has seen both works as a tragic epilogue to Caravaggio's life, and perhaps even as a reflection on the consequences of his delinquency and his flight from justice. Bellori noted that Caravaggio painted the *Salome* for Wignacourt soon after the artist returned to Naples in late 1609, which is likely. There followed the slashing of Caravaggio's face at the Osteria del Cerriglio, which is mentioned in an *avviso* in Rome of October 24, 1609. The *Salome* must have been painted—or at least begun—before this date. Mahon has expressed the following opinion to the present writer:

I should like to take this opportunity of enlarging on a somewhat cryptic reference to an oral report of an idea of mine regarding the National Gallery *Salome* which you included at the end of entry 20 on page 135 of the recent Royal Academy exhibition catalogue. I am inclined to associate the picture with Bellori's story of the picture which Caravaggio painted at Naples with a view to sending to Malta as a "peace offering." My suggestion is that he could have begun it with this end in view immediately on reaching Naples from Palermo, but that after there occurred a (possibly Malta-inspired) attack upon him at the Osteria del Cerriglio towards the end of October 1609 he abandoned that project, and put the painting on one side (possibly not entirely finished?). It then became "stock in trade," and could have been on the *felucca* with a view to possible disposal by him on arrival in Rome. I would doubt if the official at Port'Ercole who dealt with his belongings can be relied upon to be meticulous about precise iconographical descriptions, and so could easily have described the National Gallery painting merely as "San Juan Bautista."

According to Plesters's report, the picture was cleaned and restored prior to its loan to the National Gallery in 1961. The painting is in fair condition, although the flesh portions of the figure of Salome are somewhat worn and both her left eye and the right-hand side of the executioner's forehead are damaged. Levey (1971, p. 54) presumes that the left hand of the executioner was repainted. A number of paint samples were taken, and these revealed that the golden-brown ground was composed of lead white mixed with brown ocher and some carbon black. In places, the ground was covered with a thin layer of a slightly darker brown (for example, in the shadows on the cloak of the executioner), while, elsewhere (for example, in the background, to the left of the executioner's head), the ground has been gone over thinly with a color similar to it. Plesters writes, "Because the paint layers are so thin, the brown ground will have become more evident as the upper layers have become more translucent with age. Also, wherever the paint layers have become abraded, even slightly, or there is a wide craquelure, the brown ground has become more apparent. The net result is that the picture probably looks more worn than it actually is. There is no evidence from the paint sections that the picture is unfinished."

Kitson (1967, p. 109) has noted in the present painting apparent stylistic discrepancies—while the head of Salome recalls that of the Virgin in the *Madonna of the Rosary*, the head of the executioner is closer to those in Caravaggio's Sicilian paintings—as well as technical and qualitative weaknesses. Both he and Levey (1971, p. 54) have maintained reservations regarding the picture's attribution to Caravaggio; it is catalogued as "ascribed to Caravaggio," and it was kept in storage for a time. However, within the last few years new light has been shed on Caravaggio's late paintings, and there is no reason to doubt the authenticity of the *Salome* (M. Gregori, 1982 a, pp. 133 ff., no. 20).

M. G.

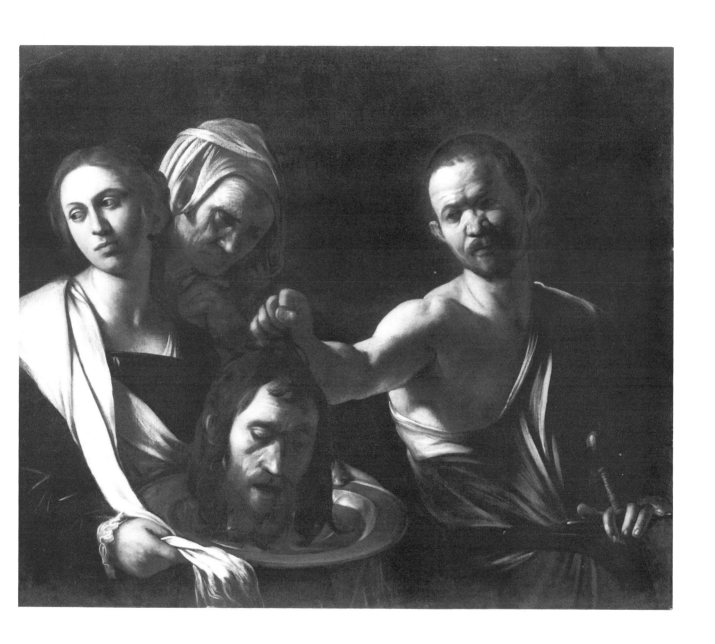

97. David with the Head of Goliath

Oil on canvas, 49 1/4 x 39 3/4 in.
(125 x 101 cm.)
Inscribed (indistinctly, on the blade of the
sword): H [or M] AC [or S] O [or G]
Galleria Borghese, Rome

The inscription on the sword, which Wagner (1958, p. 213, n. 517) tentatively interpreted as Caravaggio's signature (M[ichaeli] A[ngeli] C[aravaggio] O[pus]), is more likely to be the maker's mark, as Macrae (1964, p. 415) suggested.

The three paintings on this theme by Caravaggio—in the Prado, Madrid (cat. no. 77); the Kunsthistorisches Museum, Vienna; and the Galleria Borghese—differ profoundly, and their sequence documents not only the stylistic but also the psychological changes that marked the artist's relatively short life. In the Prado version David, having killed Goliath, is shown in the unheroic act of tying the hair of the giant, whose body lies on the ground, in order to lift his head in triumph. In the second version, in Vienna —a picture that, despite contrary opinions, is an autograph work—the young hero returns from the battlefield, exalted by his victory, in accordance both with the biblical text and with a symbolic interpretation of the subject that saw in David a prefiguration of Christ and regarded his victory as that of Virtue and Good triumphing over Vice and Evil. Longhi (1952, pl. XLV) perceived in the Vienna picture a reflection of the psychological lucidity that also characterizes the *Madonna of the Rosary*. In the Borghese painting, which is usually considered a late work, David's sad and gloomy mien, which cannot be accounted for in the biblical text, has been explained as a reflection of Caravaggio's own psychological state and the difficulties and reversals that plagued the last years of his life. In this sense, the *David with the Head of Goliath* is, together with the Cremona *Saint Francis* (cat. no. 88) and the Malta *Beheading of Saint John the Baptist* (fig. 14, p. 45), a striking document.

David's glance toward the severed head of Goliath has a possible precedent in Giorgione's brooding interpretation of the subject—almost a *memento mori*—as it has come down to us in Hollar's etching. There is also a parallel in Reni's canvas in the Louvre (cat. no. 51; see H. Röttgen, 1974, pp. 203 f.). However, far from depicting an elegiac moment, Caravaggio has chosen, as usual, to express a condition of ineluctable inner conflict and tension, as well as an attraction to death.

Already in the seventeenth century, an autobiographical interpretation of the *David* was widespread. Manilli (1650, p. 67), who described it as in the Villa Borghese, asserted that "in that head [Caravaggio] wished to portray himself, and in the David he portrayed his Caravaggino" ("in quella testa volle ritrarre se stesso, e nel David ritrasse il suo Caravaggino"). Bellori (1672, p. 208) also took the autobiographical point of view: "For the same Cardinal [Scipione Borghese] he painted . . . the other half-length figure of David holding Goliath's head—his own portrait—by the hair" ("Per lo medesimo Cardinale dipinse . . . l'altra mezza figura di Davide, il quale tiene per li capelli la testa di Golia che è il suo proprio ritratto"). Longhi (1952, pl. XXXIX) rightly questioned the identification of Goliath as a self-portrait, although it is evident that, as in the *Beheading of Saint John the Baptist*, Caravaggio identified himself with the victim (the characterization of Goliath as victim is clearer here than in the Vienna picture). However, the identification has been generally accepted, and it has been explained as a self-inflicted punishment for the guilt Caravaggio felt over the murder of Ranuccio Tommasoni, which precipitated his flight from Rome (see M. Fagiolo dell'Arco, 1968, pp. 50, 60, n. 45; H. Röttgen, 1974, pp. 206 ff.; H. Hibbard, 1983, p. 262). The *David with the Head of Goliath* would thus be the ultimate reflection of the conflict between the ego and the superego that tormented the artist during his last years (H. Röttgen, 1974, p. 209).

Frommel (1971 a, pp. 52 ff.) has offered a different interpretation. Referring back to Manilli's description, he has seen in the picture the projection of a homosexual relationship of Caravaggio's. However, the biblical description of the event offers no support for this interpretation, which Röttgen (1974, pp. 203 ff.) has also refuted. For Frommel (1971 a, p. 52), the model for the figure of David also posed for the Cupid in the *Amor Vincit Omnia* (cat. no. 79). This seems unlikely, if only because of the chronological distance that separates the two pictures. Cinotti (1983, p. 504) maintains that the same youth served as a model for the *Saint John the Baptist* in the Galleria Borghese, but even this hypothesis is not completely convincing. The identity of the "Caravaggino" mentioned by Manilli is problematic. Tommaso Luini was known by this name, but he was born about 1600 and therefore cannot have been the person in question (H. Röttgen, 1974, p. 202).

The iconographic novelty of the Borghese picture—and of the earlier version in Vienna—is underscored by the fact that precedents for the isolated figure of the young biblical hero with the head of Goliath occur in sculpture rather than in painting; Berenson (1951, p. 36) found the beauty of David's head, torso, and arm worthy of Lysippus. The outstretched arm has parallels in sixteenth-century Cremonese paintings of the beheading of Saint John the Baptist: This was recognized by Longhi (1928–29; 1968 ed., p. 125), who compared David's gesture to that of the executioner in Antonio Campi's fresco of the subject in San Sigismondo, Cremona. In light of this comparison, David may be seen as the executioner and Goliath the victim.

The earliest reference to the picture—dating from 1613, when it was already in the collection of Scipione Borghese—is a payment for a frame "for the painting of David with the head of the giant Goliath" (P. Della Pergola, 1959, p. 79, no. 114); the dimensions given correspond roughly with those of the present painting. In the same year, the picture is mentioned by Scipione Francucci in stanzas 182–188 of his verse description of the Villa Borghese (the poem was published in 1647; see L. Venturi, 1929, p. 42). Francucci does not convey the peculiar significance that Caravaggio attaches to the theme, and to the figure of David; he conforms, rather, to tradition: "The shepherd is shown all victorious" ("Tutto vittoria il Pastorel si mira"). The *David* was described by Manilli (1650, p. 67) and by Bellori (1672, p. 208), who believed that it was painted for Scipione Borghese. It is listed as a work by Caravaggio in the 1693 inventory and in all subsequent inventories and guides to the collec-

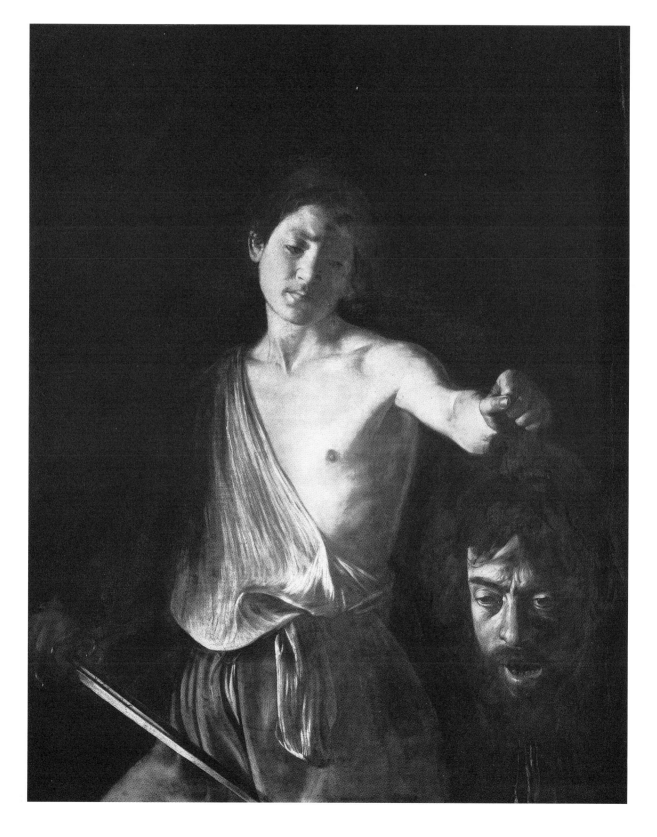

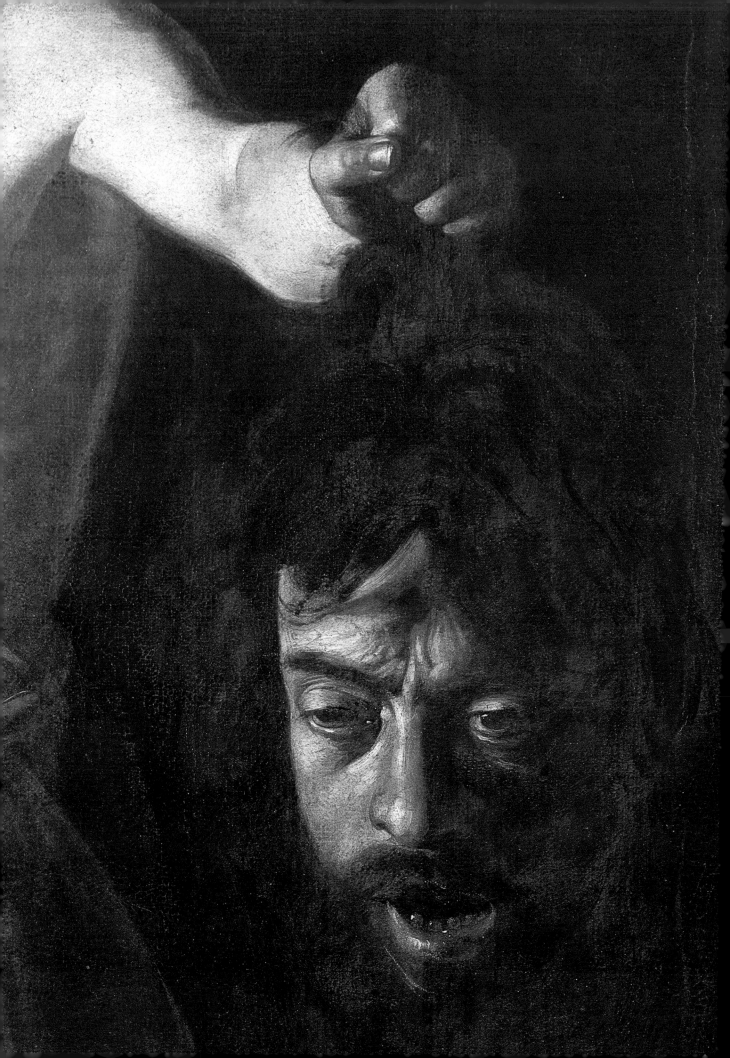

tion. The attribution has been accepted without comment and the picture is generally dated between May 16, 1605, when Scipione arrived in Rome, and the end of May 1606, when Caravaggio left the city. However, in 1959 Longhi published the *Salome Receiving the Head of John the Baptist*, now in London (cat. no. 96), as a work datable to the beginning of Caravaggio's second Neapolitan period. He noted a close analogy between David's foreshortened arm and that of the executioner in the *Salome*, and he proposed that the two pictures were contemporary. (It should be mentioned, however, that the motif of the foreshortened arm occurs in even more similar form in the *David* in Vienna.) For various opinions about the date of the picture, see Cinotti (1983, p. 503). The Borghese *David* is certainly later than the Vienna version, which is nearly contemporary with the *Madonna of the Rosary*, and it is closely related in style to the *Flagellation* in Naples (cat. no. 93). As with the *Flagellation*, the picture probably dates from the second Neapolitan period.

The picture was cleaned in 1915 and in 1936, and again, by Mauro Pellicioli, in 1951, when it was also relined, for the Milan Caravaggio exhibition (P. Della Pergola, 1959, p. 79). A tent, summarily indicated by means of touches of light, was revealed by this restoration.

A number of copies are recorded (see M. Cinotti, 1983, p. 502). One, Caracciolo-like in character, was cited by Pacelli (1977, p. 829; 1978 b, p. 67), who published a payment made in Naples on November 5, 1610, to the artist Baldassare Alvise to paint two copies of a *David* by Caravaggio. The picture in question is probably the present *David*, and this would confirm the hypothesis that it was painted in Naples. Scipione Borghese would then have acquired it later, perhaps about 1613, either in Naples or in Rome, where it may have been sent. It is worth mentioning that a "Davide"—almost certainly not the present picture—was owned by the Conde de Villamediana in Naples (Bellori, 1672, p. 214); Stoughton (1978, p. 408, no. 47) believes that Alvise's two copies were painted in 1610 after the Villamediana picture, which is probably identifiable with the Vienna *David*. The date of the copies, however, does not seem

to coincide with Villamediana's presence in Naples (1611–17). There are no copies of the Vienna picture (see A. Moir, 1976, pp. 118 f., n. 8), perhaps because it belonged to the viceroy and was not readily visible. The large number of copies after the Borghese *David* suggest that, by contrast, it was easily accessible.

M. G.

98. The Toothpuller

Oil on canvas, 54 7/8 x 76 5/8 in.
(139.5 x 194.5 cm.)
Gallerie, Florence (on loan to the Palazzo di Montecitorio, Rome, since 1925)

The subject is first treated as an incidental detail in paintings by Hieronymus Bosch and as an isolated subject in an engraving, of 1523, by Lucas van Leyden (K. Reuger, 1978, pp. 107 f.). In the engraving the three figures of the surgeon, the patient, and a woman who robs the patient are shown standing. The surgeon wears a large hat decorated with a brooch, as was the fashion, and this seems to have inspired the singular cap worn by the dentist in the present picture. Several figures are grouped around a table, in accordance with a formula used by Caravaggio in such pictures as the *Cardsharps* (fig. 2, cat. 67), the *Conversion of the Magdalen* (cat. no. 73), the *Calling of Saint Matthew* in the Contarelli Chapel (fig. 4, p. 34), and the two versions of the *Supper at Emmaus* (cat. nos. 78, 87; see L. Salerno, 1974, p. 588). On the table, which is covered with a carpet, is a still life composed of the surgeon's bottles and receptacles.

Portions of the composition are not fully legible, and it is difficult to ascertain whether the principal subject is the patient having his tooth pulled, or one of the bystanders being robbed. The latter incident is associated with the theme of the toothpuller and figures in two paintings by Gerrit van Honthorst: One, of 1622, in the Gemäldegalerie, Dresden, and another in the Musée du Louvre, Paris. Surgical themes like the present one trace their origins to representations of the sense of Touch (K. Reuger, 1978, pp. 67, 107 ff.). Slatkes (1976, p. 153) has noted the similarity of the gesture of the patient in Honthorst's two pictures with that of the *Boy Bitten by a Lizard* (cat. no. 70).

In an inventory of the Palazzo Pitti made in 1637 (A. S. F., Guardaroba 525, fol. 572), the picture is described as "a painting on canvas by Caravaggio of someone pulling the teeth of another with other figures around a table . . . with a gilt, wooden frame about 2 3/4 *braccia* high and 3 3/4 *braccia* wide" ("un quadro di tela di mano del Caravaggio dipinto che uno levava i denti a un

altro e altre figure intorno a una tavola . . . con adornamento di legno tutto dorato circa alto bracci 2 e 3/4 largo 3 e 3/4"). Scannelli (1657, p. 199) describes it as follows: "I also saw some years ago in the apartments of his highness the Grand Duke of Tuscany a painting of half-length figures carried out with [Caravaggio's] accustomed naturalism, that shows a surgeon pulling a tooth from a peasant. And if this picture were in good condition instead of obscured in many areas and ruined, it would be one of the most worthy pictures he painted" ("Viddi pure anni sono nelle stanze del Serenissimo Gran Duca di Toscana un Quadro di meze figure della solita naturalezza, che fà vedere quando un Ceretano cava ad un Contadino un dente, e se questo Quadro fosse di buona conservatione, come si ritrova in buona parte oscuro, e rovinato, saria une delle più degne operationi, che havesse dipinto"). As Scannelli's description demonstrates, the picture was already darkened and in poor condition in the mid-seventeenth century. It has suffered vast losses of paint and damages to the surface, especially on the left side. It was restored in 1966 and again in 1975. On loan to the Palazzo di Montecitorio, with an attribution to the school of Ribera, it was published and ascribed to Caracciolo by Briganti (1967, p. 404), who, according to Borea (1970, pp. 12 f.), later changed his opinion. It was exhibited in 1970 (E. Borea, 1970, pp. 12 f., no. 6) as by an unknown follower of Caravaggio and described as painted "in the manner of" Caravaggio with the intent of "plagiarizing the aggressive and tragic traits" of Caravaggio's last works. Noting that the secular theme is typical of Netherlandish painting, Borea cited the two pictures in Dresden and in Paris by Honthorst and another by Rombouts in the Prado, and she noted that the subject was also treated by the Bamboccianti. She held that the theme—"of a quotidian nature and impossible to evaluate critically except as tragicomedy"—was incompatible with an attribution to Caravaggio, especially late Caravaggio, since she excluded the possibility that he would have painted secular or genre subjects at a late date. Such a conclusion is based on a dangerous historical preconception that is, in and of itself, unacceptable. Other scholars have fol-

lowed Borea's line of reasoning, daunted by the subject and by its too "picturesque" and "expressive" treatment (see C. Volpe, 1970, p. 110; F. Bologna, 1980, p. 41, n. 8; M. Cinotti, 1983, p. 559).

Borea found analogies in the painting of some of the heads in the *Toothpuller* with passages in works by Manfredi in the 1970 exhibition, such as the *Christ Disputing with the Elders in the Temple* and the *Tribute Money*. She also compared the typology of the figures on the left (which she considered the best part of the picture) to that of certain heads in paintings by Saraceni, suggesting that the same models were used; this was a common practice in Caravaggesque circles in Rome.

After the picture was exhibited in Florence in 1970, Volpe (1970, pp. 110 f.) and Schleier (1971, p. 88) gave it serious critical attention. Although their conclusions differed, both scholars underscored the singularity of the painting. Volpe emphasized the difference in approach from the popular, anecdotal painting typical of Dutch tradition, noting a disparity between the "truculent, almost tragicomic" invention of the surgeon and the patient (with whom he associated the boy and the still life, as well), on the one hand, and, on the other, the powerful verisimilitude of the five striking spectators. He attributed this disparity to two artists working at two successive moments, suggesting that the picture was begun by an early follower of Caravaggio and completed later by a painter close to Pietro Paolini. Schleier adopted a contrary position: Reaffirming the stylistic unity of the picture, noting the attribution to Caravaggio in the 1637 and 1657 descriptions of it, and calling attention to the relationship of the present work and the *Knight of Malta* (cat. no. 95) to Caravaggio's late, Maltese style, he suggested that the *Toothpuller* might be by Caravaggio. His opinion was shared by the present writer, who was already aware of the mention of the picture in the 1637 inventory and who, in 1974 (M. Gregori, 1975, pp. 42 ff.), also proposed attributing the painting to Caravaggio.

Nicolson (1979, p. 34) classified the *Toothpuller* as by Caravaggio, calling it an uncertain, ruined work. Its attribution to Caravaggio has recently been rejected by Ferrari (1978, p. 372), Hibbard (1983, p. 342),

Cinotti (1983, p. 559), and Spear (1984, p. 165). A careful reexamination of the painting will, it is hoped, produce more positive results. The light that plays violently over the figures is focused but intermittent: This feature (which is accentuated by the poor state of the work and by the loss of transitional passages through alterations of the pigments with the passage of time—a phenomenon encountered in other late works by Caravaggio) is characteristic of Caravaggio's Maltese or second Neapolitan period. Also typical of this phase of Caravaggio's career are the apparent speed with which the right-hand figures have been painted and the extreme economy of technical means employed. There is, furthermore, a variety in the execution that would be difficult for a follower to imitate.

At the recent exhibition of Neapolitan paintings in London, Washington, Paris, and Turin, a number of late Caravaggios were shown together, and it is easier now to recognize the artist's abbreviated, powerful style here: in the face of the man at the right, leaning on the table; in the singular pattern of the light on his arm, with its rippling skin; and in the aggressive stare of the curious old woman, whose kerchief, despite paint losses, preserves dazzling passages. The old woman is a leitmotiv in Caravaggio's paintings: She cannot fail to recall the old servant with her sharp profile—like that of a bird of prey—in the *Judith and Holofernes* (cat. no. 74), the old woman in the Brera *Supper at Emmaus* (cat. no. 87), the servant in the London *Salome* (cat. no. 96), and the old woman in the *Crucifixion of Saint Andrew* (cat. no. 99). (An echo of this figure is also found in Georges de La Tour's *Fortune Teller* in the Metropolitan Museum: see fig. 4, cat. no. 67.)

Of the three men on the left-hand side of the picture, the fat, bald one in the foreground, with his amusing features, is especially noteworthy. Like that of the two protagonists in the center, his role is that of a comic or tragicomic character. His profile is enveloped in a half-shadow of a luministic variety that would be impossible to imitate, precisely because it is not stylized. His fully lit bald head, despite abrasion, reveals the circular brushwork that Caravaggio characteristically used to define the point of maximum illumination. His ear casts a clear,

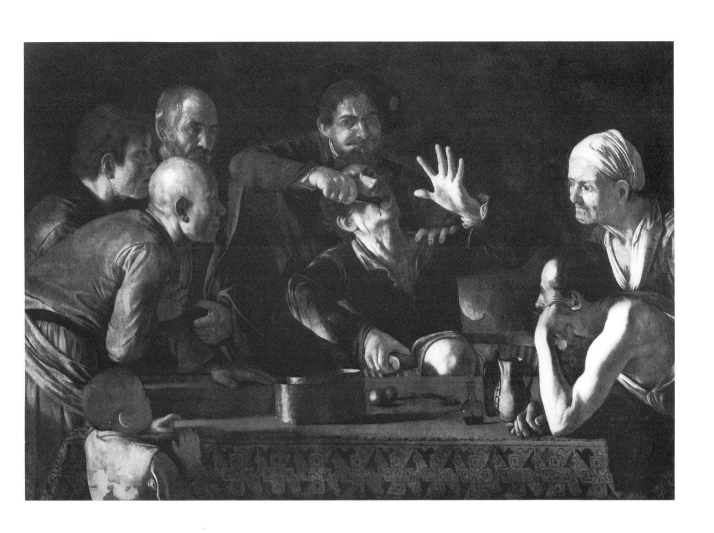

geometric shadow. These details, painted with an economy of means, both imitate and "correct" nature with an authority that none of Caravaggio's followers possessed. The heads of the other two men at the left, although seriously damaged, exhibit Caravaggio's inimitable qualities, as well as his typical "errors." In the transparent half-shadows on the two faces, modeling and physiognomic description are carried out economically; the light creates a silvery sheen on the hair and forehead of the old man. These effects recur in the *Beheading of Saint John the Baptist* in Malta and in such Sicilian pictures as the *Raising of Lazarus* in Messina and the *Adoration of the Shepherds* (stolen from Palermo). The intermittence of light and shadow on the faces of these men is a characteristic of Caravaggio's post-Maltese work. Although the play of light on the ears is rendered with great beauty and variety, the ears themselves are viewed at almost the same angle, despite the fact that the head of the old man is not in profile. They exhibit the same morphology—as if Caravaggio resorted to archetypes, an impression frequently encountered in his late works (see the remarks of R. Wittkower, 1958, p. 26). Even the hands are described in an abbreviated, typically Lombard fashion, with "errors" that no follower would dare to imitate.

Similar traits are encountered in the central figures: There is no question but that the same artist painted them. The exaggerated features of the surgeon, unfortunately much weakened by the painting's condition, hark back to Caravaggio's early experiments with figures whose expressions, although bordering on the grotesque, are studied from life—there is an analogy in the head of the central figure in the *Cardsharps* (fig. 2, cat. 67)—and they recall the recommendations of both Leonardo and Lomazzo. It would therefore appear that at this late moment Caravaggio returned to his earlier interest in genre painting: Recognition of the *Toothpuller* as a work by Caravaggio refutes a widespread assumption that the artist abandoned such subjects after his youth.

Caravaggio's tendency to exaggeration in the late works has not received sufficient attention. Yet, it is a key to understanding, for example, the trivial but ominous ex-

pression of the Hun king who has pierced Saint Ursula with an arrow (cat. no. 101). Caravaggio's revival of this sort of painting—whose precedents in Lombard painting are now more familiar, as a result of the studies of Meijer (1971) and Wind (1974)—seems to have been coupled with a new interest in such typically Northern subjects as the toothpuller, as well as in the expressionism of sixteenth-century German engravings and of prints by Lucas van Leyden. The present writer intends to take up this discussion more fully elsewhere, with new documentation, but here it may be suggested that Caravaggio was inspired in a general way by Lucas van Leyden's *Toothpuller*, of 1523, by the *Surgeon*, of 1524, or by other, similar Northern engravings.

The summary but highly descriptive modeling of the surgeon's plump hand and of the patient's head and neck is associable with Caravaggio's late work: The variety of tone and a certain asperity is also found in the figure of the old woman in the *Crucifixion of Saint Andrew* (cat. no. 99). The way in which the raised hand emerges from the shadow is consistent with Caravaggio's conception of dynamic action, throughout his career. This is the last appearance of a gesture that occurs earlier in the *Martyrdom of Saint Matthew* (fig. 5, p. 35), the *Agony in the Garden* (formerly in Berlin; now destroyed), the Vatican *Entombment* (fig. 11, p. 42), and in the approximately contemporary *Raising of Lazarus* (fig. 15, p. 46), to name only the most closely related examples. Moreover, the dimly lit carpet with its patterned design, hanging over the table and viewed frontally, is a motif found in the two paintings of the *Supper at Emmaus* (cat. nos. 78, 87). Because of these numerous analogies, the *Toothpuller* exemplifies in a most significant way the evolution of recurring ideas and motifs in Caravaggio's career.

Following Schleier's tentative proposal and that of the present writer, who recently reaffirmed her opinion (M. Gregori, 1982 a, pp. 37, 39), the hypothetical attribution of the *Toothpuller* to Caravaggio has been accepted by Testori (1975, p. 3) and Calvesi (1975 a, p. 3). Marini (1981, p. 427) believes that the picture may be by a Flemish artist "sensible to Rodriguez's example, but also to one of the painters designated as the

Master of the Judgment of Solomon," and he asserts (without citing specific examples) the existence of other paintings by the same hand in Sicily, called to his attention by Francesco Negri Arnoldi. He also notes affinities with the work of Louis Finson, but believes that the composition derives from the pictures by Honthorst and Rombouts mentioned above. As Scannelli's early attribution of the picture would lead one to believe, and as Schneider (1933, p. 26) assumed, the relationship between these pictures and the *Toothpuller* is the opposite of what Marini postulates—notwithstanding the fact that Honthorst and Rombouts were from the North, where the subject originated. Caravaggio's authorship of the *Toothpuller* would go a long way toward explaining the diffusion of genre scenes by his followers and imitators (G. Testori, 1975, p. 3). The picture was probably sent from Malta to Florence at an early date—this is only a hypothesis—like other works by the artist. Honthorst and Rombouts could have seen it in Florence (the latter was summoned by the grand duke and was active in Pisa in 1622: see A. von Schneider, 1933, p. 106). In any event, there can be no doubt that the three pictures by Honthorst and Rombouts in Dresden, Paris, and Madrid were dependent, for some of their motifs, on the *Toothpuller*. The relationship of works by Rodriguez, the best Sicilian follower of Caravaggio, to the picture is also one of dependence. In Rodriguez's *Supper at Emmaus* in Messina, in particular, details of the still life on the table and the profile of the surprised youth, shown in shadow, derive from the *Toothpuller*, lending added weight to the hypothesis of a Maltese or Sicilian origin for Caravaggio's painting.

M. G.

99. The Crucifixion of Saint Andrew

Oil on canvas, 79 3/4 x 60 1/8 in.
(202.5 x 152.7 cm.)
The Cleveland Museum of Art

The picture is mentioned by Bellori at the end of his life of Caravaggio (1672, p. 214) in the following terms: "The Conde de Benavente, who was Viceroy of Naples, also took to Spain the Crucifixion of Saint Andrew." It is described in greater detail in two inventories of 1653 (E. Garcia Chico, 1946, p. 393), drawn up at the death of the Viceroy's nephew, the tenth Conde de Benavente, when the picture was in the family palace in Valladolid: "A very large painting on canvas of Saint Andrew, disrobed, being hung on the cross, with three executioners and one woman. . . . It is an original work by Michaelangelo Caravaggio" ("Un lienco muy grande de pintura de san andres desnudo quando le estan poniendo en la cruz con tres sayones y una muger. . . . Es de micael angel caraballo, orixinal"). A note to one of these inventories (A. Tzeutschler Lurie and D. Mahon, 1977, p. 10) adds that the three "executioners" were at the foot ("al pie") of the cross. In fact, in the picture there are, in addition to Saint Andrew, four male figures: the executioner on the ladder, a soldier in armor, and two bystanders. In all likelihood, the mention of only three figures ("sayones") in the inventory was an oversight, since one of the three male figures at the foot of the cross is not readily visible. In accounting for the third figure at the foot of the cross, the author of the note in turn omitted the executioner on the ladder (see also M. Cinotti, 1983, p. 421).

Traditionally, Saint Andrew is depicted on an X-shaped cross rather than a Latin cross, but an engraving in a popular translation of Jacobus de Voragine's *Golden Legend*, the *Leggendario delle vite de' santi*, shows the saint on a Latin cross with his hands tied rather than nailed, and with a number of bystanders, as in the present picture (B. Nicolson, 1974 a, p. 608). Caravaggio has chosen to represent not the act of Saint Andrew being hung on the cross, as the inventory would have it, but the rarely shown scene of the saint's death, as derived from the *Acta Apostolorum Apocrypha* and described and cited in the *Leggendario*, the

Flos Sanctorum, and the *Libro de las Vidas de los Sanctos*, which was published in 1601 and 1604 by the Jesuit Pedro de Ribadeneyra, and again, in Italian, in 1604–5 (A. Tzeutschler Lurie and D. Mahon, 1977, pp. 13, 23, nn. 43, 44). According to these accounts, the saint hung on the cross for two days; during this time he preached to the crowds, who, stirred by his words, demanded his liberation. As a result, Aegeas, the proconsul of Patras, ordered that the saint be taken down, but Andrew's desire to die like Christ was miraculously accomplished. As the *Leggendario* recounts: "Although the people wished to see the saint free, they could in no way approach him, lest their arms become as dry as if they were wood." Indeed, the arms and legs of the man on the ladder seem paralyzed in the act of unbinding Saint Andrew, who is breathing his last.

On the basis of Bellori's description, Longhi (1927 a, p. 10; 1967 ed., p. 124; 1943 a, pp. 8, 17 f., fig. 26) recognized a copy of Caravaggio's picture—then still lost—in the Museo de Santa Cruz, Toledo, where it was attributed to Ribera. The idea that this was a copy after Caravaggio was widely accepted, although Hinks (1953, pp. 84, 120) and Marini (1974, p. 433; retracted, 1979, p. 19) considered the Toledo picture an original. Lacking the inventory notices of 1653—which were published only in 1946 (in E. Garcia Chico) and brought to the attention of scholars by Ainaud de Lasarte (1947, p. 380)—and referring to Bellori's notice in an incomplete fashion, Longhi supposed that the picture was first taken not to Spain but to Amsterdam, where in 1619 a group of painters authenticated a picture of this subject as a work by Caravaggio. The original picture would then have been sent from Amsterdam to Spain, where the one known copy in Toledo was painted. But in fact, the picture recorded in Amsterdam was probably a copy by Louis Finson (W. Friedlaender, 1955, p. 210; D. Bodart, 1970 a, p. 136, no. 19, fig. 60), who was in Naples as early as 1604 (V. Pacelli and F. Bologna, 1980, p. 29, n. 4), before the original was taken to Spain by the Conde de Benavente when he left Naples on July 11, 1610; Finson's copy may be identified with a picture in the Back-Vega collection, Vienna. On the other hand, the example cited by

Marini (1974 a, p. 434), in the Musée des Beaux-Arts, Dijon, could be a copy after Finson's painting, by Abraham Vinck, who was a friend and companion of Finson's and is recorded with him in Neapolitan documents (A. Tzeutschler Lurie and D. Mahon, 1977, p. 9, refer to a notice published by N. de Roever, 1885, p. 186). The existence of these copies testifies to the importance of Caravaggio's picture, which, despite its poor state of preservation, remains one of the most striking works he painted after fleeing Rome.

In the 1653 inventory, where the *Crucifixion of Saint Andrew* is mentioned for the last time, it was valued at 1,500 ducats, the highest valuation of any painting in Benavente's important collection. The picture was discovered in the José Manuel Araiz collection in Madrid, and purchased by the Cleveland Museum in 1976. It was first published—as a copy—by Salas (1974, p. 31), and exhibited with a tentative attribution to Caravaggio by Pérez Sánchez in 1973 (no. 4). Both scholars called attention to the quality of the picture—far higher than in any of the other known examples —although Pérez Sánchez hesitated in identifying the subject as the Martyrdom of Saint Andrew because of the presence of the Latin cross and of four rather than three men, as cited in the inventory; these apparent discrepancies have now been explained by Tzeutschler Lurie and Mahon (1977, pp. 10 ff.). Nicolson (1974, p. 608) published the painting for the first time as an autograph work. There can be no objections to the identification of the picture with the painting owned by the Conde de Benavente and recorded by Bellori, especially since the 1974 restoration (carried out by Jan Dick in consultation with Luigi Salerno and Denis Mahon: see B. Nicolson, 1974, p. 608; and A. Tzeutschler Lurie and D. Mahon, 1977, p. 23), which has revealed not only damages, such as the tear in the canvas that runs through the eye of Aegeas, the man in armor (see A. Tzeutschler Lurie and D. Mahon, 1977, p. 11, fig. 18), but also the extreme freedom in handling and in the use of light. As a result of the cleaning and X-ray examination of the picture—which is painted on Flemish linen (M. Marini, 1978, p. 19)—a number of important changes in the head of Aegeas and of the old

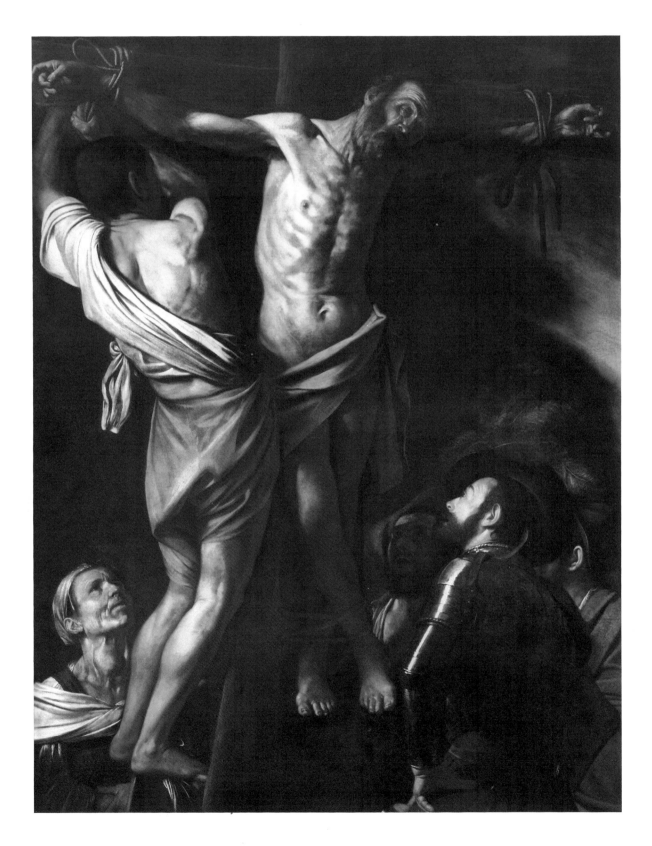

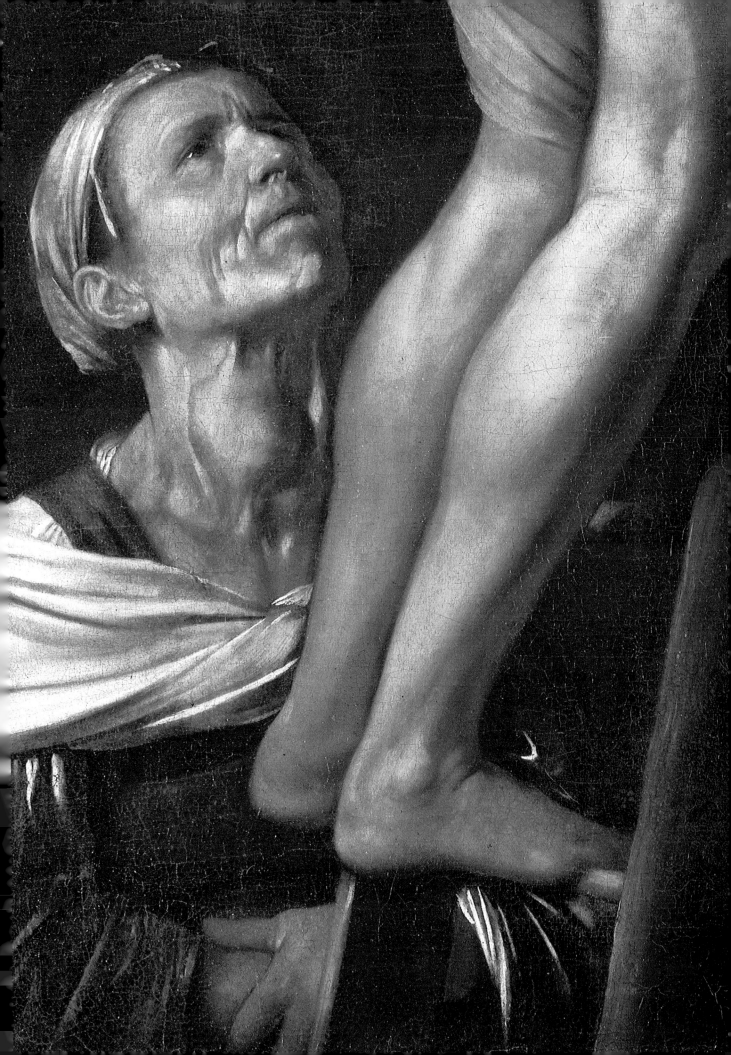

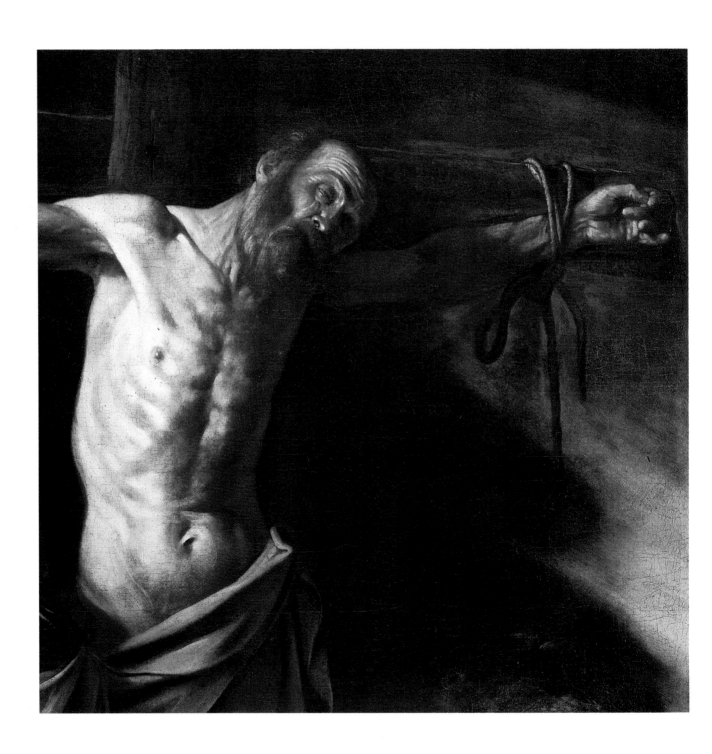

woman are now legible. Caravaggio initially depicted the woman—whose realistic characterization was perhaps inspired by the famous Hellenistic sculpture, the so-called *Vecchia capitolina* (R. Longhi, 1952, p. 42)—with her hands clasped to her throat (see B. Nicolson, 1974, p. 608; A. Tzeutschler Lurie and D. Mahon, 1977, p. 10). Eventually, he portrayed her with a prominent goiter, a trait common in poor regions of Campania as well as in the area of Bergamo, and one that is frequently shown in Neapolitan crèche figures.

Most critics, beginning with Longhi (1943 a, p. 18; see also, most recently, R. Spear, 1984, p. 162), date the painting to about 1607—that is, during Caravaggio's first Neapolitan period. Nicolson (1974, p. 608) has compared the head of the saint to that of the Saint Jerome—in the Museum of the Co-Cathedral of Saint John in Malta—a work that, according to Levey (1970, p. 557), was painted in Naples in 1607 and sent by Ippolito Malaspina to the Grand Master of the Knights of Malta. However, for reasons of style—the fragmented light and discontinuous forms, and the abbreviated and free execution—the present writer believes the picture was painted in Caravaggio's final phase, after his return to Naples from Sicily (see M. Gregori, 1974, 1975, p. 43, 1984, p. 129; D. Mahon, 1952, p. 19, who based his opinion on the known copy; and M. Cinotti, 1983, p. 422).

The hypothesis that the picture was commissioned by the Viceroy for the altar of the crypt of the cathedral of Amalfi, where the body of Saint Andrew is preserved, seems to be incorrect. The chapel was restored by Philip III of Spain by 1607, the date that appears on a stone in the chapel. The space in the chapel is not large enough for the painting, and in Amalfi the traditional X-shaped cross was preferred in depictions of the saint (A. Tzeutschler Lurie and D. Mahon, 1977, pp. 19 ff., 24, nn. 60–63, with previous bibliography). Considering the popular devotion to the saint, it is probable that the picture was commissioned for one of the Viceroy's chapels in Naples or, possibly, in Valladolid—or even that the picture, originally intended either for the Amalfi cathedral or another religious building, was, instead, acquired by Benavente. Before the *Crucifixion of Saint Andrew* was sent to Spain, where it was studied and admired (Zurbarán's *Crucified Christ with a Painter* in the Prado, for example, is recognizably derivative), it was certainly seen by Neapolitan painters, as is clearly demonstrated by Caracciolo's *Crucifixion* in the Ospedale dell'Annunziata (V. Pacelli, 1978 a, pp. 493 ff.) or Carlo Sellitto's *Crucifixion* in Santa Maria in Cosmedin, Naples (Naples, 1977, pp. 82 ff., no. 9). There were probably copies of the picture in Naples, from which the *Crucifixion of Saint Andrew* in the Museum of Fine Arts, Boston—a painting attributed to Francesco Fracanzano and incorrectly thought to show the crucifixion of Polykrates—was derived.

M. G.

100. The Denial of Saint Peter

Oil on canvas, 37 x 49 3/8 in.
(94 x 125.5 cm.)
Inscribed (on reverse): illa / [?] N. 8 AM 9 f
Private collection

The treatment of the subject—a rare one in Seicento painting; the theme of Saint Peter's penitence was generally preferred (J. Gash, 1980, p. 126)—is faithful to the Gospel narrative. A fireplace is visible in the background, in accordance with the accounts of Mark, Luke, and John; the fire, which shoots sparks, possibly has some symbolic relation to Saint Peter. The representation, with just three figures, reduces the scene described in the Bible to its essentials.

There is no mention of this picture in the known sources. In recent times it belonged to the principi Imparato Caracciolo of Naples, who purchased it on the Neapolitan art market after the war; it left Italy after 1964. The painting has no connection with the *Denial of Saint Peter* by Caravaggio, described by Bellori (1672, p. 209), in the sacristy of the Certosa di San Martino, Naples, where there is a picture of this subject by an anonymous, possibly Flemish, follower of Caravaggio. However, a 1650 inventory of the Savelli collection in Rome lists a similar-sounding picture of this subject, of approximately equal dimensions, by Caravaggio ("un'ancella con S. Pietro negante, et una altra meza figura per traverso, p.m 5 e 4 del Caravaggio, D. 250": G. Campori, 1870, p. 162). Although there is no proof that the Savelli picture is identical with the present one, the high valuation placed on it suggests that it was an original, not a copy (M. Cinotti, 1983, p. 548).

The soldier wears a parade helmet, of a Milanese type, decorated with acanthus leaves; a similar helmet is depicted in Giovanni Battista Caracciolo's *Liberation of Saint Peter* in the Pio Monte della Misericordia, Naples (M. Marini, 1974, p. 428). Caravaggio's authorship was recognized by Longhi in 1964 (see M. Cinotti, 1983, p. 549), following the restoration of the picture by Pico Cellini (for an account of which see M. Marini, 1973, pp. 189 ff.; 1974, p. 428); since that time it has been almost unanimously accepted. The ground, of dark bole, is partly visible in areas where the color has become transparent, while the shaded areas of the face and figure of the maidservant have suffered somewhat; alterations of this type are characteristic of Caravaggio's last works. A recent restoration revealed a pentimento in the woman's left hand, which was first painted with an open palm.

Except for Marini (1973, pp. 189 ff.; 1974, pp. 224 f., 428 f., and *passim*), scholars have generally agreed that the picture dates from Caravaggio's last Neapolitan period, after the Maltese and Sicilian works. Typical of his style at this moment are the cursory execution, the instability of the pigments (noted by F. Bardon, 1978, p. 174), and the audacious and superficially incorrect formal abbreviations of such features as the hands—which accords with Moir's just observation (1976, p. 162) that the picture anticipates the work of Giovanni Serodine. The at once agitated and concentrated relationship among the figures, accentuated by the violent lateral lighting, is similar to what one finds in the *Martyrdom of Saint Ursula* (cat. no. 101), which was certainly painted in the last months of Caravaggio's life. Even the gesture of Saint Peter, who holds his hands to his chest as though expressing remorse after his denial of the servant's accusation, is analogous to Saint Ursula's gesture of humility and acceptance, as well as to that of the Virgin in the *Annunciation* of 1609–10 in the Musée des Beaux-Arts, Nancy.

No copies of the work have come to light (A. Moir, 1976, p. 120), but the picture seems to have been known: As Volpe noted (1972 a, p. 71), the *Denial of Saint Peter* by the Master of the Judgment of Solomon in the Galleria Corsini, Rome, is related to it, and as Nicolson pointed out (verbally), so is the painting of the same subject by the Pensionante del Saraceni in the Pinacoteca Vaticana (B. Nicolson, 1979, p. 77, identifies the subject of the Vatican picture as Job and his wife: see cat. no. 47).

M. G.

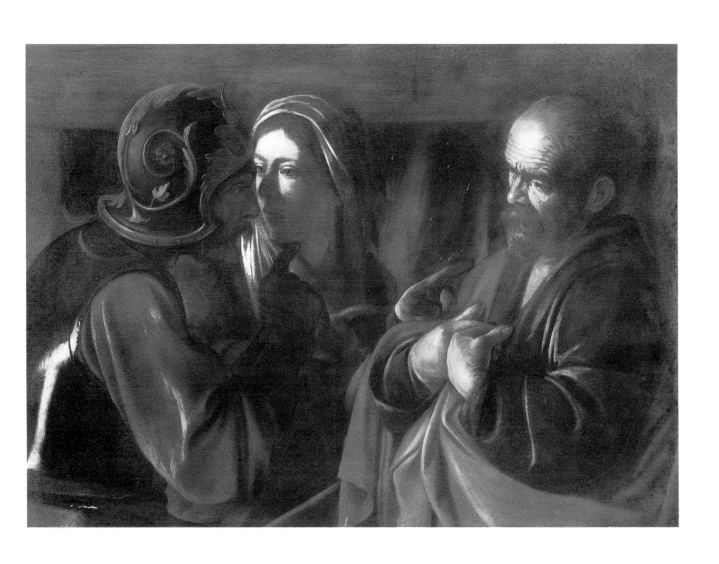

101. The Martyrdom of Saint Ursula

Oil on canvas, 60 5/8 x 70 1/8 in.
(154 x 178 cm., including additions made
prior to 1831 of 13.5 cm. at the top and 7.5
cm. at the left)
Inscribed (on reverse): D. Michel Angelo da /
 Carauagio. 1616. ☩ / M.A.D. [Marco Antonio
 Doria]; *(at top):* Del Caravaggio
Banca Commerciale Italiana, Naples

The subject of the picture, previously interpreted as an allegory, has recently been shown by documents that also confirm its authorship (V. Pacelli and F. Bologna, 1980, pp. 24 ff.), to represent the martyrdom of Saint Ursula. In contrast to the traditional iconography of the theme, Caravaggio has carefully followed the legend according to which, after the martyrdom of her companions, the saint was killed by the king of the Huns, following her refusal to marry him.

When exhibited in Naples in 1963 (it was lent by the Romano Arezzano collection; previously, it had been owned by the Doria d'Angri family), the picture was attributed to Mattia Preti. It was acquired in 1973 by the Banca Commerciale Italiana, and in 1975 the present writer proposed the attribution to Caravaggio on stylistic grounds—an idea that achieved no consensus. The picture was cited as a Caravaggio by Nobile in 1845, when it was in the Palazzo Doria d'Angri, Naples, and it was listed in the Doria inventories as such as early as May 15, 1620, when the picture was still in Genoa; the 1620 inventory also describes the subject with exactitude as "Sant' Orsola confitta dal tiranno" ("Saint Ursula pierced by the tyrant").

According to recent findings, the picture was painted by Caravaggio in Naples for the Genoese patrician Marcantonio Doria (son of Doge Agostino) and the Prince of Angri, whose initials appear on the reverse of the canvas. Like his brother Gian Carlo, Marcantonio was interested in Caravaggesque painting and personally knew the artist. In fact, following his denunciation on July 29, 1605, for his attack on Mariano Pasqualone, Caravaggio had taken refuge in Genoa, where he was offered 6,000 *scudi* to fresco a loggia for Doria, an offer he refused. On May 11, 1610, the Doria family's correspondent and procurator in Naples, Lanfranco Massa, wrote to Marcantonio that he had already received the painting of Saint Ursula from Caravaggio and was waiting for it to dry. However, exposure of the picture to the sun proved deleterious, since, according to Massa, Caravaggio employed a thick varnish ("la vernice . . . assai grossa": see V. Pacelli and F. Bologna, 1980, pp. 24 f.). The painting, whose subject is perhaps related to Marcantonio's much adored stepdaughter (referred to in a letter as Sister Ursula), was sent to Genoa May 17, 1610, and arrived there June 18. In his will of October 19, 1651, Marcantonio left the picture, along with his most prized works of art and some "notable" relics, to his eldest son, Nicolò, Prince of Angri and Duke of Eboli. It remained in the family and was transferred to Naples with the better part of the estate by Maria Doria Cattaneo in 1832; in 1854–55, it was listed in the inventory of Giovan Carlo Doria's inheritance in the Palazzo Doria d'Angri allo Spirito Santo, Naples.

In the *Martyrdom of Saint Ursula*, the protagonists—the murderer and the victim—are brought unusually close to each other: The dramatic climax is described in a concise and concentrated fashion, suggesting that Caravaggio wished to observe the unities of time, place, and action proper to classical theater. Caravaggio himself can be recognized among the secondary figures. The artist repeatedly introduced self-portraits in paintings with tragic themes: in the *Martyrdom of Saint Matthew* in the Contarelli Chapel (see fig. 5, p. 35); the *Taking of Christ* (the best version of which is in the state museum in Odessa); the *Burial of Saint Lucy*, painted for Santa Lucia al Sepolcro, Syracuse; and in the *Raising of Lazarus*, in Messina (see fig. 15, p. 46). This perhaps suggests a subjective participation, and may carry a moral significance, but it is more probable that by the inclusion of a self-portrait, a tradition that can be traced back to fifteenth-century Flemish painting, Caravaggio wished to underscore the realism of the scene.

The archival evidence indicates that the work was painted just two months before the death of the artist, and, indeed, the *Martyrdom of Saint Ursula* represents, in its cursory execution and dramatic physiognomic characterization, the most extreme realization of the tendencies of his last Neapolitan period. Several motifs link it with other paintings done in this brief time—the *Annunciation*, datable to 1609–10 (in the Musée des Beaux-Arts, Nancy), and the *Denial of Saint Peter* (cat. no. 100; see M. Gregori, 1982 a, p. 132).

No copies of the picture are known, although two derivative works confirm that in the seventeenth century it was in the collection of Marcantonio Doria in Genoa, where Genoese painters could have seen it: One, by Fiasella, is in the church of Sant' Anna, Genoa; the other, by Bernardo Strozzi (to be published by the present writer), is in a private collection and is a direct derivation—even in format—but alters in a profound way the realistic significance of the prototype.

The picture is poorly preserved.

M. G.

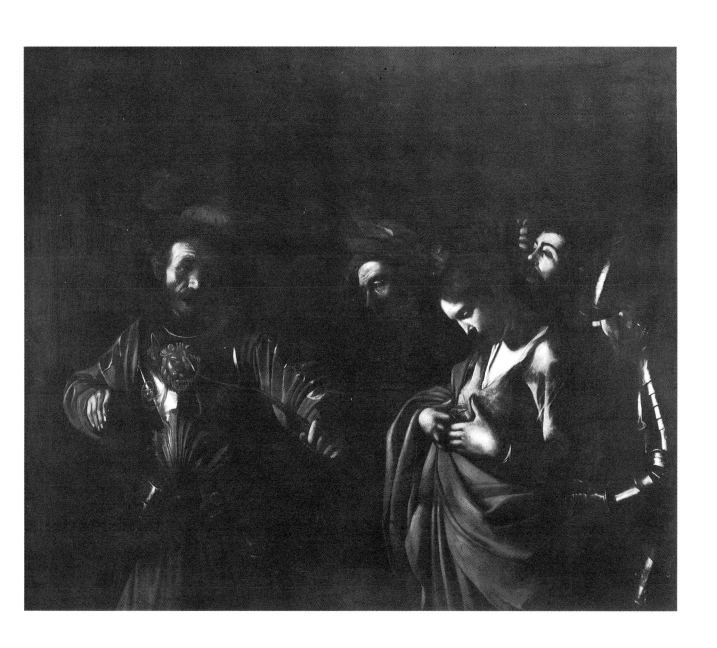

Bibliography
Photograph credits

Abrams, M. H.
1953. *The Mirror and the Lamp: Romantic Theory and Critical Tradition.* New York.

Ainaud de Lasarte, J.
1947. "Ribalta y Caravaggio," *Anales y Boletín de los Museos de Barcelona,* no. 3–4, pp. 345–413.

Alveri, G.
1664. *Della Roma in ogni suo stato,* vol. II of *Roma in ogni stato.* Rome.

Amayden, T.
about 1640. "La storia delle famiglie romane." Ed. C. A. Bertini, 2 vols., Rome, 1914.

Andrews, K.
1977. *Adam Elsheimer: Paintings, Drawings, Prints.* New York.

Angeli, D.
1903. *Le chiese di Roma: Guida storica e artistica delle basiliche, chiese e oratorii della città di Roma.* Rome.

Arcangeli, F.
1956 a. "Sugli inizi dei Carracci," *Paragone,* no. 79, pp. 17–48. **1956 b.** In *Mostra dei Carracci,* exhib. cat. Bologna, Palazzo dell'Archiginnasio. **1966.** "Un nuovo Saraceni," *Paragone,* no. 199, pp. 46–55.

Argan, G. C.
1956. "Il 'realismo' nella poetica del Caravaggio," in *Scritti di storia dell'arte in onore di Lionello Venturi,* vol. II, pp. 25–41, Rome. **1974.** "Caravaggio e Raffaello," in *Colloquio sul tema Caravaggio e i caravaggeschi, organizzato d'intesa con le Accademie di Spagna e di Olanda* (Rome, Feb. 12–14, 1973), pp. 19–28. Rome, Accademia Nazionale dei Lincei.

Arslan, E.
1951. "Appunto su Caravaggio," *Aut Aut,* no. 5, pp. 414–51. **1959.** "Nota caravaggesca," *Arte antica e moderna,* no. 6, pp. 191–218; no. 7, pp. 352–53.

Arslan, W. (= E.)
1931. *I Bassano.* Bologna.

Ashford, F.
1935. "Caravaggio's Stay in Malta," *Burlington Magazine,* 67, pp. 168–74.

Askew, P.
1969. "The Angelic Consolation of St. Francis of Assisi in Post-Tridentine Italian Painting," *Journal of the Warburg and Courtauld Institutes,* XXXII, pp. 280–306.

Aumale, H. E. P. Louis d'Orléans, duc d', ed.
1861. *Inventaire de tous les meubles du Cardinal Mazarin. Dressé en 1853, et pub. d'après l'original, conservé dans les archives de Condé.* London.

Azzopardi, J.
1978. *The Church of St. John in Valletta,*

1578–1978: An Exhibition Commemorating the Fourth Centenary of its Consecration, exhib. cat. Valletta, The Museum of the Church of Saint John.

Baccheschi, E.
1978. "Simone Peterzano," in *I pittori bergamaschi dal XIII al XIX secolo: Il Cinquecento,* vol. IV, pp. 473–82, 490–557. Bergamo.

Bacci, P. G.
1699. *Vita di S. Filippo Neri Fiorentino, fondatore della Congregatione dell'Oratorio.* Rome.

Bacou, R., and J. Bean
1958. In *Dessins florentins de la collection de Filippo Baldinucci,* vol. XIX of *Exposition du Cabinet des dessins (Musée du Louvre).* Paris.

Baglione, G.
1642. *Le vite de' pittori, scultori et architetti. Dal pontificato di Gregorio XIII del 1572 in fino a' tempi di papa Urbano Ottavo nel 1642.* Rome. Facsimile ed., with introd. by V. Mariani, Rome, 1935.

Bailly, N.
1899. *Inventaire des tableaux du roy redigé en 1709 et 1710,* ed. F. Engerand. Paris.

Baldinucci, F.
1681–1728. *Notizie de' professori del disegno da Cimabue in qua,* 6 vols. Florence. Ed. F. Rinalli, 5 vols. Florence, 1845–47.

Bardi, E., ed.
1837–42. *L'imperiale e reale Galleria Pitti illustrata,* 4 vols. Florence.

Bardon, F.
1978. *Caravage, ou l'expérience de la matière.* Paris.

Baroni, C.
1940. "Aggiunte a Simone Peterzano," *L'Arte,* XI, pp. 173–88. **1944.** "Un Peterzano inedito a S. Agostino in Como e alcuni disegni al Castello Sforzesco di Milano," in *Raccolta di scritti in onore di A. Giussani,* pp. 305–7. Milan. **1951.** *Tutta la pittura del Caravaggio,* 2nd ed. Milan.

Battisti, E.
1955. "Alcuni documenti su opere del Caravaggio," *Commentari,* no. 3, pp. 173–85. **1960.** *Rinascimento e barocco.* Turin. **1962.** *L'Antirinascimento.* Milan.

Bauch, K.
1956. "Zur Ikonographie von Caravaggios Frühwerken," in *Kunstgeschichtliche Studien für Hans Kauffmann,* ed. W. Braunfels, pp. 252–61. Berlin.

Bauer, K.
1978. " 'Quando si disegna, si dipinge ancora': Some Observations on the Development of the Oil Sketch," *Storia dell'arte,* no. 32, pp. 45–47.

Baumgart, F.
1954. "Die Caravaggio-Forschung seit 1943," *Zeitschrift für Kunstgeschichte,* XVII, pp. 196–203. **1955.** *Caravaggio: Kunst und Wirklichkeit.* Berlin.

Bellori, G. P.
1672. *Le vite de' pittori, scultori et architetti moderni.* Rome. Ed. E. Borea, Turin, 1976.

Bellu, A.
1969. In *La Pinacoteca Ambrosiana,* ed. A. Falchetti. Milan.

Benadduci, G.
1888. *Di un quadro del Caravaggio.* Tolentino.

Berenson, B.
1896. "Les peintures italiennes de New York et de Boston," *Gazette des Beaux-Arts,* ser. 3, XV, pp. 195–214. **1907.** *The North Italian Painters of the Renaissance.* New York. **1951.** *Del Caravaggio: Delle sue incongruenze, e della sua fama.* Florence. **1953.** *Caravaggio: His Incongruity and His Fame.* New York.

Berne-Joffroy, A.
1959. *Le Dossier Caravage.* Paris.

Berti, L. et al.
1979. *Gli Uffizi: Catalogo generale.* Florence.

Bertolotti, A.
1876. "Esportazione di Oggetti di Belle Arti nella Liguria, nella Lunigiana etc., nei Secoli XVI, XVII, XVIII," *Giornale Ligustico,* IV, pp. 117 ff. **1877.** "Esportazione di oggetti di Belle Arti da Roma nei secoli XVI, XVII, XVIII," *Archivio Storico Artistico, Archeologico e Letterario della città e provincia di Roma,* vols. I–II. **1881.** *Artisti lombardi a Roma nei secoli XV, XVI e XVII: Studi e ricerche negli archivi romani,* 2 vols. Milan.

Białostocki, J.
1955. *Caravaggio.* Warsaw. **1956.** "Puer Sufflans Ignes," in *Arte in Europa: Scritti di storia dell'Arte in onore di Eduardo Arslan,* vol. I, pp. 591–95. Milan.

Bissell, R. W.
1971. "Orazio Gentileschi: Baroque without Rhetoric," *Art Quarterly,* XXXIV, pp. 274–300. **1974.** "Concerning the Date of Caravaggio's *Amore Vincitore,*" in *Hortus Imaginum: Essays in Western Art,* ed. R. Enggass and M. Stokstad, pp. 113–23. Lawrence, Kansas. **1981.** *Orazio Gentileschi and the Poetic Tradition in Caravaggesque Painting.* University Park, Penn.

Bodart, D.
1966. "Intorno al Caravaggio: La Maddalena del 1606," *Palatino,* 10, pp. 118–26. **1970.** *Louis Finson: Avant 1580–Amsterdam, 1617.* Brussels. **1977.** *Rubens e la pit-*

tura fiamminga del Seicento nelle collezioni pubbliche fiorentine, exhib. cat. Palazzo Pitti, Florence.

Bodmer, H., ed.
1931. *Leonardo: Des Meisters Gemälde und Zeichnungen.* Stuttgart. **1939.** *Lodovico Carracci.* Magdeburg.

Bohlin, D.
1979. *Prints and Related Drawings by the Carracci Family: A Catalogue Raisonné,* exhib. cat. Washington, National Gallery of Art.

Bologna
1975. See Emiliani, A. 1975.

Bologna, F.
1968. *Aspetti dell'antica natura morta italiana,* vol. I of *Natura in posa,* exhib. cat. Bergamo, Galleria Lorenzelli. **1974.** "Il Caravaggio nella cultura e nella società del suo tempo," in *Colloquio sul tema Caravaggio e i caravaggeschi, organizzato d'intesa con le Accademie di Spagna e di Olanda* (Rome, Feb. 12–14, 1973), pp. 149–87. Rome, Accademia Nazionale dei Lincei.

Bologna, F., and V. Pacelli
1980. "Caravaggio, 1610: La 'Sant'Orsola confitta dal Tirano' per Marcantonio Doria," *Prospettiva,* no. 23, pp. 24–44.

Bon, C.
1979. "Precisazioni sulla biografia di Giovanni Baglione," *Paragone,* no. 347, pp. 88–92. **1981.** "Una proposta per la cronologia delle opere giovanili di Giovanni Baglione," *Paragone,* no. 373, pp. 17–48.

Bona Castellotti, M.
1979. "Un altro Peterzano e alcuni disegni," *Paragone,* no. 357, pp. 80–82.

Bonaffé, E.
1884. *Dictionnaire des amateurs français au XVII siècle.* Paris.

Bora, G.
1977. "La Cultura figurativa a Milano, 1535–1565," in *Omaggio a Trizano: La Cultura artistica milanese nell'età di Carlo V,* exhib. cat. Milan, Palazzo Reale, pp. 45–54. **1980.** *I disegni lombardi e genovesi del Cinquecento.* Treviso.

Bordeaux
1955. *L'Âge d'Or espagnol: La Peinture en Espagne et en France autour du caravaggisme,* exhib. cat. Bordeaux, Palais des Beaux-Arts.

Borea, E.
1970. *Caravaggio e caravaggeschi nelle gallerie di Firenze,* exhib. cat. Florence, Palazzo Pitti.

Borenius, T.
1925. "An Early Caravaggio Rediscovered," *Apollo,* II pp. 23–26.

Borgese, L.
1950. "La Mostra del Caravaggio sarà una manifestazione di interesse mondiale," *Corriere della sera,* Sept. 16.

Borghini, R.
1584. *Il Riposo.* Florence.

Borromeo, F.
1625. *Musaeum.* Milan. Ed. E. Beltrami, Milan, 1909.

Boschini, M.
1660. *La carta del navegar pitoresco.* Venice. Ed. A. Pallucchini, Venice, 1966.

Boselli, C., ed.
1959. *Le Glorie di Brescia: 1747–1751,* by F. Maccarinelli. Brescia (*Supplemento ai Commentari dell'Ateneo di Brescia per il 1959*). **1961.** *Catalogo delle chiese di Brescia,* by B. Faino. Brescia (*Supplemento ai Commentari dell'Ateneo di Brescia per il 1961*).

Bossaglia, R.
1967. "La pittura del Cinquecento: I Maggiori e i loro scolari," in *Storia di Brescia,* vol. II, pp. 1011–1101. Brescia.

Bottari, G., and S. Ticozzi, comps.
1822–25. *Raccolta di lettere sulla pittura, scultura ed architettura scritte da più celebri personaggi dei secoli XV, XVI, e XVII, pubblicata da M. Gio. Bottari, e continuata fino ai nostri giorni da Stefano Ticozzi.* Milan.

Brandi, C.
1972–73. "Michelangelo Merisi da Caravaggio." Lecture notes, University of Rome. **1974.** "L'episteme caravaggesca," in *Colloquio sul tema Caravaggio e i caravaggeschi organizzato d'intesa con le Accademie di Spagna e di Olanda* (Rome, Feb. 12–14, 1973), pp. 9–17. Rome, Accademia Nazionale dei Lincei.

Brejon de Lavergnée, A.
1979. "New Paintings by Bartolomeo Manfredi," *Burlington Magazine,* 121, pp. 305–10.

Brejon de Lavergnée, A., and J. P. Cuzin, eds.
1974. *Valentin et les Caravagesques français,* exhib. cat. Paris, Grand Palais.

Briganti, G.
1967. "I quadri antichi," in *Il Palazzo di Montecitorio,* p. 404. Rome.

Brigstocke, H.
1973. "Domenichino Copies after Annibale Carracci," *Burlington Magazine,* 115, pp. 525–26. **1978.** *Italian and Spanish Paintings in the National Gallery of Scotland.* Edinburgh.

Brugnoli, M. V.
1968. "Un 'San Francesco' da attribuire al Caravaggio e la sua copia," *Bollettino d'arte,* 53, pp. 11–15. **1970.** In *Mostra dei restauri 1969: XIII settimana dei musei,* exhib. cat. Rome, Palazzo Venezia.

Bucci, M. et al.
1959. *Mostra del Cigoli e del suo ambiente,* exhib. cat. San Miniato, Accademia degli Euteleti.

Buchowiecki, W.
1970. *Handbuch der Kirchen Roms,* vol. II. Vienna.

Burchard, L.
1926. In *Sitzungsberichte der Kunstgeschichtliche Gesellschaft,* Oct. 8. Berlin. **1943.** *Rubens und sein Werk: Neue Forschungen.* Brussels. **1950.** *A Loan Exhibition of Works by Peter Paul Rubens Held Under the Auspices of the Royal Empire Society,* exhib. cat. London, Wildenstein and Co.

Burns, D. G.
1952. "'Una Musica' by Caravaggio," *Burlington Magazine,* 94, pp. 119–20.

Busiri Vici, A.
1971. *I Poniatowski e Roma.* Florence.

Busse, K. H.
1911. *Lodovico Cigoli.* Ph.D. diss., University of Leipzig.

Calì, M.
1980. "'Verità' e 'religione' nella pittura di Giovan Battista Moroni (a proposito della mostra di Bergamo)," *Prospettiva,* no. 23, pp. 11–23.

Calvesi, M.
1954. "Simone Peterzano, maestro del Caravaggio," *Bollettino d'Arte,* 39, pp. 114–33. **1966 a.** "Buonasera Maestro," *Marcatré,* 4, pp. 286–92. **1966 b.** "Amore carnale e divino: Discussione sulla galleria dei Carracci," *Marcatré,* 4, pp. 302–3. **1969.** "A Noir (Melancolia I)," *Storia dell'arte,* no. 1–2, pp. 37–96. **1971.** "Caravaggio o la ricerca della salvazione," *Storia dell'arte,* no. 9–10, pp. 93–142. **1973.** "La canestra del Caravaggio, gemma del Seicento Lombardo," *Corriere della sera,* June 17, p. 3. **1975 a.** "Il Culto del Caravaggio per la croce e la spada," *Corriere della sera,* Oct. 20, p. 3. **1975 b.** "Lettere iconologiche del Caravaggio," in *Novità sul Caravaggio: Saggi e contributi,* ed. M. Cinotti, pp. 75–102. Milan. (Paper presented at the Convegno Internazionale di Studi Caravaggeschi, Bergamo, Jan. 25–26, 1974.) **1978.** "Simone Peterzano," in *I pittori bergamaschi, dal XIII al XIX secolo: Il Cinquecento,* vol. IV, pp. 483–89. Bergamo. **1979.** "Nature morte resuscitate," *L'Espresso,* Feb. 11, pp. 75–76.

Camelli, I.
1930. "Pinacoteca del Museo Civico," Cremona.

Camesasca, E.
1966. *Artisti in bottega.* Milan.

Camiz, F.
1983. "Due quadri musicali di scuola caravaggesca," *Musica e filologia*, pp. 99–106.

Camiz, F., and A. Ziino
1983. "Caravaggio: Aspetti musicali e committenza," *Studi musicali*, 12, pp. 67–90.

Campori, G.
1870. *Raccolta di cataloghi ed inventarii inediti di quadri, statue, disegni, bronzi, dorerie, smalti, medaglie, avorii, ecc. dal secolo XV al secolo XIX.* Modena.

Cantalamessa, G.
1908. "Un quadro di Michelangelo da Caravaggio," *Bollettino d'arte*, 2, pp. 401–2.

Cantelli, G.
1983. *Repertorio della pittura fiorentina del Seicento.* Fiesole.

Caracciolo di Torchiarolo, A.
1939. *Una famiglia italianissima: I Caracciolo di Napoli nella storia e nella leggenda.* Naples.

Carboni, G. B.
1760. *Le pitture e le sculture di Brescia che sono esposte al pubblico, con un'appendice di alcune private gallerie.* Brescia.

Cardi, G. B.
before 1628. "Vita di Lodovico Cardi Cigoli." Ed. G. Battelli, Florence, 1913.

Carman, C.
1972. "Cigoli Studies." Ph. D. diss., Johns Hopkins University, Baltimore.

Carroll, E. A.
1971. "Some Drawings by Salviati Formerly Attributed to Rosso Fiorentino," *Master Drawings*, IX, pp. 15–37.

Castiglione, B.
1967. *The Book of the Courtier.* Trans. G. Bull. Baltimore.

Catalani, L.
1845–53. *Le chiese di Napoli.* 2 vols. Naples.

Causa, R.
1960. In *Catalogo 4: Mostra di restauri*, exhib. cat. Naples, Palazzo Reale. **1972 a.** "La pittura del Seicento a Napoli dal naturalismo al Barocco," in *Storia di Napoli*, vol. V, pt. 2, pp. 915–20, Naples. **1972 b.** "La natura morta a Napoli nel Sei e nel Settecento," in *Storia di Napoli*, vol. V, pt. 2, pp. 997–99. Naples. **1978.** "La nature morte italienne au XVIIᵉ siècle en Italie," in *La Nature morte de Brueghel à Soutine*, exhib. cat. Bordeaux, Musée des Beaux-Arts, pp. 39–48.

Cavalca, D.
1540. *Libro chiamato specchio di croce, novamente stampato, & con diligentia corretto, in lingua fiorentina ridotto.* Venice.

Cavazzoni-Zanotti, G. P.
1776. *Il Claustro di S. Michele in Bosco di Bologna.* Bologna.

Celano, C.
1692. *Notizie del bello dell'antico e del curioso della città di Napoli*, 6 vols. Naples. Ed. G. B. Chiarini, 5 vols. Naples, 1856–60.

Celio, G.
1638. *Memoria Fatta dal Signor Gaspare Celio dell'habito di Christo. Delli nomi dell'Artefici delle Pitture, che sono in alcune Chiese, Facciate, e Palazzi di Roma.* Naples.

Chantelou, P. Fréart de
1981. *Journal du voyage du Cavalier Bernin en France*, ed. J. P. Guibbert. Aix-en-Provence.

Chappell, M.
1971 a. "Lodovico Cigoli." Ph. D. diss., University of North Carolina, Chapel Hill. **1971 b.** "Some Paintings by Cigoli," *Art Quarterly*, XXIV, pp. 202–18. **1976.** "Cardi, Lodovico," in *Dizionario biografico degli italiani*, vol. XIX, pp. 771–76. Rome. **1980.** "Missing Pictures by Cigoli: Some Problematic Works and Some Proposals in Preparation for a Catalogue," *Paragone*, no. 373, pp. 54–104. **1981.** "Lodovico Cigoli and Annibale Carracci," in *Per A. E. Popham*, pp. 137–46. Parma.

Chappell, M., and W. C. Kirwin
1974. "A Petrine Triumph: The Decoration of the 'Navi Piccole' in San Pietro under Clement VIII," *Storia dell'arte*, no. 21, pp. 119–70.

Chappell, M. et al.
1979. *Disegni dei toscani a Roma (1580–1620).* Florence.

Chiappini di Sorio, I.
1983. "Cristoforo Roncalli detto il Pomarancio," in *I pittori bergamaschi dal XIII al XIX secolo: Il Seicento*, vol. I, pp. 1–201. Bergamo.

Chipp, H., comp.
1968. *Theories of Modern Art: A Source Book by Artists and Critics.* Berkeley.

Christie's
1971. *Highly Important Pictures by Old Masters*, sale cat., June 25. London.

Cinotti, M.
1971. In M. Cinotti and G.A. Dell'Acqua, *Il Caravaggio e le sue grandi opere da San Luigi dei Francesi.* Milan. **1973.** In *Immagine del Caravaggio: Mostra didattica itinerante*, exhib. cat. Milan, pp. 23–27, 113–48, 149–91, 179–211. **1983.** In M. Cinotti and G.A. Dell'Acqua, "Michelangelo Merisi detto il Caravaggio," in *I pittori bergamaschi dal XIII al XIX secolo: Il Seicento*, vol. I, pp. 205–56, 287–309, 408–579. Bergamo.

Clark, J.
1951. "[1619–1621]—Giulio Mancini—Trattato della Pittura, Biblioteca Nazio-

nale, Firenze; cod. Pal. 597," in Longhi, R., "Alcuni pezzi rari nell'antologia della critica caravaggesca," *Paragone*, no. 17, pp. 46–49.

Clark, K.
1966. *Rembrandt and the Italian Renaissance.* London.

Cochin, C. N.
1763. *Voyage d'Italie, ou Recueil de notes sur les ouvrages de peinture & sculpture, qu'on voit dans les principales villes d'Italie*, 3 vols. Paris.

Colnaghi, D. E.
1928. *Dictionary of Florentine Painters from the 13th to the 17th Centuries.* London.

Cordaro, M.
1980. "Indagine radiografica sulla 'Buona ventura' dei Musei Capitolini," *Ricerche di storia dell'arte*, no. 10, pp. 100–106.

Cosnac, G.-J.
1885. *Les Richesses du palais Mazarin.* Paris.

Costello, J.
1981. "Caravaggio, Lizard, and Fruit," in *Art the Ape of Nature: Studies in Honor of H.W. Janson*, pp. 375–85. New York.

Crinò, A. M.
1960. "More Letters from Orazio and Artemisia Gentileschi," *Burlington Magazine*, 102, pp. 264–65.

Cummings, F.
1974. "Detroit's 'Conversion of the Magdalen' (the Alzaga Caravaggio): 1. Introduction; 3. The Meaning of Caravaggio's 'Conversion of the Magdalen.'" *Burlington Magazine*, 116, pp. 563–64, 572–78.

Cutter, M.
1941. "Caravaggio in the Seventeenth Century," *Marsyas*, I, pp. 89–115.

Cuzin, J. P.
1977. *'La Diseuse de bonne aventure' de Caravage*, exhib. cat. (Les dossiers du département des peintures, no. 13.) Paris, Musée du Louvre.

Cuzin, J. P., and P. Rosenberg
1978. "Acquisitions: Saraceni et la France. À propos du don par les Amis du Louvre de la 'Naissance de la Vierge.'" *La Revue du Louvre*, no. 3, pp. 186–96.

Czobor, A.
1954–55. "Autoritratti del giovane Caravaggio," *Acta Historiae Artium Academiae Scientiarum Hungaricae*, II, pp. 201–14. **1957.** "L''Arrestation du Christ' du Caravage," *Bulletin du Musée Hongrois des Beaux-Arts*, no. 10, pp. 26–31.

Dal Poggetto, P.
1970. "Nota sul restauro," in E. Borea, *Caravaggio e caravaggeschi nelle gallerie di Firenze*, exhib. cat. Florence, Palazzo Pitti, pp. 119–26.

Dal Pozzo, B.
1703. *Historia della sacra religione militare di S. Giovanni Gerosolimitano detta di Malta, parte prima, che proseguisce quella di Giacomo Bosio, dall'anno 1571 fino al 1636.* Verona.

De' Dominici, B.
1742–45. *Vite de' pittori, scultori ed architetti napoletani,* 3 vols. Naples.

Dell'Acqua, G. A.
1971. In M. Cinotti and G. A. Dell'Acqua, *Il Caravaggio e le sue grandi opere da San Luigi dei Francesi.* Milan. **1983.** In M. Cinotti and G. A. Dell'Acqua, "Michelangelo Merisi detto il Caravaggio," in *I pittori bergamaschi dal XIII al XIX secolo: Il Seicento,* vol. I, pp. 257–87. Bergamo.

Del Bravo, C.
1974. "Lettera sulla natura morta," *Annali della Scuola Normale Superiore di Pisa,* no. 4, pp. 1565–91.

Della Pergola, P.
1954. " 'Un quadro de man de Zorzon de Castelfranco,' " *Paragone,* no. 49, pp. 27–35. **1959.** *Galleria Borghese: I dipinti,* vol. II, Rome. **1964 a.** "L'inventario Borghese del 1693," *Arte antica e moderna,* no. 26, pp. 219–30, no. 28, pp. 451–67. **1964 b.** "Nota per Caravaggio," *Bollettino d'arte,* 49, pp. 252–56. **1973.** "Breve nota per Caravaggio," *Commentari,* n.s., no. 1–2, pp. 50–57.

Dempsey, C.
1968. " 'Et nos cedamus amori': Observations on the Farnese Gallery," *Art Bulletin,* 50, pp. 363–74.

Denucé, J.
1932. *De Antwerpsche "Konstkamers": Inventarissen van Kunstverzamelingen te Antwerpen in de 16ᵉ en 17ᵉ eeuwen.* Antwerp.

De Ricci, S.
1913. *Description raisonnée des peintures du Louvre. I. Écoles étrangères, Italie et Espagne.* Paris.

De Rinaldis, A.
1928. *Pinacoteca del Museo Nazionale di Napoli: Catalogo.* Naples. **1928–29.** "Cristo legato alla colonna di Michelangelo da Caravaggio," *Bollettino d'arte,* 8, pp. 49–54.

De' Sebastiani, P.
1683. *Viaggio curioso de' Palazzi e Ville più notabili di Roma.* Rome.

Dézallier d'Argenville, A. J.
1745–52. *Abrégé de la vie des plus fameux peintres,* 3 vols. Paris.

D'Onofrio, C.
1967. *Roma vista da Roma.* Rome.

Drost, W.
1933. *Adam Elsheimer und sein Kreis.* Potsdam.

Egan, P.
1959. " 'Poesia' and the 'Fête Champêtre,' " *Art Bulletin,* 41, pp. 303–13. **1961.** " 'Concert' Scenes in Musical Paintings of the Italian Renaissance," *Journal of the American Musicological Society,* 14, pp. 184–95.

Emiliani, A.
1958. "Orazio Gentileschi: Nuove proposte per il viaggio marchigiano," *Paragone,* no. 103, pp. 38–57. **1975.** *Mostra di Federico Barocci,* exhib. cat. Bologna, Museo Civico.

Enggass, R.
1967. " 'La virtù di un vero nobile': L'Amore Giustiniani del Caravaggio," *Palatino,* XI, pp. 13–20.

Enggass, R., and J. Brown
1970. *Italy and Spain 1600–1750: Sources and Documents in the History of Art Series.* Englewood Cliffs, N.J.

Evers, H.
1943. *Rubens und sein Werk: Neue Forschungen.* Brussels.

Fagiolo dell'Arco, M.
1968. 'Le Opere di misericordia': Contributo alla poetica del Caravaggio," *L'Arte,* no. 1, pp. 37–61. Reissued, with additions, 1969.

Fagiolo dell'Arco, M., and M. Marini
1970. "Rassegna degli studi caravaggeschi 1951–1970," *L'Arte,* n.s., no. 11–12, pp. 117–28.

Faino, B.
1630–69. *Catalogo delle chiese di Brescia.* Ed. C. Boselli, Brescia, 1961 (*Supplemento ai Commentari dell'Ateneo di Brescia per il 1961*).

Faldi, I.
1953. "Gli affreschi della Cappella Contarelli e l'opera giovanile del Cavalier d'Arpino," *Bollettino d'arte,* 38, pp. 45–55. **1970.** *Pittori viterbesi di cinque secoli.* Rome.

Farinelli, A.
1921. *Viajes por España y Portugal desde la edad media hasta el siglo XX.* Madrid.

Ferrari, M. L.
1961. *Il Romanino.* Milan. **1979.** *Itinerari: Contributi alla storia dell'arte in memoria di Maria Luisa Ferrari,* vol. I. Florence.

Ferrari, O.
1978. "Le arti figurativi nel Seicento," in *Nuove conoscenze e prospettive del mondo dell'arte* (Suppl., *Enciclopedia universale dell'arte*), pp. 371–74. Rome.

Ffoulkes, C. J.
1894. "Le esposizioni d'arte italiana a Londra," *Archivio storico dell'arte,* VII, pp. 249–68.

Filangieri di Candida, A.
1902. "La Galleria Nazionale di Napoli: Documenti e ricerche," in *Le Gallerie Nazionali Italiane,* vol. V, pp. 208–354. Rome.

Fiocco, G.
1957. "Francesco Vecellio e Jacopo Bassano," *Arte veneta,* XI, pp. 91–96.

Fiorio, M. T.
1974. "Note su alcuni disegni inediti di Simone Peterzano," *Arte lombarda,* 19, pp. 87–100.

Florence
1922. *Mostra della pittura italiana del Seicento e del Settecento,* exhib. cat. Florence, Palazzo Pitti. **1979.** *Disegni dei toscani a Roma (1580–1620),* exhib. cat. Florence, Gabinetto Disegni e Stampe degli Uffizi.

Fogolari, G. et al.
1927. *Il ritratto italiano dal Caravaggio al Tiepolo alla mostra di Palazzo Vecchio nel MCMXI sotto gli auspici del comune di Firenze.* Bergamo.

Forlani, A.
1959. In *Mostra del Cigoli e del suo ambiente,* exhib. cat. San Miniato, Accademia degli Euteleti.

Frabetti, G.
1977. In *Rubens e Genova,* exhib. cat. Genoa, Palazzo Ducale.

Francastel, P.
1938. "Le réalisme de Caravage," *Gazette des Beaux-Arts,* ser. 6, XX, pp. 45–62.

Fredericksen, B.
1984. "A New Painting by Rosso Fiorentino," in *Scritti di storia dell'arte in onore di Federico Zeri.* Milan.

Freedberg, S. J.
1971. *Painting in Italy: 1500–1600.* Baltimore. **1983.** *Circa 1600: A Revolution of Style in Italian Painting.* Cambridge, Mass.

Friedlaender, W.
1945. " 'The Crucifixion of St. Peter': Caravaggio and Reni," *Journal of the Warburg and Courtauld Insititutes,* VIII, pp. 152–60. **1953.** "Book Reviews: Lionello Venturi, *Caravaggio;* Roberto Longhi, *Il Caravaggio,*" *Art Bulletin,* 35, pp. 315–18. **1954.** "Book Reviews: R. Hinks, *Michelangelo Merisi da Caravaggio,*" *Art Bulletin,* 36, pp. 149–52. **1955.** *Caravaggio Studies.* Princeton. Rev. ed., New York, 1969.

Frimmel, T. von
1913. "Zur Herkunft des neuerworbenen Elsheimer (St. Christoph) im Kaiser Friedrich-Museum," *Studien und Skizzen zur Gemäldekunde,* I, pp. 45–46.

Frommel, C. L.
1971 a. "Caravaggio und seine Modelle," *Castrum peregrini,* XCVI, pp. 21–56. **1971 b.**

"Caravaggios Frühwerk und der Kardinal Francesco Maria del Monte," *Storia dell'arte*, no. 9–10, pp. 5–52.

Fry, R.
1922. "Settecentismo," *Burlington Magazine*, 41, pp. 158–69.

Fulco, G.
1980. " 'Ammirate l'altissimo pittore': Caravaggio nelle rime inedite di Marzio Milesi," *Ricerche di storia dell'arte*, no. 10, pp. 65–89.

Gabburri, F. M. N.
about 1730. "Le vite dei pittori." Florence, Biblioteca Nazionale, ms. Palatino E. B. 9–5.

Galli, G.
1977. "Una proposta di risarcimento per due dipinti di Dosso Dossi (ed una scheda di restauro)," *Bollettino annuale dei musei ferraresi*, 7, pp. 54–56.

García Chico, E.
1946. *Documentos para el estudio del arte en Castilla*, vol. III, pt. 1. Valladolid.

Gash, J.
1980. *Caravaggio.* London.

Gere, J. A., and P. Pouncey
1983. *Artists Working in Rome c. 1550 to c. 1640*, vol. 5 of *Italian Drawings in the Department of Prints and Drawings in the British Museum.* London.

Gilbert, C.
1945. "Milan and Savoldo," *Art Bulletin*, XXVII, pp. 124–38. **1952.** "Per i Savoldo visti dal Vasari," *Studi vasariani*, pp. 146–52. Florence. **1983.** In *The Genius of Venice 1500–1600*, exhib. cat. London, The Royal Academy of Arts.

Giustiniani, V.
1620–30. "Lettera sulla pittura al signor Teodoro Amideni." See Bottari, G., and S. Ticozzi, 1822–25, vol. VI, pp. 121–29; Longhi, R., 1951 b, no. 17, pp. 49–50. **1981.** *Discorso sulle arti e sui mestieri*, ed. A. Banti. Florence.

Gombosi, G.
1943. *Moretto da Brescia.* Basel.

Gombrich, E. H.
1963. "Tradition and Expression in Western Still Life," in *Meditations on a Hobby Horse and Other Essays on the Theory of Art.* London. **1972.** "Introduction: Aims and Limits of Iconology," in *Symbolic Images*, vol. III of *Studies in the Art of the Renaissance*, pp. 1–25. London.

Greaves, J. L., and M. Johnson
1974. "Detroit's 'Conversion of the Magdalen' (The Alzaga Caravaggio): 2. New Findings on Caravaggio's Technique in the Detroit Magdalen," *Burlington Magazine*, 116, pp. 564–72.

Gregori, M.
1959. "Artisti operanti nell'ambiente del Cigoli," in *Mostra del Cigoli e del suo ambiente*, exhib. cat. San Miniato, Accademia degli Euteleti, pp. 191–230. **1972 a.** "Caravaggio dopo la mostra di Cleveland," *Paragone*, no. 263, pp. 23–49. **1972 b.** "Note su Orazio Riminaldi e i suoi rapporti con l'ambiente romano," *Paragone*, no. 269 pp. 35–66. **1973 a.** "Notizie su Agostino Verrocchi e un'ipotesi per Giovanni Battista Crescenzi," *Paragone*, no. 275, pp. 36–56. **1973 b.** *Gli affreschi della Certosa di Garegnano.* Milan. **1974.** "A New Painting and Some Observations on Caravaggio's Journey to Malta," *Burlington Magazine*, 116, pp. 594–603. **1975.** "Significato delle mostre caravaggesche dal 1951 ad oggi" in *Novità sul Caravaggio: Saggi e contributi*, ed. M. Cinotti, pp. 27–60. Milan. (Paper presented at the Convegno Internazionale di Studi Caravaggeschi, Bergamo, Jan. 25–26, 1974.) **1976 a.** "Addendum to Caravaggio: The Cecconi 'Crowning with Thorns' Reconsidered," *Burlington Magazine*, 118, pp. 670–80. **1976 b.** "Caravaggio," in *Enciclopedia europea*, vol. II, pp. 868–71. Rome. **1979 a.** *Giovan Battista Moroni (1520–1578)*, exhib. cat. Bergamo, Palazzo della Ragione. **1979 b.** "Giovan Battista Moroni," in *I pittori bergamaschi dal XIII al XIX secolo: Il Cinquecento*, vol. III, pp. 97–377. Bergamo. **1982 a.** In *Painting in Naples 1606–1705: From Caravaggio to Giordano*, exhib. cat. London, The Royal Academy of Arts, pp. 36–40. **1982 b.** *Giacomo Ceruti.* Bergamo. **1983.** In *La Pittura napoletana dal Caravaggio a Luca Giordano*, Naples.

Gronau, G.
1936. *Documenti artistici urbinati.* Florence.

Grossato, L.
1957. *Il Museo Civico di Padova: Dipinti e sculture dal XIV al XIX secolo.* Venice.

Grosso Cacopardi, G.
1821. *Memorie de' pittori messinesi e degli esteri.* Messina.

Guazzoni, V.
1981. *Moretto: Il tema sacro.* Brescia. **1983.** In *The Genius of Venice 1500–1600*, exhib. cat. London, The Royal Academy of Arts.

Gudiol, J.
1983. *The Complete Paintings of Greco, 1541–1614.* Trans. K. Lyons. New York.

Gugliemi Faldi, C.
1954. "Intorno all'opera pittorica di Giovanni Baglione," in *Bollettino d'arte*, 39, pp. 311–26. **1963.** "Baglione, Giovanni," in *Dizionario biografico degli italiani*, vol. V, pp. 187–91. Rome.

Guillet, H.
1956. "La Réorganisation du Musée des Beaux-Arts de Rouen. Nouvelle présentation de la collection de peinture," *Revue des Sociétés savantes de Haute-Normandie*, no. 4, pp. 69–96.

Harris, A. S.
1983. "Exhibition Reviews: New York, Italian Still Life," *Burlington Magazine*, 125, p. 514. **1984.** Review of *Domenichino* by Richard E. Spear, *Burlington Magazine*, 126, pp. 166–68.

Hartlaub, G. F.
1925. *Giorgiones Geheimnis: Ein kunstgeschichtlicher Beitrag zur Mystik der Renaissance.* Munich.

Haskell, F.
1963. *Patrons and Painters: A Study in the Relations between Italian Art and Society in the Age of the Baroque.* London.

Held, Julius
1980. *The Oil Sketches of Peter Paul Rubens: A Critical Catalogue.* Princeton.

Held, Jutta
1966. In *Adam Elsheimer: Werk, künstlerische Herkunft und Nachfolge*, exhib. cat. Frankfurt am Main, Städelsches Kunstinstitut.

Hess, J., ed.
1934. *Die Künstlerbiographien von Giovanni Battista Passeri.* Leipzig.

Hess, J.
1954. "Modelle e modelli del Caravaggio," *Commentari*, V, pp. 271–89. **1958.** "Caravaggio's Paintings in Malta: Some Notes," *The Connoisseur*, 142 (1958), pp. 142–47. **1967.** *Kunstgeschichtliche Studien zu Renaissance und Barock*, 2 vols. Rome.

Hibbard, H.
1965. "Notes on Reni's Chronology," *Burlington Magazine*, 107, pp. 502–10. **1971.** *Carlo Maderno and Roman Architecture, 1580–1630.* London. **1972.** " 'Ut picturae sermones': The First Painted Decoration of the Gesù," in *Baroque Art: The Jesuit Contribution*, ed. R. Wittkower, pp. 29–47. New York. **1983.** *Caravaggio.* New York.

Hinks, R.
1953. *Michelangelo Merisi da Caravaggio: His Life, His Legend, His Works.* London.

Holmes, C.
1923. " 'Giorgione' Problems at Trafalgar Square—II," *Burlington Magazine*, 42, pp. 230–39.

Holzinger, E.
1951. "Elsheimers Realismus," *Münchner Jahrbuch der bildenden Kunst*, II, pp. 208–24.

Hoogewerff, G. J.
1942. *Nederlandsche Kunstenaars te Rome*

(1600–1725): Uittreksels uit de parochiale archieven. The Hague.

Huemer, F.
1977. *Portraits I,* pt. XIX of *Corpus Rubenianum Ludwig Burchard: An Illustrated Catalogue Raisonné of the Work of Peter Paul Rubens Based on the Material Assembled by the Late Dr. Ludwig Burchard, in Twenty Parts.* London.

Hüttinger, E.
1942. *Das italienische Stilleben von den Anfängen bis zur Gegenwart,* exhib. cat. Zurich, Kunsthaus.

Ignatius of Loyola, Saint
1977. *Esercizi spirituali,* in *Gli scritti di Ignazio di Loyola,* ed. M. Giola, pp. 91–184. Turin.

Isarlov, G.
1935. "Avant l'exposition Vermeer: Le caravagisme," *L'Amour de l'art,* 16, pp. 115–19.

Isarlo[v], G.
1941. *Caravage et le caravagisme européen, II. Catalogues.* Aix-en-Provence. **1956.** "Les indépendants dans la peinture ancienne," in *Souvenirs et documents,* pp. 111–34, 143–45. Paris.

Jaffé, M.
1960. "Annibale and Ludovico Carracci: Notes on Drawings," *Burlington Magazine,* 102, pp. 21–31. **1963.** "Peter Paul Rubens and the Oratorian Fathers," *Proporzioni,* IV, pp. 209–40. **1966.** "Rubens, Peter Paul," in *Encyclopedia of World Art.* cols. 590–606. New York. **1977.** *Rubens and Italy.* Ithaca.

Joppi, V.
1894. "Contributo quarto ed ultimo alla storia dell'arte nel Friuli ed alla vita dei pittori, intagliatori, scultori, architetti ed orefici friuliani dal XIV al XVIII secolo," in Deputazione di Storia Patria per le Venezie, *Miscellanea di storia veneta,* ser. 4, vol. XII. Venice.

Jullian, R.
1961. *Caravage.* Lyons.

Kallab, W.
1906–7. "Caravaggio," *Jahrbuch der Kunsthistorischen Sammlungen des allerhöchsten Kaiserhauses,* XXVII, pp. 272–92.

Keller, H.
1968. "Das Jünglingsbildnis des Domenichino in Darmstadt," in *Festschrift Ulrich Middeldorf,* vol. I, pp. 409–13. Berlin.

Kinkead, D.
1966. "Poesia e simboli nel Caravaggio: Temi religiosi," *Palatino,* X, pp. 112–15.

Kirwin, W. C.
1971. "Addendum to Cardinal Francesco Maria Del Monte's Inventory: The Date of

the Sale of Various Notable Paintings," *Storia dell'arte,* no. 9–10, pp. 53–56. **1972.** "Cristofano Roncalli (1551/2–1626), an Exponent of the Proto-Baroque: His Activity Through 1605." Ph.D. diss., Stanford University, Palo Alto.

Kitson, M.
1969. *The Complete Paintings of Caravaggio.* New York.

Klessmann, R.
1978. *Herzog Anton Ulrich-Museum, Braunschweig.* Munich.

Klibansky, R., E. Panofsky, and F. Saxl
1964. *Saturn and Melancholy: Studies in History of Natural Philosophy, Religion and Art.* London.

Kultzen, R.
1978. "Ein unbekanntes Frükwerk von Carlo Saraceni," *Pantheon,* 35, pp. 139–42.

Landcastle, M.
1961. "A painting of Saint Francis by Caravaggio." *Vassar Journal of Undergraduate Studies,* 18, pp. 55–63.

Landon, C. P.
1812. *Galerie Giustiniani, ou Catalogue figuré des Tableaux de cette célèbre Galerie.* Paris.

Lanzi, L.
1795–96. *Storia pittorica della Italia,* Bassano. Ed. M. Capucci, Florence, 1968–74.

Lavin, M. A.
1967. "Caravaggio Documents from the Barberini Archive," *Burlington Magazine,* 109, pp. 470–73. **1975.** *Seventeenth-Century Barberini Documents and Inventories of Art.* New York.

Le Cannu, M.
1980–81. "Les collections Farnèse: Les tableaux," in *Le Palais Farnèse,* vol. I, pp. 369–86. Rome.

Levey, M.
1970. " 'The Order of St. John in Malta' Exhibition at Valletta," *Burlington Magazine,* 112, pp. 554–57. **1971.** *The Seventeenth and Eighteenth Century Italian Schools.* (National Gallery Catalogues.) London.

Levi D'Ancona, M.
1977. *The Garden of the Renaissance: Botanical Symbolism in Italian Painting.* Florence.

Lomazzo, G. P.
1584. *Trattato dell'arte della pittura, scultura et architettura.* Milan. Reprinted in *Scritti sulle arti,* ed. R. P. Ciardi, vol. II. Florence, 1974, pp. 7–589. **1587.** *Rime di Gio. Paolo Lomazzi, diuise in sette libri.* Milan. **1590.** *Idea del tempio della pittura.* Milan. Reprinted in *Scritti sulle arti,* ed. R. P. Ciardi, vol. I. Florence, 1974, pp. 242–373.

Longhi, R.
1913. "Due opere di Caravaggio," *L'Arte,* XVI, pp. 161–64. Reprinted in *Opere complete,* vol. I, pt. 1. Florence, 1961, pp. 23–27. **1915.** "Battistello," *L'Arte,* XVIII, pp. 58–75, 120–37. Reprinted in *Opere complete,* vol. I, pt. 1. Florence, 1961, pp. 177–211. **1916.** "Gentileschi padre e figlia," *L'Arte,* XIX, pp. 245–314. Reprinted in *Opere complete,* vol. I, pt. 1. Florence, 1961, pp. 219–83. **1917.** "Cose bresciane del Cinquecento," *L'Arte,* XX, pp. 99–114. Reprinted in *Opere complete,* vol. I, pt. 1. Florence, 1961, pp. 327–43. **1918.** Review of F. Sapori, "Un quadro ignorato di Gherardo delle Notti" (*Rassegna d'arte,* Jan.–Feb. 1918), *L'Arte,* XXI, p. 239. Reprinted in *Opere complete,* vol. I, pt. 1, 1961, pp. 418–19. **1926.** "Recensione: Di un libro sul Romanino," *L'Arte,* XXIX, pp. 144–50. Reprinted in *Opere complete,* vol. II, pt. 1. Florence, 1967, pp. 99–110. **1927 a.** "Un 'San Tommaso' del Velázquez e le congiunture italo-spagnole tra il Cinque e il Seicento," *Vita Artistica,* II, pp. 4–12. Reprinted in *Opere complete,* vol. II, pt. 1. Florence, 1967, pp. 113–27. **1927 b.** "Precisioni nelle gallerie italiane: I, R. Galleria Borghese, Michelangelo da Caravaggio," *Vita artistica,* II, pp. 28–35. Reprinted in *Opere complete,* vol. II, pt. 1. Florence, 1967, pp. 300–306. **1927 c.** "Due dipinti inediti di Giovan Gerolamo Savoldo," *Vita artistica,* II (1927), pp. 72–75. Reprinted in *Opere complete,* vol. II, pt. 1. Florence, 1967, pp. 149–55. **1927 d.** "Ter Breugghen e la parte nostra," *Vita artistica,* II, pp. 105–16. Reprinted in *Opere complete,* vol. II, pt. 1. Florence, 1967, pp. 163–78. **1928.** "Note brevi al catalogo del 1893," in *Precisioni nelle gallerie italiane: La R. Galleria Borghese.* Rome. Reprinted in *Opere complete,* vol. 2, pt. 1. Florence, 1967, pp. 331–57. **1928–29.** "Quesiti caravaggeschi: I. Registro dei tempi," *Pinacotheca,* no. 1, pp. 17–33; "Quesiti caravaggeschi: II. I precedenti," *Pinacotheca,* no. 5–6, pp. 258–320. Reprinted in *Opere complete,* vol. IV, Florence, 1968, pp. 82–143. **1930.** "Baglione, Giovanni," in *Enciclopedia italiana,* vol. V, pp. 851–53. Milan. **1935 a.** "I pittori della realtà in Francia, ovvero i caravaggeschi francesi del Seicento," *L'Italia letteraria,* Jan. 19, pp. 1 ff. Reprinted in *Paragone,* no. 269 (1972), pp. 3–18. **1935 b.** "Momenti della pittura bolognese," *L'Archiginnasio,* XXX, pp. 111–35. **1939.** "Un ritratto equestre dell'epoca genovese del Rubens," *Annuaire des Musées Royaux des Beaux-Arts de Belgique,* II, pp. 123–30. Reprinted in *Opere complete,* vol. IX, Florence, 1979, pp. 85–90. **1943 a.** "Ultimi studi sul Cara-

vaggio e la sua cerchia," *Proporzioni*, I, pp. 5–63. **1943 b.** "Ultimissimi sul Caravaggio," *Proporzioni*, I, pp. 99–102. **1947.** *Documentario sul Caravaggio.* Rome. **1948.** "Calepino veneziano. XIV. Suggerimenti per Jacopo Bassano," *Arte veneta*, II, pp. 43–55. Reprinted in *Opere complete*, vol. X, Florence, 1978, pp. 90–98. **1950.** "Un Momento importante nella storia della natura morta," *Paragone*, no. 1, pp. 34–39. **1951 a.** *Mostra del Caravaggio e dei Caravaggeschi,* exhib. cat. Milan, Palazzo Reale. **1951 b.** "Alcuni pezzi rari nell'antologia della critica caravaggesca," *Paragone*, no. 17, pp. 44–63; no. 19, pp. 61–63; no. 21, pp. 43–56; no. 23, pp. 28–53. **1951 c.** "La 'Giuditta' nel percorso del Caravaggio," *Paragone*, no. 19, pp. 10–18. **1951 d.** "Sui margini caravaggeschi," *Paragone*, no. 21, pp. 20–34. **1952.** *Il Caravaggio.* Milan. 2nd ed., Rome, 1968. 3rd ed., Rome, 1982. **1954 a.** "L'Ecce Homo' del Caravaggio a Genova," *Paragone*, no. 51, pp. 3–14. **1954 b.** "Una citazione tizianesca nel Caravaggio," *Arte veneta*, VIII, pp. 211–12. **1959.** "Un' opera estrema del Caravaggio," *Paragone*, no. 111, pp. 21–32. **1960.** "Un originale del Caravaggio a Rouen e il problema delle copie caravaggesche," *Paragone*, no. 121, pp. 23–36. **1963.** "Giovanni Baglione e il quadro del processo," *Paragone*, no. 163, pp. 23–31. **1967.** "Anche Ambrogio Figino sulla soglia della 'natura morta,'" *Paragone*, no. 209, pp. 18–22. **1968.** *Caravaggio*, trans. B. D. Phillips. Leipzig.

Loria, G.
1950. *Storia delle matematiche dall'alba della civiltà al secolo XIX*, 2nd ed. Milan.

Luzio, A.
1913. *La Galleria dei Gonzaga venduta all'Inghilterra nel 1627–28: Documenti degli archivi di Mantova e Londra.* Milan.

Lynch, J. B.
1964. "Giovanni Paolo Lomazzo's Self-Portrait in the Brera," *Gazette des Beaux-Arts*, ser. 6, LXIV, pp. 189–97. **1966.** "Lomazzo and the Accademia della Valle di Bregno," *Art Bulletin*, 48, pp. 210–11. **1968.** "Lomazzo's Allegory Painting," *Gazette des Beaux-Arts*, ser. 6, LXXII, pp. 325–30.

Maccarinelli, F.
1747–51. *Le Glorie di Brescia.* Ed. C. Boselli, Brescia, 1959 (*Supplemento ai Commentari dell'Ateneo di Brescia per il 1959*).

Macrae, D.
1964. "Observation on the Sword in Caravaggio," *Burlington Magazine*, 106, pp. 412–16.

Magne, E.
1939. *Images de Paris sous Louis XIV d'après des documents inédits.* Paris.

Mahon, D.
1951 a. "Egregius in Urbe Pictor: Caravaggio Revised," *Burlington Magazine*, 93, pp. 223–35. **1951 b.** "Caravaggio's Chronology Again," *Burlington Magazine*, 93, pp. 286–92. **1952 a.** "Addenda to Caravaggio," *Burlington Magazine*, 94, pp. 2–23. **1952 b.** "An Addition to Caravaggio's Early Period," *Paragone*, no. 25, pp. 20–31. **1953 a.** "Contrasts in Art Historical Method: Two Recent Approaches to Caravaggio," *Burlington Magazine*, 95, pp. 212–20. **1953 b.** "On Some Aspects of Caravaggio and His Time," *The Metropolitan Museum of Art Bulletin*, vol. 12, pp. 33–45. **1956 a.** "Un tardo Caravaggio ritrovato," *Paragone*, no. 77, pp. 25–34. **1956 b.** "A Late Caravaggio Rediscovered," *Burlington Magazine*, 98, pp. 225–28.

Mahon, D., and D. Sutton
1955. *Artists in 17th Century Rome*, exhib. cat. London, Wildenstein and Co.

Maindron, M.
1908. "Le Portrait du grand-maître Alof de Wignacourt au Musée du Louvre, son portrait et ses armes à l'arsénal de Malte," *Revue de l'art ancien et moderne*, XXIV, pp. 241–54, 339–52.

Mâle, É.
1932. *L'Art religieux après le Concile de Trente: Étude sur l'iconographie de la fin du XVIᵉ siècle, du XVIIᵉ siècle, du XVIIIᵉ siècle; Italie–France–Espagne–Flandres.* Paris.

Malvasia, C. C.
1678. *Felsina pittrice: Vite de' pittori bolognesi.* 2 vols. Bologna. Ed. G. Zanotti, Bologna, 1841. **1686.** *Le Pitture di Bologna.* Bologna. **1694.** *Il Claustro di S. Michele in Bosco di Bologna.* Bologna.

Mancini, G.
about **1617–21.** *Considerazioni sulla pittura.* Ed. A. Marucchi, with commentary by L. Salerno, 2 vols. Rome, 1956–57.

Manilli, J.
1650. *Villa Borghese fuori di Porta Pinciana descritta da Iacomo Manilli romano guardaroba di detta villa.* Rome.

Manselli, R.
1982. In *L'imagine di San Francesco nella Controriforma*, exhib. cat. Rome, Palazzo Venezia.

Marangoni, M.
1917. "Valori malnoti e trascurati della pittura italiana del Seicento in alcuni pittori di natura morta," *Rivista d'arte*, 10, pp. 1–31. **1922 a.** "Quattro 'Caravaggio' smarriti," *Dedalo*, 2, pp. 783–94. **1922 b.** *Il Caravag-*

gio. Florence. **1922 c.** In *Mostra della pittura italiana del Seicento e del Settecento*, exhib. cat. Florence, Palazzo Pitti. **1922–23.** "Note sul Caravaggio alla Mostra del Sei e Settecento," *Bollettino d'arte*, 2, pp. 217–29. **1927.** *Arte barocca.* Florence. **1929.** "An Unpublished Caravaggio in Trieste," *International Studio*, 94, pp. 34–35.

Mariette, P. J.
1857–58. *Abécédario et autres notes inédites*, ed. P. de Chennevières and A. de Montaiglon, vol. IV. Paris. **1969.** *Écoles d'Italie*, vol. I of *Les Grands Peintres*. Facsimile ed. Paris.

Marini, M.
1971. "Tre proposte per il Caravaggio meridionale," *Arte illustrata*, 4, pp. 43–44, 56–65. **1973.** "Caravaggio 1607: La 'Negazione di Pietro,'" *Napoli nobilissima*, 12, pp. 189–94. **1974.** *Io Michelangelo da Caravaggio.* Rome. **1978.** *'Michael Angelus Caravaggio Romanus': Rassegna degli studi e proposte.* Rome. **1979.** "Caravaggio a Genova," *Bollettino dei Musei Civici Genovesi*, no. 3, pp. 28–41. **1980.** *Caravaggio: Werkverzeichnis*, Frankfurt am Main. **1981.** "Caravaggio e il naturalismo internazionale," in *Storia dell'arte italiana*, pt. 2, *Dal Medioevo al Novecento*, vol. II, *Dal Cinquecento all'Ottocento*, I, *Cinquecento e Seicento*, pp. 347–445. Turin. **1983 a.** *Michelangelo Merisi da Caravaggio.* New York. **1983 b.** "Equivoci del caravaggismo 2: A) Appunti sulla tecnica del 'naturalismo' secentesco, tra Caravaggio e 'Manfrediana methodus'; B) Caravaggio e i suoi 'doppi.' Il problema delle possibili collaborazioni," *Artibus et historiae*, no. 8, pp. 119–54. **1984.** *In proscenio*, exhib. cat. Rome, Regine's Gallery.

Marino, G. B.
1619. *La Galeria... Distinta in Pitture & Sculture.* Venice, 1619; Milan, 1620.

Mariotti, F.
1892. *La Legislazione delle Belle Arti.* Rome.

Martellotti, G., and E. B. Zanardi
1980. In *Gli affreschi del Cavalier d'Arpino in Campidoglio: Analisi di un'opera attraverso il restauro*, exhib. cat. Rome, Musei Capitolini.

Martin, J. R.
1965. *The Farnese Gallery.* Princeton.

Martini, A.
1959. "Un singolare dipinto del Passignano," *Paragone*, no. 109, pp. 55–58.

Martinelli, V.
1959. "L'Amor 'tutto ignudo' di Giovanni Baglione e la cronologia dell'intermezzo caravaggesco," *Arte antica e moderna*, 5, pp. 82–96.

Martinez, J.
about 1650–60. *Discursos practicables del nobilísimo arte de la pintura…* Ed. V. Carderera y Solano, Madrid, 1866; excerpted in F. J. Sánchez Cantón, ed., *Fuentes literarias para la historia del arte espanol*, III, pp. 13–84. Madrid.

Mascalchi, S.
1984. *Le collezioni di Giovan Carlo de' Medici: Una vicenda del Seicento fiorentino riconsiderata alla luce dei documenti.* Florence.

Matteoli, A.
1980. *Lodovico Cardi-Cigoli, pittore e architetto.* Pisa.

Matthiesen, P., and D. S. Pepper
1970. "Guido Reni: An Early Masterpiece Discovered in Liguria," *Apollo*, XCI, pp. 452–62.

Mauceri, E.
1921–22 a. "Restauri a dipinti del Museo Nazionale di Messina," *Bollettino d'arte*, I, pp. 581–85. **1921–22 b.** "Restauri a dipinti siracusani compiuti tra il 1920 e il 1921," *Bollettino d'arte*, I, pp. 585–86.

McTavish, D.
1981. In *Da Tiziano al Greco: Per la storia del manierismo a Venezia*, exhib. cat. Venice, Palazzo Ducale.

Meijer, B. W.
1971. "Esempi del comico figurativo nel Rinascimento lombardo," *Arte lombarda*, 16, pp. 259–66.

Meiss, M.
1964. *Giovanni Bellini's St. Francis in the Frick Collection.* New York.

Mellini, G. L.
1977. "Momenti del Barocco: Lanfranco e Caravaggio," *Comunità*, no. 177, pp. 390–421.

Meloni Trkulja, S.
1977. "Per 'L'Amore dormiente' del Caravaggio," *Paragone*, no. 331, pp. 46–50.

Migne, J. P., ed.
1849. *Sancti Gregorii Papae I cognomento Magni: Opera omnia, Tomus secundus*, vol. LXXVI of *Patrologiae cursus completus… Series Latina prima.* Paris.

Mirimonde, A. P. de.
1966–67. "La musique dans les allégories de l'amour," *Gazette des Beaux-Arts*, ser. 6, LXVIII, pp. 265–90; LXIX, pp. 319–46.

Moir, A.
1961. " 'Boy with a Flute' by Bartolomeo Manfredi," *Los Angeles County Museum Bulletin of the Art Division*, 13, pp. 1–15. **1965.** In *Art in Italy: 1600–1700*, exhib. cat. Detroit, Institute of Arts. **1967.** *The Italian Followers of Caravaggio*, 2 vols. Cambridge, Mass. **1972.** "Drawings after Caravaggio," *Art Quarterly*, XXXV, pp. 123–42. **1976.** *Caravaggio and His Copyists.* New York. **1982.** *Caravaggio.* New York. **Forthcoming.** Article on Bartolomeo Manfredi, in *Chicago Art Institute, Museum Studies.*

Montelatici, B.
1700. *Villa Borghese fuori di Porta Pinciana.* Rome.

Mormone, R.
1963. "Un Battistello inedito." *Napoli nobilissima*, 3, pp. 136–40.

Mortari, L.
1968. In Soprintendenza alle Gallerie e alle Opere d'Arte Medievali e Moderne del Lazio, *Mostra di opere d'arte restaurate nel 1967: XI settimana dei musei*, exhib. cat. Rome, Palazzo Venezia.

Mossakowski, S.
1968. "Raphael's 'St. Cecilia': An Iconographical Study," *Zeitschrift für Kunstgeschichte*, 31, pp. 1–26. **1983.** In *Indagini per un dipinto: La Santa Cecilia di Raffaello*, pp. 51–79. Bologna.

Müller Hofstede, J.
1964. "Rubens's First Bozzetto for Sta. Maria in Vallicella," *Burlington Magazine*, 106, pp. 442–50. **1965.** "Rubens St. Georg und seine frühen Reiterbildnisse," *Zeitschrift für Kunstgeschichte*, 28, pp. 69–112. **1977.** *Rubens in Italien; Gemälde, Ölskizzen, Zeichnungen Triumph der Eucharistie; Wandteppiche aus dem Kölner Dom*, vol. I of *Peter Paul Rubens 1577–1640*, exhib. cat. Cologne, Kunsthalle.

Münster
1979. *Stilleben in Europa*, exhib. cat. Münster, Westfälisches Landesmuseum für Kunst und Kulturgeschichte.

Murtola, G.
1603. *Rime del Sig. Gasparo Murtola. Cioè: Gli occhi d'Argo. Le lacrime. I pallori. I nei. I baci. I veneri. Gl'amori.* Venice.

Naples
1977. *Mostra didattica di Carlo Sellitto, primo caravaggesco napoletano*, exhib. cat. Naples, Museo e Galleria Nazionale di Capodimonte.

Negri-Arnoldi, F.
1977. "Alonzo Rodriguez: un caravaggesco contestato," *Prospettiva*, no. 9, pp. 17–37.

Neppi, L.
1975. *Palazzo Spada.* Rome.

Nicolson, B.
1970. "The Art of Carlo Saraceni," *Burlington Magazine*, 112, pp. 312–15. **1974.** "Caravaggio and the Caravaggesques: Some Recent Research," *Burlington Magazine*, 116, pp. 603–16. **1977.** " 'The Fortune Teller' at the Louvre," *Burlington Magazine*, 119, p. 597. **1979.** *The International Caravaggesque Movement: Lists of Pictures by Caravaggio and His Followers Throughout Europe from 1590 to 1650.* Oxford.

Nissman, J.
1979 a. "Domenico Cresti (Il Passignano), 1559–1638: A Tuscan Painter in Florence and Rome." Ph.D. diss., Columbia University, New York. **1979 b.** *Disegni dei toscani a Roma (1580–1620).* Florence.

Oehler, L.
1967. "Zu einigen Bildern aus Elsheimers Umkreis," *Städel-Jahrbuch*, n.s. I, pp. 148–70.

Oertel, R.
1938. "Neapolitanische Malerei des 17.–19. Jahrhunderts: Ausstellung im Castel Nuovo in Neapel," *Pantheon*, 22, pp. 225–32.

Olsen, H.
1961. *Italian Paintings and Sculptures in Denmark.* Copenhagen. **1962.** *Federico Barocci*, 2nd rev. ed. Copenhagen.

Orbaan, J.
1920. *Documenti sul barocco in Roma.* Rome.

Ortolani, S.
1925. "Di Gian Girolamo Savoldo," *L'Arte*, 28, pp. 163–73.

Ottani Cavina, A.
1967. "Per il primo tempo del Saraceni," *Arte veneta*, 21, pp. 218–23. **1968.** *Carlo Saraceni.* Milan. **1974.** "Il tema sacro nel Caravaggio e nella cerchia caravaggesca," *Paragone*, no. 293, pp. 29–53. **1976 a.** "On the Theme of Landscape, I: Additions to Saraceni," *Burlington Magazine*, 118, pp. 82–87. **1976 b.** "On the Theme of Landscape, II: Elsheimer and Galileo," *Burlington Magazine*, 118, pp. 139–44.

Ottino della Chiesa, A.
1967. *L'opera completa del Caravaggio.* Milan.

Pacelli, V.
1977. "New Documents Concerning Caravaggio in Naples," *Burlington Magazine*, 119, pp. 819–29. **1978 a.** "Caracciolo Studies," *Burlington Magazine*, 120, pp. 492–97. **1978 b.** "Nuovi documenti sull'attività del Caravaggio a Napoli," *Napoli nobilissima*, 17, pp. 57–67.

Pacelli, V., and F. Bologna
1980. "Caravaggio, 1610: La 'Sant'Orsola confitta dal Tirano' per Marcantonio Doria," *Prospettiva*, no. 23, pp. 24–44.

Pallucchini, R., ed.
1966. *La carta del navegar pitoresco*, by M. Boschini. Venice.

Pallucchini, R., and P. Rossi
1982. *Tintoretto: Le opere sacre e profane*, 2 vols. Milan.

Panazza, G.
1975. "I precedenti bresciani del Caravaggio," in *Novità sul Caravaggio: Saggi e contributi*, ed. M. Cinotti, pp. 163–74. Milan. (Paper presented at the Tavola Rotonda "Immagine del Caravaggio," Brescia, June 17, 1974.)

Panciroli, O.
1625. *Tesori nascosti dell'alma città di Roma.* Rome.

Panofsky, D.
1949. "Narcissus and Echo: Notes on Poussin's Birth of Bacchus, in the Fogg Museum of Art," *Art Bulletin*, 31, pp. 112–20.

Panofsky, E.
1969. *Problems in Titian, Mostly Iconographic.* London.

Passeri, G. B.
1670–80. *Vite de' pittori, scultori ed architetti che hanno lavorato in Roma.* Rome. Ed. J. Hess, Leipzig and Vienna, 1934.

Pearce, S. M.
1953. "Costume in Caravaggio's Painting," *Magazine of Art*, 47, pp. 147–54.

Pepper, D. S.
1971. "Caravaggio and Guido Reni: Contrasts in Attitudes," *Art Quarterly*, 34, pp. 325–44. **1984.** "Baroque painting at Colnaghi's," *Burlington Magazine* 126, pp. 315–16.

Pérez Sánchez, A. E.
1964. *Borgianni, Cavarozzi y Nardi en España.* Madrid. **1965 a.** "Mas sobre Borgianni y Nardi," *Archivio Español de Arte*, 38, pp. 105–14. **1965 b.** *Pintura italiana del siglo XVII en España.* Madrid. **1970.** *Pintura italiana del siglo XVII: Exposición conmemorativa del ciento cincuenta aniversario de la fundación del Museo del Prado*, exhib. cat. Madrid, Casón del Buen Retiro. **1971.** "Caravaggio e i Caravaggeschi a Firenze," *Arte illustrata*, no. 37–38, pp. 85–89. **1972.** "Nuevas obras de Oracio Borgianni en España," *Boletín del Seminario de Estudios de Arte y Arqueología*, 38, pp. 527–30. **1973.** In *Caravaggio y el naturalismo español*, exhib. cat. Seville, Sala de Armas de los Reales Alcazares. **1974.** "Caravaggio y los caravaggistas en la pintura española," in *Colloquio sul tema Caravaggio e i caravaggeschi, organizzato d'intesa con le Accademie di Spagna e di Olanda* (Rome, Feb. 12–14, 1973), pp. 57–85. Rome, Accademia Nazionale dei Lincei. **1982.** "La Academia madrileña de 1630 y sus fundadores," *Boletín del Seminario de Estudios de Arte y Arqueología*, 48, pp. 281–90.

Pevsner, N.
1927–28. "Eine Revision der Caravaggio-Daten," *Zeitschrift für bildende Kunst*, 61, pp. 386–92. **1928.** *Barockmalerei in den romanischen Ländern.* Potsdam. **1928–29.** "Die Lehrjahre des Caravaggio," *Zeitschrift für bildende Kunst*, 62, pp. 278–88.

Picault, J. M.
1793. *Observations de Picault artiste restaurateur de tableaux à ses concitoyens, sur les tableaux de la République.* Paris.

Pietrangeli, C., ed.
1975. *Guide rionali di Roma. Rione X: Parte I, Campitelli.* Rome.

Pigler, A.
1956. *Barockthemen: Eine Auswahl von Verzeichnissen zur Ikonographie des 17. und 18. Jahrhunderts*, 2 vols. Budapest.

Piles, R. de
1708. *Cours de peinture par principes.* Paris.

Pino, P.
1548. *Dialogo di pittura.* Ed. R. and A. Pallucchini, Venice.

Pio, N.
about 1724. *Le vite di pittori, scultori et architetti in compendio in numero di duecentoventicinque scritte e raccolte da Nicola Pio dilettante romano.* Ed. C. and R. Enggass, Vatican City, 1977.

Posner, D.
1971 a. *Annibale Carracci: A Study in the Reform of Italian Painting around 1590*, 2 vols. London. **1971 b.** "Caravaggio's Homo-erotic Early Works," *Art Quarterly*, 34, pp. 301–24. **1975.** "The Alzaga Caravaggio" (letter), *Burlington Magazine*, 117, p. 302. **1981.** "Lizards and Lizard Lore, with Special Reference to Caravaggio's Leapin' Lizard," in *Art the Ape of Nature: Studies in Honor of H.W. Janson*, pp. 387–91. New York.

Posse, H.
1911. "Caravaggio," in *Allgemeines Lexikon der Bildenden Künstler*, ed. U. Thieme and F. Becker, vol. V. Leipzig, pp. 570–74.

Potterton, H.
1975. *The Supper at Emmaus by Caravaggio*, exhib. cat. London, National Gallery (Painting in Focus, no. 3).

Pouncey, P.
1952. "Two Drawings by Cristofano Roncalli," *Burlington Magazine*, 94, pp. 356–59.

Praz, M.
1977. "Di alcune interpretazioni moderne del Caravaggio," in *Barocco fra Italia e Polonia*, ed. J. Slaski, pp. 79–87. Warsaw. (Paper presented at the IV Convegno di Studi Promosso ed Organizzato dal Comitato degli Studi sull'Arte dell'Accademia Polacca delle Scienze e dalla Fondazione Giorgio Cini di Venezia, Warsaw, Oct. 14–18, 1974.)

Previtali, G.
1973. "Gentileschi's 'The Samaritan Woman at the Well,'" *Burlington Magazine*, 115, pp. 358–60.

Procacci, L. and U.
1965. "Il carteggio di Marco Boschini con il Cardinale Leopoldo de' Medici," *Saggi e memorie di storia dell'arte*, IV, pp. 85–113.

Prohaska, W.
1980. "Untersuchungen zur 'Rosenkrantz Madonna' Caravaggios," *Jahrbuch der Kunsthistorischen Sammlungen in Wien*, 76, pp. 111–32.

Pugliatti, T.
1977. *Agostino Tassi: Tra conformismo e libertà.* Rome.

Puerari, A.
1951. *La Pinacoteca di Cremona.* Cremona. **1953.** "Due dipinti di Vincenzo Campi," *Paragone*, no. 3, pp. 41–45.

Ramdohr, F. W. B. von
1787. *Über Mahlerei und Bildhauerarbeit in Rom für Liebshaber des Schönen in der Kunst.* 3 vols. Leipzig.

[Ratti, A.]
1907. *Guida sommaria per il visitatore della Biblioteca Ambrosiana e delle collezioni annesse.* Milan.

Ratti, C. G.
1780. *Istruzione di quanto può vedersi di più bello in Genova in Pittura, Scultura, ed Architettura*, 2nd ed. Genoa.

Rearick, W. R.
1976. *Tiziano e il disegno veneziano del suo tempo*, exhib. cat. Florence, Gabinetto Disegni e Stampe degli Uffizi. **1980.** "Tiziano e Jacopo Bassano," in *Tiziano e Venezia*, Convegno Internazionale di Studi, Venice, 1976, pp. 371–74. Vicenza.

Réau, L.
1955–59. *Iconographie de l'art chrétien*, 3 vols. Paris.

Reuger, K.
1978. In *Die Sprache der Bilder: Realität und Bedeutung in der niederländischen Malerei des 17. Jahrhunderts*, exhib. cat. Braunschweig, Herzog Anton Ulrich-Museum.

Ripa, C.
1603. *Iconologia.* Rome.

Robertson, G.
1954. *Vincenzo Catena.* Edinburgh.

Roever, N. de
1885. "Drie Amsterdamsche Schilders: Pieter Isaaksz., Abraham Vinck, Cornelis van der Voort," *Oud Holland*, 3, pp. 171–208.

Rome, 1970
Acquisti, doni, lasciti, restauri e recuperi, 1962–1970: XIII settimana dei musei, exhib. cat. Rome, Palazzo Barberini, Galleria Nazionale d'Arte Antica.

Rosci, M.
1971. *Baschenis, Bettera & Co.: Produzione e mercato della natura morta del Seicento in Italia.* Milan. **1977.** "Italia," in *Natura in posa: La grande stagione della natura morta europea,* pp. 85–112. Milan.

Rosenberg, P.
1965. *Le Seizième siècle européen.* Paris. **1966.** In Rouen, Musée des Beaux-Arts, *Tableaux français du XVIIe siècle et italiens des XVIIe et XVIIIe siècles.* Paris. **1982.** *France in the Golden Age: Seventeenth-Century French Paintings in American Collections,* exhib. cat. New York, The Metropolitan Museum of Art. **1983.** "Temps modernes: XVIIe–XVIIIe siècles. Tableaux français du XVIIe siècle," *La Revue du Louvre,* no. 5–6, pp. 350–57.

Rossi, F.
1973. "Catalogo delle opere del Caravaggio," in *Immagine del Caravaggio: Mostra didattica itinerante,* exhib. cat., pp. 57–111. Milan.

Rossi, F. de
1727. *Descrizione di Roma moderna,* vol. II. Rome.

Röttgen, H.
1968. "Repräsentationsstil und Historienbild in der römischen Malerei um 1600," in *Beiträge für H. G. Evers, anlässlich der Emeritierung im Jahre 1968.* Darmstadt, pp. 71–82. **1969.** "Caravaggio-Probleme," *Münchner Jahrbuch der bildenden Kunst,* 20, pp. 143–70. **1973.** In *Il Cavalier d'Arpino,* exhib. cat. Rome, Palazzo Venezia. **1974.** *Il Caravaggio: Ricerche e interpretazioni.* Rome.

Rousseau, T.
1953. In D. Mahon, "On Some Aspects of Caravaggio and His Times," *The Metropolitan Museum of Art Bulletin,* 12, p. 33–45.

Ruotolo, R.
1973. "Collezioni e mecenati napoletani del XVII secolo," *Napoli nobilissima,* 12, pp. 118–19, 145–53.

Ruskin, J.
1903–12. *The Works of John Ruskin,* ed. E. T. Cook and A. Wedderburn. 39 vols. London.

Saccà, V.
1906–7. "Michelangelo da Caravaggio pittore," *Archivio storico messinese,* 7, pp. 40–69; 8, pp. 41–79.

Šafařík, E.
1972. In Faldi, I., and E. Šafařík, *Acquisiti 1970–72; XV settimana dei musei italiani,* exhib. cat. Rome, Palazzo Barberini.

Salas, X. de
1974. "Caravaggio y los caravaggistas en la pintura española," in *Colloquio sul tema Caravaggio e i caravaggeschi, organizzato d'intesa con le Accademie di Spagna e di Olanda* (Rome, Feb. 12–14, 1973)), pp. 29–43. Rome, Accademia Nazionale dei Lincei.

Salerno, L.
1956. *Il Seicento Europeo,* exhib. cat. Rome, Palazzo delle Esposizioni. **1960.** "The Picture Gallery of Vincenzo Giustiniani: Introduction and Inventory," *Burlington Magazine,* 102, pp. 21–27, 93–105, 135–48. **1966.** "Poesia e simboli nel Caravaggio: I dipinti emblematici," *Palatino,* X, pp. 106–12. **1970.** "Caravaggio e i caravaggeschi," *Storia dell'arte,* no. 7–8, pp. 234–48. **1974.** "Detroit's 'Conversion of the Magdalen' (The Alzaga Caravaggio): Art-Historical Implications of the Detroit 'Magdalen,'" *Burlington Magazine,* 116, pp. 586–93. **1975.** "Caravaggio e la cultura del suo tempo," in *Novità sul Caravaggio: Saggi e contributi,* ed. M. Cinotti, pp. 17–26, Milan. (Paper presented at the Convegno Internazionale di Studi Caravaggeschi, Bergamo, Jan. 25–26, 1974.) **1977–80.** *Landscape Painters of the Seventeenth Century in Rome; Pittori di paesaggio del Seicento a Roma,* 3 vols. (In English and Italian.) Rome. **1981.** "Immobilismo politico e accademia," in *Storia dell'arte italiana,* pt. 2, *Dal Medioevo al Novecento,* vol. 2, *Dal Cinquecento all'Ottocento,* I, *Cinquecento e Seicento,* pp. 456–509. Turin. **1984.** "Caravaggio: a Reassessment," *Apollo,* CXIX, pp. 438–41.

Sammut, E.
1959. "The Armory of Valletta and a Letter from Sir Guy Laking. *Scientia,* 15, pp. 7–18.

Sánchez Cantón, F. J.
1963. *Catalogo de las pinturas,* 5th ed. Madrid, Museo del Prado.

Sandrart, J. von
1975. *L'academia todesca della architectura, scultura e pittura, oder Teutsche Academie der edlen Bau- Bild- und Mahlerey-Künste.* Nuremberg, 1675. Ed. A. Peltzer (*Joachim von Sandrarts Academie der Bau, Bild, und Mahlerey-Künste von 1675*). Munich, 1925.

Sansovino, F.
1581. *Venetia città nobilissima et singolare, descritta in XIIII libri.* Venice.

Scannelli, F.
1657. *Il Microcosmo della Pittura.* Cesena.

Scavizzi, G.
1963. In *Caravaggio e caravaggeschi,* exhib. cat. Naples, Palazzo Reale.

Scherliess, V.
1973. "Zu Caravaggios 'Musica.' Anhang: Notenbücher auf Bildern Caravaggios," *Mitteilungen des Kunsthistorischen Instituts in Florenz,* 17, pp. 141–48.

Schleier, E.
1962. "Lanfranco's 'Notte' for the Marchese Sannesi and Some Early Drawings," *Burlington Magazine,* 104, pp. 246–57. **1970.** "Pintura italiana del siglo XVII," *Kunstchronik,* 23, pp. 341–49. **1971.** "Caravaggio e i Caravaggeschi nelle Gallerie di Firenze: Zur Ausstellung im Palazzo Pitti, Sommer 1970," *Kunstchronik,* 24, pp. 85–102. **1978.** In *Catalogue of Paintings. Picture Gallery, Staatliche Museen Preussischer Kulturbesitz: 13–18th Century,* 2nd rev. ed. Berlin. **1983.** *Disegni di Giovanni Lanfranco,* exhib. cat. Florence, Gabinetto Disegni e Stampe degli Uffizi.

Schneider, A. von
1933. *Caravaggio und die Niederländer.* Marburg. 2nd ed., Amsterdam, 1967.

Schneider, T. M.
1976. "Addendum to Caravaggio: The Cecconi 'Crowning with Thorns' Reconsidered," *Burlington Magazine,* 118, pp. 679–80.

Schudt, L.
1942. *Caravaggio.* Vienna.

Scribner, C.
1977. "'In alia effigie': Caravaggio's London Supper at Emmaus," *Art Bulletin,* 59, pp. 375–82.

Sebregondi Fiorentini, L.
1982. "Francesco dell'Antella, Caravaggio, Paladini, e altri," *Paragone,* no. 383–385, pp. 107–22.

Shapley, F. R.
1979. *Catalogue of the Italian Paintings,* 2 vols. Washington, National Gallery of Art.

Sigismondo, G.
1788–89. *Descrizione della città di Napoli e suoi borghi.* Naples.

Silos, G. M.
1673. *Pinacotheca sive Romana pictura et scultura.* Rome. Ed. M. Basile Bonsante, 2 vols., Treviso, 1979.

Slatkes, L.
1972 a. "Caravaggio's Painting of the Sanguine Temperament," in *Actes du XXIIe Congrès International d'Histoire de l'Art, Budapest, 1969: Évolution générale et développements régionaux en histoire de l'art,* II, pp. 17–24. Budapest. **1972 b.** "Caravaggio's 'Pastor Friso,'" *Nederlands Kunsthistorisch Jaarboek,* 23, pp. 67–72. **1976.** "Caravaggio's 'Boy Bitten by a Lizard,'" *Print Review,* V, pp. 148–53.

Snyder, J.
1976. "Jan van Eyck and Adam's Apple," *Art Bulletin,* 58, pp. 511–15.

Soprani, R.
1674. *Le vite de' pittori scoltori et architetti genovesi.* Genoa.

Spear, R.
1965. "The 'Raising of Lazarus': Caravaggio and the Sixteenth Century Tradition," *Gazette des Beaux-Arts*, ser. 6, LXV, pp. 65–70. **1971 a.** *Caravaggio and His Followers*, exhib. cat. Cleveland, The Cleveland Museum of Art. **1971 b.** "Caravaggisti at the Palazzo Pitti," *Art Quarterly*, XXXIV, pp. 108–10. **1971 c.** "A Note on Caravaggio's 'Boy with a Vase of Roses,'" *Burlington Magazine*, 113, pp. 470–73. **1972.** *Renaissance and Baroque Paintings from the Sciarra and Fiano Collections.* University Park, Penn. **1975.** *Caravaggio and His Followers*, rev. ed. New York. **1979.** Review of B. Nicolson, *The International Caravaggesque Movement*, in *Burlington Magazine*, 121, pp. 317–22. **1982.** *Domenichino*, 2 vols. New Haven. **1984.** "Stocktaking in Caravaggio Studies," *Burlington Magazine*, 126, pp. 162–65.

Spezzaferro, L.
1971. "La cultura del Cardinale Del Monte e il primo tempo del Caravaggio," *Storia dell'arte*, no. 9–10, pp. 57–92. **1974.** "Detroit's 'Conversion of the Magdalen': 4. The Documentary Findings: Ottavio Costa as a Patron of Caravaggio," *Burlington Magazine*, 116, pp. 579–86. **1975 a.** "Ottavio Costa e Caravaggio: Certezze e problemi," in *Novità sul Caravaggio: Saggi e contributi*, ed. M. Cinotti, pp. 103–18. Milan. (Paper presented at the Convegno Internazionale di Studi Caravaggeschi, Bergamo, Jan. 25–26, 1974.) **1975 b.** "Una testimonianza per gli inizi del caravaggismo," *Storia dell'arte*, no. 23, pp. 53–60. **1981.** "Il recupero del Rinascimento," in *Storia dell'arte italiana*, pt. 2, *Dal Medioevo al Novecento*, vol. II, *Dal Cinquecento all'Ottocento*, I, *Cinquecento e Seicento*, pp. 185–274. Turin.

Spike, J. T.
1983. *Italian Still-Life Paintings from Three Centuries*, exhib. cat. New York, National Academy of Design.

Sterling, C.
1943–44. "Early Paintings of the Commedia dell'Arte in France," *The Metropolitan Museum of Art Bulletin*, n.s., 2, pp. 11–32. **1952 a.** *La Nature morte de l'antiquité à nos jours*, exhib. cat. Paris, Musée de l'Orangerie. **1952 b.** *La Nature morte de l'antiquité à nos jours*. Paris. 2nd ed., Paris, 1959. **1959.** *Still Life Painting from Antiquity to the Present Time*. New York. Rev. ed., New York, 1981.

Stoughton, M. W.
1976. Review of A. Moir, *Caravaggio and his Copyists*, in *Art Quarterly*, n.s., I, pp. 405–9.

Strinati, C.
1979. *Quadri romani tra '500 e '600: Opere*

restaurate e da restaurare, exhib. cat. Rome, Palazzo Venezia.

Strong, S. A., comp.
1900. *Reproductions in Facsimile of Drawings by the Old Masters in the Collection of the Earl of Pembroke and Montgomery.* London.

Suida, W.
1929. *Leonardo und sein Kreis.* Munich.

Summers, D.
1977. "Contrapposto: Style and Meaning in Renaissance Art," *Art Bulletin*, 59, pp. 336–61.

Susinno, F.
1724. *Le vite de' pittori messinesi.* Ed. V. Martinelli, Florence, 1960.

Testori, G.
1975. "Tre nuovi Caravaggio che faranno discutere," *Corriere della sera*, Oct. 8, p. 3. **1980.** "Voi sapete ch'io vi amo," *Corriere della sera*, July 30. **1983.** "Se la Realtà non è solo un fotogramma...," in *Francesco Cairo, 1607–1665*, exhib. cat. Varese, Musei Civici, pp. XI–XXVIII.

Thiem, C.
1977. *Florentiner Zeichner des Frühbarock.* Munich.

Thuillier, J.
1978. *La peinture en Provence au XVIIᵉ siècle*, exhib. cat. Marseilles, Musée des Beaux-Arts. **1982.** *Claude Lorrain e i pittori lorenesi in Italia nel XVII secolo*, exhib. cat. Rome, Accademia di Francia a Roma.

Toesca, I.
1957. "Pomarancio a Palazzo Crescenzi," *Paragone*, no. 91, pp. 41–45. **1960.** "Un' opera giovanile del Cavarozzi e i suoi rapporti col Pomarancio," *Paragone*, no. 123, pp. 57–59. **1961.** "Observations on Caravaggio's 'Repentant Magdalen,'" *Journal of the Warburg and Courtauld Institutes*, XXIV, pp. 114–15. **1969.** In *Attività della Soprintendenza alle Gallerie del Lazio: XII settimana dei musei*, exhib. cat. Rome, Sala di Santa Marta.

Torre, S.
1962. "Abbiamo trovato un quadro: È un Caravaggio?" *Il giornale d'Italia*, May 9–10.

Torriti, P.
1971. "Apporti toscani e lombardi," in *La pittura a Genova e in Liguria dal Seicento al primo Novecento*, vol. II of *La Pittura a Genova e in Liguria*, pp. 13–65. Genoa.

Tzeutschler Lurie, A., and D. Mahon
1977. "Caravaggio's 'Crucifixion of Saint Andrew' from Valladolid," *Bulletin of the Cleveland Museum of Art*, 64, pp. 2–24.

Vagnetti, L.
1980. "Il processo di maturazione di una

scienza dell'arte: La teoria prospettica nel Cinquecento," in *Convegno Internazionale di Studi Tenuto sulla Prospettiva Rinascimentale: Codificazioni e Trasgressioni* (Milan, 1979), vol. I, pp. 427–74. Florence.

Valletta
1970. *The Order of St. John in Malta, with an Exhibition of Paintings by Mattia Preti, Painter and Knight*, exhib. cat. Valletta, The Museum of the Church of Saint John.

Valsecchi, M.
1971. "Nuove aggiunte al Peterzano," in *Studi in onore di Antonio Morassi*, pp. 172–83. Venice.

Van Mander, C.
1604. "Het Leven der Moderne oft deestijtsche doorluchtige Italiaensche Schilders," in *Het Schilder-boeck*. Haarlem.

Van Schaack, E.
1984. In *Old Master Paintings and Sculpture: Long-term Loans to the Picker Art Gallery*, exhib. cat. Hamilton, N. Y., Picker Art Gallery, Colgate University.

Vasari, G.
1568. *Le vite de' più eccellenti pittori.* Florence. Ed. G. Milanesi, 9 vols., Florence, 1906.

Vecellio, C.
1590. *De gli habiti antichi e moderni in diverse parti del mondo libri due.* Venice.

Venturi, A.
1893. *Il Museo e la Galleria Borghese.* Rome. **1928 a.** *Storia dell'arte italiana*, vol. IX, *La Pittura del Cinquecento*, pt. III. Milan. **1928 b.** "Un quadro ignorato di Michelangelo da Caravaggio," *L'Arte*, XXXI, pp. 58–59. **1932.** *Storia dell'arte italiana*, vol. IX, *La Pittura del Cinquecento*, pt. V. Milan. **1934.** *Storia dell'arte italiana*, vol. IX, *La Pittura del Cinquecento*, pt. VII. Milan.

Venturi, L.
1909. "Note sulla Galleria Borghese," *L'Arte*, XVIII, pp. 31–50. **1910.** "Studii su Michelangelo da Caravaggio," *L'Arte*, XIII, pp. 191–201, 268–84. **1912.** "Opere inedite di Michelangelo da Caravaggio," *Bollettino d'arte*, 6, pp. 1–8. **1921.** *Il Caravaggio*. Rome. **1930.** "Caravaggio," in *Enciclopedia italiana*, vol. VIII, pp. 941–44. Milan. **1951.** *Il Caravaggio*. Reissue of 1921 ed. Novara.

Versailles
1961. *Malte—Huit siècles d'histoire*, exhib. cat. Château de Versailles.

Vezzoli, G.
1974. "Incontri di Sant'Angela Merici con l'arte," in *Studi in onore di Luigi Fossati*, pp. 291–96. Brescia.

Villari, R.
1967. *La rivolta antispagnola a Napoli: Le origini (1585–1647).* Bari.

Villot, F.
1872–73. *Notice des tableaux exposés dans les galeries du Musée National du Louvre,* 3 vols. in 1. Paris.

Volpe, C.
1970. "Caravaggio e caravaggeschi nelle gallerie di Firenze," *Paragone,* no. 249, pp. 106–18. **1972 a.** "Annotazioni sulla mostra caravaggesca di Cleveland," *Paragone,* no. 263, pp. 50–76. **1972 b.** *Mostra di dipinti dal XIV al XVIII secolo,* exhib. cat., Milan, Finarte. **1973.** "Una proposta per Giovanni Battista Crescenzi," *Paragone,* no. 275, pp. 25–36.

Voragine, J. de
1941. *The Golden Legend.* Trans. G. Ryan and H. Ripperger. New York.

Voss, H.
1912. "Italienische Gemälde des 16. und 17. Jahrhunderts in der Galerie des Kunsthistorischen Hofmuseums zu Wien," *Zeitschrift für bildende Kunst,* n.s., 23, pp. 41–55, 62–74. **1923.** "Caravaggios Frühzeit: Beiträge zur Kritik seiner Werke und seiner Entwicklung," *Jahrbuch der Preussichen Kunstammlungen,* XLIV, pp. 73–98. **1924.** *Die Malerei des Barock in Rom.* Berlin. **1929.** "Elsheimers 'Heilige Familie mit den Engeln.' Eine Neuerwerbung der Gemäldegalerie," *Berliner Museen,* 50, pp. 20–27. **1951 a.** "Die Caravaggio-Ausstellung in Mailand," *Kunstchronik,* 4, pp. 165–69. **1951 b.** "Caravaggios europäische Bedeutung," *Kunstchronik,* 4, pp. 265, 267–94. **1951 c.** "Ein unbekanntes Frühwerk Caravaggios," *Die Kunst und das schöne Heim,* 49, pp. 410–12.

Vsevolozhskaya, S., and I. V. Linnik
1975. *Caravaggio and His Followers.* Leningrad.

Waddingham, M.
1972 a. "A Landscape Masterpiece by Saraceni," *Burlington Magazine,* 114, p. 159. **1972 b.** "Elsheimer revised," *Burlington Magazine,* 114, pp. 600–611.

Wagner, H.
1958. *Michelangelo da Caravaggio.* Berne.

Walters, G.
1978. *Federico Barocci: Anima Naturaliter.* New York.

Waterhouse, E.
1962. *Italian Baroque Painting.* London.

Wehle, H.
1940. *The Metropolitan Museum of Art: A Catalogue of Italian, Spanish and Byzantine Paintings.* New York.

Weigert, R. A.
1961. In *Mazarin, homme d'état et collectionneur, 1602–1661,* exhib. cat. Paris, Bibliothèque Nationale.

Weizsäcker, H.
1936. *Adam Elsheimer: Der Maler von Frankfurt,* pt. 1: *Des Künstlers Leben und Werke.* Berlin. **1952.** *Adam Elsheimer: Der Maler von Frankfurt,* pt. 2: *Beshreibende Verzeichnisse und geschichtliche Quellen.* Ed. H. Möhle. Berlin.

Wethey, H. E.
1964. "Orazio Borgianni in Italy and in Spain," *Burlington Magazine,* 106, pp. 146–59. **1970.** "Borgianni, Orazio," in *Dizionario biografico degli italiani,* vol. XII, pp. 744–47. Rome.

Wild, D.
1962. "L'*Adoration des Bergers* de Poussin à Munich et ses tableaux religieux des années cinquante," *Gazette des Beaux-Arts,* ser. 6, LX, pp. 223–48.

Wilson, W.
1966. "Poesia e simboli nel Caravaggio: Realtà e composizione storica," *Palatino,* X, pp. 115–17.

Wind, B.
1974. "Pitture Ridicole: Some Late Cinquecento Comic Genre Paintings," *Storia dell'arte,* no. 20, pp. 25–35. **1975.** "Genre as Season: Dosso, Campi, Caravaggio," *Arte lombarda,* no. 42–43, pp. 70–73.

Winternitz, E.
1967. *Musical Instruments and their Symbolism in Western Art.* London.

Wittkower, R.
1952. *The Drawings of the Carracci in the Collection of Her Majesty the Queen at Windsor Castle.* London. **1958.** *Art and Architecture in Italy, 1600–1750.* Baltimore.

Zahn, L.
1928. *Caravaggio.* Berlin.

Zamboni, S.
1965. "Vincenzo Campi," *Arte antica e moderna,* no. 30, pp. 124–47.

Zeri, F.
1954. *La Galleria Spada in Roma: Catalogo dei dipinti.* Florence. **1957.** *Pittura e Controriforma: L'arte senza tempo di Scipione da Gaeta.* Turin. (Paperbound ed., Turin, 1970.) **1959.** *La Galleria Pallavicini in Roma: Catalogo dei dipinti.* Florence. **1973.** *A Catalogue of the Collection of the Metropolitan Museum of Art. Italian Paintings,* vol. I: *Venetian School.* New York. **1976 a.** "Sull'esecuzione di 'nature morte' nella bottega del Cavalier d'Arpino, e sulla presenza ivi del giovane Caravaggio," *Diari di lavoro,* vol. II, pp. 92–103. Turin. **1976 b.** *Italian Paintings in the Walters Art Gallery,* 2 vols. Baltimore.

Zuccari, A.
1981. "La politica culturale dell'Oratorio Romano nelle imprese artistiche promosse da Cesare Baronio," *Storia dell'arte,* no. 42, pp. 171–93.